PHOTOGRAPHY
AND THE
AMERICAN SCENE

PHOTOGRAPHY
AND THE
AMERICAN SCENE

A Social History, 1839-1889

ROBERT TAFT

DOVER PUBLICATIONS, INC.
NEW YORK

International Standard Book Number: 0-486-21201-7

Library of Congress Catalog Card Number: 64-18373

Manufactured in the United States of America

Dover Publications, Inc.
180 Varick Street
New York 14, N. Y.

*This Dover edition is dedicated
to the memory of
Dr. ROBERT TAFT (1894-1955)
by his family*

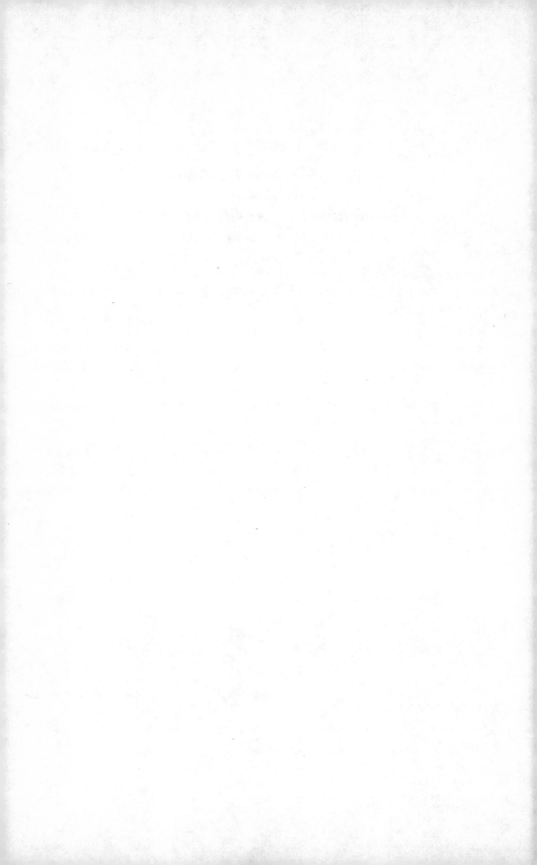

INTRODUCTION

NO LESS a historian than John Richard Green has called photography the greatest boon ever conferred on the common man in recent times. Green cannot be far wrong. Photography affects the lives of modern individuals so extensively that it is difficult to enumerate all of its uses. In addition to preserving for us the portraits of loved ones, it illustrates our newspapers, our magazines, our books. It enables the physician to record the inner structure of man and thus aids in alleviating man's ills. By its means, man has been able to study the infinitely small, to explore the outer reaches of space, to discover planets, and to reveal the structure of atoms. Crime has been detected through its agency as readily as have flaws in metal structures. It has recorded the past, educated our youth, and last, but not least, it has given us the most popular form of amusement ever devised.

It is indeed strange that, with all these important contacts with mankind, its history in this country has never previously been traced, despite the fact that photography has been practiced in this country for nearly a century. This seems all the more remarkable when one reflects that photography is the most universally practiced of all arts or crafts.

For some years I have been interested in the history of photography from a purely technical standpoint—a field in which there are several excellent handbooks. Over six years ago, in reading an account of the explorations of Frémont, the question arose in my mind as to the first use of photography in the exploration of the West. Upon looking this matter up, I found no ready reference to which I could turn for information. I then began the accumulation of facts, which as it grew, gradually evolved into a history of American photography.

Since technical histories are available which are, or should be,

independent of country, the only justification for adding to such literature, if it may be called that, would be a review of developments in this country. Not primarily from a technical viewpoint, but from that of social history. And such has been my attempt. I have endeavored to trace, however imperfectly, the effects of photography upon the social history of America, and in turn the effect of social life upon the progress of photography.

In seeking for a suitable method of expressing this thesis, which would serve layman and professional alike, I took as my outline a discussion of the history (as it affected this country primarily) of the various forms of photographs, each of which in its day has had its turn as the reigning favorite. After all, it is just as important historically to know who and what were photographed, and by whom, as it is to know how the photographing was done.

The illustrations have been collected not only from the standpoint of recording personalities and processes important in the field of photography, but also because they provide what is a more important service—a brief outline of the American scene in photograph. Personalities, scenes, events, incidents, dress, pathos and humor, work, play and progress live again in these photographs in a fashion which would be impossible from any written description, however vivid. If the efforts of one individual working largely at his own initiative and expense can make such a start as is represented by the photographs in this book, I venture to say that organized effort on a larger scale could assemble, given sufficient time, a duplication of the past in photograph that would leave little to be desired. The wealth of such material lying unused and uncared for in attics all over the country must *in toto* be truly astounding. In my judgment the effort would be well worth while; but it must be undertaken before many years pass.

Since this field has had no previous historian, my work in some respects has been easier than if there had been previous ones. On the other hand, first-hand facts (reliable source material, as the historian calls them) have had to be found and appraised. To condense the work of a century into these pages, considering this fact, was too large an undertaking. For that reason, my history is largely the history of the first half-century in photography, 1839-1889, although

there have been brief excursions into more modern history where these have seemed logical.

If I have seemed unduly punctilious about recording and stating references to the original literature, I hope the reader will bear with me, for this is primarily the report of a research and, as such, must give the evidence. Most of the material found within these pages I have not previously published. Chapter Thirteen (Civil War Photographers), however, appeared in the *American Annual of Photography* for 1937 in modified form, and portions of Chapters Three and Four were published in *American Photography* during 1935 and 1936. The notes on this previously published portion are included in the present book for the first time.

I am indebted to so many, for help in locating valuable material, that an enumeration of all such persons would itself run into several pages of text. The correspondence involved has run into well over two thousand letters. For this reason I have attempted to give due credit in the text or notes and trust that I shall be forgiven any omissions. I must acknowledge, however, the very great aid or encouragement of the following persons: Mr. K. D. Metcalf, formerly Chief of the Reference Department, New York Public Library; Mr. R. W. G. Vail, Librarian, American Antiquarian Society; Mr. Alfred Rigling, Librarian, The Franklin Institute; Dr. A. J. Olmsted of the United States National Museum; Mr. F. R. Fraprie, editor of *American Photography;* Mr. John A. Tennant, editor, *Photo-Miniature;* Mr. Frank V. Chambers, editor, *The Camera;* the late Frank H. Hodder, Professor of American History, University of Kansas; the late Frederick S. Dellenbaugh of New York City; Mr. C. M. Baker, Librarian, the University of Kansas; Professor F. B. Dains, the University of Kansas; Mr. Oren Bingham, photographer, the University of Kansas; Mr. C. B. Neblette, the Eastman Kodak Company; Mr. Beaumont Newhall, The Museum of Modern Art, New York City; Edward Epstean, New York City; my cousin, Miss Mildred Goshow of Philadelphia; my brother, Dr. K. B. Taft, of Chicago, who read and criticized my work in manuscript form and whose many suggestions have materially improved the readability of the text; and lastly and most important of all, Mr. W. H. Jackson of New York City, a survivor of pioneer days in American photography, who has

given generously of his time and knowledge in answering my many questions. I am also indebted to the committee on research of the University of Kansas, for a grant which aided in the preparation of the illustrations for this volume. Acknowledgment is gratefully made also to Harriet Magruder Bingham for suggestions used in designing the book cover.

However, any errors found in the following pages are chargeable to me alone. I should very much appreciate constructive criticism and additional information on the topics treated herein from those interested.

UNIVERSITY OF KANSAS,
 LAWRENCE, KANSAS

ROBERT TAFT

October 19, 1937

CONTENTS

PHOTOGRAPHY
AND THE
AMERICAN SCENE

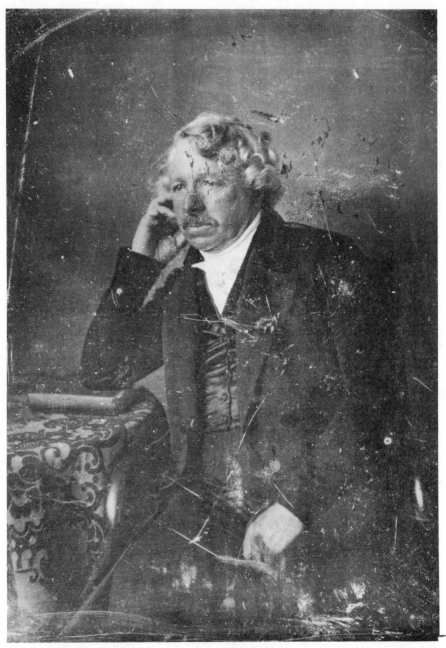

L. J. M. Daguerre. A photographic copy (1935) of an original daguerreotype made by Charles R. Meade of New York in 1848. The daguerreotype is now in the possession of the United States National Museum, through whose courtesy the copy is reproduced.

"Their Exquisite Perfection Almost Transcends the Bounds of Sober Belief"

HOW WOULD you describe a photograph if you had never seen one before and were totally unfamiliar with its appearance? It is difficult in our day to imagine such a circumstance, but less than a hundred years ago when the process of making photographs in an elementary form was introduced into this country, the problem was a real one. You will agree that Lewis Gaylord Clark, editor of *The Knicker-bocker,* a New York magazine, gave a good answer when he was asked the same question in 1839.

"We have seen the views taken in Paris by the 'Daguerreotype' and have no hesitation in avowing that they are the most remarkable objects of curiosity and admiration, in the arts, that we ever beheld. Their exquisite perfection almost transcends the bounds of sober belief. Let us endeavor to convey to the reader an impression of their character. Let him suppose himself standing in the middle of Broadway, with a looking glass held perpendicularly in his hand, in which is reflected the street, with all that therein is, for two or three miles, taking in the haziest distance. Then let him take the glass into the house, and find the impression of the entire view, in the softest light and shade, vividly retained upon its surface. This is the Daguerreotype! . . . There is not an object even the most minute, embraced in that wide scope, which was not in the original; and it is impossible that one should have been omitted. Think of that!" [1] *

The daguerreotype described by Clark was the result of the most extensively used of the early photographic processes. It was named from the originator of the process, Louis Jacques Mandé Daguerre, a citizen of France. Like many technical processes, Daguerre's final achievement was based on the experience of others as well as his own long and arduous labors. Daguerre was by profession a painter of the diorama, a form of amusement very popular

* Numbers in text refer to notes at the end of the book.

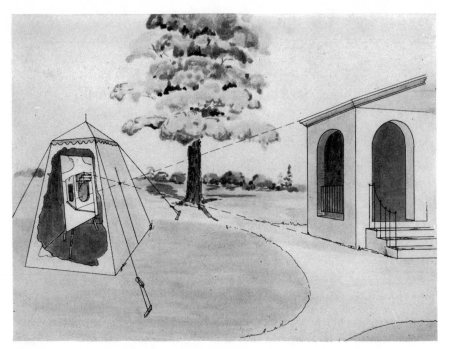

Illustrating the principle of the camera obscura—the original camera. Light passing through a small opening into a darkened space projects an inverted and laterally reversed image of the external scene on a screen opposite the opening. (Drawn for this history by Harriet Bingham, 1937.)

during the early part of the nineteenth century, of which he was co-inventor.[2] The diorama was essentially a succession of scenes painted on a canvas which was caused to pass before the observer, or else the observer himself was slowly moved before the paintings. Transparencies, openings and lights were combined with the paintings to produce quite remarkable effects.*

The idea occurred to Daguerre that possibly there might be some method of reproducing scenes upon the canvas without the labor of painting them, and to this end he began a series of experiments. While thus engaged he made, in 1826, the acquaintance of another Frenchman, Joseph Nicéphore Niepce (pronounced "knee eps"),

* The diorama, logically, if not technically, to be regarded as the predecessor of the modern cinema, was an exceedingly popular form of amusement for many years both abroad and in this country. For example, Longfellow in his diary (Dec. 19, 1846) records, "Went to see Banvard's moving diorama of the Mississippi. One seems to be sailing down the great stream, and sees the boats and the sand banks crested with cottonwood and bayous by moonlight. Three miles of canvas, and a great deal of merit." This he saw at a time when he was working on his poem "Evangeline"; and undoubtedly he made use of it, for he says, "The river comes to me instead of my going to the river; and as it is to flow through the pages of the poem, I look upon this as a special benediction." [3]

[4]

who was engaged in a somewhat similar study. Niepce was attempting to reproduce designs on lithographic stone without the necessity of actually copying by hand the design from the original. In 1829, after several preliminary conferences following their meeting, Daguerre and Niepce executed a partnership agreement which was to remain in force for some ten years. Niepce, however, died in 1833 and Daguerre continued his work—work which culminated in 1839 in the announcement of his discovery. How much of the credit is due Niepce and how much is due Daguerre for the discovery of this process has long been a debated question; as this is a record of American progress in photography, no judgment on the question will here be passed.[3a] Daguerre announced the discovery of the process which bears his name in January, 1839, and exhibited specimens of his work to the scientific world of Paris, although he was very careful not to reveal the nature of the process by which they were produced.[4] He had evidently become familiar with the process prior to this date, as he had tried unsuccessfully to float a commercial venture to sell and license rights to the process. As the result of this failure, Daguerre decided to appeal for government aid, which he did by interesting Arago, the most influential French scientist of the time, and secretary of the French Academy of Sciences.

Arago was dumfounded by Daguerre's specimens. "The most minute details of a scene are reproduced with an exactitude and sharpness well-nigh incredible," he commented before the French Academy and lost no time in laying the matter before the French government.[5] At Arago's recommendation a bill providing an annuity for Daguerre and for the heirs of Niepce was introduced and passed by the French legislative assemblies. In return for an annual income of six thousand francs (afterwards increased to ten thousand) and of four thousand francs for the heirs of Niepce, Daguerre was to describe his process publicly, and anyone who chose was to be permitted to employ it. France thus adopted the discovery immediately and most generously hoped to make it free to the entire world—a hope which was not entirely fulfilled. In passing, attention might be directed to the fact that this is one of the few instances in which prompt national recognition has been given an important discovery. To be sure, the annuity granted Daguerre was not large,

[5]

but it allowed him to retire and use his time as he pleased. From the standpoint of posterity, the French government's action has proved to be, in this case at least, a far better procedure than recourse to patent law would have been.

The contract of the French government with Daguerre was made on June 15, 1839.[6] The description of the process was not made, however, until two months later, when a public meeting of the French Academy of Sciences was arranged for the purpose on August 19, 1839.[7] Arago himself described the process at this meeting. Although Daguerre was present he could not be prevailed upon to speak. He possessed, according to Arago, "a little too much modesty, a burden which is so generally lightly borne." The London *Globe* of August 23, 1839, reported the meeting as follows:

"It having been announced that the process employed by M. Daguerre for fixing images of objects by the camera obscura would be revealed on Monday, at the sitting of the Academy of Sciences, every part of the space reserved for visitors was filled as early as one o'clock, although it was known that the description of the process would not take place until three. Upwards of two hundred persons who could not obtain admittance remained in the court yard of the Palace of the Institute."

The process of Daguerre, as described by Arago, was briefly as follows: A sheet of copper was plated with silver, the silver surface being well cleaned and polished. The silver surface was then exposed, in a small box, to the action of iodine vapor at ordinary temperature until the surface assumed a golden yellow color, a step which took from five to thirty minutes. The sensitized surface (now known to be a film of the silver compound, silver iodide) was placed in a camera obscura, an instrument which had been known for several centuries.*

* The camera obscura, shortened to simply "camera" after the advent of photography, was known, in principle at least, to Euclid (300 B.C.). Leonardo da Vinci described it in some detail during the fifteenth century. It became best known through the efforts of the Italian, Porta, about a century after da Vinci's time. Porta apparently did not improve it, but a countryman and contemporary of his, Barbaro, suggested the use of a lens in conjunction with the camera obscura. The initial instrument consisted essentially of a window shutter, closed to exclude all light from a small room. Through the shutter a small hole was made, admitting a small ray of light. The light thus admitted fell upon a white screen where there appeared in reverse an image of the exterior objects which had reflected the light through the opening. It was but a step further to use a small box with a convex lens to secure better illumination and definition, and a ground glass as the receiving screen. The instrument in this form had been used by artists in reproducing scenes for many years.

[6]

The sensitized metallic surface, according to Daguerre, was to remain in the camera obscura from "five to six minutes in summer and from ten to twelve minutes in winter. In the climate of the tropics, two or three minutes should certainly be sufficient." [8]

It was then withdrawn from the camera, but "the most experienced eye could detect no trace of the drawing." [9] Daguerre had recognized that an image was present (now technically called *the latent image*), but that it must be brought out by a subsequent process. This is a fact of very common knowledge for the present-day amateur photographer who "develops" his own film. Daguerre's developing agent, however, was none of the solutions of the present day, but the liquid metal, mercury. That is, the daguerreotype plate with its latent image supported in a closed box was exposed to the action of mercury heated to 167 degrees Fahrenheit. The mercury vapor rising from the warm liquid metal "developed" the image. Where the plate had received the most light a film of mercury was deposited; where no light (i.e., the deep shadows) had fallen on the plate no mercury deposited. In order to remove the sensitive material left upon these areas, the developed daguerreotype plate was washed with the now familiar solution of "hypo" or, as it was then called, "hyposulfite of soda." The picture thus produced was washed with distilled water, dried and mounted under glass to produce the finished daguerreotype. The glass was a very necessary protection as the high lights (that is, the bright areas in the original subject) were produced by the film of mercury as described above and could be rubbed off. The shadows were, of course, produced by the darker bare silver.

A well made daguerreotype is a thing of real beauty, and in some respects is not surpassed by the products of any modern process, for a good daguerreotype possesses brilliance and shows detail far better than any paper print. There are, nevertheless, some outstanding defects which should be noted. Because of the mirror-like surface, the image can be seen only when held in a certain position. If held at most angles it simply reflects light over its entire surface into the eyes of the observer. Examination is best made in a fairly

Without doubt many a user had devoutly wished for some method of "fixing" the image of the camera obscura, but until Daguerre's time it had not become a reality.

strong but diffuse light. Furthermore, only one copy of the image could be obtained from each exposure of the camera. That is, the method did not permit of making duplicate copies from a master negative as does our modern process. Finally the daguerreotype image is reversed from right to left.*

Even with these defects the daguerreotype continued for nearly fifteen years to be the most important of all photographic processes. Those of you who have had the good fortune to examine a large and well made daguerreotype will not wonder at the amazement of the scientific and artistic worlds when the early products of Daguerre's skill were introduced into a photographless world. One might even have believed with Paul Delaroche, the famous French painter, who was among the first to see Daguerre's original work, that "Painting is dead from this day." [10]

* * * * * * *

The introduction of daguerreotypy into America followed shortly after its first public announcement abroad. As has been pointed out, Daguerre did not describe his process until August 19, 1839, but the popular and scientific press of France and England had printed various accounts of the daguerreotypes on exhibition as early as January of 1839. Some of these accounts were reprinted in the American press. The Boston *Mercantile Journal,* early in March, 1839, printed a description of the finished result of Daguerre's process as compared to a rival process proposed by the Englishman, Talbot.† This was reprinted in a number of the papers of that day, including the *National Intelligencer* of Washington (March 7, 1839). A little over a month later there appeared in many of the American newspapers an account of the daguerreotype written by Samuel F. B. Morse who at that time was in Paris. This originally appeared in the New York *Observer* for April 20, 1839, and was reprinted in newspapers throughout the country. Most of these accounts were received with considerable caution, not to say skepticism, by the intelligent men of the day and the public at large.[11] And well might the public be cautious, for it had been only a few

* If the reader is unfamiliar with this effect, turn to the illustration on page 94 which shows such reversal.

† To be described in Chapter Six.

years since there had been perpetrated on the American public one of the most celebrated scientific hoaxes of all time.

This hoax was based on a series of articles appearing in the New York *Sun* from August 21 to August 31, 1835, which were supposed to be the reports of the work of Sir John Herschel, an eminent English astronomer, who had been sent by the British government to the Cape of Good Hope to make certain astronomical observations. With this much foundation of fact the *Sun* articles proceeded to describe an enormous telescope built by Herschel for observing the moon. The articles were clothed in pseudo-scientific language, so that even the more learned were rendered gullible. It was alleged that by the aid of the telescope Herschel saw the geographical features of the moon in considerable detail, as well as living inhabitants, including man-like bats. As the *Sun* was the only newspaper printing the original articles, its circulation increased enormously; and, as it eventually turned out, the articles had been devised for that particular purpose.[12] It is no wonder, then, that when the early reports of the daguerreotype reached this country they were discredited with, "Ah, another edition of the famed moon-hoax."

The first American citizen to come into close contact with Daguerre before the publication of his process was Samuel F. B. Morse, whose letter to the New York *Observer* has already been mentioned. Morse played an important part in the early development of daguerreotypy in this country, and his visit to Daguerre therefore deserves special mention.

In the summer of 1838 Morse had gone abroad with the object of securing patents in England and in France for his electro-magnetic telegraph, upon which he had been working for some years. After meeting failure in England he went to Paris and was there able to secure a French patent on his invention. He remained in Paris for some time, hoping to get a contract from the Russian government for the same invention. The negotiations were so long continued that he was forced to remain in France until the early spring of 1839, and was thus in Paris when Daguerre's discovery was receiving large publicity in January of that year. Morse in addition to being the inventor of the telegraph had achieved in his early life considerable distinction as a portrait painter, and was, in fact, for some

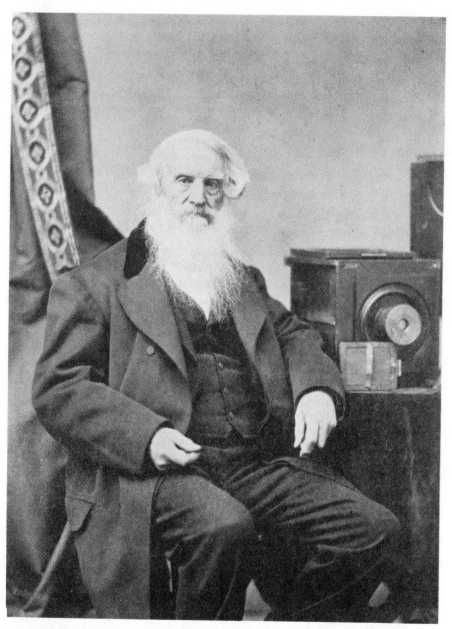

Samuel F. B. Morse and his first daguerreotype camera. The camera is now in the possession of the United States National Museum. (Photograph by A. Bogardus, New York, 1871.)

eighteen years (1827-1845) president of the National Academy of Design, an association of many of the prominent artists of that day. In addition, Morse had received some training in science as a student at Yale and had apparently actually made some unsuccessful experiments during his student days with the object of "fixing" the image of the camera obscura. The announcement of Daguerre's discovery naturally interested him and he sought an audience with Daguerre. As Morse had also achieved considerable reputation in Paris for his discovery, Daguerre readily consented and suggested a Sunday on which Morse could view the results of his work. Morse's Puritan training exerted such an influence that he politely replied to Daguerre by inquiring if "Monday, or any other day" would be agreeable to Daguerre. Daguerre cheerfully consented and during the early part of March, 1839, Morse was able to obtain his first view of the photographs on silver. His impressions of this visit are of interest and were described two days later in the letter which was published in the New York *Observer*, a portion of which reads as follows:

"You have perhaps heard of the Daguerrotipe, so called from the discoverer, M. Daguerre. It is one of the most beautiful discoveries of the age. I don't know if you recollect some experiments of mine in New Haven, many years ago, when I had my painting room next to Professor Silliman's—experiments to ascertain if it were possible to fix the image of the Camera Obscura. I was able to produce different degrees of shade on paper, dipped into a solution of nitrate of silver, by means of different degrees of light; but finding that light produced dark, and dark light, I presumed the production of a true image to be impracticable, and gave up the attempt. M. Daguerre has realized in the most exquisite manner this idea.

"A few days ago I addressed a note to Mr. D. requesting, as a stranger, the favor to see his results, and inviting him in turn to see my Telegraph. I was politely invited to see them under these circumstances, for he had determined not to show them again, until the Chambers had passed definitively on a proposition for the Government to purchase the secret of the discovery, and make it public. The day before yesterday, the 7th, I called on M. Daguerre, at his rooms in the Diorama, to see these admirable results.

"They are produced on a metallic surface, the principal pieces about 7 inches by 5, and they resemble aquatint engravings; for they are in simple chiaro oscuro, and not in colors. But the exquisite minuteness of

the delineation cannot be conceived. No painting or engraving ever approached it. For example: In a view up the street, a distant sign would be perceived, and the eye could just discern that there were lines of letters upon it, but so minute as not to be read with the naked eye. By the assistance of a powerful lens, which magnified fifty times, applied to the delineation, every letter was clearly and distinctly legible, and so also were the minutest breaks and lines in the walls of the buildings; and the pavements of the streets. The effect of the lens upon the picture was in a great degree like that of the telescope in nature.

"Objects moving are not impressed. The Boulevard, so constantly filled with a moving throng of pedestrians and carriages was perfectly solitary, except an individual who was having his boots brushed. His feet were compelled, of course, to be stationary for some time, one being on the box of the boot black, and the other on the ground. Consequently his boots and legs were well defined, but he is without body or head, because these were in motion.

"The impressions of interior views are Rembrandt perfected. One of Mr. D.'s plates is an impression of a spider. The spider was not bigger than the head of a large pin, but the image, magnified by the solar microscope to the size of the palm of the hand, having been impressed on the plate, and examined through a lens, was further magnified, and showed a minuteness of organization hitherto not seen to exist. You perceive how this discovery is, therefore, about to open a new field of research in the depth of microscopic nature. We are soon to see if the minute has discoverable limits. The naturalist is to have a new kingdom to explore, as much beyond the microscope as the microscope is beyond the naked eye.

"But I am near the end of my paper, and I have unhappily to give a melancholy close to my account of this ingenious discovery. M. Daguerre appointed yesterday at noon to see my Telegraph. He came, and passed more than an hour with me, expressing himself highly gratified at its operation. But while he was thus employed the great building of the Diorama, with his own house, all his beautiful works, his valuable notes and papers, the labor of years of experiment, were, unknown to him, at the moment becoming the prey of the flames. His secret indeed is still safe with him, but the steps of his progress in the discovery and his valuable researches in science are lost to the scientific world. I learn that his Diorama was insured, but to what extent I know not. I am sure all friends of science and improvement will unite in expressing the deepest sympathy in M. Daguerre's loss, and the sincere hope that such a liberal sum will be awarded him by the Government as shall enable him, in some degree at least, to recover from his loss."

[12]

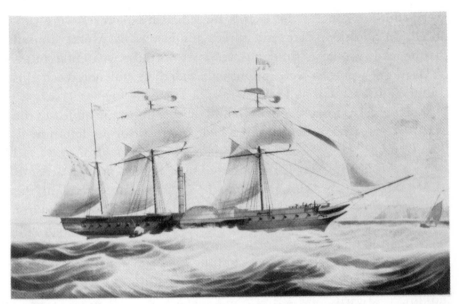

The *British Queen,* the steam packet which first brought a description of Daguerre's process to this country; one of the first of the transatlantic steam-driven vessels, "the largest and finest steamship ever built." (After an aquatint engraved by Edward Duncan about 1839. Courtesy, New York Public Library.)

The fire alluded to by Morse was a severe blow to Daguerre, as can be well imagined. Fortunately it did not interfere with the publication of his results.

As a result of this letter and Morse's visit to Daguerre, the impression has been created that Morse became acquainted with the details of the process prior to the public description of Daguerre's process which it will be recalled was not made until August 19, 1839. In the *Letters and Journals* of Morse, prepared by his son, E. L. Morse, it is stated that Daguerre at the time of Morse's visit "generously imparted the secret of the new art to the American by whom it was carried across the ocean and successfully introduced into the United States." [13]

There is little evidence for the truth of this statement, and, as a matter of fact, much direct evidence against it. It does not appear at all reasonable that Daguerre would impart the exact nature of his process to a foreigner at a time when he was carrying on negotiations with the French government for its purchase. An examination of the various contemporary accounts shows that Daguerre made

[13]

every effort to conceal the details by which his pictures were produced. In addition, there are direct admissions by Morse himself that he made no successful daguerreotypes until the written accounts of Daguerre's process were published, and these did not reach this country until the fall of 1839.[14]

Fortunately, from the standpoint of the historian at least, the exact date on which this news reached America can be determined. The October, 1839, issue of the *American Journal of Science and Arts* (published in New Haven) stated that the first printed account of M. Daguerre's process was brought by "the late arrival of the *British Queen*." [15] In the *Morning Courier* and New York *Enquirer* of September 21, 1839, we find in the "Maritime List Arrived," on September 20, the notice, "Steamship *British Queen,* Lieut. Roberts, R. N., Commander, from Portsmouth, 3rd September, . . . 17th, exchanged signals to an English schooner, standing E; passed a brig standing westward."

The date of clearance from Portsmouth, September 3, would have given the *British Queen* ample time to receive the printed accounts of Arago's description of Daguerre's process made on August 19. The French newspapers immediately published accounts of the process, and on August 23 the accounts were available in the English newspapers.[16]

This date, then, of September 20, 1839, marks the beginning of practical photography in America, for immediately upon the reception of these published accounts we find a number of individuals beginning experiments trying to duplicate Daguerre's results in this country. Copies of the London *Globe* of August 23 were available in New York City, and as the *Globe* article contained sufficient information for those interested, the first trials were undoubtedly made soon after September 20. By September 25, the method had been published in other American cities. The *United States Gazette* of Philadelphia on September 25, 1839, published a brief description which was translated from a French account by Dr. Alexander Dallas Bache, a great-grandson of Benjamin Franklin.[17] On the same date the London *Globe* account of Daguerre's process was published in the *National Intelligencer* of Washington; on September 28 it was published in *Niles' Weekly Register* of Baltimore. Consequently, a

few days after its arrival in this country, the nature of the method of obtaining daguerreotypes was known in most of the principal cities of this country, and while not detailed, the account was sufficient to start America's first amateurs to work.

And who were these "first amateurs"?—for, of course, all were amateurs then. The names of a few have been recorded; doubtless there were some whose names are lost in obscurity. Since New York was the first to receive the news, it can be reasonably assumed that the amateurs of that city made the first experiments, especially as Samuel Morse, whose interest had been greatly aroused by his "preview" of the process, was a resident of that city. Morse states that immediately upon receipt of the news he had a Daguerrean camera made for him by Prosch, an instrument maker who also made Morse's telegraph instruments.[18] As Morse recalled it sixteen years later, he made the first successful daguerreotype with this instrument in September of 1839. It was a view of the Unitarian church, from the window on the staircase of the third story of the New York City University. Morse also says that there were several persons who immediately began experimenting in September, 1839, among them an Englishman whose name he could not recall.

Certain New Yorkers, however, were probably much impressed when they read in the *Morning Herald* for September 30, 1839, a news story that began:

"THE NEW ART.—We saw the other day, in Chilton's, in Broadway, a very curious specimen of the new mode, recently invented by Daguerre in Paris, of taking on copper the exact resemblances of scenes and living objects, through the medium of the sun's rays reflected in a *camera obscura*. The scene embraces a part of St. Paul's church, and the surrounding shrubbery and houses, with a corner of the Astor House, and, for aught we know, Stetson looking out of a window, telling a joke about Davie Crockett. All this is represented on a small piece of copper equal in size to a miniature painting."

The nature of the process is then described and the article continues: "Mr. Segur, of this city, on this description, set to work his powers, and, about three days ago, succeeded in making the experiment." An interesting comment is made on the exposure Segur required to obtain the above view; the camera is directed in the clear

sunlight at the objects to be represented "for eight or ten minutes . . . in Europe a longer exposure is required, because an American sun shines brighter than the European." The Yankee trait of bragging about one's belongings and environment had evidently, even at this early date, been well established as a habit.

The article concludes by saying: "The specimen at Chilton's is a most remarkable gem in its way. It looks like fairy work, and changes its color like a camelion according to the hue of the approximating objects. Ladies, if they are pretty, with small feet and delicate hands, fond of science, ought to call and see it. It is the first time that the rays of the sun were ever caught on this continent, and imprisoned, in all their glory and beauty, in a morocco case, with golden clasps."

Evidently, if we are to believe the reporter, plain ladies with large feet would not be interested in viewing an example of the new art. Apart from its pleasant ambiguity, however, the account is important because it records the making of the first daguerreotype produced in this country. This claim is further strengthened by the fact that a few days after the *Morning Herald's* story had been published, the following advertisement appeared in the same paper:

"THE DAGUERREOTYPE.—A lecture will be given by Mr. Seager, at the Stuyvesant Institute, on Saturday evening, the 5th inst. at half past seven o'clock, upon the Daguerreotype, or art of imprinting, in a few minutes, by the mode of Mr. Daguerre, the beautiful images of Landscapes, Architecture, Interiors, etc. formed in the Camera Obscura. These drawings will be found so perfect that distant houses, appearing not larger than a pin's head, may be magnified to discover doors, windows, etc.—The process is rapid and simple, but requiring delicacy, and a certain adherence to rules which will be explicitly laid down, as well as the particular minutiae to be observed to ensure a certainty of success. The process cannot be carried to ultimate completion by candlelight, but every stage of the operation will be exhibited to familiarise others with the mode.

"The following scientific gentlemen have given permission to be referred to as being familiar with the process and its extraordinary results:

"President Duer, Columbia College; Professor Morse; James R. Chilton, Esq.; Jno. L. Stephens, Esq.

"Tickets, 50 cents, may be had of Dr. Chilton, 263 Broadway; at the

Messrs. Carvill's, at the Booksellers', and at the Stuyvesant Institute,—Broadway." [19]

And on the day following we find Mr. Seager again mentioned in the day's news:

"THE NEW ART—DAGUERREOTYPE.—Mr. Seager, the ingenious artist of this city, who has first succeeded in catching the sun's rays and imprisoning them in a morocco case, that is to say, who has transformed figures and landscapes to copper, by the medium of light alone acting on chemical substances—gives a lecture on the art tomorrow evening, at the Stuyvesant Institute. We have a specimen of his ingenuity in our possession, which looks like a piece of fairy work in golden colors."

Morse, who at the time was professor of the literature of the arts of design in the University of the City of New York, was thus a sponsor of Seager's and doubtless was well aware of the claims made for him by the *Morning Herald,* and as far as is ascertainable made no effort to refute them. The claims which Morse made, as has been stated, were published some sixteen years later, when his memory could well have become dulled; but he did recall that there was another who also began to experiment with the daguerreotype "immediately." To Seager then, must go the honor, as far as available evidence goes, of having made the first daguerreotype in the new world.

Our knowledge of Mr. Seager is indeed limited. If we piece together what little information we have of him at present the result would be something like this: D. W. Seager was an Englishman residing in New York City in 1839. He was the first person to make a successful daguerreotype in the United States, which he did on September 27, 1839. For a few months he gave lectures in New York City on the art of taking daguerreotypes. During the latter part of his life he lived in Mexico.[20] Rather a meager biography to write for an individual who occupies as important a position as does Seager in the history of American photography.

Other early New York amateurs who tried Daguerre's process were Dr. James Chilton, a physician and chemist, whose address is mentioned in the newspaper accounts already given; a Professor C. E. West; and Dr. John W. Draper.[21] Draper was professor of

Professor John W. Draper (from a photograph made in 1860).

chemistry in the University of the City of New York, the same institution with which Morse was connected. Draper was one of the outstanding men intellectually of his time. An Englishman by birth, he received his education at the University of Pennsylvania, and there was a student of Robert Hare, one of the foremost chemists of his day. Although a chemist by training, Draper achieved a wide reputation not only in chemistry, but in the fields of physiology, of history, and of philosophy. While the extent of human learning was far more limited, especially in the scientific branches, during Draper's day, it was no mean accomplishment to gain an international reputation in four divisions of thought. Several years before notices of Daguerre's work had found their way into the press, Draper had been interested in the properties of light and had actually used silver iodide and bromide to record its action.[22] He was therefore quick to realize the importance of Daguerre's discovery, and was one of the first in this country to try the process. Since he and Morse were colleagues, it was but natural that they should soon become associated in their experiments on the daguerreotype.

With Draper's chemical training and previous investigations in the properties of light, it is not to be wondered at that Draper's results were acknowledged at the time to be the best produced. He soon pointed out that the lens of the camera brought the rays which were most active in producing the daguerreotype image to focus at a shorter distance from the lens than those which are seen by the eye, so that it was necessary to reduce somewhat the distance between plate and lens when the image was seen to be in visual focus. "The amount of shortening to be given the camera," he says, "where the lens is fifteen inches focus, does not commonly exceed three-tenths of an inch." Not a very great distance, to be sure, but it produced the difference in the finished daguerreotype between a sharply defined image and the hazy one which resulted when the "shortening" was not made. The reader must recall that this was before the day of the highly corrected lens systems of the present, the lenses available being those made for use in telescopes, reading glasses, eye glasses, and the like. In fact, Draper has stated that some of his finest specimens of the daguerreotype were obtained "with a com-

mon spectacle lens of fourteen inches focus, arranged at the end of a cigar box as a camera." [23]

While the experimenters were thus busily at work in New York, interest in the daguerreotype was being shown in other cities. In Philadelphia we find that on October 16, 1839, Joseph Saxton exhibited what was presumably the earliest daguerreotype made in that city. This was a view taken from the window of the United States Mint, where Saxton was employed, "of the old Arsenal and the cupola of the old Philadelphia High School." [24] Others who were early active in Philadelphia were Robert Cornelius, a metal work and chandelier manufacturer; Dr. Paul Beck Goddard, at that time connected with the chemistry department of the University of Pennsylvania; and a Professor W. R. Johnson.[25]

In Boston a Professor Grant and a Mr. Davis produced a daguerreotype view the third day after an account of the process had been published in that city.[26] But the most distinguished of the Bostonians to try his hand at daguerreotypy shortly after its introduction into this country was Edward Everett Hale, his first daguerreotype being of the Boston church "of which, queerly enough, I became minister sixteen years after," as Hale stated in a letter written many years later."[27]

Very likely, too, in many smaller cities and in colleges and universities experiments were soon under way, many no doubt resulting in passable examples of the daguerreotyper's art.

Even in far away Kentucky, daguerreotypes, with imported apparatus, were made during the fall of 1839. It appears that Drs. Bush and Peter of the Transylvania College faculty were sent abroad by the city council of Lexington, Kentucky, to purchase apparatus for the recently organized medical school of Transylvania, an appropriation of $15,000 having been made by the council for this purpose. On August 22, Professor Bush wrote home from London: "We shall sail on the First or Second of September on the *British Queen*. . . . It has cost us a great deal of labor and research to get all the articles we wanted, but we are repaid by the satisfaction of knowing that we shall have such a collection of the means of medical instruction as is rarely to be found in the country." As can be seen from the date of the letter and the reference to the *British Queen,* these gen-

[20]

tlemen were abroad when the daguerreotype process was first publicly announced, and consequently must have shared in the widespread interest that the announcement caused in scientific circles. It is no wonder then that they included in their scientific purchases a complete daguerreotype equipment, as described by Daguerre and prepared in Paris. It may be doubtful whether this equipment was ready in time to accompany Drs. Bush and Peter on their return on the *British Queen,* but certain it is that the imported equipment reached Transylvania in the fall of 1839, and that the same fall Dr. Robert Peter took with this camera the first daguerreotype in Kentucky, a copy of the death mask of Talleyrand, still in possession of the heirs of Dr. Peter.[28]

Facsimile of an early Philadelphia daguerreotype made by Dr. Paul Beck Goddard, October, 1842. "The eleventh annual exhibition of The Franklin Institute." The daguerreotype was photographed in 1893 by J. F. Sachse. (Courtesy, The Franklin Institute.)

First Portraits and First Galleries

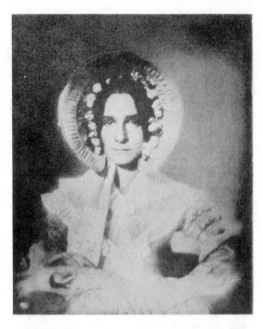

Miss Dorothy Catherine Draper, the daguerreotype
portrait made by Professor Draper, probably in the
summer of 1840. Reproduced from a negative of the
original daguerreotype, made in 1933 especially for
this history through the courtesy of the owner, the
Reverend Sir John C. W. Herschel, Bart., of Slough,
England. The image has now (1937) disappeared
from the daguerreotype.

THE READER may have noticed that the early American daguerreo-
types already described were either outdoor views or copies of still
objects. The exposures required for making a photograph on silver
were so long as to make it almost a physical impossibility for the
sitter to remain still long enough to obtain a distinct portrait. Morse
was especially interested in this point, for as will be recalled, he had
been for many years a portrait painter. On his visit to Daguerre in
March of 1839 he had asked about the possibility of portraiture by
[22]

photography. Daguerre, according to Morse, held little hope for the practicability of portrait taking by his process.

The necessary length of exposure of the first daguerreotypes made in this country is to be found in a table prepared by D. W. Seager, and published in the *American Repertory of Arts, Sciences and Manufactures* for March, 1840.[29] As it is the first exposure table published in this country, it possesses enough interest to warrant its reproduction in full.

TABLE OF GENERAL RULES FOR EXPOSURE
OF THE PLATE IN THE CAMERA, IN TAKING EXTERIOR VIEWS

The following table is compiled partly from observation, and partly from analogy, and applies only to the period from the month of October to February. The observations were made upon ordinary city views.

State of the Weather	Hours of the Day						
	8	9	10	11-1	1-2	2-3	3 and after
				—Minutes—			
Very brilliant and clear, wind steady from W. or N.W., very deep blue sky, and absence of red rays at sunrise or sunset.							
Time employed	15	8	6	5	6	7	12-30
Clear, wind from S.W., moderately cold, but a slight perceptible vapor in comparison with above.							
Time employed	16	12	7	6	7	8	15-40
Sunshine, but rather hazy, shadows not hard nor clearly defined.							
Time employed	25	18	14	12	14	16	25-40
Sun always obscured by light clouds, but lower atmosphere clear from haze and vapor.							
Time employed	30	20	18	16	15	20	35-50
Quite cloudy, but lower atmosphere free from vapors.							
Time employed	50	30	25	20	20	30	50-70

"It is impossible, at present," the editor of the *Repertory* goes on to say, "to state precisely the time required to expose the plate in the camera at all seasons of the year . . . the time will necessarily decrease as the summer months approach."

As can be seen by examining the table given above, the shortest exposure tabulated was five minutes, and even if this were reduced by half in the summer months the time required would still preclude the likelihood of obtaining portraits by the daguerreotype camera.

Such seeming impossibilities were but incentives to Yankee ingenuity, however, for the process had not much more than been introduced to the new world before we find four or five claims, all American, for use of the daguerreotype process for taking portraits. It is sufficient to say, for the present, that the process had not been public property for a year before there were a number of individuals, both at home and abroad, who were making their living, either in whole or in part, by making daguerreotype portraits.

Since all the early claimants for the honor of having taken the first photographic portraits were Americans, the problem of determining who was the first of these is somewhat simplified; but it must be said that for none of the claims advanced can sufficient authentic evidence be adduced to settle without doubt the question as to who took the first photographic portraits.[30] As usual, the question "Who was first?" did not arise for some years after the daguerreotypists' profession had become well known. By that time men's memories had become somewhat obscured, and, as a result, there has been considerable controversy waged among the few who have been interested in the problem since that day. None of these interested persons has looked at the matter dispassionately, however, nor have the existing records been examined carefully—some, indeed, have been overlooked completely. For these reasons an attempt will be made here to produce as authoritative an answer to the question of "Who made the first daguerreotype portrait?" as the evidence will permit.

To begin with, let us list those who at one time or another have maintained, or have had claims made for them, that they produced the first photographic portrait. These claimants are Samuel F. B. Morse, John W. Draper, and Alexander S. Wolcott of New

York City; Joseph Dixon of Jersey City; and Robert Cornelius of Philadelphia.

The claims of Draper and of Wolcott are to be considered more seriously than the rest; for that reason the assertions by or about the others will be disposed of first.

Writing in 1853, Morse states that he began his experiments with daguerreotype portraiture as soon as he had mastered the process itself. The first of these experiments were made "in September or the beginning of October, 1839," and were portraits of his daughter and groups of her friends. Morse continues, "About the same time, Professor Draper was successful in taking portraits; *though whether he or myself took the first portrait, I cannot say.*" *

As will be seen, this claim was made sixteen years after his experiments, so that the exact date was quite uncertain in Morse's mind. Very likely Morse did make attempts to take portraits by the new photographic process, but it is very doubtful if his attempts succeeded. Morse himself stated that the portraits required ten to twenty minutes exposure, a period so long that no sitter could remain still. The most convincing testimony against Morse's claim is found in a letter written by Morse to Daguerre and dated November 19, 1839, which, it will be noticed, is coincident with the time under discussion.[30a] In this letter he wrote Daguerre that he had been experimenting "with indifferent success" with Daguerre's process. Morse further remarked to Daguerre, "You shall have the first that is in any degree perfect." It is apparent that any success that Morse obtained must have come after November 19, 1839. This fact together with Morse's admission that his claim is coincident with Draper's, practically eliminates him from consideration for the honor in question.

The claim of Dixon was not made until 1868, when he stated that he had made the first photographic portrait in this country in "the early part of September, 1839." [31] As no other evidence is available, his claim must be disallowed, for we have seen that the nature of the process did not become known until after September 20, 1839, that is, until the latter part of September.

* The italics in this quotation are the author's and are made to emphasize the fact that Morse's claim to priority was practically coincident with Draper's claim.

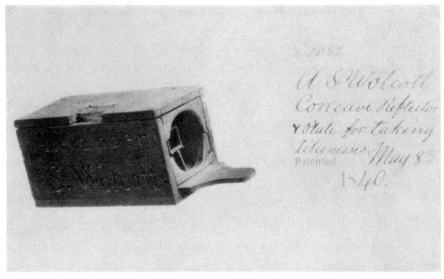

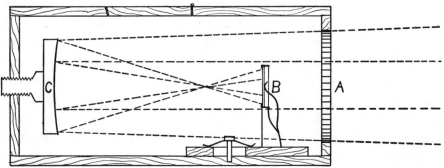

Upper. The camera of Alexander S. Wolcott, filed with Wolcott's application for the first photographic patent issued in this country. Photograph made in 1935. (Courtesy, United States National Museum.) *Lower.* Diagrammatic cross-section of Wolcott's camera drawn from the patent specifications by O. R. Bingham, 1935. *A* is the large aperture, *C* the concave mirror used to reflect the image back upon the daguerreotype placed in the adjustable holder, *B.* Notice the hinged door at the top of the instrument which was used to make any necessary adjustment of focus.

The claims of Robert Cornelius of Philadelphia were not advanced until 1893, when Julius F. Sachse, a Philadelphian, without considering any other claims, asserted that Cornelius was entitled to the honor of having made the first daguerreotype portrait.[32] The evidence which Sachse presents is neither clear nor conclusive, and is based on a word-of-mouth statement from Cornelius to Sachse, presumably shortly before the time that Sachse published his researches. Undoubtedly this story at that time (1893) must have come from a man well along in years, if Cornelius had made the

first daguerreotype portrait in the fall of 1839, so that the statement would therefore be subject to the vicissitudes of the old man's memory. "Unfortunately," says Sachse, "the exact date of this successful experiment at portraiture has not come down to us, nor is Mr. Cornelius able to recall it with certainty."

According to Sachse, the experiment was made after Cornelius had seen the first daguerreotype made in Philadelphia by Joseph Saxton, which is said to have been on October 16, 1839. Just how soon after October 16th Cornelius saw Saxton's effort and how soon he began his own attempts at daguerreotypy we have no way of knowing. Since Cornelius, at the time that he saw Saxton's daguerreotype, had no apparatus and was not familiar with the process, it is reasonable to suppose that some time must have elapsed before such attempts were made. It is further stated that Cornelius' first subject was himself in his own back yard. Were this true, undoubtedly long exposure must have been used to obtain any image at all, and it is extremely unlikely that Cornelius was able to obtain what could be called a successful portrait. After all, the question to be settled is not "Who first tried to make a photographic portrait?" but "Who succeeded in making the first successful portrait?" As a matter of fact, the earliest authenticated date which has been found indicating that Cornelius had made successful daguerreotype portraits is April 23, 1840.[33] Very probably, however, Cornelius had been successful before this date.

Draper's claim to having made the first successful photographic portrait rests upon a letter which he wrote and dated March 31, 1840, and sent abroad for publication. Notice of its receipt was published in the *Philosophical Magazine* for June, 1840.[34] It briefly stated that Draper had "succeeded during the winter in producing portraits by the Daguerreotype." The winter referred to, of course, is that of 1839-40. Just when Draper's first successful portrait was obtained is not stated in the communication. March 31, 1840—the date of Draper's letter—has by many been erroneously regarded as the date of the first successful portrait. Draper maintained with vigor during his later life that he took the first portrait, but nowhere does he state the time when he first succeeded.[35] In searching for sources of information which were actually published during 1839

and 1840, I have found a brief article published by Draper in July, 1840, in that obscure and short-lived journal, *The American Repertory of Arts, Sciences, and Manufactures,* to which reference already has been made. In this article occurs the sentence, "The first portrait I obtained last December was with a common spectacle glass." [36] While possibly open to several interpretations, the statement, to judge from its context, probably refers to Draper's first successful portrait. If so, we can fix Draper's claim as closely as December, 1839, and it is doubtful if any better claim can now be made for him. Draper kept no diary, nor are there available any of his contemporaneous letters which might throw more light upon the matter.[37]

As will soon become apparent, I do not think that Draper's claim, upon the information now available, can be justified. Nevertheless, Draper played a leading and important part in early daguerreotypy and photographic portraiture in this country. Draper, as we have seen, for at least ten years prior to 1839 had been interested in the chemical effects of light, and the numerous experiments he made gave him a decided advantage over those who did not have this interest and training. Undoubtedly he almost immediately recognized that the problem of photographic portraiture, which seemed dubious to Daguerre, resolved itself into either increasing the amount of light which fell upon the sensitized silver surface, or producing a sensitized surface which would respond more quickly to a given amount of light.

As a matter of fact, he states that after making the early attempts at portraiture described above he employed a lens four inches in diameter and of short focus. Such a lens would pass at least four times as much light as one the size of an ordinary spectacle lens and would thus reduce the period of exposure to at least one-fourth. Draper's knowledge of the difference in the chemical focus and optical focus has already been mentioned as contributing to his early success, and it may be possible that he, as a chemist, made more or less successful efforts to increase the sensitivity of the silver surface. The substances chlorine and bromine are closely related chemically to the iodine which Daguerre employed for producing his light-sensitive surface. Knowing this, Draper probably made ex-

[28]

periments, either substituting these materials for iodine or using them in conjunction with it. We know, in fact, that he did employ chlorine and he may thereby have been able to increase the speed of his daguerreotype plate. Within a year or so after its introduction, the problem of speeding up the daguerreotype plate was actually solved by such a procedure.

Apparently, none of the earliest attempts at portraiture by any of the five men we have mentioned has survived. The earliest surviving portrait which has been found is one taken by Draper. I think it likely that this was made in the summer of 1840. The original is still in existence, and a reproduction of it will be found on page 22. The present owner of this daguerreotype, the Rev. Sir John C. W. Herschel of England, inherited it from his grandfather, Sir J. F. W. Herschel, the distinguished English scientist, to whom Draper had sent it. Through the courtesy of Sir John C. W. Herschel, I have been able to obtain a copy of the letter which Professor Draper sent with the daguerreotype across the water, and which has never before been published. The letter is self-explanatory and corrects several common errors which have been frequently stated in connection with the well-known reproductions of this daguerreotype.

<div align="right">

University of New York
July 28, 1840

</div>

Sir:

Though I have not the honor of your personal acquaintance, I do not hesitate to send to you through the Editor of L. and E.,* a heliographic portrait taken from the life by the Daguerreotype—the process I have described in a communication to the L. and Edin. Phil. Mag.,* which is probably published by this time. We have heard in America that all attempts of the kind had been unsuccessful both in London and Paris, but whether or not it be a novelty with you, allow me to offer it to your acceptance as an acknowledgement of the pleasure with which I have read so many of your philosophical researches.

This portrait, which is of one of my sister, was obtained in a sitting of 65 seconds, the light not being very intense and the sky coated with a film of pale white cloud. It is not better in point of execution than those ordinarily obtained. I believe I was the first person here who succeeded

* *The London, Edinburgh and Dublin Philosophical Magazine.*

in obtaining portraits from the life. This plate will show how the art is progressing—a close examination will at once give satisfaction that no aid whatever of an artificial kind—no touching with the pencil is resorted to, but that the proof remains in the same state as brought out by the mercury. If, sir, you should find time to look at the paper I have alluded to, you will see a reference to a remark of yours in relation to the propriety of using an achromatic lens for the photographic camera. This picture was procured by two double convex *non-achromatic* lenses set together, each lens being of 16 inches focus and 4 inches aperture—the indistinctness which may be detected in some parts arises mainly from the inevitable motions of the respiratory muscles—a slight play of the features, and the tedium of a forced attitude. Where inanimate objects are depicted the most rigid sharpness can be obtained.

JOHN W. DRAPER

The letter reveals the formal and somewhat ponderous style of correspondence of the time, but is of more importance, of course, in its relation to the matter of early photographic portraiture. In the first place it will be noted that the letter is dated July 28, 1840, and that no reference is made to the date on which the portrait was made. It will also be noted that the exposure of this early daguerreotype portrait was only 65 seconds. Previously published accounts concerning this daguerreotype have given exposures ranging from ten to twenty minutes, which have evidently been based on such general information as was available in Seager's exposure table already quoted. Judging from these facts, the date of the letter, the relatively short exposure required, and an examination of the portrait itself which shows rather great contrasts, I am of the opinion that it was taken outdoors during the summer of 1840. As Draper states, the portrait is that of one of his sisters, who, I find by correspondence with living members of the Draper family, was Miss Dorothy Catherine Draper.

Herschel's reply to Draper is of almost equal interest, as it clearly shows that even a year after the public description of the daguerreotype process, portraits were not successfully executed in England, or at least were unknown to Herschel, who was one of the outstanding authorities on such matters in his country.

[30]

Collingwood, Hawkhurst, Kent
Oct. 6, 1840

Sir:

To your favour of the 28th July with its beautiful and exquisite accompaniment of the Daguerreotyped Portrait of your sister, I reply as it may appear to you tardily, but in fact they only arrived here two days ago through the kindness of Mr. Brayley, into whose hands they came after having lain sometime unnoticed among other parcels, in the absence from London of the party to whom they were addressed in the first instance.

I have no hesitation in declaring it by far the most satisfactory *portrait* which I have yet seen, so executed, and considering the shortness of the sitting, does equal credit to the brilliancy of your trans-Atlantic sunshine and to your own perfect mastery of the details of that most surprising process. I beg you, Sir, to accept my best thanks for this favour which I shall take care on an early opportunity to bring under the inspection of those among my scientific friends who are most conversant with the subject in this country.

I trust you will excuse me if in reference to your remark about the non-achromaticity of the camera employed by you,—that, beautiful and finished as this picture is, a microscopic examination of it affords clear evidence of what (supposing the figure rigidly fixed) could only be referred to a considerable amount of aberration in the lenses, (whether chromatic or spherical, there is no means of deciding). For instance the bright speck in each eye *ought,* if the figure were rigid and the camera perfect, to exhibit a picture of the external landscape as seen through the window of the apartment. But this may be considered as too severe a test for a living figure.

I shall make a point of perusing the paper you have referred to, and shall seize the earliest opportunity of conveying to you by some private hand unaccompanied with expense a copy of a paper lately published by myself in which you will find the grounds (as it appears to me unanswerable) establishing the necessity of employing achromatic lenses for attaining the utmost perfection of which this exquisite art is susceptible.

I remain, Sir,
Your most obliged and faithful servant,
J. F. W. HERSCHEL

J. W. Draper, Esq.,
University,
New York,
United States.

Herschel's proposed test for the accuracy of the lens is certainly severe enough—in fact, so severe that probably the vast majority of modern lenses would fail to meet it.

The paper to which both Draper and Herschel refer was published in September, 1840, and is of considerable interest in that it describes in detail some of the difficulties which early portrait photographers encountered.[37a] Draper states in this article that in his early attempts he dusted the face of his sitter with white powder, probably flour, to secure greater contrast. A few trials, however, showed him that this device gained no advantage. To secure greater illumination on the subject, Draper employed mirrors to reflect the sun directly on the individual, "but in the reflected sunshine, the eye cannot support the effulgence of the rays." Blue glass was therefore interposed between the source of the "effulgent rays" and the sitter. These ideas, however, appear to have been borrowed from Wolcott without due credit being given.[38] Draper was familiar with Wolcott's method of taking portraits, which will be described shortly, for he mentions Wolcott by name late in the article.

Draper suggests that the background may be arranged to suit the taste of "the artist"; a blanket or a cloth of drab color would serve the purpose were a uniform effect desired. Urns or other ornaments might also be introduced.

In order to support the head and keep it still during the long exposures required, the sitter's chair was provided with a staff terminating in an iron ring, and so "arranged as to have motion in all directions to suit any stature and any altitude." [39]

The modern patron of the photographer's art may not recognize the instrument of torture described above, but to those who had photographic portraits made "in the long ago" it will be remembered as the familiar head rest which was part of every photographer's equipment, a device which was used, as can be seen, from the early inception of the art up to fairly modern times.

Draper concludes this early story of portraiture by saying:

"Miniatures procured in the manner here laid down, are in most cases striking likenesses, though not in all. They give of course all the individual peculiarities, a mole, a freckle, a wart. Owing to the circumstance, that yellow and yellowish browns are long before they impress

the substance of the Daguerreotype, persons whose faces are freckled all over give rise to the most ludicrous results, a white, mottled appearance with just as many black dots as the sitter had yellow ones. The eye appears beautifully; the iris with sharpness, and the white dot of light upon it, with such strength and so much of reality and life, as to surprise those who have never before seen it. Many are persuaded, that the pencil of the painter has been secretly employed to give this finishing touch."

Draper's important contributions to this field may be summed up as follows: He was among the earliest to attempt photographic portraiture. These attempts were based on such scientific principles as were then known; he sent abroad an early daguerreotype portrait, apparently the earliest which has survived; he published an extensive account of these experiments, thereby enabling and encouraging others to benefit from his experience; and he became associated with Morse in the opening of an establishment for the purpose of taking portraits, thus becoming one of the founders of a new profession, as will be seen shortly.

We must, however, proceed to the claims of Alexander S. Wolcott of New York. Wolcott was an instrument maker and manufacturer of dental supplies and was well versed in optics. His interest in the daguerreotype was aroused by his partner, John Johnson, who had secured a copy of Daguerre's directions. Wolcott immediately conceived the idea that the necessary exposure could be reduced by a type of instrument different from that used by Daguerre. Wolcott's extremely ingenious idea consisted in the use of a concave reflector of relatively large diameter and short focus, the image formed on the reflector being thrown back on the sensitized silver surface. This arrangement as employed by Wolcott is shown in the diagram on page 26. With this device Wolcott was able to obtain successful portraits of small size (about $2\frac{1}{2}'' \times 2''$). Wolcott stated in a letter dated March 13, 1840, that he made his first successful portrait in October of 1839.[40] Both the date of the letter and that of the portrait are prior to Draper's letter and claim. It will be recalled, too, that the article published by Draper (in September, 1840) made mention of Wolcott's method, so that it is evident that Draper was familiar with Wolcott's work. Seven years after the fall of 1839, John Johnson, Wolcott's partner, stated that the date of

[33]

Wolcott's first successful portrait was October 7, 1839, and that the portrait was a profile of Johnson himself. If Johnson's memory is reliable, this date of October 7, 1839, is probably that of the first successful photographic portrait ever made. It might be stated in passing that certain indirect evidence corroborates Johnson's claim for this date.[41] Whatever the validity of Johnson's claim, the present available evidence indicates that to Wolcott should go the honor of having taken the first portrait. Not only did he take the first portrait, but he was first to publish his method of taking it, Wolcott's description appearing in the *American Repertory* for April, 1840. In addition, to Wolcott goes the credit for securing the first photographic patent issued in this country. This is covered by U. S. Letters Patent No. 1582 and is dated May 8, 1840. The patent deals with Wolcott's method of taking a portrait by use of the concave reflector.

While Wolcott's process in time was superseded by the more conventional method, for reasons which will become apparent shortly, it was a successful one and led eventually to the establishment of a very early, if not the first, professional studio, or "Daguerrean parlor," as it was then called. Our evidence for this statement is to be found in the New York *Sun* for March 4, 1840, which contains the following account of Wolcott's work:

"SUN DRAWN MINIATURES.—Mr. A. S. Wolcott, No. 52 First street, has introduced an improvement on the daguerreotype, by which he is enabled to execute miniatures, with an accuracy as perfect as nature itself, in the short space of from three to five minutes. We have seen one, taken on Monday, when the state of the atmosphere was far from favorable, the fidelity of which is truly astonishing. The miniatures are taken on silver plate, and enclosed in bronze in cases, for the low price of three dollars for single ones. They really deserve the attention of the scientific, and are a valuable acquisition to art, and to society in every respect."

A few days after this description was published, there appeared the following announcement in the same paper (March 13):

"DAGUERREOTYPE PORTRAITS.—Mr. Wolcott, the portrait taker, of whom we spoke a few days since, has taken the rooms Nos. 21 and 22 in the granite building corner of Broadway and Chambers streets."

[34]

Robert Cornelius visited Wolcott's parlor in April, 1840, to study the lighting arrangements, and returned to Philadelphia to open the first Daguerrean parlor in that city.[42]

It is almost certain that most of the American professional daguerreotypists of 1840 and 1841 relied upon Wolcott's method. It had the great advantage of much shorter exposure, an advantage which was not lost until the advent of better lenses and faster daguerreotype plates. Wolcott's correspondence of the period and the comments of contemporary authorities show this quite clearly.[43] Wolcott's system, however, not only was the first to be used widely in this country but also was the first extensively used in England.

Wolcott's system of illumination. After Johnson in *Eureka*, 1846. A-A are the mirrors used to reflect a beam of light on the sitter. *B* is a trough of plate glass filled with a solution of blue vitriol to protect the eyes of the sitter from the intense light thus reflected. Notice also the head-rest and the screen serving as a background.

For early in 1840, Wolcott and John Johnson, his partner, decided to introduce the process abroad and to this end sent William S. Johnson, the father of John Johnson, to London. Here W. S. Johnson entered into an agreement with Richard Beard for the use of Wolcott's camera and method. As neither of these men was mechanically or scientifically inclined, John F. Goddard, a lecturer on science, was employed to undertake the actual operation. Their first gallery in London was opened in the mid-summer of 1840 and business increased so rapidly that John Johnson was sent for in the fall of that year. He was followed in July, 1841, by Wolcott himself, and the firm was exceedingly busy in introducing the process in other English cities and towns. How successful they were in 1840

can be judged by the statement of A. Claudet, later to become one of the leading English daguerreotypists, who ruefully remarked, ". . . I could not use the patented mirror [Wolcott's], so that I was obliged to do the best I could with Daguerre's slow object-glass."

Wolcott remained abroad for three years and then returned to this country. He died on November 10, 1844, at Stamford, Connecticut, at the age of forty years. American photography suffered a severe loss in the untimely death of this photographic pioneer and genius. Had he lived, it is quite possible that a system of photography upon glass would have been devised much earlier than it was,

Robert Cornelius. From an oil painting made shortly after his experiments in daguerreotype. (Courtesy, Mrs. Robert G. Barckley, Milford, Pa.)

and to an American would have gone this honor. Shortly before his death he was engaged on this project as will be described in a subsequent chapter.[44]

As we have said, Wolcott and Johnson were probably the first to open a "Daguerrean parlor" in this country; at least no reference to any prior attempts has been found in the extensive literature which has been examined. Morse and Draper, whose association has already been mentioned, also opened a studio, but no record of the date of this opening is available. Their first gallery was "a glass building constructed for that purpose on the roof of the University." [44a] The university referred to was the University of the City of New York by which both Morse and Draper were employed. The gallery was constructed after Draper's successful trials to produce portraits so that probably it was in the summer of 1840.

Draper did not continue long in partnership with Morse, as he

was interested chiefly in the scientific aspects of the process, but Morse actually supported himself for well over a year by practising the new profession and training others in it. While Morse's original experiments (his own and those with Draper) were made on the roof of the New York University, when Morse began his professional career as a photographer, his brothers Sidney E. and Richard C. Morse erected for him another "palace for the sun," or room with a glass roof, on their new building at the northeast corner of Nassau and Beekman streets.[45]

I do not believe that it has been recognized how important was this phase of Morse's life. He had by this time given up painting and therefore had no means of support. His connection with the University was only nominal: apparently he had students of art only and these were extremely few. Although Morse at this period had his telegraph well along toward completion he was constantly remodeling and improving it. He was awaiting recognition and financial support from the United States government, support which was slow in coming. It was a period of great depression for Morse as his letters during the period show. But among these letters are notes such as "I am tied hand and foot during the day endeavoring to realize something from the Daguerreotype portraits," and on February 14, 1841, we find him writing his cousin, "I am at present engaged in taking portraits by the Daguerreotype. I have been at considerable expense in perfecting apparatus and the necessary fixtures and am just reaping a little profit from it. My ultimate aim is the application of the Daguerreotype to accumulate for my studio models for my canvas."

How extensively Morse went into daguerreotypy can be judged from the fact that among Morse's papers in the Library of Congress is a bill dated Paris, January 28, 1841, for $320.65, solely for daguerreotype plates. Morse's income from this source must have been considerably augmented by fees from students who desired to learn the details of the new "art." His fee for these lessons was "twenty-five or fifty dollars," and the number who took them must have been rather large, if we can judge from his correspondence and from references in the contemporary literature. Among these students are

the names of many who afterwards became well known in the photographic world; such names as Edward Anthony, later founder of the photographic supply house of E. Anthony and Company; M. B. Brady of New York; Samuel Broadbent of Philadelphia; F. A. Barnard of Alabama; Albert S. Southworth of Boston, who later established the celebrated firm of Southworth and Hawes; and T. W. Cridland, the first professional daguerreotypist in Lexington, Kentucky, and probably the first west of the Allegheny Mountains; to mention the more prominent ones.[46] It is quite probable that Morse's reputation as an artist (it will be recalled that he was president of the National Academy of Design) and his well known mechanical ability gave him a prestige that none of the other teachers of daguerreotypy possessed, and consequently he attracted more students. It is for his teaching record in the new profession that his title of "Father of American Photography" is most nearly justified, and not for the claims of his having made the first daguerreotype and the first daguerreotype portrait in this country.

Morse has a clear claim to one "first" title, however, and one that should not be overlooked when the vast number of such photographs made since his day is considered. This was the taking of the first photograph of a college class. The occasion is described in manuscript material found among Morse's papers in the Library of Congress. The incident is dated August 18, 1840, and refers to a reunion of the Yale class of 1810, of which Morse was a member, which occurred during the annual commencement. The secretary of the class recorded at the reunion that "S. F. B. Morse stated that he had come with the necessary instrument and plates to take a Daguerreotype impression of the Class in group and requested that some hour might be appointed for the class to assemble for the purpose, at such place as might in the meantime be selected, information of wh. shd. be given at the adjourned meeting; it was voted to attend to this business at 8 o'clock A.M. the next day (Aug. 19, 1840)." At 8:00 A.M. the body went with S. F. B. Morse to the place "wh." had been selected—"the yard north of the President's house—where the class were grouped and two impressions (*sic*) were taken." A list of those present (eighteen in number) is included in the notes. The class met again that evening at the house of C. A. Goodrich,

Morse bringing one of the plates, "the one wh. had taken the best impression—neatly framed for the class inspection. The likenesses were most of them very distinct and good." Photographers would do well to erect a marker on "the yard north of the President's house" to commemorate the first effort in this lucrative branch of their business.

The students of American history will recall that the years of 1839 and 1840 comprised a period of extremely severe financial depression which had originated as early as 1837, and undoubtedly there existed a considerable amount of unemployment. As a result of this condition the possibility of the growth of a new profession must have attracted the hopes and interests of a considerable number. Coupled with the possibility of working in a new profession was the advantage that only a small capital was necessary; for all that was required was a room with a window and the relatively inexpensive instrument of Wolcott or "the cigar box and spectacle lens" of Draper. In fact, the earliest "portrait takers" were more besieged with individuals wishing to be trained in the art of portrait taking than they were with clients desiring to have their portraits made. The interest of the majority of these enthusiasts must have soon waned when they encountered the technical difficulties of the process and were confronted with the very serious problem of the early daguerreotypists—that of securing usable silver-plated copper on which to prepare their plates, a problem which was solved in the first year of the daguerreotype art only by importing the material from abroad.[47]

It is evident that the art of the daguerreotype was begun in this country by a limited group of men, all of whom were trained scientists or individuals interested in scientific matters with a strong mechanical bent of mind. Morse, for instance, as we have stated, was a portrait painter by profession, but achieved a far wider reputation as the inventor of the magnetic telegraph. With a group so limited in the earliest days, it was a matter of public interest when an individual was able to produce a daguerreotype. For example, the news is given in the New York *Sun* for January 8, 1840, that "a gentleman in Wheeling, Mr. Mathers, has been successful in the construction and use of the Daguerreotype." Try to imagine

the condition of the press if, at present, it was thought necessary to record each successful snapshot of the multitude of amateur photographers.

By the summer of 1840, daguerreotypes were being made in many of the principal towns of the country. The contemporary newspapers of these cities carry a few advertisements of itinerant daguerreotypists. In Washington, for example, the following advertisement appeared in the *National Intelligencer* for June 30, 1840:

"DAGUERREOTYPE LIKENESSES.—Mr. Stevenson would inform the citizens of Washington and the District that he has taken rooms at Mrs. Cummings' on Penn. Ave. a few doors from the Capitol where he is prepared to take miniature likenesses by the Daguerreotype every fair day from 10 A.M. till 4 P.M."

A few weeks later Stevenson, who was a pupil of Wolcott, advised the Washington public that, if they wished their miniatures taken "by this very astonishing process," they had better hurry, as he was leaving the city on the twenty-third of July.[48]

The majority of the early efforts could not have been greatly successful. In fact, such quips as the following were common in the period: "Some witty man corrupts the word 'daguerreotype' into 'derogatory type.' " This derision may, in part, be due to the failure of the early photographs to flatter the individuals whose portraits were made, but it was more probably due to the difficulties of the process itself. In Boston, a Mr. Schwartz, the operator of a "parlor," must have encountered difficulties, for he advised the citizens of Boston on October 14, 1840, in the Boston *Evening Traveler,* that

"Ladies and Gentlemen are respectfully informed that the taking of Daguerreotype Miniature Portraits is now deferred till the later part of November when it is expected the said portraits will possess greater perfection than anything of the kind before produced."

The skeptical attitude of the public underwent some revision in time, but announcements such as those of Schwartz and the probable poor ability of daguerreotypists, in general, did not greatly extend the daguerreotype in public favor. Exhibitions of imported daguerreotypes, many of which were made by Daguerre himself or his immediate students, did more to acquaint the public at large

[40]

with the possibilities of the new art. The principal one of these exhibitions was brought to this country by François Gouraud, and was exhibited in many of the larger cities. The exhibition called forth universal praise from the contemporary press. Lewis Gaylord Clark's rhapsody in *The Knickerbocker* quoted at the beginning of the first chapter was incited by a view of Gouraud's exhibition. Philip Hone, New York's man about town of the fabulous forties, received, along with many other personages of the day, the following verbose invitation from Gouraud to a preview of the exhibition:

Dear Sir: As the friend and pupil of Mr. Daguerre, I came from Paris by the *British Queen,** with the charge of introducing to the New World the perfect knowledge of the marvelous process of drawing, which fame has already made known to you under the name of "The Daguerreotype." Having the good fortune to possess a collection of the finest proofs which have yet been made, either by the most talented pupils of Mr. Daguerre, or by that great artist himself, I have thought it my duty, before showing them to the public, to give the most eminent men and distinguished artists of this City the satisfaction of having the first view of perhaps the most interesting object which has ever been exposed to the curiosity of the man of taste; and therefore, if agreeable to you, I shall have the honor of receiving you on Wednesday next, the 4th of December, from the hour of 11 O'clock to 1 O'clock, inclusive, at the Hotel Francois, No. 57 Broadway, where this invitation will admit you. I remain, sir, your most obedient servant,

FRANÇOIS GOURAUD [49]

New York, Nov. 29th, 1839.

In his celebrated diary, Hone devoted several pages to his impressions of the exhibit of daguerreotypes. He marveled, as countless others must have, at the exact and detailed reproduction of the original object—"the hair of the human head, the gravel on the roadside, the texture of a silk curtain," were all there on the silver plate. It is, of course, no wonder that what is commonplace now should have been a cause of amazement nearly a century ago, for only the hand of the artist was then available to copy either crudely, or with suggestion, such minutiæ of a scene.

* This is the third time that the *British Queen* has been mentioned in our text, all references being to the same arrival, as Gouraud's name appears in the passenger list of Sept. 21, 1839. The *British Queen* is of considerable importance in connection with the history of American photography!

Evidently Gouraud's exhibit did not arrive with him, for the exhibit was not displayed until early December.

It is curious to note that the exhibit caused Hone to reflect upon further wonders—"whether we may not be called upon to marvel at the exhibition of a tree, a horse, or a ship produced by the human voice muttering over a metal plate, prepared in the same or some other manner, the words 'tree,' 'horse,' and 'ship.' How greatly ashamed of their ignorance the bygone generations of mankind ought to be." Nearly a century has elapsed, however, and Hone's reflection has not yet been realized.

That Gouraud's exhibit created very great interest can be readily seen by examining the contemporary press. Notices of the exhibit were uniformly complimentary to say the least, and the exhibits must have been a source of considerable revenue to the owner, as Gouraud made an admission charge of one dollar.[50] The exhibit was accompanied by two lectures daily in which the process was explained and actual demonstrations of the taking of daguerreotype views were given.

. It will be noted that many American amateurs had already made considerable progress before Gouraud's exhibit and lectures began. Nevertheless, the efforts of Gouraud must have served as introductions to the process for a considerable number. Gouraud also took pupils for private instruction, some of whom undoubtedly became professionals.

Evidently Gouraud's success went to his head, for he attempted to capitalize on his reputation by selling drugs, nostrums, and toilet preparations.[51] He granted himself a doctorate and began referring to himself as "Doctor Gouraud."

Evidently these practices of Gouraud did not sit well with Morse and his friends, possibly in part because of professional jealousy, but more probably because Morse thought that Gouraud was degrading the artistic profession. At any event a quarrel developed in which both Morse and Gouraud took up considerable space in the columns of the New York and Boston newspapers explaining their respective sides of the case. The incident eventually reached Daguerre's ears and resulted in the removal of Gouraud.[52]

In justice to Gouraud it should again be pointed out that his exhibits did much to bring the daguerreotype into popular favor. Gouraud must receive the credit, furthermore, for having published

[42]

the first photographic manual issued in this country. This was printed in Boston in the summer of 1840, and described the daguerreotype process, as well as "a provisory method for making human portraits." [53] The provisory method was not greatly different from those of Wolcott and of Draper: It advised getting as much light as possible into the camera and suggested that if the sun was made so brilliant that the *patient* * was not able to bear its reflections comfortably, a blue glass should be interposed between the *patient* and the source of light, which device was obviously borrowed, without credit, from Wolcott and Draper. It specified the colors of dress which should be worn and advocated the use, as did both Wolcott and Draper, of a head rest, "a semicircle of iron, fitted to the back of the chair."

Before we can consider the introduction of the daguerreotype complete, mention should be made of three improvements in the process which had much to do with its eventual success. As all of these improvements were added within a year or two from the time of the public description of the initial process we shall consider them here. The first of these modifications was due to a countryman of Daguerre's, M. Fizeau. Fizeau recommended in the summer of 1840 that the silver plate, after development and fixing, should be bathed with a warm solution of gold chloride.[54] This process, which soon became known as "gilding," was immediately adopted. Such a treatment improved the image on the silver plate by making it more durable and by increasing the contrasts between light and shade. As has been stated, the highlights (i.e., the white areas on the plate) consisted of mercury in very small droplets "resembling dew," as one experimenter put it; the shadows, the dark areas, were bare silver. By being bathed in the solution of gold chloride, the droplets of mercury were spread into a film making the highlights whiter; the bare silver became coated with a thin film of gold, and the shadows were made browner and therefore darker. It transformed the original, rather weak daguerreotype into a thing of real beauty and life. The film of mercury after gilding was much less sensitive to touch, i.e., could not be removed so readily by accidental rubbing, as had been true of the specimens produced by Daguerre's

* The italics are not mine, but were used by Gouraud himself.

original process; and the image produced was thereby made more durable. It was still necessary, however, to cover the silver plate by a protecting glass to prevent scratches on the soft metallic surface.

The second improvement which had much to do with making daguerreotype portraiture commercially successful was the introduction of several substances which increased the sensitivity of the light-recording compound and thus very materially reduced the time of exposure in the camera. The credit for the introduction of these substances has been extensively debated, but the merits of the respective claims need not concern us here.[55] Suffice it to say that by 1841 such accelerators (called "quicks") were in common use and reduced the time exposure from minutes to seconds. One of the most successful of the "quicks" used extensively at home and abroad was "Wolcott's American Mixture," named after A. S. Wolcott, one of the first to attempt the preparation of such materials. This was a water solution of bromine, iodine, and chlorine, to which the plate was exposed after its original sensitization according to Daguerre's process. The plate, after being exposed to iodine, was then exposed to the quick, and then again to the iodine, the operator judging the time of exposure by the color of the sensitive film produced. By such procedures, plates could be produced that, at *best,* made images "in the fraction of a second, even late in the afternoon." [56] The great increase in speed, however, cannot be attributed solely to the increase in sensitivity of the photographic surface. Opticians had succeeded in producing special lenses for photographic purposes which passed considerably more light than did the original make-shift ones. The most successful of these was designed by Petzval of Vienna in 1840 and was scarcely improved for over fifty years. The introduction of the Petzval lens and of the "quicks" in time rendered Wolcott's process obsolete.

The last improvement to be noted may not be considered an improvement by some critics of the present day and was regarded with similar disdain by many professional daguerreotypists. I refer to the coloring of daguerreotypes. However its critics may have regarded it, "it created more popular clamor than all the other improvements combined," according to a contemporary.[57]

As has been stated, Wolcott's patent was the first photographic

[44]

patent issued in this country. The third, fourth, and fifth patents, however, all had to do with various processes of coloring daguerreotypes. The first of these is dated March 28, 1842.[58] The method most successfully employed was to dust a very minute amount of pigment by means of a camel's hair brush upon the area to be colored. To color buttons or flowers, i.e., to make a spot of color, the pigment was mixed with a little water, and applied with a very fine brush. If delicately done, the process adds considerably to the charm of these old-fashioned photographs.

As the result of these improvements, daguerreotypy, in the course of three or four years, became well established in this country as a profession in all the principal cities, and daguerreotypes became well known to the public at large.

DESCRIPTION

OF THE

DAGUERREOTYPE PROCESS,

OR

A SUMMARY

OF

M. GOURAUD'S PUBLIC LECTURES,

ACCORDING TO THE PRINCIPLES OF

M. DAGUERRE.

———

WITH A

DESCRIPTION OF A PROVISORY METHOD FOR TAKING

HUMAN PORTRAITS.

———

BOSTON:
'DUTTON AND WENTWORTH'S PRINT.
............
1840.

Title page of the first photographic manual
published in this country.

The Era of the Daguerreotype

IT MUST NOT be supposed that after the introduction of the improve-
ments just described, all became plain sailing for the practitioners
of the art, and that the number of men who supported themselves
solely by this means increased enormously. On the contrary, because
of their hasty training, the results turned out by the majority of
the workers in daguerreotypy during the three or four years imme-
diately following its introduction must have been pretty bad, if we
can judge from available accounts. John Quincy Adams, for instance,
made a tour of the West during the summer and fall of 1843, and
several times encountered daguerreotypists. At Utica, New York,
he records in his diary: "On my returning to Mr. Johnson's I
stopped and four daguerreotype likenesses of my head were taken,
two of them jointly with the head of Mr. Bacon—all hideous." Mr.
Adams may have thought they were hideous because they were too
accurate, but he never appeared to be desirous of flattery, and for
that reason his judgment must have been based in a large measure
on faults due to workmanship. A few weeks later he was in Cin-
cinnati and made mention of the fact that "before returning to the
Henry House, we stopped at a daguerreotype office, where three
attempts were made to take my likeness. I believe that none of them
succeeded." [59]

Poor training, however, was not solely responsible for the medi-
ocre quality of the work during the beginning of the daguerreotype
era. As we have seen, those who were first interested in the process
at its introduction were men of considerable scientific or mechanical
ability. These men had other interests, which were to them more
important, and consequently, save for short periods, as in the case
of Morse, they were not interested in practicing daguerreotypy as a
profession. Following this group were many who were interested in
the possibility of procuring a livelihood by practicing the art. With

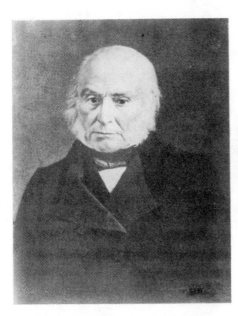

John Quincy Adams, a photographic copy of the Brady daguerreotype. The original daguerreotype was made about 1847. (Courtesy, Signal Corps, U.S.A.)

John Plumbe, Jr. From a daguerreotype (date unknown) first copied in *Annals of Iowa*, 1903.

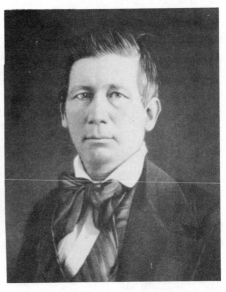

Miss Anna Louisa Chesebrough, age three. From a daguerreotype made in Plumbe's New York gallery, 1846. Miss Chesebrough became in later life the wife of United States Senator John J. Ingalls of Kansas. (Reproduced through the courtesy of Ellsworth Ingalls, Atchison, Kansas.)

United States Senator Edward A. Hannegan of Indiana. (From an engraving by T. Doney after Plumbe's daguerreotype in the *Democratic Review*, June, 1846.)

some notable exceptions, these were men of poor talents. They were interested not so much in making it a sole means of supporting themselves as they were in adding it as a side line to their regular business, thereby augmenting their incomes. Such individuals were not willing to make any great investment or spend much time in acquiring the skill necessary to master what was really a process of some difficulty. Ryder, the well known Cleveland photographer, who lived through this period, describes the situation in the early forties:

"It was no uncommon thing to find watch repairers, dentists, and other styles of business folk to carry on daguerreotypy 'on the side'! I have known blacksmiths and cobblers to double up with it, so it was possible to have a horse shod, your boots tapped, a tooth pulled, or a likeness taken by the same man; verily, a man—a daguerreotype man—in his time, played many parts." [60] No wonder their artistic efforts were hideous.

This second group of daguerreotypists, especially those in smaller towns, made their work appear mysterious; that is, they imposed themselves as magicians on the credulous villagers. The process readily lent itself to such deception, as it required a darkened closet to which the daguerreotypist retired in order to prepare his plates and develop them. Like magicians, they readily acquired the title of professor, a title which has always covered a multitude of sins, mostly of omission.

Such a professor, especially if he had a smattering knowledge of phrenology, might go far, for a time at least, in a given community, and yet turn out very mediocre work. He would probably be besieged by young men desiring to learn "the trade," and he made many an additional dollar by selling equipment and imparting his knowledge to those who had the necessary funds. Such a professor must have been "a sun that could afford to shine on other and lesser planets without dimming his own luster." A young hopeful seeking an audience with "the professor" would have his bumps felt, and, if ideality was prominent, color good, and form excellent (which doubtless depended upon the condition of the applicant's pocketbook), he was assured that he was a promising candidate who would succeed at this newest of arts.

Probably the artist of the dark closet did not linger long in one community, as his artistic efforts would call for continual explanation, but the glib professor had a stock of phrases which enabled him to put off the evil day for a time. Of these, "You moved" could be used the most; and "You did not keep still," "You winked," "You looked too serious," "You breathed too deep," could all be used on occasion. Incidentally, it made little difference in the earliest days of daguerreotypy whether the subject winked or not. In an exposure approximating a minute, if the sitter did not hold his eyes shut too long, the eyes would appear open, since the process of winking requires only a fraction of a second.

But there were successful practitioners who established themselves by virtue of good work at the beginning of this era. Among the first of these to achieve any considerable reputation was John Plumbe, Jr. Plumbe, a Welshman by birth, was a man of restless and energetic disposition, well trained for his day. During the early thirties he was associated with the first railroad in the South; first as a construction engineer, and later as division superintendent. In 1836, he suddenly gave up this work and moved west into the newly organized territory of Wisconsin. He traveled extensively in this country (which then included Iowa) and as a result he published in 1839 a brief book, *Sketches of Iowa and Wisconsin,* a written description of the country intended to increase emigration to the new territory. I imagine that the returns from this book did not yield Plumbe any great sum, but a copy of it recently (1934) sold for two hundred dollars; probably much more than Plumbe ever made from it. But Plumbe's place in American history rests very largely upon the fact that he was the first to advocate a railroad connecting the East with the West, an Oregon, or as it was also called, a Pacific, railroad. He wrote extensively in the newspapers, organized public meetings, and memorialized Congress with this object in view. Plumbe first suggested such a railroad to the citizens of Dubuque, Iowa, in 1837; during the next few years he worked for it throughout the West. In 1840, he went east, apparently with the object of securing eastern capital and of furthering the interests of his project in Congress. Here he became acquainted for the first time with the daguerreotype, and was so struck with its possibilities

[49]

that he learned the art and began to practice it, his initial attempts being made the same year (1840). It is very probable that Plumbe became a daguerreotypist in order to earn a livelihood while he was fostering his railroad interests in Congress. His enterprising spirit soon made itself manifest in his new profession, for he opened shortly a Daguerrean gallery in Boston, then another in New York, and soon had a chain of such galleries in Philadelphia, Baltimore, Petersburg, Albany, Saratoga Springs, and other American cities. (Notice his advertisement reproduced on the following page.) He was careful to secure competent agents in these cities, and, as a result, Plumbe's daguerreotypes became known the country over. At the National Fair, held in Washington in the spring of 1846, his extensive and splendid collection on display received very special commendation from the newspapers.

Plumbe's enterprise is also made apparent in other ways. For example, it has been mentioned that but one copy of a daguerreotype could be secured from each exposure of the camera; and, of course, many patrons desired additional copies. Plumbe met the situation by employing artists who copied the original daguerreotype on a lithographic stone, from which any number of printed lithographs could be obtained. These he sold under the name of "Plumbeotypes." One other incident also indicates the business acumen of the man. Titian's "Venus" was on display in Washington during the winter of 1845 and 1846, and was attracting large crowds. Plumbe received permission to make daguerreotype views of the painting, and the views were then placed on sale where the painting was exhibited. Plumbe also became a publisher and from his office in Philadelphia there appeared the *National Plumbeotype Gallery* (1847), a collection of some twenty-seven portraits lithographed from daguerreotypes made in his galleries. *Plumbe's Popular Magazine* was also published irregularly during the years 1846 and 1847.

During this part of his career, while accumulating a very considerable competence, Plumbe traveled widely and continued to advocate the railroad to the Pacific. With so many irons in the fire he failed to pay careful attention to his daguerreotype business. Partly because of his laxity and partly because of the dishonesty of some of his agents, Plumbe met financial disaster in 1847. His gal-

The United States Capitol, 1846. A "Plumbeotype." (Courtesy New York Public Library.)

An advertisement of Plumbe's, from the *Scientific American,* Sept. 11, 1845.

leries were all sold to meet the demands of his creditors. He returned to Iowa after his failure, joined the California gold rush of 1849 in an attempt to recoup his fortunes, and spent the next five years in California. His California venture apparently was not successful, for he returned to Dubuque, where he died in 1857 by his own hand, during a fit of despondency. A varied and checkered career for a man but forty-six years old! [61]

Two other men whose names loomed large for many years in American photography began their photographic careers during the beginning of this era of the daguerreotype. They were Edward Anthony and Matthew B. Brady, both of whom have been mentioned as pupils of Morse.

Edward Anthony, born in 1818 in New York City, received a training at Columbia College in civil engineering, and began work after his graduation in 1838 on the Croton aqueduct, which was under construction at that time for the purpose of obtaining an adequate supply of water for the metropolis. It was while Anthony was engaged in this work that the daguerreotype arrived in this country, and Anthony took lessons in the art during his spare time from Morse. Before the aqueduct was finished, Anthony was requested by one of his former instructors, Professor James Renwick, of Columbia, to accompany him on a government mission, the survey of the northeast boundary of the United States, the location of which at the time was in dispute with Great Britain. The United States claimed that there were highlands of considerable prominence on the boundary, but England denied the existence of any such areas. Renwick employed Anthony because of his familiarity with the daguerreotype process, and directed Anthony to carry with him a complete daguerreotype outfit for the purpose of photographing the disputed highlands. This Anthony did, and the daguerreotypes were submitted to the joint boundary commission, composed of Daniel Webster and Lord Ashburton, and are said to have influenced the final decision of the commission. This is doubtless the first time photography was employed in a government survey.

After Anthony's return from the survey, he became more and more interested in the possibilities of the process, and, in conjunction with J. M. Edwards, backed by Dr. Chilton, the New York

chemist mentioned in Chapter One, he began the practice of the art as a profession.* In 1843, they made an ambitious venture in Washington, always a fertile field for the photographer. They secured daguerreotypes of all the members of Congress, doubtless by offering them free daguerreotypes for themselves. As a number were made at each sitting, their profit must have come from the sale of the additional daguerreotypes secured.

Business affairs at the nation's capital were then conducted in a free and easy manner, for Thomas H. Benton, the chairman of the Senate committee on military affairs, offered Anthony and his partner the use of the committee room for the practice of their profession.

John Quincy Adams was photographed by this firm, for he records in his diary under date of April 12, 1844, "At the request of J. M. Edwards and Anthony, I sat also in their rooms while they took three larger daguerreotype likenesses of me than they had taken before. While I was there President Tyler and his son John came in; but I did not notice them." [62]

Regardless of Mr. Adams's feeling for President Tyler, it is apparent that with ex-presidents and presidents as sitters, Edwards and Anthony were doing a very good business, and they succeeded in recording on the silver plate all the notables of Washington. The likenesses which they secured here formed a National Daguerrean Gallery, which was for many years on exhibition in New York City. This collection, which at the present day would be nearly priceless, recording as it did the images of many figures famous in American history during the first four decades of the last century, was unfortunately, save for a single piece, destroyed by fire in 1852. The single exception was the portrait of none other than John Quincy Adams! [63] The spirit of the grim old warrior (who had passed to his reward by this time) must have been comforted at the ability of his image to withstand this trial by fire, while the metallic immortality of Tyler and his contemporaries proved to be no immortality at all. The Edwards and Anthony gallery also formed the original

* Probably the financial depression of this period which we have already mentioned had something to do with Anthony's decision to become a daguerreotypist. Public works had practically ceased, and Anthony was without work in the profession for which he had been trained.

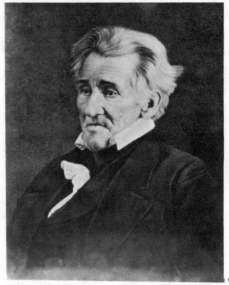

Andrew Jackson—the Brady photograph of the disputed daguerreotype of Jackson made at the Hermitage, April 15, 1845. (Courtesy, Signal Corps, U.S.A.)

Matthew B. Brady as he appeared in 1850. From the lithograph by Francois D'Avignon. First published in the *Photographic Art Journal*, January, 1851.

from which a large engraving was prepared in 1845. This was the striking picture "Clay's Farewell to the Senate," which is stated to have been the first notable engraving copied from daguerreotypes. It was published by Anthony, Edwards, and Clarke in 1846.[64]

About this time (1847) Anthony sold out his interest in the daguerreotype gallery and became a dealer in daguerreotype materials. At first these materials were imported from abroad, chiefly from France, but through Yankee ingenuity it was soon found possible to make as good or better materials at lower cost; and Anthony became a manufacturer as well as a dealer. In 1852, Edward Anthony took into partnership his older brother, Henry T. Anthony, but the firm name of E. and H. T. Anthony and Company was not adopted until ten years later. This firm for nearly half a century was the principal photographic supply house in this country. The considerable growth and success which American photography enjoyed in the thirty years after the founding of this firm are due in no little measure to the far-sightedness of these two men. We shall have occasion to mention this firm many times in subsequent pages.*

* No history of E. and H. T. Anthony and Company would be complete without mention of the Scovill Manufacturing Company, located at Waterbury, Connecticut. The

The most prominent name in the whole history of American photography is that of Matthew B. Brady. Brady, of Irish descent, was born near Lake George, Warren County, New York, about 1822. While a boy he met William Page, the artist, who was well known in his day. Brady evidently acquired an ambition to become a painter as a result of his friendship with Page, who gave him some instruction. Page in turn was a pupil of Morse, and through Page, Brady became acquainted with Morse when the latter was first beginning his experiments with the daguerreotype. Brady was immediately attracted by these metallic miniatures and received some instruction from Morse in the art of taking them. Draper and a Professor Doremus also advised him in his attempts to learn the practice of daguerreotypy.

In 1844, Brady began business as his own operator in New York City, at the corner of Broadway and Fulton. Taking advantage of the idea utilized by Draper and Morse in employing a glass house on a roof, Brady rented the top floor of the building at this location and had constructed not one, but several skylights to secure greater illumination. Brady was probably the first to use this method, which is the common practice in the majority of modern photographic studios.

In his early years Brady was an indefatigable worker and experimenter in his efforts to produce the best results which the art was capable of giving. The annual fair of the American Institute early offered prizes for plain and colored daguerreotypes, and these prizes were eagerly sought for by the increasing number of professionals in

Scovills were manufacturers of metals and metal products, and owned the oldest brass company in America. With the introduction of the daguerreotype, a demand was created for silver-plated copper. Wolcott and Johnson called on the Scovills for this material, which at first they could not supply. The gradual growth of the art created a sufficient demand so that the Scovills were soon able to provide a satisfactory product. Consequently American daguerreotypists were no longer dependent upon the French supply.[65]

The Anthonys secured this metal stock from the Scovills, their own manufacturing being confined largely to cameras, daguerreotype cases, chemicals, and later albums. The Scovill Manufacturing Company later became producers of cameras and many other photographic items not related to the metal-working processes, and in 1889 the photographic division was separated from the metal-working company under the name of The Scovill and Adams Company of New York. The original Scovill Manufacturing Company is today a flourishing metal-working company in its original home, Waterbury. In 1901, E. and H. T. Anthony and Company combined with the Scovill and Adams Company to form the Anthony and Scovill Company, which in 1907 was to become the Ansco Company, a name which is familiar to many amateurs of the early nineteen hundreds. Still more recently (March, 1928) a merger was effected with the Agfa interests, resulting in the formation of the Agfa Ansco Corporation, one of the largest photographic organizations in the country, the Eastman Kodak Company, whose history will be traced in a subsequent chapter, being another.[66]

Brady's first daguerreotype establishment as it appeared in 1848. After the aquatint of Henry Papprill. Courtesy, New York Public Library. The gallery (center foreground) was in the top floor of the building at the corner of Broadway and Fulton. Notice the skylights in the roof. Notice also the very celebrated Barnum's Museum across Broadway from Brady's.

the new art. Brady, always quick to realize the value to be gained by such publicity, competed for the first time at the fair in 1844, where his work received favorable mention, and he was awarded a premium. In 1845, he again exhibited, this time winning first prize in two classes; and in 1846 his efforts were awarded the highest prize.

By 1845, Brady had conceived the idea for which he deserves rank equal to the greatest historian of the American scene. This idea was the project of collecting all the portraits of the distinguished

Millard Fillmore John J. Audubon

(Both illustrations from Brady's *Gallery of Illustrious Americans*, published in 1850.)

and notable individuals he could induce to sit before his camera. How well he succeeded is apparent from the fact that in an amazing number of instances, biographies of Americans achieving distinction in the period 1845-1880 contain portraits obtained by him. The phrase "Photograph by Brady" is a better known by-line in the illustrated journals of the early part of this period than are those of all his competitors combined, as we shall have occasion to mention later. To illustrate the breadth of his photographic career: He recorded by his camera every president of the United States from John Quincy Adams, the sixth president, down to and including

[57]

William McKinley, with but a single exception. Not all, of course, were photographed during their term of office, as Adams's term, for example, had expired in 1829, ten years before the introduction of daguerreotypy. The single exception noted above was William Henry Harrison, who died in office in 1841, only one month after he was elected. Harrison's death, as can be seen, occurred before Brady had started in business.

Andrew Jackson, the seventh president of the United States, died in 1845. Nevertheless, the year of his death Brady sent an operator to the Hermitage, and secured one of the few daguerreotypes ever made of Jackson.[67]

The first president whom he appears to have photographed while in office was James K. Polk. Polk records in his diary February 14, 1849, a few weeks before he became an ex-president: "I yielded to the request of an artist named Brady of New York by sitting for my daguerreotype likeness today. I sat in the large dining-room." [68]

Brady had by this time opened a branch gallery in Washington during the sessions of Congress, as there it was easier to secure the portraits of the country's politicians and statesmen. The present generation has called Brady "the Civil War photographer"; and, while this phase of his career was exceedingly important, I am inclined to think his collection of portraits of still greater value. Although many have been destroyed, a very considerable number of his negatives still survive. Brady took the precaution, after photography on glass was introduced, to copy all of his remaining daguerreotypes, so that many of his earliest portraits are still available.

The statement has been made that Brady confined himself to the photographing of politicians only, but an examination of the list of his portraits shows that this is not so. In the first two volumes of *Frank Leslie's Illustrated Newspaper* (1856) are reproductions of many of Brady's portraits which include, in addition to the notables of Washington, explorers, merchants, engineers, the military, philanthropists, medics, editors, college presidents, poets, lawyers, prima donnas, chess players, actors and actresses, ship-builders, seamen, firemen, foreign visitors of note, impresarios, and clergymen. Scarcely a man or woman before the public eye but was recorded first on the silver plate, and later by means of the glass negative. Is it too much

to credit Brady with being one of the foremost historians of his day? Not a conventional one, to be sure, but one who deserves a place along with a Bancroft or a Prescott.

I have no sympathy with some of the pseudo-critics of the modern day who see in any photograph bearing Brady's imprint the hand of the artist.[69] Although it is true that, during his early years, Brady worked long and diligently to master his art, once this mastery had been achieved, and his competence assured, Brady left the actual photographic work to others. He kept abreast of his times, however, employed only the most competent operators, and did not hesitate to spend money upon the introduction of new devices or new methods. But he was absent from his business for long intervals, and during such periods the quality of the work turned out by his galleries did not suffer. Even during the Civil War, when actually engaged in photographic work, he employed a large number of operators, and many of the photographs, in fact a large proportion, of those credited to Brady were made by his employees. The credit which is due Brady is for his original idea as a photographic historian, his persistence in this idea, and for sufficient business acumen and management to carry it out—and not for any artistic merit his work may possess. One judges an artist by the work of his own hand, not by the work turned out by his employees. This is not to say that some of the work turned out from Brady's studio may not have artistic value, but in most instances we do not know who deserves the praise for such merit.

We shall have occasion to refer to Brady again in the pages which follow, but one other enterprise of his deserves immediate comment, as it falls within the era under discussion. This was the publication in 1850 of the *Gallery of Illustrious Americans*.[70] As originally projected the *Gallery* was to contain the portraits and biographies of "twenty-four of the most eminent citizens of the American republic since the death of Washington." Actually only twelve were published, Zachary Taylor, Calhoun, Webster, Silas Wright, Clay, Frémont, Audubon, Prescott, General Scott, Fillmore, Channing, and Cass. The portraits were all copied from daguerreotypes made by Brady, who also financed the venture, paying $100 each for the lithographic stones upon which the portraits were copied. The lithog-

rapher was an able one, Francis D'Avignon, and the literary material was contributed by C. Edwards Lester, who at that time was much admired for his "condensed and brilliant style." Lester himself stated that this work was "the most magnificent publication which has ever been brought out in this country, and which has seldom been equaled and never surpassed in the Old World." Lester's style, as might be surmised from this statement, consisted in clothing a few facts with a multitude of words, a failing common to many writers of his day; but Lester seems to me to have achieved the acme of perfection in this form of writing. Be that as it may, the *Gallery* was not a financial success, although its portraits are among the best surviving ones of the time; and again the credit must go largely to Brady, the historian, who furnished all the original portraits and the funds for publication.[71]

The reader must not suppose that Brady, even though we have discussed his early career at length, was the only able daguerreotypist of this era. As a matter of fact, the number in the profession was increasing with great rapidity as the century drew toward the half-way mark. By 1850, every large city had a number of excellent artists of the silver plate. The successes achieved by Plumbe, Anthony, and Brady, coupled with the difficulty of obtaining work in the depression of 1837, which extended into the early forties, were sufficient to induce many to attempt the venture into the new profession. As the depression passed, the public had more money for non-essentials and consequently the growth in the number of the profession was accelerated. The census of 1850 tabulates 938 males over fifteen years of age who give their profession as daguerreotypists.[72] This number is admittedly small for the reason that many persons followed a variety of professions. When a given individual employed himself at different trades or professions, he was listed under the "leading" one. But, as the census report itself states, the question as to which was the leading profession was "a point about which there would be much difference of opinion, and no uniformity of action (in recording)." It seems reasonable to assume that in 1850 there were at least double the number given in the census report (approximately 2,000), who were practising daguerreotypy in order to obtain a live-

[60]

lihood, either in whole or in part. The census of 1840, of course, does not list the profession at all.*

This figure indicates that by 1850 Brady had considerable competition. His contemporaries, while admitting that daguerreotypes from Brady's establishment were good, were not unanimous in their opinion that Brady's were the best. An examination of the awards of the annual fair of the American Institute shows that Brady did not always obtain the gold medal.[73] As a matter of fact, during the last few years of the daguerreotype era, Jeremiah Gurney, also of New York, consistently excelled all his competitors, or, at least, received more important awards than they did. The most striking of these was a massive silver pitcher valued at five hundred dollars— most of the competitors would doubtless have preferred the cash— offered by Edward Anthony for the best whole plate daguerreotype submitted to the award committee between July 1 and November 1, 1853. The award committee consisted of Samuel F. B. Morse, John W. Draper, and James Renwick, all of whose names have already appeared in these pages.

As a result of these awards, Gurney was referred to in the press as "the foremost Daguerrean artist." Gurney was one of the earliest of American daguerreotypists, for he began his professional career in 1840. He was a jeweler at Saratoga Springs, New York, when one day a stranger entered and offered to trade him a daguerreotype

* To the student interested in figures the following table shows the growth of the profession over a period of ninety years:

Year	Total Population	Photographers
1840	17,069,453	0
1850	23,191,876	938
1860	31,000,000	3,154
1870	39,000,000	7,558
1880	50,000,000	9,990
1890	63,000,000	20,040
1900	76,000,000	27,029
1910	92,000,000	31,775
1920	106,000,000	34,259
1930	123,000,000	39,529

The data are taken from the official *U. S. Decennial Census Reports* for each decade.

In the census of 1850, the only occupation listed is that of daguerreotypist; in 1860, 2,650 daguerreotypists and 504 photographers are tabulated. It must be remembered, however, that most of the daguerreotypists were then practising collodion photography as well. The term "photographer" was a comparatively new one; in 1870, there is but a single entry, daguerreotypists *and* photographers; in 1880 and subsequently the entry is *photographer* only. It is interesting to note that the largest relative increase in these numbers came in the decades 1840-1850, 1850-1860 and 1880-1890. It was in these decades that the new processes were introduced, i.e., daguerreotypy, then collodion photography, and last, dry plate photography.

camera for a watch. Gurney made the trade, and went to New York, where he opened a jewelry shop and took lessons—from whom, I have been unable to learn, probably from either Morse or Plumbe. After he had learned the trade he placed four daguerreotypes in one of his show cases to advertise this branch of his business. The first day he had one sitter; the second day, two sitters. Soon the sitters became so numerous that special quarters had to be fitted up, and the jewelry end of the business was dropped. In the fifties, Gurney became associated with C. D. Fredricks. This partnership was dissolved in 1856, but both men continued in business. The Gurney gallery was continued for over fifty years by the elder Gurney's son, Benjamin Gurney.[74]

Daguerreotypes and the Public

FROM THE facts and instances which have been presented, it is apparent that, by 1850, daguerreotypy was well established in this country. In 1853, the New York *Daily Tribune* estimated that three million daguerreotypes were being produced annually and, judging from the known number of daguerreotypists, this does not seem unreasonable.[75] The daguerreotype had indeed become well established, and the word itself was finding its way into the literature of the times. A town by the name of Daguerreville was formed on the banks of the Hudson.[76] *The Daguerreotype,* a short-lived journal, was established in 1847. This was not, as the name might imply, a journal dealing with the daguerreotype itself, but was a magazine of foreign literature and science, the name being selected because it was "designed to reflect a faithful image of what is going on abroad in the Great Republic of Letters," as was stated in its initial number.

Nathaniel Hawthorne selected a daguerreotypist as one of the characters in his famous book, "The House of the Seven Gables," published in 1850. This character was Holgrave, one of the dwellers in the house of the seven gables. The account of Holgrave given by Hawthorne must have been typical of the experience of many country daguerreotypists. Holgrave had been in turn a country schoolmaster, a salesman in a country store, the political editor of a country newspaper, then a peddler of cologne water and other essences, a dentist "with very flattering success," and next a lecturer on mesmerism. "His present phase, as a daguerreotypist, was of no importance," says Hawthorne, "nor likely to be more permanent, than any of the preceding ones. It had been taken up with the careless alacrity of an adventurer . . . and would be thrown aside as carelessly." Hawthorne's impressions of the daguerreotype are well stated, when Holgrave, in talking to Phoebe (the heroine), remarks:

[63]

"If you should permit me, I should like to try whether a daguerreotype can bring out disagreeable traits on a perfectly amiable face. . . . Most of my likenesses do look unamiable; but the very sufficient reason, I fancy, is because the originals are so. There is a wonderful insight in Heaven's broad and simple sunshine. While we give it credit only for depicting the merest surface, it actually brings out the secret character that no painter would ever venture upon, even if he could detect it. There is, at least, no flattery in my humble line of art." [77]

That there was no flattery in this art was a statement common among the public at large, which no doubt had been led to expect flattery at the hand of the artist of brush and pencil. Indeed, *The Living Age* in 1846 remarks: "It [the daguerreotype] is slowly accomplishing a great revolution in the morals of portrait painting. The flattery of the countenance delineators is notorious. . . . Everybody who pays, must look handsome, intellectual, or interesting at least—on canvas. These abuses of the brush the photographic art is happily designed to correct." [78] This recalls the classic story which has now been the photographer's joy for nearly a hundred years and has appeared in many variant forms. The first account of it, published in 1840, runs like this:

A patron complained to a daguerreotypist that his portrait, just taken, made him look like an assassin, to which the heliographer replied with significant brevity, "Sir, that is not my fault." [78a]

Not even this lack of flattery on the part of the new craft prevented its wide acceptance in portraiture as is evidenced by the fact that the art of miniature painting comes to an almost abrupt halt with the advent of the daguerreotype. A revival of this form of portraiture is a matter of recent times, as anyone interested can readily ascertain by reviewing the history of miniature painting.

Although the profession and its craftsmanship were well known within ten years after its introduction into this country, the public at large manifested considerable ignorance in regard to the process itself. This was especially so in the smaller towns and country villages which had no "resident artist" but were visited occasionally by a wandering daguerreotypist fitted up with a horse-drawn van in much the same manner as the tin peddler, a still more common character in the rural districts. The stories furnished by these peripatetic

"The Daguerreotypist"—a cartoon from a wood engraving in *Godey's Lady's Book,* 1849. The daguerreotypist may be M. A. Root of Philadelphia, as he is referred to in the text of the original article accompanying the illustration.

disciples of the sun are legion, and from among them I have selected two as representing the conditions under which they labored. A young operator, in his traveling van, had reached a small inland town in Madison County, New York, and after advertising his profession he opened the van for business. Among the first of his customers were two respectable young ladies (all the ladies of that day apparently were respectable). The "Professor" posed the first

[65]

young lady and then retired into his darkened cubby hole to prepare the silver plate. The second young lady took advantage of the operator's absence to satisfy the age-old woman's curiosity by peeking into the camera. Imagine her surprise to find her friend upside down on the focusing glass. "Oh, Katy," she exclaimed, "you are standing on your head." Katy leaped from her chair in great confusion, and both ran with unmaidenly vigor from this den of iniquity that had so grossly insulted their girlish modesty. They were not content with running, however, for they spread the news of their experience to the villagers, with the result that an indignant mob formed, besieged the van, and finally sent it rolling over the hill, where it and its contents were destroyed; the operator felt lucky to get away with his life. Such were the experiences of the daguerreotyper in the effete East.[79]

Another incident must suffice. Let us call it, "A Scene in the Daguerreotyper's Van," or "The Day Is All Too Long." A mother and her daughter and a young gentleman have entered, and the artist is busy posing the daughter:

YOUNG LADY: "I feel so stiff and awkward with this prong behind my head. Oh! for mercy's sake, take it away, it makes me think I am at the dentist's again having my teeth operated on."

MOTHER: "Hush, my daughter, Mr. T. will believe that you have false teeth if he should hear you, and then you know you might produce a bad impression."

OPERATOR: "Please to keep still, Miss." To mother and friend: "Will you please step a little to this side, as I cannot well take the lady when you are in front of the camera. Now, then, ready! When I take the cover off the front of the instrument, keep still. I will detain you only fifteen seconds. . . . That will do."

The mother then gets into the chair and expresses her desire that the picture will not show her gray hairs. As she is as gray as a badger, the operator merely says, "I will do my best, Madam." Mother then wants to know, "Must I look one way all the time?"

OPERATOR: "If you please, Madam; should you change the position of your eyes you might look cross-eyed in the picture."

This made the old lady quite indignant, as she was sure her eyes were very straight and good. The operator was able to pacify her

and proceeded to pose her. After several more questions he was able to make the exposure. It was then the young gentleman's turn. The operator tactfully told him that, since he had heard the instructions given the ladies it would not be necessary to repeat them. To this the young man agreed, and, after smoothing down his locks, straightening up his shirt collar, and arranging his toilet in a most precise manner, said that he was ready. As the operator was about to uncap the lens, the young gentleman imparted the final instructions that he wanted his imperial, a sandy and almost imperceptible mustache, to show, as well as his watch chain and finger rings. Also, "Please be very careful not to show a black streak across the mouth." After listening to this all the day, the operator surely deserved any rest that he could get at night. It should be added, for anyone interested in knowing how these daguerreotypes "came out," that those of the mother and of the young man were satisfactory, but the young lady had four hands! Quite a serious defect for one not a museum curiosity, so the operator retook the young lady, cautioning her to keep her hands still, as well as her head.[80]

Not only were there traveling vans by land, but similar outfits plied the principal rivers. The Father of Waters, of course, had its share, for on its broad bosom floated boats on which were practised every profession, vice, virtue, and fad that had its counterpart on land. One operator, Sam F. Simpson by name, described his experience as follows:

"Our flat-boat Gallery (called Magic No. 3) is fitted out with every convenience for taking likenesses. In front of all is the reception room, back of that, the sitting room, and still further back the chemical room. In our sitting room we have a large side and sky light that enables us to operate in from five to ten seconds in fair weather. If business is good we can remain as long as we please; if dull, we can leave. When we are not employed, we can fish or hunt, as best suits our fancy, as the rivers are thronged with ducks and wild geese.

"Last year [1853] I left New Albany, on the first of March; stopped at about fifty landings, took something over one thousand likenesses, traveled by water near fourteen hundred miles, and arrived by June upon the sugar coast (about a hundred miles above New Orleans) where the French language is universally spoken." [81]

[67]

As a result of this universal canvas of the daguerreotyper, the press began to speculate on what new wonders were in store for these artists of the sun. Listen to this prediction of the photographic future made in the late forties: [81a]

"For our own part we are unable to conceive any limits to the progress of this art. On the contrary, it tasks the imagination to conjecture what it will *not* accomplish. . . . Experienced professors (every art now has its *professors*) shall visit foreign parts, the courts of Europe, the palaces of the pashaws, the Red Sea and Holy Land, and the pyramids of Geza, and bring home exact representations of all the sublime and ridiculous objects which it now costs so much to see. . . . Popular vocalists will be *taken* in the very art and attitude of vocalizing, wordy demagogues in the attempt to hood-wink the sovereignty, and government defaulters at the critical moment of absconding. Apparatus so extensive will doubtless be constructed that a whole assembly may be taken at once. . . . Indeed it will be impossible for a tree to bud and blossom, a flower to go to seed, or a vegetable to sprout without executing at the same time an exact photograph of the wonderful process. . . . A man cannot make a proposal or a lady decline one—a steam boiler cannot explode, or an ambitious river overflow its banks—a gardener cannot elope with an heiress, or a reverend bishop commit an indiscretion, but straightway, an officious daguerreotype will proclaim the whole affair to the world."

With what remarkable certainty this prediction has come true! In fact, the wonders predicted in this paragraph are now commonplaces; it is difficult to imagine occasions when the ubiquitous news photographer is not on the spot. The only possibility which the astute prophet did not foretell was the duplication of the original scene in *motion*.

And how did the work of these several thousand daguerreotypists compare with the work of their contemporaries across the Atlantic? In the various forms of art and literature it was customary, during this period, to acknowledge, despite considerable "eagle-screaming," the superiority of the European over that of the American. Surely in France, the land of its birth, there would be every reason to believe that daguerreotypy would achieve its highest perfection; surely in England and Germany, with their long tradition of excellent artists and scientists, conditions would be conducive to the production of daguerreotypes superior to those of America.

[68]

We must, however, consider the fact that a new art, or craft, had been born in which there was no tradition save that which might be of value from artistic and scientific culture in general. And apparently, such general culture had little or no influence, for in the heyday of daguerreotypy (1851-54) the superiority of American daguerreotypes, or at least the product of the best daguerreotypers of our country, in general, was recognized. As Horace Greeley so modestly put it: "In daguerreotypes we beat the world." [82]

Very probably, the only world-wide competition of daguerreotypists occurred at the great world's fair of 1851, the Crystal Palace exhibition held in England. The critic of the *Illustrated London News* reports this judgment on the exhibit of daguerreotypes at the Crystal Palace:

"After a very minute and careful examination we are inclined to give America the first place. Whether the atmosphere is better adapted to the art, or whether the preparation of Daguerreotypes has been congenial with the tastes of the people, or whether they are unfettered with the patents in force in England, certain it is that the number of exhibitors has been very great and the quality of production super-excellent. The likenesses of various distinguished Americans by Mr. Brady are noble examples of this style of art. The family of Mr. Churchill is a very pretty group; and the series of views illustrating the falls of Niagara are a very appropriate example of American industry by Mr. Whitehurst, of Baltimore. The large specimens by Mr. Harrison are also excellent. In fact the American display of Daguerreotypes in some degree atones for the disrespect with which they have treated all other nations, in having applied for so large a space, and yet at last having left their space comparatively unfilled." * [83]

The London correspondent of the *National Intelligencer* also wrote that "the American daguerreotypes are pronounced the best which are exhibited." [84]

Not only did these critics think so, but the official jury thought so, too, for the only medals (three in number) awarded for daguerreotypes were given to Americans; M. B. Brady and M. M. Lawrence of New York City, and John A. Whipple of Boston—despite competition from England, France, Austria, Prussia, and other Germanic countries. The official report reads:

* The last sentence is typical of a universal criticism of the British press. Americans apparently did not realize the magnitude of the Crystal Palace, which was really one of the most elaborate and extensive of the many world's fairs.

"On examining the daguerreotypes contributed by the United States, every observer must be struck with their beauty of execution, the broad and well toned masses of light and shade, and the total absence of all glare, which render them so superior to many works of this class. Were we to particularize the individual excellencies of the pictures exhibited, we should far exceed the limits of the space to which we are necessarily confined."

In the official catalog of the exhibit, similar comment is made:

"The Americans, from the first announcement of the wonderful art of sun-painting, have zealously made the subject one of much patient experiment. The first portraits from life were taken by the daguerreotype in New York, and a variety of manipulatory processes have originated in that country. The success with which the art is practiced, and the degree of perfection to which it has been brought, may be estimated by the specimens exhibited by various artists. The brilliancy and sharpness of some of these are highly remarkable." [85]

The jury reported on the daguerreotypes of Lawrence as follows:

"They are remarkable for clear definition and general excellence of execution. In this series two large portraits of General J. Watson and W. Bryant, Esq., each of which measures $12\frac{1}{2}$ x $10\frac{1}{2}$ in., deserve particular commendation. Notwithstanding their large size, they are, throughout, perfectly in focus, and are beautifully finished in all details. These are two of the best pictures in the American collection."

Brady exhibited forty-eight daguerreotypes, all of which were uncolored, as were Lawrence's. Brady's "are excellent for beauty of execution. The portraits stand forward in bold relief, upon a plain background. The artist, having placed implicit reliance upon his knowledge of photographic science, has neglected to avail himself of the resources of art." *

To Whipple, the award was made for a daguerreotype of the moon which was "mentioned with the highest commendation; this is, perhaps, one of the most satisfactory attempts that has yet been made to realize, by a photographic process, the telescopic appearance of a heavenly body, and must be regarded as indicating the commencement of a new era in astronomical representation." [86]

* In this last sentence, the jury is referring to the custom, introduced by Claudet, the London daguerreotypist, of placing painted backgrounds behind the sitter.

Draper, with the advent of the daguerreotype, made photographs of the earth's satellite, the moon sitting for her first photographic portrait in the early spring of 1840.[87] The image obtained by Draper of the moon was very small, but those of Whipple, secured with the

A daguerreotypist at work—Jacob Byerly of Frederick, Maryland, who opened his gallery in 1842. (Courtesy of Charles Byerly, a grandson and also a photographer; photograph of daguerreotype made by Edmonston, Washington, 1936.)

aid of the Harvard College observatory telescope, were large enough to attract universal attention.

The Crystal Palace Exhibition showed quite clearly that American daguerreotypists were as good as any in the world, and this judgment is confirmed many times by other unbiased observers. John Werge, an English daguerreotypist, visited this country in 1853, and remarked that "Americans produce more brilliant pictures than we do." [88] The French correspondent of *Humphrey's Journal* in Paris states that "the specimens of the Daguerreotyper's art fall far behind those of the United States."

European daguerreotypists advertised "Pictures taken by the American process." [89] One of the most celebrated of the London daguerreotypists was Mayall, an American who, for some years before going to London, had operated a "parlor" in Philadelphia. [90] Thomson, one of the leading daguerreotypists in Paris, was also an American. [91]

It can be reasonably asked why Americans were superior in this craft of foreign origin. From the beginning, the popular impression continually advanced in the press was that the superiority was due to the climate. "An American sun shines brighter," said the reporter for the New York *Herald* on the successful completion of the first daguerreotype on this side of the water; and this reason was advanced again and again to account for the results of the Americans. But did an American sun shine brighter than a European one? Very probably there were some days when it did,* but this did not account for the success of our daguerreotypists. The answer, I think, can be given in these words—mechanical ingenuity and competition. The love for things mechanical was traditionally a Yankee trait, and this Yankee ingenuity is apparent in the art of daguerreotypy, as well as in other lines of endeavor. The brilliance of the American daguerreotype, which was so much admired, was secured by the use of power-driven buffs and the studied use of abrasives and metal polishes. [92] John Werge, the Englishman whom we have just mentioned a moment ago, confirms this opinion with the statement:

"The superiority of the American Daguerreotype was entirely

* Meteorological statistics do show a greater percentage of cloudy days in England and the Continent.

Zachary Taylor (a photographic copy of the Brady daguerreotype made in 1849; courtesy Signal Corps, U.S.A.). The excellence of the original can be imagined from the fact that the illustration seen by the reader was copied four times before the print in this book was made.

Daguerreotype portrait of unknown woman by M. A. and S. Root, New York City, about 1853. (From the daguerreotype collection of M. Therese Bonney.)

due to mechanical appliances. . . . All employed the best mechanical means for cleaning and polishing their plates, and it was this that enabled the Americans to produce more brilliant pictures than we did. Many people used to say it was the climate, but it was nothing of the kind." And again, the Americans' "plain Daguerreotypes were all of fine quality and free from the 'buff lines' so noticeable in English work at that period." [93] The buff lines, of course, were due to poor abrasives, their application being made by hand.

Americans had also discovered that buffing agents could be used to increase the sensitivity of the finished plate.[93a] As these "accelerating buffs" employed leather and were saturated with organic material, it is not at all unlikely that the increased sensitization was produced by the presence of sulfur compounds, which have been found in recent years (1925) to increase remarkably the sensitivity of modern photographic materials.*

* The reference made here is to the work of S. E. Sheppard of the Eastman Kodak Company, who found that gelatin, which is used in producing modern photographic film, must contain certain sulfur compounds in order to produce marked light sensitivity in the final product.

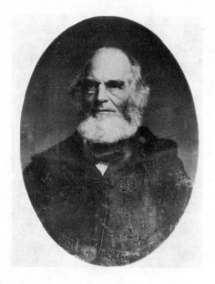
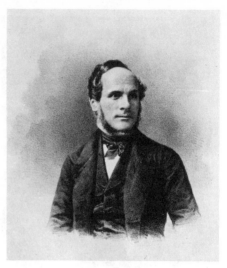

William Cullen Bryant—one of the forty-eight daguerreotypes exhibited by Brady at the Great Exhibition of 1851. (Courtesy of M. Therese Bonney, its present owner.)

M. M. Lawrence of New York, one of the prize-winning daguerreotypists at the Great Exhibition of 1851. Brady was another, and John A. Whipple of Boston was the third. Whipple's portrait appears in Chapter VI. The portrait of Lawrence is from a lithograph by Sarony and Major and was first published in the *Photographic Art Journal*, February, 1851.

Boston, as might be expected, took the lead in the application of mechanical contrivances to the daguerreotyper's establishment. Southworth and Hawes, Masury and Silsby, and especially John A. Whipple, were particularly enterprising in this respect; their work was recognized as equal to any the country produced. Whipple, who it will be recalled received one of the Crystal Palace prizes, used steam-driven appliances for nearly all his operations. A fan, operated by steam, cooled his subjects during the warm summer weather; by steam he cleaned his plates and polished them, heated his mercury for developing the silver plates, and prepared distilled water for washing them.[94]

New Yorkers and Philadelphians and enterprising daguerreotypists in other leading cities were quick to follow the example set by the Bostonians; as a result of such ingenuity and competition, fine work was characteristic of the leading establishments over the country. For these reasons, also, the prices of daguerreotypes were kept

down, and business of considerable magnitude followed, as we have already pointed out.

Any superiority that American daguerreotypes may have had over those of French or German origin is satisfactorily explained, I believe, by the account given. In England, daguerreotypists were confronted with a difficult situation. For some reason, Daguerre had felt justified in patenting his process in England, and had licensed his procedure to Beard and Claudet, who in turn were authorized to sub-license. The license fee apparently was heavy, for the number of daguerreotypers in England was never large. At the height of its popularity, only six or seven such establishments were reported in London, as against nearly a hundred in New York City alone.

The remark of one Britisher shows plainly why English daguerre-otypists were not in a position to offer serious competition to the rest of the world: "In London, the trade being centered in three licensees, who are under obligations of the most stringent kind, we are required to pay as many pounds for a picture as it costs shillings on the continent." [95]

Daguerreotypy at Its Zenith

AS THE POPULARITY of the daguerreotype grew to its height in this country, Daguerrean establishments in the principal cities grew more and more elaborate in character. Both Brady and Lawrence in New York opened larger establishments in 1853; Whipple and the firm of Southworth and Hawes had the largest establishments in Boston; in Philadelphia, M. A. Root, and McClees and Germon were leading daguerreotypists. Jesse H. Whitehurst, with a chain of galleries in many of the large cities, was also well known in this period.

The impression which such establishments made upon a visitor from Paris can be judged by the following report which appeared in the French photographic journal, *La Lumière:*

"The American daguerreotypists go to enormous expense for their rooms, which are most elegantly furnished. They are palaces worthy of comparison with the enchanted habitations which the Orientals erect for their fabulous heroes. Marble, carved in columns or animated by the chisel of the sculptor, richly embroidered and costly draperies, paintings enclosed by sumptuous frames, adorn their walls. On the floor lie rich carpets where the foot falls in silence. Here are gilded cages with birds from every clime, warbling amidst exotic plants whose flowers perfume the air under the softened light of the sun. This is the American studio. Everything is here united to distract the mind of the visitor from his cares and give to his countenance an expression of calm contentment. The merchant, the physician, the lawyer, the manufacturer, even the restless politician, here forget their labors. Surrounded thus, how is it possible to hesitate at the cost of a portrait?" [96]

It must have been from such sources that the modern movie magnate obtained his ideas for our present cinema palaces. No wonder that 3,000,000 daguerreotypes were taken annually in such surroundings.

The enterprise of the American daguerreotypist in attracting and seeking business is again illustrated by the fact that, of the six

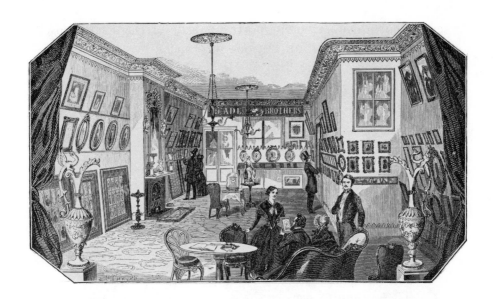

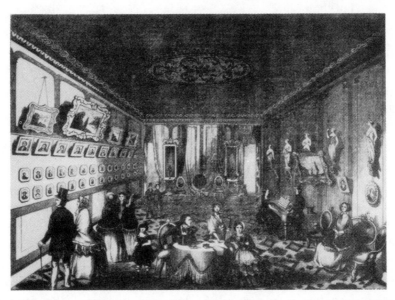

Typical daguerreotype galleries of the fifties. *Upper.* The Meade Brothers establishment, New York City. (From a wood engraving in the *Photographic Art Journal*, February, 1853.) *Lower.* "Balls' Great Daguerrian Gallery of the West" in Cincinnati. (From a wood engraving in *Gleason's Pictorial Magazine*, April, 1854.)

or seven known daguerreotype portraits made of Daguerre himself, before his death in 1851, all but one were made by an American—Charles R. Meade, of the firm of Meade Bros. of New York City, who visited Europe in 1848. Daguerre was very averse to having his portrait taken, but by Yankee persuasion and the efforts of Madame Daguerre, Meade obtained five or six daguerreotype portraits, two of which, it is said, are now in the United States National Museum.[97]

Daguerreotypes were made in this country in many sizes, and sold for a variety of prices. The favorite size in which Daguerre made his pictures appears to have been $6\frac{1}{2}'' \times 8\frac{1}{2}''$, which subsequently became known as the "whole plate" size. Based on the size of the whole plates, there were manufactured smaller and larger sizes, which became well standardized. These were: *

The one-sixth size	$2\frac{3}{4}'' \times 3\frac{1}{4}''$
The one-fourth size	$3\frac{1}{4}'' \times 4\frac{1}{4}''$
The half-plate	$4\frac{1}{4}'' \times 6\frac{1}{2}''$
The whole plate or 4/4 size	$6\frac{1}{2}'' \times 8\frac{1}{2}''$
The double whole plate	$8\frac{1}{2}'' \times 13''$

This standardization of size, it may be said, has survived in some instances up to the present time in our modern plates and films, although many additional sizes have been introduced.

In addition to the list of sizes given above, daguerreotypes were also made very small, for rings and lockets; and some very large ones, measuring $15'' \times 17''$, were produced late in the daguerreotype era. Of these sizes, the one-sixth plate was probably the commonest size, if my examination of a good many hundred daguerreotypes represents typical cases, and the one-fourth plate the next most frequently made. For the one-sixth plate, operators received various prices, depending upon the date, the place, and the operator. During the early part of the daguerreotype era this size probably brought $5.00 apiece to the operator. As business increased the price was gradually lowered. A very considerable impetus to the eastern daguerreotypists' trade came with the California gold rush of 1849. Prospective miners, with their tents, blankets and frying pans, had their daguerreotypes made to leave with the loved ones at home,

* There are slight variations, due doubtless to trimming and casing.

Brady's "new" gallery of 1853. From the New York *Illustrated News*, June 11, 1853.

and in turn took with them around the Horn, or across the plains, the daguerreotypes of those held most dear. As a result of the increase in business, prices were reduced to about $2.50, a level which was consistently maintained by the better establishments up to the introduction of paper photographs. D. D. T. Davie, a prominent operator of Utica, New York, kept a careful record of his business, and stated in 1853 that he had received on the average $2.53 for the one-sixth size and $4.35 for the one-fourth size.

The elaborate prize won by Gurney in the Anthony Competition of 1853.

Jeremiah Gurney. From a wood engraving in *Leslie's Illustrated Newspaper*, 1859.

The mammoth size, which was not standardized as were the smaller ones (I have found dimensions 13″ x 17″, 13½″ x 17½″, 15″ x 17″ given), sold for as much as fifty dollars apiece, the plates alone costing the operator nearly ten dollars. Obviously only the very rich or the extravagant young bloods would purchase these. By 1853, however, they were made in all of the larger daguerreotype establishments.[98]

The prices given applied to daguerreotypes of the sitter himself, for the daguerreotypist had another source of revenue in the sale of daguerreotypes of celebrities. He had to induce the celebrity to sit

[80]

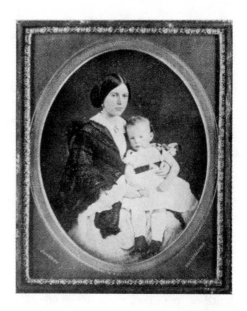

One of the daguerreotypes which won Gurney first place in the Anthony competition of 1853. The name of the subject is unknown. The original, which is tinted, is now in the collection of M. Therese Bonney, through whose courtesy it is reproduced.

for a number of portraits—an inducement usually accomplished, no doubt, by the promise of one of the portraits. Once the portraits were made, they were offered for sale at prices that depended upon the fame of the sitter. Usually, too, the daguerreotypist retained one of the plates to adorn the walls of his "salon," a common custom.

Of these celebrities, Jenny Lind was probably photographed the most. Hardly a city in which she appeared, but that the photographic journals would carry reports similar to that of Ryder, who said, "I secured several portraits of Jenny Lind upon her visit to Cleveland." Patient Jenny Lind—or maybe it would be better to say, astute Mr. Barnum, her American manager. For these portraits, operators received from five to twenty-five dollars, depending upon the magnitude of the furor caused by the songster's visit. How much Mr. Barnum received is not recorded.

It was inevitable, with the growing demand for daguerreotypes, that competition should force the price lower and lower. A class of operators sprang up in 1853 who actually advertised daguerreotypes for twenty-five cents apiece. The size of the twenty-five cent daguerreotypes, I have not been able to determine, but they were without doubt smaller than the one-sixth size. The lowering of the price level, of course, invoked the wrath and concern of those with elab-

orate establishments. For example, we find Mr. Brady advertising in the New York papers:

"Address to the Public—New York abounds with announcements of 25 cent and 50 cent Daguerreotypes. But little science, experience, or taste is required to produce these, so called, cheap pictures. During the several years that I have devoted to the Daguerrean Art, it has been my constant labor to perfect and elevate it. The results have been that the prize of excellence has been accorded to my pictures at the World's Fair in London, the Crystal Palace in New York and wherever exhibited on either side of the Atlantic. . . .

"Being unwilling to abandon any artistic ground to the producers of inferior work, I have no fear in appealing to an enlightened public as to their choice between pictures of the size, price, and quality, which will fairly remunerate men of talent, science, and application, and those which can be made by the merest tyro. I wish to vindicate true art, and leave the community to decide whether it is best to encourage real excellence or its opposite; to preserve and perfect an Art, or permit it to degenerate by inferiority of materials which must correspond with the meanness of the price."

"M. B. BRADY." [99]

It is doubtful if Mr. Brady's address had any effect on reducing the business of the cheap operators, as their clientele was drawn largely from a class that could not afford two dollars or more for a portrait. The low-price establishments were able to produce their cheap pictures by standardizing all processes. A visitor to one of these daguerreotype factories has left us a record of his experience after a trip through the establishment.[100] This customer bought his tickets, each ticket entitling him to a sitting. After paying his money he was shown into a crowded anteroom where he awaited his turn. At last he was "next," and entered the operator's room after surrendering his tickets to a boy at the door. He was told by the operator to sit down and look "thar." The camera man then passed his hand into a hole in the wall where he received a prepared plate in a covered slide, from the coating room. After exposing, the operator passed the plate through another hole into the mercury or developing room. This was repeated for each likeness for which a ticket had been bought. The operator, of course, had nothing to do with the preparation, developing, fixing, or mounting of the silver plate,

[82]

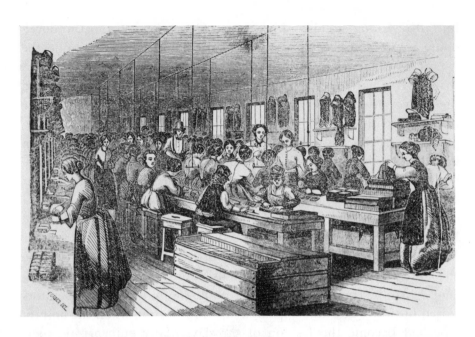

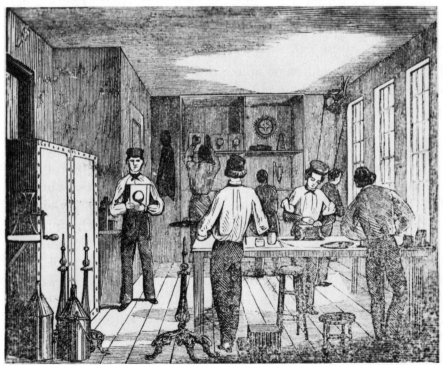

Anthony's establishment in 1854. *Upper.* The daguerreotype case-covering and finishing room. *Lower.* The apparatus department. (From wood engravings in the *Photographic Art Journal,* 1854.)

but all day long stood by his camera. Occasionally from the developing room would come the cry "Short" or "Long," to guide the operator in making his exposures. The sitter left by a different door than he had entered and after walking through the passage reached the delivery desk. After a few minutes wait here, he would receive his portraits fitted in "mat, glass, and preserver," the plates having passed from the developing and fixing room to the gilding room and then to the fitting room and finally to the delivery desk while he waited. The camera operator, it is evident, never saw the result of his handiwork. The visitor, who had had four likenesses made at this establishment, remarks, "Three of the four portraits were as fine Daguerreotypes as could be produced anywhere." It was no wonder that the more fashionable "palaces worthy of comparison with the enchanted habitations of the Orientals" were worried over their advent. With the coming of the paper photograph, the cheap operators ceased business, but they appeared again for a time when the ambrotype had become the fashion of the day. Many enterprising merchants sensed the advertising possibilities of these cheap daguerreotypes and offered them with their wares. For instance, Rafferty and Leask of New York City, in advertising their fall hats for gentlemen in 1853 at $4.00 and $5.00 apiece, inserted a daguerreotype in the lining of the hat without additional expense. "This," they said, "is a great convenience in indicating one's own hat." [101]

Much of our knowledge of the daguerreotype era is due to the publication of two journals or magazines of photography. With their accustomed eye for business the Americans were the first to commence publications devoted to the interest of the Daguerrean. The first of these, and therefore the first photographic journal in the world, was *The Daguerrean Journal,* edited by S. D. Humphrey of New York. The first issue of this journal appeared November 1, 1850, and continued publication under several titles until 1870. Shortly after the publication of the first number of *The Daguerrean Journal,* the first issue of the second publication appeared. This was *The Photographic Art Journal,* edited by H. H. Snelling, also of New York. The first issue of Snelling's *Journal* is dated January, 1851, but it apparently was somewhat behind its announced publication date for several issues.

LAWRENCE'S
DAGUERREAN GALLERY,

381

BROADWAY,

Cor. of White St.,

Is one of the oldest, most extensive, and best arranged in the World. His PICTURES are pronounced, by Artists, SUPERIOR to all others. Mr. L. received the *highest* Premium at the WORLD'S FAIR in LONDON for the BEST PICTURES ; and also at the Exhibition in New York. In addition to Daguerreotypes, Mr. L. has introduced Photography, or Daguerreotypes on Paper, plain (like a fine mezzotint) or colored (like a fine ivory miniature,) possessing all the accuracy, of the Daguerreotype.

PARTICULAR ATTENTION IS GIVEN TO COPYING DAGUERREOTYPES AND OTHER PICTURES.

SMALL PICTURES
CAN BE ENLARGED TO ANY DESIRED SIZE.
Children of all Ages taken.

SCHOOL AND FAMILY GROUPS TAKEN — OF TEN, TWENTY, OR FIFTY PERSONS.

☞ **PICTURES TAKEN JUST AS WELL IN CLOUDY AS CLEAR WEATHER.**
A LARGE COLLECTION OF PORTRAITS
of Prominent Men can be seen at the Rooms (which are free to all) at all times.
A VISIT IS SOLICITED.

June 1t D

M. M. LAWRENCE.

BRADY'S
CARD TO THE PUBLIC.
A NEW FEATURE IN DAGUERREOTYPES HAS RECENTLY BEEN INTRODUCED BY BRADY,
AT HIS OLD GALLERY,

205 *BROADWAY, CORNER OF FULTON STREET.*

THE extent of his Establishment enables him to produce for 50 cents, and $1, pictures of a quality infinitely superior to the phantoms usually designated cheap pictures. This is a new feature in first-class establishments, and the fame of the artist is too well known to doubt its success. The public can now rely on obtaining as good a picture for that price as can possibly be put up, and a far better picture than can be obtained elsewhere at the same rates. Brady's New Gallery, 359 Broadway, over Thompson's Saloon, is fitted up with great taste and beauty, and possesses greater facilities for the production of first-class portraits than any similar establishment in this country. These Galleries form an elegant resort for persons of taste—containing as they do the largest collection of distinguished portraits in America. Prize Medals were AWARDED to Brady at the World's Fair in London, 1851, and at the Crystal Palace, New York, 1853.

BRADY'S DAGUERREAN GALLERIES, Nos. 205 & 359 Broadway, over Thompson's Saloon.
July tf. D.

Typical advertisements of Lawrence and Brady. (From the *American Phrenological Journal* for 1854, courtesy Hubert Kucera, Riverside, Iowa.)

Both of these journals did much to improve the quality of work over the entire country, and kept the workers in the profession abreast of all the recent advances. *The Photographic Art Journal* was an especially ambitious enterprise; it is likely that Snelling patterned his magazine after the well-known *London Art Journal*. It was large and well printed, illustrated at first by means of lithographs, and later by paper photographs pasted into blank pages.

The illustration above and the one on the opposite page are title pages of America's first photographic journals.

Although Snelling's enterprise was extremely commendable, he could not secure sufficient circulation to keep his journal in print for long, and it died a lingering death in 1860.[102]

In the first volume of each of these journals appear lengthy discussions of a subject which at that time was of extreme importance to daguerreotypists in general. In the first number of *The Photographic Art Journal,* there appeared a note which the editor assures us "was announced a little nervously." The announcement was to the effect that a Mr. Levi Hill had succeeded in impressing the image upon the daguerreotype plate in all the beauty and brilliance of the natural colors. Photographs in their natural color! A problem

that has been worked on for nearly a century, with still no simple method achieved.

The Daguerrean Journal made a more positive statement: "It was a new and valuable discovery that ranks with Daguerre's original invention and that of the telegraph by Morse." The newspapers, then as now, always eager to announce without verification scientific intelligence, took up the chorus in full cry, and stated with evident self-satisfaction that at last an American had made a major contribution to the science of photography, which so far had been confined to French and English experimenters.

The daguerreotypes in color (not to be confused with the hand-colored ones) were described by Hill to Snelling in a letter dated February 4, 1851. Hill stated that he had then prepared forty fine specimens, one of which was "a view, containing a red house, green grass and foliage, the wood-color of the trees, several cows of different shades of red and brindle, colored garments on a clothes-line, blue sky, and the faint blue of the atmosphere, intervening between the camera and the distant mountains, very delicately spread over the picture, as if by the hand of a fairy artist." His greatest difficulty, Hill said, was in recording yellows properly, but he added that the exposure was less than for an ordinary daguerreotype. Such descriptions whetted the appetites of both daguerreotypists and the public; and as a result of the newspaper publicity the ordinary daguerreotype business came to a practical standstill during the summer of 1851, as the public was not going to have a "plain" daguerreotype made if it could soon have one in color.

Mr. Hill, it developed, was a Baptist clergyman who, on account of ill health, had given up his ministerial calling to become a daguerreotypist. This statement in itself should have offered some warning to the more astute members of the profession, but it was entirely overlooked. Further, Mr. Hill lived in West Kill, Greene County, New York, a small, remote, and almost inaccessible village among the Catskills.

Hill stated that he needed more time and financial support to continue his study before the process could be patented, but that as a means of supporting himself during the period, he had written a book, a manual of daguerreotypy, which he proposed to sell. This

[88]

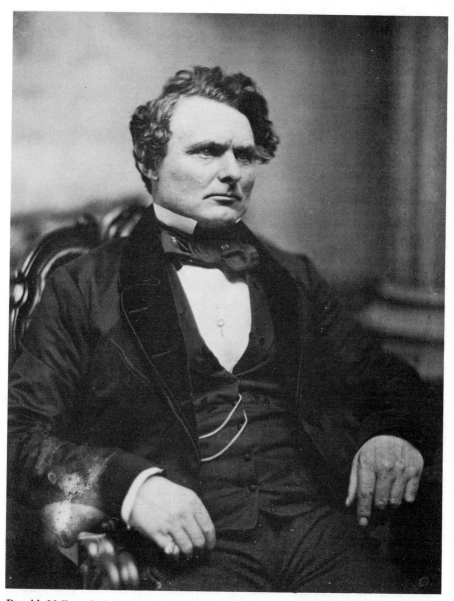

Donald McKay, designer and builder of clipper ships. From a daguerreotype made by Southworth and Hawes, 1854 (courtesy Edward S. Hawes, Boston). The original, a whole plate, is by all odds the best daguerreotype portrait I have ever seen.

statement sounded dubious to both Humphrey and Snelling, but both printed the announcement in their journals, quoting a price of $3.00 for the manual.

Interest continued to grow as Hill kept up his correspondence with the journals. He repeated that progress was being made in perfecting his discovery, but greater progress could be made if he were left alone, for apparently he was soon besieged with offers of help. During the summer of 1851, he was made co-editor of *The Daguerrean Journal*. He said at that time, "I am now so absolutely certain of overcoming every difficulty that One Hundred Thousand Dollars would not purchase my discovery as it now stands."

Morse, who had now achieved some affluence from his telegraph, became much interested in Hill's purported discovery, and actually visited Hill at his home. Morse stated, "He is unquestionably a man of genius, intelligence, and piety, retiring and sensitive"; but Morse *saw none of Hill's forty-five specimens*. In fact, no one, save one or two individuals who had no knowledge of daguerreotypy, seems to have seen them at this time. Without Morse's indorsement of Hill, the matter doubtless would have been dropped sooner than it was, but as Morse had considerable influence the daguerreotype community bore with Hill for some time, and continued to buy his book. Morse stated that he had persuaded Hill not to apply for a patent, for "a patent," Morse said, "is a mockery. It is a mirage cheating the sense with unreal images of comfort and delusive ramparts of protection. A patent is an announcement that another prize is afloat that pirates may contend for its possession over the murdered body of its rightful owner." Morse's eloquent feeling in this matter undoubtedly arose from the long and expensive litigation which followed his invention of the telegraph.

Even Morse's affirmation that Hill was a "man of genius, intelligence and piety" could not long keep the profession in its place, for they were suffering severely from loss of trade; the demands became louder and louder for a description of the process. Hill procrastinated, pleading that ill health kept him from working out the details of the process to his satisfaction. In the fall of 1851 he resigned his co-editorship of *The Daguerrean Journal* and the affair soon became regarded as another hoax devised solely for the purpose

Josiah Hawes, a partner of the famous firm which included Albert S. Southworth. (From an original daguerreotype, courtesy Edward S. Hawes.)

Mrs. Vincent, a favorite player of the Boston Museum. (From an original whole-plate daguerreotype by Southworth and Hawes about 1854, courtesy Edward S. Hawes.)

of securing a large sale of Hill's manual. Hill continued to maintain he had found a process of color photography; and, although daguerreotypists had completely disregarded if not forgotten these claims, we find Hill appearing in 1853 before a committee of the United States Senate to request a special patent and government aid. The committee was favorably impressed when Hill showed them specimens of his work, but the matter apparently never reached the floor of the Senate.

The impression prevailed at the time and for some years subsequently that Hill had worked his hoax by cleverly coloring his daguerreotypes by hand, and this theory, I believe, is correct. There is a faint possibility that Hill actually discovered a color process. He stated that the process was based upon the use of a new substance (its nature, of course, not stated) which he used in place of mercury, the developing agent for the daguerreotype plate. The new developer produced the natural color. The only justification for assuming such a possibility is based upon Hill's statement that he was unable to record yellows correctly; these appeared as "buff." This region of the spectrum has been one of the most difficult to reproduce cor-

Niagara Falls. (From an original daguerreotype made by A. S. Southworth about 1854, courtesy Edward S. Hawes.)

rectly with modern photographic color processes and this fact suggests the remote possibility that Hill may have stumbled on a process of color photography. Hill died a few years after his last endeavor to receive recognition; and, if he had a secret, it died with him.[103]

Before closing our history of the daguerreotype era, it seems appropriate to discuss briefly the collections of those daguerreotypes which have survived since their heyday, now over fourscore years in the past. To begin with, there is, so far as I know, no extensive collection of American daguerreotypes in existence. M. Therese Bonney, probably the foremost daguerreotype collector in the world, exhibited her collection in this country at the Knoedler Galleries in New York and in the National Museum in Washington during the winter of 1933-34. The collection called forth expressions of admira-

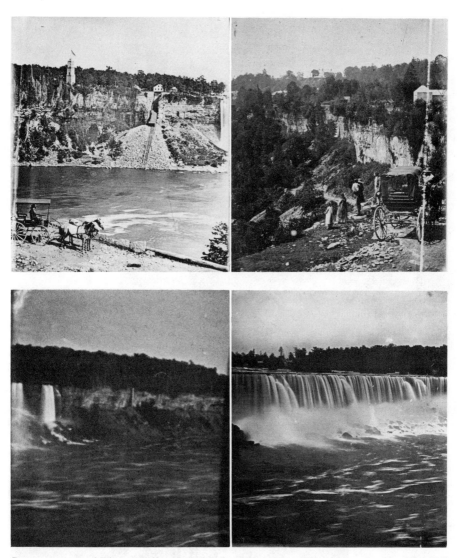

Daguerreotypes of Niagara Falls, taken from near the Clifton House, Canada side, July, 1845, by W. and F. Langenheim, Philadelphia. (Courtery F. D. Langenheim, Philadelphia.)

tion from an unusually large number who saw it exhibited and may have encouraged some to adopt daguerreotype collecting as a hobby.

When one considers that some fifteen to twenty millions of daguerreotypes were made during the period of their popularity, and that practically every individual in the public eye from 1841

[93]

Brattle Square Church, Boston, 1852. Daguerreotype by Southworth and Hawes. (Courtesy the Metropolitan Museum of Art, New York City. Photograph of daguerreotype by Beaumont Newhall, July, 1937.)

Copy of the above daguerreotype reversed. The scene (notice signs especially) now appears in its proper position.

on was portrayed by the method, the extent of the field for collection can be seen.[104]

Not only would such a collection portray the heroes of the past more faithfully than does any other form of pictorial art, but it would depict in an equally faithful manner the dress, the hobbies, the houses, the streets, and the scenes of a bygone age. It is surprising that those with the collecting mania have not paid much attention to the daguerreotype. About the only interest collectors appear to have taken in daguerreotypes is in the collection of daguerreotype cases, which in some instances bring very high prices. These cases, which apparently are now used for cigarette containers, are usually of hard rubber, into which have been molded fancy designs or scenes. To meet the demand, dealers in antiques have collected daguerreotypes in considerable quantity and have ruthlessly destroyed the picture. I realize, of course, that photographs of unknowns, save in exceptional cases, would be of no particular interest in a collection such as I have described, but many times dealers themselves have no idea of the identity of an individual whom a daguerreotype portrays. For example, I have found daguerreotypes of Jenny Lind and of Henry Clay in antique shops, and in each instance the dealer had no idea of its identity.

But not only portraits should be included in such a collection. The daguerreotype, contrary to many published statements in the modern press, was used to reproduce views as well as portraits; and many of these views must still be in existence in various out-of-the-way places.

We have mentioned the views of Niagara Falls on display at the Crystal Palace in London in 1851. These views, made by Whitehurst, were made on double whole plates (that is, they were about 9 x 13 inches in size), and aroused marked interest both at home and abroad. John Werge, the English daguerreotypist, whom we have already mentioned, saw these daguerreotypes at the Great Exhibition. He then said, "Of all the wonderful things in that most wonderful exhibition, I was most interested in the photographic exhibits and the beautiful specimens of American Daguerreotypes, both portraits and landscapes, especially the views of Niagara Falls, which

made me determine to visit America as soon as ever I could make the necessary arrangements." [105]

The Falls, ever a favorite theme of the photographer, appear to have been first daguerreotyped by the Langenheims of Philadelphia, early leaders in photography in this country, in the summer of 1845. These views were sent abroad to many of the crowned heads of Europe, and were acknowledged by them with thanks and medals. The kings of Saxony and of Württembern, Frederick of Prussia, and Queen Victoria, as well as Daguerre himself, took occasion to commend the Langenheims for their efforts. [106]

By 1853, there was a professional daguerreotypist at the Falls, a Mr. Babbitt, who held a monopoly in this art, granted by General Porter, then manager of the American side. Babbitt had a pavilion under which he placed his camera; when a group of visitors stood on the shore to survey the Falls, he would daguerreotype the group without their knowledge, finish the daguerreotype, and offer it for sale to the visitors before they left. Usually the "visitors" were glad to have the picture and paid Babbitt well for his enterprise.

Not only did the Langenheims, Whitehurst, and Babbitt make such daguerreotypes, but so did many others. John Werge, who was so attracted by Whitehurst's daguerreotypes of Niagara that he came to this country, took a large number of views himself and described his experiences in securing them in a lengthy article which appeared in the London *Photographic News*. [107] It can be seen that there must have been many, many daguerreotypes of the Falls made, and many of these must have survived.

Other scenes were also daguerreotyped, as statements in the literature of that day show. For instance, in 1851, Mr. Cady of New York took instantaneous daguerreotypes of steamboats leaving the wharf, the wheels in rapid motion; in the same year, Alexander Beckers made instantaneous views of Broadway, all moving objects being clearly defined. [108] In 1849 and 1850, Robert Vance obtained over 300 views of the California mines and miners; Fitzgibbon of St. Louis made daguerreotypes of the frontier and the river trade of St. Louis;* Fontayne and Porter secured a number of daguerreo-

* The Vance and Fitzgibbon daguerreotypes are discussed at greater length in Chapter Fourteen.

The restoration of a daguerreotype: above, the original daguerreotype; below, the daguerreotype restored by the method described in the Appendix. The subject is a Free State Battery in the days of "Bloody Kansas." Daguerreotype made at Topeka, Kansas Territory, summer of 1856. (Courtesy the Kansas State Historical Society.)

type views of Cincinnati which constituted the entire panorama of the city of that date (about 1850); and Alexander Hesler of Chicago secured daguerreotypes in the Northwest (Minnesota Territory at that time), including a number of Minnehaha Falls.[109] We must take time to mention one of Hesler's daguerreotypes of these Falls, as the episode illustrates the far-reaching influence of the new art. Hesler was one of the recognized leaders of American daguerreotypy, specimens of his art ranking with Gurney's, Brady's, and Southworth and Hawes's best efforts. In 1851, Hesler made the trip upon which he secured daguerreotypes of the Falls. He had one of these daguerreotypes on exhibition in his studio in Chicago for some time. While there, it was seen by George Sumner, a brother of Senator Charles Sumner of Massachusetts. George Sumner bought the picture, gave it to his brother the Senator, who in turn gave it to his friend Henry W. Longfellow. Over a year later, Hesler received an autographed copy of the poem "Hiawatha" as well as a letter in which Longfellow stated that the incentive for his famous poem came after viewing Hesler's daguerreotype. The book is still the prized possession of the Hesler family.[110]

Contrary to another impression prevailing at present, it was possible to make "instantaneous" views of the kind described above. Of course, no shutters were used; the exposure was secured by capping and uncapping the lens. "Instantaneous" meant removing the cap and replacing it on the lens as soon as possible—an exposure of possibly a fifth of a second, which would be sufficient to arrest slow action when the camera was some distance from the moving object.

Studio exposures, since the light intensity was less, would quite obviously be somewhat longer than those required for exterior views. The length of the exposure was determined by the operator, the camera and plate which he employed, and the condition of the weather. After considerable study of this point, I believe that I am safe in saying that the average studio exposure, in the fifties at least, was fifteen or twenty seconds for a portrait daguerreotype. I have found mention of exposures as short as two seconds and as long as sixty. My statement concerning the relative shortness of exposures will come as a surprise to those present-day writers who have asserted that "minutes" were required to make a daguerreotype.

Draper's daguerreotype of his sister, made in 1840, required only sixty-five seconds, it will be recalled; and that was before the introduction of accelerators.[111]

In the discussion which has been presented, the embryo collector of daguerreotypes should find enough information to guide him in starting his collection. The daguerreotype can be distinguished from other forms of early photographs by its mirror-like luster and by the fact that the image disappears if viewed at the same angle at which the illuminating beam strikes it; that is, the daguerreotype must be viewed at a certain angle in order to see the image at all. At other angles it is simply a mirror. If still in doubt as to its authenticity, gently pry the specimen from the case; this can be done readily with a knife blade. A daguerreotype fits snugly in its case, but is not glued in place. If the back of the specimen thus removed is a copper plate, you can be sure that it is a daguerreotype. Sometimes, too, the removal of the daguerreotype from its case will give information as to the identity, date, and maker. These facts are seldom found (unfortunately), but occasionally they are written on a slip of paper inclosed loosely in the case or pasted to the back of the copper plate. If the collector desires to make a further examination, the gilt metallic binder around the glass and plate can be bent back, the glass and the metallic mat removed, and the face of the photograph on silver examined. Care should be exercised here not to touch the silver surface, or scratch it, as the picture will be seriously marred by finger prints or marks; the plate itself should be handled by the edges. The opportunity offered by the removal of the daguerreotype from its case can be used to clean the glass on the inside, a process that will often remarkably improve the appearance of the daguerreotype. Cloudy, dingy, and faded daguerreotypes can at times be restored to nearly their pristine clearness. If one has had no experience in making restorations, he will do well to take his faded picture to one of the experts who advertise such service. For those who are interested, however, the method is described in the appendix to this book.

The collector should remember, also, that in the majority of cases the daguerreotype reverses the image from right to left; that is, gives a mirror image of the subject photographed. This is not

always so, as daguerreotypists were familiar with the method of correcting the error. The correction, in principle, amounted to securing a view of the subject in a mirror and then taking a daguerreotype of the mirror image. As this process considerably increased the time of exposure, it was not extensively employed save in copying illustrations and documents. It is safe to say that in the majority of instances, portraits and original scenes are reversed. The position of a sword, of a pencil, of a cigarette, or of some other object will show this reversal. One weary operator commented indirectly on this reversal when he complained about the lovesick swains who in sitting for their portraits would persist in placing a huge paw over the region of the heart and after a few days would return with the daguerreotype for repairs because the heart was on the *wrong side*. If any printing appears in the finished daguerreotype, the reversal is then very easy to detect. The printing can be read easily by holding it up to a mirror.

Retouching of the finished picture, in the modern sense, was not employed in the daguerreotype. As we have said, however, it was frequently colored. This coloring does not destroy the original lines, when lightly done, so that a faithful representation of the original subject is still apparent. It should be stated that artifice was occasionally practiced on original portrait subjects. One old timer says, "We always had sticking wax by us to keep wing-shaped ears from standing out from the head, and we often placed a wad of cotton in hollow cheeks to fill them out. The ladies called them plumpers." [112]

Measured even by modern standards, daguerreotypes are excellent photographs. Edward Weston, one of the foremost of present day photographers, lists the following physical characteristics of a well made photograph. "It should be sharply focussed, clearly defined from edge to edge—from nearest object to most distant. It should have a smooth or glossy surface to better reveal the amazing textures and details to be found only in a photograph. Its values should be convincingly rendered; they should be clear-cut, subtle or brilliant—never veiled." [113] These qualities are all possessed by the daguerreotype, especially with respect to brilliance and rendering of detail; in these respects, in fact, it surpasses any modern

[100]

process. The range of contrast in the daguerreotypes is not as great as in the modern paper print, but intermediate tones are well shown. Daguerreotype portraits are not flat, because, as we have seen, top and side lighting was almost immediately adopted. Then, too, the practice of cluttering the background with elaborate scenery and artificial accessories is very largely absent, in American daguerreotypes, at least; the resulting portraits gained much by this simplicity—a simplicity which has been regained only within present times. Bogardus, who was familiar with and practiced all the common photographic processes from the daguerreotype down to and including gelatin dry plates, stated that he considered the daguerreotype the best picture yet made with the camera—and there are many who will agree with him.

We have said that the daguerreotype era reached its heyday in 1853. It was still largely practiced in 1854 and 1855, but during the late fifties it was superseded by collodion photography, although some of the larger establishments made daguerreotypes on demand for many years. There were one or two daguerreotypists in New York as late as 1870 and several individuals have practiced it as a novelty in modern times. It is probable that the collodion process replaced daguerreotyping more slowly in country towns than in the metropolitan centers, but I am sure that almost all daguerreotype operating had disappeared by 1865. The transition period (1855-1860) is discussed in greater detail, however, in the latter part of the next chapter.

Photography

ONE BRIGHT DAY in the fall of 1833, a well-to-do young Englishman, Talbot by name, sat on the shore of Lake Como in northern Italy. He gazed at the scene spread out before him, famed throughout the world for its beauty. Across the lake on the gentle slopes of the receding hills lay cultivated groves of olive and fig; these merged farther back into the dense forests of the higher hills and these in turn were backed in the far distance by the towering Alps. To the right and left long arms of the lake gradually receded into other green-clad hills. The clear soft light, the azure sky and fleecy clouds, combined with the warm and gentle breeze, were enough to make the most prosaic being long to record the scene in a more permanent fashion than upon the elusive tablets of the memory. Talbot, who had an interest in drawing, tried several sketches with his pencil, but was not satisfied with the perspective and tore up his early efforts. The next day, however, he was back at the same spot with a camera obscura in the hope that he might better portray the picture which had so appealed to him. On the glass at the back of this instrument he fastened a sheet of tracing paper, upon which he drew in the outlines of the scene thrown by the lens upon the paper. He obtained a sketch which served as souvenir of the scene, but still he was not satisfied with the result. The camera had moved as the pencil pressed against the paper and it was difficult to get it back in its original position. What was still more baffling was the difficulty of reproducing all the minute details visible upon the paper, which made up the image, the counterpart in miniature of the original scene. As Talbot gazed on this detailed miniature, he became thoughtful. "What *is* the image," he mused, "divested of the ideas which accompany it? Why, I have it! It is but a succession or variety of stronger lights thrown upon one part of the paper, and of deeper

shadows on another. Now light can produce chemical action and since the amount of chemical action should be greater where the light is more intense, there should be some chemical method of fixing the image of the camera obscura." The idea so impressed him that he wrote it down and upon his return to England actually started on a series of investigations with the specific purpose of "fix· ing the image." It will be observed that this was six years before Daguerre's discovery was announced, although Daguerre and Niepce had been at work for some years with the same object in view.

Talbot, not familiar, of course, with their attempts, had only the work of Scheele, Davy, Wedgwood, and others, early pioneers in the study of the chemical action of light, to guide him. He had persisted in his efforts with some degree of success when in January of 1839 the announcement came from Paris that Daguerre had succeeded in reaching the long sought goal of fixing the image of the camera obscura.[114]

The announcement, although the process was not described, served to arouse Talbot to describe his efforts at a meeting of the Royal Society of London on January 31, 1839. His report bore the cumbersome title, "Some Account of the Art of Photogenic Drawing, or the Process by which Natural Objects may be made to delineate themselves without the aid of the Artist's Pencil." Talbot, at this time, contented himself with stating that he had overcome the difficulties of Davy and of Wedgwood, who, although they had copied objects by direct contact some years earlier, had not been able to produce a material that was sensitive enough to record the image of the camera obscura, nor able to make their copies permanent.

Three weeks later Talbot described his process in detail. First, he obtained the best grade of writing paper; a firm sheet with a smooth surface was necessary. This was dipped into a weak solution of ordinary salt and then wiped dry with a soft cloth. After this treatment, one side of the paper was brushed over with a water solution of silver nitrate, a compound prepared from metallic silver. The sheet was then dried before a fire and was ready for use. Such a paper was very useful for recording the images of leaves and flowers. The process was to place the leaf over the sensitive surface of the

paper (the one which had been brushed with silver nitrate) and expose it to the action of the sun. The light, in passing through the more transparent portions of the leaf, left a record of its minute "veins," and the outline of the leaf was clearly drawn by the sun. To fix this image, it was bathed with a very strong solution of ordinary salt, which removed the light-sensitive material (silver chloride) not acted upon by light; in this manner the image was made permanent.

To fix the image of the camera obscura required a more sensitive paper. This was secured by alternately washing the sheet with common salt, wiping it dry, washing with the silver solution, drying, and repeating the cycle a sufficient number of times until the desired sensitivity was secured. Such a process was treacherous, however, as a number of sheets all prepared at the same time and by the same procedure varied considerably in sensitivity, so that the time of exposure necessary to secure an image in the camera obscura showed large variations, and at best had to be very long. The paper, once the image had been secured, was *fixed* by washing in a strong solution of salt. The present day amateur will at once recognize that this process gave Talbot what we now call a *negative*—a picture in which the light areas of the original subject were dark and the dark areas were light.

Talbot, in neither of his two early publications, indicates that he had thought of the possibility of transferring his original negative to a second sheet and securing what we would now call a positive print.[115]

This possibility was suggested by Sir John Herschel, whose letter to Professor Draper has been given. Herschel, too, had been seeking for some time a method of fixing the image of the camera obscura. It is difficult to decide how long Herschel had been working on this problem; but apparently interested, or spurred on, by the announcement of Daguerre's success in January, 1839, he systematically considered the various chemical possibilities which might lead to such a result. He was early acquainted with Talbot's process but appears to have arrived at a solution of the problem independently of a knowledge of the details of either Daguerre's or Talbot's method. On March 14, 1839, he appeared, as Talbot had done, before the Royal Society of London, his report being called, "Note on the Art

of Photography, or the application of the Chemical Rays of Light to the purposes of Pictorial Representation." Herschel's method was not greatly different from that of Talbot; it employed paper as the receptive medium on which was coated the light-sensitive substance, silver chloride.

Of all the strange coincidences of science and invention, this appears to me to be the strangest. Here within the space of two months, three men, each unaware of the details of the work of the others, announced a process which had remained a secret from man for centuries.

William Henry Fox Talbot. (From an original card photograph by Moffat of Edinburgh, about 1860; courtesy, Miss M. T. Talbot, Lacock Abbey, Wiltshire.)

It should be observed, however, that each of these men had not arrived at his results unaided, but each had been helped by either the knowledge gained from associates or the combined knowledge of the ages, or both. The time must have been ripe for such discoveries! [115a]

Herschel's report was distinctive in some respects. He definitely used the term *photography* for this offspring of science and art; in the second place, he stated that copies made from the original picture reversed the light and shaded areas and restored them to the same order as that of the original. At first he called these *second transfers* or *re-reversed* pictures, and said that it was infinitely more difficult to secure them than the original picture, a statement that gives one some idea of the very small sensitivity of the paper employed for this purpose. Herschel realized immediately the very practical advantage of these re-transfers. In 1840, he introduced the now familiar terms *negative* for the original produced in the camera and *positive* for the print obtained from the negative. Finally, Herschel's report suggested the use of hyposulfites as fixing agents.

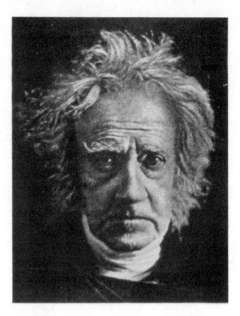

Sir John Herschel. (From a photographic portrait by Julia Margaret Cameron, about 1867; reproduced from *Camera Work*, No. 41, 1913, through the courtesy of the copyright owner, Alfred Stieglitz.)

This recommendation was based upon an observation of Herschel's made some years previously, to the effect that apparently insoluble silver compounds are dissolved by these agents. Herschel's suggestion was adopted by both Daguerre and Talbot; the compound he recommended is the common fixing agent employed at present under the name of "hypo." [116]

It is interesting to note the variety of names which were employed for the processes which are now called collectively "the photographic art": sun drawing and sun pictures, the heliographic art and heliographs, the pencil of nature, photogenic drawings, calotypes (suggested by Talbot for his pictures), which later were called Talbotypes, as well as the more familiar term, daguerreotypes. Even Talbotypes were at times called "paper daguerreotypes"; so it can be seen that Herschel's terms, *photography, positive* and *negative* were only slowly adopted.

After the publication of Talbot's original description of his process, work was continued on improving the sensitivity of the material placed in the camera. Borrowing the results of a fellow countryman, the Rev. J. B. Reade, and adding some contributions of his own, Talbot announced in 1841 some marked improvements in the process.[117] Briefly, these were the substitution of potassium iodide for common salt and the addition of gallic acid to the silver nitrate solution. The use of these substances speeded up the paper negatives to such an extent that portraits were possible. In addition, Talbot pointed out that with these modifications the image was latent (as in Daguerre's process), and that the negative needed to

Gore Hall, Harvard College, 1844. (From the original talbotype negative made by Cooke; courtesy Harvard College Library.)

be developed in order to be made visible. The developer recommended was a solution of silver nitrate to which gallic acid had been added, that is, the same solution used in preparing the sensitive material. Not only was the process capable of producing portraits, but it was possible with the increased sensitivity to make prints much more readily; for these prints Talbot used the term *positives* as suggested by Herschel. To make the production of the positive prints still easier, Talbot recommended waxing the negative paper to make the high lights (in the negative) more transparent.

For some unaccountable reason, beginning in 1841, Talbot took out a series of patents, both at home and abroad. To enumerate but a few of them: He patented the improved process for making calotypes, just described; he patented the use of a colored backing paper to improve the appearance of transparent prints; he patented a *hot* solution of hypo for fixing; he patented the publication of photo-

Part of the Boston City Hall and the Boston Museum, 1842. (From the original talbotype negative made by Josiah Parsons Cooke; courtesy Harvard College Library.)

Merchants Exchange, Philadelphia, Aug. 16, 1849. (From an original talbotype made by the Langenheim Brothers of Philadelphia; courtesy Miss M. T. Talbot.)

A talbotype, 1849, made by the Langenheim Brothers. The subject has not been identified with certainty but is probably a cast-iron lighthouse under construction for Carysfort Reef, Florida.

graphic prints. The English patent covering his second process for securing pictures is dated February 8, 1841; the American patent covering the same procedure was not issued until June 26, 1847.[118] It is difficult to estimate the effect of these patents, but they undoubtedly hindered the wide use of Talbot's process, especially in this country.

American newspapers early in March of 1839 were publishing the news that both Daguerre and Talbot had succeeded in arresting the image of the camera obscura. As we have seen, however, the nature of Daguerre's process did not become known in this country until September 20, 1839. Talbot, however, had disclosed his first process in February of 1839, and by April of the same year accounts of his method had been published in this country, the first of these appearing in the *Journal of the Franklin Institute,* a well known scientific journal still in existence.[119] The scientific fraternity in this country were interested in Talbot's results and some attempts were made to duplicate them. Draper stated in 1858 that he had repeated Talbot's directions "with variation. I tried to shorten the long time required

for getting the picture of a house or tree, by using lenses of large aperture and short focus, and from this the germ of portraiture finally arose. This was prior to the publication of anything by Daguerre." [120]

It will be recognized that the photographs obtained by Draper and other Americans were negative in character and did not show the detail typical of the daguerreotype. For these reasons the early Talbotypes did not achieve the popular response that the daguerreotype obtained upon its introduction. The original process of Talbot was extremely slow and uncertain; the daguerreotype, therefore, must be regarded as the first *practical* process of photography.

Because of the patent restrictions, Talbotypes (or calotypes), even after increased sensitivity had been obtained, were never extensively made by professional photographers in this country. The Langenheim brothers of Philadelphia obtained the American rights to Talbot's patent, and while they tried hard to secure its wider use they were not successful.[121] Some professionals adopted it for trial but soon gave it up in

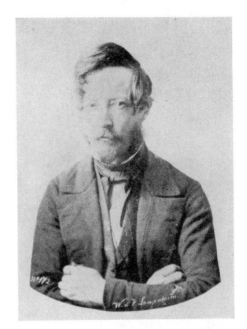

Upper, Frederick Langenheim. (From a talbotype portrait made in the Langenheim Gallery, 1849; courtesy **F. D. Langenheim,** Philadelphia.)
Lower, William Langenheim. (From a talbotype portrait made March 20, 1849; courtesy **F. D. Langenheim.**)

John A. Whipple, one of the leaders in intro-ducing photography into the United States. (From a lithograph by François d'Avignon, originally published in the *Photographic Art Journal*, Aug., 1851.)

Edward Anthony. (From the crystallotype of Whipple published in the *Photographic Art Journal*, April, 1853.)

Fitchburg Depot, Boston—a Whipple crystallo-type made in 1853. It was of this building that Henry Thoreau wrote (in 1859, *Familiar Letters*), "The only room in Boston which I visit with alacrity is the gentleman's waiting-room at the Fitchburg depot, where I wait for the cars, sometimes for two hours, to get out of town."

preference to the far more popular daguerreotype process.

Although professionals did not use the Talbotype, it proved to be the amateur's delight, if we can judge from the few contemporary ac-

[110]

counts that have been found. The process was cheaper to use than that of the daguerreotype; it was slower in speed, and it possessed the ability to reproduce positive copies of the original negative. Many of the early amateurs who practiced this form of photography were youngsters interested in science. In Philadelphia, in 1840, for instance, Mr. Isaac Lea brought some forty specimens of Talbotypes to the February meeting of the American Philosophical Society and proudly announced that they were made by his son, Carey Lea. Carey, at this time, was seventeen years old; it may have been his interest in the Talbotype that led him to devote his life to the study of chemical phenomena, so that at his death in 1897 he was regarded as one of the outstanding authorities in the field of photochemistry.[122]

In Boston, another young man, William F. Channing, at the age of twenty-two, published the results of some experiments he had made with the Talbotype process in 1842. The results obtained by Channing were acclaimed by Hunt, a great English authority on photographic matters at that time, as "the first by which the calotype process could be simplified." [123]

Channing stated that he was able to secure photographs by his method for which "one minute is sufficient for a building on which a February sun is shining, four or five minutes for general views." Channing, trained in medicine, became interested in scientific and technical processes and later achieved success as one of the cooriginators of our modern electric fire alarm systems. Two other young enthusiasts in Boston were Edward Everett Hale and Samuel Longfellow, younger brother of the poet. The author of "The Man Without a Country" wrote many years later: "My classmate and near friend, Mr. Samuel Longfellow (who died last year) and I were both much interested, and he repeated Talbot's experiments at once. I took from my window in Massachusetts Hall a picture of the college library—Harvard Hall—opposite me. The camera was a little camera made for convenience of draftsmen with a common lens of an inch and a quarter. We were delighted, because, in a window of the building which 'sat for us,' a bust of Apollo 'came out' so distinctly as it did. It came out dark brown—all the lights and shades being marked." [124] These experiments must have been made in the

spring of 1839 as both Hale and Longfellow were graduated from Harvard in this year, and their efforts are therefore among the earliest attempts at photography on record in this country. Both were very young at this time, Hale being seventeen and Longfellow three years older.

The record for precocity in this direction, however, goes to another Bostonian and natives of that city, therefore, have another link in the chain of evidence supporting their claim to be regarded as the intellectual hub of the country. The link in question is supplied by the work of Josiah Parsons Cooke. Cooke, later well known as professor of chemistry at Harvard, early showed an interest in scientific affairs and as a school boy spent his spare time in reading and studying chemistry. He did not enter college (Harvard) until 1844, but several years prior to this date had made successful Talbotypes. Fortunately, some of these early negatives of Cooke's, the earliest of which is dated 1842, are still in existence. The earliest is a view which includes part of Boston city hall and Boston Museum on School Street, which buildings stood on the site that the City Hall of Boston now occupies.[125] This view was made when Cooke was but *fifteen* years old. At present such a feat by a fifteen-year-old boy would be looked upon as commonplace, but this, it must be recalled, was in the day when photographs were virtually unknown. A print from this negative has been reproduced (on page 108) as well as another made by Cooke two years later, when he was a freshman at Harvard. They are among the earliest American negatives still in existence.

We have commented at considerable length upon the work of Talbot and Herschel and its introduction into this country, for the reason, no doubt already perceived, that their processes, rather than that of the daguerreotype, are the basis of the modern system of photography. Both the daguerreotype and the Talbotype, it will be recognized, involved the use of silver compounds as the light-sensitive material, both required development and fixing, the developing agents being different, the fixing process the same. Here the similarity ends. Only a single daguerreotype could be obtained for each exposure of the camera; in the Talbotype an indefinite number of copies could be obtained, at least theoretically, for each exposure;

[112]

in the daguerreotype the image was reversed from right to left, in the Talbotype print it appeared in its correct relation to the original subject; the daguerreotype could be seen only at a suitable angle of illumination; this mirror-like quality was totally lacking in the Talbotype. These distinctions will all be recognized as advantages in favor of the Talbotype. The daguerreotype, on the other hand, was superior in its record of detail and in a much greater sensitivity and therefore far shorter period of exposure than the Talbotype. These differences were recognized at the time, for a critic of 1844 writes:

"The neutral tints [of Talbotypes] are of a warm brownish hue, with occasionally a tinge of red or purple; the tint different in every instance, its hue depending upon the chemical operation of light on the paper. This variation of tint is rather pleasing than otherwise; for all the varieties are mellow and agreeable to the eye and much preferable to the metallic glare and hard blackness of the Daguerreotype-plates. The images of the Calotype are only inferior to those of the Daguerreotype in this respect— the definition of form is not so sharp, nor are the shadows so pure and transparent. By looking through a magnifying glass at a Daguerreotype-plate, details imperceptible to the naked eye become visible in the shaded parts; not so with the Calotype drawings—they do not bear looking into. This arises chiefly from the rough texture and unequal substance of the paper; which cannot, of course, present such a delicate image as the finely-polished surface of a silvered plate." [126]

The defect arising chiefly from "the rough texture and unequal substance" of the paper negatives was the incentive for the next important advance in the field of photography; it had its origin in one of Herschel's experiments. Herschel was the first to realize the very practical importance of duplication of prints and, as his paper negatives were not very transparent, he sought to increase this quality. He conceived the idea of preparing the light-sensitive material, silver chloride, by itself, and then coating it upon glass, the most transparent of all common solid substances. His method consisted in preparing the silver chloride in water and then allowing it to settle out on a glass plate which he had carefully placed in the bottom of the vessel in which the silver chloride had been prepared. By this method he was able to get an even coating of silver chloride on the plate. After settling was complete, the liquid above the plate

was carefully decanted off and the film of silver chloride allowed to dry on the glass, which was then exposed. Herschel by this method was able as early as 1839 to produce a *glass* negative, but, as can be seen, his method would be extremely tedious in the preparation of any number of negatives.[127]

It was soon recognized that any advance in the use of a glass negative must be accomplished by the addition of a third substance, a binder or vehicle, to hold the light-sensitive material to the glass, and a number of such substances were tried by both amateurs and professionals, not only abroad, but in this country.

The first to suggest the use of such a vehicle in this country appears to have been America's early photographic genius, Alexander Wolcott. Wolcott, in a letter to his partner, Johnson, in 1843, stated that he had tried coating glass with the whites of eggs to hold the silver compounds in place, but that he had not been particularly successful and had given up the attempt. It is to be regretted that his efforts were not continued, as they doubtless would have led to a successful process for the preparation of glass negatives. Incidentally, it should be noted that Wolcott, who at this time was in London, apparently was interested in a method for projecting photographic pictures on a screen, that is for using photographic pictures in the magic lantern, such instruments having been in use many years before the advent of photography.[128] There is no evidence indicating what success Wolcott achieved in this field, but a few years later the Langenheims of Philadelphia were quite successful in such a venture; from this beginning, there grew, a few years later, that very popular institution "the illustrated lecture."

Another American who made early efforts to obtain glass negatives was the enterprising and ingenious John A. Whipple, the Boston daguerreotypist. Whipple stated that his experiments were begun as early as 1844, when "the idea naturally suggested itself, why could not an even film of some kind be laid upon mica or glass and the negative impression be taken upon that, thus avoiding the great evil of copying the texture of the paper?" After thinking it over, Whipple first tried milk as a vehicle and succeeded in securing some successful negatives, but the process was slow and extremely uncertain; consequently, he tried other substances, among

Gurney's Daguerrean Gallery, 349 Broadway, New York (from a waxed-paper negative made
by Victor Prevost about 1854; courtesy N. Y. Historical Society). Victor Prevost was a New York
photographer from 1853 until 1857 and was an early user of both the waxed-paper process
and the collodion process. The New York Historical Society possesses a number of Prevost's
original paper negatives.

Bradhurst Cottage on Bloomingdale Road near 148th Street, New York, occupied by Molineaux Bell. (From a paper negative made by Victor Prevost about 1854; courtesy N. Y. Historical Society.

them "substances of a gelatinous and albuminous nature—but none operated quite so well as albumin from the hen's egg." Again it is unfortunate that Whipple did not publish these results soon after he tried them. He waited until 1850, when (in conjunction with W. B. Jones) he applied for and was granted a United States patent for making glass negatives in this fashion.[129] Although the patent was allowed, Whipple's results had been anticipated by a Frenchman, M. Niepce de Saint-Victor (nephew of Daguerre's partner), who published in 1848 a successful method of making glass negatives by the use of albumen (egg white) as a vehicle.

In this country the Langenheims of Philadelphia used the glass negative process of Niepce as early as 1849, introducing their products to the public as hyalotypes; Frederick Langenheim secured a patent for the improvement of these pictures a few months after the granting of Whipple's patent of 1850.[130] The Langenheims printed their positives, not only on paper, but on glass as well, and made them quite popular in Philadelphia by using them in the stereoscope—which will be discussed in greater detail in a later chapter.

From the above discussion it is evident that photography on glass began in this country as early as 1849, perhaps earlier, and that Whipple of Boston and the Langenheims of Philadelphia were the most active among professional photographers in introducing it.

At the Great Exhibition of 1851 in London, the Langenheims were the only American competitors to exhibit Talbotypes and their so-called hyalotypes—both of which created favorable comment. It is curious to note, however, that in the jury report of the Great Exhibition mention is made of the superiority of the American daguerreotypes, as already noted, of the French calotypes (a process of English origin), and of the English photographs made from glass negatives (a process of French origin). The greenest grass always grows on the other side of the fence! Mention should be made of the fact that many of the exhibits and buildings of this great world's fair were recorded photographically by both Talbot and Niepce de Saint-Victor's processes. In fact, photography upon both paper and glass negatives was far more extensively employed at this time abroad than it was in this country. Even as late as June of 1852, the editor of *Humphrey's Journal* published the following review, a revealing

comment on the relative merits of the processes then employed in this country:

"At present the art may be divided into three principal branches—the daguerreotype, in which the silver plate is employed; photography, or the Calotype, in which prepared paper is used; and albuminised glass. These are the principal media for receiving the sensitive coating and we may, therefore, classify the Heliographic art under these three heads— Plate, Paper, and Glass, each of which has its admirers, who eulogize their peculiar favorite, to the exclusion of others.

"*In America, the Silvered plate,* the discovery of Daguerre, who has given his name to the art, is *almost exclusively patronized,** and must continue to be so while the patent right of Mr. Talbot exists. This branch of the art has been carried to a high degree of perfection by our American Daguerreotypists and their productions need not fear comparison with those of their fellow-artists of Europe.

"But, in the other departments, we cannot make the same boast; the calotype is, comparatively speaking, almost neglected.

"With regard to the other material that is sometimes used by photographers, viz., glass, many objections might be argued against its universal adoption—the nature of the material will always be an insuperable obstacle to its general use." [131]

A year before Humphrey made these remarks, however, a process of photography on glass had been publicly described which was destined within a few years to replace the daguerreotype and all other photographic processes. In 1851, Frederick Scott Archer, an English sculptor and photographer, described the use of *collodion* as a vehicle to hold the light-sensitive material to the glass plate.[132] Collodion is a thick syrupy liquid made by dissolving nitrated cotton in a mixture of alcohol and ether. Its discovery, a few years previous to Archer's announcement, has been attributed to Menard of France and to Maynard of the United States. The alcohol and ether evaporate quickly when collodion is allowed to stand, leaving a transparent film behind. It was the formation of this transparent film which Archer utilized. To the collodion was added a soluble iodide, and the viscous liquid was poured out on a glass plate. It was allowed to flow evenly over the plate, an accomplishment requiring some little knack, and the ether-alcohol allowed to evaporate. This

* The italics are mine.

process left a thin, even, transparent film which was sensitized by bathing in a solution of silver nitrate. This formed the light-sensitive compound, silver iodide, upon the surface of the collodion film which in turn adhered tenaciously to the glass. If allowed to dry after coming from the silver bath, such a plate had practically no sensitivity, but if used while still wet or damp (an hour after preparation at the most) it was quite sensitive. For this reason, the method is usually referred to as the "wet process." With some comparatively simple modifications the collodion, or wet, process held sway in this country from 1856 until 1881. Such negatives were easier to prepare, more transparent, more uniform, more sensitive, and more stable than the albumen plates. They had the advantage over the daguerreotype of unlimited reproducibility from a single exposure. Even at best, however, they were not much more sensitive than was the daguerreotype at the zenith of its popularity.

The favorite developer for producing the image in the collodion process was a solution of ferrous (iron) sulfate made acid with acetic acid. An acid solution of pyrogallic acid was another favorite developer, although not employed as extensively as the iron salt. The collodion negatives were "fixed" by a dilute solution of potassium cyanide in preference to "hypo" as the potassium cyanide produced somewhat greater contrasts than did the more familiar hypo.[133]

Although the process was described in 1851 it was not rapidly adopted either at home or abroad. Close students of photography, however, soon recognized its value. Robert Hunt, the English authority, stated in the *London Art Journal* of 1851 that "the collodion process promises to be of exceeding importance." The two American photographic journals described it soon after its announcement, the *Photographic Art Journal* publishing a translation of a French manual on the process in 1852.[134] Toward the end of this year it was remarked that "a large number of our first artists have commenced the paper practice." [135] The efforts of most of these artists were probably not very successful at first as they had to prepare not only their collodion, but the gun-cotton as well. For example, an inquiry directed to *Humphrey's Journal* in this year received this reply: "Collodion is at present in high repute but even with the most experienced operators, results are often uncertain." [136]

[119]

Such uncertainties would not lead to very wide adoption of the process, especially at a time when the details of the daguerreotype process had very nearly reached perfection.

Of the various operators, Whipple of Boston was the first to achieve marked success with paper photography. We have already mentioned his early attempts in this field and his use of albumen as a vehicle. With the advent of collodion, Whipple adopted the new process and set himself patiently at work until he had mastered it. His paper prints from the albumen negatives had created much local interest and had achieved the elegant name of "crystallotypes," a name which Whipple continued to use for prints obtained from the collodion negatives.

By 1853, Whipple had achieved considerable success with his "crystallotypes." At the World's Fair held in New York in that year, he received the highest award in photography (a silver medal) for his paper photographs. The vast majority of his competitors showed only daguerreotypes.[137] During this year, he furnished the *Photographic Art Journal* with a number of paper prints made by this process, which were used as illustrations in several issues of the journal. The prints, although small, were made on large paper and bound into the magazine.

The first of these prints, which appeared in April, 1853, was fittingly a portrait of Edward Anthony, but it was copied from a daguerreotype, a fact which indicates that the process was so slow that at first portraits from life could not be made.[138] These early paper prints were made on smooth paper, but they contain no glaze or gloss. They are various shades of brown because the print was gold-toned after its preparation.* The paper used for these early prints was practically the same as that used by Talbot in the preparation of his first negatives, that is, made by the use of common salt; and for this reason, it was referred to as "plain salted paper." A few years later albumen was used to confer a gloss upon the finished print.

As a result of his successes during 1853, Whipple was recognized as the leading authority on paper photographs in this country and

* Gold-toning was continued for many years, a brown print always being typical of this process.

Print from an early collodion negative. "Broadway from the Hospital," 1857. (Photograph by L. E. Walker.)

his establishment was thronged with operators anxious to learn the process. For such tuition, he charged fifty dollars, a fee that all were glad to pay, as considerable fear had been expressed that Whipple would be extortionate. As a result of Whipple's instructions, paper photography received its first real boom. Gurney, followed by Law-

rence, and by Brady, was practicing it professionally in New York City in 1854, as were McClees and Germon in Philadelphia, and Whitehurst in his chain of galleries. Fitzgibbon of St. Louis imported a man trained in the process in the same year, and early in the following year Hesler of Chicago followed suit.[139] The photographic journals, in 1854, made frequent comments on the impending change. We read: "There have been more apparatus sold in the United States the last three months for paper manipulation than during the whole time previous since its discovery" (April, 1854).[140] The following month the prediction was made that:

"Two years more will effect an entire revolution in the Daguerreotype business throughout the United States. The superiority of paper photographs as illustration, the rapidity with which they can be multiplied, their distinctness, and the great number of purposes to which they are applicable, must cause them, in a great measure, to supersede the daguerreotypes. . . . Those who will hang a daguerreotype and a paper photograph side by side against the wall of their parlors as an ornament cannot but give preference to the latter. For this reason, the daguerreotype will of necessity be confined to the smaller sizes, while the paper photograph will assume even greater dimensions than those now obtained, and in a few years take the place of the finest engravings." [141]

Snelling, whose remarks these are, correctly foretold the future. The year 1854 marked the beginning of the decline of the daguerreotype—not that the daguerreotype was immediately superseded, for it was during 1854 and the early part of 1855 the major process practiced, but 1856 saw its rapid decline and by 1857 it was a minor branch of the photographic trade. Humphrey, for instance, stated early in 1856 that there were more portraits and views made by the collodion process than by all others combined.[142]

The Ambrotype

"A Daguerreotype on Glass"

THE RAPID DECLINE of the daguerreotype in 1856 would probably have occurred much more slowly had James A. Cutting, a Bostonian, lived in another era. Cutting, in July of 1854, was able to secure three United States patents in photography. One of these patents remained a source of contention among photographers for many years. All three patents dealt with modifications of photographs obtained by the wet process and were devised to cover the production of a form of photograph which became known as the *ambrotype*.[143] (Anyone who finds the profusion of *types* bewildering should at least be grateful to the author for not mentioning all the *types* that flourished during the first quarter century of photography.)

The ambrotype was a thin collodion negative on glass. If, when developed, fixed, and dried, it was laid on a black surface and viewed by reflected light (as contrasted to *transmitted* light) the appearance of a positive picture was obtained. This illusion was due to the fact that the white areas of the negative, when backed by the black surface, became black, and the dark areas of the negative, which were silver, reflected light and by contrast appeared bright. The inversion from negative to positive was thus secured without resort to the preparation of a print. The reader can produce the same effect by taking one of his thin kodak negatives and placing it on black paper, where it will appear as a positive. The effect can also be seen by examining the two illustrations on page 125.

The ambrotype was thus a photograph on *glass* and can be identified in this manner. It was usually mounted in a case similar to those used for daguerreotypes. The black background was obtained in a variety of ways. Black velvet, black paper, or black japanned metal was placed behind the glass plate. In the cheaper ambrotypes, the

collodion film was brushed over with black varnish to secure the effect. A black background was sometimes rendered unnecessary by making the photographs on dark colored glass. In many ambrotypes a second clear glass plate was used and sealed by balsam to the original (one of Cutting's patents) to protect the image. Ambrotypes, like daguerreotypes, were made in a variety of sizes, but the one-sixth and one-fourth sizes (see page 78) were the most common. They were sometimes colored by hand.[144]

While it is apparent that, as in the daguerreotype, a single picture was obtained for each exposure, the image of the ambrotype was not necessarily reversed from right to left. Whether such inversion occurred or not depended upon the method of mounting. Since the plate was now transparent, the correct position could be obtained by viewing the image through the glass upon which the collodion film was formed.* This necessitated viewing the picture not only through the glass but through the film as well, and rather than thus reduce the brightness and detail of the picture, most photographers preferred to mount it so that the image was reversed.

The Cutting patents did not attempt to cover the process of converting a negative into a positive as this procedure was already known. Herschel, in his experiments in 1840, had pointed out that a thin negative could be made positive in appearance by putting it upon a black background. Only the method of sealing and modifications in the process of producing were covered by the patents, and the name of ambrotype does not appear in the patents themselves, although in Cutting's English patent of July 26, 1854, the word *ambrotype* is used.

The word does not appear to have been used in this country until some time after Cutting's patents had been issued. The first mention of this form of photograph appearing in the professional journals occurs in the *Photographic Art Journal* for December, 1854, when a news note from Philadelphia states: "Messrs. Richards and Betts of Philadelphia have shown us some very fine daguerreotypes on glass. These pictures possess qualities entirely foreign to those upon the silver plate. They can be protected from the influence of

* As we have said, there are sometimes two glasses cemented together. Notice especially that it is the glass upon which the collodion film is formed that is referred to here.

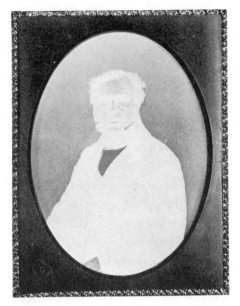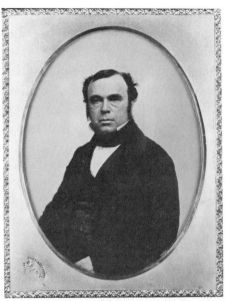

The Brady ambrotype of Draper. (Courtesy, Professor John W. Draper, Morgantown, W. Va.)
Left, the ambrotype photographed with white paper as a backing, showing the negative
character of this form of photograph. *Right,* the same ambrotype photographed against
a piece of black velvet. The frame appears darker at the left than at the right, because
a somewhat longer exposure was needed to bring out detail in the positive form.

the atmosphere much better—and are not marred by the double
reflection so annoying in the daguerreotype." [145]

The new pictures were mentioned by name the following month
when Rehn's display of ambrotypes at the Fair of the Franklin In-
stitute was described.[146] *Humphrey's Journal* mentioned them first
by name on February 1, 1855, again in correspondence from Phila-
delphia.[147]

Cutting, although a Bostonian, had as his first partner Isaac
Rehn, of Philadelphia, a very able man, who was responsible for the
appearance of the first notices of the ambrotype in Philadelphia.
Rehn, in turn, was a close friend of M. A. Root, the Philadelphia
daguerreotypist and the first historian of photography in this coun-
try. Rehn showed Root some of these "daguerreotypes on glass" and
Root suggested the name *ambrotype* for them, "because," said Root,
"it is a derivative from the Greek 'Ambrotos' signifying 'immortal,'
'imperishable.'" [148]

By the summer of 1855, ambrotypes were becoming known to the

public at large, and, as they were very largely free from the glare of the daguerreotype, they became more and more popular. By 1856, they were the fashionable form of photograph and the eclipse of the daguerreotype was under way. The mode of the ambrotype continued through 1857, but by that time paper photographs had gradually gained the ascendancy. The changes in the favorite form of photograph in this transition period can be followed very readily by examining the illustrated journals of that time. The illustrations in such popular magazines were reproduced from woodcuts, which were prepared by the hand of the wood engraver from original copy. With the advent of photography, the original copy was frequently some form of photograph; the print was usually credited "From a daguerreotype by so and so." During the early fifties the prints in American illustrated magazines (such as Gleason's *Pictorial Drawing Room Companion* of Boston, for example) when taken from any form of photograph were invariably copied from daguerreotypes. In volumes I and II of *Frank Leslie's Illustrated Newspaper,* which first appeared in 1856, there are one hundred and twenty-three illustrations which were copied from some form of photograph. Of these, one hundred are from ambrotypes, thirteen from daguerreotypes, and ten from paper photographs—a good measure of the popularity that the ambrotype was enjoying in 1856. Incidentally, of these illustrations, ninety-seven were made in Brady's gallery, which shows that Brady was the fashionable photographer of the day. In 1857 (volumes III and IV), *Leslie's* reproduced one hundred and twenty-eight illustrations from some form of photograph; of these, sixty-five are credited to ambrotypes, sixty to paper photographs, two to daguerreotypes, and one to a melainotype (which will be described in the next chapter). In the following year (1858, volumes V and VI) only forty-four such illustrations appear in *Leslie's;* but of these, forty-two are credited to paper photographs, two to daguerreotypes, and none to ambrotypes. Evidently the popularity of the ambrotype departed as rapidly as it came. This does not mean that ambrotypes were not made after 1858, for they were, but their great popularity extended through only 1856 and 1857. It should be noted, however, that ambrotypes were made up to the beginning of the dry plate era (1881).

One of the interesting uses to which the ambrotype was put was in the making of the first photographic rogues' gallery of New York City—early in 1858. When it had been in operation for some time the following news item was published:

"The Rogues' Gallery is located at police headquarters corner of Grand and Crosby. The Rogues' Gallery has been in successful and systematic operation a little more than a year. The number of pictures now on exhibition is 450. The pictures are all ambrotypes of the medium size, neatly put up, and displayed in large show frames, protected by glass doors. The photographer, Mr. Van Buren, is a regularly appointed policeman." [149]

As this and the previous discussion suggests, the ambrotype was used very largely for portrait work. Mention of ambrotype views is rare; one of the few instances I have found describes some very large and excellent ambrotypes of Niagara Falls—that never failing subject for the photographer—taken by S. A. Holmes of New York.[150]

Most ambrotypes are of poor quality, but well made ones are quite striking in appearance. The large metropolitan galleries all made very creditable specimens of this type of photograph. The glass used in these was heavy plate and clear white; the detail obtained was quite surprising when one considers that, to secure a thin negative, they were purposely underexposed. The exposure, at best, was somewhat greater than was required for a daguerreotype. For instance, a correspondent wrote to *Humphrey's Journal* at the time the ambrotype was reaching the height of its popularity:

"I have a top light (100 square feet) which will produce a Daguerreotype in *two* seconds, while it requires *twenty* seconds to take an Ambrotype, making ten times longer exposure. I received instructions of Messrs. Cutting and Bowdoin of Boston, and follow Cutting's process, and have visited various other establishments, but have never taken an ambrotype portrait, nor seen one taken, in less time than fifteen seconds—although Madam Rumor would have us believe that they are produced in less time than the Daguerreotype." [151]

The editor suggests to the correspondent that the speed of the process could be increased if he used *fresher* collodion and that he (the editor), by using freshly prepared collodion, had made ambro-

types with exposures of two to four seconds. After standing a week, such collodion required an exposure of fifteen to twenty seconds.

The "portrait factories," common in the daguerreotype era, returned again with the advent of the ambrotype. The larger galleries charged prices for ambrotypes which were on the same level as those for daguerreotypes, but the "factories" advertised ten-, twelve-, and twenty-cent ambrotypes.[152]

The changing style in photographs during the latter half of the eighteen-fifties is reflected not only in the records of the press, but in the exhibitions held during the period. Of these, the annual fair of the American Institute held in New York City probably drew more exhibitors from the outlying districts than did any other. Boston and Philadelphia operators did not show largely here, as the former exhibited at the fair of the Massachusetts Charitable Association and the latter at the annual fair of the Franklin Institute. As a result, a large proportion of the prizes at the fair of the American Institute went to New Yorkers; but good competition was afforded by Alexander Hesler of Chicago, G. N. Barnard of Syracuse, Hawkins and Faris of Cincinnati, Webster Brothers of Louisville, Kentucky, and Fitzgibbon of St. Louis, among others. In 1854, the exhibition of the American Institute consisted almost entirely of daguerreotypes; in 1855, ambrotypes and paper photographs were present in larger numbers, although daguerreotypes still predominated; in 1856, the major prizes went to paper photographs, but daguerreotypes were still exhibited. At this same time photographs on stained glass, silk, and canvas made their appearance; by 1857, the character of the exhibition had changed very materially from its appearance three years before. Snelling reviewed the photographic department of the fair in 1857:

"Three years ago the Daguerreotype filled the walls and to exhibit a fine picture on a plate 11 x 13 at that time was the acme of the Daguerreotyper's ambition. Then only a few meagre small size paper photographs—we may say—incumbered the walls, generally placed by the side of the daguerreotype as a strong contrast in favor of the latter, and, as it were, in derision of the former. How many then looked upon the exhibition and admired the exquisite softness, and minute detail of the daguerreotypes and said in his heart, 'Photography now does its best, perfection has

[128]

been attained. Can miserable shadows like these paper pictures ever overcome the prestige of the daguerreotype?'

"Now, what is the result? Scarcely a daguerreotype is seen and fewer ambrotypes. Photographs on paper and canvas, from the miniature to life size, eclipse every other photographic style. The improvements effected during the last two years are truly wonderful." [153]

It was not until 1857, then, that the paper photograph assumed a position of commanding importance in this country—a position which it has maintained to the present day. The ambrotype, or rather the Cutting patent which covered the production of the ambrotype, led indirectly to this development. We have pointed out that paper photography, as practiced by Whipple in his crystallotypes, was at first available only for copy work because of the extreme slowness of the sensitive material. Whipple, when he adopted the collodion method, used Archer's published process, the light-recording substance being silver iodide. Cutting, on the other hand, had discovered that when Archer's process was modified so that both silver bromide and silver iodide were formed on the collodion film, a far more sensitive material was produced. Cutting's method, in fact, so speeded up the wet negatives that portraiture became possible.

Cutting included this modification in one of his patents (No. 11,266, July 11, 1854) which became subsequently known as "the bromide patent." As can be seen, the inclusion of this feature in the patent would cover not only the making of ambrotypes, but all of the negatives made by the wet process. Whether Cutting actually discovered this fact himself, whether it was Rehn's idea, or whether he found mention of such a feature in the scientific literature, is not known. It may be that Cutting obtained his idea from the daguerreotype process, in which, as has been pointed out, the combined use of bromine and iodine produced a remarkable increase in the speed of the daguerreotype plate. At any rate, the use of bromides in photography at the time Cutting obtained his patent was not new and it is remarkable that the patent was issued. During the life of the patent (1854-1868), however, it was able successfully to withstand numerous assaults, and it must have netted Cutting and his heirs a considerable revenue. All photographers who

used the wet process during this period were subject to the provisions of the patent, and although many escaped paying a royalty, others did pay. It was even attempted to make the United States government pay the owners of the Cutting patent for the use which the government made of photography during the Civil War.

When Cutting's original patent expired in 1868, the owners of the patent at that time made application for its renewal. The renewal was denied, the patent office tacitly stating that error had been made in the original issue of the patent; and photographers in general breathed a very large sigh of relief.[154] The professionals of the era, nevertheless, owed a considerable debt to Cutting, for it was through his efforts that the collodion process became a practical one in this country; and this brought about a large increase in the photographic trade.

The first paper photographs made from wet negatives were of the standard sizes, usually the smaller ones, which had originated with the daguerreotype. In 1856, M. B. Brady brought to this country a Scotchman, Alexander Gardner, who had obtained training in the collodion process abroad, where it was practiced extensively before it was largely adopted in America.[155] Gardner brought with him the ability to make enlargements (then a process of some difficulty) of large size, 14″ x 17″ and 17″ x 20″, which Brady introduced into New York as the "imperial photograph." These at once struck the popular fancy, as the ambrotype was declining in 1857. Soon Brady's imperials were the prized acquisition of the élite—for, of course, only the élite could pay for such large-sized pictures; most had to be satisfied with twelve-cent ambrotypes.[156]

The demand for imperials provided an incentive to the profession to produce still larger photographs; and their activity in this direction became prodigious. Life-size portraits were introduced and applauded by a never very discriminating public.

In the fall of 1857, *Harper's Weekly* stated with evident satisfaction, if not with truth, "Photography was born in the United States and the sceptre has not departed from us.—The vocation of the portrait painter is not gone but modified. Portrait painting by the old methods is as completely defunct as is navigation by the

stars." [157] This encomium was called forth by a view of Brady's imperials and his life-size portraits. It incorrectly credited Brady with the introduction of the mammoth photographs, for the first of these in New York City appeared at Fredricks' gallery in 1854, and they had been made independently by Charles Fontayne of Cincinnati in 1855.[158] These early efforts at life-size portraits were evidently attempts to follow the lead of French photographers who were using tremendously large cameras to produce such pictures. Charles Meade of New York, who was abroad in the spring of 1855, describes one of these leviathan cameras which he saw

Franklin Pierce, the fourteenth President of the United States. From an imperial photograph made by Brady and "finished" in india ink. The imperial is an enlargement made from a daguerreotype taken during Pierce's term of office, 1853-57. (Courtesy L. C. Handy Studio, Washington, D. C.)

at Thomson's in Paris. It had a lens thirteen inches in diameter and was three feet in length. The camera box was twelve feet long and was "made like our Bellows boxes, and runs on a small railroad, which he has laid on the floor." [159] The passion for doing things on a large scale had evidently gone abroad; it must be remembered, however, that Mr. Thomson was an American.

The difficulties of preparing wet negatives for such an instrument must have been likewise tremendous and it is no wonder that the early specimens were not particularly successful, when viewed from any standpoint save that of curiosity. The more successful efforts of 1857 came as the result of using an enlarging camera, several of which were in use during the middle fifties. The most widely used was Woodward's solar camera, for which a patent was secured early in 1857 by David A. Woodward of Baltimore.[160] As the name implies, the sun's rays were employed as the source of light, since

[131]

very intense light was necessary to produce the image on the slow photographic paper then available.*

Making these enlargements was, as a contemporary says, "a tedious operation; requiring several hours before it is complete and sometimes even a day or two by reason of the cloudiness of the day." [161]

Because of the long exposures and faulty materials, the finished enlargement, at best, must have been an imperfect picture. The Yankee photographer was not stopped by this handicap, for he employed artists who retouched, not the original negative, a practice introduced some ten or twelve years later, but the finished enlargement. The retouching took the form of laying on quite generously india ink, water and oil colors, or pastel. Such life-size portraits, finished, sold for as much as $750.00 each. It was a view of Brady's retouched life-size oil portraits that caused *Harper's Weekly* to exclaim, "The vocation of the portrait painter is not gone, but modified." Some of these efforts were as large as 5 x 7, not inches but *feet*—no wonder they were called *life* size.[162] A more severe critic than *Harper's Weekly* left us a truer estimate of the worth of these efforts when he wrote: "Compare the colored—for we cannot yet say they are painted—photographs with the productions of our Church's, Elliott's, Huntington's, Page's, and a host of other painters, and we can but turn in disappointment away; yet the colored photograph has an advantage over the best works of the best art masters—for the latter cannot rival the former in truthfulness to nature." [163] The merit which these portraits possessed, however, must have been largely due to the skill of the artists whom the photographer employed, as they could readily destroy any "truthfulness to nature" which the original photograph possessed. And in many galleries, this possibility became an actuality, for photographers were interested in making a living—not in making portraits truthful to nature. The effects which could be produced by means of retouching are sug-

* For the benefit of those unfamiliar with making enlargements it can be said that the principle of the magic lantern is employed—a small transparent image is placed in the lantern and a greatly magnified image is thrown on the screen. In this case the small image is a negative prepared in the usual way—the screen is sensitized photographic paper. Theoretically, there is almost no limit to the size of the enlargement produced; practically, there is.

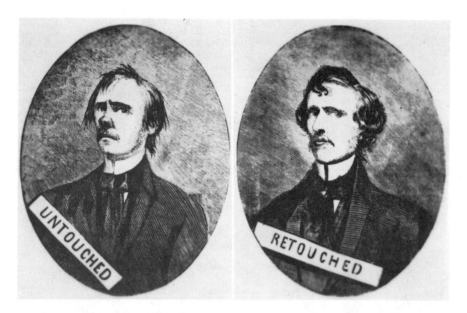

The photographic cartoon mentioned below. (From *Leslie's Illustrated Newspaper,* 1858.)

gested by the very apt cartoon from *Leslie's Newspaper,* which is reproduced above. The bibulous bum has become the perfect gentleman! It is more than probable that equally amazing transformations were actually effected by many a photographic "artist."

The crowning glory in bigness for this era appears to have been achieved by Brady in the fall of 1858. This was a transparency (which could be illuminated from behind) containing portraits of Field, Franklin, and Morse, which measured 50 feet by 25 feet. It decorated the front of Brady's establishment in honor of the completion of the Atlantic Cable—a celebration in which all the establishments on Broadway attempted to outdo themselves and their competitors in elaborateness of decoration. Brady secured illumination for his transparency by the use of 600 candles! [164]

The achievement of the acme of perfection on the metal plate and the introduction of the paper photograph left their impressions on all the arts. The painter was warned with the advent of photographers in large numbers that "the unrivalled precision attained by photography renders exact imitation no longer a miracle of crayon or palette; these must now create as well as reflect, invent and har-

The Charles D. Fredricks establishment at 585 Broadway, New York, about 1857. (From a photograph in the collection of A. Gilles, Paris; courtesy Museum of Modern Art, New York.)

monize as well as copy, bring out the soul of the individual and of the landscape, or their achievements will be neglected in favor of the facsimiles obtainable through sunshine and chemistry."[165] Of the fact that such a warning was heeded there is indirect evidence. Isham, the able historian of American painting, points out that a natural division in the history of his field occurs in 1860, that is, just prior to the Civil War and in the period with which we are now dealing. Although he attributes this break to other and deeper social causes, it is probable that the encroachments of photog-

[134]

An imperial photograph (14 by 17 inches), The City of Washington from the Capitol, June 27, 1861. Pennsylvania Avenue is seen on the left. (An imperial photograph, 14 by 17 inches; photographer unknown but probably Alexander Gardner.)

raphy in the field of the artist played a not inconsiderable part in the division.[166]

But the artist's profession was not the only one affected—the camera made its appearance on the stage during this era. In *The Octoroon,* first performed at the Winter Garden, New York, on December 5, 1859, the camera was the instrument which revealed the crime of the villain. It must be said that the eminent playwright, Dion Boucicault, took liberties that may at least be described as dramatic license, for the camera was made to perform a photographic impossibility in recording only one scene from a series of scenes enacted while the lens of the camera was uncapped, and in then delivering a finished picture. The play achieved an immense success, although any photographers who happened to be in the audiences must have been its severest critics.[167]

In the field of letters, no less a personage than Oliver Wendell Holmes, the autocrat of the breakfast table, contributed a series of three articles to the *Atlantic Monthly* dealing with photographs and photography, the first of which appeared during this period (1859). We shall have occasion to refer to these articles in greater detail shortly, as they form a really important contribution to the history of American photography.[168]

With the exception of the stereograph, we have now traced the most important developments in American photography up to 1860. For the larger part of this time the daguerreotype had been preeminent, but by the end of the period the paper photograph had largely displaced it. It should be reiterated again that daguerreotypes were still being made as late as 1860. Oliver Wendell Holmes, writing in 1859, remarked: "Mr. Whipple tells us that even now he takes a much greater number of miniature portraits on metal than on paper." Even in 1862, Bogardus, Anson, Gurney, and Williamson of the New York operators alone were making "lots of them, and always when wanted at all, they were called for by *first class* people. The ambrotype is indeed in little demand now." [169]

Although we have discussed the imperial and life-size paper photographs at considerable length, it should be understood that the smaller sizes, especially the stereograph, were also made, and made in large number. In fact, stereographs are of such importance that a

special chapter has been devoted to them. Street and view scenes were common, and so-called instantaneous pictures had made their appearance.[170]

It is unfortunate that there are not more paper photographs of this period (1855-1860) available. Without doubt, many exist, but they are difficult to locate, and, in the absence of positive information, are difficult to classify. There should have been a law that every photograph should have had included upon it the name of the maker, the name of the subject, and the date upon which it was created! About the only method of recognizing plain paper photographs of this half decade is by means of the brown color and the lack of any glaze or polish in the print.

Our predecessors recognized the historical value of such records, for we find a contemporary writing in 1858, "Posterity, by the agency of photography, will view the faithful image of our times; the future students, in turning the pages of history, may at the same time look on the very skin, into the very eyes, of those long since mouldered to dust, whose lives and deeds he traces in the text." [171] If only they had devised some method of insuring that posterity would receive these pictorial documents!

The Family Album

"Our cabin measured 16 x 20 feet in the clear. The logs were chinked and painted with clay. The floor was of earth, beaten hard and smooth,— a box cupboard held our stock of dishes and cooking utensils. Beside it stood the churn. The flour barrel was converted into a center-table whereon reposed the family Bible and photograph album with their white lace covers." *

THUS WRITES a pioneer of Montana in 1864; home was complete when the Bible and the album could be brought out from the trunks and placed in the center of the room. The Bible was the consolation of these wayfarers from a far country; the album was the most direct tie to their past life, for it contained the images of those most loved but now far distant: Father—Mother—Aunt Sue—Sister Mary, and a host of others.[172]

It is curious that no one has previously described the origin of the ubiquitous family album—a most familiar and important institution. A very useful institution, too. How many a bashful beau has had his pangs of embarrassment eased by the relieving words, "Let's look at the pictures in the album!" How many an unsuspecting swain has had his likeness examined by ardent eyes that to him were forever unknown! How many a tear-stained mother has leafed through an album until she reached a well-worn page and there gazed on the one whose presence was still insured by the blessed bit of cardboard! How many a tottering warrior has renewed the spirit of his youth, and relived his vigorous past by still other bits of cardboard and paper! How many a grandchild of such a warrior has been seized with sudden and uncontrollable mirth when carelessly thumbing its thick pages! Can this be grandpa? this dandy lined up beside the tall column, looking so amazingly self-conscious and

* The quotation is reprinted by permission of The Arthur H. Clark Company, from their publication *Covered Wagon Days.*

so vastly self-satisfied? And that—can that be Uncle George? that youngling, looking so rakish, leaning against the selfsame column, possessing the same self-satisfied air? Uncle George, if he is present, sees no occasion for mirth. "What's the matter with it?" he asks, belligerently. One hastily says that there is nothing the matter and turns rapidly to the following pages, only to be confronted with numberless repetitions of the same character. Always the inevitable column, always the stiff and attitudinizing expression of the human male. The likenesses of the fairer sex, when they appear in the album, show to a far better advantage—women were permitted to sit occasionally and their poses are usually natural and agreeable.

But we are getting away from our story—what gave the album its start? What are these full-length portraits in miniature which adorn the pages of the earliest of these albums? To answer the last question is to answer both, for these small portraits brought the family album into existence.

These small photographs are "card photographs," or, as they were originally called, *carte de visite* photographs. They measure about 2½″ x 4″ on the mount; the print is somewhat smaller, a narrow margin being left on the top and sides and a wider margin at the bottom of the mount, so that the prints themselves seldom exceed 2⅛″ x 3½″.

They owe their name to the Duke of Parma, who, in 1857, went to his photographer and directed him to make photographs the size of calling cards. These pictures the Duke mounted on his cards, which he used in lieu of the conventional ones; hence the name *carte de visite* for the small photographs.

They were introduced to Paris by Desdéri, the court photographer of Napoleon III. Desdéri, an excellent advertiser, started a considerable fashion by their use. The fad spread to London and eventually reached the United States.[173]

The earliest reference to their use in this country occurs in a photographic journal published in 1859, and they are mentioned in that year but once.[174] Broadway photographers began advertising them early in 1860; S. A. Holmes of New York, for example, called attention to them in *Leslie's* of January 7, 1860:

The London Style
Your Photograph On a Visiting Card
25 copies for One Dollar
Apply only at—
S. A. Holmes, 317 Broadway
Adjoining the New York Hospital, N. Y.

Holmes was not the first to introduce the style, however, for both C. D. Fredricks and George Rockwood, also of New York, were making *cartes de visite* before Holmes. Rockwood in later years claimed that he was responsible for their introduction into this country, and there is contemporary evidence that confirms his claim. According to Rockwood, "The first *carte de visite* made in this country was of Baron Rothschild by myself; and the first lady to make an appointment for such a sitting was Mrs. August Belmont, at my gallery." Rockwood does not state just when this sitting occurred, but it was probably in the fall of 1859.[175] John Werge, the Englishman, whom we mentioned in connection with the era of the daguerreotype, returned to this country for a second time in April of 1860. He purchased an interest in the Meade Brothers establishment on Broadway, and introduced there the *carte de visite* which, when he left London, "had not exhibited much vitality at that period, but in Paris it was beginning to be popular." His nearest competitor was Rockwood, who was already making such pictures for three dollars a dozen. Werge, in order to get any business at all, reduced his price to four for a dollar; evidently the price set by Holmes (twenty-five for one dollar) was not long maintained.

At the beginning of 1860 there were only a few operators producing this style of picture, but its popularity grew rapidly throughout the year, and by its end the fad was developing into a major fashion over the entire country.

Why? It is not very difficult to guess. It was a new sensation to be able to see, not one, but many miniature portraits of one's self. The daguerreotype and the ambrotype had given but one picture and that at a price for which a dozen of these small likenesses could be had. The imperial and the life-size photograph, while discussed in the newspapers and on view in the display windows, could be bought only by the few, but, at least, they had made the public con-

scious of the paper photograph. In addition, the new photographs were small and light so that they could easily be placed in a letter and sent to a distant friend.

No wonder the fashion grew—and grew. At first, the *cartes de visite* left by visitors were placed on a card tray; then, as the number increased, a basket was employed, but still the number grew. From the necessity, thus created, of finding a place to put the "cards," came the family album.

Early in 1861 we find the editor of the *American Journal of Photography* counselling his subscribers: "The card photographic album is especially adapted to the cards, so that two or more may be displayed on one page and hundreds in a whole book. This fashion is reasonable and there is little doubt that it will become a permanent institution. We, therefore, advise our readers to be prepared for it with suitable instruments and albums." [176] Very good advice it proved to be, as the countless albums possessed by homes in every hamlet in the country soon came to testify.

Albums had been in use before this day, but they were albums for a different purpose. Noah Webster, in the second edition (1840) of his now celebrated dictionary, defines an album as follows: "A book, originally blank, in which foreigners or strangers insert autographs of celebrated persons, or in which friends insert pieces as memorials for each other."

Now the "memorials for each other" were to be traced by the sun and not by the pen. The problem was to get these memorials to stay in the albums—a problem which soon found an answer, as is shown by an examination of the patent literature of the time. No fewer than fifteen patents were issued in the period 1861-65 for photographic albums, or for modifications of this popular method of collecting "cards." The first patent was issued to F. R. Grumel, a native of Switzerland, on May 14, 1861; the second was issued two weeks later to H. T. Anthony and F. Phoebus of the firm of E. Anthony and Company.

The rights to Grumel's patent were acquired by C. D. Fredricks & Company, the Broadway photographers. It included the features which are now familiar in all albums; recessed pockets in each leaf of the album, each pocket being provided with a slot so that the

RISTORI—The great Italian Tragedienne.

Entered, according to Act of Congress, in the year 1862, by Chas.
D. Fredricks & Co., in the Clerk's Office of the District Court of the
United States for the Southern District of New York.

MISS NELLIE GRANT.

Card photographs, illustrating three styles of mounting employed by C. D. Fredricks & Co., a leader in this style of photographic portraiture. *Upper left,* Ristori, photographed in 1862. *Upper right,* Agnes Sormi, a popular German actress. This mount with the imprinted border lines was used extensively in the middle sixties, not only by Fredricks but by most operators. *Lower,* Miss Nellie Grant, daughter of the President, photographed about 1870.

mounted photographs could be added or removed at will. The pockets were so constructed that the photographs did not protrude above the page and two photographs could be placed back to back.

The Anthony patent merely modified the method of inserting the photograph; between them Anthony and Fredricks had a clear field in what proved to be an extremely lucrative branch of the photographic business.[177]

Although the original patents for these albums are dated 1861, such devices were in use in 1860. Because of the growing demand for card photographs through 1861 and 1862, manufacturers were hard pressed to keep the supply equal to the demand.[178]

Some albums were ornate, elaborately decorated affairs and were advertised to sell for prices ranging from $5.00 to $40.00, although as a small girl remarked to her father when attempting to induce him to buy one, "You can get an album for $1.50 just as good as the $40.00 ones, only the hinges and clasp ain't solid gold."

The introduction of the card photograph and the album effected a revolution in the photographic business; any tendency toward a revival of daguerreotypes was completely obliterated by the new fashion. The photographic journals comment on the new fad again and again. For instance we read (May, 1863), "In Boston, as in every other city and town in this country, the card photograph has for the past two years been in universal demand, almost to the complete exclusion of every other style of photographic portraiture, and has in fact produced a revolution in the photographic business." And again, "It is interesting to see what changes in the photographic business have been wrought by the paper pictures; *carte de visite* especially. There has been a great falling off in the demand for cases, mats, preservers, glass, etc. and proportional increase in the sales of albumen paper, cardboard, iodides, bromides, toning dishes, and baths." [179]

These card photographs, "the social currency, the sentimental 'green-backs' of civilization," as Holmes gracefully called them, were of course made by the wet process. The negatives were prepared by the usual collodion formula and ordinarily required exposures of fifteen to thirty seconds in the professional studios, although with favorable light, exposures of three to five seconds were possible. In the

Charles D. Fredricks. (From a photograph made in his gallery, 1869.)

George G. Rockwood, who introduced card photographs to this country. (From a photograph made in his gallery, 1881.)

larger studios, a camera with four tubes was employed. Each tube had its own lens and produced its own picture so that it was possible to secure one to four negatives at one sitting—to judge from most of the cards I have seen, "standing" would be a preferable term. A whole-size plate ($6\frac{1}{2}''$ x $8\frac{1}{2}''$) was used, the four tubes covering only one-half of the plate at a time. By a device invented by A. S. Southworth of Boston in 1855, the remaining half of the plate could be moved into place and then exposed, so that eight card negatives were secured on one whole plate, a process that resulted in an obvious saving of material and a very considerable saving of time in printing. Smaller galleries, while employing four-tube cameras, did not attempt to make more than four negatives to a plate.[180]

The negatives were printed on albumen paper, which, although used to some extent before the card photograph was introduced, did not find wide acceptance until *cartes de visite* made their appearance. The albumen added a pleasing gloss to the finished print. The paper was prepared by manufacturers of supplies—the Anthonys being probably the largest producers of this staple of trade. The

paper stock was imported from Germany and France; the Anthonys required, in the early sixties, fifteen thousand reams annually to supply their market. This paper was sized with common salt and albumen in the manufacturing establishment. According to Oliver Wendell Holmes, who visited the Anthony establishment in 1863 and described his visit for the readers of the *Atlantic Monthly*, the Anthonys required the cooperation of ten thousand Yankee hens to coat the large stock of paper. "The hens," said Holmes, "cackle over the promise of their inchoate offspring, doomed to perish unfeathered, before fate has decided whether they shall cluck or crow, for the sole use of the minions of the sun." Holmes, in similar vein, described his efforts to learn the photographic art under the able instruction of Mr. Black (a one-time partner of John A. Whipple) of Boston.

The albumen paper, prepared as described above, was sold dry to the trade. To sensitize the sheets the photographer floated them, albumen side downward, on trays containing silver nitrate solution. As the sensitivity was speedily lost, the paper required was prepared each day. This affords a marked contrast to modern methods, whereby photographic papers of a wide variety of characteristics, which keep indefinitely, can be bought ready to use.

The printing on this albumen paper was effected in the usual way. It was placed in the printer's frame against the collodion film of the negative and exposed to the sun. Printing was a slow process; if a dull day came along, it had to be postponed. In the large photographic galleries, printing was done on the roof of the establishment, one or more employees doing this work, only. Long racks containing fifty to a hundred frames were built; the printer would walk up and down the line examining the prints from time to time. Albumen paper was of the printing out variety, that is, the image appeared on the paper without the use of a developer, the action of the sun being continued until the print had obtained its suitable contrasts.

The print as it came from the printing frame was transferred to a series of washing baths in a dark room dimly illuminated by light passing through a yellow curtain. From the washing baths it was transferred to the toning bath, a solution of gold chloride.

From a Family Album. *Upper left,* portrait of an unknown lady (photograph by A. C. McIntyre, Brockville, Ontario). *Upper right,* portrait of an unknown youngster. Notice the two legs of the head rest behind him (photograph by D. B. Garton, Barrie, Ontario). *Middle,* the White House, Washington, 1865 (photograph by John Goldin & Co.). *Lower left,* the Fairy Wedding Group (photograph by Brady, 1864). Those in the group, left to right, are G. W. McNutt, Charles S. Stratton, Mrs. Lavinia Warren Stratton, Minnie Warren. *Lower right,* Major General Frémont (photograph by Brady, about 1864).

As it came from the printing frame, the paper possessed a purple color, but as it passed through the washing baths and the toning solution, a succession of colors appeared; dull red, lilac and finally the brown tone, familiar in the prints of this period. The prints were then fixed, as they are today, in hypo.[181]

The use of painted backgrounds and accessories first becomes noticeable with the card photographs. Claudet, the London daguerreotypist, employed such backgrounds extensively before 1851 and the jury at the Great Fair of 1851, admiring his efforts in this direction, pointedly suggested that the Americans might do well to follow Claudet's lead. Although accessories were used to some extent by American daguerreotypists, they did not employ them in elaborate detail—limiting themselves to a chair, a table, and a book or two. But with the coming of the card photograph, painted backgrounds were introduced quite generally, as was the inevitable column, upon which we have already commented, and other accessories in increasing number. The zenith of these efforts was not realized, however, for some years, culminating in the elaborate effects produced by Mora, Sarony, and others, which are to be described later.

The effects produced by these innovations were sometimes extremely ludicrous,—especially so, when some rustic on a visit to the city wandered into a metropolitan gallery particularly addicted to the use of accessories, and wanted a "card" to take home to show the folks how they made pictures in the city. The resulting "composition" was likely to show Joshua standing beside the always present column, his hand placed on a pedestal (which also carried as part of its burden an ornate urn or two), contemplating the ruins of Nineveh in the distance, while the Hudson rolled serenely on through the center of the picture. A curtain with tassels, an elaborate chair or two, and some fancy trellis work with artificial vines entwining it, completed the picture. What do you suppose the folks at home thought of it? Whatever they may have thought, it is not at all improbable that Joshua's card photograph, falling into the hands of an unappreciative later generation, gave rise to the familiar phrase common not so long ago, "Isn't he a card!"—a "card" being anyone who was excruciatingly funny in the observer's judgment.[182]

Such incongruities were not without their caustic critics—to

whom credit is due for attempting to exert a restraining influence on over-ambitious operators.[183]

The vogue of the card photograph continued for many years. From 1861 to 1866 it was the popular favorite, its only competitor being the lowly tintype, whose origin is described later.

Two important causes favored the continuation of the card photograph as the reigning favorite. The Civil War was one, and the lack of a suitable method for the facsimile reproduction of photographs in newspapers and magazines, the other. Unaided by these

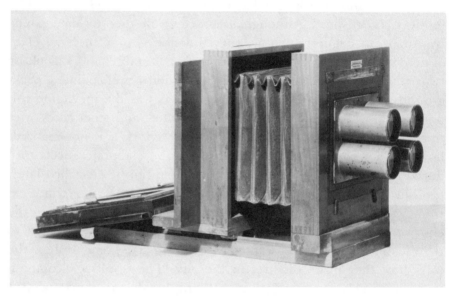

A four-tube camera made by the Anthonys. (Photograph courtesy U. S. National Museum, owner of the original instrument.)

factors, it is doubtful that the vogue of the card photograph would have long survived. Indeed, only a year or so after such pictures were introduced, the photographic journals were complaining of them as a nuisance and asking: "How long are card pictures to be the rage? In a few months or years at the most, our good patrons will have their albums full of dirty and yellow and faded pictures. Will they replace them with new ones, or pass us by with contempt and disgust?" [184]

It will be noted, however, that the introduction of the card photograph was nearly coincident with the beginning of the Civil

[148]

War, and every call for troops meant a revival of the photographic business and of card photographs in particular. *Humphrey's Journal* comments on September 1, 1862, "Stock dealers are having it all their own way—recent calls for 600,000 more troops have given a prodigious impetus to the photographic business; operators are getting desperate (no supplies) and dealers have advanced prices." [185] Every boy called into the army wanted mementoes to leave the folks at home and it is more than likely that one or two similar mementoes went with him. More than one card photograph was found among the human wreckage left on the field after the smoke of battle had cleared away!

The other cause for the continued popularity of the card photograph was equally important. Facsimile methods of reproduction were not employed on any large scale until the seventies; and the common methods in use at present were not developed until the eighties. The illustrated newspapers and journals were dependent for their illustrations upon the hand of the engraver. For the most popular of these periodicals the engraver reproduced by hand the original copy on wood. From the wood engraving a stereotype or electrotype was made from which the prints were reproduced. Although interesting and valuable as illustrations of the period, they were far from exact duplicates of the original copy, and consequently shrewd business men, such as the Anthonys, were quick to realize the advantage of the card photograph as a much superior and more exact copy of the original person or scene. Negatives of individuals constantly in the public eye were in great demand by the large photographic houses, which printed card photographs in tremendous numbers from such negatives. The cards were then placed on sale at book stores, galleries, magazine shops—wherever the public passed by. It is difficult at the present day to realize the tremendous volume of business done; card photographs could be found "piled up by the bushel in the print stores, offered by the gross at book stands." At one time the Anthony firm was making thirty-six hundred *cartes de visite* of celebrities a day, and other firms must have done as well. Among the cards for sale were those of eminent generals, pugilists, members of Congress, ballet dancers, politicians, pretty actresses, negro minstrels, circus riders, doctors of divinity,

poets, freaks, beheaded brigands—Heaven only knows who wasn't for sale—in miniature.[186] In addition, there were copies of celebrated engravings, paintings, and statuary, for photography afforded the only cheap method of exact reproduction. Line engravings and statuary, on the whole, showed up most satisfactorily, for the photography of that day could not cope adequately with the problem of reproducing color in black or white, or rather *brown* and white.

The requests made of celebrities to secure negatives to fill the tremendous demand must have been, in some cases, wearisome in the extreme. Others, with an eye to business, recognized it as a source of revenue. For instance, we find Tom Sayers, the English champion, crying out to a crowd of unfortunate photographers after his celebrated fistic encounter with Heenan, the gallant Benicia Boy and the American champion, "It's no good, gentlemen, I've been and sold my mug to Mr. Newbold." Whether Mr. Newbold had also contracted for Heenan's "mug," is one of the unrecorded facts of history. Not that it matters greatly, for after the battle, Heenan's face was so battered that there was little human semblance left in it.[187]

Actors and actresses were also quick to realize the advantage of the publicity and profit to be gained by the sale of their card portraits, and it is still fairly easy to obtain pictures of the theatrical celebrities of the day in a variety of postures, attitudes, characterizations, and dress.

Not only were portraits produced on these cards; so were views and scenes as well, although they were by no means as common as portraits. The horse made his appearance, too, in cartes de Horse, as someone facetiously called them. Dexter, the King of the Turf, and his numerous competitors appeared in such photographs. Flowers, colored by hand, cartoons, some decent, but many indecent, could also be had—the last probably *sub rosa,* if we are to believe the written records of the time.

These card photographs recorded by far the most interesting history of their time. Collectors, in my judgment, are overlooking here an exceedingly important field and one which will become more important as the years pass. These photographs are still available in prodigious numbers but such a condition cannot always

remain so. A word of caution to potential collectors may be in order. Do not, unless otherwise unobtainable, add to your collection those card photographs that do not have the maker's name (that is, the name of the photographic gallery) upon them. Such imprints will be found on the side opposite the print. The reason for this caution is that card photographs not bearing the maker's name have almost invariably been pirated from an original. Such piracy ("bootlegging" seems also appropriate) was quite common. A small operator would buy a photograph made from the original and posed negative, and would then proceed to recopy it and sell the prints from the copy negative. Such copies are of inferior quality—much of the detail is lacking, and in addition, they have a fuzzy, faded, and dingy appearance that prints from the original negatives do not possess.

Another valuable aid to the collector is offered by the tax stamp, which may also be found on the reverse side of many card photographs. These stamps were required by law in the period from September 1, 1864, to August 1, 1866; they will be found on all photo-

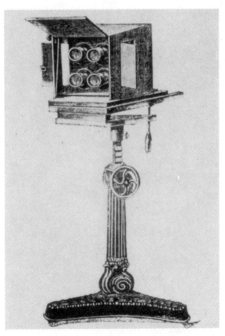

A four-tube camera in the studio. (From A. Liebert, *La Photographie en Amérique,* 3rd ed.)

graphs, with certain minor exceptions, sold in this period. For the card photograph, a two cent stamp was required, and the presence of the stamp serves to indicate approximately its date of production.[188] Sometimes, too, the date of cancellation on the stamp can also be deciphered, which serves to fix the date still more definitely. If the specimen is without a stamp, other facts, if available, will have to serve. The style of mounting, costume, and other details are helpful when the collector has had some experience in the field.

Although the great popularity of the card subsided after 1866, it continued to be produced in considerable numbers as long as the wet process was practiced.

The Tintype

ANOTHER FAMILIAR OCCUPANT of the family album is the tintype. Like the card photograph, it has an interesting origin and history and is one of the few distinctly American forms of photographs.

The tintype, which had its origin during the ambrotype period, technically is a modification of the ambrotype. It is a photograph made on black japanned iron. It will be recalled that the ambrotype, a thin negative on glass, when placed on a black background, appears as a positive picture. In the tintype, the base (sheet iron) and black background are combined, the collodion film being formed on the black smooth surface of the japanned metal.

The earliest mention of this form of photograph which I have found appears in *Humphrey's Journal* for November, 1855:

"FERROGRAPHS, OR PICTURES ON SHEET IRON

"The following extract from a letter has been handed to us as a piece of news. We give it for what it is worth, leaving our readers to attach to it what degree of importance they please:

" 'There is a Prof. Smith * who has been experimenting for several years in order to get something cheap and easy of manipulation. He has at length succeeded in producing a *beautiful* picture on a piece of common sheet iron without any polish whatever. I have seen some of the pictures, and they are equal to any daguerreotype that I have ever seen, and much superior in some respects; there is no reflection from them and they can be seen in any position in which you may hold them. Mr. Smith says he can take a piece of sheet iron and use it as it comes from a large sheet, without polishing,—make a picture and finish it complete in half the time and expense you can in the old way, and every picture will be good,—no failures.

" 'Prof. Smith is a gentleman in whom confidence may be placed, and stands high as a professor of Natural Sciences. He has spent a great deal of money and time in experimenting, and he says he will be compelled to

* "Of Ohio."

make some charge *for the secret,* however galling it may be to his feelings: The time has been with him when he would have published it to the world with pleasure.' " [189]

The cautious comment heading this news was born of experience. The memory of the Hill fiasco concerning daguerreotypes in color was still fresh in the editor's mind, and scarcely a week went by without the announcement of new photographic processes—processes which usually proved to be very minor modifications of existing ones.

In this instance, the method eventually developed into one of the most extensively used of all the modifications of collodion photography and one of the few that have survived to the present day. It is still possible to get a tintype at many a county fair, although collodion plates have been replaced by modern materials.

The mention made of the "ferrograph" as given above, was followed in February of the following year (1856) by the appearance of a United States patent issued to Hamilton L. Smith of Gambier, Ohio, for "photographic pictures on japanned surfaces." [190] The patent, as published, described the tintype, but further suggested that the black japan could be applied to any metallic or other solid surface and photographs upon such a base could then be obtained by the usual wet process. Among such materials mentioned were glass, leather, fibrous materials, rubber, and metals other than iron. Although all these materials were used occasionally, japanned iron proved eventually to be the favored one.

The inventor of this form of photograph, Hamilton L. Smith, was a graduate of Yale University in 1839, and at the time this patent was issued was professor of natural science in Kenyon College at Gambier. It may be noted that he was in the East the year that the daguerreotype was announced and he probably there saw some of these remarkable innovations. They attracted his interest and, like many other young men of the time with a scientific bent of mind, he began experimenting with the new art. He returned to Cleveland the following year, and may have been the first to make daguerreotypes in that city, as mention is made of his work in the contemporary literature. His interest in photography, aroused at its birth in this country, continued throughout his life. In 1853, he was

[154]

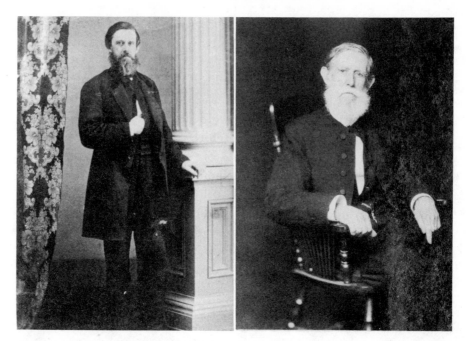

Hamilton L. Smith, the inventor of the tin- Hamilton L. Smith, a self-made portrait on
type. (A card photograph made about 1865; platinum paper, 1889. (Courtesy Dr. Howard
courtesy Mrs. Helen B. Neff, Canton, Ohio.) Jones, Circleville, Ohio.)

offered a position at Kenyon College and in that year began his experiments which resulted in the patent mentioned above. Associated in these experiments with Smith was Peter Neff, Jr., of Cincinnati. Neff was a former student at Kenyon and was, at the time that Smith moved to Gambier, a resident of that town. Neff was attracted by the knowledge of photography which Smith possessed, and he continued to help Smith for several years.[191]

When Smith's patent was granted, Peter Neff interested his father, William Neff, in the patent and together they bought the patent rights of Smith.

The patent covered only the production of the photographs and not the manufacture of the materials for them. The manufacturing process, in itself, was a considerable problem as it involved the production of *thin* sheet iron, a problem which the Neffs succeeded in solving. In 1856, the process was advertised to the profession, licenses being announced for sale at $20.00 a gallery.[192]

Here we have an unusual situation. Previously all new processes

or modifications originated either abroad or in the eastern metropolitan centers. In this instance, the new form of patent originated in the West and had to work east.

In the summer of 1856, the editor of the *Photographic Art Journal* comments briefly on the Neff advertisement concerning the pictures on japanned iron: "We have heard these highly spoken of, but have never seen them, and therefore give no opinion in regard to them." Neff had given the name of "melainotype" to these pictures and so advertised them—the name originating from the prefix "melaino" meaning black or dark colored—evidently referring to the black japan upon which the collodion film was fixed. For many years following its introduction, these pictures were therefore called melainotypes (also spelled "melanotype").[193]

In the fall of 1856, Peter Neff exhibited some of these melainotypes at the Fair of the American Institute in New York City and was awarded a bronze medal for his specimens.[194] These pictures created favorable comment in the East; we find *Humphrey's Journal* reviewing them in terms more favorable than those of its original comment. "We have seen some of the early productions [of Neff] which lead us to believe that these pictures might become quite popular. These plates can be furnished at a much less price than glass, and in point of economy possess some advantage. They are designed for the positive picture and can be easily fitted to lockets, pins, etc."[195]

The interest in this form of photograph grew slowly, very probably because it was a patented process and a fee was required for its use, but the business of Neff gradually increased and a rival firm began to manufacture plates at Lancaster, Ohio. The rival manufacturer was Victor M. Griswold, another pioneer daguerreotypist, and also a former student of Kenyon College.[196]

Griswold called his product "ferrotype plates," a name strenuously opposed by the photographic journals at the time on the ground that there was already a well known name for these plates.[197] Griswold persisted, however, and eventually his name superseded the term "melainotype." The name was unfortunate in some respects as it was confused with a photographic process devised by Robert Hunt, the English scientist, some years earlier. Hunt's process in-

[156]

volved the use of iron salts in place of silver compounds; his product was entirely different in character from the tintype. Because of this confusion of names, Hunt has occasionally been credited with the invention of the tintype. The modern photographer also uses the term "ferrotype" for a still different purpose—that is, to describe a sheet of polished or lacquered metal designed to give a high gloss to a photographic print.

For the above reasons, I have preferred to call photographs in this form tintypes, although I am aware that photographers of the old school do not like the term—and that logically the name is incorrect, as they contain no tin; but certainly there is no confusion of terms when it is used, and without doubt it was used by the public far more frequently than either "melainotype" or "ferrotype." Just when it was introduced, or by whom, I am unable to say—probably some unknown Artemus Ward began using it and the custom rapidly spread, for the phrase "not on your tintype" is almost as old as the patent itself.

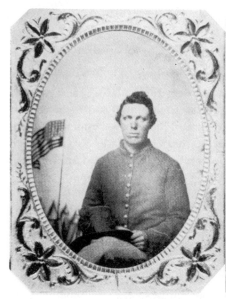

Tintype of a Civil War soldier, 1862. Stanley J. Morrow, aged twenty, Company F, Seventh Wisconsin Infantry. Morrow became in later life a well known frontier photographer (see Chap. XV). (Courtesy Dr. W. H. Over, director the Museum, University of South Dakota.)

Peter Neff, who with his father acquired the rights to Smith's patent and first began the manufacture of tintype plates. (Courtesy *Bulletin of the Geological Society of America.*)

A great impetus to the tintype industry, if we may dignify it by so formal a phrase, came in the summer of 1860. An ingenious Yankee, D. F. Maltby, conceived the idea of preparing medals bearing small tintype portraits of the presidential candidates of 1860.[198] The desire to wear a medal was apparently inborn in the breast of the human male, and when this tendency was coupled with the fact that an actual portrait of one's favorite candidate was included in the medal, the lure was irresistible, and the fortune of the tintype, if not of the inventor, was made.

Humphrey's Journal records this rising popularity with this paragraph (September, 1860):

"It is an ill wind that blows no one any good! Politics help our friend Neff, whoever else they may bother and annoy. There is no knowing who will be President until after election. Therefore, the admirers of 'Old Uncle Abe,' Breckenridge, Douglas and all the other candidates, whose name is legion, want pictures of their leaders, and, as they want them on melainotype plates, in the shape of brooches, pins, studs, etc., an unprecedented demand has arisen for this article. The manufacturer has all he can do to keep up with his orders." [199]

But after the election we read:

"We hear that the proprietors of the melainotype were extremely busy for some time before the election getting their plates ready for pictures of the different Presidential candidates; but that is all played out now. There may spring up another demand by-and-by from the south, for they will have to get melainotypes of their candidates for the Presidency of the *Southern Confederacy,* should our Glorious Union be so unfortunate as to be split in twain during the present momentous crisis! But we hope for better things. We learn that our friend Neff is all ready for additional orders in his line; and, as the melainotype is now thought of more than ever, we think he will get them as soon as this rascally panic blows over." [200]

Both Neff and Griswold were manufacturing their plates on a large scale by 1860 and there naturally developed considerable rivalry between the two firms. As Griswold had his factory at Lancaster, Ohio, this competition became known as "The War of the Roses." The advantage, at first, was all on Neff's side. Griswold

[158]

persisted, however, and was able to produce a somewhat thinner plate than Neff, which was regarded as an advantage. In addition, Griswold had the foresight to move his factory east, nearer the source of demand, removing in 1861 to Peekskill, New York, where he continued to manufacture ferrotype plates until 1867.[201]

V. M. Griswold. (From a photograph made about 1870; courtesy of his son, Ezra P. Griswold, Peekskill, N. Y.)

The continued business of both Griswold and Neff came, not from the preparation of plates to record the faces of candidates for "the Presidency of the Southern Confederacy," but from the production in large quantity of plates destined to record the faces and forms of the boys in blue who had come at Father Abraham's call to subdue this Southern Confederacy.

We have seen that the war gave a tremendous stimulus to the sale of the card photograph—a stimulus which operated with equal effect on the tintype. There was a difference, however: The card photograph was the favorite form of photograph for the soldier boy to leave with his family when he departed for camp. After he got to camp he found the tintype operator waiting for him to record his appearance from week to week as his whiskers gradually grew longer. It is not difficult to see why the tintype was the favorite of the camp-following photographer. His stock was more durable, he did not have to bother with the making of prints, and further, only one picture could be obtained for each sitting. If his patron wanted two tintypes he had to pose twice, and therefore paid for two pictures rather than one negative. On the other hand, the boy in camp found that these tintypes would stand the vicissitudes of the army mail service far better than card photographs or ambrotypes. We read, for instance (February, 1862):

"The Post Office Department is now doing a heavy business in the transportation of photographs and ambrotypes. The photographer accompanies the army wherever it goes and a very large number of soldiers get their pictures taken and send them to their friends. Friends at home, in return, send their portraits to the soldiers, and in this way an immense transportation business has been done by the Post Office. Not infrequently a number of bags go out from the Washington office entirely filled with sun pictures, enclosed in light but bulky cases.

"Most of these pictures are taken on the melainotype plate for the reason that it is light, durable, and easily sent in a letter."

The war correspondent of the New York *Tribune* also noticed these camp-following photographers during the summer of 1862, and sent in an account which gives a picture of their actual activities:

"Decidedly, one of the institutions of our army is the traveling portrait gallery. A camp is hardly pitched before one of the omnipresent artists in collodion and amber-bead varnish drives up his two horse wagon, pitches his canvas-gallery and unpacks his chemicals. Our army here [Fredericksburg] is now so large that quite a company of these gentlemen have gathered about us. The amount of business they find is remarkable. Their tents are thronged from morning to night, and while the day lasteth, their golden harvest runs on. Here, for instance, near General Burnside's headquarters, there are the combined establishments of two brothers from Pennsylvania, who rejoice in the wonderful name 'Bergstresser'. They have followed the army for more than a year, and taken, the Lord only knows how many thousand portraits. In one day since they came here, they took in one of the galleries, so I am told, 160 odd pictures at $1.00 (on which the net profit was probably ninety-five cents each). If anybody knows an easier and better way of making money than that, the public should know it. The style of portrait affected by these traveling-army-portrait-makers is that known to the profession as the melainotype, which is made by the collodion process on a sheet-iron plate and afterward set with amber-bead varnish." [202]

As the first of the above quotations suggests, tintypes were frequently mounted in cases similar to daguerreotype cases, but of lighter construction. The demand for daguerreotype cases had practically ceased, but with the coming of the war and the increasing interest in tintypes, and a revival of interest in ambrotypes, the manufacture of cases took a new life. In the summer of 1862, one stock-

Leaves from a tintype album of unknown origin. The album pages measure 3 by 3¼ inches. Each tintype is about ¾ by 1 inch.

A well made tintype portrait. (From the frontispiece of Trask's *Practical Ferrotyper,* 1872.)

house received an order for three thousand gross of these cases from one operator alone.

The tintype was mounted not only in cases, but in paper envelopes with a cutout through which the picture could be seen. In addition, since it was also made in card size, it began to find its way into the family album. Somewhat later small albums for tiny tintypes were introduced as a novelty and achieved some success, if we can judge by the number still existing.[203]

The rising demand for this form of photograph attracted the attention of other manufacturers and a number of rivals of both Neff and Griswold entered into competition with them during the early sixties. Several of these, among them the Scovill Manufacturing Company, were better financed and better equipped to make the iron plates used in the tintype process, so that they were able to overcome the early lead of these two pioneers in their trade. Neff found the competition too keen and sold out his interests in 1863, but Griswold, as we have already stated, continued to make his ferrotype plates until 1867. "Ferrotype" had by this time completely replaced the term "melainotype," which has departed to the limbo of lost words.[204]

One odd use to which tintypes were put, but which probably did not cause any great demand on the manufacturers, was to mount a tintype of a deceased person on his tombstone—and several patents were actually granted for methods of mounting these photographs on the stone. The same idea had been employed with the daguerreotypes some years earlier, and occasionally there will be found a tombstone in some country graveyard bearing the image of the departed who sleeps beneath the sod. The shadow has lasted, but the original has faded away![205]

Tintypes were made in a far greater variety of sizes than any other form of photograph of the period, ranging from tiny miniatures that could be worn on a ring, up to whole-plate size (6½" x 8½"). They were frequently colored by hand as were ambrotypes and daguerreotypes. In the vast majority of cases the image is reversed from right to left as in the daguerreotype, although some large operators made it a practice to take non-reversed pictures.

The large metropolitan galleries, as a rule, did not condescend

to make this form of portrait, but a class of operators grew up who developed galleries which made the tintype their specialty. This development came, however, only after the war, as the camp-following photographer was probably the most instrumental factor in making tintypes known to the entire country.

In these large and progressive tintype galleries, quite creditable work was turned out. But the tintype at its best does not equal a good daguerreotype, ambrotype, or paper print. The "whites" are usually gray, which gives the picture a cold, dull appearance, and the range of contrasts is not great. By far the most satisfactory of the tintypes is that made on *brown* japanned iron—"chocolate colored," as it was called. Brown is a "warm" color, and the resulting tintype, if well made, is far more pleasing than those in gray and black. The chocolate colored tintype, however, was a relatively late introduction in this field, being patented on March 1, 1870, by H. M. Hedden of Newark, New Jersey.[206] It should be stated also that Griswold had introduced, as early as 1859, tintype plates in almost every conceivable color, but at that time they created little interest.

Not only were tintypes made on iron, but similar forms appeared on black oil cloth, patent leather, and enameled paper and cardboard. These were usually called by special names, the number of which is almost legion; in many cases different operators gave different names to the same thing.

As we have already stated, one exposure was required for each tintype obtained. This was generally true of the smaller resident operator and the itinerants who appeared in large numbers after the war. In the larger establishments, however, by the use of more than one tube to a camera, it was possible to obtain several tintypes at each exposure, all the tubes being opened and closed at once. This was the device used by card photographers, but it was carried to greater extremes by the tintype operator, as he produced no negatives which could be multiplied indefinitely in the finished print. In some cases the tintype artist used as many as nine tubes on a camera, and by the device of moving the plate about to bring in a new and unexposed portion of the plate after each exposure, he could produce as many as thirty-six pictures on a whole-size plate with four exposures and four moves of the plate. The plate, after

[163]

development and fixation, was then cut up into the individual pictures. If one can judge by the comment found in the manuals of the period, it doubtless required an agile operator to manipulate such a device. For this reason, the four-tube camera, making as many as sixteen tintypes on a quarter-size plate, with four exposures and four moves of the plate in the camera, was probably the most frequently employed. The small tintypes made this way and mounted in a small paper container were known as "gems"— the popularity of which was enormous from 1865 on. In 1872, for instance, a supply house of Cincinnati received at one shipment two tons of these plates to be retailed to the operators in their territory.[207]

The tintype for many years remained a distinctively American form of photograph. It appears to have been made to some extent in England and continental Europe, but only long after it was well known in this country. For instance, Dr. Hermann Vogel, a German authority on photography, writes as late as 1873 that "the ferrotype is a specific American style" and was scarcely known in his country.[208]

The exposure required for a tintype was the same as that of an ambrotype, since in effect they were both under-exposed negatives—

Early tintypes. *Left,* a tintype made by Smith and Neff, January, 1855: "Tom, the boy at Yellow Springs." Now in the United States National Museum through whose courtesy it is reproduced. *Right,* a campaign medal of 1860. The small tintype of Lincoln measures ½ inch in diameter in the original. (Courtesy the late Prof. F. H. Hodder, University of Kansas.)

probably six to ten seconds was the average exposure given in a gallery. The directions given in one manual for making an exposure are interesting enough to quote—"Place the cap on the lens; let

Dr. John Towler. (From a photograph made at Geneva, N. Y., about 1880; courtesy Mrs. R. L. Slosson, East Aurora, N. Y.)

the eye of the sitter be directed to a given point; withdraw the ground-glass slide; insert the plate holder; raise or remove its slide. Attention! One, two, three, four, five, six! (Slowly and deliberately pronounced in as many seconds, either aloud or in spirit.) Cover the lens. Down with the slide gently but with firmness. Withdraw the plate-holder and yourself into the dark-room, and shut the door." Ah, yes! Be sure to close the door—a precaution which many an amateur has learned only through sad experience.

The manual from which we have quoted deserves special mention as it was the best known of its day. It was called *The Silver Sunbeam,* and was written by Dr. John Towler, who was "professor of natural philosophy; college professor of mathematics, and acting professor of modern languages, in Hobart College; professor of chemistry and pharmacy, and Dean of the Faculty in Geneva Medical College; and editor of *Humphrey's Journal of Photography.*" Despite these multitudinous duties, Professor Towler found time to write a number of manuals on photography, of which *The Silver Sunbeam* was the best. It was a good one, too, as the quotation we have given may show. It was detailed, explicit, and gracefully written, and went through some nine editions. In addition, it was translated into German, French, and Spanish. Such popularity was deserved. The first edition appeared December 15, 1863, and from this date until the end of collodion photography, it was by far the best known manual in this country for amateur and professional alike.[209]

The Stereoscope

"I think there is no parlor in America where there is not a Stereoscope."—Dr. Hermann Vogel.

STILL ANOTHER REMINDER of the family life of a bygone generation was the basket containing stereoscopic views, and the stereoscope, which, like the family album, was often found on the center table in the parlor. Looking at these "double photographs" must have been as comforting an occupation for the embarrassed suitor as were perusals of the family album. It did have the disadvantage, though, that it did not afford as close a proximity to one's beloved as did leafing through the pages of the album. On the other hand, if the suitor could, for the moment, forget the girl by his side, the stereoscope would reveal a far more interesting world than could be suggested by any family album. Indeed, it is surprising that these amazing photographs have lost their once great popularity, for the stereograph, a name coined by Holmes, produces, when viewed in a good instrument, a sense of reality that no other form of picture can remotely equal.

Probably the severest criticism which can be made of the photograph of a scene is that it destroys rather completely the sense of distance. Foreground, middle ground, and background are all condensed in one plane, and that usually small. Modern materials in the hands of real students of the art can overcome this defect to some extent, but in the prints of the wet negative days, the defect is all too apparent. Placed in the stereoscope, the failure to portray the distant vista is magically removed, and there lies before the observer the original scene in *space;* all but color is there. As I write I have before me a stereograph, bearing the caption "No. 852, Custer's Expedition." It is one of a series of such stereographs made by W. H. Illingworth, a well known St. Paul photographer, of Custer's expedition to the Black Hills of Dakota Territory in 1874. The

Stereographs "Broadway on a Rainy Day, Instantaneous View No. 213," published by E. Anthony in 1859. This is very similar to the one described by Holmes in the *Atlantic Monthly*, which was numbered 203. The difference in the two halves of the picture can be seen by examining the building lying on the left-hand margin of each half.

brown prints are somewhat faded, which is not surprising when we remember that they are now over sixty years old, but detail is still shown quite clearly. Over half of each print is taken up with foreground—a foreground that is apparently a level plain. Four long trains of army wagons stretch away into the distance, with scattered riders here and there among the train. In the extreme distance lies a long even line of hills. I drop the print into the stereoscope and a third dimension is miraculously added. The foreground is no longer a level prairie—I am standing on a hill which drops abruptly to the plain below, whereon the train of wagons is traveling. At my feet each blade of grass, each stalk of weed, stands boldly forth in its own position. My hand sways slightly and the illusion of motion is imparted—the grass ripples in the breeze. As my eye travels along the train of this elaborately equipped expedition, each wagon stands out distinctly, separated from its neighbor, each rider *is* a man in space and not his projected image. In the distance the long, even, and monotonous hills of the flat print are now a series of hills, gradually ascending through three distinct slopes into rugged mountains. It has been transformed from a record of the scene to the original scene itself. I have looked back over sixty years and can feel that I have lived before my time on this broad and treeless

plain, in the burning sun of the Dakotas. No wonder that, in his day, as he looked at other scenes by means of the same device, Oliver Wendell Holmes cried, "It is a leaf torn from the book of God's recording angel." [210]

Let us take a few moments to trace the origin of the device which thus so readily projects the past into the present. The principle of stereoscopic vision rests upon the fact that the two eyes see slightly different images when directed at a given object. The reader can readily verify this fact by fixing his gaze upon a given scene at some distance with both eyes open, and selecting some particular object as a reference point. If one eye is closed, maintaining the gaze of the second eye in the same position, a slightly different field of vision is seen than when the second eye is closed and the first opened.

The two images of the eyes are combined in the brain to produce the sensation of relief or perspective. It is, however, a difficult fact for one to believe who has always been blessed with vision in both eyes, as on closing one eye the space perceptions are still apparent. This appearance must be due to long continued use of both eyes, so that the education to varying light and shade and its relation to objects in space can supply the want of perspective, which is lacking in untrained monocular vision.

It is thus apparent, if two drawings of a given scene were produced, one scene as viewed by the right eye and the other as by

Blondin on the Tight Rope at Niagara (Anthony's Instantaneous View No. 125, 1859).

[169]

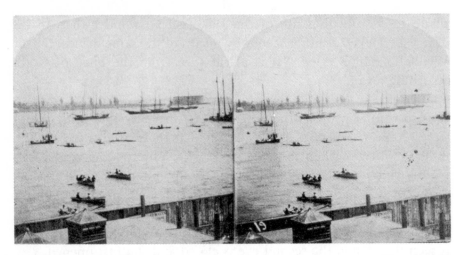

The Regatta, New York Harbor, July 4, 1859 (Anthony's Instantaneous View No. 19). Castle William may be seen in the background. It is interesting to note that the date and number of this photograph serve to establish the fact that the Anthony stereographs were first made and probably sold in the summer of 1859. Up to 1863 the stereographs bear the imprint "E. Anthony and Company"; after this date "E. and H. T. Anthony & Company." All three stereographs (Anthonys #19, #125 and #213) courtesy Mrs. Fannie Anthony Morriss, Washingtonville, N. Y.

the left, the sensation of relief or perspective could be produced on subsequently looking at the two drawings if some mechanism could be devised that would enable the left eye to see only its drawing and the right eye only the other.

The production of such a device was the work of Wheatstone, an English physicist, who called the instrument a stereoscope; that is, an instrument for viewing objects in space. Wheatstone first announced and demonstrated his stereoscope in 1838, just a year prior to the announcements of Daguerre, Talbot, and Herschel in photography.[211]

Wheatstone's stereoscope was received with surprise and delight in the scientific circles of his day, but it did not become widely known immediately for the reason that, at the time of its announcement, all pictures viewed by the stereoscope had to be executed by hand. With the advent of photography and its subsequent development, the preparation of photographic prints suitable for stereoscopic examination naturally followed.

While the preparation of stereoscopic prints by means of the camera doubtless came close on the heels of the announcement of the various photographic processes in 1839, the world-wide popularity

[170]

of the stereograph was not reached for many years—in fact, not until the wet process was well developed. The Talbotype, because of patent restriction, and the daguerreotype, because of lack of extensive duplication of copies, although used to some extent for this purpose, did not make the stereograph widely known.

The albumen process was more adaptable for the production of stereographs, and many prints from such negatives were made for this purpose, not only on paper, but on glass itself. The rise of the collodion process, however, in some of its many modifications, soon supplanted the extensive production of the stereograph by means of albumen negatives.

In making stereoscopic views, a special form of camera was devised and widely employed. The stereoscopic camera employed two lenses which were placed about two and a half inches apart on the same horizontal plane. This distance is the average distance between the human eyes from center to center. Each lens records the image seen by one eye, and for this purpose, the interior of the camera was divided by a thin partition, running from the lens board to the negative. The stereoscopic camera is in effect a double camera. The same results could be obtained, of course, by using an ordinary camera twice, shifting the position of the camera to the right (or left) two or three inches between exposures. This would serve, however, only if the scene to be photographed remained fixed, which is seldom true, so that the simultaneous exposure of both compartments of the stereoscopic camera was much to be preferred.

When a negative process was employed for the production of a stereograph, the prints from the stereoscopic negative (a single negative was employed in the stereoscopic camera, usually 3½ x 7 inches in size) were cut in two at the dividing line produced by the septum in the camera, and the right hand print mounted on cardboard on the left side of the mount and the left hand print on the right. This is necessary, for while in each print the inversion from right to left in the negative has been corrected, the two pictures themselves are laterally inverted. That is, the right side picture is in the place of the left side picture, and vice versa, and consequently the method of mounting described above must be employed. It would also be possible to make the correction by cutting the negative in two,

Left, stereoscope case patented by William Lloyd in 1856. The case served as both viewer and storage space. All stereographs, save the one to be examined, were removed from the case. The stereograph examined could be put in any one of the slots shown, to secure the necessary adjustment of focus. If a transparent stereograph were to be examined, a door in the back of the instrument could be opened. Frederick Langenheim evidently was interested in this instrument as his name appears as a witness of Lloyd's signature. *Right*, stereoscope case patented by Alexander Beckers of New York, 1859. It held from 12 to 300 stereographs mounted on blades which could be moved into view by rotating the knob shown on the side of the instrument. (Both drawn from the original patent specifications by Harriet Bingham, 1937.)

Another instrument patented also by William Lloyd, 1859. Two observers could view two different stereographs at the same time through the eyepieces shown and a second pair on the opposite side. The knob on the side was used to bring new stereographs into place. The drawer beneath the instrument was used to store the photographs. (Drawn from the original patent specifications by Harriet Bingham, 1937.)

transposing the divided halves and then printing on a single sheet of sensitized paper. In the latter instance, the mounted prints are continuous; when the first method is used there are two separate prints. I mention this fact as it is sometimes useful in identifying an unknown stereograph, for each operator had his own style of printing and mounting the finished stereoscopic prints.

A careful examination of a finished stereograph will show the reader that the two prints are not identical—the lack of identity is more apparent along the right and left hand borders of each print, the right hand print showing a somewhat greater field to the right (as the scene is faced) and the left hand print a greater field of vision to the left.

Stereoscopic views produced by the camera were introduced commercially into this country by the Langenheim Brothers of Philadelphia, in 1850. Their early attempts at producing this type of pho-

tograph were made from albumen negatives and printed on glass, which was also coated with albumen. It will be recalled that they called such prints "hyalotypes" and that these prints were used not only as stereographs, but as slides for the magic lantern.

Their early efforts at introducing these glass stereographs were not particularly successful, but with the advent of collodion, more permanent pictures resulted and their efforts were rewarded with growing sales.

These early attempts of the Langenheims and their early products deserve more than a passing notice, as they were the forerunners of the stereographs, which appeared in most homes on the American continent some time during the fifties, sixties, and seventies.

During 1854 and 1855, the Langenheims began to push their interest in stereoscopic views more extensively. Frederick Langenheim, a brother-in-law, by the way, of Voigtlander of Vienna, the celebrated manufacturer of photographic lenses and equipment, sent copies of his stereoscopic views to Snelling, the editor of the *Photographic and Fine Art Journal*. Snelling acknowledged them and stated that they were the most beautiful stereoscopic views he had ever seen. He commented, further, that although such stereoscopic pictures did not receive the attention they merited, they were increasing in popularity. "We find, among those who best appreciate art, that the stereoscope is creating, at present, more inquiry than any other branch of Photography, and that portraits adapted to the stereoscope are fast becoming popular."

Snelling also published, at the same time, a letter of Langenheim's which is important in showing the relative popularity of such photographs at home and abroad.

<div style="text-align: right;">

Philadelphia, Pennsylvania
September 19, 1854

</div>

H. H. Snelling, Esq.
Dear Sir:

An article in the last number of your valuable journal, containing, incidentally, a very flattering notice of my stereoscopic views on glass, induces me to hope that you will have the kindness to accept the few samples I have taken the liberty to transmit, today, through the kindness of Messrs. Meade Brothers.

The great encouragement this especial kind of pictures has found

in Europe, has led me on to produce them here also, confident that the American public will patronize this branch of the Photographic Art, in a similar degree as the European public, as soon as the results are brought before them in a presentable shape and at reasonable prices. Until now, all the stereoscopic glass pictures have been imported from Europe, and principally from France; whether my pictures will compare favorably with them, I leave to those able to form a judgment for themselves, and particularly to the "artists who use the Pencil of Light."

It is a singular fact that stereoscopic pictures, in general, have been produced by our photographic artists, and have been demanded by the American public in, comparatively, very small quantities, to what is done in them in Europe, and far less than the particular beauty of stereoscopic pictures seems to warrant. As far as I am able to judge, the fault lies principally with our operating artists. They have not paid the attention to the subject it richly deserves, and a better investigation, I think, might yet procure, for stereoscopic pictures, that appreciation here which they have elsewhere.

F. LANGENHEIM.

The following year (1855), Langenheim interested a group of Philadelphia business men in financing an extensive photographic expedition for the purpose of securing a collection of representative American views, to be reproduced as stereographs upon glass, porcelain, and albumenized paper; the paper ones, as might be expected, being considerably cheaper than the glass or porcelain ones. The views were secured by the Langenheims upon a trip which began at Philadelphia and followed the south route of the Reading, Catawissa, Williamsport and Elmira Railroad to Niagara Falls. In addition, there were "twelve very interesting views of scenery in the coal regions, near Pottsville, on the Mine Hill Railroad." It is unfortunate that these views are not now available. Sachse, nearly forty years ago, made an extended but unsuccessful search for them, and inquiries directed to many of the leading museums of Philadelphia, New York, and Washington, have not been more successful. Very likely, in some Philadelphia attic there reposes a complete set of these Langenheim stereographs, the first of the nearly numberless series of American views in stereoscopic form, which have instructed, amused, and beguiled many generations of American citizens.

For the next half dozen years, the Langenheims devoted their attention to the specialty of making stereographic views which, be-

Mascher's combined daguerreotype and stereoscope case, patented in 1853. (Courtesy Miss Minnie Moodie, Spooner-Thayer Museum, University of Kansas.)

cause of their efforts, became increasingly popular as the decade advanced. They were instrumental in the formation of the American Stereoscopic Company, for many years one of the big producers of this form of photograph. At the outbreak of the Civil War, the Langenheims sold their interests in this concern and devoted the remainder of their business lives to the production of magic lantern slides, which, curiously enough, were called stereopticon slides. As a result of this term, the two forms of photographs are frequently confused. Stereographs are flat, opaque prints viewed in the stereoscope—stereopticon slides are photographic prints on glass (technically called "transparencies"), which can be placed in the magic lantern, or as it is now called, "the projection lantern," and an en-

[176]

larged image of the slide thrown upon a screen. To the Langenheims, however, countless American families are indebted for the introduction of both of these forms of entertainment.[212]

Enterprising photographers were quick to follow the lead of the Langenheims in introducing the stereograph to their patrons. Thus Hesler, the leading Chicago photographer, who went east in the summer of 1854 to receive instruction in the rapidly spreading vogue of the wet process, doubtless saw some of the Langenheims' work, for that fall he had a stereoscope and stereoscopic views on exhibition at the seventh annual fair of the Chicago Mechanics Institute, and a local newspaper thought the exhibit of enough value to describe for its readers:

"Mr. Hesler exhibits a new branch of his art—the Stereoscope. Two pictures are taken, each the exact counterpart of the other, which are placed in a case and viewed through lenses, which accompany it. By this method, one picture is seen by one eye and the second by the other, yet the two blend in the vision and form a more perfect image than can be formed in other known methods. It seems to stand out from the plate and possess the fulness of reality. All who visit the Fair should examine the Stereoscope." [213]

The discussion of stereographs thus far might lead the reader to believe that daguerreotypes were never used stereoscopically. As a matter of fact, they were so used, and were well known before paper and glass stereographs. The leaders in this country, in adapting the daguerreotype to stereoscopic purposes, were J. F. Mascher of Philadelphia, and Southworth and Hawes of Boston.

Mascher patented on March 8, 1853, an ingenious daguerreotype case which, upon being opened, unfolded a small panel bearing two lenses. Opposite these lenses were placed the two daguerreotypes which were taken stereoscopically, and then mounted in the case. The case was thus the holder and the stereoscope for the daguerreotypes, as is seen in the illustration on the opposite page. Mascher devised a similar arrangement that folded up into a small locket. These stereoscopic cases became quite well known after their invention, but those that I have examined are not particularly striking in producing the stereoscopic effect; as far as I know, they were used only for portraits.[214]

The type of stereoscope most popular before the invention of the Holmes form. Coleman Sellers (from a self-made photograph of 1859 or 1860; courtesy Mrs. Horace W. Sellers, Ardmore, Pa.).

The contribution of Southworth and Hawes in this field was the construction of a "grand parlor stereoscope" which exhibited a number of stereoscopic pictures. The device automatically brought in new pictures for examination when the observer desired a change. All the spectator had to do was to turn a crank at the side of the instrument. It was really a large and complex piece of machinery, and was, therefore, very expensive. Southworth and Hawes had one of these devices in the reception room of their Daguerrean gallery in Boston, for the entertainment of their customers.

The pictures were whole-plate daguerreotypes, and a person sat comfortably in front of it, and by turning the handle, could bring in a new picture with the greatest of ease. It was a splendid advertisement, and drew large crowds to their "salon." [215]

But, as we have already said, the introduction of the wet process, through the efforts of the Langenheims, eventually made the stereograph popular. Although the Langenheims began their first extensive commercial venture in this field in 1854, the growth of popularity was relatively slow, but gradually increased. In the galleries the early tendency, upon the introduction of paper photographs, was to make larger and larger prints. The bulk of the gallery trade, when paper prints came into vogue, was for whole-size (6½″ x 8½″) portraits, but the imperials, a still larger size, achieved some popularity in 1857 and 1858, and were followed in turn, it will be recalled, by the still larger life-size portraits. The total volume of

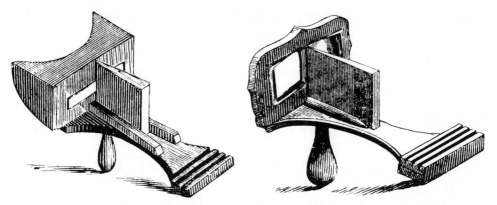

Left, the original stereoscope devised by Holmes in 1859. *Right,* the instrument modified and first manufactured by Bates of Boston. (From wood engravings copied from photographs, in the *Philadelphia Photographer,* Jan., 1869.)

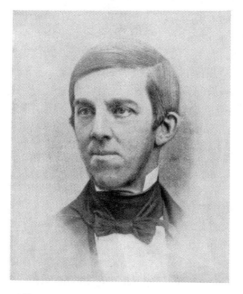

Oliver Wendell Holmes. (After the print in *McClure's Magazine,* Nov., 1896, from an original daguerreotype made by Josiah J. Hawes of Boston, about 1855.)

this business, done by the collodion process, was rapidly increasing through the late fifties. This impulse was due to the ambrotype fad of 1856 and 1857, and to the rising popularity of the stereograph. Interest in these stereoscopic views was becoming more widespread in 1858 and 1859, as is evidenced by occasional comments in the photographic journals of the period. Seely, of the

[179]

American Journal of Photography, remarks early in 1858 that "stereoscopes are at last coming into vogue with us," and a correspondent of *Humphrey's Journal,* living in Atlanta, writes the editor of this journal in 1859, "The stereoscope is just now beginning to be popular in Georgia, having never been generally introduced until this season." [216]

The first of the articles written by Oliver Wendell Holmes on photography, appeared in June of 1859, in the *Atlantic Monthly,* and aided in the rapidly spreading vogue of the photograph. This article, the title of which was "The Stereoscope and the Stereograph," reviewed briefly the history and method of obtaining daguerreotypes, photographs (that is, paper prints by the collodion process), and the stereoscope, and then continued by describing some actual stereographs and commenting on the ideas which they suggested to Holmes. Most of the stereographs which Holmes mentions in this article are of foreign scenes, although he does refer to a view of the "Shanties of Pike's Peak," which shows that the American photographer was actually pushing into the frontier. Holmes also furnishes the reader with advice on the selection of subjects for a stereoscopic library, comparing the relative merits of glass and paper stereographs: "Twenty-five glass slides well inspected in a strong light, are good for one headache."

Holmes further recommended the establishment of national or city stereographic libraries. "We do now distinctly propose the creation of a comprehensive and systematic stereographic library, where all men can find the special forms they particularly desire to see as artists, or as scholars, or as mechanics, or in any other capacity. Already a workman has been traveling about the country with stereographic views of furniture, showing his employer's pattern in this way, and taking orders for them. This is a mere hint of what is coming before long."

As far as I have been able to determine, Holmes' proposal was never adopted. Many public libraries had stereographic views in considerable quantity, but as they became shabby and worn with continued use, they were discarded. Further, they were seldom catalogued.

It is extremely unfortunate that Holmes' suggestion was not

followed carefully and extensively, for had this been done, many such views would still be extant, and an authentic pictorial record of this country from 1859 until the era of facsimile reproduction would have been readily available. The historical value of stereographs has been almost completely overlooked.

A prophecy made by Holmes in the article referred to above also deserves comment, especially when it is recalled that the American nation, at the time the article was published, was on the threshold of civil war. "The next European war will send us stereographs of battles. It is asserted that bursting shell can be photographed. The time is perhaps at hand when a flash of light, as sudden and brief as that of lightning, which shows a whirling wheel standing stock still, shall preserve the very instant of the shock of contact of the mighty armies that are even now gathering."

Holmes followed this essay with a second one, also in the *Atlantic*, "Sun-Painting and Sun-Sculpture; with a Stereoscopic Trip Across the Atlantic." This essay was published two years later (1861) and like the first is of considerable interest and importance in the history which is here being outlined.

The most important feature of the second essay, from our standpoint, is that it contains mention of a simple stereoscope for examining stereographs. This stereoscope is, in most respects, the one familiar to all who have ever seen such an instrument: a light, portable board, bearing two lenses, and a projecting arm which, in turn, carries a small cross-piece on which the stereograph to be examined is placed, and a small wooden handle beneath, with which the whole instrument is carried to the eyes of the beholder. To Holmes, then, goes the credit of modifying the stereoscope into its present form.

The earlier forms of the stereoscope, in general, were bulkier, more inconvenient to handle, and more expensive than that devised by Holmes, so that undoubtedly his contribution added still further to the growing popularity of the stereoscope. Holmes did not patent his modification, nor did the manufacturer who constructed the first stereoscope of Holmes' design. The maker, Joseph L. Bates, did contribute still another modification which can be recognized in the modern stereoscope—the sliding carrier, and method of holding pic-

CUT THIS OUT
AND LOOK AT IT
IN YOUR STEREOSCOPE.

It will appear as a pyramid five inches high. The letters will stand perpendicularly, and each line an inch back of the preceding—a most remarkable optical illusion.

E. ANTHONY, 501 Broadway,
At Wholesale & Retail by
OF EMINENT MEN, &c
PORTRAITS
CARD
501
SOLE
AGENT FOR THE
U. STATES FOR THE
PHOTOGRAPHIC ALBUM
FOR CARD PORTRAITS,
THE LARGEST IMPORTER OF FOREIGN VIEWS FOR THE STEREOSCOPE,
THE LARGEST PUBLISHER OF AMERICAN VIEWS FOR THE STEREOSCOPE,
E. ANTHONY, 501 Broadway,

E. ANTHONY, 501 Broadway,
At Wholesale & Retail by
OF EMINENT MEN, &c
PORTRAITS
CARD
501
SOLE
AGENT FOR THE
U. STATES FOR THE
PHOTOGRAPHIC ALBUM
FOR CARD PORTRAITS,
THE LARGEST IMPORTER OF FOREIGN VIEWS FOR THE STEREOSCOPE,
THE LARGEST PUBLISHER OF AMERICAN VIEWS FOR THE STEREOSCOPE,
E. ANTHONY, 501 Broadway,

FOR THE HOLIDAYS
WE HAVE JUST RECEIVED
A New and most Exquisite Assortment,
The cream of the London and Paris markets, selected with great care on the spot by one of our house. We have also just published about
500 New Views of American Scenery.
No more instructive and entertaining present can be imagined than
A STEREOSCOPE AND VIEWS.
Parties at a distance, by remitting $5, $10, $15, $20 or $25, can have the worth of it sent by express, carefully selected and warranted to please.
Catalogue sent on receipt of stamp.
265 E. ANTHONY, 501 Broadway.

An Anthony advertisement in
Leslie's Illustrated Weekly,
1860.

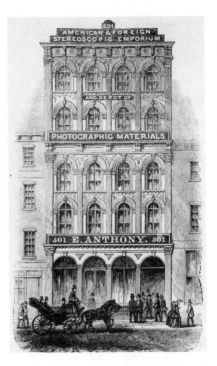

Wood engraving of Edward Anthony's establishment on Broadway (from *Humphrey's Journal,* 1860).

ture. The evolution of the stereoscope into its present form, can be traced in the series of illustrations found on the previous pages.[217]

How seriously Holmes took his study of stereographs can be judged from the following paragraph, which appears in his second essay:

"We had a stereoscopic view taken by Mr. Soule out of our parlor window, overlooking the town of Cambridge, with the river and the bridge in the foreground. Now, placing this view in the stereoscope, and looking with the left eye at the right stereographic picture, while the right

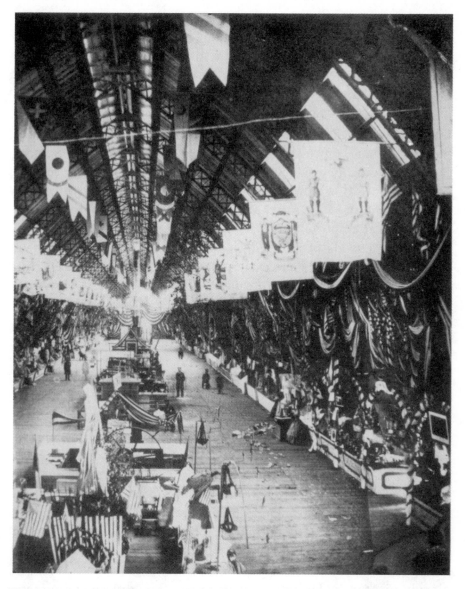

The Great Central Sanitary Fair, Philadelphia, June, 1864 (photograph by R. Newell, an amateur: "½ inch stop and 5 minutes exposure on a clear day"). The very slow speed of the wet plate is clearly shown by this illustration. Notice the "ghosts" of a number of persons who have changed their position while the plate was being exposed.

eye looked at the natural landscape, through the window where the view was taken, it was not difficult so to adjust the photographic and real views that one overlapped the other, and then it was shown that the two almost exactly coincided in all their dimensions."

This statement explains still further the popularity of the stereograph, and its illusion that the observer had actually before him the original scene—the original scene in all but color and motion. It is interesting to note that it was with the stereograph that the illusion of motion, resulting in the modern cinema, was first attempted. This point is of considerable importance in our history, and will later be discussed in greater detail, but it seems appropriate to mention it here, especially since the cinema industry has succeeded in recent years in producing a passable reproduction of scenes in natural color. It is surprising that even with the huge financial, technical, and scientific forces at the command of this industry, it has only begun attempts to reproduce form in space on the silver screen.

The magnitude of the trade in stereoscopic views is difficult to estimate, and, during their early popularity, we have little to base such estimates upon. Holmes said in 1861 that he had examined "perhaps a hundred thousand stereographs"; very probably the larger number of these were of foreign origin. The two largest producers of foreign views at this time were the London Stereoscopic Company, and Ferrier, in Paris. The London Stereoscopic Company sold nearly a million such views in 1862, and the French concern was probably as active.[218] In this country the American Stereoscopic Company formed by the Langenheims was the first large producer, but the commercial organization which eventually had the biggest trade in this business was E. and H. T. Anthony and Company. This enterprising firm not only imported stereographs in great quantities, but devoted a large part of its establishment to the printing of such photographs from original negatives. The negatives were secured by purchase from itinerant photographers, amateurs, and from professionals, especially sent out by the firm, to secure views of a particular nature, all over the American continent. We have already mentioned Holmes' visit to the Anthony place of business, and its description, which was published in the third of the Holmes articles in the *Atlantic Monthly*.

We have seen that the stereograph had reached a considerable popularity by 1859, far exceeding in number any other form of paper photograph. This, it will be noted, was before the use of the *cartes de visite* and the astounding fad their introduction produced.

[184]

The card fad had, of course, its effect upon the popularity of the stereograph. In fact, for a time, the stereograph was totally eclipsed, but it was too good to become altogether obsolete. After the height of the card fashion had been passed, stereographs made their appearance again in large numbers. In 1867, for instance, among other news of interest to the profession, we find the statement, "The Stereograph trade of the Anthonys is reviving." [219] The American stereograph thus has the longest history of any form of photograph. The introduction of new and popular varieties of other photographs would temporarily cause a decrease in the sales of the stereograph, but as soon as the new fad passed, the ubiquitous stereograph resumed the even tenor of its way as the leader in the trade. As our account has shown, stereoscopic photographs were made in the early fifties, and in every subsequent decade up to the present. Stereographs have been made by all the photographic processes: Talbotype, albumen negatives, daguerreotype, wet and dry collodion, and eventually by the gelatin dry plate or film—a remarkable record. It would be totally impossible to trace the influence of these stereographs in millions of American homes, and over a period of eighty years!

"Boston as the Eagle and the Wild Goose See It"

THE THREE previous chapters have traced the history in this country of the card photograph, the tintype, and the stereograph. Other events of interest in the photographic world were also occurring in the decade from 1856 to 1866. During this period the amateur photographer first made his appearance in any numbers and the Civil War was recorded by the camera. These events are of sufficient importance to devote separate chapters to their description, but in addition to these major events, several others deserve our notice. One of these was the first successful attempt to make aerial views in this country. These views were made October 13, 1860, and were the result of the joint effort of Samuel A. King of Providence and J. W. Black, a well-known photographer of Boston. A previous attempt had been made by Black and King in Providence, the two making an ascension in a tethered balloon, the "Queen of the Air." The attempt was unsuccessful as it became so cloudy after the ascent that no photographs could be secured. The second attempt was made several weeks later on a clear day, at Boston. The "Queen of the Air" was allowed to rise 1200 feet above the city, and there held by a cable. Black, who, of course, was the photographer (King the navigator), made eight exposures, only one of which produced a successful picture. The difficulties under which he worked, however, should be remembered. He was using wet plates and consequently had to prepare them in the balloon before each exposure. The balloon, although tethered, was in constant motion,—a fact which made the process still more difficult, especially when the slow speed of his materials is recalled. After making eight negatives, they descended, took on more supplies, removed the cable, and ascended again in the free balloon, their object being to obtain views not only of Boston, but of the surrounding country.

[186]

Here they encountered a peculiar difficulty which made it impossible to secure any further photographs. The gas (hydrogen) expanded as they rose, and as the neck of the balloon was open, the gas flowed down over their equipment. Every plate, as rapidly as it was prepared, turned dark by the action of the gas upon it, so they gave up their photographic experiments and permitted themselves to enjoy the novelty of their trip. They were up several hours and traveled some thirty miles. They came down safely in a clump of high bushes in the small town of Marshfield (Massachusetts), which was only a mile from the ocean!

Their single successful effort, however, was much admired, and they naturally received considerable newspaper publicity as the result of this novel picture. The Boston *Journal* described the finished print as including "the area bounded by Brattle Street on the north, the harbor on the east, Summer Street on the south, and Park Street on the west, forming a view at once novel and picturesque of the entire business portion of the city. The impression is similar to that experienced by the aeronauts themselves."

King, while he no doubt was pleased with the publicity, realized that his experiment with Black had a significance far greater than that of novelty. "This," he says, "is only the precursor, no doubt, of numerous other experiments, for no one can look upon these pictures obtained by the aid of the balloon, without being convinced that the time has come when what has been used for public amusement can be made to subserve some practical end."

Oliver Wendell Holmes commented also in a similar vein on this photograph, which he said showed "Boston, as the eagle and the wild goose see it. As a first attempt it is, on the whole, a remarkable success; but its greatest interest is in showing what we may hope to see accomplished in the same direction." [220]

Such was the crude beginning of aerial photography in our country. Contrast it with an age when scarcely a day goes by that the daily newspaper does not present its readers with such a photograph taken possibly hundreds of miles away and sent by *wire* to all the world.

The year 1860 was a remarkable one for American photography —the card photograph obtained its start, the tintype rose to popu-

larity in the presidential election of that year, the first aerial view was made, and in addition, the Japanese embassy arrived in America, the Prince of Wales visited this country, and the *Great Eastern* docked at New York. All of these events created plenty of work for enterprising photographers.

The Japanese embassy was regarded with considerable interest by the public, as Japan for many years had been closed to the outside world. In 1854, as a result of Commodore Peary's Treaty, com-

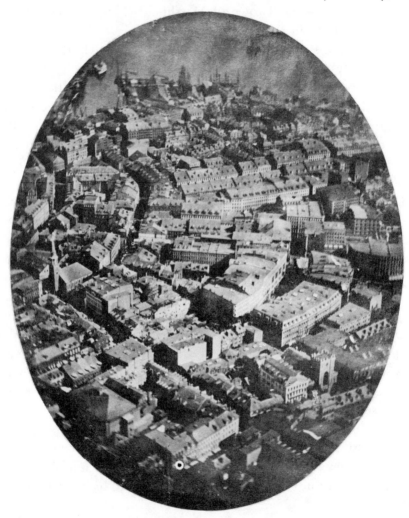

"Boston as the Eagle and the Wild Goose see it." The first aerial view made in this country (Oct. 13, 1860) by King and Black. (Print for this history from the original negative in possession of W. N. Jennings, Rose Valley, Pa.)

mercial relations were established with the United States. The Treaty did not become an actuality until 1859, and the following year the first embassy was sent from Japan to this country. The public awaited with eagerness to see these men of the Orient, and those who could not see them wanted their pictures. As a result, says a contemporary, "The Japanese Embassy has been photographed from San Francisco to New York. In Broadway, the embassy will run a gantlet of a hundred cameras. There is scarcely a town in the United States where any one of them could not be recognized and called by his right name." [221]

These gantlets of cameras, however, were not composed of the instruments of the ubiquitous newspaper cameramen, be it recalled, as daily newspapers were not then illustrated, but of the cameras of professional photographers, who secured the negatives from which card and other photographs were made for sale.

Each visit of the *Great Eastern,* the largest steamship of the age, was likewise the occasion of work for the photographers. But the climax of this eventful year must have been the visit of the Prince of Wales, the prince who later became Edward VII. For a democratic country we have always been particularly conscious of and curious about royalty—a curiosity which was particularly virulent during the middle of the nineteenth century, because there were few of the modern methods of satisfying this trait of the American character. Wherever the Prince went, upon his arrival, he was greeted by almost unbelievably large throngs. Such a situation was altogether to the liking of the photographer, who made ready to reap a harvest. It must have been difficult, though, with the huge crowds, to secure a favorable location for operation, but some did succeed. Brady, in New York, however, was the most fortunate of all, for the Prince and his party actually visited his gallery to have their portraits made. Brady inquired of one of the Prince's party why he was the only one so selected. "Are you not the Mr. Brady," was the answer, "who earned the prize nine years ago in London? You owe it to yourself. We had your place of business down in our note-books before we started."

Brady's good fortune was an incentive to Gurney, his greatest

The Japanese Embassy (photograph by Brady, 1860; courtesy Signal Corps, U.S.A.).

competitor, to make efforts in the same direction. How well he succeeded is evident from the following illuminating comments:

"There is a tremendous struggle between Brady and Gurney as to who shall have the honor of being Photographer to Royalty. Brady managed his cards well. He did not make any preparations to secure the 'Youthful Guelph' as soon as he was advised of his intended visit—modest man—not he. And how immensely surprised he was when the Prince sent for him, and merely intimated his intention to visit 'Brady's splendid gallery,' whose praises had occupied columns of our city papers. How very fortunate that the Prince should have selected *him* of all others; particularly when he had not had the slightest idea of being so distinguished! But Brady is evidently a lucky man; he knows how to trim his sails—Brady does! He succeeded admirably with His Royal Highness—took some splendid pictures of Prince and suite, and came off with flying colors.

"We suppose that his fortune is made now. Of course 'Upper-Tendom' will have to visit Brady's. Of course the 'Cod-fish aristocracy' will go nowhere else to get photographs of the little Tom-cods. Nothing but a veritable 'Brady' will hereafter answer for the *parvenu* set who could not make a floor strong enough to hold up the Royal Party when engaged in their Terpsichorean exercises.

"Where was Gurney all this time, and Fredricks, and lots of others? Of course they could not all have Brady's good fortune. We believe that Gurney did go to Boston and get some excellent negatives of the Royal Party. And now the two rivals for Princely favor are advertising 'to kill.' One says his is the only gallery in the United States visited by the 'Royal Party,' and the other says that he went to Boston expressly by the 'Royal Desire.' " 222

As this comment shows, Brady had a new gallery in 1860—his third New York gallery since he began business in 1844, each one more elaborate than the previous one. Fortunately, some idea of the reception room to this gallery is preserved for us by *Leslie's Illustrated Newspaper* in a woodcut that is reproduced on page 193. The numerous portraits practically covering the walls are specimens of the work of Brady's gallery, many of them being the "life-sized" portraits which have already been described, and many of the remaining ones were "imperials." In the collection were found many of the notables of the country whom Brady had so assiduously recorded since 1845. The Prince of Wales, upon his

Edward, Prince of Wales, Oct. 13, 1860 (photograph by Brady; courtesy Signal Corps, U.S.A.). Notice the striking resemblance to Edward VIII.

visit to Brady's establishment, examined this gallery of illustrious Americans, and "gave expression to the gratification which the spectacle of this magnificent collection afforded him. He inspected with curious interest the portraits of the statesmen, literary and other celebrities of this country, pointing out to the members of his suite such as them as he had been familiar with by reputation."

The woodcut, although executed by hand, furnishes us with some idea of the magnificence of Brady's gallery. In an age when ornateness was a criterion of artistic approval, the room must have appeared chaste and simple, but even then "the elegant and artistic gas fixtures" were pointed to with pride. In addition, "a costly carpet covers the entire area, while elegant and luxurious couches abound in liberal profusion." "Elegant" was a favorite word of these days.

It must be remembered that the woodcut shows only the anteroom or reception room, where the patron awaited his turn to enter the "operating" rooms, of which there were several. It is unfortunate that the artist did not record one of these for us. A special feature, which the thoughtful Mr. Brady provided, was a private entrance to the operating rooms for ladies in evening dress, which obviated "the unpleasant necessity of passing, so attired, through the public gallery."[223] Brady had an eye for fashionable patronage, for he was astute enough to know that where the fashionables went, the rest of the crowd went also; and he had achieved the ultimate when the Prince favored him with a call. In fact, this period (1860-1861)

Brady's New Photographic Gallery at Broadway and Tenth Street, New York (from *Leslie's Illustrated Newspaper*, Jan. 5, 1861).

Brady as he appeared about the time of the Prince of Wales' visit (courtesy Signal Corps, U.S.A.).

One of the two photographs of Lincoln made by Brady, February 27, 1860 (courtesy Mr. F. H. Meserve, New York City).

marks the high point of Brady's achievement as the fashionable photographer of his day. The beginning of the War between the States saw Brady embark upon a new phase of his career. After the war he never regained the position which was his at the beginning of this decade.

Very probably, the most important photograph that Brady made during his heyday as a portrait photographer was that of Abraham Lincoln. Lincoln came to New York in February, 1860, a relatively unknown man, to deliver an address at the Cooper Union. While in New York he was taken by his host, R. C. McCormick, to Brady's gallery. On February 21, 1860, Brady secured several portraits of the obscure country lawyer. At the time that these photographs were made, what reputation Lincoln possessed was that of a rough, uncouth, backwoods lawyer, "half-alligator and half-horse" in appearance, but not without a shrewd and humorous wit. His speech at the Cooper Union, the evening after he had posed for his portrait, convinced the country that Lincoln was a man of marked ability, with a clear and forceful logic. But the popular impression of his appear-

[194]

ance still worked to his disadvantage. After this speech, demand for his portrait arose. The Brady photographs were available and were reproduced in a number of ways. The illustrated journals prepared woodcuts from these photographs, and Currier and Ives, the famous lithographers, published one of them among their numerous offerings. These Brady portraits revealed Lincoln as a man of dignified bearing and human aspect, and when Brady and Lincoln met at the White House several years later, Lincoln, on being introduced to Brady, remarked to those present, "Brady and the Cooper Union [speech] made me President of the United States." [224]

Brady made many subsequent portraits of Lincoln, some among them being probably the best known aspects of Lincoln at the present day. In addition to Brady, however, other photographers secured his likenesses. Among the best known of these were Alexander Hesler of Chicago, and Alexander Gardner of Washington. Hesler's photographs were made prior to Lincoln's removal to Washington— Gardner's after 1862. Several of Gardner's are striking; one of these is reproduced on page 242 and will be discussed in a later chapter. Gardner also secured the last photographs of Lincoln while living. These were made on April 9, 1865, five days before Lincoln was assassinated and are frequently referred to as the last Lincoln photographs made.[225] As a matter of fact, Lincoln was photographed after his death, the photographer being Gurney, one of Brady's principal competitors. The fact is recorded in *Humphrey's Journal* for 1865:

"It is known that Messrs. Gurney took some very fine negative scenes in and around the hotel where the remains of our late lamented President laid in state in this city [New York]. They had uninterrupted possession of the premises for several hours, and no other artist was allowed any similar privilege by the city authorities. This did not please some other photographers in New York, so they sent on a statement of facts in the case to Secretary Stanton, when that official immediately dispatched officers to Gurney's and seized all the above mentioned negatives they could lay their hands upon and sent them off to Washington. Mr. Gurney followed after, post haste, but whether he succeeded in recovering the negatives we are not informed." [226]

The negatives, it is now known, were destroyed by Stanton's orders. It should be said that the photographing of the dead was

quite a common practice of the day and had been ever since the introduction of daguerreotyping. It is not at all uncommon to come across the daguerreotype of a deceased child—the memento of a tragic event in the life of some family. In most instances it is likely that the original had never had his portrait made while living. Although such daguerreotypes or photographs may have offered solace to bereaved mothers, they are too gruesome to contemplate with pleasure. Fortunately, the practice disappeared with the aging of the art.

The most formidable competition encountered by Brady and Gurney at this time was that of C. D. Fredricks and Company. Although they had not been in the profession as long as either Brady or Gurney, they had in the early sixties the largest establishment in the country. Like Brady and Gurney, they were located on Broadway. Werge, who saw them in 1861, describes their gallery as follows:

"The whole of the ground and first floor was thrown into one 'crystal front' and made a very attractive appearance. The windows were filled with life-sized portraits in oil, crayons, and other styles, and the walls of the interior were covered with life-sized portraits of eminent men and beautiful women. The floor was richly carpeted, and the furnishing superb! A gallery ran around the walls to enable the visitors to view the upper pictures and obtain a general view of the 'salon,' the haut ensemble of which was magnificent. . . . Some of the Parisian Galleries were fine, but nothing to be compared with Fredricks', and the finest establishments in London did not bear the slightest comparison."

Cartes de visite, upon their introduction, it will be recalled, were made a specialty at Fredricks', and the number produced at this gallery were prodigious. The number of card photographs that I have examined runs into many thousands and I believe that it is safe to say that the greatest number of these were made at Fredricks'.[227]

In the other cities of the country, those establishments which had taken the lead in daguerreotyping, with few exceptions, continued to lead in the production of *cartes de visite* and other forms of paper photographs. Of smaller operators, this was less frequently true; the change in technique from the silver plate to the wet plate process was a considerable one, and, on the whole, the wet plate process was of greater difficulty. The smaller operators who were

[196]

not able to master its details, or who did not have the capital to employ others skilled in its use, were gradually forced out of business. Indeed it was the card photograph which caused the final disappearance of the daguerreotype from the scene. In June, 1863, Whipple of Boston advertised for a daguerreotypist, an advertisement which drew this comment from Seely:

"The card of Mr. Whipple, in our advertising pages, comes like a voice from antiquity. A daguerreotypist wanted forsooth! And at the hub of the Universe! Perhaps a revival of lost art is attempted. . . . But if this by chance meets the eye of any veteran who has not forgotten the daguerreotype of his youth, he will do well to apply for the position of daguerreotypist. Very few places are more desirable than those which Mr. Whipple has to give." [228]

It can reasonably be asked if the standard of excellence achieved by the American daguerreotypist at his best was maintained by these craftsmen of the paper photograph. No very definite answer can be given to this question—very largely because there was no extensive international competition in the period from 1860 to 1866. A large exhibit was held in London in 1862, but the only American to enter was Brady. His work was criticized unfavorably in comparison with the French and English productions. The war undoubtedly prevented any serious competition from the American profession. What judgment we can get from individual observers varies somewhat, but on the whole, it indicates that both French and English were superior in paper photography, especially when it came to landscape and other outdoor work—in fact, landscape photography was almost a neglected field for Americans until after 1870.

Charles Waldack, a well known professional of Cincinnati, who was abroad in 1862 and saw the exhibition in London, thought the French excelled in their portraits, the English for their views, but that the large photographs (imperials and life-size) were inferior to those in American galleries. Professor Edwin Emerson of Troy (New York) University, himself an able amateur, who was abroad the same year, stated: "I found myself forced to the conclusion that England is in advance of America in the practice of photography, even in portraiture—in landscape photography, which is almost a specialty of the English, there can be no doubt." [229] The sole voice

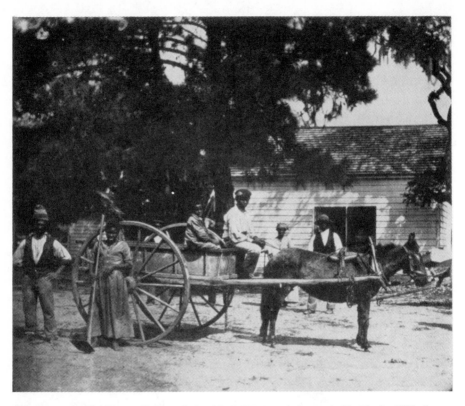

"Gwine to de Field"—a photograph by H. P. Moore of Concord, N. H., in 1862. It was made on Edisto Island, South Carolina, at the plantation of James Hopkinson. The planters had left when Union forces captured the territory, and the slaves had possession of the property. This is one of the few photographs which I have seen, made of the negroes while technically still in slavery.

raised in defense of the American was that of the London corre-spondent of the New York *Express,* who writes, "The three best and best known experts in this modern and money-making art are Brady of New York; Nadar of Paris; and Silvy of London; and I name them, I think, in the order of merit, for I have never seen anything in London or Paris superior, if equal, in the shape of the sun pic-tures to those done under the practiced hand of Brady." This cor-respondent, however, can hardly be regarded as an unbiased ob-server, for he gives himself away in his final sentence,—"To this complexion it has come at last—Americans excel in everything, from an iron plated monster to a *carte de visite.*" [230]

The outstanding scientific application of photography in this

period was made by two Americans, Lewis M. Rutherford and Dr. Henry Draper. Rutherford as early as 1857 had begun to apply photography to astronomical purposes, and for the next twenty years he devoted himself to this field. A modest and retiring man, his important contributions to astronomy have been overlooked even by his countrymen. Yet a competent authority has called him "the father of celestial photography." His photographs of the moon, of stars, and of sun and star spectra were marvels of their day and helped to lay the foundations for modern astrophysics.[231]

Dr. Henry Draper was the son of Dr. John W. Draper, whose connection with the early history of daguerreotyping has already been described. As a boy Henry Draper had acquired considerable skill as an amateur photographer and had aided his father on a number of occasions. In the early sixties he constructed and erected a silvered telescope of fifteen and a half inches aperture, with the

Starved Rock, La Salle County, Illinois, long a picturesque spot and now included in a state park. (Photograph made by John Carbutt of Illinois in the fall of 1864—"1¼ minutes exposure, light very dull, small stop.")

object of applying it to astronomical photography. By its aid he was able to secure a number of photographs of the moon on a far larger scale than any which had been previously attempted. We have mentioned Whipple's daguerreotypes of the moon, made before 1851, but the photographs secured by Draper were of far larger dimensions, some being fifty inches in diameter. They were secured by making a relatively small negative (by the wet process, of course), and then enlarging it. Considerable care was exercised in making the original negative so that it would be capable of producing a sharp image when enlarged. The average exposure required for these photographs was half a second, a speed which is not surprising as Draper condensed the reflection of his 15½" mirror (nearly 188 square inches) directly on to the negative some few inches square. The brilliancy of the moon's radiation was so great with this telescope that it "impaired vision, and for a long time the exposed eye failed to distinguish any moderately illuminated object," if an observer were unwary enough to view the moon with his eye.

Needless to say, these photographs, which were made in 1863, created considerable popular interest, both at home and abroad. *Harper's Weekly* reproduced one of them in a double page print, and the scientific savants of Europe were duly impressed by them. The prints were used abroad in rectifying the names given to the lunar mountains.

While Rutherford's and Draper's photographs of the moon were important in their day, it must be stated that the great advances in astronomical photography did not come until after the advent of the gelatin dry plate, and again Draper was one of the first to adapt this medium to record such phenomena as the sun and stellar spectra—records upon which the modern science of astronomy is largely based.[232]

Photography was finding its uses in professions other than science during this period. Various government bureaus adopted its use, notably the Patent Office, which, in 1860, began using it to reproduce drawings. The magnitude of its use here can be imagined from the fact that Isaac Rehn of Philadelphia (he who had been associated

with Cutting in the early beginnings of the ambrotype) was awarded a yearly contract with the Patent Office calling for $50,000 for his photographic services and materials. *233

Two other ventures connected with this period deserve mention. One of these was the attempt to use burning magnesium as a source of light for taking photographs. Rather than magnesium powder found in the familiar flash powders of the present (now being replaced, however, with flash "bulbs"), the early experimenters utilized burning magnesium wire. The experiments with this material were made largely by amateurs, Dr. John Towler of *Silver Sunbeam* fame being one of the most prominent.234

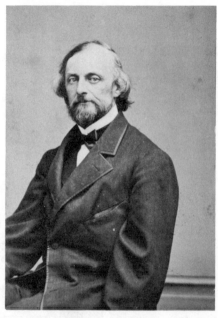

Lewis M. Rutherford (from a photograph made in 1862 by C. D. Fredricks).

The other venture is mentioned to illustrate how extremely difficult it is to do anything "new." Possibly many readers have seen advertisements in recent years: "Have your photograph taken the modern Photoreflex way. See yourself as you take your picture." This idea, that of having the sitter view himself in a mirror as he sat for his photograph, was suggested and employed many years ago. The suggestion appears, for instance, in the *Scientific American* for March 22, 1862, in a letter from a correspondent, Edward L. Porter. Porter stated that the sitter viewing himself in the mirror was "enabled at once to assume and retain his ordinary expression of countenance, or take any other that best pleases himself." Practical operators, in trying out Porter's suggestion, condemned it as it failed to

* Edward Everett, the well-known orator and statesman, was one of the first to suggest a somewhat similar, and important, use of photography. In a letter dated Feb. 6, 1864, to the *Philadelphia Photographer* he recommends the use of photography for copying manuscripts in facsimile, a practice which he himself had employed. He also mentions the possibility of using photography in the comparisons of handwriting and the detection of forgery.

An early attempt at magnesium light photography in this country. The men in the group are Edward L. Wilson (standing), editor of the *Philadelphia Photographer*, and the Reverend H. J. Morton, an enthusiastic amateur photographer. The names of the women are not known. (Photograph made in Philadelphia, Oct. 26, 1865, by J. C. Browne; exposure, twenty seconds with a one-inch stop using five magnesium tapers.

produce the ordinary countenance desired, but instead "a perfect and comical caricature." [235] Again it must be remembered that modern materials are somewhat more favorable to the method. The sitter does not have as long to wait for the record to be made, so that self-consciousness does not have quite as long to develop. Possibly, too, human beings have become somewhat more habituated to having their likenesses recorded, and are not as likely to become self-conscious as they did when the art was young.

Real Amateurs

IN THE DAYS of the daguerreotype, at least after the rise of the professional school, there were but few amateur photographers. It is safe to say that the majority of the earliest amateurs were teachers of science in the schools and colleges of the country, or the students of such teachers. Most of these individuals were interested in photography mainly as a scientific curiosity. Many of them, it should be added, used the process of Talbot rather than that of Daguerre for, on the whole, it was somewhat cheaper and more convenient to use.

The introduction of the collodion process and the growing popular interest in the stereograph were responsible for the first real interest and growth of the amateur ranks. Americans probably followed the lead of English amateurs, who, for the first fifteen years of photography at least, were far more active than were Americans. The rising interest in stereographs over the country, accelerated no doubt by Holmes's first and second essays, caused a considerable and extended growth in the amateur ranks during the period from 1858 to 1864. This growth would doubtless have been very materially augmented but for the Civil War. Photographic societies were formed during this period in all the larger cities of the country— the societies including in their membership not only amateurs, but professionals as well. In fact, professionals found it to their advantage to make the acquaintance of the amateurs, as they were frequently requested to give paid instruction in the art of photography to beginners.

The amateurs in these societies took their labors quite seriously —regular meetings were held, usually monthly, their difficulties discussed at length, suggestions made for improvement, and tests and experiments planned. In fact, it can be said that for many years these organizations were largely responsible for any growth in the art. Professionals, by themselves, had made feeble attempts to organize, but

[204]

they were not generally successful until 1869, when the National Photographic Association was formed—the first of the national organizations.

In 1864, the Philadelphia Society established its own publication, the *Philadelphia Photographer,* with Edward L. Wilson as editor. Through the efforts of Wilson this journal achieved an outstanding place in the photographic literature of the times. For many years it was the foremost publication of its kind in this country, although at the time it was established, it had two well-known competitors, *Humphrey's Journal* and the *American Journal of Photography.* The *American Journal,* however, was absorbed by *Humphrey's Journal* in 1867, but two years later *Humphrey's Journal* itself ceased publication, leaving the *Philadelphia Photographer* the outstanding independent journal.[235a]

During the first half of the sixties, the number of amateurs must have increased greatly, if we may judge by the reports in the photo-

"Upper Falls of Pond Run"—one of the views secured by the Philadelphia trio of amateurs in their trip to Pike County, October, 1863. (The photograph appeared in the *Philadelphia Photographer,* June, 1864.)

Some photographs made by members of the Amateur Photographic Exchange Club in the early sixties. *Left,* "Marie," May 16, 1861. Photograph by Charles Meinerth. *Center,* "A Family Group," September, 1860. Photograph by Robert Shriver, Cumberland, Md. *Right,* "The Wind Gap," July 4, 1862. Photograph by H. T. Anthony, New York City. (I am greatly indebted to Mrs. Horace W. Sellers of Ardmore, Pa., for the use of the above photographs—the originals are all stereographs—as well as for the photographs from which the illustrations of Coleman Sellers and his work were copied.)

graphic magazines. The minutes of the meetings of several of the societies were published, and in addition, amateurs were constantly writing up their photographic experiences in sketches which found a ready publication. Almost invariably the efforts of the amateurs were confined to the production of stereoscopic views, usually landscapes. Professional work had been very largely confined to portrait work, although the work of Robinson and Rejlander was well known and much admired in America; but it remained for the amateur to begin work in this direction in this country.

It is surprising, when one recalls the difficulties of the collodion process, that amateurs in any number were attracted to its practices. The amateur had to prepare his iodized collodion, flow it on the plate, allow the film thus formed to "set," bathe it in the silver sensitizing solution, and then expose and develop it while it was still damp. Photographic trips and excursions to remote and picturesque scenes were favorite pastimes of these early amateurs, but such trips added still another difficulty for the dark room, of necessity, had to be carried with them.

It was here that the ingenuity of the amateur could really be used, and strange and fearful looking must have been some of the dark shelters devised. The most usual form was some form of tent, which comprised a laboratory in small compass. The "tent" was mounted on a tripod, similar to the camera tripod, so that, with comparative ease, it could be dismounted, folded up, and transported to a new location. Some amateurs, in similar fashion, fitted up wheelbarrows or two-wheel push carts which could be trundled over the country; while still others mounted their dark-room tents on wagon beds which could be horse-drawn. Even at best, these devices were burdensome, and presented a real handicap to the amateur. In the summer they were exceedingly hot to work in. In the winter they offered but little shelter from the cold. Patching was frequently required to exclude strong light. One amateur complained that he had to throw his overcoat over his tent, not to keep warmer, but because the dark tent wasn't dark enough.

During the late fifties and early sixties, amateurs in considerable number began "practicing"—in fact, amateur photography became quite fashionable. It was recommended by a popular journal to

[207]

MEMOIR.

Jamin Jules.

view arrangement!

3/8' — opening)

wet — collodion)

20 " — exposure)

Col. Gosline's Regiment —
Fire Zouaves

Sep 26 –1861—

No.

Photographed by
COLEMAN SELLERS.

AMATEUR PHOTOGRAPHIC EXCHANGE CLUB.

The Wind-gap
Fig. Island.

Negative *Loud: milk fores:*

Print

By *J. V. I. Anthony*

No. 9. July 24 '6.2

Labels used by members of the Amateur Photographic Exchange Club. That of Anthony was on the reverse side of the photograph shown on page 206, that of Sellers on the upper photograph shown on page 214.

young people and to ladies. The editor of the journal enthusiastically told his public that photography "is by no means as difficult or laborious as ordinary needle work." [236] With such urging, many began the practice, and photographers reaped something of a harvest, hurrying from house to house giving instruction in the art. It is easy to see why this fad did not last long, when the difficulties of the process are considered. In addition, the society lady must have looked with consider-

able disfavor upon the sticky collodion, and with still greater dismay at the dark stains produced on lily-white hands when they came in contact with the silver bath. Of course, rubber gloves were advised, but this minor detail was oftentimes overlooked.

The field was soon left to hardier souls, the real enthusiasts, to whom these difficulties served but as an added incentive for their labors. But even among this hardened gentry existed a desire for freedom from the shackles of the wet plate and the dark tent, and it is no wonder that any mention of a *dry* process was hailed with delight and given an immediate trial.

A number of dry processes were introduced and tried by these amateurs. In effect they were all modifications of the wet collodion process, as we have already described it—the principle involved in the modification being to add some substance to the collodion which insured sensitivity when dry or to add some hygroscopic substance which would prevent the sensitized collodion film from drying out. If we wished to be quite technical in the matter, we should really distinguish between a moist process and a truly dry one, but for our purposes such a classification is not necessary. Most of the modifications in devising a dry process were due to English amateurs, and the substances which were suggested to be added to obtain a sensitive, dry, or moist collodion plate were almost legion. Among these were tannin, albumen, gelatin, sugar, milk, honey, glycerine, magnesium nitrate, orange juice, beer (beer, of all things, in a *dry* process!) and resin, to mention those substances which received more elaborate trial than a multitude of others.

Of these, by far the most popular, at least among American amateurs, was the tannin process. It was devised by an Englishman, Major Charles Russell, and an account of it first published in 1861. In many respects it was similar to the ordinary collodion process, save that after sensitization in the silver solution, the negative plate was bathed in a dilute alcoholic solution of tannic acid and then dried in the dark. The tannic acid bath had a tendency to make the collodion film break loose from the glass support of the negative around the edges, and to get around this difficulty, several procedures were used. One of these was to edge the plate (that is, prepare

a small border around the collodion film) with gelatin or gutta percha.

Such plates could be stored in the dark for long periods (I have found mention of six weeks, or longer) and still retain their sensitivity. It was necessary to develop them quite soon after exposure. The *Silver Sunbeam* cautions the amateur—"It is advisable not to postpone the development long after the exposure; during the evening of the day on which the pictures were taken, is, in all respects, an appropriate time for the development, and although in many instances this operation can be put off, it is not advisable."

As can be seen, such negatives were a boon to the amateur in that they freed him from the necessity of carrying the dark room with him, for he could prepare a number of such plates at home, and, if he had enough plate holders, carry quite a stock with him on his excursions. The big drawback to their use was the fact that they were extremely slow, at least five times as slow as the wet plate, and exposures of five minutes were not at all uncommon on a cloudy day.[237] It is obvious that the process could be used only for landscape work, including no moving figures, and that on a comparatively still day.

Because of this defect, not all amateurs used the tannin dry plates, and many printed pages can be found in the photographic journals of the sixties, in which "wets" and "drys" advocated the relative merits of their processes with vigor and oftentimes with considerable heat.

The photographic excursions made by the amateurs in search of "views" must have been pleasant, if arduous. Frequently a number would go together, not just for a day, but for several days, or a week at a time. By using different processes and different equipment, it was possible to obtain considerable information which was promptly published, and was thereby of help to all who read.

The following contemporary account relates some of the difficulties which the amateur of wet-plate days encountered. It is entitled "A Trip to Pike County, Pennsylvania," and records the experiences of a trio of Philadelphians: [238]

"On a fine October morning, three amateur photographers left the city of Philadelphia, to repeat an excursion taken in the spring [of 1863],

with the same object and a determination to meet with better success. On their return in the spring, they had attempted to describe to their friends a district in the State but little known, quite accessible, and abounding with attractions to the lover of nature. A good stock of apparently spotless tannic plates had been exposed, which only needed careful development to be brought out 'fine.' However, after attempts made by each separately, the plates failed to yield much, even to the most powerful known agencies, and in some cases which had been exposed over half an hour, after being 'coaxed' with fuming, alkaline development, etc., gave merely the high lights. Having failed to discover the cause of such insensibility, it was unanimously carried that the wet process alone should be trusted in the next attempt, and we now propose to narrate our success, explain its causes, and induce our brother photographers to complete the series we began.

"An ordinary spacious tent, made of four bamboo corner sticks, connected together and composed of white calico outside, yellow inside, with black canton flannel 'sandwiched' between the two, proved, with a very compact camp-stool, most comfortable. A sheet of India rubber, connected in the centre with a hose, carrying the waste outside of the tent and forming a spacious sink, by being suspended at four corners to loops fastened in the tent, prevented splashing, and was quite an acquisition, with very little additional trouble and weight. The chemicals were all contained in one box, made on purpose. The stock was ample. Two rows of bottles were in the box, the upper row within reach as soon as the lid was opened, the lower contained in a drawer. The bath rested on the lid of the opened box, which was propped by a stick to insure firmness, and the drawer being pulled out, every article within the box was within reach without being taken out of its proper place,—a convenience easily appreciated by anyone who has worked in the field. We will not attempt to state all that the box contained; it would be easier to enumerate what it did not contain, which the most fastidious photographer would require in his laboratory, not excepting bath for whole size plate, collodion filter,—bottle, pneumatic holder, several collodions, etc., etc.; but in order not to alarm anyone who might feel that it attained the dimensions of the trunk of a fashionable lady going to a watering-place, we will simply add that its outside dimensions were 9 x 10 x 13 inches.

"The chemical box was easily carried in the hand. In the tent were strapped the stool, the sink, a rope, and a hatchet, the last two additions to a photographer's baggage being very useful in such a district. The cameras (three in number) and a tripod were strapped on the back by a Baxter supporter, the great superiority of which over the ordinary

[211]

soldier's knapsack straps, we can speak of in the highest terms, from former sore back experience."

It took them one day to reach their destination, but on the next day, a bright one, their work began in earnest and they attempted to secure some views of many picturesque waterfalls in "Pike County," after having secured the services of a local guide and his team to aid in transporting their equipment.

"We reached with the carriage within about one hundred yards of a series of waterfalls, following each other in rapid succession. We found the rocks on the banks of the stream worn out by the action of the water, standing, in many places, almost perpendicularly and for a considerable height, over the creek and the falls, so close together, and making such abrupt turns, that one only, and not the highest, could be photographed. We were confined to a rock but a few feet square for pitching our tent and working. The rope, by being tied to a tree, and held as we progressed to the foot of the falls, carrying our traps, proved, as it did in several instances afterwards, a great auxiliary."

Even under these conditions, experiments were made to determine the best proportions of ingredients in their collodion, and in the developer used. Their exposures ranged from twenty seconds to two minutes, depending upon the lens used. The next two days, the most suitable formulas for their baths having been settled by the first day's efforts, their picture making continued. But these days were cloudy and exposures from two to six minutes were required.

"We also began to think that our long exposures with dry plates in the spring were not, after all, so much out of the way, and very likely had been too short in most instances, since six minutes were required with a bath and collodion working remarkably quick, for ordinary open views.

"A short distance up the creek there is a third fall, not so high as the lower two, but quite peculiar, and in a dark corner, where the sun never penetrates. We came to the conclusion that no wet plate would remain wet long enough to give us sufficient exposure, and that it should be intrusted to the dry process. This would have necessitated the loss of several days, and it was proposed that we should wait until the railroad in contemplation, connecting the Belvidere Railroad with that valley, should be made, so that a dry plate might be exposed and left there,

when we could return to the city, attend to other occupations, and go back after one week or a fortnight."

Evidently their experiences with dry plates were not all that they desired. They must have been "dyed-in-the-wool" enthusiasts, however, for they continued work for seven days altogether, until their glass and collodion were exhausted—after which they repaired to the village of Milford to await the daily train for their return. In waiting, they whiled their time away "by practicing on what is called in Milford a French billiard-table, the peculiarity of which is, that it is almost impossible for a large ball to pass within six inches of what appears to be a very small pocket, without falling into it." So they had interests in life other than their photographic ones.

The illustration on page 205 is a reproduction of one of the efforts of these amateurs and shows the character of the country in which they were working. Even with modern materials, considerable exposures would be required to obtain satisfactory negatives.

One interesting outgrowth of the work of these amateurs of the sixties was the formation of an exchange club, "The American Photographic Exchange Club," the membership of which comprised nearly all the successful amateurs (and amateurs only) in the country, according to a contemporary. It was formed in 1861 with the object of the exchange of photographic prints among its members. One of the requirements of membership was that "every member shall forward each other member on or before the 15th of January, March, May, July, September, and November, at least one stereoscopic print, a copy of which has not been sent before, mounted and finished." [239]

Holmes was an honorary member of this club, for in "The Doings of the Sunbeam" he refers to the practice of exchange and the friendships this produced. He writes:

"A photographic-intimacy between two persons who never saw each other's faces (that is, in nature's original positive, the principal use of which, after all, is to furnish negatives from which portraits may be taken) is a new form of friendship. After an introduction by means of a few views of scenery or other impersonal objects, with a letter or two of impersonal exploration, the artist sends his own presentment, not in the stiff shape of a purchased *carte de visite,* but as seen in his own study

[213]

Left, Colonel Goslin's Regiment, Sept. 26, 1861. *Right,* Rembrandt Peale and his wife with one of Peale's famous paintings of Washington. Peale was Sellers' uncle, and was at the time of the photograph the only surviving artist who had painted Washington from life. Photograph probably made in 1859. *Center,* Mill Bank, the Sellers family home. Photograph made about 1861. It was apparently of this photograph that Holmes wrote (*Atlantic,* 1863) "an old homestead—caught in one of nature's loving moments, with the sunshine gilding it like the light of his own memory." (Photographs made by Coleman Sellers.)

or parlor, surrounded by the domestic accidents which so add to the individuality of the student or the artist. You see him at his desk or table with his books and stereoscopes around him; you notice the lamp by which he reads,—the objects lying about; you guess his condition, whether married or single; you divine his tastes, apart from that which he has in common with yourself,—and so these shadows have made him with his outer and his inner life a reality for you; and but for his voice, which you have never heard, you know him better than hundreds who

[214]

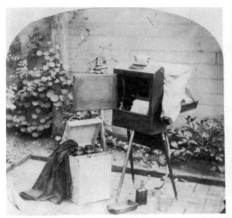

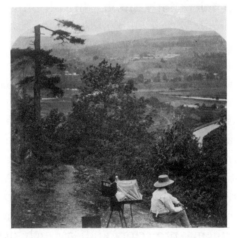

Left, Dark tent and stereoscopic camera (in case). *Right,* Packed up and ready to go. *Center,* The equipment in use on a trip in the country near Mill Bank. (All photographs made by Coleman Sellers, 1860 or 1861.)

call him by name, as they meet him year after year, and reckon him among their familiar acquaintances." [240]

Holmes mentions, by name, two of his distant "exchanges," Coleman Sellers of Philadelphia and S. Wager Hull of New York. Incidentally these two had lengthy passages at arms through the columns of the press, on the relative merits of the wet and dry processes, Hull being an ardent advocate of the dry process and Sellers of a modified wet process. In addition to Holmes, Hull, and Sellers, other prominent amateurs were Lewis M. Rutherford, who has been previously

[215]

mentioned, H. T. Anthony of the firm E. and H. T. Anthony, and August Wetmore, Jr., all residents of New York City. In Philadelphia were Sellers, Professor Fairman Rogers, Constant Guillo, and several others. Outside these cities Titian R. Peale of Washington, Professor Emerson of Troy, New York, and Robert Shriner of Cumberland, Maryland, were especially prominent.

But of these, none was more active than Coleman Sellers. I believe, in fact, that he was the most energetic amateur of his day. Not only did he spend considerable time and money in the actual practice of the art, but he was a prolific correspondent of the photographic journals. All three of the American journals of photography contain numerous articles from his pen, and, in addition, he was the American correspondent for a similar British publication. The first volume of the *Philadelphia Photographer,* which appeared in 1864, contains ten contributions of Sellers, some of considerable length; and a similar number appeared in the *American Journal of Photography* in the two volumes published between 1861 and 1863. These articles deal with a variety of photographic topics; merits of the wet process, methods of exchanging prints, advice to amateurs, photography as an art, methods of photographing machinery—are all treated at greater or less length.

But the outstanding contribution of Sellers to American photography was the invention of a device for exhibiting stereoscopic pictures of moving objects. This, in a crude fashion, was the forerunner of the modern cinema projector, and, as such deserves extended consideration.*

* Coleman Sellers, a grandson of Charles Wilson Peale, the celebrated artist, was born in Philadelphia in 1827. While the name of Peale is probably at present the best known among those of his progenitors, the family from which he descended was, for many generations, of marked artistic and mechanical aptitude. Sellers' early scholastic training was not extensive, ceasing when he was graduated from Balmar's Academy in West Chester, Pennsylvania, but as he was of an inquiring and studious turn of mind, he continued his own training, especially in mechanical and scientific methods and principles. He entered the employ of a rolling mill in Cincinnati when nineteen, and for the next ten years was a close student and worker in this industry. Before he was twenty-one he was manager and superintendent of the Globe Rolling Mills, and later he was foreman of a locomotive works in the same Ohio town.

In 1856, he was offered the position of head of the drafting room and chief engineer of William Sellers and Co. of Philadelphia (William Sellers was a cousin of Coleman Sellers, and a large manufacturer of machinery), a position which he held for over thirty years. The crowning achievement of his career, however, was in the development of hydroelectric power at Niagara Falls. Work toward this end was initially begun by Sellers in 1889; he later became chief engineer of the Cataract Construction Company and president of the Niagara Falls Power Company, pioneers in this field of endeavor. For five years he was president of the Franklin Institute of Philadelphia, professor of Engineering Practice at

Sellers' interest in photography, first aroused in 1858, was suggested by the thought that photographs of machinery might be employed for advertising purposes. Professional photographers were called in to try their hand, but their efforts were uniformly unsuccessful, doubtless because the lenses employed were of short focal length, and used with large aperture, which resulted either in badly distorted pictures, or in pictures which lacked sufficient depth of focus. As a result of these failures, Sellers resolved to learn the practice, and hired a professional to teach him what he knew about photography.

He soon acquired considerable skill, and had a dark room prepared as part of the drafting room equipment of William Sellers and Company, with whom he was then associated. By using the "globe" lens devised by C. C. Harrison, the foremost American lens maker of the period, he was able to obtain really remarkable photographs of machinery, which were used extensively in advertising. Usually

Coleman Sellers, 1860. While apparently posed in a photograph gallery, it was a self-made portrait as is the one opposite.

Sellers at home. Very probably the one that he sent to Holmes, and that Holmes mentioned in the *Atlantic* article.

these were stereographic views, as the stereoscopic effect added considerably to the attractiveness of such pictures. So successful were Sellers' efforts that the Baldwin Locomotive Works asked his aid in preparing similar photographs of their huge wares.

Stevens Institute of Technology, a lecturer on mechanics, the holder of nearly thirty patents, an expert magician, and a member of the Seybert Commission to investigate the phenomena of spiritualism.[241]

Sellers became interested in producing the effect of motion by means of photography through an interest in a toy which had been known for many years prior to the time of his invention (1861). This was the phantasmascope, a device which contained a series of *drawn* pictures mounted in a circle on cardboard, and viewed through a series of holes corresponding in number to the pictures. When such a device was rotated, the illusion of motion was imperfectly produced, the greatest defect being a blurring of the picture and difficulty in seeing any great detail in the picture. After considerable experimentation, Sellers discovered an important principle in producing the illusion of motion with any degree of perfection, one which is used in the modern moving picture camera and projector. This was the fact that it is "absolutely necessary that the pictures should be entirely at rest during the moment of vision, or that motion should be in a direction of the line of vision, that is, advancing toward the eye, or receding from it." This, of course, is not the basic principle upon which all such illusion is based, known long before the time of Sellers; namely, that it is necessary to view a series of pictures with sufficient rapidity to insure that the image of one picture is retained by the retina until the next one is brought into view. Sellers' important contribution to this field was in recognizing the secondary principle (stated in quotation marks above) and in applying photography to this purpose.

The particular method which Sellers employed was to photograph a series of posed pictures (posed, because long exposure was necessary), and then mount the finished prints (stereographs) in a device patented by Sellers on February 5, 1861, and called by him a "kinematoscope," a word which, as Sellers said, was intended to convey the idea of "I see motion." [242]

The kinematoscope, as can be seen from the accompanying illustrations, consisted of a series of rotatable blades, each blade bearing a stereograph, which was viewed through an ordinary stereoscope built on the instrument. The blades were encircled by a band of metal (the band rotating with the blades) which would have shut off all view of the pictures save for the fact that two adjacent slits close to each blade were cut through the band. "It is through these slits that the pictures are to be seen in succession, and that as they

[218]

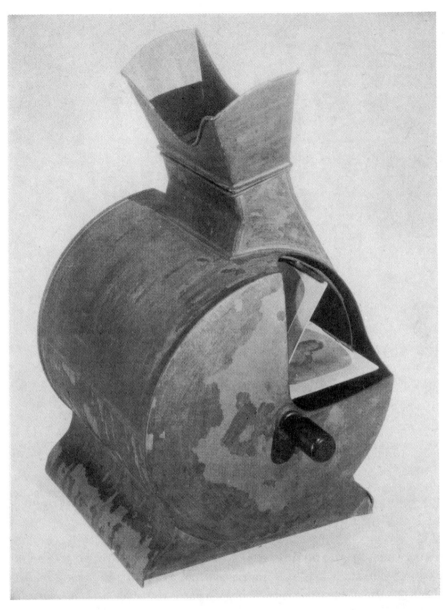

Sellers' original kinematoscope (courtesy Franklin Institute of Philadelphia, present owner of the instrument).

advance toward or recede from the eye in the direction of the line of vision, and within the range of the focus of the prisms. This form of instrument has a great advantage in keeping the picture in view for

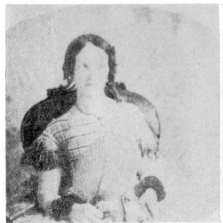

The stereographs (half only shown) in Sellers' kinematoscope showing the three photographs necessary. The subject is Mrs. Coleman Sellers, and they were taken about 1861.
(Courtesy Franklin Institute.)

a long time, for the picture cannot be seen entirely through these slits except when the wheel is in motion, when as the slit is passing before the eye, the picture is advancing toward the eye, and its various parts are seen in succession, and yet it seems to be quite at rest," the patent itself states.

The number of stereographs necessary to produce the illusion of motion depended upon the type of motion to be depicted. Motion was classified by Sellers as being either reciprocating or rotary in character. Reciprocating motion includes the simpler types, such

[220]

operations as "pounding" or "sawing," which exhibit two extreme positions. In this type of motion it was necessary to make three pictures, one of each extreme and the other of a position halfway between. For instance, the best known of Sellers' pictures portrayed a man pounding a nail. Three stereographs were posed and made, one with the hammer at the end of its upswing, another as it came in contact with the nail, and the third when the hammer was halfway between these two positions. Two prints of each picture were made, since the backward and forward motions were necessary, and were represented by identical photographs. The six stereographs were then placed in the kinematoscope, one on each blade in the proper order,* and were viewed through the stereoscopic hood, the blades being rotated.

The observer saw the man pounding the nail, the arm and hammer rising and descending on the nail. It should be noted that this mode of observation produced the sensation not only of motion, but of stereoscopic relief. As Sellers said, what he aimed to accomplish was to exhibit stereoscopic pictures so as to make them represent objects in motion, "adding to the wonders of that marvelous invention the stereoscope a semblance of life that can only come from motion."

The second type of motion referred to by Sellers (rotary, or that in which no two positions are the same until the completion of the series) required at least six different pictures to produce the desired effect in the kinematoscope, and some types of motion required even more. In such instances, Sellers recommended a change in the type of the device, an important modification being the use of a series of the stereographs on an endless chain. Doubtless this constituted the first moving picture reel.

As can be seen, in no case could very elaborate effects be produced, so that actually the kinematoscope was not a great improvement in this direction over the older phantasmoscope, save that the pictures were photographic and could be seen in better detail. It is difficult at this late date to determine how extensively Sellers' kinematoscope was employed. It is mentioned several times in the con-

* The two pictures of each extreme position were placed on successive blades to produce a pause at each end of the stroke.

temporary press,—Holmes, for instance, refers to it briefly in discussing stereographs:

"As to motion, though of course it is not present in stereoscopic pictures, except in those toy-contrivances, which have been lately introduced, yet it is wonderful to see how nearly the effect of motion is produced by the slight difference of light on the water or on the leaves of trees, as seen by the two eyes in the double-picture." [243]

D. Appleton and Co., the New York publishers, who were among the earliest to push sales of card and stereographic photographs, were interested in the Sellers instrument and introduced a form of it on the market which they called the "motoscope." [244]

At best the kinematoscope, or motoscope, could not have attained more than the position of a passing fad. Its chief interest at present is the fact that it eventually led to the moving picture projector; and to Sellers should go his due share of credit for originating and studying this important problem.

In addition to the kinematoscope, Sellers patented many other devices in the photographic field, all of which are essentially improvements in mechanisms used by the photographer.

The Amateur Photographic Exchange Club to which Sellers and his friends belonged was most active from 1861 to 1863. War called several of its members, including its secretary, and interest waned during the pressing anxieties of the day. Holmes reflected the times when he wrote Sellers on July 6, 1862, "I know you will excuse my negligence when I tell you that I have neglected almost everything in the tremulous interest with which I have followed the fortunes of the army before Richmond, in which my first-born is serving as Captain. It has been almost impossible for me to think of anything except what is going on there. . . . If it were not for this war, I should begin selecting my photographic apparatus tomorrow." [245]

Civil War Photographers

OVER SEVENTY YEARS have passed since the war between the states came to a close and yet there remains a more extensive and vivid pictorial record of this heartbreaking struggle than of any other major conflict of modern times up to the World War. Many of the photographic records of the Civil War have been reproduced in the monumental ten-volume *Photographic History of the Civil War;* the reader, by turning its pages, can look into the very faces of countless young men who took part in the struggle, can view the scenes of conflict and carnage, and can look upon "Yank" or "Reb" in the routine of his daily life during his non-sanguinary moments. The importance of this record has been attested by the army, by men of prominence in the affairs of the nation, and by historians many, many times. But through some curious indifference very little attention has been paid to those who actually made these important historical records. True, a few pages of the *History* are given over to real photographic history and Brady and Gardner are mentioned, but at no place is any special effort made to give the actual photographer of each scene his due.[246]

Now, after three quarters of a century, actual facts bearing upon this phase of history are becoming more and more difficult to find. An extended search for such information has brought the names of some of these forgotten historians to light.

It is difficult at this late date to determine to whom credit should go for originating the idea of recording photographically the Civil War scenes. It should be pointed out that prior to the war between the states, photography had been employed for the purpose of recording war and its ravages.

The earliest photographic records of war now known are some four or five daguerreotypes made during the Mexican War (1846-1848). These daguerreotypes are now in the possession of Mr. H.

Armour Smith of the Yonkers (New York) Museum of Science and Art. From the little definite information that exists concerning them, it is probable that they were made by a local daguerreotypist in the town of Saltillo, Mexico. Although interesting, they are not of great significance from the standpoint of the portraiture of war as they were so few in number as to be scarcely known. For this reason, their example doubtless played little part in influencing photographers subsequent to their day in making similar records. However, it may possibly be that one of them is the first photographic record of a battlefield, that of Buena Vista, which was fought February 23, 1847.[246a]

The Crimean War, too, ending in 1856, had its photographers, who left far more extended records than the few surviving daguerreotypes of the Mexican War. The English armies in India and China were also followed by a "knight of the camera," a Mr. Beato.[247]

From statements in one of Holmes's articles, it is certain that the Franco-Austrian conflict of 1859 also had its photographer, for Holmes describes two stereographic views of this war, one of the battlefield of Magenta, and the other of that at Melegnano.[248]

It will be recalled that Holmes, in his first article published in 1859, had stated that "the next European war will send us stereographs of battles." The possibility of making pictorial records by the camera of war scenes had thus been amply suggested to American photographers.

More definite suggestions than these, however, were made at a regular meeting of the American Photographical Society, held in New York on June 10, 1861, when an extended discussion of the application of photography to military purposes was held. As a result of this discussion, the president of the Society, John W. Draper, appointed a committee to take up the matter with the War Department at Washington. The committee offered its suggestions and services to the Department, but, as may well be imagined, the Secretary of War had far more serious business on hand than reading the letters of amateur photographers, for President Draper reported three months later to the Society—"Little progress has been made in the matter owing to the extraordinary preoccupation of the Department."[249]

Although the efforts of the Society were unsuccessful, it may have

Mexican War daguerreotype: General Wool and Staff, Saltillo, winter 1846-47. (From the personal collection of H. Armour Smith, Yonkers, N. Y.)

called the topic more directly to the minds of professional photographers, for we find definite record of the fact that at least two photographers were present at the first major engagement of the Civil War, that at Bull Run, Virginia, on July 21, 1861.

One of these was Brady—the second one I do not know. If one stops to reflect for a moment, it seems curious that Brady, the fashionable photographer, of all men, should attempt such an undertaking. The reasons for Brady's decision to photograph war scenes I have discussed at length elsewhere, but it can be pointed out here that it was a logical decision, when it is recalled that Brady had early in his professional career regarded himself as the pictorial historian of his times.[250] As Brady himself stated, "I felt that I had to go. A spirit in my feet said 'go,' and I went." He encountered considerable difficulty in obtaining permission to get to the front, for

[225]

Brady and most of the other photographers of war scenes had no official connection with the Army. Brady's own story of the initial venture in this direction is extremely interesting, and reveals one of the reasons why he had so many friends. Brady says:

"I had long known General Scott, and in the days before the war, it was the considerate thing to buy wild ducks at the steamboat crossing of the Susquehanna, and take them to your choice friends, and I often took Scott, in New York, his favorite ducks. I made to him my suggestion in 1861. He told me, to my astonishment, that he was not to remain in command. Said he to me, 'Mr. Brady, no person but my aide, Schuyler Hamilton, knows what I am to say to you. General McDowell will succeed me tomorrow. You will have difficulty, but he and Col. Whipple are the persons for you to see.' I did have trouble; many objections were raised. However, I went to the first battle of Bull Run with two wagons from Washington. My personal companions were Dick McCormic, then a newspaper writer, Ned Hause, and Al Waud, the sketch artist. We stayed all night at Centreville; we got as far as Blackburne's Ford; we made pictures and expected to be in Richmond next day, but it was not so, and so our apparatus was a good deal damaged on the way back to Washington; yet we reached the city." [251]

Brady gave this account some thirty years after the events described had taken place, but there are two contemporary accounts of the first conflict, which substantiate Brady in general, and in themselves are amusing accounts of the aftermath of the battle.

The first of these appeared in the *American Journal of Photography* for August 1, 1861:

"The irrepressible photographer, like the warhorse, snuffs the battle from afar. We have heard of two photographic parties in the rear of the Federal army, on its advance into Virginia. One of these got so far as the smoke of Bull's Run, and was aiming the never-failing tube at friends and foes alike, when with the rest of our Grand Army they were completely routed and took to their heels, leaving their photographic accoutrements on the ground, which the rebels, no doubt, pounced upon as trophies of victory. Perhaps they considered the camera an infernal machine. The soldiers live to fight another day, our special friends to make again their photographs.

"The other party, stopping at Fairfax, were quite successful. We have before us their fine stereo-view of the famed Fairfax Court House.

"When will photographers have another chance in Virginia?" [252]

M. B. Brady in middle age (photograph by L. C. Handy, 1875; courtesy L. C. Handy Studio, Washington).

Brady was the one who, with the Union Army, was completely routed, but his loss was not as severe as this account would lead us to believe. He managed to stick to the wagons bearing his equipment, together with some exposed negatives, but as we have seen above he had to ruefully admit, "Our apparatus was a good deal

damaged on the way back to Washington, yet we reached the city."

His account is better corroborated by the note in *Humphrey's Journal* than it is in the record of the *American Journal:* [253]

"The public is indebted to Brady, of Broadway, for numerous excellent views of 'grim-visaged war.' He has been in Virginia with his camera, and many and spirited are the pictures he has taken. His are the only reliable records at Bull's Run. The correspondents of the Rebel newspapers are sheer falsifiers; the correspondents of the Northern journals are not to be depended upon, and the correspondents of the English press are altogether worse than either; but Brady never misrepresents. He is to the campaigns of the republic what Vandermeulen was to the wars of Louis XIV. His pictures, though perhaps not as lasting as the battle pieces on the pyramids, will not the less immortalize those introduced in them.

"Brady has shown more pluck than many of the officers and soldiers who were in the fight. He went—not exactly like the 'Sixty-ninth,' stripped to the pants—but with his sleeves tucked up and his big camera directed upon every point of interest on the field. Some pretend, indeed, that it was the mysterious and formidable looking instrument that produced the panic! The runaways, it is said, mistook it for the great steam gun discharging 500 balls a minute, and immediately took to their heels when they got within its focus! However this may be, it is certain that they did not get away from Brady as easily as they did from the enemy. He has fixed the cowards beyond the possibility of a doubt.

"Foremost among them the observer will perhaps notice the well-known correspondent of the London *Times;* the man who was celebrated for writing graphic letters when there was nobody by to contradict him, but who has proved, by his correspondence from this country, that but little confidence can be placed in his accounts. See him as he flies for dear life, with his notes sticking out of his pockets, spurring his wretched-looking steed, his hat gone, and himself the picture of abject despair.

"But, joking aside, this collection is the most curious and interesting we have ever seen. The groupings of entire regiments and divisions, within a space of a couple of feet square, present some of the most curious effects as yet produced in photography. Considering the circumstances under which they were taken, amidst the excitement, the rapid movements, and the smoke of the battlefield, there is nothing to compare with them in their powerful contrasts of light and shade."

Brady realized, as the scale of wartime operations developed, that he himself would be able to record only a small fraction of the war

scenes. In order to meet this difficulty he employed a number of photographers, equipped them, and sent them out to the various fronts. "I had men in all parts of the army," said Brady, "like a rich newspaper." At one time he is said to have had a staff of twenty men thus employed. Supporting and paying this staff in the field was an expensive undertaking, as may be well imagined, and Brady estimated that it cost him well over a hundred thousand dollars.

This fact is important when one considers that Civil War photographs are almost invariably credited to Brady. Brady deserves due credit, for it was his idea and his money that financed the venture, but the actual work of photographing the War was carried out by many others as well as by Brady himself. This does not mean that he took no actual war scenes after the disaster at Bull Run, for he did. He was on the field at Antietam in 1862; he was present at Gettysburg in 1863 a few hours after that conflict was over and was busy with his camera; at Fredericksburg in 1862 and at Petersburg in 1864 he was present during the actual conflicts and was under fire; he was also a frequent

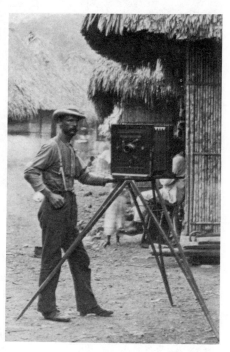

T. H. O'Sullivan—a self-made photograph made on the Isthmus of Panama, 1870.

visitor to the front during the comparatively quiet interludes between the actual conflicts. All of these were places, however, not far removed from Washington, which he used as headquarters and where much of his time must have been spent directing the work of his extensive staff in the field and the operations of his two very fashionable galleries in New York and Washington.[254]

The facts mentioned above seem worth stating quite clearly, as more than one would-be critic in recent years has discussed at length the artistic merits of many Brady war photographs, which, as a

Gardner's Gallery in Washington, 1865 (courtesy L. C. Handy Studio).

matter of fact, were very probably not made by Brady at all, but by some of his staff. It is all very well to give Brady his just credit, but artistic criticism should be confined to work which is known to come from his hands and his alone. This principle, the would-be critics have ignored completely.

Who, then, were the actual photographers of the Civil War in addition to Brady? The names of some have been found but there are probably others whose names will never be recovered. Included among those who were at some time or other on Brady's staff were Louis H. Landy, his personal assistant, Alexander and James Gardner, David Knox, Wm. R. Pywell, T. H. O'Sullivan, D. B. Woodbury, J. Reekie, J. F. Coonley, T. C. Roche, Samuel C. Chester, a Mr. Wood, a Mr. Gibson, and a Mr. Fowx.[255] In addition, much photographic work was done by operators having army appointments, although the bulk of their work consisted in the preparation of copies of maps and plans; included among these army men were Capt. A. T. Russel, Sam. A. Cooley, and Geo. M. Barnard. The Confederates, too, had their photographers; the more prominent of them

were George F. Cook of Charleston, S. C. (who had had charge of the Brady gallery in 1851), A. D. Lytle of Baton Rouge, Edwards and Mc-Pherson, and Oliver of New Orleans. Not a great deal of information about these men has been found. Some facts are available concerning the Gardners, O'Sullivan, Roche, Russel, and Barnard, but the remainder are known by name alone.

Alexander Gardner was a Scotchman brought to this country by Brady in the fifties upon the introduction of the paper print made from the collodion negative. He was placed in charge of the Washington gallery which Brady opened in 1858. For the next four years he continued in this position, but early in 1863 he opened his own gallery in Washington. During the last years of the war, Alexander Gardner and his son James, familiarly known as "Jim," were employed at the headquarters of the army of

Gardner's first advertisement in the *National Intelligencer,* Washington, May 26, 1863. Previously Gardner had charge of Brady's Washington gallery.

the Potomac in making maps, but they employed their "leisure time" in making many important war scenes. Like Brady, Gardner employed a staff of photographers for the purpose.

In 1866, Gardner published a two-volume work, *Sketch Book of the War,* which was chiefly a collection of 100 photographs (actual photographs, not reproductions) each measuring approximately 7″ x 9″. Each print has a description, and in addition, contains the name of the photographer who actually made the negative, and the date upon which it was taken. The book is one of the most important sources of information that we have on the subject, as from it

[231]

we learn the names of many of the men who actually made the photographs of the Civil War, and were employed by Brady and by Gardner, and whose identity editors of the *Photographic History of the Civil War* made little attempt to determine.

O'Sullivan and Roche had probably the most extensive and varied war experiences of any of this group. They were present on many fronts during actual engagements and were under fire many times. Both deserve far more credit than either has previously received, and both had an important history in the field of American photography after the close of the war, as will be seen later.

Russel's work, which was confined rather largely to the Quartermaster's Department, includes many views of the railway systems

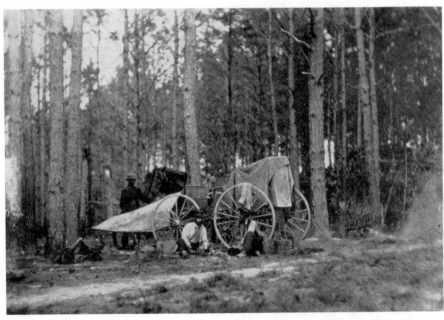

Civil War photographers and their outfit, names unknown (courtesy Signal Corps, U.S.A.).

and devices used by the Union army.[256] Barnard was the official photographer of the chief engineer's office, Division of Mississippi, and was one of the few photographers mentioned in the official records of the Union army. His most important series of war views was made as he accompanied Sherman on his famous march to the sea.[257]

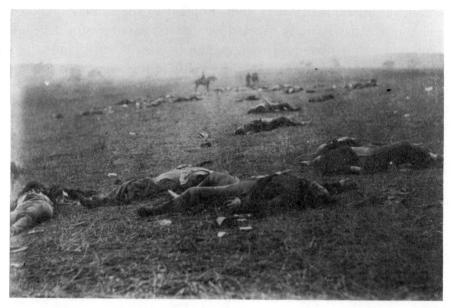
"The Harvest of Death"—the Confederate dead at Gettysburg. (Photograph made in the early morning of July 4, 1863, by T. H. O'Sullivan.)

The Southern photographers worked under a far greater handicap than did their Northern colleagues, however, for their supplies had to be smuggled in from the North. The Anthonys supplied not only Brady and Gardner and their men, but also the Confederate photographers mentioned previously, and probably many others. Of the Confederate photographers, Lytle must have led by far the most exciting and dangerous life, for he engaged in the pastime of photographing the Union forces and fortifications, and forwarded his pictures to Confederate headquarters. What a story he could have told![258]

The life of field photographers who attempted to keep up with armies on the march, and to photograph the scenes of conflict, was as exciting and as full of interest as that of their brother historians, the war correspondents. But the life of the photographer was far more distracting. The war correspondent had only his notebook and his pencil to look after, but the photographer had to carry his dark room and all his supplies—glass, collodion, silver nitrate, developer—with him, for the wet process was the only one yet available to the commercial photographer. His plate had to be flowed with col-

[233]

lodion, sensitized in his dark tent, hurried to the camera, exposed from ten to thirty seconds, hurried back to the dark tent for development, and a new plate prepared. As can be seen by an examination of the prints illustrating the photographic outfits employed during the war, the operators worked in pairs. One in the dark tent—the other manipulating the camera. What a pleasant life it must have been—especially for the man in the dark tent when shot and shell were flying!

The dark tents employed were various modifications of those used by the amateurs whose work we discussed in the previous chapter. The tents were usually mounted on a wagon bed, and horse-drawn. Because of this arrangement, disasters were of more or less frequent occurrence when the horses took fright. Such disasters could only be remedied by a visit to the base of supplies for a new stock.

Several cameras were included in the outfit of a field photographer—large, cumbersome instruments as compared to modern equipment. Always, however, there was a stereoscopic camera, for by far the greatest number of the war views were made on stereographic negatives. Brady and Gardner hoped to finance their ventures by the popular sale of such views—a vain hope in Brady's case. Larger cameras than the stereoscopic ones usually completed the outfit, either those sufficiently large to take whole-plate negatives or to secure 8″ x 10″ views. Some negatives of war scenes were as large as 17″ x 20″ (consider the difficulty in flowing and sensitizing such a plate) but these were doubtless not attempted save at the base camps.[259]

With the slow speed of the photographic materials available to these men, action pictures were virtually out of the question. A record of a bursting shell was regarded as a photographic marvel and was rarely obtained. As a result, the actual conflicts were not photographed, save at some distance, so that the individual figures are scarcely discernible. Occasionally a photograph of a battery firing on command will be found, as the pause between commands made such records possible. The battle scenes, of necessity, were restricted to the events after the actual conflict, when the leaden slugs had found their mark and rendered their subjects sufficiently still for

A portion of the camp and inspection of troops at Cumberland Landing. (Photograph by Wood and Gibson, May, 1862, when the Army of the Potomac was becoming a powerful unit of the Union forces.)

even the slow wet plate to record their images. These photographs, such as the "Harvest of Death" by O'Sullivan reproduced in these pages, were made in considerable number and widely circulated at the time. They brought to the people at home the actual meaning of war in no uncertain language. Holmes, writing in the *Atlantic Monthly* for January, 1863, reveals this fact in commenting on some of the views made by Brady after the Battle of Antietam. Holmes writes with a feeling that can be only partly imagined, for he himself had visited this battlefield only a few hours after the conflict in search of his wounded son, the captain to whom he referred in his letter quoted in the last chapter. "Let him who wishes to know what war is," writes Holmes, "look at this series of illustrations. These wrecks of manhood thrown together in careless heaps or ranged in ghastly rows for burial were alive but yesterday. How dear to their little circles far away most of them!—how little cared

[235]

Battery D, Fifth U.S. Artillery in action at Fredericksburg, Virginia, May, 1863. (Photograph by T. H. O'Sullivan.)

for here by the tired party whose office it is to consign them to earth! An officer, here and there, may be recognized; but for the rest—if enemies, they will be counted, and that is all. . . . It was so nearly like visiting the battlefield to look over these views, that all the emotions excited by the actual sight of the stained and sordid scene, strewed with rags and wrecks, came back to us, and we buried them in the recesses of our cabinet as we would have buried the mutilated remains of the dead they too vividly represented. . . . The sight of these pictures is a commentary on civilization such as the savage might well triumph to show its missionaries." [260]

Although they were not able to photograph the actual conflicts, the Civil War photographers were not unexposed to dangers. As we have said, Brady was under fire on several occasions; O'Sullivan had his camera knocked down by fragments of shells twice; on one occasion his camera-cloth was torn and sand was scattered over his plates, but he stuck to his task and secured his photographs while veteran

"What do I want, John Henry?" Camp life had its compensations, as witness this photograph by Alex Gardner made at Warrenton, Virginia, in November, 1862.

artillerists, who were his companions at the time, wisely took to their bomb-proofs. Roche at Dutch Gap Canal was photographing Confederate works in action with heavy shells bursting around him. A ten-inch shell exploded only a short distance from him, "but nothing daunted and shaking the dust from his head and his camera he quickly moved to the spot and, placing it over the pit made by the explosion, exposed his plate as coolly as if there were no danger, and as if working in a country barnyard." Coonley, commissioned to make photographs of a number of Union bridges, was about his work one day when a body of Confederate cavalry appeared in the ravine below the bridge and opened fire on him; he completed his work unhurriedly, but then made haste to regain the engine and box-car which had been assigned him for his task.[261]

These few stories which have been laid away for over half a century illustrate the fact that the Civil War camera men were intrepid and courageous characters, and, though forgotten, deserve

Another diversion of camp life, a cock fight. Photograph made by David Knox in August, 1864, when the Army of the Potomac was encamped before Petersburg.

their share of credit and glory in the making of these important historical records.

The negatives secured by Brady and his staff have had a long and complex history.[262] After Brady had his staff organized, instructions were given to make all negatives, when possible, in duplicate, and many were made in triplicate. The large outlay Brady had made in securing the Civil War views had been met only in small part by the sale of stereographs. Many were sold during the War but the returns fell far short of realizing Brady's investment. After the War the natural reaction set in; people wanted to forget it as soon as possible, and in consequence, the sale of war views came nearly to a halt. E. and H. T. Anthony and Company was Brady's most important creditor, since the supplies for his men in the field had come almost solely from this house. In order to meet their bill, Brady gave them one set of the negatives acquired at such great cost of time, money, skill, and courage. For some years after the close of the

[238]

War, the Brady stereographs bear the imprint of the Anthonys. The second set of negatives, Brady attempted to dispose of to the highest bidder. In 1869, he prepared a catalogue of war negatives which included, in addition, "portraits of many distinguished men who figured in the early years of the present century; likenesses of all prominent actors in the War with Mexico, and portraits of eminent men and women of the whole country." As can be seen, this collection embraced the principal results of his labors for twenty-five years. Unfortunately for Brady no buyer appeared. Brady attempted to interest Congress and a report of the Library Committee in 1871 recommended the purchase of two thousand portrait negatives, but Congress failed to take action.

When it became clear that no purchaser was interested, Brady stored the valuable collection. In 1873, one of the most serious financial crises in American history occurred, and many men of means were ruined in the resulting panic. Brady, who had invested heavily

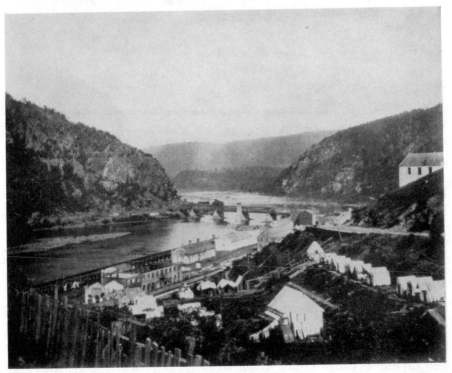

The famous Harpers Ferry at the confluence of the Potomac and Shenandoah rivers.
(Photograph by James Gardner, July, 1865.)

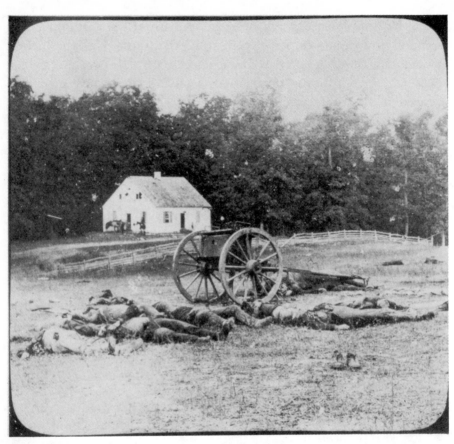

Dunkard Church at Antietam, September 17, 1862. Rebel battery and its remaining defenders. (Photograph by Brady.)

in real estate, suffered with the rest, and much of his property was lost. His fashionable New York gallery and many Central Park lots were sold to meet the demands of his creditors; all that was left from the crash was his Washington gallery. He was unable to pay the storage bill on his collection of negatives, and it was offered for sale at public auction to satisfy the claims of the storage company. The buyer was the War Department, which on July 31, 1874, purchased the collection from the storage company for $2,840. The following year General Benjamin F. Butler pointed out to Congress that Brady himself had not given title to the government for these negatives, and urged action. James Garfield, later President Garfield, also pressed the matter in the House of Representatives with these words:

Brady's Headquarters in front of Petersburg, March, 1865. (Photograph by Brady.)

"Here is a man who has given 25 years of his life (and the life of any man, however humble his station may be, is worth something considerable) to one great purpose—to preserving national monuments so far as photographic art can do so, with a view of making such a collection as nowhere exists in the world. . . . This man went so far as to send his organization into the field and some of his men were wounded in going near the battlefield to take pictures of the fight that was going on." [263]

Through the advocacy of Garfield and Butler, an appropriation of $25,000 was finally voted to Brady in payment for the collection which Garfield said was worth $150,000. Knowing that their value was recognized at the time, one finds it difficult to understand the subsequent treatment of the collection. The negatives were im-

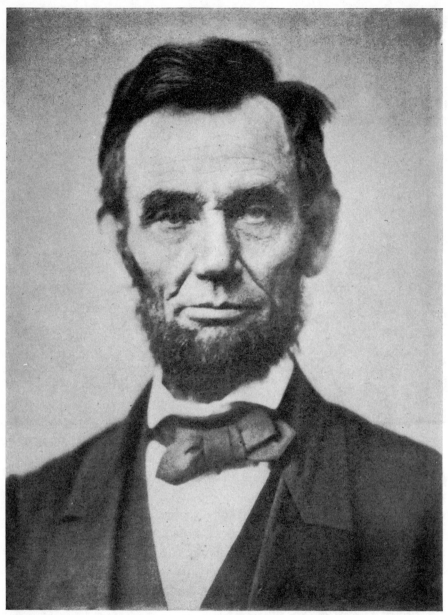

Abraham Lincoln (photograph by Alexander Gardner, November 15, 1863; courtesy the late Prof. F. H. Hodder). The print was made from the original negative which measures 4¼ by 5½ inches.

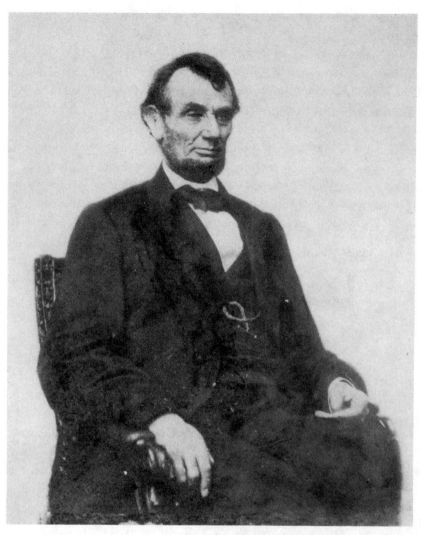

Abraham Lincoln (photograph by Brady, February 9, 1864; courtesy the late Prof. Hodder). The print was made from the original negative in 1929.

properly and carelessly handled, loaned to individuals outside the War Department, not catalogued, and otherwise neglected for some years. As a result many were lost or broken and others scratched and cracked. In 1897, a catalogue of the remaining negatives showed that they totaled 6001, including 125 transparencies. At the present time, they are properly cared for by the Army Pictorial Service, a branch of the Signal Corps of the United States Army, and prints from mas-

ter copies of the surviving negatives are obtainable under reasonable conditions.

The duplicate set of Brady negatives acquired by the Anthonys possesses a still more devious history. After the demand for war views fell off, the Anthonys stored the negatives. They were virtually forgotten for some years until discovered by John C. Taylor of Hartford, Connecticut, who found them in an attic and used them. Taylor sold a number of views made from these negatives during the early eighties. The title to the collection, however, was secured by Colonel Arnold A. Rand of Boston and General Albert Ordway of Washington. Rand and Ordway were private collectors who were deeply interested in their hobby.

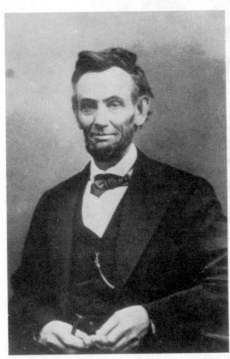

Abraham Lincoln (photograph by Gardner, April 9, 1865; courtesy the late Prof. Hodder).

Their collection was carefully preserved, catalogued, and additions made. The most important addition was the inclusion of two thousand negatives made by, or under the direction of, Alexander Gardner while he was with the Army of the Potomac. The Ordway-Rand collection was thus a far more extensive and better preserved collection than the Brady negatives acquired by the War Department. In 1884, Ordway and Rand offered to sell their collection to Congress to supplement and enlarge the Brady collection already in possession of the government. Congress, however, took no action and the matter was dropped. Ordway and Rand finally sold their collection to Taylor, and for some twenty years the history of the collection again becomes obscure. Finally E. B. Eaton of Hartford, Connecticut, rediscovered them and suggested their reproduction, a suggestion which finally resulted in the publication (1911) of the

[244]

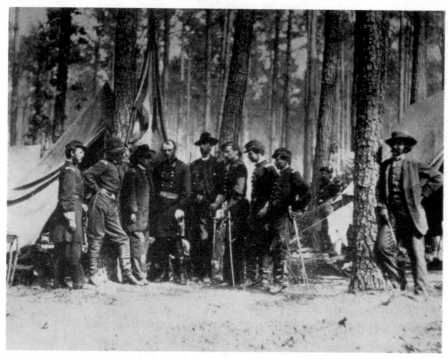

General Potter and Staff—Brady in civilian clothes. (Photograph about 1864; courtesy the L. C. Handy Studio.)

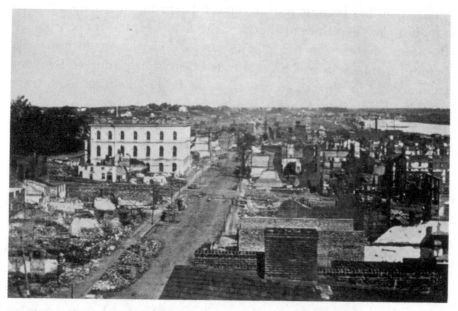

Richmond, Virginia, June, 1865. The building left standing in the left center is the First National Bank of Virginia. (Photograph by Levy and Cohen.)

ten-volume *Photographic History of the Civil War* to which ref-
erence has already been made.[264]

No history of the Civil War photography would be complete
without at least mentioning the recording of its most outstanding
figure, Abraham Lincoln. Lincoln was photographed over one hun-
dred times. It is indicative of Brady's place in the photographic
world that he made at least thirty-five of these portraits. Gardner,
too, was a favorite photographer of Lincoln's, and Lincoln sat for
him many times. It has been said that Lincoln was Gardner's first
patron when he separated from Brady and began business for him-
self. Brady and Gardner between them, without doubt, made over
half of the known photographic portraits of Lincoln.

Four of these portraits, two by Brady and two by Gardner, are
reproduced in this book. The first of these, made by Brady on Feb-
ruary 27, 1860, at his gallery at 359 Broadway, we have already
described in Chapter Eleven.

The second of these photographs was made by Alexander Gard-
ner in Washington on November 15, 1863—only three and one half
years after the Brady portrait just mentioned. It seems scarcely pos-
sible that so short a time could produce so marked a change—a
young man has become old. True, the beard heightens the effect of
age, but the deep lines of the face, the firm lips, the tragic eyes tell
the story of these few years. The photograph was made four days
before Lincoln delivered his celebrated Gettysburg Address. By many
students of Lincoln, it is regarded as his best photographic portrait.

The third of the Lincoln photographs here shown was made by
Brady in Washington, on February 9, 1864. Of all the photographs
of Lincoln, this is by far the best known. It is the Lincoln which
has appeared on the three-cent postage stamp (issue of 1923) and
the five-dollar Federal Reserve notes, and it has been copied many
times in woodcut, lithograph, and engraving. The lines of the face
are less marked than those in the previous one; again the photograph
traces the changing fortunes of war.

The last of these photographs was made by Gardner in Washing-
ton on April 9, 1865, five days before Lincoln's death. Here again
the marks of the times are revealed in the face. Lincoln had just
received news, when this photograph was made, that Lee had surren-

dered! The weary smile of victory is tempered still by kindness. How remarkably well these four photographs reflect the emotions of this brief, but tragic, span of years! [265]

If Lincoln, the pre-eminent character of the day, had his photographic Boswells, so did the lesser figures of the times. Brady and Gardner, between them, in their Washington galleries, missed very few of the notables. But the portrayal of the humblest yet most important of all the Civil War characters—the soldier in the ranks—we have already described in tracing the history of the tintype. Many of these portraits in sheet-metal are cherished mementoes of the descendants of those who fought for the blue and for the gray in the war between the states.

Photographing the Frontier:
First Phase

THE IMPORTANCE of the frontier in American history has been stressed by a number of able historians. Paxson, for example, has stated that the most American thing in all its history is the frontier.[266] The frontier, however, was no stationary line, but an ever-changing one, and from year to year occupied different positions.

The term "frontier" is used variously, but for our present purpose, the well-known definition by Turner is quite acceptable: *The frontier includes the Indian country and the outer margin of the settled area.*[267] By 1820, the American frontier thus defined was beyond the Mississippi. Advancing slowly, by 1850, it had reached the eastern boundary of the present states of Oklahoma, Kansas, and Nebraska.

At the time that the processes of Daguerre and of Talbot were introduced into this country, however, the frontier was roughly one hundred miles west of the Mississippi. Had there been a Brady of the borderland, it is obvious that it would have been possible to have a pictorial record of nearly the entire trans-Mississippi frontier from its inception until its disappearance. Actually the depiction of the frontier by the camera did not begin until nearly fifteen years after the process was introduced into this country. Furthermore, the vast majority of the early records made by the camera either have been destroyed or are so widely scattered as to be of little value at present. Not until after the Civil War do we begin to have anything like a complete camera record of frontier conditions. By this time the frontier was well advanced, but many records have disappeared, or depict only partially the frontier scene.

Probably the nearest approach to making a photographic record of the early frontier was that of J. H. Fitzgibbon of St. Louis. Fitz-

J. H. Fitzgibbon (photograph made in 1877 by Abraham Bogardus of New York). John M. Stanley (courtesy U. S. National Museum).

gibbon began practice in 1841 at Lynchburg, Virginia, soon after the process was introduced into this country. In 1847, he moved to St. Louis and opened a daguerreotype gallery, which in the course of ten years achieved a country-wide reputation. Fitzgibbon was something of a traveler and a writer and, like other leading daguerreotypists, established a large display gallery of daguerreotypes in connection with his operating rooms. Included in this display were pictures of the prominent personages of St. Louis, the celebrities who visited there, and—what is more important for the present purpose—daguerreotypes of Indian chiefs, frontier scenes, river boats, and river traffic.[268] Many of these were made by Fitzgibbon himself, but others were acquired by purchase. To the last class belonged the famous Vance collection, which will be described later.

It is probably because of the industry of Fitzgibbon that the Missouri Historical Society possesses one of the most extensive collections of daguerreotypes of any American museum. In its collection of more than six hundred daguerreotypes there are over one hundred views. Unfortunately, only a few of these can be regarded as frontier photographs.

[249]

S. N. Carvalho, from a photograph made late in life. (Courtesy Claire Carvalho, Hermosa Beach, Calif.)

There were doubtless other hardy daguerreotypists located in frontier towns, some of whose names might be located by long and laborious search of local records. Certainly their names never found their way into the more accessible sources of information. Probably, too, there were occasional army officers or doctors assigned to frontier posts who were familiar with and practised the art of daguerreotypy. Their records, too, have been covered by the dust of nearly a century.

After Fitzgibbon, the first definite and extensive records available concerning daguerreotypy on the frontier deal with the forty-niners. There were, without doubt, many daguerreotypists who joined in the mad rush to California, as there was hardly a profession that was not represented in that continuous procession that stretched from the Missouri to the Pacific. John Plumbe, it will be recalled, was one of these. But all of these travelers were interested in the land of gold and in getting there as quickly as possible; so it is exceedingly doubtful if many daguerreotypists among the would-be gold miners even took their photographic equipment with them. Three years later, however, there is a record of a daguerreotypist who laboriously trundled his two-wheeled cart, containing his equipment, across the plains and the Rockies. This was Peter Britt, who migrated to Oregon in the summer of 1852. Upon reaching a favorable site in the southwestern part of the state, he pitched his tent in a small hamlet, which later became the town of Jacksonville. His gallery, probably the first in Oregon, was erected on the site of his camp ground. Britt seems not to have made any daguerreotypes en route.[269]

Either among the forty-niners or preceding them were at least

The first photograph gallery in Oregon, built by Peter Britt in 1854. (Courtesy Emil Britt, Jacksonville, Ore.)

two far-sighted daguerreotypists who were prepared to practice their profession. These were S. S. McIntyre and Robert H. Vance. Information about both these men is meager. McIntyre first appears in print in *Humphrey's Journal* for 1851, when it is stated that he sent to New York City daguerreotypes of San Francisco and the gold diggings. The account also mentions the fact that McIntyre's establishment was destroyed in one of the numerous fires of that city. Included among his views were five half-plate daguerreotypes representing the city as seen from "the most favorable point." The gold diggings were represented by six views of the same size. Humphrey generously states that "as Mr. McIntyre has met with a severe loss, I will furnish copies of his daguerreotypes at reasonable rates and give Mr. M. the sole benefit, without any charge for our time in copying."[270] With this brief notice McIntyre and his daguerreotypes are lost to view.

A few weeks later, *Humphrey's Journal* reported that R. H. Vance was back from California with 300 *whole-plate* views of the West, which would be placed on exhibition in New York City. These were shown in the eastern metropolis in the fall of 1851, and, as may

Salt Lake City, 1851—a pencil sketch presumably copied from a daguerreotype made by J. Wesley Jones.

Steeple Rocks, Oregon Territory, 1851. (From the original sketches in the Templeton Crocker Collection, California Historical Society, first reproduced in *California Historical Society Quarterly*, Vol. VI, 1927.)

well be imagined, created considerable interest. A contemporary account gives this description of Vance's interesting exhibit:

"This collection comprises a complete panorama of the most interesting scenery in California. There are over three hundred daguerreotypes so arranged that a circuit of several miles of scenery can be seen at a glance. They are most artistic in design, and executed with a skill evincing, not only a perfect mastery of the manipulatory art, but an exquisite taste for the sublime and beautiful. On looking upon these pictures, one can imagine himself among the hills and mines of California, grasping at the glittering gold that lies before him; wandering over the plains, along the beautiful rivers that flow into the California gulf, or through the streets of San Francisco, Sacramento, and Monterey.

"Almost every variety of scenery is presented to the view. Three or four hours can be very profitably and amusingly spent in studying Mr. Vance's collection, and no Daguerreotypist, visiting the City of New York, should neglect the opportunity of seeing one of the most interesting exhibitions of Daguerreotypes ever presented to the inspection of the public in any country. Persons contemplating a trip to the gold regions should also avail themselves of Mr. Vance's instructions, as he is intimately acquainted with all the places of note in California, and takes pleasure in imparting any information desired by his visitors." [271]

Vance was over a year in making the collection. As the description given above appeared in the October, 1851, issue of the *Photographic Art Journal,* most of the daguerreotypes must have been made in 1850 and possibly some were made as early as 1849.

Vance's views were on exhibition for some time in New York and were then advertised for sale. A published catalogue of the daguerreotypes was issued in connection with the sale, an examination of which still further reveals the important character of these pictorial records. The preface to the catalogue states:

"They embrace, among a variety of others, a splendid Panoramic View of San Francisco from the heights at the head of Clay street, taking in the whole entire range of the city, harbor, and bay, from Rincon Point to North Beach, with a distant view of the Contra Costa, and the islands in the Bay. Also, views of Stockton, Coloma, Carson's Creek, Makelame Hill, the Old Mill where the gold was first discovered, Nevada, Gold Run, Marysville, Sacramento, Benicia, etc., etc. Also, a large collection of views taken of the miners at work, in different localities; also a likeness of Captain Sutter, and a large collection of sketches of the different tribes

Table Mountains, Utah Territory, near Goose Creek, 1851.

Sunday on the Plains, 1851. Both illustrations are from pencil sketches based on the Jones daguerreotypes. (Courtesy California Historical Society.)

of Indians on the Pacific coast. Embracing in all some 300 views, on largest sized plates, elegantly framed in rosewood and gilding, which, taken altogether, furnish a complete picture of California, an object of attraction to everyone, from the associations connected with the country, and doubly so to those about visiting the Golden Land.

"Mr. Vance was disappointed in the realization of his hopes, and although they are among the best daguerreotype views ever taken, they failed to attract that attention necessary to the support of an exhibition of any character. Mr. Vance consequently closed his rooms in this city, and returned to California. In procuring these views, Mr. Vance expended $3,000, and the frames cost him $700 more. He is now desirous of selling them, and we are commissioned to dispose of them collectively, or in portions to suit purchasers." [272]

They were offered for $1500 for the entire collection; half for $900; a quarter of it for $500; or one-eighth for $300. They were sold first to Jeremiah Gurney, the New York daguerreotypist, in 1852, who possessed them for a year, and who in turn sold them to Fitzgibbon of St. Louis. They were on display for some years in St. Louis, but their final fate is still a mystery. Fitzgibbon kept his gallery in St. Louis until 1877, but whether the Vance daguerreotypes were still in his possession at that time I have been unable to ascertain.[273]

Mr. H. C. Peterson, the curator of Sutter's Fort Historical Museum, writes me that in 1906 he was cataloguing the extensive photographic collection of C. E. Watkins, the pioneer California photographer. Peterson says: "The Sunday before the fire I unearthed an oaken chest from a closet. Opened it and found it filled with dozens of rare daguerreotypes, including that of Sutter at Sutter's Mill. It was late in the afternoon, so I told him [Watkins] that I thought the best thing I could do was to take it to Palo Alto where it would be safe from fire, as I realized its great value. I also figured that if I made copies I could make prints that would be easier to describe.

"But the chest was too heavy for me to handle alone, so I put it near the rear door and told him I would bring one of the boys with me the next Sunday and in that way get it to the station. Wednesday came the fire and everything went up in smoke. In the box were a

Mirror Lake and Mount Watkins—named for C. E. Watkins. (From one of the large nega-
tives, 18 by 22 inches, made by Watkins himself in 1860; courtesy Yosemite Museum,
Yosemite National Park.)

great many scenic views. The collection included work of nearly all
the early daguerreotype artists of those days." [274]

As Watkins had received his early training under Vance it is
probable that many of the daguerreotypes described by Peterson
were made by Vance, but whether they were the collection exhibited
in New York and St. Louis is another question. Further inquiry to
Mr. Peterson with respect to their size elicited the response that in
his memory most of them were considerably smaller than $6\frac{1}{2}$ x $8\frac{1}{2}$
inches. As it has been stated that the Vance exhibit consisted of
whole-size plates, there is the possibility that this extremely impor-
tant collection is still in existence, perhaps stored away in some St.
Louis cellar or attic. The historical value of this collection would
well repay further search for it.

Galen Clark and the Grizzly Giant in Mariposa Grove of Big Trees. (Photograph by C. E. Watkins, 1858 or 1859; courtesy Yosemite Museum, Yosemite National Park.)

If the claims of J. Wesley Jones, however, can be completely authenticated, some fifteen hundred daguerreotypes made by Jones in the summer of 1851 are of even greater historical value than the Vance collection. Jones claimed to have daguerreotyped not only California and the gold diggings but the plains and the Rockies from San Francisco to the Missouri River!

Going East, Jones had pencil sketches and oil paintings copied from his daguerreotypes. The paintings, valued by Jones at $40,000, were used in a lecture "The Pantoscope of California" which proved to be exceedingly popular in the eastern cities. He lectured in New York City in the winter of 1853-54, his paintings finally being raffled off by lottery in March, 1854. Their subsequent fate and that of the original daguerreotypes are unknown. The California Historical Society, however, is fortunate enough to possess the original lecture notes of Jones and a number of pencil sketches said to have been copied from the daguerreotypes.

Savage and Ottinger, partners in the celebrated firm of that name.
Savage is on the left. (Courtesy W. H. Jackson, New York.)

The opening paragraph of the Jones lecture (following the original spelling and punctuation) sets forth his plan:

"With the Immense Emmigration who crossed the plains a few years since to California our artist found himself traveling among some of the wildest and grandest scenery in the world, Not satisfied with the sketches which filled his note book on the journey outward, it was resolved In San Francisco though involving enormous expence, to daguereotype that intenseley interesting region, its towns, cities, and diggings, and thence recrossing the plains to daguereotype everything there found to interest, and instruct, the curias and observing traveller from an immence collection of Daguereotypes thus obtained at great cost of means and toil, and immenent perils, this collasal triumph of genius has been elaborated by the United Labors of some of the first artists of the union."

While Jones' claim lacks complete verification, the circumstantial evidence leaves little room to doubt his veracity. If his claim is admitted, Jones holds the honor of being the first to photograph the Rockies, as his journey was made two years prior to that of Stanley or of Carvalho—whose experiences are to be described—and for whom such claims have been made.[275]

Between 1850 and 1860, there were many photographic galleries

Joining of the Rails, Promontory Point, Utah, May 10, 1869. (Photograph by Savage; courtesy Joseph L. Smith, Historian, Church of Latter Day Saints.)

established in the frontier towns. Although the bulk of their work was the making of portraits, occasionally a view of a town, an incident, or an occasion was recorded by their cameras. In total, there must have been many of this type made. For the most part they have been lost or destroyed. Where they do exist it is difficult many times to determine authentically when they were made, and the name of the subject. The most fruitful source in looking for material of this character is in state and local historical societies. It seems to me that local historians would find a fertile field of research in this direction, not only in locating such material, but in preparing brief photographic histories of their localities.[276]

The names of a few of these frontier photographers have found their way into the contemporary photographic literature of their era. The expeditions of Hesler into the "Northwest," that is, the upper Mississippi region, have already been mentioned. Hesler began his practice in Galena, Illinois, but removed to Chicago in 1854.[277] Joel E. Whitney photographed in the early fifties in St. Paul; a few years later (1857) B. F. Upton made a number of interesting views in the same frontier town; E. L. Eaton began the practice of photography in Omaha in 1858, shortly after the founding of the town.[278] The early issues of the *Daguerrean Journal,* published in 1850 and

[259]

Western emigrants at Coalville, Utah, about 1863. (Photograph by Savage; courtesy Joseph L. Smith.)

Brigham Young—seated on chair—and party on an excursion to the junction of the Virgin and Colorado rivers, March 17, 1870. (Photograph by Savage; courtesy Joseph L. Smith.)

The United States Mail and Overland Stage about to leave Salt Lake City in the early sixties. (Photograph by Savage; courtesy Joseph L. Smith.)

1851, contain correspondence with residents of Texas, some of whom, it may be judged, were on or near the frontier. Among the more prominent of the early Texas photographers was H. B. Hillyer, who began practice in Austin, Texas, in 1857, and in the course of many years established a wide reputation as a photographer.[279]

The first instance of the employment of the daguerreotype camera on a western expedition sent out by the government appears to have been that of the artist, J. M. Stanley, who accompanied one of the Surveys sent out by direction of Congress in locating the best railroad route to the Pacific.* Stanley accompanied the party which was surveying the northern route under the command of Governor I. I. Stevens, of Washington Territory. The Stevens party left St. Paul in the spring of 1853, and, although Stanley's photographic experiences are not discussed at length, there are two distinct references to the use of the camera. The first of these is recorded in Stevens' diary of the expedition, in an entry dated August 7, 1853, and reads: "Mr. Stanley, the artist, was busily occupied during our

* The first photographer on an American government expedition appears to have been E. Brown, a daguerreotypist on Commodore Perry's expedition to Japan which sailed November 24, 1852. See reference 280.

[261]

stay at Fort Union with his daguerreotype apparatus, and the Indians were greatly pleased with their daguerreotypes." About a month later (September 4, 1853), while at Fort Benton, still farther up the Missouri and far within the frontier, Stevens writes: "Mr. Stanley commenced taking daguerreotypes of the Indians with his apparatus. They are delighted and astonished to see their likenesses produced by the direct action of the sun. They worship the sun, and they considered Mr. Stanley was inspired by their divinity, and he thus became in their eyes a great medicine man." [281] Stanley was an artist of the pencil and the brush, and achieved a considerable reputation in his day as a painter of Indian subjects. Just when he acquired his photographic skill and how extensively he used it is not stated in any of the available biographical sketches of Stanley.[282] W. H. Jackson, who was acquainted with Stanley's son, made an extensive search for some of these Stanley daguerreotypes but was unsuccessful.[283] Perhaps an occasional one may still be found in a Blackfoot tepee in Montana.

A few months after the Stevens party left St. Paul, Colonel John C. Frémont fitted out, at his own expense, an exploring party that assembled at Westport, Missouri, in September of 1853. Frémont had conceived the idea of taking a photographer with him, and, while in the East in the preceding summer, had persuaded S. N. Carvalho of Baltimore, an artist and daguerreotypist, to accompany him. The use of a daguerreotypist on such an expedition had been suggested to Frémont by reading Humboldt's *Cosmos*.[284] Humboldt, himself one of the leading explorers of his day, in discussing photography had ventured the hope that it would be used extensively by travelers and explorers.

Carvalho wrote a lengthy account of his experiences with this expedition, the only extensive report which was made of the trip. From our point of view, it would have been more interesting if he had described the photographic incidents in connection with the journey from Westport to Utah, but these are of secondary importance to Carvalho. He relates several incidents of interest, however, the first of which deals with a photographic contest in which he took part on the edge of the frontier.[285]

A Mr. Bomar, "a photographist," as Carvalho calls him, had

joined the expedition at St. Louis. Bomar employed the wax paper process, a modification of Talbot's procedure, and Frémont decided that he could not take two photographers with him. At Westport he asked both Bomar and Carvalho to prepare specimens of their work, so that he could choose between them. Carvalho reports concerning this contest: "In half an hour from the time the word was given, my daguerreotype was made; but the photograph could not be seen until next day, as it had to remain in water all night, which was absolutely necessary to develop it." Bomar could not have been well versed in the process he employed, as none of the manuals of that day state that any such lengthy washing was necessary; but the trial convinced Frémont that Bomar's process was too long and required too much water to be of value in expeditionary photography—so Bomar was left behind.

The Frémont party traveled slowly through Kansas, where Carvalho made occasional daguerreotypes of Indian settlements. Upon reaching the buffalo country, Carvalho states, "I essayed, at different times, to daguerreotype them [the buffalo] while in motion, but was not successful, although I made several pictures of distant herds."

On encountering the Cheyennes, Carvalho underwent the same experience that Stanley had on the upper Missouri: "They wanted me to live with them, and I believe if I had remained, they would have worshipped me as possessing extraordinary powers of necromancy." This attitude was not solely a result of his ability to make sun pictures, but was also due to the fact that Carvalho employed the mercury he had with him as part of his daguerreotype equipment, to "silver" the brass rings and ornaments of the Indians.

Carvalho's equipment was not looked upon with particular favor by the packers employed in Frémont's train, and he had to be constantly on guard to see that his apparatus was properly packed every day. This was not only once, but as many times as the equipment was needed. "To make a daguerreotype view," says Carvalho, "generally occupied from one to two hours; the principal part of that time was spent in packing, and reloading the animals."

As they neared the Rockies the difficulties of travel became greater, since Frémont had essayed the foolhardy attempt of crossing these mountains in the dead of winter. Carvalho, although an in-

experienced traveler and not a young man, stayed with his task with commendable energy and fortitude. Difficult views of the mountains and passes were obtained. In crossing the Continental Divide, in what is now south central Colorado, Carvalho climbed to the top of a lofty peak, too steep to allow the use of the mules in carrying the equipment, and there, "plunged up to my middle in snow, I made a panorama of the continuous ranges of mountains around us."

As the party approached the present state of Utah their supplies gave out, tremendous snows were encountered, and the entire party nearly perished. One, indeed, died from exhaustion. The daguerreotype equipment and all heavy baggage were abandoned in the mountains, but the plates, prepared with great toil, were carried with the party, which finally reached the Mormon settlement of Parowan. Carvalho was so completely exhausted by the rigors of travel that he abandoned the party here and had to spend several weeks in recuperating.

After spending some time among the Mormons at Salt Lake City, where he was entertained by Brigham Young, he eventually went on to California by stage. From there he took boat passage back to New York City.

Upon his return he was asked to write an account of his photographic experiences by Snelling, the editor of the *Photographic Art Journal,* but he condensed his narrative into the following brief letter:

"I am very sorry I am unable to respond to your request for particulars of my tour with Colonel J. C. Frémont, in his late Exploring Expedition across the mountains, not having any private notes. But this much I am at liberty to say, that I succeeded beyond my utmost expectation in producing good results and effects by the Daguerreotype process, on the summits of the highest peaks of the Rocky Mountains with the thermometer at times from 20 degrees to 30 degrees below zero, often standing to my waist in snow, buffing, coating, and mercurializing plates in the open air. In nearly every instance Barometrical, and Thermometrical observations were obtained at the same moment, with the picture. The time given to each example was also noticed and marked on the plate. I requested permission from Coloniel Frémont, who readily afforded the means to make these observations, and they may account for the very great difference of time, which it took to make pictures under

apparently the same combination of circumstances. All these observations have been carefully noted and will be published for the benefit of the scientific world, in Colonel Frémont's forthcoming Journal, which these pictures will serve in some measure to illustrate.

"I had considerable trouble with the iodine, which under ordinary circumstances requires 80 degrees Fht. before it will part with its fumes. I had to use artificial heat in every instance; I found it necessary to make up in quantity for the loss of temperature. I generally employed Anthony's anhydrous sensitive [iodine], and my boxes during a continuous use of five months only required replenishing four times, notwithstanding they were opened every time I made a picture, to arrange it smoothly at the bottom. The coating boxes were made expressly for my use on the Expedition by E. Anthony, Esq., and I cheerfully recommend the use of similar ones for like purposes. Notwithstanding the earnest prognostications of yourself and my professional friends, both in New York and Philadelphia, that under the difficulties I was likely to encounter on the snow-capped mountains, I would fail, I am happy to state that I found no such word in my vocabulary, although I had not much youthful, or physical strength to bring into the scale." [286]

Unfortunately, Frémont never published the report mentioned in Carvalho's letter. A brief account was published in the *National Intelligencer* in which Frémont refers to the daguerreotype views as valuable evidence concerning the character of the country.[287] An extensive report was to follow, but, in 1856, while engaged in its preparation, Frémont was nominated for the presidency by the National Republican party. In the heat of the campaign, the report was forgotten, and Frémont did not complete it after his defeat in the fall of 1856.

The daguerreotype plates made by Carvalho were brought back to New York by Frémont, and in the winter of 1855 and 1856 Brady was engaged to copy them all by the wet process, so that paper prints could be made. There were a large number of these, as Mrs. Frémont stated that some months were necessary in completing the copy work. The paper prints, in turn, were used as copy by artists and engravers in preparing plates to illustrate Frémont's proposed report.

The daguerreotypes and the Brady negatives seem to have been destroyed, possibly in a fire in which Mrs. Frémont states that many

of their possessions were lost. Extended search (including inquiry to the heirs of Frémont, of Carvalho, and of Brady) has failed to reveal any trace of them. There is a possibility, however, that some of the Brady prints may still be in existence.[288]

An investigation of the official reports of western expeditions from 1854 to 1860 shows that there were at least four exploring parties that employed photographers, who had for the most part indifferent success. The first of these was Lieutenant Ives' expedition, which explored the Colorado River in 1857. The expedition started from the mouth of the Colorado and worked up stream. Ives mentions his photographic experiences casually by stating that "there being a little photographic apparatus along, I constructed a tent of india-rubber tarpaulin that excluded light"; and in this he attempted to prepare his materials. Ives does not state what process he employed, but I infer from the statement he makes concerning the character of the chemicals employed that he was using the wet process. His photographic experiences were short-lived, however, as the expedition was not much more than under way when a gale blew the tent and the photographic apparatus away, whereupon Ives remarks in his diary, "But that was of comparatively little importance." In the official report of Ives a lithographic reproduction of only one of his photographs is included, although there are a number of illustrations reproduced from hand sketches.[289]

In 1859, Captain J. H. Simpson, who conducted an exploration of the Great Basin of Utah for the government, carried with him at least two men who were familiar with photographic processes, one of whom, C. C. Mills, was called the official photographer of the expedition. Here again no specific statement as to the process employed by Mills is made, but the assumption can be made that it was the wet process, as by this date collodion had become well known— this despite the fact that Simpson uses the term "daguerreotyped" in his report, which I am inclined to believe he uses in the general sense of "pictured" or "photographed." The photographs obtained by Mills cannot have been very successful, if we can judge by their mention in Simpson's official report:

"I carried out with me a photographic apparatus, carefully supplied with necessary chemicals by Mr. E. Anthony of New York and a couple

of gentlemen accompanied me as photographers, but although they took a large number of views, some of which have been the originals from which a few accompanying my journals have been derived, yet, as a general thing, the project proved a failure. Indeed, I am informed that in several of the Government expeditions a photographic apparatus has been an accompaniment, and that in every instance, and even with operators of undoubted skill the enterprise has been attended with failure. The cause lies in some degree in the difficulty in the field, at short notice, of having preparations perfect enough to secure good pictures, but chiefly in the fact that the camera is not adapted to distant scenery. For objects very close at hand, which of course, correspondingly contracts the field of vision, and for single portraits of persons and small groups, it does very well; but as, on exploring expeditions, the chief desideratum is to daguerreotype extensive mountain chains and other notable objects having considerable extent, the camera has to be correspondingly distant to take in the whole field, and the consequence is a want of sharpness of outline and in many instances, on account of the focal distance not being the same for every object within the field of view, a blurred effect, as well as distortion of parts. In my judgment, the camera is not adapted to explorations in the field, and a good artist, who can sketch readily and accurately, is much to be preferred." [290]

It is quite obvious that the difficulty Simpson encountered was due to a lack of proper training in his photographers. Stops were in use in cameras long before 1859. The difficulty was due in part, also, to the haze which is nearly always present in photographing mountain scenery, and is more dense at some periods of the year than at others. The successes achieved by Carvalho before the time of Simpson, and by contemporary and subsequent photographers employing the wet process, show that Simpson was mistaken in his judgment concerning the value of the camera in expeditionary work.

This opinion is confirmed by a report found in an expedition sent out in the same year (1859). This was Captain F. W. Lander's party which was employed to survey a road from Salt Lake City over the South Pass and to the east. Lander says in his report: "A. Bierstadt, esq., a distinguished artist of New York, and S. F. Frost of Boston accompanied the expedition with a full corps of artists, bearing their own expenses. They have taken sketches of the most remarkable views along the route and a set of stereoscopic views of emigrant trains, Indians, camp scenes, etc., which are highly valuable and

would be interesting to the country. I have no authority by which they can be purchased or made a portion of this report." [291] The Bierstadt referred to is Albert Bierstadt, whose work as an artist was extremely popular in his day. As a result of this trip Bierstadt obtained many sketches, which with the stereoscopic views formed the foundation for many paintings of the Rockies, from which his fame was chiefly obtained. It is unfortunate that a set of the stereoscopic views was not made a part of Lander's report, as they seem to have disappeared completely.[292]

The next year, J. D. Hutton accompanied W. F. Raynolds on an expedition which explored the region bordering on the Yellowstone and Missouri rivers. Hutton presumably employed the wet process. Reference to his work in Raynolds' report is very meager. Under date of July 13, 1860, Raynolds records in his diary, "Mr. Hutton returned to Great Falls [of the Missouri] to obtain a photograph of them. . . . Mr. Hutton returned at nightfall, having indifferently accomplished the object of his expedition." [293] Hutton may have been the first to photograph the Great Falls of the Missouri, famous since the day of Lewis and Clark, but Stanley possibly preceded him in this undertaking, as the Falls were on the route of Stevens' expedition of 1853.

Again the remark must be made that none of these views, no matter how indifferent they may have been, are now accessible for any of these expeditions. This does not mean that all have now disappeared; doubtless many copies of the better stereoscopic photographs were made, and some of these may at some time or other show up. They should prove to be extremely interesting and important pictorial records of the Western frontier before it was penetrated by the railroad.

Expeditionary photography came to an abrupt halt after 1860 for a reason which is quite apparent. With the outbreak of the Civil War, the entire energy of the Federal army was needed for purposes other than exploring and mapping the Great West, a task which had been the army's lot almost from the time of its acquisition by this country. The Geological Survey of the Government, which later took over the duty, was not organized until some years after the War.

Although expeditionary photography was interrupted by the War between the States, the camera was used occasionally during this period to picture the frontier. Independent photographers were gradually pushing west (or east from the west coast) as the line of the frontier gradually changed. It is true that for the most part these were portrait photographers who were interested almost entirely in studio work. There are two names which form marked exceptions to this rule, and for that reason they are still remembered. These men were C. E. Watkins of San Francisco and C. R. Savage of Salt Lake City.

Watkins cannot truthfully be said to have photographed the frontier, but at least he was among the first to photograph the interior of California at a time when it was but little known and difficult of access. Watkins was trained by R. H. Vance, the daguerreotypist, whose views of California we have already described at some length. The story of Watkins' entry into the profession is interesting and illustrates again the fact that chance very frequently has the controlling voice in determining an individual's destiny.

Watkins was born in New York, but went as a young man to California, probably with the forty-niners. At least, in 1854, we find him clerking in a store in San Francisco, where through accident, he became acquainted with Vance, who had galleries not only in San Francisco and Sacramento, but in San Jose as well. The operator of the San Jose gallery suddenly left Vance's employment and Vance asked Watkins to go to San Jose to take charge of his affairs until he had time to get another operator. At this time Watkins knew nothing at all of daguerreotypy, but he went to San Jose and assumed charge of the Vance gallery there. Fortunately, it was the middle of the week when he arrived, which meant that there was no business, since practically the entire trade of the California galleries at that time was done on Sundays.

Vance arrived in San Jose the following Saturday, but had been unable to obtain an operator. He gave Watkins a few directions concerning daguerreotype operations and told Watkins to go through the motions of making the metallic pictures on the following day. Vance stated he would come back the next week and make any "retakes" that were necessary. When he did return, he found

that Watkins had mastered the craft sufficiently to satisfy the patrons of the gallery; so he remained in charge as the operator of the gallery for some time. He returned to San Francisco in the latter part of 1857 or the early part of 1858 and opened a gallery of his own, having in the meantime learned the wet process thoroughly.

Although his living may have been made from portrait practice, Watkins' outstanding capabilities lay in landscape work. The great trees of California had been the subject of much comment in the early tales of this region, and drawings of them had appeared in the descriptive journals of the day. In 1858 or 1859, Watkins made the field trip necessary to secure his first photographs of these natural wonders. But it was the photographs of the Yosemite—called in his day Yo Semite—that brought him international fame. His first trip into this valley was made in 1861, and was distinguished by the fact that he took with him a huge camera, constructed by himself, capable of taking a plate 18″ x 22″ in size.

The use of these large plates by a wet plate photographer working under the most favorable circumstances was attended with considerable difficulty. It was a feat of no mean skill to flow the collodion on these plates, obtain a uniform film, and then sensitize, expose, and develop them while they were still moist. If one wonders why Watkins felt the need of a large instrument, he should recall that methods of enlargement on paper in 1861 were uncertain and extremely slow.

Furthermore, Watkins was not working under the most favorable circumstances. The trails entering the area, which later became one of our famed national parks, were crude, and travel was difficult. A twelve-mule train was necessary to transport Watkins and his supplies to the valley, and five of these mules carried his equipment as he made his photographic tour of the region. As each photograph was made, the dark tent had to be unpacked and set up, the plates prepared in the small tent, and developed immediately after exposure. The equipment was then repacked and the mule train moved on to obtain the next view.

Only a young and active man of considerable ambition could have succeeded in such an enterprise, and Watkins' success attests these qualities. A love of outdoor life was likely the compelling

motive in this enterprise, for we find that for many years Watkins devoted his summers to this type of work. As a result, his photographs became known the world over.[294]

In addition to using the large camera described above, Watkins employed the stereoscopic camera, as did practically every other landscape photographer in the West after 1860. The Watkins stereographs were, of course, far more widely distributed than were the large prints, and it is no uncommon thing to find many of his stereographs in the collections of double photographs which have survived since grandfather's day. Holmes, writing in 1863, mentions some of them in one of the much quoted *Atlantic Monthly* articles:

"One of the most interesting accessions to our collection is a series of twelve views, on glass, of scenes and objects in California, sent us with unprovoked liberality by the artist Mr. Watkins. As specimens of art they are admirable, and some of the subjects are among the most interesting to be found in the whole realm of nature. Thus, the great tree, the 'Grizzly Giant,' of Mariposa, is shown in two admirable views; the mighty precipice of El Capitan, more than three thousand feet in precipitous height, . . . the three conical hill-tops of Yo Semite, taken not as they soar into the atmosphere, but as they are reflected in the calm waters below, . . . these and others are shown, clear, yet soft, vigorous in the foreground, delicately distinct in the distance, in a perfection of art which compares with the finest European work." [295]

Not only the amateur and the layman marveled at Watkins' work, but the profession itself gave praise. "The wonderful views of C. E. Watkins" were a matter of frequent mention in the photographic literature, and requests were sent Mr. Watkins to describe his methods for the benefit of all operators.[296]

Many of Watkins' negatives of this period (the sixties) were destroyed in the San Francisco fire and earthquake, as already mentioned by H. C. Peterson in connection with the Vance daguerreotypes. It should be remembered, too, that many times wet plate negatives were not saved after a number of prints had been made from them. As the photographer prepared his own plates, the glass was frequently cleaned and re-used, because glass was one of the items of greatest expense.

* * * * * * *

The second name mentioned in connection with that of Watkins, as being particularly outstanding in the photography of the West at that time, was that of Charles R. Savage.

Savage was an Englishman, born in Southampton in 1832. After a precarious boyhood, he was converted to Mormonism upon hearing a missionary sent abroad by the Latter Day Saints. For several years he traveled through Europe in the interests of the church, and eventually came to New York in February, 1857. While living in New York, he decided to become a photographer, and, after receiving some training, he began to practice the art in the frontier town of Florence, Nebraska, in 1859. His equipment, typical of such border towns, consisted of a camera, a background made from an old gray blanket, and a large tea chest that served as a miniature dark room.

Savage tarried but a short time in Florence, for in June, 1860, he crossed the plains to the promised land and arrived in Salt Lake City, where he immediately hung out his shingle. From this date until the nineteen hundreds he was probably the best known photographer between the Mississippi and the Pacific. Like Watkins, Savage was fond of outdoor life, and his views of Rocky Mountain scenery and life on the plains were present in every stereographic collection worthy of the name.

The most widely known of these photographs were the views made by Savage at Promontory Point, Utah, May 10, 1869, at the ceremony celebrating the completion of the railroad across the country. There is hardly a text book of American history that does not have a reproduction of this famous scene recorded by Savage.[297]

The Savage photographs also received indirect publicity from the famous lecture of Artemus Ward on Mormonism. Ward (C. F. Browne) used in this humorous lecture a series of painted panoramas, all of which were based on photographs by Savage.[298]

In 1866, Savage made a trip East to obtain an extensive stock of photographic materials, going by way of California and the water route, and returning across the plains. Upon his return trip he fitted up a huge wagon to carry his supplies and for photography en route. He described his experiences at length in a letter to the *Philadelphia Photographer*. The letter is of sufficient interest to

quote in part, not only for the photographic experiences which it records, but also as an account of overland travel in the days immediately preceding the completion of the transcontinental railroad:

"One of the objects of my visit eastward was to obtain a wagon suited for taking a series of views on the overland route on my return trip. By Mr. Rech, Girard Avenue, Philadelphia, I had a wagon made suitable for the purpose, and shipped by rail and steamboat to Nebraska City. With the exception of being a little too heavy, it answers pretty well. . . . It is about nine feet long and six feet high in the dark room, leaving three feet of space in front for carrying a seat and provisions. The sides are fitted with grooved drawers, for the different sized negatives, and proper receptacles for the different cameras, chemicals, etc., forming a very complete outdoor dark room. . . .

"With two span of mules and provisions for two months, I joined a Mormon train which left Nebraska City for Salt Lake about the 8th of July. As the Mormon trains are well armed and completely organized, I found it a great advantage, rather than attempt the trip alone, which, by the way, our kind Uncle will now allow anyone to do beyond Fort Kearney.

"We travel more slowly the first few days, and gradually increase our pace until we make about twenty-five miles a day. The modus operandi of managing a train is as follows: About five o'clock the bugle or reveille is sounded to call up the passengers to prepare their breakfast. About six o'clock all hands are called for prayers; that duty over, preparations are then made to roll out; the caravan then travels until about half past eleven or twelve o'clock, then dinner is prepared, and two P. M. the journey is resumed, and another camp is made about 6 o'clock. The night-herders then take charge of the herd, and drive them to a good feeding-ground for the night; supper is then prepared, then prayers by the night camp fires, and the orders for the next day's travel are given by the captain, which winds up the day's journey; guards are then placed around the camp, who are expected to keep a sharp lookout for any sneaking red-skins.

"The road from Nebraska City to Fort Kearney presents but few objects of special interest to the photographer. I secured negatives of one or two of the overland stations, and a few rural scenes not remarkable for any particular features different from the same genre of subjects elsewhere. When we reached Fort Kearney it was blowing a gale, but, in spite of that, I made desperate efforts to *take* the Fort, with indifferent success.

"From Fort Kearney on to the crossing of the South Platte, near the

[273]

present terminus of the U. P. R. R., the road follows the Platte Valley, and a more uninteresting road can hardly be found. Very few trees to be seen, and what with the swarms of green flies and mosquitos, and the strong wind that blows regularly every day, your photographic enthusiasm gets cooled down so much that you see nothing worth taking under the circumstances of such a trip. Added to this, you are never free from Indian attacks, for, at the time of our passing along that route, the few settlers on the mail road were almost scared out of their wits from rumors of Indian troubles.

"Now to photograph successfully on the Plains, you must be perfectly safe from Indians, as on two or three occasions in our efforts to secure some views, we found ourselves alone several miles from the train, and ran one or two risks of being gobbled up by a few stray rascals who are always on the lookout for a weak party, and generally manage to pounce down upon a few defenceless wagons that happen to be passing. The sad fate of your former correspondent, Mr. Glovers, shows how uncertain is life in such a place, and the wisdom of keeping a good lookout. The necessary conditions for success under such circumstances are, that you must have plenty of time at your disposal, a strong party well armed with Henry rifles, and good animals." [299]

In this manner such noted points of interest as Chimney Rock, Fort Laramie, Independence Rock, Devil's Gate, and South Pass were photographed. Scott's Bluff was passed by with no record "on account of arriving there in the middle of the day, for our wagon got so hot that we could only work in the morning or in the evening."

It was real work to photograph on such a trip, for in addition to the vicissitudes of climate and the danger of Indian attack, the animals had to be cared for, the meals prepared, and one's turn at night guard taken.

Glover's fate, mentioned in the letter of Savage, shows that the Indian danger was an extremely real one. Ridgway Glover, a Philadelphia boy, had left home in the summer of 1866 for the purpose of securing photographs "to illustrate the life and character of the wild men of the prairie." His adventures were related in a series of letters to the *Philadelphia Photographer*. The first is dated June 30, 1866, at Fort Laramie. Glover had made fifty negatives by this time, but was able to obtain prints from only twenty-two of these, because "the water was so muddy." He mentions photographic predecessors

Captain Fisk's expedition to Montana, 1866: forming the circle for a night's encampment.
(Photograph by Bill and Illingworth.)

at this army post, for he says, "There was a Mr. and Mrs. Laramie who used to take a mean style of ambrotype here, but he died and she was captured by the Indians and after suffering many hardships, escaped, and returned to the States." Among the photographs he secured was "a good picture of the Fort; also a group of eight Brulie Sioux and six Ogholalla."

He is next heard from on July 29, 1866, at Fort Phil Kearney, Montana Territory. To gain this objective he had joined an army train. On the way they were attacked by Indians who killed an officer of the party. "Our men with their rifles held the Indians at bay until we reached a better position on a hill, where we kept them off until night, when Captain Burroughs, coming up with a train, caused the red-skins to retreat. I desired to make some instantaneous views of the Indian attack, but our commander ordered me not to."

[275]

He managed to get some views along the way, but did not succeed with some Cheyennes who came into camp, as "the collodion was too hot."

Another letter, dated August 29, relates that he was still at Fort Phil Kearney, but was doing no photography as he had run out of certain materials and was waiting for the medical supply train to come up to replenish his supplies, probably of ether and alcohol with which to prepare the collodion. The train must have arrived, for the next record of Glover's activities is the brief notice, "Mr. Ridgway Glover was killed near Fort Phil Kearney on the 14th of September by the Sioux Indians. He and a companion had left the Fort to take some views. They were found scalped, killed, and horribly mutilated." [300]

It is quite evident that Glover was inexperienced and foolhardy in the ways of the frontier, but nevertheless his needless sacrifice was a contribution of American photography to the advancement of the frontier. Such destruction of life by the Indians (no matter with what justification) served to hasten the day when their power was broken.

Some of Glover's negatives reached Philadelphia and were published and sold by the firm of Wenderoth, Brown and Taylor of that city.

The accounts of frontier photography which have been given illustrate the difficulties which the wet plate photographer encountered. The wonder is that any were obtained, and, in fact, not all were successful. One correspondent writing East states, "Owing to the hurry and difficulty of transport, I was unable to obtain any photographs." [301] All the more credit, then, to those who did succeed.

Among the most successful series of western photographs of this period that I have seen is that obtained by Messrs. Bill and Illingsworth of St. Paul, which was published and sold by John Carbutt of Chicago. This series was made on Captain Fisk's emigrant expedition from St. Paul to Montana in the summer of 1866. There were some thirty stereographs in the group, which depict life and incidents in crossing the Plains in the day of the ox team. [302]

Photographing the Frontier:
Second Phase

ALTHOUGH a few independent photographers were thus recording the frontier scene during the Civil War and in the years immediately succeeding, expeditionary photography, halted at the beginning of the War, was not immediately resumed at its close. The reason for this neglect undoubtedly lay in the Army's preoccupation with the plains Indians; little time was available for exploratory work.

The severe Indian troubles on the plains were brought on very largely by the beginning of the construction of the western railroads: the Union Pacific Railroad, which began active construction at Omaha in 1866, and the Union Pacific Railway, Eastern Division, the first rails of which were laid at Wyandotte (near Kansas City), Kansas, in 1864. Both of these roads were built westward, the first crossing the present state of Nebraska and the second traversing the state of Kansas. As the railroads advanced, Indian troubles increased, for the plains tribes realized that they were making their last stand.

The construction of the railroads naturally focused the attention of the country upon Nebraska and Kansas; in consequence, considerable interest was aroused among easterners concerning the appearance of the country, its inhabitants, and its foes. As a result of this interest, a number of photographers worked along the railroads as they gradually extended westward, and many interesting views of this country, just past the frontier stage or on its edge, were obtained. Three of these photographers are worth mentioning by name, and, indeed, they already have been spoken of in these pages. They were Alexander Gardner of Washington, Captain A. J. Russel of New York, and John Carbutt of Chicago.

Carbutt accompanied the famous and elaborate excursion on the Union Pacific from Omaha to the 100th meridian in October, 1866; the 100th meridian was about 250 miles west of Omaha, and at that

time was the end of the road. The excursion had been organized by T. C. Durant, vice-president of the road, very largely as a means of interesting eastern capital. Among the excursionists, besides Mr. Carbutt and his assistant, Mr. Hien, were "two hundred and fifty of the most distinguished citizens of America," two brass bands, reporters from practically every important newspaper in the country, a staff of chefs, a French marquis, an English earl, government commissioners, and Union Pacific directors.[303]

This delegation was provided with tents to camp out on the plains. It must have been a glorious time for the excursionists. Even a mock Indian scare was staged for their benefit when they least expected it—at four in the morning. The photographs obtained by Carbutt on this excursion are now very scarce, but many were sold at the time. Carbutt was also out on the same road the following year, and spent a month photographing on the plains.[304] He published a catalog of his views made on these trips—a catalog which indicates that over three hundred such photographs (all stereoscopic) were made.

Alexander Gardner, the photographer who followed the Army of the Potomac during the War, went west to Kansas in the fall of 1867 and made a series of views along the Union Pacific Railway, Eastern Division. A fairly complete set of these views is available at present, thus furnishing a striking example of how effective, if recorded by the camera on a more extensive scale, the story of western history could have been.

At the time of Gardner's visit to Kansas a considerable proportion of the population lived along the line of the railroad. Gardner visited every town along the line, and in addition, he made several side trips. He photographed towns in their entirety, the principal streets of these towns, important state and federal institutions, striking geographical and geological structures, and much of the flora and fauna of "the great American desert." In all, over a hundred and fifty views were obtained on this trip. That Gardner viewed the West with the eyes of an easterner is quite evident from many of the titles given to the stereoscopic prints, for the broad sweep of prairie and plain evidently impressed him. For example, one is entitled, "View embracing twelve miles of prairie," and another,

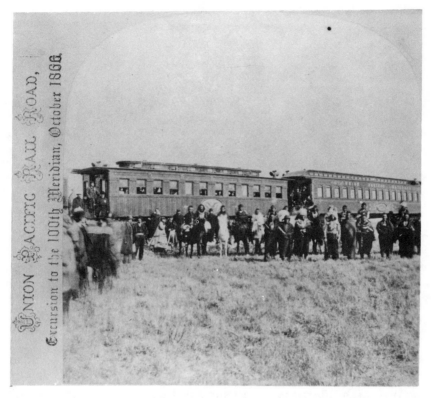

The excursion to the 100th Meridian, October, 1866. The "palace cars," as shown, transported the excursionists to the rail head, which was near the present town of Cozad, Nebraska, about two hundred and fifty miles west of Omaha. (Photograph by John Carbutt.)

"The extreme distance is five miles off." [305] Because of Gardner's energy, there is thus available a fairly complete and an exceedingly important pictorial history of Kansas in 1867.

Gardner, of course, employed the wet plate on this photographic excursion, and his dark room appeared in several of the photographs. It was simply a shelter of black cloth erected on a wagon bed, which he doubtless hired locally as he moved from one town to the next. Not only stereoscopic negatives, but whole-plate, 8″ x 10″ and 11″ x 14″ sizes were made as well. The prints from these large negatives, as might be expected, created considerable interest when shown in the East.[306]

In the spring of 1868, Gardner photographed an important frontier event, the well known peace conference between the United

[279]

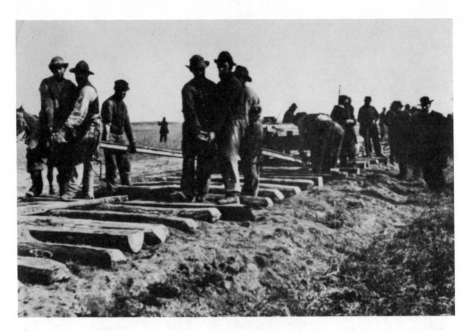

"Laying rails at the rate of two miles per day." The small figure in the background between the two groups of rail carriers has his gun pointed at a distant object, possibly an antelope. (Photographed at the 100th Meridian, October, 1866, by Carbutt.)

States Government and the Arapahoes and Cheyennes at Fort Laramie, Wyoming Territory. Of this event, there are a number of valuable historical photographs still available in the Missouri Historical Society. A number of these pictures were made, some as large as 13″ x 18″. They were, of course, printed from wet plate negatives.[307]

Captain A. J. Russel, another one of the Civil War photographers, was employed by the Union Pacific Railroad as its official photographer to record the construction of the road as it progressed westward. He apparently did not begin work before 1868, but during 1868 and 1869 he made a large number of views along the part of the road then under construction, which was by that time west of Cheyenne. Russel's photographs were made in various sizes, chiefly stereoscopic and whole-plate negatives.

For the benefit of eastern photographers, Russel described his photographic experiences along the Union Pacific, and he complained, as we have already noted in other instances, of the heat and the difficulty of getting clear water.[308]

Photographic work similar to that of Russel was conducted along

[280]

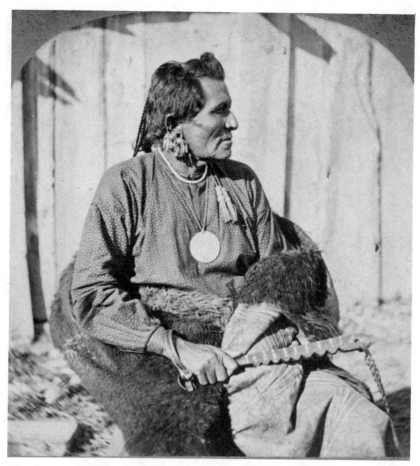

The Pawnee Indians, who "entertained" the excursionists to the 100th Meridian.
(Photograph by Carbutt, October, 1866.)
Peter LaCherre, the celebrated head chief of the Pawnees.

the Central Pacific Railroad. This was the road, built east from California, which finally connected with the Union Pacific at Promontory Point, Utah, where Savage secured his important negatives on May 10, 1869. The photographs along the route of the Central Pacific were made by A. A. Hart, a Sacramento operator. The Hart negatives were soon acquired by C. E. Watkins, of Yosemite fame. Watkins made and sold prints from these negatives for many years. Over three hundred stereographs were made by Hart, a fairly complete set of which is now owned by the Society of California Pioneers.[309]

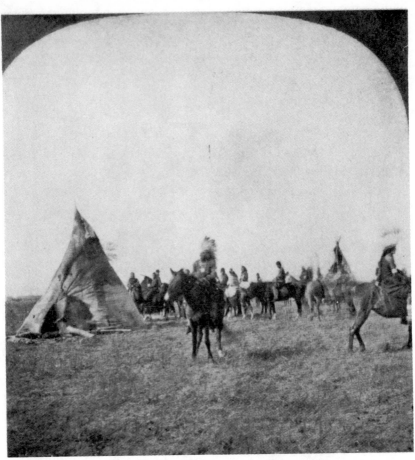

The Pawnee Indians, who "entertained" the excursionists to the 100th Meridian.
(Photograph by Carbutt, October, 1866.)
A Camp of Pawnees on the Platte River, close to the rails.

As we have seen, photography was used with more or less success in some of the explorations of the West immediately preceding the Civil War. The majority of such explorations were primarily geographic in purpose; that is, they were mainly concerned with the location and mapping of important geographical features—rivers and mountains. The knowledge of geography thus gained was primarily for the purpose of locating the most accessible trails, wagon roads, and possible rail routes from the East to the Pacific.

When exploration was resumed after the War, the objective had changed somewhat. The geography of the country, at least that of its salient features, was then thoroughly known, and the efforts were

now directed toward acquiring detailed geographic, geologic, and ethnographic knowledge of the country. Geologic interest was aroused principally because of the possibility of locating important mineral resources of the western country. As for the ethnography of the region, interest was probably due to the fact that the United States Army had begun a reduction in the Indian population. Although they were not successful in completely destroying the Indian, they were certainly successful in changing his mode of life. Probably the number interested in the study of Indian life was few, but there were some far-sighted individuals who realized the decided change that was about to take place in Indian customs, and who made attempts to record the old ways of living in their last stages.

Whatever may have been the incentive for these post-war explorations, certain it is that the official ones were granted government funds for *geological* surveys, and usually these surveys carried photographers with them. The photographic work of these later explorations was far more successful than that of the earlier ones had been. This greater success was undoubtedly a result of the thorough mastery of the wet process, for by this time (that is, after 1865) prepared collodion was commercially available, and the uncertainties attendant upon the preparation of this material by the individual operator had been eliminated. Without doubt, too, the training and experience of four years' expeditionary photography during the War was another contributory cause to the greater successes of photographers in the field. As a matter of fact, the first of the important geological surveys to be made after the War included in its personnel a Civil War photographer of very considerable experience, T. H. O'Sullivan. The expedition was the United States Geological Exploration of the Fortieth Parallel under the direction of Clarence King. The survey began in western Nevada, July 1, 1867, and was continued for several years. O'Sullivan was the photographer for the expedition during the years 1867, 1868, and 1869.[310]

The reports of this expedition contain many illustrations copied from O'Sullivan's photographs (all lithographic copies), but the most extensive account of O'Sullivan's own experiences during the first year of this expedition was given in *Harper's Magazine* for

Omaha in October, 1866 (photograph by Carbutt).

September, 1869, in an article entitled, "Photographs from the High Rockies." [311] The article, by John Sampson, curiously enough, does not mention O'Sullivan by name, but it does contain thirteen illustrations (from wood engravings) copied from his photographs. Fortunately, through the courtesy of Captain W. H. Crosson of the Engineers' Corps, U. S. A., I have been able to obtain a number of O'Sullivan's original photographs, some of which, originally published in *Harper's Magazine,* served to establish definitely the identity of the photographer.

The party with which O'Sullivan was associated first visited Nevada City and obtained a number of interesting and important views of the Great Comstock Lode in the days when mining in that region was near its zenith. O'Sullivan even went into the mines

[284]

The dark tent devised by Carbutt for field work. The view at the left with the back removed shows the interior equipment. (From the *Philadelphia Photographer*, 1866.)

themselves and made a number of photographs hundreds of feet below the surface, using burning magnesium wire to obtain sufficient light for his picture-taking. As far as I know, these were the first "interior" mine views made in this country. The year before O'Sullivan's photographs were made at Nevada City, Charles Waldack of Cincinnati had photographed the interior of Mammoth Cave in Kentucky by the use of magnesium light.[312] It may have been Waldack's photographs that suggested to O'Sullivan the possibility of securing mine pictures, as the Waldack photographs were quite widely known and regarded as one of the miracles of "modern" photography.

The expedition which O'Sullivan accompanied soon left the haunts of civilization and proceeded eastward along the 40th parallel through a country which was, for the most part, "absolutely wild and unexplored, except what the Indians and fur trappers who frequent the mountains may have accomplished in the way of exploitation." The Humboldt and Carson Sinks, the Ruby Range, "one of the finest of the Rocky cordon," the Shoshone Falls of the Snake, among other scenes, were recorded by O'Sullivan's camera. Some of the hardships attendant upon such work of exploration,

[285]

Alexander Gardner's photographic outfit used on his visit to Kansas in the fall of 1867. (Courtesy Kansas State Historical Society.)

which fell doubly hard upon the photographer, with far more than his share of equipment, are described by O'Sullivan in an account of the Humboldt Sink:

"It was a pretty location to work in, and *viewing* there was as pleasant work as could be desired; the only drawback was an unlimited number of the most voracious and particularly poisonous mosquitoes that we met with during our entire trip. Add to this the entire impossibility to save one's precious body from frequent attacks of that most enervating of all fevers, known as the 'mountain ail,' and you will see why we did not work up more of that country. We were, in fact, driven out by the mosquitoes and fever. Which of the two should be considered as the most unbearable it is impossible to state." [313]

In 1870 O'Sullivan temporarily forsook the West to accompany Commander Selfridge's expedition, which was sent out by the government, to make a survey for a ship canal across the Isthmus of Panama (called at that time the Isthmus of Darien). O'Sullivan

[286]

Fort Harker, an army post established in 1866 to protect settlers and railroad construction parties, now long since dismantled. (Photograph by Gardner, October, 1867; courtesy Kansas State Historical Society.)

recorded the wonders of the tropics as he had those of the high Rockies. Without doubt, his experience with mosquitoes in the Humboldt Sink stood him in good stead in the steaming swamps of the Isthmus.[314]

The next year he was back again in the States, where he joined Lieutenant George M. Wheeler in a series of surveys in the Southwest. He was associated with Wheeler not only in 1871, but also in 1873 and 1874. During the last year he secured a number of photographs of the Pueblo ruins in Canyon de Chelle in what is now northern New Mexico. Like the reports of the King expedition, those of Wheeler's explorations contain many lithographic illustrations copied from O'Sullivan's photographs, and his work was highly commended by Wheeler in the official reports. In the report of the 1871 explorations, Wheeler states, for example: "In the hands of Mr. O'Sullivan, well known in connection with his labors on the Fortieth Parallel Survey and Darien Expedition, a little less than 300 negatives have been produced, illustrating the general appear-

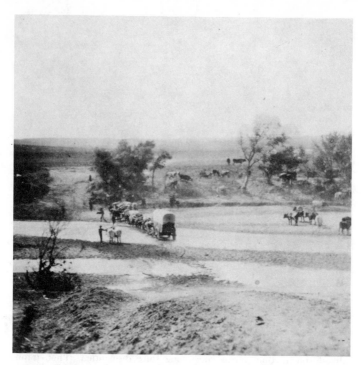

A bull train crossing the Smoky Hill River near Ellsworth, Kansas.
(Photograph by Gardner, October, 1867; courtesy Kansas State Historical
Society.)

ance of the country, the mining districts, certain geological views, and a full and characteristic representation of that very grand and peculiar scenery among the cañons of the Colorado; a more unique series has hardly been produced in this country." [315] W. H. Jackson writes me, "I knew O'Sullivan quite well. He was one of the best of the government photographers." This is generous praise from one regarded as the most outstanding of all frontier photographers.

Before we describe Jackson's work, mention should be made of the labors of John K. Hillers with the Powell Surveys, chiefly in southern Utah and Arizona. In 1869, John W. Powell, with a small party, had descended the previously unknown Colorado River, through its majestic canyon, "one of the greatest feats of exploration ever executed on this continent." As a result of this feat, the government employed him for a number of years in the exploration of this region. The second Powell expedition was fitted out in 1871,

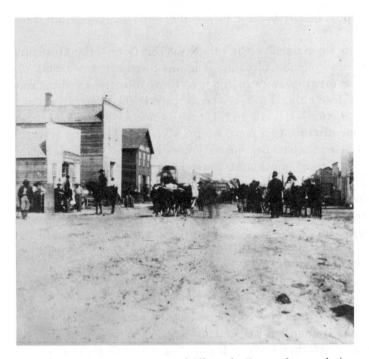

A frontier town: the main street of Ellsworth, Kansas, famous during the days of the Texas cattle trade. The town was but three months old when photographed by Gardner, October, 1867. (Courtesy Kansas State Historical Society.)

and its personnel included two photographers, E. O. Beaman, and his assistant, Clement Powell. Beaman left the Powell survey after 1871, and for the years 1872, 1873, 1874, 1875, 1876, and 1878, Hillers was its photographer.

Hillers' photographs, on the whole, are somewhat better known than are O'Sullivan's, chiefly for the reason that a member of the second Powell expedition, the late Frederick S. Dellenbaugh, has written extensively of these explorations in recent years, and in his writings has reproduced many of the photographs by facsimile methods.[316]

Several years ago Mr. Dellenbaugh kindly wrote me concerning Hillers' initiation into a photographic career, and I believe what he says is worth recording here:

"Jack Hillers was engaged by Powell for the second trip, in Salt Lake City, to pull an oar and to help generally. He knew nothing then about

photography, but he became much interested as we went on down Green River.

"When we arrived at the mouth of the Green, the sandbank on the right, at head of the Colorado, as it was then, where we were obliged to camp, was melting away in huge sections into the swirling waters. We were therefore obliged to take special care of the boats. In order to guard our boat better—Hillers and I rowed in the same boat—we dropped down some distance to a place where we could run a line across the sandbank and tie to a hackberry tree. There he and I camped. Sitting by the fire, Hillers asked me about photography—about the chemical side. I explained about the action of light on a glass plate coated with collodion and sensitized with nitrate of silver, the bath to eliminate the silver in hypo, and so on.

" 'Why couldn't I do it?' he said. I replied that he certainly could, for he was a careful, cleanly man, and those were the chief qualities needed. I advised him to offer his help to Beaman whenever possible (and aid was then necessary to transport the heavy boxes), and perhaps Beaman would let him try a negative. He did, and in two or three weeks had made such progress that he overshadowed Clement Powell.

"When Beaman left at the end of our first season of river work, the photography fell on Clement. He made a trip with Hillers as assistant and returned with nothing. He declared Beaman had put hypo in the developer. Beaman, who had lingered in Kanab, where our headquarters for the winter was established, said he had not done so—that the trouble was Clem's carelessness.

"Meanwhile, Powell had sent to Salt Lake City to see if a photographer could be found there who would come down and who would go through the Grand Canyon with us the next summer. James Fennemore came. He was an excellent photographer and a genial fellow. He still lives in Salt Lake City. He was good to Hillers and gave him much instruction, with the result that Hillers became expert in the work; became assistant, in fact.

"In the spring of 1872, some of us made a trip to explore the southeast corner of Utah. Four of us were sent down through Glen Canyon in the *Canonita,* which had been cached for the purpose the previous year, to make photographs and further studies.

"Hillers did some excellent work with Fennemore's guidance. When we were preparing to enter the Grand Canyon in the summer of 1872, Fennemore was taken sick, as was also Johnson, another who had joined us for the winter's work. They could not proceed. And we could not find anyone else who desired to do the Grand Canyon with us. This left us with only seven men. One boat had to be left behind. All the boats

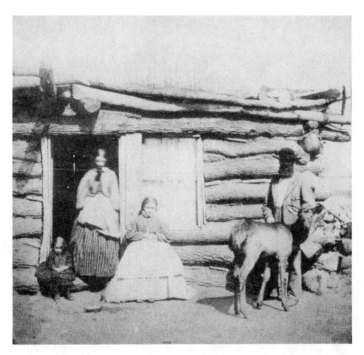

A ranch house of central Kansas. Notice the sod roof and the tame elk. (Photograph by Gardner, October, 1867; courtesy Kansas State Historical Society.)

were badly battered. We discarded the *Nellie Powell,* which was in the worst condition. Well, what I am coming at is this; there was nothing for it but to make Jack Hillers photographer-in-chief. He was equal to the job. In spite of enormous difficulties, great fatigue, shortage of grub, etc., he made a number of first class negatives." [317]

That these are really first class, anyone interested can discover by examining the many excellent illustrations to be found in Dellenbaugh's *Canyon Voyage.*

* * * * * * *

William H. Jackson, whose photographs of the West became the best known of all, began his photographic career at Omaha at the age of twenty-five. A veteran of the Civil War, at its close he went West, traveled across the plains and the mountains to California before the coming of the railroad, and eventually became a professional photographer in the growing frontier town of Omaha in the early part of 1868. Several years of life in the open made it difficult

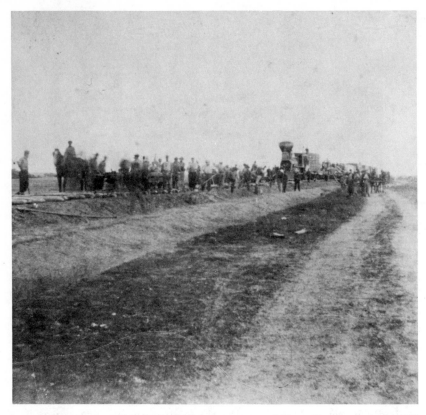

Laying track twenty miles west of the present town of Hays, Kansas, Oct. 19, 1867. (Photograph by Gardner; courtesy Kansas Historical Society.)

for him to accommodate himself to the sedentary life of a village photographer. Having secured the services of his brother to take care of much of the gallery work, he fitted up a traveling dark room on a buckboard "chassis" and toured the country around Omaha, photographing chiefly the local Indians.

In 1869, he went on a photographic tour along the newly completed line of the Union Pacific, and, while on this trip, he met Dr. F. V. Hayden, who was engaged in one of the several geological surveys of the West then under way. Hayden became much interested in Jackson's work, and as a result made arrangements with Jackson to accompany the Hayden survey of 1870. From this time until 1879, Jackson was the official photographer of the Hayden Surveys.

[292]

Trestle at Promontory Point, Utah, recorded shortly after the completion of the first transcontinental line, May 10, 1869. (Photograph by Capt. A. J. Russel.)

Jackson brought to this work an artistic temperament, considerable experience as an artist of the pencil and the brush, a love of life in the open, and the benefit of his several years of photographic work. This fortunate combination of factors accounts in some measure for his marked success, but he was also fortunate in that the country Hayden was then exploring was destined to become well known the world over.[318]

The work of the Hayden survey of 1870 followed chiefly the Oregon trail through Wyoming, passing such famous landmarks as Independence Rock, South Pass, and Fort Bridger. Encamped at South Pass was Washakie, the famous Shoshone chief, and his tribe. Jackson obtained photographs of this tepee village and of Washakie, the negatives of which are still in the possession of the Smithsonian Institution in Washington. These photographs are among the few of the Indian in his native habitat before he was forced into reservation life. Hayden was directly responsible for such photographs, as

Thousand Mile Tree. The tree, a thousand miles west of Omaha, was a well known landmark on the Union Pacific Railroad for some years. (Photograph by Russel, 1868.)

he was one of the small number interested in the ethnology of the Indian, and he encouraged Jackson's work in this direction. Jackson was himself interested in this subject, as we have already mentioned, and needed no urging. Not only did Jackson make Indian photographs, but, in 1877, he compiled an extensive catalog of the then available photographs of North American Indians.[319]

It was on the Hayden survey of 1870 that Jackson Canyon was named. This is a picturesque canyon a few miles southwest of the present town of Casper, Wyoming. Not only is there a canyon named for a photographer; several mountains commemorate the names of other prominent photographers of the West who have already appeared in these pages. They are Jackson Butte of the Mesa Verde, also named for W. H. Jackson, Mt. Watkins in the Yosemite National Park, named for C. E. Watkins, and Mt. Hillers in the Henry Mountains of southeast Utah, named for Jack Hillers of the Powell surveys in 1872. In addition, Mt. Haynes in Yellowstone National

Flume and railroad at Gold Run, Central Pacific Railroad under construction. (Photograph made 1865 or 1866.)

Excursion at Cape Horn, three miles from Colfax (about fifty miles west of Sacramento), Central Pacific Railroad, 1865. (Both photographs by A. A. Hart; courtesy Society of California Pioneers.)

Park is named for F. T. Haynes, whose work will be mentioned within a few pages. There should be geographical memorials for several other photographers of the early West; O'Sullivan especially deserves the honor.[320]

Gold Hill and Silver City. famous in mining annals. (Photograph by T. H. O'Sullivan, 1867; courtesy Captain W. H. Crosson, U.S.A.)

O'Sullivan's outfit with the King expedition. Photograph made 100 miles south of the Carson Sink in a desert of shifting sand mounds, 1868. (Courtesy Captain W. H. Crosson, U.S.A.)

The Hayden survey of 1871 in many respects was the most important of the entire Hayden series. Its work was confined entirely to the region now known as the Yellowstone National Park. In fact, the Park probably owes its present status to the Hayden survey of this year.

The wonders of the Yellowstone had been related around the camp fires of the West for many years, but no exploration of the country had been undertaken until 1869, when a group of Montana

The start of Lieutenant Wheeler's expedition from Camp Mojave, Arizona, September 15, 1871. The expedition ascended the Colorado River through a portion of the Grand Canyon to the mouth of Diamond Creek; thirty-one days were required to travel 260 miles. (Photograph by T. H. O'Sullivan.)

A characteristic mountain park and Apache Indian Farm, ten miles east of Camp Apache, Arizona. (Photograph by T. H. O'Sullivan on Wheeler's expedition of 1873.

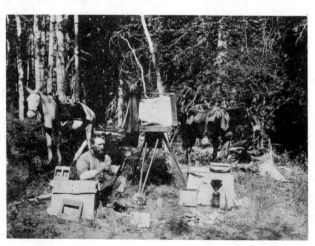

Jack Hillers, Photographer of the Powell surveys, and his equipment, 1871. (Courtesy the late F. S. Dellenbaugh.)

Jackson (in lead), his pack mule, and his helper on Hayden's Survey of 1870. The mule was appropriately called "Hypo." (Both photographs, courtesy W. H. Jackson, New York.)

William H. Jackson, from a self-made portrait, 1873.

citizens undertook the now well known Cook-Folsom expedition. This was followed the next year by further exploration under a party directed by General H. D. Washburn. As a result of the efforts of the Washburn expedition, Hayden decided to visit the region to obtain exact scientific data and photographic records. A well equipped party entered the present park from the north in July, 1871, and for over a month were engaged in exploring its wonders. Jackson recorded by the camera practically all of the scenic marvels now so well known. The Mammoth Hot Springs, Old Faithful, the Grand Canyon of the Yellowstone, the Geyser Basins, the waterfalls, and the prominent mountains and valleys were thus recorded. The first photographs of the present park were made in the vicinity of Mammoth Hot Springs. As first events are always of interest to the historian, I wrote Mr. Jackson several years ago asking if he could tell me what was the first photograph ever made in Yellowstone Park, a photographic event of some importance when one reflects for a moment upon the millions of pictures taken in the Park since

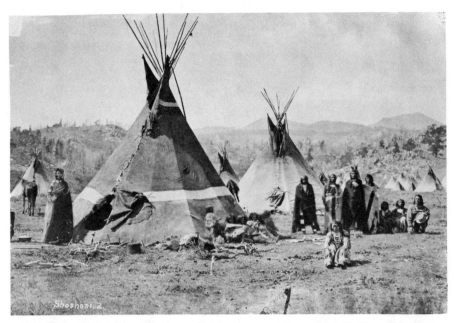

A part of Washakie's tepee village encamped near South Pass, 1870. (Photograph by Jackson.)

Washakie, the celebrated Shoshone chief, and friend of the whites. The Washakie National Forest and Fort Washakie in west central Wyoming are both named for this warrior. (Photograph by Jackson near South Pass, 1870; both photographs, courtesy U.S. National Museum.)

1871. (Any one who has been in the Park knows that "millions" is no exaggeration, for the sound of the shutter is heard the livelong day.) Mr. Jackson replied as follows: "I cannot identify the *first* picture made at Mammoth Hot Springs, that being the first subject for photography within the present limits of the Park; but it was either the general view from the top of 'Lookout Hill' or one of the so-called pulpits or terraced basins at the foot of Jupiter Terrace, our first camp being pitched at the foot of this terrace."

The real value of Jackson's photographs became apparent the following winter, when through the efforts of Hayden and of N. P. Langford and William H. Clagett, a bill was prepared and intro-

[299]

Some of the views that helped to make the Yellowstone region better known to the public.

One of the first photographs ever made in Yellowstone National Park—Mammoth Hot Springs. (Photograph by W. H. Jackson, July 15 or 16, 1871.)

Thomas Moran inspecting Mammoth Hot Springs. (Photograph by W. H. Jackson, July 15 or 16, 1871.)

Hayden's expedition encamped in the present Yellowstone Park, summer, 1871. (Photograph by Jackson.)

duced into both houses of Congress setting aside the Yellowstone as a National Park—the first National Park.

Jackson's photographs were prepared and placed on exhibition

The Grand Canyon of the Yellowstone. (Photograph by Jackson, 1871, courtesy G. E. Mitchell, U.S. Geological Survey.)

One of the first views of the wonderful falls of the Yellowstone River: the Lower Falls (photograph by Jackson, 1871).

A view in the lower canyon of the Yellowstone River. The small figure seated on the rock is Thomas Moran, the landscape painter. (Photograph by Jackson, summer, 1871.)

and had an immense influence in securing the desired legislation. Senator Pomeroy, of Kansas, who introduced the Senate bill, had some difficulty in getting its consideration. The second time he attempted to bring up the matter in the Senate he remarked, "There are photographs of the valley and the curiosities, which Senators can see." [321] The Senators must have seen them, for the next time the bill came up for consideration it was passed without dissent, and on March 1, 1872, President Grant signed the bill creating the Yellowstone National Park.

The value of these photographs in aiding in the passage of this bill is also attested by Chittenden, the historian of the Park, who says, "The photographs were of immense value. Description might exaggerate, but the camera told the truth; and in this case the truth was more remarkable than exaggeration. . . . They did a work which no other agency could do and doubtless convinced every one who saw them that the region where such wonders existed should be carefully preserved to the public forever." [322]

The photographs of Yellowstone made by Jackson were not the only *first* photographs of regions now become National Parks which this pioneer photographer was fortunate enough to secure. In 1872, the year after the Yellowstone expedition, he photographed extensively in the Grand Tetons, and was therefore the first photographer in the region which is now the Grand Teton National Park. In 1874, southwestern Colorado was visited and Jackson and Ernest Ingersoll of the New York *Tribune* discovered and photographed ruins of cliff-dwellings in what is now the Mesa Verde National Park.

One other photographic record made by Jackson plays a part in the history of American literature. The photograph was that of the Mount of the Holy Cross, in the heart of the Colorado Rockies. It was made in 1873 on a trip which included, by the way, the making of many views in what is now the Rocky Mountain National Park. I am inclined to think, however, that Jackson was not the first photographer in this region. The Mount of the Holy Cross had never before posed for its photograph, although it had long been an object of much wonder and veneration. Jackson, after many

The first photograph in the present Mesa Verde National Park. The Mesa Verde Cliff House, photographed by Jackson, September 7, 1874. The standing figure is "Capt." John Moss, guide, and the seated one, Ernest Ingersoll of the *New York Tribune*.

One of the first photographs made in the present Grand Teton National Park by W. H. Jackson, July, 1872. Jackson and his dark tent far above timber line. The Three Tetons appear dimly in outline in the upper right as photographed from the west. (Courtesy G. E. Mitchell, U.S. Geological Survey.)

Custer's Expedition to the Black Hills, 1874. (Photograph by W. H. Illingworth; courtesy the late F. S. Dellenbaugh.)

Mount of the Holy Cross. (Photograph by Jackson, 1874; courtesy W. H. Jackson.)

Main Street, Deadwood, Dakota Territory. (Photograph by F. J. Haynes, 1877; courtesy J. E. Haynes, St. Paul.)

F. J. Haynes at the Great Falls of the Fort Benton, Montana. in 1878. (Photograph
Missouri, 1878. Note the stereoscopic camera. by F. J. Haynes, both photographs, courtesy
 J. E. Haynes, St. Paul.)

difficulties, secured a set of remarkable views of the peak and the
Cross, one of which was subsequently published in Hayden's report.

This report chanced one day to fall into the hands of Longfellow,
the poet. Longfellow, in whom, as we have already seen, pictures
readily induced a creative mood, "was arrested by a picture of that
mysterious mountain upon whose lonely, lofty breast the snow lies
in long furrows that make a rude but wonderfully clear image of a
vast cross. At night, as he looked upon the pictured countenance
that hung upon his chambered wall (that of his wife, dead for many
years), his thoughts framed themselves into the verses that follow.
He put them away in his portfolio, where they were found after his
death." [323] The poem is the familiar one that contains the lines:

> "There is a mountain in the distant West
> That, sun-defying, in its deep ravines
> Displays a cross of snow upon its side."

* * * * * * *

O'Sullivan, Hillers, and Jackson were not the only photographers
employed on exploratory surveys of the West between 1865 and
1880. The work of the others, while not so extensive as was that of
these three stalwarts, was important in its day, but unfortunately

[305]

their photographs are difficult to find and consequently are not so well known. In some instances, the name of the photographer on these expeditions has not been determined. Although we cannot describe their work in detail, they at least deserve mention, and their activities may be briefly summarized.

1865: Major R. S. Williamson's expedition in California and Idaho. Photographer, John D. Hoffman.[324]

1870: Although not a government expedition, E. and H. T. Anthony and Co. of New York sent T. C. Roche, another Civil War photographer, across the entire country to obtain a series of stereographic views along the Union and Central Pacific Railroads. Roche also included Yosemite Valley in his photographic travels.[325]

The same year S. J. Sedgwick began his photographic tours in the West. From his negatives, and from those of Russel and others, Sedgwick made over two thousand lantern slides to illustrate stereopticon lectures on the West, which he successfully gave in the East for over six years.[326]

1871: Captain J. W. Barlow's reconnaissance of Wyoming and Montana Territories. Photographer, T. J. Hines. Barlow's expedition entered the region of Yellowstone Park at practically the same time as the Hayden survey of the same year, and many of Hines' views were made in the present Park. Unfortunately, Hines, who was a Chicago photographer, waited until his return home to make prints from the negatives. Sixteen prints were made on the day that Hines began work, but the next day came the great Chicago fire, which destroyed all of Hines' negatives. The sixteen prints were apparently saved, for they are mentioned in Barlow's report, and are probably in the archives of the War Department.[327]

1872: Lieutenant George M. Wheeler's expedition in Utah and Arizona. Photographer, William Bell. Bell was one of the few expeditionary photographers during wet plate days to employ a dry process, very probably the tannin process. Jackson had attempted the use of the dry process in 1869 and again in 1877 but was successful neither year.[328]

1873: Lieutenant E. H. Ruffner's expedition to the Ute country. Photographer, T. Hines.[329]

The same year a photographer (probably S. J. Morrow) accom-

[306]

panied the Yellowstone expedition, under General D. S. Stanley, which had been sent out to protect the exploring and construction parties of the Northern Pacific Railway. General George A. Custer was a member of this party, and under date of September 6, 1873, wrote his wife, mentioning the work of the camera artist as follows: "The photographer who accompanied the scientists hitched up his photographic wagon and drove over to take a picture. . . . The picture is to form one of the series now being collected on the expedition under the auspices of the Smithsonian Institution." [330]

1874: General George A. Custer's expedition to the Black Hills of the Dakotas. Photograp_her, W. H. Illingworth of St. Paul. The photographs of this expedition are fairly well known, and many have been reproduced photo-mechanically within the last few years. A number of the original negatives are now in the possession of the South Dakota State Historical Society.[331]

1875: Jenney and Newton's expedition to the Black Hills of the Dakota Territory. Photographer, V. T. McGillycuddy, M.D.[332]

1877: Captain W. S. Stanton's survey of routes in Wyoming Territory. One of the enlisted men on this survey served as photographer, but his name is not reported.[333]

Four other widely known photographers were fortunate enough to begin their work in the wet plate days, although their reputations were largely established after 1880; that is, after the introduction of the gelatin dry plate. These men were S. J. Morrow, D. F. Barry, L. A. Huffman, and F. J. Haynes.

S. J. Morrow, a veteran of the Civil War said to have been trained by M. B. Brady, began his professional career at Yankton, Dakota Territory, about 1870. He is best known for his photographs of the Custer battlefield taken the year after the Custer tragedy (1876), for his views of frontier forts, and for views and portraits of interest to Dakotans from 1875 up to fairly recent times.[333a]

Barry began his photographic career at Bismarck, Dakota Territory, about 1875; he is noted chiefly for his Indian portraits, most of which were made after 1880.[334] Huffman's work began in 1878 at Miles City, Montana. Huffman was one of the few photographers to record the buffalo when they still roamed the range, but it can

be seen that the above date was very close to the end of the buffalo era, and the huge herds were rapidly diminishing.[335]

Frank Jay Haynes' professional career started at Moorhead, Minnesota, in 1876. The following year he made a photographic tour by stagecoach to Deadwood, Dakota Territory, a mining town then in its infancy. In 1878, he undertook a three-thousand-mile tour up the Missouri River to Fort Benton. Many of these negatives still exist and constitute an important record of the last frontier. It was as the official photographer of Yellowstone Park that Haynes achieved his lasting fame, an appointment made in 1884, and continued for thirty-two years. When he relinquished it in 1916, his son, J. E. Haynes, succeeded him. For over fifty years the name and photographs of the Haynes Studios have brought pleasure and pleasant memories to thousands of Park visitors.[336]

These wet plate photographers of the West, without exception as far as I know, always made stereoscopic negatives, as it was from these that their main income was derived. Many times the expeditionary photographers, at least those employed on government surveys, received but little except subsistence from the government, and therefore depended upon the sale of prints for any returns on their venture. Since at that time stereoscopic views were still popular, such prints were the best sellers. Usually, however, additional equipment was taken along to take larger views; whole size and eight by ten inches were popular for the larger sizes.

Jackson, on his trip into the San Juan Mountains of Colorado in 1875, used a camera that took tremendous negatives 20″ x 24″ in size, possibly suggested by Watkins' large negatives of the Yosemite. But Jackson's pictures were much larger than those Watkins had attempted. Imagine the difficulties of using such equipment—not only of flowing and sensitizing the plates, but of transporting the camera and the glass plates over hazardous mountain trails. At one time the pack mule bearing the huge camera actually fell off the trail. The contemporary accounts describing the prints from these negatives express amazement that such plates could be made in the mountains in almost inaccessible positions. "Most photographers consider manipulation of 20 x 24 plates formidable enough under the most favorable circumstances." [337]

[308]

Jackson's 1875 trip was his only attempt to use so large a camera, for each camera added to the load to be packed and transported, usually by mule train, and for this reason the equipment was carefully selected. A typical list of equipment carried by an expeditionary photographer of the early seventies actually included on one trip:

Stereoscopic camera with one or more pairs of lenses
5 x 8 Camera box plus lens
11 x 14 Camera box plus lenses
Dark tent
2 Tripods
10 lbs. Collodion
36 oz. Silver nitrate
2 quarts Alcohol
10 lbs. Iron sulfate [developer]
Package of filters
1½ lbs. Potassium cyanide [fixer]
3 yds. Canton flannel
1 Box Rottenstone [cleaner for glass plates]
3 Negative boxes
6 oz. Nitric acid
1 quart Varnish
Developing and fixing trays
Dozen and a half bottles of various sizes
Scales and weights
Glass for negatives, 400 pieces

This was the equipment of W. H. Jackson on his first trip with the Hayden surveys. Imagine packing and unpacking this material, possibly several times a day, and always after a long and strenuous day's travel. True, not all had to be unpacked every time, as by proper sorting the equipment necessary for the day's work could be separated in advance from the rest, but at best it was a trying task. Jackson, who has left a more extensive account of his experiences than have the rest, states: "When hard pressed for time, I have made a negative in fifteen minutes, from the time the first rope was thrown from the pack to the final repacking. Ordinarily, however, half an hour was little enough time to do the work well. Thirty-two good negatives is the largest number I ever made in one day." In

response to an inquiry concerning exposures employed, Mr. Jackson wrote to me:

"No shutters were employed, all exposures were by cap. In my landscape work I usually stopped down to about F/32 with an average exposure on a bright, clear day of 10 to 15 seconds (5 seconds in absence of near foliage)—more or less according to the condition of the collodion and the silver bath. A rather new but 'ripe' collodion and a new, nearly neutral silver bath gave the maximum results. On a well lighted subject at F/8 'instantaneous' exposures could be made with the primitive drop shutter." [338]

The Cabinet Photograph

THE WORK of the professional photographers in the West marks the beginning of a "landscape school" in American photography, although so formal a phrase may scarcely be justified. American professionals up to 1870 had been interested almost entirely in portrait work, and even after this date such labors continued to form by far the greater part of the photographic trade.

Certainly the landscapes of Watkins and of Jackson were of sufficient merit to warrant their being called "photographic art." Both were skillful workers and possessed considerable ability in composition. Considering the freshness of the field, it is no wonder that their labors drew well deserved attention. Dr. Hermann Vogel, the well known German authority on photography, and a juror on several international photographic exhibitions, was especially impressed with Jackson's work and made the remark that his views were "the most magnificent collection of landscape photographs I had anywhere ever seen." [339]

The work of the other photographers of the West, although not so impressive as Jackson's, brought to the rest of the world the first authentic pictorial records of this rapidly developing country. Those of Jackson formed an important link in the creation of our present National Park System. It is almost impossible to estimate the effect of these photographs, especially when we consider the number of people who have visited our Parks since 1872. If we admit that the American photographer played even a small part in making the Parks possible, we are helpless in attempting any estimate of his influence on American life. Consider also the equally devious train of events that often followed the chance inspection of a stray stereograph of any Western scenery or event. Many times, doubtless, an idle glance created the desire to see for oneself the original of the scene depicted, and putting the desire into action, many were led to

"Delaware Water Gap"—a photograph by John Moran in September, 1863, with a 3-inch Globe lens, smallest stop; exposure, twenty seconds.

"Noonday Rest"—a photograph by John Moran, summer of 1864.

new experiences, new modes of life, and to the attendant changes in the destiny of the individual. If we cannot evaluate these influences, we can at least call attention to them in passing.

It should not be understood that the East was without enthusiasts in landscape photography. It will be recalled that in the early sixties many amateurs became interested in this fascinating pastime. After the Civil War several Eastern professionals became interested in landscape work, and their names deserve proper entry in our chronicle of events. The work of the Kilburn Brothers of Littleton, New Hampshire, belongs in this class. The brothers, Benjamin West Kilburn and Edward Kilburn, were natives of the town of Littleton, and of English descent, but so far as I have been able to ascertain, were not related to the English firm of Kilburn Brothers, whose landscape work was so much admired in England in the early fifties.

The partnership between these brothers was formed shortly after the Civil War, the actual photographic work being done by B. W. Kilburn. Kilburn at first confined himself to making views in the White Mountains, views which soon became widely known. As the business of this firm increased, Kilburn began traveling farther away from home in search of material—a search which finally extended all over the world. Negatives were bought from other photographers, and a very extensive collection of stereoscopic views was published. The brothers continued to do business until the date of the death of B. W. Kilburn in 1909, at which time they owned over 100,000 negatives. These negatives were subsequently acquired by the well known firm, the Keystone View Company.[340]

Another landscape photographer of considerable ability was John Moran of Philadelphia. Moran was a brother of Thomas Moran, the celebrated painter, and both were members of a celebrated family of artists. The early issues of the *Philadelphia Photographer* contain a number of his original photographs, several of which are here reproduced. One of the chief points of interest concerning Moran is that photography found in him an able positive advocate of the question, "Is photography an Art?" This question had been raised almost at the birth of the new process for making pictorial records. Delaroche's celebrated prophecy, "Painting is from this day dead," made in 1839, had fallen far short of fulfill-

Echo Lake and Mt. Lafayette, Franconia Notch, New Hampshire. (Photograph by B. W. Kilburn, about 1875.)

ment. From that time on, one frequently encounters argument and counterargument on the question of whether photography were an art, painters for the most part maintaining that it was not, and practitioners of the new process that it was—if not with equal logic, certainly with equal heat.[340a]

The social historian, obviously, is not in a position to answer this question, nor is it his function. The question is still argued, but there appears to be developing at present a satisfactory and logical system of aesthetics based on the distinguishing features of the photograph.* The social historian is interested, however, in a question which is interwoven to some extent with the above question; namely, "Are photographs historic documents?" Such a question can be answered.

The camera, potentially at least, has the ability to record *everything* save color, down to exceedingly minute detail, which appears before it, in exactly the same proportions as it appears in the original. Not that the camera does not lie, for it does—or, what is more strictly accurate, *it can be made to lie*. Some of these abuses we have listed in a later chapter (Chapter Twenty-one), but the factual ability of the camera is of the greatest importance when we consider the photograph as a historic document, that is, a record upon which history is to be based. From the historian's point of view the subject is more important than the artistic qualities displayed in its delineation and in recording the subject as it is—or was—the photograph has the advantage over any graphic art. The artist can at will, and

* Beaumont Newhall's recent penetrating analysis of the problem, which at least outlines a system of photographic aesthetics, deserves the most careful consideration of any one concerned in its answer.[341]

[314]

Washington from the Capitol, June 27, 1861. The Smithsonian Institution is seen in the left center, the unfinished Washington Monument to its right, and Pennsylvania Avenue on the extreme right.

Washington from the Capitol, December, 1937. (Photograph by Dr. A. J. Olmsted, Photographic Laboratory, U.S. National Museum.)

frequently does, leave out or insert objects not in the scene before him, or he can depict a scene as he *imagines* it to be. As a result there has developed a psychological difference in our regard for the photograph as contrasted to graphic art, a difference which Beaumont Newhall has so intelligently pointed out.

We believe—no matter how well founded our belief—that the photograph re-creates the original scene with absolute fidelity to fact. For these reasons, real or psychological, it is asserted that photographs are valuable historic documents. Like other facts upon which recorded history is based, they must be appraised and their authenticity determined.* Suitable criteria for this purpose will shortly be given, but that the photograph gives a vivid and valuable supplement to written history cannot be denied. In some years' reading, I have never encountered serious argument against such a proposition. Occasional criticisms are encountered, but, when analyzed, such criticisms are found to be based upon an assumed face value which, as has been pointed out above, is not warranted without due appraisal.

Note possibly should be made of an implied criticism in a recent editorial in the New York *Times*.† The *Times*, commenting on a historical picture book for adults—a kind of book which has apparently increased in popularity in recent times—called attention to the fact that in the middle of the book there is a shift from reproduction of paintings and drawings to that of photographs. The *Times* complains that the change to the photograph renders recent history much less romantic than that portrayed by graphic art. Such a view naturally raises the question of whether history should be made romantic.

It is quite probable that our nearness to recent events would render any *truthful* portrayal of contemporary happenings disillusioning. Time has a habit of lending dignity and a romantic aspect to events far in the past, no matter how portrayed, whether by the painter or by the photographer. George Bernard Shaw, however, does

* It might be pointed out that historians and writers, in general, have shown a singular disregard for this principle. "From a contemporary photograph (or print)" is a frequent caption—without other documentation—for an illustration. These same writers, many times, have given most careful attention to the sources of written fact, but almost none to pictorial ones.

† October 26, 1935, p. 14.

Prize landscape photographs. *Upper*—"Old Mill." Photograph by John C. Browne, a Philadelphia amateur, May, 1870, with a Dallmeyer rapid rectilinear lens of 11-inch focus, stopped down to 0.45 inch; exposure, thirty seconds. *Lower*—The Dalles of St. Croix. Photograph by C. T. Zimmerman, a St. Paul professional, 1870, with a "Scovill Achromatic Meniscus Stereo lens" of 9-inch focus, stopped down to ⅜-inch; exposure, 45 seconds at 4 p.m. In a contest sponsored by the *Philadelphia Photographer*, the Browne photograph was awarded first prize and the Zimmerman, second prize.

not see eye to eye with the editor of the *Times,* for he had written some years previously: "True, the camera will not build up a monumental fiction as Michael Angelo did, or coil it cunningly into a decorative one, as Burne-Jones did. But it will draw it as it is, in the clearest purity or the softest mystery, as no draughtsman can or ever could. And by the seriousness of its veracity it will make the slightest lubricity intolerable. . . . Photography is so truthful—its subjects so obvious realities and not idle fancies—that dignity is imposed on it as effectually as it is on a church congregation." Shaw later pointed out that "there is a terrible truthfulness of photography which sometimes makes a thing ridiculous"; possibly it was such a circumstance that the editor of the *Times* had in mind but the implied criticism, mentioned above, is, in truth, a recognition of the psychological difference between the photograph and graphic art, and further emphasizes its value in recording the past.[342]

The criteria by which the historic value of a photograph may be judged can be stated as follows:

1. Such a photograph should truthfully record significant aspects of our material culture or environment, the development of such culture or environment, or any indivividual, incident, or scene of possible historic value. To best show development, the photograph must show not only arrested time but elapsed time, which may be done by securing photographs at intervals, recorded from the same location. The lapses of time should be of sufficient length for significant changes to have occurred, but short enough for some recognizable landmarks to be still present in the immediately succeeding photograph in a sequence of views. Although important, this type of photographic record has been seldom employed. Imagine the value of a series of photographs taken, say, at five-year intervals, of Broadway from the same viewpoint as that shown on page 168. Sixteen such photographs for the seventy-five-year period from 1859 to 1934 would be a history in brief of metropolitan architecture, of transportation, of commerce, of dress, and of changing fortunes!

2. The photograph should be properly documented. That is, the pictorial record should be accompanied by a suitable contemporary description or caption of the subject photographed, the name of the photographer should be given, and the date of recording should be

given or established, so that collectively there is sufficient information to establish without question the authenticity of the photograph.[342a]

Whether the photograph *truthfully* records the past must be determined by actual study. Comparison with written records, knowledge of the photographer and of his reliability and methods of work, suggest themselves as aids in determining such truthfulness. Especially should it be determined whether the photograph has been purposely altered or distorted, or perhaps even unwittingly changed.

It will be realized, of course, that even if a photograph could meet satisfactorily the requirements as given, some photographs—even of the same scene or event—would be more interesting, more pleasing, or more appealing than others. This difference may be due to accident or it may be due to the knowledge and ability of the photographer. The photographer has the advantage over any worker in the graphic arts of being able to make hundreds of scenes while the artist is making one. Out of such a wealth of chances some should be more significant than the others. Not only can many be made, but they can, in many instances, be made from above or below the subject, from in front or in back, or from any intermediate position. Here the camera extends human vision far more effectively than can any graphic art.* While the recording of a view from a plane different from that of the vertical appears at first sight to be merely a stunt or trick effect, its continual use in still and motion photography has forced the average individual of the present day "to look at things from points of view he has never taken and to see them in arrangements he has never made," as the *Nation* † has so pertinently pointed out.

On the other hand an exceptional photographer may recognize in his subject an elemental situation common to all human experience. Selecting intuitively, or by training, the correct angle of vision with the light available, he reveals the character of the portrayed with unmistakable clarity. Such photographs are not only chronicles of the past; they are records of the vision of an artist!

* The ability of the photograph to extend human vision has been called its greatest aesthetic function. Note that the extension is secured not only by the means suggested above, but by the ability of the camera to arrest rapid motion, and to record the invisible by means of X-rays and ultraviolet and infrared radiation.

† October 16, 1935, p. 426.

It may also be worth while noting that if a photograph can be appreciated for its historic value, another factor of evaluation can be considered. If it can be shown that a given photograph has had a marked influence on our past, that photograph should be more greatly appreciated or valued than are ordinary photographs, a viewpoint which I may have impressed upon the reader in previous pages. If, for example, I can point to a given portrait and say, "This photograph was an important factor in the election of Abraham Lincoln as President of the United States," shouldn't we value such a photograph more highly than other portraits of the same period of equal artistic merit? Or I might say, "These photographs aided in the establishment of our National Parks policy, a policy unparalleled in the history of civilization!" Such photographs are surely to be valued just as highly—or more so—than many photographs taken subsequently of the same scenes and possessing possibly even greater technical and artistic merit.

We must return, however, to the main thread of our story, for the question "Is Photography Art?" has led us far afield, as it has many others.

The card photograph from 1860 to 1865 was by far the most popular form of recording portraits photographically. The extensive demand created for these small portraits soon resulted in stereotyped work. The work of one high-class studio could not be told from any other—unless it were by the design of the floor covering. As has been pointed out, the card portrait usually showed a full-length figure standing beside a column, with other accessories thrown in for good measure, depending upon the operator's taste, or lack of it. Toward the close of this period, bust portraits became more common among the card photographs, and vignetting* of the bust was even occasionally introduced. On the whole, although these small portraits are interesting mementoes of their age, they are by no means the most satisfactory portraits produced by the collodion negative. One competent critic of the time remarks concerning these efforts: "The pose, invariably stereotyped; here the inevitable little table, the

* For the uninitiated vignetting is the gradual shading off of the background around the bust into monotone, usually the white of the paper itself.

irrepressible columns, chairs, hanging curtains, to say nothing of the head-rest, whose foot generally makes a third in the picture." [343]

True, these photographs are so small that the "third foot" often escapes detection unless specifically sought, but sure enough, there it is, if one takes the trouble to make the search. The small size undoubtedly obscured many faults, both artistic and mechanical, that would have been all too obvious had the portraits been made in larger proportions.

Although the greater part of the portrait trade was done in the card photograph, larger sized portraits were made on whole-plate negatives and printed in that size. In addition, imperial photographs, finished in crayon, India ink, or color, were still in vogue among those able to pay for them.

The portrait of Lincoln by Alexander Gardner taken on November 15, 1863 (see page 242), is a remarkable example of the collodion negative in the larger sizes. Of those I have seen, I regard it as the best photographic portrait made on glass prior to 1865. The care-worn expression, the firm mouth, the saddened eyes have been faithfully preserved by the camera for all time. When one recalls that possibly twenty seconds were necessary to secure the portrait, one realizes all the more that the expression was habitual with the man in those trying and tragic days. The portrait is not without fault— the texture of the skin and other details could have been brought out to better advantage in the portrait of a face so homely, yet magnificent, and a portion of the subject is out of focus. Modern photographers and modern materials could produce a still more striking portrait and many a leading photographer of the present must have envied Gardner his opportunity.

The original negative (entirely untouched), from which this print was made, was $4\frac{1}{4}$ x $5\frac{1}{2}$ inches in size, and emphasizes again the fact that real merit in portraiture was more effective in the larger sizes than in the small *carte de visite*.[344]

Professional photographers themselves soon realized the limitations of the small portrait. For this reason and also because the card photograph was beginning to lose its popularity, with a resultant decrease in the revenues of the galleries, demand was made by the profession shortly after the war for a new size which would restimu-

late business. Whole-plate and imperial photographs were too expensive for business in large volume, and were usually "doctored," as we have mentioned.

Several sizes were suggested among the professionals, but the one which soon caught public favor was commonly credited to G. Wharton Simpson, the editor of one of the British photographic journals.

It made its appearance in this country in the fall of 1866 and was described by Wilson in the *Philadelphia Photographer* as follows:

"Something must be done to create a new and greater demand for photographs. The carte-de-visite, once so popular and in so great demand, seems to have grown out of fashion. Every one is surfeited with them. All the albums are full of them and every body has exchanged with every body. Since their introduction in 1861, they have had an immense run.

"The adoption of a new size is what is wanted.—Some discussion as to new size has taken place, and there have already been two or three suggestions.

"From Mr. G. Wharton Simpson we have received a specimen picture made by Messrs. Window and Bridge of London—they call it the cabinet size. It is something like a carte-de-visite enlarged. The mounting card measures $4\frac{1}{4}'' \times 6\frac{1}{2}''$, the print $4'' \times 5\frac{1}{2}''$, and opening in the album $3\frac{7}{8}'' \times 5\frac{1}{4}''$.

"Messrs. E. and H. T. Anthony & Company inform us they are manufacturing albums for the new size."

A little later Wilson informed the trade that the new size was meeting approval where it had been shown, and that it seemed "best to fall in with our Britannic friends." [345]

The cabinet size (for it was soon known by that name in this country) rapidly achieved popular favor. Within a year after its introduction it became a brilliant success, as far as photographers were concerned, and its popularity continued for many years. The card photograph was still made after the introduction of the cabinet photograph, and probably in total volume of business even passed the cabinet photograph when at the height of its favor.[346]

The new size, however, as far as portraiture was concerned, marked a turning point in the annals of the profession. Photographers had, in effect, to begin anew, for the much larger size gave greater opportunity for the portrait artist with respect to posing,

lighting, background, and accessories. Flaws which were not particularly obvious in the small card sizes now became conspicuous, so that greater skill in the mechanical routine of making portraits was required.

The first of the important changes in photographic procedure which followed the introduction of the cabinet photograph was the process of retouching the negative. The process of "improving" the finished print by working over the paper print with India ink, crayon, or oil, was quite common almost from the inception of the collodion process, especially in the larger sizes. The retouching to which we are now referring, however, was done upon the negative. But here, again, we must be careful to indicate the type of retouching that is meant. It had been the custom almost from the time of the first collodion negative to cover small pinholes or obvious scratches in the collodion film with some opaque material. In landscape work, the whole sky was almost always blocked out, usually by pasting to the negative, dark-colored paper cut out to fit the sky-line. Such a procedure was necessary because the collodion negative was unduly sensitive to blue and violet rays, and the sky, in the finished print, would appear blank white. Or, as was more often true, the thin, more or less irregular film (due to the hand-flowing of the collodion solution upon the glass) gave a foggy, smudgy appearance to the sky. By blocking out in such negatives, the sky was made to appear in the print, of course, clear white. The more careful workers would, in printing out, shade a portion of the sky so that a graduated tint was obtained. More ambitious workers blocked out their skies and printed in clouds from cloud negatives, or worked clouds into the original negatives by smoking them, painting them in with an opaque medium, or resorting to other devices. Seldom are the clouds found in prints from wet plate negatives those which were present in the initial scene.[347]

But all of these artifices, which, in general, could be called "retouching the negatives," were not of the type of retouching which followed upon the introduction of the cabinet photograph. The new type of retouching was the manipulation of the negative to remove wrinkles and facial blemishes, to smooth the hair, and to secure a greater variety of intermediate tones than the collodion

[324]

negative was capable of record-
ing. As first practiced, this was
accomplished by abrading the
surface of the film (which was
varnished) over the area to be
worked up. The "artist" then
worked up the abraded areas to
suit his taste by means of a spe-
cial pencil.

Such retouching was not
generally practiced in this coun-
try until after 1867. A foreign
correspondent, writing to the
Philadelphia Photographer in
the summer of 1867, remarks
that it is his belief that "the re-
touching of negatives in the

James F. Ryder (from a photograph made in his own gallery, 1880).

United States is not known as a practice, but only by way of experi-
ment," and the editor (Wilson) corroborates him by adding the
note, "Retouching the negative is not practiced here." [348]

American photographers soon became aware of the results ob-
tained abroad by retouching, and inquiry was made as to how the
results were obtained. The following year (1868) we find the state-
ment, "The exquisite effects of softness and halftone, portrayed in
many French and German photographs, are secured by skillfully
retouching negatives." [349]

The process of retouching, as practiced abroad, owes its intro-
duction into this country largely to the initiative of James F. Ryder,
the well known Cleveland photographer. Ryder was, at the time that
retouching was introduced, one of the relatively few professionals
who had begun as daguerreotypists—members of the itinerant
class who traveled chiefly from country town to country town. In
the course of his travels, after beginning daguerreotyping in 1847,
he came to Kirtland, Ohio, where the original Mormon temple had
been built. By the time Ryder arrived, the Mormons had gone to
Salt Lake City and their Kirtland temple was deserted. Ryder took
possession of it for a few weeks, and used it as his gallery. It is doubt-

ful if any other American photographer ever had the opportunity
of using a Mormon temple for this purpose! He finally settled in
Cleveland about 1850 and remained there until his death in 1904.
He was one of the most progressive of the profession and for many
years had a large and up-to-date gallery in Cleveland. He was ac-
quainted with many prominent Clevelanders during his life, and
was one of the close friends of the popular humorist, Artemus Ward.
Ryder was also one of the few American photographers who have left
us autobiographies. In 1902 he published an account of his life
with the title *Voigtlander and I in Pursuit of Shadow Catching.*[350]
The "Voigtlander" refers not to a partner, but to the well known
camera lens, of German manufacture, which was widely used in this
country for portrait work. Although in his biography Ryder dis-
cusses at some length his photographic experiences and career, a
larger proportion is given over to personal reminiscences of his ac-
quaintances. It nevertheless forms one of the important sources of
information on the history of American photography.

It furnishes a direct account of the introduction of retouching
into this country. Wilson, the editor of this *Philadelphia Photog-
rapher,* had received from his German colleague, Dr. Hermann
Vogel, a number of prints made from retouched negatives. This was
in 1868, and the prints were doubtless those which we have already
referred to as being much admired for their "exquisite effects of
softness and halftone." Ryder, in turn, secured these prints from
Wilson, and immediately became possessed of the idea of doing
similar work in his own gallery. He wrote to Vogel, instructing him
to employ a competent retoucher and send him to Ryder's establish-
ment. Vogel sent Herr Karl Leutgib of Munich, one of the leading
German professionals; Leutgib reached this country in the fall of
1868, and was immediately employed by Ryder. The same year
(1868) there had been formed the National Photographic Associa-
tion, an organization of the professional photographers of the United
States. The first convention of this Association was held in Boston,
on June 1, 1869, and lasted for several days.[351] In connection with
the convention an extensive photographic exhibition was arranged.
Ryder took to this exhibition a number of prints made from nega-
tives which had been retouched by Leutgib. They created a sensa-

An example of retouching from Ryder's Gallery, 1869. I have not been able to identify the subject although he is said to have been prominent in the profession. Possibly it is Leutgib.

tion among the knights of the camera, the majority of whom had probably heard rumors or statements in print concerning such work, but were unacquainted with its actual results. To quote Ryder, "It caught like measles and became epidemic. Now came a craze for retouching and retouchers. Great was the demand and meager the supply. I had applications galore for instructors," and Ryder reaped a harvest on his venture.

The account given above is essentially that of Ryder himself, but his story is corroborated by examining the contemporary photographic journals. As a result of Ryder's activities the Association decided to hold its 1870 convention in Cleveland, and Ryder was appointed general chairman in charge.[352]

But with the advent of retouching, the battle was on! If anyone thinks he can introduce a popular innovation in any art, craft, or pastime into American life without being subject to some adverse criticism, let him try it. There is always some recalcitrant brother who doesn't see the light and who says so in no uncertain terms. And this was doubly true of a practice which could produce such a

Abraham Bogardus. A photograph made in his own gallery, 1871.

Dr. Herman Vogel. A photograph sent to E. L. Wilson in 1872.

marked change in the appearance of the finished print. Retouching had no sooner reached some popular favor among professionals than it was condemned by others as a "degenerating, demoralizing, and untruthful practice." Another critic claimed that it was suggested by "some miserable photographic tyro who, satisfied with his inability to produce a passable photograph, was obliged to call in the aid of an 'artist' to cover up his malpractice, or else by some poor artist starving on the legitimate use of his pencil in hopes of eking out a livelihood."

The practitioners of retouching did not meekly receive these criticisms, but returned them in greater volume. "What are you going to do with warts and pimples?" frankly inquires an advocate. "The sitter won't take it if they appear on the finished print." Another one counters: "For years photographs have been sneered at as pictures. So many black and white daubs, mere maps of faces, and maps of very strange countries to some of the sitters, and now— photographers have found out it is possible to improve their work by the judicious use of the pencil."

We could go on citing many pages of the arguments for and

[328]

The photographic exhibit of the Convention of the National Photographic Association at Cleveland, 1870 (photograph by T. T. Sweeney of Cleveland).

against retouching, but the above are sufficient to show the general trend and heat of the discussion. In fact, the correspondence to the *Philadelphia Photographer* on this subject became so voluminous that the editor had to cry for relief. "We think this subject has now been touched up sufficiently, and beg our correspondents to let it alone." [353]

Despite the criticisms of retouching, which have been made since it was first introduced into this country in 1868, it is still practiced today in professional studios, and where not overdone, is generally regarded as an effective improvement. It is interesting to note that the comparatively recent introduction of panchromatic negative materials has materially lessened the amount of retouching on a portrait negative that most professionals regard as necessary.

Almost simultaneously with the practice of retouching, there appeared a fad or a fancy on the part of the photographers and their patrons for portrait photographs with diffuse effect. Both this effect, which was produced in another fashion than by the retouching of the negative, and the retouching itself, were in marked contrast to the qualities thought desirable previous to 1868. Previously, lenses

Members in attendance of the Convention of the National Photographic Association at Cleveland, 1870. Of the officers (seated in front), Wilson, the secretary, is on the extreme right; Bogardus, the president, the third from the right; and Vogel, the guest of honor, the fourth from the right. Notice the "ghost" of a second photographer in the foreground who apparently stepped back when Sweeney began his exposure. The photograph was given to me by W. H. Jackson, who attended the convention (photograph by T. T. Sweeney of Cleveland).

were wanted that would give negatives of utmost sharpness: every hair on the head, every line in the face was desired to register its effect on the negative and to be clearly discernible on the finished print. The introduction of retouching seems to have brought the diffuse effect along with it, and various devices were employed to obtain the desired "softness." The lens was intentionally put out of exact focus; the negative and the paper were separated slightly during printing; but most ingenious of all, although by whom devised I have not been able to ascertain, was the following curious method.

[330]

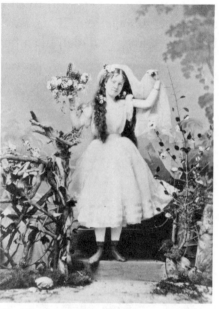

A prize photograph of 1868, made by T. R. Burnham, a Boston professional. This photograph, of cabinet size, won a prize of fifty dollars in a contest sponsored by the *Philadelphia Photographer*. The name of the charming lady is unfortunately not recorded.

"The May Queen"—photograph by Fox of St. Louis, 1869. The subject is said to be "the daughter of one of the most respectable gentlemen of St. Louis." Although it appears fatuous today, it was greatly admired when first printed. It should be pointed out that the photography is good, even if the composition is not that admired at present. It was no mean feat to record the detail that the original photograph shows with the collodion negative.

A piece of catgut was stretched from the lens board of the camera to the floor, and fastened there. While the exposure was being made, the photographer played on this improvised string with a violin bow! Certainly a photographer was called upon in his day to play many parts. Fortunately, Dallmeyer, the English optician, came to the relief of the profession and devised a soft focus lens for portrait work, and the photographer was able to dispense with his impromptu violin practice.[354]

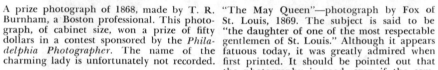

The National Photographic Association mentioned above deserves fuller discussion than we have given it. There had been a number of attempts to organize a professional association among photographers, even in daguerreotype days. None of these efforts

had been greatly successful until the formation of the National Photographic Association. This was organized through the efforts of New York and Philadelphia photographers, on December 1, 1868,

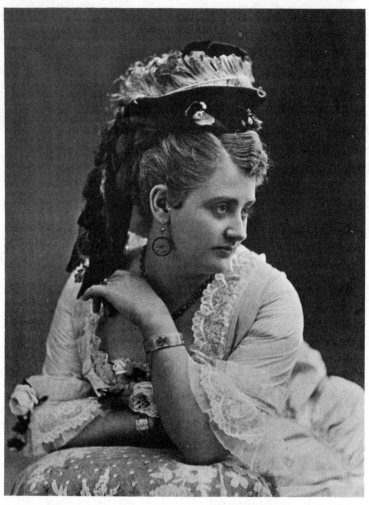

A prize-winning cabinet photograph of 1874, made by Bradley and Rulofson, San Francisco. No information on subject or exposure is given in the *Philadelphia Photographer* where the portrait was first published. Whoever the beautiful lady was, her interesting hat doesn't distract from her charms.

in Philadelphia. Abraham Bogardus, of New York, was chosen president, a happy choice, and E. L. Wilson, editor of the *Philadelphia Photographer*, secretary. The Boston convention was held, as we have said, in 1869, the Cleveland convention in 1870, and the asso-

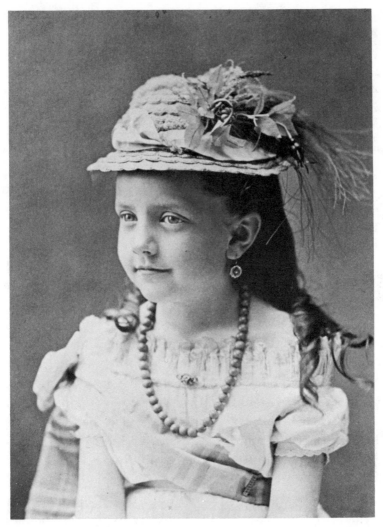

An excellent child portrait of wet-plate days. (Photograph G. M. Elton, Palmyra, N. Y., 1874; subject unknown.)

ciation then met successively for the next few years in Philadelphia, St. Louis, Buffalo, and Chicago. Among the honorary members elected when it was first organized were Oliver Wendell Holmes, Samuel F. B. Morse, John W. Draper, and H. L. Smith, the inventor of the tintype. It had at one time well over a thousand members and its conventions attracted large numbers. Internal dissensions nearly wrecked it during the late seventies, but it was revived under the

[333]

name of the Photographic Association of America in 1880 and is still active under this name.

The conventions were undoubtedly of value to those who attended, as the exhibitions held in connection with the meetings gave opportunity to see the best work of the year, enabled members to become acquainted with new apparatus and to discuss methods and difficulties. Bogardus continued as president for the first several years of the association's existence and much of its success was due to his efforts. He had been for many years a photographer in New York City, starting as a daguerreotypist, and was widely known as an able worker. In addition, he was well liked by the entire profession—a personal quality that was particularly desirable for the administration of a group that was frequently torn by dissension.[355]

A frequent guest at these conventions during the seventies was Dr. Hermann Vogel of Germany. Vogel had an international reputation as an authority on photographic matters and, like Bogardus, had an extremely likable personality. He was always accorded an enthusiastic welcome on his visits and although he did not understand or speak English well, he was able to fit into the programs of the Americans with ease. For instance, I find it noted in the report of one of these conventions that it was opened by singing of "The Star Spangled Banner" "with Dr. Hermann Vogel at the piano." He was a kindly critic, a photographic enthusiast, and kept his American audiences informed of the latest practices and processes used abroad.[356]

With the cabinet photograph came retouching, which was soon followed by other changes equally noticeable in the photographs of the period. An examination of the illustrations given in the following chapter will show what is meant. The card photograph characterized by the column, the pedestal, the drapery, and the well marked floor design is giving way to the painted background, the rustic gate, the artificial leaves and rocks. On the whole, the setting seems not greatly out of keeping with the costume itself. True, the voluminous crinoline and hoop skirt were practically obsolete by the time the cabinet photograph was well established, but they must have passed each other in the hall as the cabinet photograph came in. Crinoline had been replaced by the bustle and a variation of the chignon,

that huge mass of hair worn at the back of the head.* These were elaborate *accessories* to the well dressed lady's toilet—why shouldn't the photographer follow suit with elaborately introduced accessories in his art, especially since the cabinet photograph gave him ample room for the exercise of his imagination?

The photographer, then, in introducing the balustrade of imitation stone, often covered with paper ivy, the uprooted tree, the parchment rocks, the portico, pardon me, the *piazza,* a castle or two, the mock furniture,† the boats, and the sleighs in endless profusion, was but reflecting the day in which he lived.

* If it be argued that I have confined my attention to the accessories of the weaker sex, I am willing to concede that the hirsute adornment of the stronger sex, popularly known as Lord Dundreary whiskers, is just as grotesque as the chignon and the bustle.

† A piano, for instance, which weighed less than ten pounds and cost but ten dollars was a popular "piece."

Kurtz, Sarony, and Mora

THERE WERE, of course, outstanding photographers who did not follow the beaten track and others who accentuated some phase of the elaborate style. Belonging to the first class was William Kurtz, regarded by his colleagues both at home and abroad as the leading American photographer of the seventies.

Kurtz was born in Germany in 1834. After a common-school education he was drafted into the army. Having served his time he left Germany and went to London. Here he joined the British-German Legion in the Crimean War. Upon returning to London he became a lithographer, obtained some art education, and eventually became a teacher of art. Times were hard, and Kurtz's spirit was adventurous. He obtained a job as a sailor before the mast and made several voyages. On the last of these journeys, the sailing vessel of which he was a member of the crew was shipwrecked while on the way to California. The crew was picked up afloat and eventually landed at Old Point Comfort. From here Kurtz made his way to New York City, where he obtained work as one of the artists who "finished" the prints from the early collodion negatives in crayon and oil. This was in the very late fifties. At the outbreak of the Civil War, he went to the front with the famous Seventh Regiment.

With the close of war in 1865, Kurtz opened a photographic gallery in New York at 872 Broadway, followed in 1874 by his better known gallery on Madison Square.[357]

As can be seen, the date upon which he thus began his professional career in photography was at a time nearly coincident with the introduction of the cabinet photograph. The far greater possibilities of this form of portrait found Kurtz, with his art training, ready to take advantage of the opportunity thus presented. Probably his greatest contribution to photographic art was the introduction of the so-called "Rembrandt" photograph, which in time proved to

[336]

be very popular. The term does not refer to a style of form or size in the photograph, but to a method of lighting the subject. As the name indicates, the photographs were so called because of a similarity to the effect produced by the great Dutch artist, Rembrandt, the master of light and shade. Although these photographs introduced by Kurtz are not to be compared with an actual Rembrandt, their introduction did mark a distinct advance in photographic portraiture in general.

In order to understand the significance of such Rembrandt photographs it is necessary to recall that previous to their introduction in 1867 the common practice was to photograph that portion of the sitter's face which was turned toward the light. Further, because of the slow speed of the collodion negative, the face was well lighted in order to reduce the relatively long exposure required. This practice, of course, resulted in a loss of modeling in the face, with the result that the finished print failed to show the slight facial contours which contribute much to the characterization of the individual.

Kurtz, after considerable thought and experimentation, devised the following method of portraiture. The patron was seated on a chair placed on a movable platform whose function Kurtz explained in this manner: "When in the dark-room preparing plates, I often see my subjects assume very graceful positions, which it seems almost impossible to get myself when I go to pose them. Therefore, when they come in I seat them on this platform and watch them from the dark-room. When they assume a pose I like, I step out, ask them to keep it, and I wheel them under the light where I want them." By an ingenious use of screens, the top and side lights could be varied rapidly and at will. In addition, either a plain background was used or the patron was placed against the light which with the side lights relieved "the dark parts of the sitter on a light background and the lighter part of sitter on a darker background." But the most important adjunct devised by Kurtz was a counter reflector, a movable two-wing affair covered with tinfoil, which was used to illuminate the shadow side and thereby bring out the modeling of the face.

The plain background, the absence of rococo accessories, the variation of light, shadow, and halftone in the face, were in extreme

A "Rembrandt Effect" portrait by William Kurtz, 1870, made with "a 3B Dallmeyer lens, 2¾-inch diaphragm, one turn of the diffusion focus, time, twenty seconds." The portrait is unretouched. The sitter seems to have been a favorite subject of Kurtz.

William Kurtz. From a photograph made in his gallery in 1883. The portrait was made after the introduction of the gelatin emulsion on Eastman's Special Dry Plate by "the electric light in six seconds."

contrast to the portraits of the "full moon" type with the usual ornate trappings thrown in.

Kurtz also employed the painted backgrounds and many of the usual gallery furnishings. It was said of Kurtz, in fact, that he used this "Rembrandt" style far more sparingly than did many of his competitors. Doubtless at the hands of less skilled and less thoughtful workers, many bizarre effects were produced.

The name *Rembrandt* photograph was not suggested by Kurtz, for he, a true student of art, was not so presumptuous. . . . Kurtz's discussion of his own work is interesting enough to quote, and it gives us some understanding of the difficulties which the portrait photographer encountered with the collodion negative. Writing in 1869, he states:

"This style of picture was made by me over two years ago, of a number of persons, especially artists; as those of Messrs. E. Leutze, Lambdin, Kauffmann, Oertel, etc., etc. The negatives as well as the gentlemen are still in existence, with the exception of the lamented Leutze. These pic-

[338]

Napoleon Sarony: (left) in a favorite dramatic pose; (right) late in life. Both photographs courtesy Mr. F. H. Meserve, New York.

tures were called rather 'Rembrandtish' (not 'Rembrandts,' and were never so baptized by me. I modestly called them 'Shadow Effects'). The pictures I produced, although called 'very fine,' 'magnificent,' 'superb,' etc., were according to my ideas very poor. I knew full well that Rembrandt never took a black opaque·canvas in order to show a few patches of white paint to greater advantage, nor was he ever known for vulgar contrasts, such as black and white. On the contrary, on his dark shadowy, but transparent background, the figures are beautifully relieved, and in the deepest parts of his drapery the detail is nicely suggested. Between his highest lights and strongest shadows, you will find every imaginable gradation of tint, the same as with other artists of his time, he, however, throwing in an extra high light, which his followers and pupils were not able to reach, his high lights telling out, because he was very sparing with them. Rembrandt's pictures are all half tone and shadows, deep shadows, but not blackness, as with my 'photos.' Some of my pictures, however, came out pretty well, rather odd in effect, if you will, but still pleasing. Shadows, deep shadows must be photographed, and this I did not find difficult to do, by using reflectors and counter-reflectors which I have lately constructed. But what I *did* find difficult to do, was to preserve the drawing and proper shading of the light parts, such for

[339]

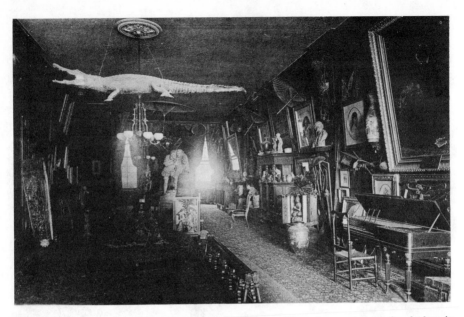

The reception room of Sarony's gallery, described as a "dumping-ground of the dealers in unsalable idols, tattered tapestry, and indigent crocodiles." (From a photograph made in 1882.)

instance as the shirt front, sleeves, collar, etc. on the shadow side. It requires the utmost care to prevent a bad 'squint' in the sitter, and as the shirt collar will reflect better than a black velvet coat, and a glossy eye better than the rough skin, the operator will find it rather hard to please an artistic eye with his production. It will always be a difficult thing to produce this most charming, but also most trying picture; that is, if you treat portraiture seriously as it should be treated. It is of course much harder to light a sitter in this manner, than in the ordinary way, and the technical part of the work requires also more care. The background must have a good deal of attention. For example: A gentleman with dark hair, and with dark draperies, should not be taken on a dark background of the same weight and color as the deepest parts of the shadows; it should be *lighter* to give relief to them. It will then be sufficiently dark to throw out the high lights on the face. Again; a lady with light hair, fair complexion and white draperies, should have a different background, since one is very apt to get too much strong and harsh contrast where harmonious contrast is what is desired."

There is more that might be quoted, but the above statement is sufficient to show that Kurtz was a serious student of portraiture. As is apparent from Kurtz's account, the collodion negative at best

was of short scale, that is, not capable of registering any great range of light intensities, and it is remarkable that he was able to succeed as well as he did.

The Rembrandt style, although introduced in 1867, did not achieve its greatest popularity for several years. In fact, it cannot be said to have had a great popularity in the sense that cabinet photographs themselves became popular. Rembrandt portraits were beyond the ability of most photographers, although W. J. Baker of Buffalo and William Notman of Montreal, the leading Canadian photographer, were quite successful with them.

The activities of Kurtz brought him not only local recognition, but an international reputation as well. At the annual fair of the American Institute in 1870, Kurtz was awarded the first premium for "the best plain photograph," for "the best photograph finished in India ink," and for "the best photograph on porcelain." Incidentally, Kurtz was also awarded a first premium "for the best crayon drawings" shown at this fair, which shows that he also must have been an acceptable artist with the pencil. He was the only American awarded a medal at the International Photographic Exhibition held in Paris in 1871, just prior to the outbreak of the Franco-Prussian War. Without doubt, the crowning recognition of his photographic career came at a similar International Exhibition held at Vienna in 1873. Here, according to Dr. Hermann Vogel, one of the jurors, Kurtz was given one of the two highest awards made to portrait photographers. The other award, equal to that given Kurtz, was made to Loescher and Petsch of Berlin.

Late in his career, Kurtz became interested in the reproduction of magazine and book illustrations in color and spent his entire fortune in making such experiments. The half-tone process was at this time coming into wide use and F. E. Ives had shown as early as 1885 that color illustrations were possible by employing three-color half-tone cuts in producing the desired result.

S. H. Horgan credits Kurtz's efforts in reproducing color as being responsible for the commercial production of such illustrations on a large scale. In March, 1893, Kurtz had a colored frontispiece in the *Engraver and Printer* of Boston. This illustration, says Horgan, "proved to the whole printing world that reproductions of colors

[341]

by photography into three half-tone blocks to be printed in colored inks had arrived." [358]

<p align="center">* * * * * * *</p>

Although Kurtz was well known in his day, the name of Napoleon Sarony is probably more familiar to later generations. Sarony, the son of German parents, was born at Quebec in 1821, the same year that Napoleon Bonaparte died. The father was a great admirer of the French general and it was for this reason that the son obtained his given name. The parents moved to New York when Napoleon was ten years old, and two years later young Sarony solicited a billiard table maker for the privilege of making a show card for him. The maker consented and was so pleased with Sarony's work that he gave him ten "Mexican" dollars for his work. This seems to have decided Sarony's career, for we immediately find him drawing and printing lithographs. At twenty-one, he established the firm of Sarony, Major, and Knapp. This organization did an enormous amount of lithographic work—in fact, so much that Sarony was able to retire from the firm in 1858 and to devote the next six years of his life to the study of art. To this end he went abroad and spent some time in several of the leading art schools of Europe. It was probably during this period that he also acquired a knowledge of photography. A brother, Oliver Sarony, had established in England a photographic gallery and supply house, which became one of the leading English establishments of its kind. Undoubtedly it was through this relationship that Napoleon Sarony became sufficiently interested in photography to make it a profession. He returned to New York in 1864, where he started a photographic gallery on Broadway, near Bond Street. Some ten years later a second establishment was opened in Union Square.

Sarony is one of the most picturesque figures to appear among American photographers. Volatile, generous, eccentric, a friend of art and an artist in his own right, he was a unique figure. He was among the founders of the well-known Salmagundi Club, an association of artists, and a member of the Tile Club, which numbered among its members some of the well known figures in American artistic and literary circles during the latter part of the 19th century. F. Hopkinson Smith, also of the Tile Club, portrayed Sarony in his

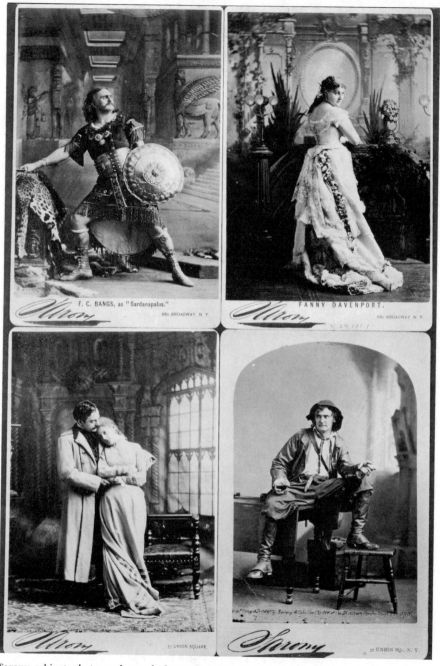

Sarony cabinet photographs made between 1869 and 1876. *Lower left*, H. J. Montague and unknown actress in one of the plays done at Wallack's Theatre in the seventies. *Lower right*, Joseph Jefferson as young Rip in "Rip Van Winkle," 1869. (All photographs, courtesy Museum of the City of New York.)

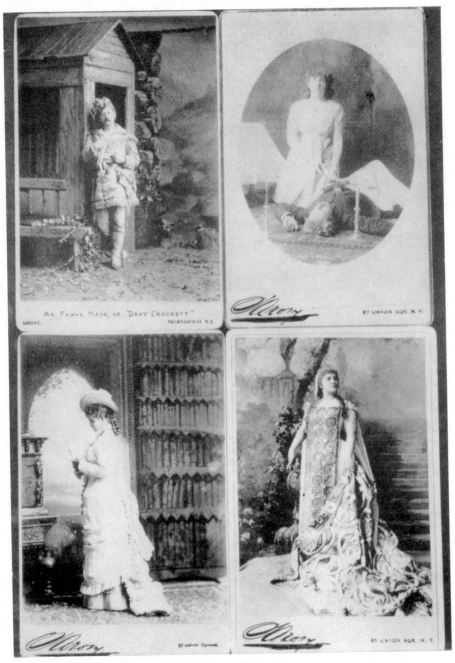

Sarony cabinet photographs made between 1875 and 1894. *Upper right,* Fanny Davenport as Tosca. The recumbent figure is Sarony himself posing as the Baron Scarpia. *Lower left,* Stella Boniface in "Baby," 1877. *Lower right,* Lillian Nordica, photographed in the early nineties. (All photographs, courtesy, Museum of the City of New York.)

well known book, *The Fortunes of Oliver Horn.* The character of Julius Bianchi in this book was based entirely on that of Sarony.[359]

His main contribution to photographic practice was an attempt, and a successful one, to get away from the conventionality of pose used by the vast majority of the profession. According to Howe, "He introduced into photography the employment of Hogarth's famous line of beauty and made photography picturesque." Another contemporary critic stated that his work "was all life and expression, only with far more abandon and intensity of action" than was shown in the photographs of any of his competitors.

R. G. White in *The Galaxy,* that "magazine of entertaining reading" so popular in the seventies, has left us a glimpse of Sarony's first gallery and of the man himself that is worth repeating for the personal touch it gives.

"Glare, bareness, screens, iron instruments of torture, and a smell as of a drug and chemical warehouse on fire in the distance. A photographer's operating room is always something between a barn, a green-room, and a laboratory. Here we find a few others like ourselves waiting their turns like the cripples at the pool of Bethesda. Sarony himself, no taller than his namesake, Napoleon, and quite as peremptory, is listening to the complaints of a man who is dissatisfied with the proofs of his sitting. A hard-featured, money-making Western pork-packer who is fifty-five years old and looks every hour of it, in the hard lines of whose leathern face devotion to the one great object of life may be traced, it might naturally be supposed that he would be quite indifferent to the degree of youth and comeliness that appears in his portrait. Vain expectation! There are many astonishing revelations of human nature in the photographer's rooms. Sarony and the sun have dealt kindly with this man, and have taken at least five years from the record of time upon his face. But he is dissatisfied and ungrateful. He points out faults here and there, and Sarony with a crayon now softens an outline and now tempers an expression. But still the man, seeing himself as others see him, grumbles. At last the artist turns to him somewhat sharply, and yet with good nature, saying, 'How young would you like to be made, sir? I could make you twenty-five, but my reputation could not bear that. Thirty-five is as low as I can go!' 'Oh, no!' is the reply, with a sudden manifestation of modesty, 'Make me look full forty-three,' drawing a fine line between forty and forty-five. 'I'll try to satisfy you, sir,' and departs. How can he look himself in the face when he shows those mahogany jaws tomorrow?

"And now a lady steps forward for her sitting, acquaintance with

whom admits us with her behind the screen, but not quite to the artist's satisfaction. For the photographer does not like to have the sitter's attention diverted by even the consciousness of the presence of a third party. She begins to talk to him and he to watch her. He sees that she is pretty, but with that kind of prettiness which consists of expression, vivacity, and brightness of eye, more than regularity of feature. These are the most difficult faces to photograph satisfactorily to the friends of the sitter. He places her, makes her take two or three positions, tempers the shadows as many times by the adjustment of screens and curtains, and at last says suddenly, 'There, so, if you please,' and sweeps his hand down the skirt and settles it with a look of satisfaction. The movement attracts her attention; and more concerned about her dress than herself, she turns her head quickly and gives her gown one of those pulls a little behind and below the waist that seem necessary to the perfect tranquillity of the female mind, and—an exclamation breaks from Mr. Sarony: 'Ah, why could not you stand still as I placed you?' 'But, my dress, sir!' 'But me, madam!' with a tragi-comic air, yet not without serious meaning. 'Do I count for absolutely nothing in this matter?' Then turning to us: 'It's gone, hopelessly. One cannot do that twice immediately in succession.' The best is done that can be done, however, and the lady descends to give place to another."

This was written nearly seven decades ago, yet, in its comments on patrons, it will stir a responsive chord in the breast of many a modern photographer. Sixty-five years, as far as changes in human nature go, is insignificant.

The establishment on Union Square bore Sarony's flowing signature in huge letters across its face and the signature was repeated in miniature on each portrait made in his gallery. His business occupied the whole building above the store on the ground floor. A hydraulic elevator which could carry only two or three patrons at best, raised them at a snail's pace to the fifth floor. Here the passenger stepped out into the reception room, which like the proprietor, was unique in character. An Egyptian mummy stood guard by the door, its case covered by wire screen to prevent probing and curious fingers from rending its wrappings. Stuffed birds, Russian sleighs, Chinese gods, ancient armor, pictures running the whole range of merit, were present in profusion. It was indeed a "dumping-ground for the dealers in unsalable idols, tattered tapestry, and

indigent crocodiles," which the generous and acquisitive Sarony bought without apparent reason or limit.

Sarony, in his later years while at Union Square, delighted to show himself on Broadway in an astrakhan cap, flowing beard and mustache, calf-skin waistcoat, hairy side out, and trousers tucked into highly polished cavalry boots. No wonder that he was the swell photographer of his day. It has been said that during his career he made forty thousand photographs of the members of the dramatic profession alone.

Although Sarony made pose his forte, he doubtless overdid this feature by including several additional waves in Hogarth's line of beauty, if we can believe one disgruntled critic, possibly the same one who insisted that retouching was "degenerating, demoralizing, and untruthful," who remarked, after viewing an exhibit of Sarony photographs, that "Sarony's display is 'the same yesterday, today, and forever.' Cannot he turn out some fresh ludicrous wiggles?" [360]

But, like Kurtz, the efforts of Sarony marked a departure from previous methods in photographic portraiture. We must remember that it was no mean feat to record satisfactory expression and posture when the usual patron of the gallery, unaccustomed to the art of posing, had to be frozen into statuesque immobility for the twenty or thirty seconds while the camera lens was uncapped.* It is true that galleries occasionally advertised exposures of only five seconds. But this speed must have been attained under the most favorable circumstances. An examination of the portraits included as illustrations in the *Philadelphia Photographer* for the period 1870-1880, when data are given, shows that actually studio exposures ranged from fifteen seconds to well over a minute. The head and back rests were invariably used and were actually regarded by the public as the "iron instruments of torture" seen by White in Sarony's gallery. It was no wonder the public dreaded going to the gallery almost as much as to the dentist. They assumed a rigidity even before they entered the gallery. Kent, a well known photographer of Rochester, told the following amusing incident, which illustrates the point.

* How Sarony secured an animated expression in his patrons is indicated by a correspondent of *Anthony's Bulletin* who refers to Sarony's amusing efforts before the camera: "Some have frequently gone so far as to interpret them as a species of buffoonery, but I believe they are Sarony's forte."

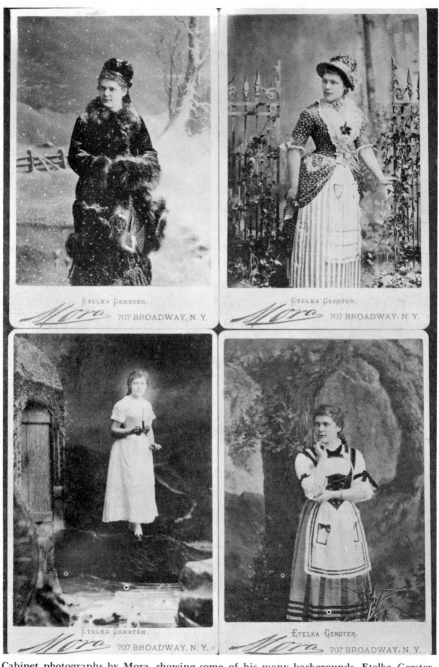

Cabinet photographs by Mora, showing some of his many backgrounds. Etelka Gerster was a popular soprano of the eighties. (All photographs, courtesy Museum of the City of New York.)

"Speaking of being rigid, reminds me of a very portly gentleman who was bracing for a picture, and during the sitting I heard a crash. I looked around and found, not that the building had fallen, but that the old gentleman had braced so hard that he had split the back of the chair."

Probably a part of the difficulty lay in the fact that most professionals placed the head-rest in position and then forced the head into the rest. At least that was Alexander Hesler's explanation. "The way to do it is, place the head in position, and then adapt the rest to the position—I usually try the candy dodge on children, get them good-natured, keep them interested, and then, when you catch their eye, take their picture." [361]

Ah, the children! How the gallery operator must have groaned every time mama's precious was brought in! Here there could be no fifteen or twenty second exposure. The child was placed in full light, the largest stop in the camera was used, and the combined efforts of the photographer, the candy, and the entire family employed to secure the necessary attention for an "instantaneous exposure," which at best must have been the major part of a second. And the results, as can well be imagined, could hardly be called a "Rembrandt"—or anything else, for that matter. The reader can satisfy himself on this point by looking through the family album if he happens to have one in which the photographs were made before 1880. Hardly a child's picture but that some part of the anatomy is portrayed as "in motion." [362]

* * * * * * *

Kurtz attained his reputation by a study of lighting, and Sarony by a study of pose, but J. M. Mora, another New York photographer, attained his fame by the employment of accessories, notably of backgrounds.

José Maria Mora was a Spaniard born in Cuba in 1849, the son of a wealthy planter. He was sent to Europe to secure an education in art but became interested in photography. The Cuban Revolution of 1868 caused the elder Mora and the remainder of his family to flee to the United States where José joined them. He received further training in photography from Sarony and in 1870 opened a gallery at 707 Broadway. Like Sarony, he made a specialty of

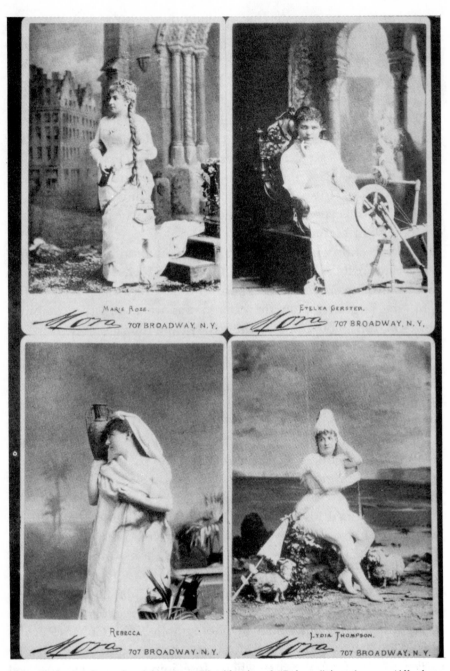

Other backgrounds employed by Mora. The identity of "Rebecca" is unknown. (All photographs, courtesy Museum of the City of New York.)

photographing stage celebrities which in turn attracted the attention of society's favorites and his elevation to prominence was rapid. For many years he was among the best known "first-nighters" of the New York theaters.

His method of work can best be judged from the following contemporary account of his establishment:

"His gallery is very plainly furnished, with nothing for glitter and show, nothing to distract the attention from the few finely furnished and tastefully mounted pictures which are negligently scattered about his large reception-room, the colors of which are all quiet, the walls being simply painted a dull maroon color, as the best foil to the bright pictures, while the plain furniture is all in keeping.

"His operating room, with its low, broad light, its rough, uncarpeted floor, and its stained walls, is not nearly so fine as many a gentleman's stable, but it has everything that is needed for the production of elegant and artistic photographic effects. There are a few pieces of rich furniture, and a piece of loose carpet as accessories for interiors, with a multitude of backgrounds, screens, profiled slips, fireplaces, window sets, balustrades, steps, rocks, etc.

"He has more than fifty painted backgrounds, representing sea and sky, plains and mountains, tropic luxuriance and polar wastes; every style of scenery from Egypt to Siberia, mostly designed by himself, and all executed with Seavey's unapproachable knowledge of photographic needs. These grounds hang against the wall compactly, without feet, and when needed, are lifted out and attached to feet readily, by the use of the ordinary dovetailed bed castings."

The fifty backgrounds in the course of a few years grew to a hundred and fifty, until his studio looked like the property room of an enormous theatre. No wonder his place attracted business—it must have been interesting enough just to see it.

If Mora was noted for the theatrical and the elaborate style, he was also a remarkable business man. His establishment was carefully organized, with a large and efficient staff and a workable system of filing negatives and finished "cabinets." It is not at all improbable that Mora did the largest photographic business in the country during the seventies. In 1878, for example, his aggregate business was nearly a hundred thousand dollars—and this in comparatively hard times. A very considerable share of this business was in the sale of what Mora termed his "publics." These were cabinet photographs

A portrait awarded a gold medal for excellence in 1871. The name of the young lady is not stated. (Photograph by W. C. North, Utica, N. Y.; exposure, "30 seconds on a light, clear day.")

Miss Jennie Lee, "a clever little actress." (Photograph by I. W. Taber, San Francisco, 1875. Exposure "30 seconds, between 2 and 3 p. m. on dull day. The early part of the day I could make the exposure in 5 seconds.")

of celebrities, usually of the stage. Mora had made, for instance, over three hundred negatives of the popular Maud Branscombe, a prominent member of the American stage in the "dreadful decade," and from these negatives over thirty-five thousand portraits had been sold. Miss Branscombe received a royalty, no doubt, but the major portion of profit went to Mora.

Mora, as a general rule, did not show at photographic exhibitions, but he nevertheless received country-wide advertising by taking care that the name of Mora was shown conspicuously on the "publics," and these photographs were distributed to hotels and theatres, not only at home, but abroad.[363]

The Seavey mentioned in the account of Mora's establishment was L. W. Seavey, also of New York. To Seavey, in a large measure, must go the credit, or the blame, for the introduction of the painted background. He rose to fame during the seventies, making a specialty of manufacturing accessories for the photographic gallery. We

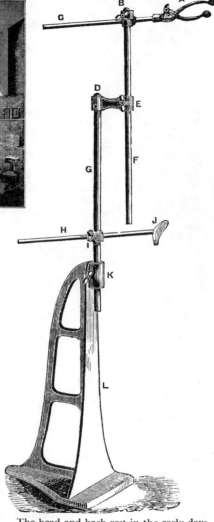

learn, from an account published in 1879, that "to L. W. Seavey undoubtedly belongs the honor of successfully introducing and making scenic background an indispensable accompaniment to any well-equipped gallery. His grounds combine the color and touch that make him prominently without a rival. To him also belongs the honor of making it possible to introduce into the photograph accessories of every description necessary to complete a composition of almost any character, by actually manufacturing the reality of a light and durable material, which admits of easy and safe transportation and long use without injury. His name is familiar to all; his reputation is

The head and back rest in the early days of the cabinet photograph. It looks the part ascribed to it, "an iron instrument of torture." (From the *Philadelphia Photographer*, 1868.) *Left*—a typical camera room of the seventies. The "operating" room of Bradley and Rulofson of San Francisco. (From the *Philadelphia Photographer*, 1874.)

not alone national, but world-wide." As indeed it was; Dr. Vogel, for instance, writing from Berlin, called Seavey "the first background painter of the world."

The apogee of Seavey's efforts in this direction, it seems to me,

Photographs by Landy of Cincinnati: *Left,* "The Last of the Queues"—a portrait of a Cincinnati character made in 1871. *Right,* Miss Fanny Davenport, a well known member of the stage (photograph 1877).

was reached in 1880. At the meeting of the Photographic Association of America in Chicago during the summer of that year, Seavey described for the benefit of those in attendance a device which aroused considerable enthusiasm. This was an ornate trellis, about six feet in height, embroidered with flowers and shaped as a letter of the alphabet. The appropriate letter, corresponding to the name of the sitter, was to be introduced into the portrait beside the patron! The use of such accessories appears fatuous to us at present, but what we now regard as being in good taste may appear equally silly to future generations. The clue to the situation, of course, lies in the fact that it was the novelty of the lettered trellis which appealed to the public. As one country photographer wrote, "We find that fancy backgrounds and appropriate accessories are the things necessary for a continued revival of trade." [364]

Although we have selected the efforts of Kurtz, Sarony, and Mora as illustrations of various types of "influences" prevalent in collodion and cabinet days there were many other American photogra-

[354]

phers well known in their time. We have had occasion to mention the names of several of these in the development of our discussion. There were, for instance, Frederick Gutekunst of Philadelphia, whose portrait of President Grant was probably the most satisfactory ever taken; J. Landy of Cincinnati, whose reputation like that of Gutekunst was international; I. W. Taber, and Bradley and Rulofson, of San Francisco; George Rockwood of New York; C. A. Zimmerman of St. Paul; W. C. North of Utica; Henry Rocher of Chicago, and George K. Warren of Boston—to mention but a few. Brady, who had suffered severe financial reverses in the depression of 1873, practiced in Washington, and his work still drew favorable comment, but his place as the fashionable photographer of the times had been taken over by the trio of New Yorkers whom I have selected as illustrative of the times.[365]

The cabinet photograph, as produced in the galleries of these well known photographers, sold ordinarily for twelve dollars a dozen, although cheaper establishments made them for as little as three dollars. The method of making these photographs was practically identical with that employed in making the card photograph. The glass plate of the negative was usually coated first with a thin layer of albumen before the collodion was flowed on, an innovation of the early seventies. This prevented curling and slipping of the collodion film, especially around the edges of the plate. After flowing, it was sensitized in the usual silver bath. Development was made in the ordinary way with acetic-acid—iron-sulfate mixture, and fixed in potassium cyanide. If the negative was weak it was intensified, usually by the so-called "mercury" process, although other methods were occasionally employed. The finished negative was varnished to prevent scratching of the thin collodion film. The paper used to make the prints was still the albumenized stock. Paper which contained the albumen and salt was available from stock houses. This did not vary greatly in photographic sensitivity, but several finishes were obtainable, depending upon the kind of paper and sizing used. The photographer had to sensitize this paper before use, by floating, albumen side down, on a bath of silver nitrate. Fuming the paper with ammonia after sensitization had been suggested probably by H. T. Anthony of New York, in 1862 or 1863, to increase the speed

of the very slow paper, and this method was frequently resorted to, especially in making enlargements. Printing was invariably done by sunlight, exposure being of sufficient duration to bring out the image, which was observed from time to time in the printing frame. Toning with gold and fixing with hypo followed. Because of the gold toning, prints of this period (up to 1885) were brown in appearance, as were card photographs.

The manipulation of carbon prints was developed and the process introduced into this country in 1864. These prints are black and white, but they were seldom used by commercial galleries. If the reader is interested in obtaining greater detail concerning technical processes employed at the end of the collodion era, he is referred to the 9th edition of *The Silver Sunbeam* published in 1879. In its 599 pages will be found the most extensive descriptions of photographic processes as practiced in America at the time.[366]

Seavey's "Letters" (from the *Philadelphia Photographer*, 1880).

Just before the advent of the gelatin dry plate in 1880, one of the photographic journals sent out a questionnaire asking gallery operators what they thought were the most important developments in the wet plate process since its advent. The consensus of opinion on this question seems to have been that photographers thought that retouching and burnishing were the greatest improvements. Retouching we have already discussed. Burnishing consisted in treating the finished print with a patent glaze, and then putting it through a burnisher. The burnisher was a device that in appearance did not differ greatly from an ordinary clothes wringer. The burnishing process left the print with a very high gloss. The process was not introduced, however, until the

late seventies.[367] An examination of the answers to this questionnaire and of the news item in the photographic journals shows also that the photographer was subject to a far greater occupational hazard than is the modern studio proprietor. Hardly an issue of these magazines but mentions the destruction of a gallery by fire. The reason for these frequent disasters undoubtedly lay in the inflammable character of collodion, which always had to be carried in stock in considerable quantities.

Although cabinet and card photographs were the "leaders" during the seventies, other sizes were made by portrait photographers. Whole-plate, 8 x 10, imperials and life-size were made for those who could afford them. The smaller of these sizes were frequently finished in vignette, and the larger ones, many times, in color. Even card and cabinet photographs of this period can occasionally be found colored, but the practice decreased somewhat during the seventies. Mora, for instance, was very vehement in denying that a colored photograph had ever been produced in his gallery.

The largest portraits were, of course, obtained as solar enlargements, and here the American photographer seems to have been in a class by himself. Vogel stated on his first visit to America in 1870 that these enlargements were the most striking and outstanding feature of American photography. The *London Photographic News,* which received a number of these enlargements from this country, stated they "very far surpass the ordinary examples of enlargements we meet with." Albert Moore of Philadelphia made a specialty of this work and had a large establishment making enlargements alone. They were surprisingly cheap, two dollars and a half for a "whole size sheet," presumably not whole size from a photographic standpoint, but from the paper dealer's standpoint. Photocrayons, that is, enlargements finished in crayon, were also commonly made.[368]

We must not forget the lowly tintype with which itinerant photographers did an enormous business. The galleries producing tintypes were usually special establishments, as the photographer making paper prints rather looked down on his "tinny" brother. The tintype was introduced abroad late in the seventies, also. Vogel

A composite photograph by Gentile of Chicago, 1877. Sheridan and Staff.

reports, as a novelty in 1878, having seen signs in Berlin, "American Photography; ferrotypes ten and twenty cents apiece."

The ambrotype was still being made, but the daguerreotype made its last stand during the seventies. Bogardus was employing a full-time daguerreotyper in 1870 and one or two other establishments possibly did likewise. In 1889, it was stated that Alva Pearsall of Brooklyn made the last daguerreotype in 1879. There have been several sporadic attempts, however, to revive this lost art as a novelty in recent times.[369]

One other feature of American photography during this period should be briefly noted. This was the appearance of the composite photograph, that is, the photograph made from several negatives or from a photograph and a drawing. Composite photographs were originated abroad by Rejlander and by Robinson about 1858, but Americans were slow in following their examples. The first of these I have found described in this country was one of Dexter, the famous race horse, produced in 1867. An "instantaneous" photograph of Dexter in motion was made and enlarged. A number of photographs

of individuals were taken as "by-standers" and prints of the horse and the bystanders cut out and pasted on a prepared painting which showed the track, a hotel, and buildings. The whole thing was then rephotographed and prints made. It was the work of John L. Gihon of Philadelphia. Somewhat later another Philadelphia firm, the Bendan Brothers, introduced the device of varying the background by the sale of a number of negatives, each containing the image of a different background. The central part of the negative was left blank and by printing a portrait negative taken against a plain background in conjunction with the background negative a variety of effects could be produced.

Alexander Hesler of Chicago. (Photograph made in his gallery shortly before his death in 1895; courtesy Mrs. Alexander Hesler, Jr., Evanston, Ill.)

Through the seventies such combination photographs are frequently mentioned in the photographic literature. One of the most celebrated of these was that of General Sheridan and his staff, made by Gentile of Chicago in 1877. Individual photographs of the general and his staff of sixteen were composed on an appropriate background containing many other human figures and a cannon which is belching flame and smoke.

Usually the composite character of these photographs can readily be detected by a careful examination. The figures are ordinarily out of proportion with one another or with their background. If skillfully done, they are not bad; but poorly done, they have an almost always ludicrous effect.[370]

It seems not inappropriate in closing this chapter to view American photography of the seventies through the eyes of a foreigner. By so doing, we obtain a different perspective and one which is probably very near the truth. Vogel, of Berlin, after one of his trips to this country, expressed his opinions to some of his British friends.

These comments were published in the *London Photographic News* with an added opinion from the Britishers, which makes it doubly valuable.

"Vogel," writes the *News*, "places the photography of the New World [in] science, art, and commerce beside that which he is familiar in the Old World, considered in the same relations, and contrasts the two, generally to the advantage of America, but not always. The result of such a comparison is just what might have been expected *a priori*. In enterprise, activity, and general technical intelligence, photography takes precedence in the New World over the Old. In art, and general refinement of result, Dr. Vogel did not find the standard so high as in his own country. In the main, the position of photography and photographers he found much better than in Europe. In Germany, the status of the photographer carries with it no social prestige, and the successful photographer is generally glad to sink all reference to his position. In the United States, no such disqualification is attached to the commercial practice of the art. In Germany, it is not common to find one photographer perfectly master of every branch of his art; whilst in the States, the universality of culture was not uncommon. Photography involves, in short, in the States, much more activity, intelligence, enterprise, and profit than in the Old World. America appears to be the paradise of the really capable photographer with skill and energy enough to seize its prizes." [371]

A New Age

THE YEAR 1876 is a memorable one in American history. In addition to being the hundredth anniversary of the birth of a nation, it was marked by many remarkable events. Custer and his command were destroyed at the battle of the Little Big Horn, in the most spectacular military tragedy in the history of the nation; Rutherford B. Hayes and Samuel J. Tilden engaged in the most closely contested of all presidential campaigns, the outcome of which was not known for many weeks after the election; Bret Harte was giving his famous lecture on "The Argonauts"; the pillory and the whip were still being used for larceny; copies of Rogers' statuary were regarded as the correct ornaments for the parlor; and chest and lung protectors were highly recommended and strenuously advertised for use in wintry weather.

To be sure, in the cold light of history, not all of these events are equally important, but to the individuals concerned at the time they were of vital concern.

But the year 1876 is marked by events which are more relevant to the present purpose than any of these. It marks the beginning of the modern economic and social world, for in this year and the two or three years immediately following there were invented such devices as the telephone, the electric light, the talking machine, and the gasoline automobile, all of which have had a profound influence on the family and the individual. Not only does this year mark the dividing line between a new and an old life in social and industrial America, but a similar line of demarcation can be drawn in the arts of painting, of sculpture, and of illustration.[372]

The transition in none of these instances is abrupt, nor does it occur exactly during the year 1876. Very probably the reason for making the division at this date at all is that it was the centennial

year, a fact which was emphasized and celebrated by the well known Centennial Exhibition.*

The Centennial, the first of the great international exhibitions held in this country, offered by its collections and exhibits a comparison of the work of artists not only from different countries but of different periods and thereby served to accentuate the fact that changes were occurring in the arts and in science and industry.

In the humbler art of photography we can almost, if not quite, cite parallel changes. Through the efforts of the National Photographic Association, $20,000 was raised by popular subscription among the profession for the purpose of erecting a building suitable for the display of an extensive photographic exhibit.[373]

The photographic exhibition was international in character; representatives from Russia, Germany, France, Austria, and England, besides the Americans, had extensive displays of their work. One is struck, however, by the very long list of exhibitors from our own country; hardly a section or a state but had work from a professional or an amateur to represent it. The vast majority of the prints displayed were those made from collodion negatives, and ranged in size from the small card to mammoth life-size portraits. There was also an extensive exhibit of daguerreotypes presented by way of contrast. Specimens of photo-mechanical methods, just being perfected, were on display and attracted much attention. Large transparencies of the scenic beauties of the West,† some as large as 28″ x 36″, were viewed with wonder by many of the ten million visitors to the Centennial, not only in Photographic Hall but also in other buildings of the Exhibition.

The list of American awards by the Centennial judges of the exhibit includes: L. G. Bigelow of Detroit; Sarony and Kurtz of New York; Rocher of Chicago; Ryder of Cleveland; Gutekunst of Philadelphia; Brady of Washington, whose name reappears in the photographic firmament after its eclipse at the close of the war; Charles Bierstadt of Niagara Falls, whose photographic views of Niagara and other scenic features gathered over the entire world

* The Centennial Exhibition at Philadelphia was formally opened on May 10, 1876, by the playing of Wagner's Centennial March. The celebrated German musician composed the march especially for this occasion.
† These were made by W. H. Jackson, of Denver.

The main entrance of the Philadelphia Centennial, 1876 (photograph by George Barker. Niagara Falls, N. Y.)

made him nearly as prominent as was his brother, Albert Bierstadt, the celebrated painter; and lastly, C. E. Watkins, whose views of Yosemite still brought fame to their author.[374]

The large and varied displays at the Centennial mark the high-water achievement of the American wet plate photographer. The collodion negative had reached its heyday. Events were occurring which in the course of four or five years caused it to disappear as the wet plate had in turn supplanted the daguerreotype. It is not without significance that in the leading American photographic journal the first report of the Centennial exhibit is followed by a

A portion of the exhibit, Photographers' Hall, the Philadelphia Centennial. (Photograph by Centennial Photographic Company.)

brief article on the "Gelatino-Bromide Process." [375] Not that the editor or his readers realized its significance at the time, but to one looking back from the vantage point of nearly sixty years, it is particularly striking. The article was not the first to be published on this process, even in this country. It was the report, however, of one of the first amateur photographers who tried out the process before a group of interested friends, after reading reports of its success in England.

It should be pointed out that the use of gelatin in photographic processes was by no means new. As early as 1847 it had been used as one of the vehicles to hold the sensitive silver salt to the glass plate; it had been employed as a preservative in one of the numerous attempts to prepare collodion *dry* plates; but its use which brought about the revolution in photography was due to other properties than those given above. True, gelatin, in the modern negative, serves as a vehicle for holding the light-sensitive material to the glass or film base, but it plays a far more important part than this alone. If its vehicular rôle had been its only one, it would never have replaced collodion.

[364]

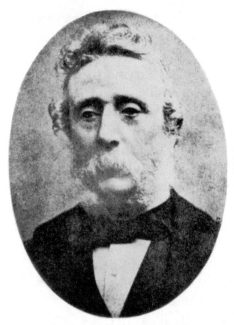

Dr. R. L. Maddox, the British amateur, whose pioneer experiments led eventually to the gelatin dry plate. (After a photograph reproduced in Werge, *The Evolution of Photography*.)

John Carbutt of Philadelphia, one of the first manufacturers of dry plates in America. (Courtesy U.S. National Museum.)

The first definite experiment with the new process was published by a British amateur, Dr. R. L. Maddox. The report appeared in the *British Journal of Photography* for September 8, 1871. Maddox described the preparation of a slightly acid solution of gelatin to which a soluble bromide had been added. The gelatin solution was then taken to the dark room and silver nitrate added. As every amateur chemist knows, this would produce the light-sensitive substance, silver bromide. But the bromide was formed in the presence of gelatin as "a fine milky emulsion," to use Maddox's words. The emulsion was then coated directly on cleaned glass plates and allowed to set and dry. "The plates [then] had a thin opalescent appearance, and the deposit of bromide seemed to be very evenly spread in the substance of the substratum." It will be noticed that in these first gelatin dry plates the method was fundamentally different from that used in the wet plate—the light-sensitive material was made first and spread with the vehicle, through which it was evenly suspended,

[365]

upon the plate. In the collodion plate the light-sensitive material was formed on the plate itself and then only in the surface of the film or but slightly beneath it.

The plates Maddox thus prepared were extremely slow, slower even than collodion plates, and for that reason would never have found wide use. As the method of preparation was different it started others to working, again chiefly English amateurs, who in the course of seven or eight years improved it so that it led eventually to the large-scale production of dry plates in England. Modern research has shown that there were several causes for the slowness of the Maddox plates. In the first place, the emulsion was formed in the presence of an acid and it was also produced in an excess of silver salt; that is, Maddox used more silver nitrate than was necessary to react completely with the soluble bromide present. Both of these conditions tended to make the final emulsion slower. By washing the emulsion devised by Maddox, the acid and the excess silver salt could be removed and its light sensitivity materially increased. It was soon found, too, that "ripening" the emulsion produced a tremendous increase in the sensitivity of the emulsion. Modern ripening may take several forms but the original procedure consisted in keeping the emulsion in the dark at a somewhat elevated temperature for periods of time as long as a week. Modern research has partly explained the cause of this phenomenon as being the presence of very small traces of sulfur compounds in the gelatin, the sulfur compounds reacting slowly with silver bromide to form substances which tremendously accelerate the light sensitivity of the final emulsion.*

Variation in the sensitivity can also be produced by preparing the emulsion in the presence of varying concentrations of gelatin, this variation producing a difference in the average size of the silver bromide (or silver iodobromide) grains. The function of the gelatin is actually fourfold: It serves as a vehicle; it furnishes a sensitizer (the sulfur compounds); it controls the grain size, which not only makes it possible to obtain a far greater speed than the wet plate was capable of producing, but also makes it possible to produce a very

* Ripening may produce an increase of a hundredfold or even more in the "ripened" as compared with the "unripened" emulsion.

The first print reproduced from a gelatin dry plate to appear in the *Philadelphia Photographer*, November, 1880: Dixville Notch, New Hampshire. (Photograph by Edward L. Wilson in the summer of 1880; "exposure, 45 seconds.")

great variety of known speeds; and in the last place, it protects the unexposed grains of silver compound from the action of the developer and thus greatly increases the contrasts as compared to those of the wet collodion plates.

The above discussion, while somewhat more technical in detail than is most of the present history, has been included to show as clearly as possible the real difference between the collodion and the gelatin processes. Of course, the outstanding fact that one was used *wet* and the other *dry* should not be lost sight of.

By 1878, a number of English firms were producing such commercial dry plates. J. W. Swan, the Liverpool Dry Plate Company, and the well known firm of Wratten and Wainright were among these. But even among professional English photographers there was considerable skepticism of the qualities of dry plates, for while the first commercial dry plates were available as early as 1873 it was not until 1879 and 1880 that they were used in any great numbers; and outside of England they were even more slowly adopted.[376] In Germany, for example, we find Dr. Vogel writing his friend Wilson of Philadelphia under date of November 28, 1878, as follows: "The

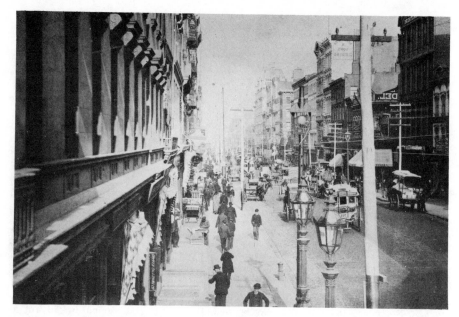

Broadway from the Herald Building, "latter part of November, 1882 at 10 o'clock"—from a negative made on Eastman's Special Dry Plate. The fact that traffic and pedestrians are shown clearly in motion caused this photograph, taken early in the dry-plate era, to be regarded as unusual. It will be noted that the building signs are reversed. This is due to the fact that an Artotype print was made from the negative, and in the hurry to get it ready for publication the usual stripping from the negative, in the preparation of the printing plate, was neglected. (From *Anthony's Photographic Bulletin,* Jan., 1883.)

gelatin emulsion plates of Bennett and Kennett are exceedingly sensitive and surpass the wet plates in regard to rapidity. At present photographers are not in favor of this process as the preparation of gelatin emulsion plates is a very inconvenient thing." Similar sentiments can be read in the French correspondence.[377]

If the dry plates were slow in being adopted in the country of their invention and in France and Germany, they were still slower in being used in this country. In 1878 photographic journals carried occasional articles concerning the new process which were for the most part reprints of articles appearing in the British technical magazines. By 1879, the number of these articles was increasing, and it is quite evident that many American amateurs were experimenting with dry plates but only exceptional professionals were willing to give them a trial. The Photographic Society of Philadelphia, composed mostly of amateurs, on its fourth annual excursion in the summer of 1879, reports "a remarkable sign of the times . . . emul-

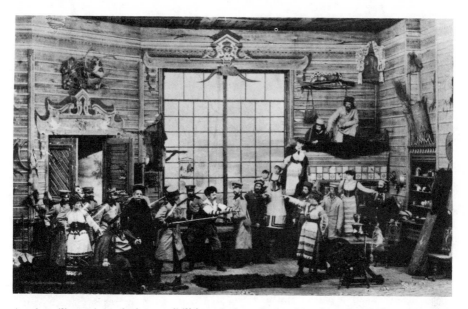

Another illustration of the possibilities of the gelatin dry plate. Scene from the play *Russian Honeymoon* taken at *midnight* by B. J. Falk of New York, spring of 1883. Made on Eastman's Special Dry Plate. It required an exposure of six seconds with thirty arc lights. (From *Anthony's Photographic Bulletin.*)

sion plates were used by the entire party, exposures were given [ranging] from 30 seconds to 15 minutes according to subject." Two hundred and twelve plates of seven different varieties were exposed. These amateurs regarded their efforts as successful but their greatest difficulty appeared to be the development of the negatives.[378]

One of the few professionals who tried out dry plates in this year (1879) was the veteran Hesler, of Chicago, who had begun his very successful photographic career with the daguerreotype in the forties —his willingness to make experiments may account in part for his long continued successes. Hesler's results were not very satisfactory, for he reported to a group of Chicago professionals that "the exposure for the dry plates was 15 seconds—wet plates, 5 seconds. I exposed six 5 x 8 dry plates which cost me $2.00. Every plate came out spotted—nearly all show crêpe-like lines in the direction which the emulsion was drained from the plate." [379] Such results would have completely discouraged most individuals, but Hesler continued his efforts and was one of the earliest professionals to abandon the wet negative and the silver bath in favor of the dry plate.

PACKED FOR TRAVEL.

The increasing popularity of dry-plate photography and the advantages it affords for outdoor work when practiced without the heavy, bulky and troublesome wet-plate outfit, has led to a demand for a special apparatus which shall be light and portable, yet simple and rigid, and at such a price as will not frighten all intending purchasers. To meet this demand the Tourograph has been invented, and it remains for us to receive the first dissenting voice. Its field of usefulness is intended for landscape work, wherein it certainly has no rival. It does not necessitate covering the head with the focussing cloth, etc. ; in fact, it is as easily and conveniently operated as could possibly be desired. By referring to the cuts it will readily be seen how compact it is and how simple the mode of operation.

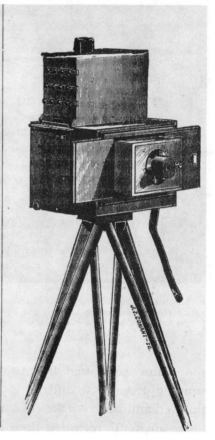

The Blair Tourograph (from a woodcut in *Anthony's Photographic Bulletin,* 1880).

Official recognition of the dry plate by the profession did not come until 1880, when the Photographers' Association of America, meeting in Chicago, appointed a committee to investigate the matter of dry plates. The committee requested that manufacturers of dry plates submit samples of their products to the committee for their examination and trial. This was in August, 1880; between this time and January of the following year three manufacturers complied with the request, although other firms were making dry plates at the time. The firms submitting plates were John Carbutt of Philadelphia, D. H. Cross of Indianola, Iowa, and Cramer and Norden of St. Louis.[380] Carbutt was at this time the president of the Association. He had moved from Chicago to Philadelphia in 1871 and was there

engaged in promoting photo-mechanical processes. He was among the first to manufacture commercial dry plates in this country, his celebrated *Keystone* plates first appearing in 1879. He was preceded in this effort, as far as I can definitely ascertain, only by Albert Levy of New York, who began the manufacture of gelatin dry plates in 1878.[381]

Cross and Cramer and Norden began their commercial production of dry plates, as far as the records show, in 1880. Other firms were putting them on the market in this year also. In May, E. and H. T. Anthony announced for sale a product said to be of their own manufacture, the *Defiance* plate. George Eastman also began commercial production of gelatin dry plates in September, 1880, although he had made them as early as 1879 for the use of several of his friends.[382]

The committee appointed by the Photographers' Association made its report in January, 1881. There were three members of the committee and each worked and reported independently. They stated that dry plates required exposures of 1/6 to 1/12 that of wet plates (the average being 1/8). Some members encountered difficulty in the use of the developers recommended for dry plates, these being either ferrous oxalate or a plain solution of pyrogallic acid. Although the familiar alkaline solutions now used were suggested early in dry plate history, solutions of ferrous oxalate or plain pyrogallic acid were the first employed. Comparisons of the two types of plates were made by first exposing a wet plate and then a dry plate, the same subject and the same light and camera conditions being used for both. One member reported that he made an 8 x 10 negative of a child on a wet plate in twenty seconds, and that this "was a little undertimed." A dry plate was then exposed for two seconds, and this was fully timed. Another committeeman states, "In portraits, I can see no difference in quality whether made with the dry plate or wet." A second one says, "We must all admit that a ready-made sensitive plate in itself is a real progress, but coupling this with the advantage of so great a gain in sensitiveness as the gelatine dry plates offer, I firmly believe that, unless something better can be found, these plates are found to take the place of the old wet collodion process."

THE SCOVILL DETECTIVE CAMERAS.

Detective cameras as listed in a catalogue of 1886 (courtesy Eastman Kodak Company).

The chief objection raised against these dry plates, however, was their cost. It must be remembered that the wet plate photographer made his own plates at a very moderate outlay for materials. Many times the glass base was cleaned, coated, and used again and again. With dry plates, each operator must, of necessity, buy the finished plate which could be used but once. It was estimated that an operator using only a dozen plates a day of various sizes would be required to spend two thousand dollars a year for his plates alone. As would be expected, this added expense delayed general adoption of the dry plate. Even with the high cost, several larger firms—Rockwood of New York, Ryder of Cleveland, Rocher of Chicago, for instance— were using them exclusively by 1881. By the late fall of 1881, the consumption of dry plates and facilities for manufacture had increased to such an extent that a considerable reduction in price was announced. Quarter-size plates were than advertised for sixty-five cents a dozen, and eight by ten plates for three dollars and sixty cents a dozen. With the establishment of these prices, adoption of the dry plate was considerably accelerated, but even then many operators were still using wet plates.[383] As late as 1883, for instance, we find a correspondent writing to *Anthony's Bulletin:* "It [the gelatin dry plate] will have its day, however, and like the 13, 14, and

[372]

15 puzzle, the sunflower craze, and other humbugs that have come and gone, will be displaced by something else for their amusement. It is the very best thing that could have been devised for amateurs." [384]

The slow adoption of the dry plate, however, can be traced to other causes than the cost. The very great sensitivity of the dry plate as compared to that of the wet plate was in itself one of these causes. Fogging was continually complained about; this fault, by competent authorities, was traced to small leaks in the camera and plate holders, diffuse light in the dark room, and the use of orange, rather than red, light in the dark room; all of which had not affected the slower wet plate. In addition, difficulties of manufacture—unevenness in coating, dust spots, large varia-tions in sensitivity and uniformity

A detective camera (from *Harper's Monthly Magazine*, Jan., 1889; courtesy *Harper's Magazine*).

of size—were encountered in the early years of production, so that it was not until after 1883 that operators were beginning to regard the dry plate as firmly established.[385]

Those who first adopted dry plates and met with any success were loud in their praises and marvelled at the new possibilities and actualities revealed to them. In addition to voicing their thankful-ness that the new negatives freed them from the necessity of prepar-ing plates, they bade fervent good-byes to the head-rest, save for young children. It was a new age for the operator as well as for his patron.

Professionals openly expressed surprise at results which now are

commonplaces. A photograph taken from the back of a train moving at forty miles an hour was exhibited by Joshua Smith of Chicago at the 1881 meeting of the Photographers' Association and was regarded as one of the seven wonders of the world; a photograph showing three tennis balls in mid-air was regarded with equal respect, as were all instantaneous photographs which showed arrested motion. George W. Rockwood, the New York operator, tells with pride how he engaged a tug, used sixteen operators and assistants, and made 160 exposures from the *moving* tug of *moving* objects in New York Bay in connection with the opening of Brooklyn Bridge in 1883. He secured 100 good negatives from his 160 trials and cites this record as an example of what could be done with dry plates—a record that would have been impossible with collodion negatives.[386]

The far greater rapidity of the gelatin dry plate, of necessity, brought with it the shutter. During the late seventies some increase in the speed of the wet plate negative had been secured by variation of the formula in making the sensitive film, and although reports can be found that exposures were reduced by 1/4 to 1/3 of that for the older type of wet plates, such plates were not extensively used. This increase in sensitivity had led to early forms of a crude shutter. In one of these, depicted in *Anthony's Bulletin* for 1879, the shutter was opened by an air bulb and tube in a manner common in many cameras of the present day. But the shutter was a huge, hinged affair in front of the lens that opened and closed like a trap door. The introduction of the gelatin plate brought forth numerous descriptions, in the photographic journals of many kinds of shutters, some of which are those still employed in the cheaper cameras of the present day.[387]

If the dry plate was slow in being adopted by the professionals, the amateur immediately recognized its benefits. As we have seen, to be an amateur in wet plate days required fondness for the art verging on fanaticism. The cumbersome camera, the dark room and its chemicals had to accompany the amateur wherever he went, unless he were willing to use the very slow collodion dry plates. Probably, too, the amateur of wet plate days had to develop a hide as thick as a rhinoceros, if he happened to be married, as there were almost certain to be silver stains on the housewife's linen and rugs, not to

mention those on the enthusiast's hands. One of the favorite topics at meetings of amateur clubs of this period was methods of removing these stains!

No wonder that the gelatin dry plate, despite its early defects, was hailed with enthusiasm by the amateur. Mention has been made of the extended use that amateurs of Philadelphia made of the gelatin plate in the summer of 1879. Amateurs of other cities were not far behind those of Philadelphia. In fact, the earliest manufacturers of dry plates (Levy and Carbutt) sold their products rather largely to amateurs. Early in 1879, Levy followed up his plates with a small camera designed for amateur trade. This was described as "a unique little camera for dry plates—and he [Levy] offers camera and lens for $12.00 for plates 4 x 5 inches. For this sum a half dozen plates, developer, pyro, and hypo are included, with full instructions for working the same." [388] The following year T. H. Blair of Chicago placed on the market a camera for "amateur photographers, college boys, and artists" which became well known. This sold with nine plates, 5" x 8", for $27.50, under the popular name of the "tourograph." The plates were contained in a second box built over the camera box proper and placed in numbered grooves which separated them. Similar numbers on a guide bar of a receptacle for moving the plates allowed them to be brought into position. They were returned to the carrying box by means of a mitten attachment. Even this sounds complex and cumbersome today, although the manufacturers were careful to state that "it weighs less than ten pounds." [389]

The Levy and Blair cameras brought in a host of others, and E. and H. T. Anthony and the Scovill Manufacturing Company, among the largest of the American photographic houses, were quick to follow with similar devices, once the demand became apparent. The Anthonys offered early in 1881 "Cameras for the Millions," a 5 x 8 outfit with a stereographic lens, for $33.00; they followed this a few months later with a 4 x 5 outfit for $10.00 which included the lens and the tripod. At the same time they announced with very evident respect for the magnitude of the business thus arising that "a large and intelligent class of amateur photographers has made its appearance," and made preparations to meet their trade.[390]

The Scovills, too, recognized the growing volume of business

and early in 1881 marketed a very complete amateur outfit which included a camera with folding bellows. The Scovills, in fact, were probably the first to take full cognizance of the possibilities of amateur trade. This was largely a result of the foresight and ability of one of its employees, W. I. Adams of New York. Adams devoted much time, thought, and experimentation to the development of amateur equipment, and much of the popularity of the camera among nonprofessionals was due to his work. His ability was recognized when in 1889 the firm of Scovill and Adams was formed.[391] But the growth of the amateur to far greater numbers than had practiced during wet plate days only anticipated the future; for the real development of the amateur trade did not come until after the perfection of the flexible support for the gelatin emulsion—the roll film.

But during the 1880's, the number of amateurs was large. Existing amateur clubs acquired new life, and many new ones were formed. The Pioneer Amateur Photographic Club of New York (a somewhat belated title, since there had been many prior amateur clubs in the city) was organized early in 1883; one in Chicago was organized slightly later, as was also the Boston Camera Club. The last-named club, the New York organization, and the Photographic Society of Philadelphia jointly sponsored annual exhibitions of the work of their clubs, the first exhibition being held in New York in 1887. The year previous to this, the famous Chautauqua Assembly at Chautauqua Lake, New York, recognizing the increasing interest in amateur photography, announced a school of photography, and employed professionals as instructors.[392]

The number of articles dealing with photography in the popular journals increased again, as it had shortly after the collodion process became known in the late fifties, and, of course, as it had when the daguerreotype was introduced. An article by F. C. Beach, entitled "Modern Amateur Photography," appeared in *Harper's Monthly Magazine* for 1888.

This review by Beach gives a very good picture of amateur photography in the days just prior to the introduction of the transparent roll film. One of the most noticeable features of Beach's article indicates that amateurs were troubled, or at least felt guilty, about carrying their instruments with them. They were still somewhat

self-conscious, for the camera was not yet so common as to be inconspicuous. Efforts were made to disguise the form, and at this time one of the most popular instruments was a box, called a "detective camera." "These mostly are made in the form of a physician's medicine case, covered with rough leather, or to look like a hand-satchel. They hold half a dozen plates, and are fitted with convenient devices for quickly setting the shutter, focusing, for changing the plates, and are provided with miniature lenses and reflectors, called finders, which enable the operator to tell when the object to be taken is in the field of view. As these cameras are quite light and portable, they have become very popular and numerous. They attract no attention, and on that account are particularly useful when photographing in crowded streets or when one is traveling." As a matter of fact, they appear decidedly conspicuous to the amateur of the present, since they were about three or four times the size of our present small box camera. But of course, Mr. Beach means that they were not as conspicuous as the predecessors of the detective camera.

Miniature cameras also made their appearance at this time—quite different, however, from our present miniatures. They took the form of the button camera, the watch camera, the hat camera, the revolver camera, and the opera-glass camera. The button camera was regarded as the most successful and was described in use as being "suspended from the neck, behind the vest, having the miniature lens projected through a button-hole in the vest and constructed so as to match the other buttons. The sensitive plate is circular in form, held in a round thin light metal case. After an exposure is made the plate is readily rotated forward until a new section is brought behind the lens. A convenient cord depends behind the vest from the releasing mechanism of the shutter. In taking a picture it is only necessary to walk up to within a few feet of the object, then to quickly pull the string; a slight sound or click at once apprises the operator that the picture is taken. Six negatives may be made on one plate, the size of each being about one and a half inches square. From these, enlarged pictures are easily made." These button cameras were doubtless satisfactory even to the most self-conscious amateur, but an uninformed friend, observing the amateur in action, doubtless wondered at his behavior.[393]

The introduction of the gelatin dry plate brought with it a new name, that of a man who proved eventually to be a commanding figure in American photographic history. George Eastman and the Eastman Kodak Company are names as well known to the modern professional photographer as were Edward Anthony and the E. and H. T. Anthony Company during the first four decades of the history we are tracing. To the world at large the name of Eastman is far better known. This is not the place for a biography of Eastman, nor is it necessary, as there is already available an interesting biography of this man.[394] We must, however, trace his early efforts as related to the field of American photography, if the present history is to make any pretence of completeness.

George Eastman's career before he entered the photographic trade was unusual. He had saved three thousand dollars before he was twenty-four years old, and that on a salary which did not greatly exceed one hundred dollars a month! As a frugal and careful bank clerk in Rochester, New York, he had amassed this sum by 1877. Most young men of that time would have been satisfied with his salary of fourteen hundred dollars and with his bank account, but he was looking for a bigger future. The United States government at this time was planning the purchase of Samana Bay in Santo Domingo as a naval base. For some reason Santo Domingo took Eastman's fancy; and, estimating carefully the expense, he decided to go there and determine if there were possibilities of investing his modest savings. He talked the trip over with one of the men at the bank in which he was employed. This man, who chanced to have been an assistant photographer on the Powell surveys we have described in Chapter Fifteen, suggested that he take a camera along and make a pictorial record of the trip. Remember that this was in 1877 and that the wet plate camera and its bulky accessories were necessary. Eastman, following this suggestion, spent nearly a hundred dollars for equipment and employed a local photographer, George H. Monroe, to give him lessons. At the time when he became interested in photography, Eastman stated that there were only two amateurs in Rochester besides himself.

The trip to Santo Domingo was not made, but Eastman was started on a career. Very probably he became so fascinated with his

new hobby that the trip was forgotten, and the chance suggestion of the Powell survey photographer initiated a new industry.

An accident that Eastman encountered shortly after taking up his hobby may have been responsible for his interest in dry plates. On his first trip away from home with his photographic outfit, the bottle containing the silver bath (the silver nitrate solution used to sensitize the collodion plates) leaked out and stained most of the clothes in the trunk in which they were all packed. Imagine the effect of this catastrophe on a young man who always considered carefully before spending money, and who as carefully recorded every cent that he expended. It was enough to make most beginners give up in disgust. At this time he read in an English photographic journal of experiments in gelatin dry plates—again remember that this was 1877 and the English journals contained many articles on the new process. Notice too that Eastman's hobby had taken a really serious hold on him—he was reading journals devoted to the art and those chiefly of interest to the professional.

Formulas for the preparation of the gelatin dry plates were given, and Eastman, remembering his difficulties and disasters with the wet plates, started to prepare dry ones. After a number of trials he succeeded in making an emulsion which gave fair results when coated upon glass and dried. In fact, by the summer of 1878 he was entirely free from the collodion process and used gelatin plates alone. His successful efforts seem to have followed the announcement of the Englishman, Charles Bennett, who on March 29, 1878, described the discovery of the ripening process which we have previously mentioned. We find Eastman, for instance, writing to a fellow amateur at this time:

"You will have no difficulty in getting great rapidity with the following provided your light is right. You will of course see it is essentially Bennett and I make no claim whatever beyond a slight change in proportions:

Gel [gelatin] 40 grs.
Bro Am [Ammonium Bromide] 23½ grs.
Silver [silver nitrate] 40 grs.
Water ¼ oz.

"Raise temperature of sólution to 150 degrees fahr. and unite slowly. Shaking between additions of silver. Then place in the bath and keep at 100 degrees five days. Then precip. with 2 oz. 95 per cent alcohol or wash in any desired way, one way being as good as another if you extract all the nitrate you can discover by testing and provided the wash water does not dilute the above to more than 1½ oz. finished emulsion. Add ¾ dr. alcohol and 10 m. of 8 gr. solution chrome alum, filter and coat. Two days in the bath gives about wet-plate rapidity. Some kept 7 days was about five times as rapid." [395]

Eastman's success with dry plates became known among the local photographers and several of these asked him to prepare plates for them. Among these operators was George Monroe, the professional whom Eastman had employed to instruct him in photography. Monroe began using the Eastman plates in the summer of 1879; in the summer of the next year he made a trip to the Thousand Islands in order to secure views of that scenic region. Monroe reports, "I averaged about 95 per cent of good negatives, although the plates were brought home for development."

On this trip Monroe met Edward Anthony and told him about the Eastman plates. The Anthonys, of course, were interested and a correspondence between Eastman and the old photographic firm was established. This led eventually to a contract between the two, Eastman agreeing to make the plates, and the Anthonys agreeing to be his sole agents and to take his output. As this incident suggests, Eastman as a result of his amateur experiences had decided to go into the business of making dry plates. In 1879, in fact, he had made a trip to England to investigate the making of dry plates by the leading English firms. While abroad, he applied for an English patent—a device for mechanically coating the emulsion on the glass plates, since he early realized that one of the main defects of the dry plates was the unevenness of the dry film on the hand-coated plates. This was followed by an application for a United States patent of the same device, which was granted April 13, 1880. [396]

Mention of the Eastman plates first occurs in the American journals in November, 1879, when a brief allusion is made to Monroe's use of them; but in January, 1880, a correspondent of the

This photograph illustrates the curiosity aroused in the passer-by during the wet-plate days of the amateur. In the summer of 1865, J. C. Browne, an amateur photographer of Philadelphia, was making a series of views along "the noble Hudson." While working one day, Browne was accosted by two walkers, who inquired what he was doing. They were in uniform, and Browne recognized them as Generals Burnside (left) and Anderson. He induced them to sit on the porch of a near-by house, and the above photograph resulted.

Philadelphia Photographer writes of a visit to Rochester to see the results of Monroe's work. He says:

"The plates I saw, negatives of both summer and winter scenes, were characterized by great delicacy of detail in either lights or shadows. This I considered a most difficult test.

"He works the modified Bennett process, but modestly disclaims any credit of his own, giving all the honor, whatever there may be, to Mr. George Eastman, an amateur there, who worked it all out his own way, and gave it to Mr. Monroe. . . .

"The power of controlling it thus is what Mr. Eastman has discovered, if I rightly understood him, and is what will make it generally practical." [397]

All this time, Eastman was still working as a bank clerk, the making of dry plates being conducted in the hours available between three in the afternoon and breakfast time. He continued until September, 1881, in his dual profession.

[381]

By September, 1880, however, he had decided to go into the business seriously, withdrew three thousand dollars of his savings to invest in his venture, rented "a room on the third floor of a building on State Street, and with one employee duly embarked on the business of making dry plates." [398]

Eastman soon realized that the business of making dry plates would be seasonal, and he was therefore quite willing to enter into a contract with the Anthonys, who agreed to take his output over the entire year. The Anthonys announced the Eastman plates in December, 1880, and the sale to the photographers of the country began at this time.

During the next few months testimonials from many prominent photographers were published in the Anthony journal as to the merits of the new plates. Competition, of course, was furnished by Carbutt's Keystone plates and by Cramer and Norden's, but Eastman had the advantage of having his plates marketed by the leading firm of photographic dealers of the day. A number of the larger professional studios that had adopted the gelatin dry plate were making the plates themselves, following the recommendation of the committee appointed by the Photographers' Association. To meet this competition, Eastman prepared a dry emulsion, which was dissolved in water and then coated on the plates, but the merits of the prepared plates were sufficient to create such a demand that the price of plates was materially reduced in the fall of 1881, and the dry emulsion was discontinued. The demand increased so rapidly that the makers were not able to keep up the supply and we find the Anthonys apologizing to the trade but stating that Eastman had increased the size of his factory.

It was in this first season that Eastman and the Anthonys encountered a serious difficulty with the dry plates. Neither was apparently acquainted with the keeping qualities of the sensitive materials. The Anthonys took Eastman's output during the winter months (1880-81) and stored most of them. As the new stock was added in the spring, it was sold and the stored stock was not reached until summer. When these were shipped out to the purchasers the complaints began to come in. The Anthonys turned the complaints over to Eastman. Eastman soon traced the difficulty to the source and replaced the defective plates, although he was not legally responsi-

ble. This courteous and courageous act did much to inspire the confidence of operators in Eastman products.[399]

The rising tide of popularity of the gelatin dry plate, the reliability of Eastman as evinced in his conduct with the Anthonys, and the merits of the product itself created a greater and greater demand for Eastman dry plates. Eastman, however, had not much more than finished his first year's business with its serious difficulty when a second obstacle arose. The Eastman plates lost their sensitivity—even the fresh ones showed only the slightest trace of an image upon exposure and development. Long hours of anxious experiment failed to locate the trouble. The factory was shut down and the stocks of defective plates recalled. After sleepless nights and harrowing days, Eastman could not locate the trouble. He gave up the search early in 1882, and went to England where he bought the formula and materials for the best dry plates made there. Returning to this country, he reopened his factory. The trouble was eventually traced to the gelatin used in making the dry plates. The stock originally used did not contain the sulfur-bearing compound that research many years later showed was necessary to secure the much sought-for sensitivity.

Even with two calamities in the first two years of his business, Eastman was able to show a profit of nearly fifteen thousand dollars each year—so the dry plate business was very much on the profit side. A new factory was decided upon, and Eastman was able to write the Anthonys with pride early in 1883: "We are building a new factory, larger than the present one, and have lately put in a fifty-horsepower sectional boiler, a twenty-five-horsepower automatic engine, and a sixty light Edison dynamo for incandescent lighting. When completed, the factory will cover 90 x 66 feet, four stories in height and basement, with a boiler house 20 x 66 feet, and we shall be able to supply the world with the new specials." [400]

As Eastman's statement indicates, he was one of the early users of the electric light just then rapidly coming into favor. Photographers, too, were attracted by the new light. Kurtz, the famous New York operator, for example, made a specialty of "portraits taken by electric light" as early as the fall of 1882.[401]

The new age, with the electric light and the dry plate, begins to take on the appearance of the modern one.

The Flexible Film

MOST MEN would have been content with the early successes which Eastman had achieved. When one stops to consider the serious difficulties he encountered in the early years of his photographic career —the labors involved in the erection of new factories and the details of office and plant organization and direction—the possibilities of finding time for experiments looking to further improvements in the art of photography appear remote indeed. But Eastman actually found time for such trials. As early as 1881, only a year after the commercial production of dry plates was under way in his "factory," Eastman began experiments toward a new system of photography. The experiments were made with the object of procuring a flexible support or base for the gelatin emulsion. The object, which was by no means new with Eastman, had been attempted many times previously but without success. Flexible support for the photographic emulsion had early been recognized as a distinct advantage for the landscape or expeditionary photographer. The flexibility would allow the sensitive material to be wound on a spool, thereby providing a far greater supply of material in a far more compact form. Those who attempted the preparation of a flexible film also recognized the necessity of producing a device for rolling, unrolling, and rerolling the flexible material. This device, called the roll holder, had been proposed as early as 1854 by the Englishman, Melhuish.[402] Melhuish employed paper prepared according to Talbot's method, but the process was never extensively used. Sporadic attempts to perfect such a device were made a number of times in the intervening years, but always with failure or indifferent success. W. H. Jackson, for example, had a particularly disastrous experience with such material and device in 1877. On a hurried trip to the Southwest in the summer of that year he took with him a flexible tissue carrying a photographic emulsion prepared in England and containing

[384]

the equivalent of four hundred negatives. Upon exposure and development not one produced the faintest sign of an image! [403]

Such failures in the twenty-five years after Melhuish first proposed his roll holder served to indicate both the need of such a system of photography and the difficulties involved in producing it. Eastman worked intermittently on the problem from 1881 until 1884, when he announced the first successful system of film photography—not the film photography of today but at least a system of film photography that worked.

The film for the new system of photography was covered by a patent issued to George Eastman. The process consisted in the use of a good grade of photographic paper coated with a thin coat of water-soluble gelatin. Over this layer of gelatin was spread the photographic emulsion, the gelatin of which had been made insoluble in water by the addition of alum. The film was made in twelve and twenty-four exposure lengths and mounted on a spool. The spool in turn was placed in a specially devised roller holder devised and patented by Eastman and one of his associates, William H. Walker.

The roller holder was the forerunner of the device employed in the present film cameras in that it provided a spool to take up the film as it was unwound, a method of securing tension so that the film would lie flat behind the lens, and an indicator showing the proper position of the film for each exposure.

Such a roller holder was an auxiliary device, not an integral part of the camera as in modern instruments, and was built to go on the cameras then in use in place of the plate holder. For this reason, the holders were constructed in large sizes. By far the greatest number were made for 5 x 7, $6\frac{1}{2}$ x $8\frac{1}{2}$, or 8 x 10 size.

The roller holder was loaded in the dark room and attached to the camera. After exposures had been made, the film was removed and cut up into the individual negatives in the dark room and developed and fixed in the usual fashion.

The subsequent process was more complex. The paper bearing the developed and fixed image was pressed face-down upon a glass plate that had been previously coated with a solution, the object of which was to make easy the subsequent removal of the gelatin film.

George Eastman. (From a photograph by J. H. Kent of Rochester, made on "Eastman's Special Dry Plate"; the photograph originally appeared in *Anthony's Photographic Bulletin*, March, 1883.)

After it was firmly pressed down on the glass plate, hot water was applied to the paper back of the film, which melted and dissolved the layer of soluble gelatin. The paper could then be readily stripped off, leaving the insoluble gelatin film containing the image upon the glass. A thin sheet of fresh gelatin was then moistened and pressed upon the image-bearing film, which was allowed to dry. Upon drying, the reinforced film could readily be removed from the glass plate and placed in the printing frame, and paper prints could be made in the usual way.*

Although this process sounds tedious and difficult to the modern amateur, it must be recalled that the amateur of 1884 was not long removed from the wet plate days of many and intricate processes and cumbersome apparatus. The new method offered a distinct gain in portability of apparatus; the very large increase in the number of amateurs in this country after 1885 is to be attributed to the paper film and roller holder of Eastman. Eastman also devised another type of flexible film that did not prove as satisfactory as the "stripping film," as it was called. This second type consisted of an emulsion coated on paper without the intervening layer of soluble gelatin. The paper film was developed and fixed in the usual manner and rendered transparent by means of vaseline oil. Prints were then made directly from the paper negatives. Such paper films were not widely used, for they showed the grain of the paper on the finished print. As can be readily seen, the second of these methods was essentially a

* The reinforcing gelatin layer was necessary since the image-bearing film was too fragile in itself. Prints were not made from the film on the glass plate as the printed image would be reversed.

[386]

return to the method which Talbot had proposed forty-five years earlier.[404]

The press, both popular and professional, was quick to recognize the possibilities inherent in the new method of photography. The London *Times* of August 11, 1885, gave the Eastman film and roller holder a lengthy review in its columns and remarked that the method "promises to effect a revolution in out-of-door photography." The *Times* review followed the announcement that Eastman had been awarded a gold medal at the International Inventors' Exhibit held in London.[405]

Eastman, however, still was not satisfied. Professional studio

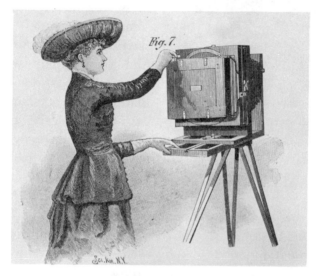

The Eastman-Walker Roller Holder of 1886.

The Roller Holder in operation. (Both illustrations courtesy Eastman Kodak Company.)

A print made from an Eastman paper-stripping negative. The subject is Mr. Eastman himself, who dated (Feb. 28, 1884) and signed the annotation on the negative. The signature may be dimly seen across the lapels of the coat and overcoat. (Courtesy Eastman Kodak Company.)

operators were not interested in the paper film, of course, and the number of landscape photographers was relatively limited. The number of amateurs, although increasing, still did not create a large demand for the new film. This indifference was probably due to the large size of negatives and roll holders, as well as to the complexity of the process of development. Eastman stated some years later, "When we started out with our scheme of film photography we expected that everybody that used glass plates would take up films, but we found that the number that did it was relatively small and that in order to make a large business we would have to reach the general public." [406]

As a result of careful thought and experiment, a camera was announced in 1888 that in a few years produced the revolution predicted by the London *Times* in 1885. The camera was patented September 4, 1888, although it had been placed on the market during July, 1888. As described in the patent, the new invention was an improvement in the detective camera which we have already mentioned. The essential difference, and a very real one, was the fact that this "detective" camera was a film camera, the roll holder being an integral part of the camera. The rear end, attached to a frame, slipped out of the case in the manner familiar to the amateur user of the small box camera of the present.

The camera was small, $6\frac{3}{4}$ inches long by $3\frac{3}{4}$ inches deep and wide, weighed twenty-two ounces, and made a picture $2\frac{1}{2}$ inches in diameter. Loaded with a spool of film of sufficient length for one hundred exposures, the camera sold for twenty-five dollars. It was

[388]

reloaded (in the dark) by the dealer for ten dollars; the exposed roll was developed by the dealer or sent in to Rochester to be processed. It may be said in passing that the introduction of this camera marked the beginning of an extensive new business, that of the photo-finisher.[407]

If the new camera marked a departure in American photography, its name became equally distinctive. Eastman purposely coined a new word for his new product, *Kodak*. He originated this word as a mark of identity for his camera and his photographic products and arrived at it

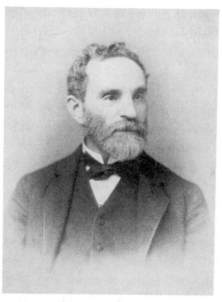

Edward Anthony. (Photograph by Fredricks, New York, about 1880; courtesy Mrs. Fannie Anthony Morriss, Washingtonville, N. Y.)

by starting with *K*, which seemed to him to be a "strong, incisive sort of letter." By trying out various combinations of other letters with *K* the short, easily pronounceable, easily spellable, and remarkably distinctive word was finally obtained.[408]

Immediately after the invention of the new camera and its name, Eastman began a national advertising campaign, describing his new instrument and its ease of operation in the popular and well known magazines. He thus reached the general public, and a new class of patrons was actually created. The evolution of the Kodak, however, was far from complete.

It can be seen that the decade 1879-1889 was an eventful one in the American photographic world. New processes and new instruments were supplanting the old—a new system replaced an old one and thousands who had never before "taken a picture" became enthusiastic over a new hobby. The decade also saw the introduction of bromide paper which replaced the old favorite, albumen paper, and freed the photographer from the burden of preparing his printing paper. Albumen paper, although purchased already coated with albumen and salt, had to be sensitized by the photographer, by

[389]

floating it face downward in a bath of silver nitrate, before prints could be made. With the introduction of bromide papers, the operator could buy his paper ready to use, and of various grades of sensitivity.

A bromide paper had been placed upon the English market as early as 1880 by the firm of Morgan and Kidd. Bromide paper, it should be stated for the uninitiated, results from the preparation of a sensitive gelatin emulsion somewhat similar to that employed in the gelatin dry plate. The emulsion is considerably slower than that employed in the negative but, upon being coated upon paper and dried, it retains its sensitivity. Through controlled production, it is possible to produce at will a variety of speeds and contrasts, and consequently the photographer, amateur or professional, has at present a considerable choice of material. Even at the time of its introduction, bromide paper surpassed albumen paper in both convenience and speed. The latter quality was of especial importance in making enlargements. With the introduction of bromide papers the process of enlargement became much easier, and many of the large photographs of grandfather or grandmother adorning the parlor walls date from this period.

Bromide papers were not used extensively in this country until after 1886, the Eastman company being the first to produce them in any quantity, although T. C. Roche of E. and H. T. Anthony and Company was probably the first to work out the process of their manufacture. The experience of the Eastman company in producing paper films, and the machinery and skill developed in coating plates and films, were largely responsible for its success.

The date at which bromide papers were introduced is very definitely determined by the annual report of progress given at the Photographers' Association convention for 1886: "A marked advance has been made during the year in the production of gelatin-bromide paper for printing. It had been known for some years that such paper could be prepared upon a large scale. It was patented by T. C. Roche and used quite extensively, especially in illustrating photographic journals, both here and in Europe, and also for many book illustrations. It never became very popular until the Eastman company took up its preparation and used American machinery to coat the

[390]

paper with emulsion. Since they have undertaken the manufacturing of gelatin-bromide paper for positives, its use has extended and many beautiful results are now obtainable by means of it." [409] But like the collodion wet plate, albumen paper died a lingering death. Many small operators continued to use it well into the nineties; it was not until after 1895 that it was practically abandoned by the American professional.

The introduction of bromide papers by Eastman marked the outbreak of serious difficulties between Eastman and the E. and H. T. Anthony Company. The Anthonys, as has already been related, were the first to market the Eastman dry plates, and they continued to do so for some years. Troubles eventually arose between the two firms, and after 1885 they were on anything but friendly terms.

Their difficulties finally (1887) went into litigation; Eastman first brought suit against the Anthonys for infringement of certain patents covering the use of machinery used in coating bromide paper, and the Anthonys in turn brought suit against Eastman for infringement of the patent issued to Roche dealing with the formula used in making the emulsion for the bromide paper. Both suits were settled out of court, but they left strained relations between the old established photographic house and the rising and progressive house of Kodak.[410] The bad blood engendered undoubtedly played some part in a far more serious legal entanglement which resulted from a patent issued to Hannibal Goodwin.

On May 2, 1887, Hannibal Goodwin of Newark, New Jersey, had filed application in the U. S. Patent Office for a "photographic pellicle and process of producing same." Webster defines a pellicle as "a thin skin or film"; therefore, Goodwin's application for a patent dealt with a method of producing a photographic film. "The object of this invention," reads Goodwin's patent, "is primarily to provide a transparent sensitive pellicle better adapted for photographic purposes, especially in connection with roller-cameras."

A *transparent* and flexible film had long been regarded by the profession as an exceedingly valuable desideratum. The successful films of Eastman in use at the time Goodwin filed his application, were constructed upon an opaque paper base, necessitating either

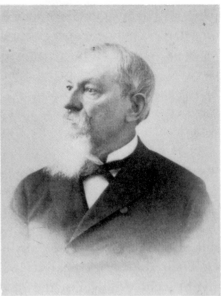

Other members of the firm of E. and H. T. Anthony and Company during the eighties: *upper left,* Colonel Vincent M. Wilcox; *upper right,* Henry T. Anthony (photograph by Bronner, Richfield Springs, N. Y.); *lower right,* F. A. Anthony (photograph by Fredricks, N. Y.); *lower left,* R. A. Anthony (photograph by Entrekin, Philadelphia). (All photographs courtesy Mrs. Fannie Anthony Morriss, a grandniece of both Edward and H. T. Anthony.)

the complex stripping process or the objectionable oiling (to render the paper transparent) in order to secure the finished print.

Many experimenters tried, with only limited success, to reach the desired goal of a transparent film. Attempts were made to produce such films of collodion, of collodion and gelatin, of collodion and rubber or gums, of celluloid, and of paper. Probably the individual who approached nearest to a solution of the problem was David of France in the early 1880's, but the David film was far from satisfactory.[411] In an American photographic journal even as late as 1888, a writer unfamiliar with Goodwin's application remarks, as a result of the multitude of such efforts and their uniform lack of success, "I consider the pursuit of a transparent film, therefore, a delusion." [412]

The filing of Goodwin's patent, which eventually turned out to be the basic patent of the film industry, was therefore an important milestone in photographic history. Goodwin proposed to make his pellicle, or film, by flowing a solution of nitrocellulose over a smooth surface such as glass. The solution of nitrocellulose was obtained by dissolving it "in nitrobenzole *or other* non-hydrous and non-hygroscopic *solvents, . . .* and diluted in alcohol *or other* hydrous and hygroscopic *diluent.*" * These are the essential words in the patent as issued, although some thirty-five hundred words of explanatory and descriptive matter are found in the final patent. The words italicized above became the crux of the important litigation in which the patent eventually figured.[413] It should be pointed out that the difficulty involved in the preparation of such a film was to prepare a solution of nitrocellulose which was fluid enough to spread readily when poured upon a smooth support, and thick enough to stay in its place after it had been smoothed out by a mechanical spreader. In addition, the solvents employed had to have sufficient volatility to evaporate (that is, to dry) after spreading, leaving a clear, transparent film. If evaporation took place too rapidly, bubbles were left in the film; if too slowly, the film became sticky. Too slow drying also caused the loss of time, an important factor, especially when expensive machinery was tied up in the drying process.

The principle enunciated by Goodwin was to use nitrobenzole, or *other solvent* of nitrocellulose, which evaporated slowly but gave

* The italics are mine. (R. T.)

a thick solution, and to dilute it with a *non-solvent* (of nitrocellulose), the general properties of which were a high volatility and an ability to thin the solution to any desired consistency. The non-solvent gave the solution of nitrocellulose a fluidity such that it could be spread readily and would evaporate rapidly, leaving a thicker solution which stayed in its place. When the remaining solvent had evaporated, the desired film of pure nitrocellulose was obtained.

Since the patent is such an important one in photographic history, one is curious to know something about the inventor, Hannibal Goodwin. Goodwin was born in Tompkins County, New York, on April 30, 1822. He was graduated from Union College, Schenectady, New York, in 1848, and later received professional training in a theological seminary. Following his graduation from the seminary, he held several rectorates in the Protestant Episcopal Church in New Jersey. The state of his health caused a removal to the Far West in 1860, but by 1867 he had improved sufficiently to become rector of the House of Prayer at Newark, New Jersey. He held this charge for twenty years, retiring when he reached the age limit of sixty-five set by his church. In the early part of his rectorate at the House of Prayer, he secured a stereopticon lantern which he used in giving lectures to the young people of his parish. Unable to find the illustrative material that he desired for these lectures, he was led into a study of photography in the hope that he could make his own illustrations. In the course of following the new hobby, in which he had become much interested, he began some experiments in the hope of finding a substitute for the glass base of photographic negatives. For ten years prior to his retirement he studied and experimented in this direction. His efforts resulted in the filing of the patent in the year that he retired. Not a man of means, Goodwin lived all his life on the meager salary of a clergyman. He was injured in a street car accident in the summer of 1900, and from this accident he never recovered. He died in Newark on December 31, 1900.[414]

The patent for which Goodwin applied had a long and somewhat devious history. It was not until September 13, 1898, that the

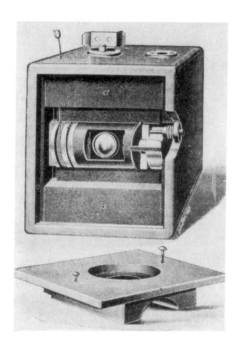
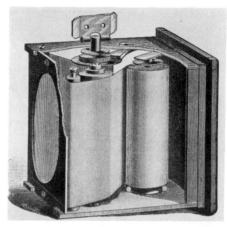

The original Kodak. (From illustrations in the
Scientific American, Sept. 15, 1888; courtesy
Scientific American.)

patent, changed considerably in form since its original filing, was finally issued to Goodwin. Briefly outlined, the history of the patent is this: Between the date of its filing and September 12, 1889, it was revised seven times. Most of the revisions were made at the suggestion of the Patent Office. On the date last mentioned an interference was declared between the Goodwin claim for a patent and similar claims for patents made by George Eastman and by Henry M. Reichenbach.

Eastman withdrew his application, but Reichenbach, who was a chemist employed by Eastman, revised his application sufficiently to secure a patent, which was issued December 10, 1889. The Reichenbach patent likewise covered a method of making a transparent, flexible film of nitrocellulose, but unlike the Goodwin application, very specifically provided the exact nature of the materials necessary to produce the film and their proportions. It specified the use of a large amount of camphor which Goodwin stated was not necessary, and further made no claims as to a general method of making nitrocellulose film. Following the Reichenbach formula, Eastman began the manufacture of a commercially successful transparent film that was first made available to the public on August 27, 1889. By the following year, Eastman was able to state: "The films have met with such favor that an enormous demand has sprung up which we have not been able to supply fully with our present facilities. We are erecting larger works for the purpose and building similar works for the English company near London." [415]

Although the Reichenbach patent was issued, the Goodwin patent was still delayed, further modifications were made, a second interference declared on January 18, 1892, and eventually the claims were rejected by the Patent Office examiner assigned to the case. Substitute specifications for the patent were filed September 18, 1895, which was within one day of the two-year period allowed by patent law following a rejection. The new form of the Goodwin patent was again rejected by the Patent Office examiner on June 18, 1897. Goodwin, through his attorneys, then filed an appeal to the examiners-in-chief, three in number, who reviewed the case and Goodwin's argument, and on July 8, 1898, reversed the decision of

[396]

the examiner,* thus clearing the way for the issuance of the patent to Goodwin on September 13, 1898.

The examiners-in-chief, in reversing the previous decisions, called attention to some points which are worthy of note, since they had an important bearing on the litigation which resulted after the issuance of the patent: (1) The material added by the numerous changes and additions while the application was held in the Patent Office was all still within the original specifications of Goodwin, being for the most part amplifications of the original wording. (2) Up to the year 1888 or '89 there was upon the market no satisfactory substitute for glass. The testimony of Eastman obtained in connection with the first interference proceedings was an important factor here, for he had stated that neither he nor Reichenbach had obtained a satisfactory film until late in 1888. (3) Prior patents, of which there were a number in somewhat related fields, had not given experts in the art sufficient information to enable them to produce a satisfactory film before the filing of Goodwin's application. (4) Goodwin had submitted affidavits which stated that with Goodwin's directions there had been actually produced a satisfactory film for photographic purposes. The well known chemist, Edward Weston, so testified to the Patent Office. On these grounds, then, the examiners-in-chief ruled in favor of Goodwin and stated that "this applicant, as far as the record before us discloses, is the first inventor of the successful photographic film pellicle." [416] It was also recognized by the Patent Office that Goodwin's claims were exceedingly broad and that the granting of the patent would undoubtedly bring important litigation in its train.

The Eastman Kodak Company since 1889 had been producing and selling flexible films, presumably under the Reichenbach patent. The demand for these films had continually increased and had been further augmented by the introduction of the daylight loading feature in 1895.† This method of wrapping the film upon the spool so that it was protected from daylight upon its insertion and removal from the camera, although the invention of Samuel W.

* Actually there were five different examiners concerned. All five had rejected the claims of Goodwin.

† The number of exposures in the Kodak roll film had been reduced from 100 to 12 and finally, after the introduction of the daylight loading cartridge, to six.

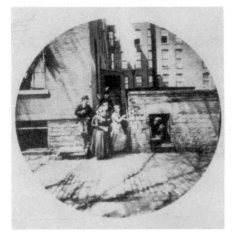

A photograph made by the first type of Kodak—a portion of the Eastman factory of 1888. (Courtesy Eastman Kodak Company.)

The Eastman factory of 1888. (Courtesy Eastman Kodak Company.)

Turner of Boston, had been immediately purchased by Eastman.[41] The paper stripping film, of course, had disappeared completely by this time, and, in fact, was not made after 1891. That the stripping film never reached large-volume production is shown by the fact that Mr. Eastman testified in the Goodwin case that the value of this film produced in its banner year (1889) amounted to only twenty thousand dollars.

The Blair Camera Company of Boston was also producing a film similar to that described by Goodwin as early as 1891. John Carbutt of Philadelphia had likewise made extensive experiments and, although not successful in producing a flexible film, had introduced a nitrocellulose base which he used in place of glass. Carbutt used thin plates of nitrocellulose which were coated with the emulsion and used in a plate holder in the same manner as glass plates. Having the advantage of lightness and nonbreakability, they achieved a very large success, especially abroad. Carbutt produced them first in the fall of 1888, but not by the method described by Goodwin, Carbutt's method being to shave or cut them from a block of nitrocellulose formed under pressure.* [418]

In the eleven years elapsing between the filing of the Goodwin

* The Carbutt film was 0.01 inch in thickness; the Eastman film about ¼ that of the Carbutt film.

patent and its final issue, the flexible film of nitrocellulose had become an article of considerable commercial importance. The long delay in the Patent Office is difficult to account for, but was due in part to the fact that Goodwin was a man of limited means and unfamiliar with Patent Office procedure. It appears from the record of the Patent Office that he could have prevented the issuance of the patent to Reichenbach if he had presented certain affidavits in time; after the first rejection by the Patent Office, the period of grace (two years) nearly elapsed before Goodwin made a move.[419] It is clear, however, that Goodwin made a number

Reverend Hannibal Goodwin, the original inventor of the celluloid flexible film. (Courtesy Newark *Sunday Call*.)

of trips to Washington, employed several sets of attorneys, was required to pay a number of fees to the Patent Office (for original filing and changes—the usual fees), all of which must have been exceedingly burdensome to a man of limited means. One biographer of Goodwin has suggested that the Eastman Kodak Company was responsible for the delay. If the Goodwin biographer has more information that I possess, he may be able to support his claim; but such information does not appear in the extensive record of the celebrated case of the Goodwin Film and Camera Company (the final owners of the Goodwin patent) *vs.* the Eastman Kodak Company. If there had been any authentic evidence to establish the charge, it would certainly have been brought up in this suit, since there was little else bearing on the case that was not produced. (The printed record of the case occupies over *fifty-five hundred* pages of printed matter.) I am of the opinion that the long delay in obtaining the patent was a result of Goodwin's lack of funds, of his lack of knowledge of patent law, and of errors in the Patent Office.[420]

Upon receiving the patent, Mr. Goodwin was at first besieged

with many offers, for the very general terms in which it was stated made its value well known. One concern offered him half a million dollars for the patent and its rights, but the transaction was not completed. Finally, early in 1900, after receiving ten thousand dollars from a friend, Goodwin decided to embark in the manufacture of film himself. A company was organized, the Goodwin Film and Camera Company, and a small plant was built at Newark. The plant was nearly complete when Mr. Goodwin suffered the accident already mentioned, and he died before production had actually begun.[421]

After Goodwin's death, no further steps were taken in the production of film under his patent until July, 1901, when, as a result of negotiations with E. and H. T. Anthony, 51 per cent of the stock of the Goodwin Film and Camera Company was acquired by the Anthonys through the efforts of F. A. Anthony (a nephew of Edward Anthony), R. A. Anthony (a son of Edward Anthony), and W. I. Lincoln Adams, a member of the firm of Adams and Scovill. In 1902, the firm of Anthony and Scovill was formed, to which the same interest in the Goodwin Film and Camera Company was assigned. The remaining interest in the Goodwin Company was owned by Mrs. Goodwin and the friends who had financed the original manufacturing venture of Goodwin.

F. A. Anthony became president of the Goodwin Film and Camera Company when the Anthonys obtained control and it was decided to proceed with the manufacture of film under the Goodwin patent. The plant at Newark was abandoned as being too small for the scale of operations desired, and a plant at Binghamton, New York, was constructed for the purpose. By December, 1902, the film was in commercial production. Presumably it was produced by the Goodwin Film and Camera Company and marketed by the Anthony and Scovill Company, but the relations between the two companies were such that they were practically identical.

At the same time that commercial production of film was begun by the Goodwin Film and Camera Company, suit for infringement was brought against the Eastman Kodak Company for the manufacture of film by that concern.[422]

The suit, like the patent itself, had a long and extended history, final settlement being made in March, 1914. The complainant (the Goodwin company) claimed infringement on the ground that the Eastman Kodak Company, almost immediately after the production of film was commenced in 1889, had departed from the specific formula of Reichenbach and had used what, in effect, was the very broad statement of the Goodwin patent. Both sides called in chemical experts who in testimony of hundreds of pages sought to confound and mislead the opposing side. The justice who rendered the first opinion in the case remarked, "The expert witnesses have given discrepant testimony on all essential matters." The most important evidence in the case was that supplied by Mr. Eastman and his associates and by the history of the Goodwin patent in the Patent Office, which was introduced by both sides.

The case came to a final hearing before Judge John R. Hazel of the United States District Court, who on August 14, 1913, held the Goodwin patent valid and infringed. Judge Hazel stated in his opinion that, "in departing from the specific formula of its patent, the defendant utilized the equivalent of the method specified by Goodwin in his patent and achieved the same result." He also stated that Goodwin was, in his opinion, "a pioneer inventor." The Eastman company was ordered to make an accounting and settlement of its profits from the sale of the infringed film.

An appeal was immediately taken by the defendant to the United States Circuit Court of Appeals. The opinion, rendered on March 10, 1914, of the Court of Appeals, consisting of United States Judges Lacombe, Coxe and Ward, and written by Judge Coxe, is a remarkably interesting document. After calling attention to the fact that over a quarter of a century had elapsed between the filing of the Goodwin application and the granting of the decree of Judge Hazel sustaining the patent, Judge Coxe in no uncertain terms stated that Judge Hazel's opinion was sustained. After briefly reviewing the evidence he stated, "We cannot resist the conclusion that Goodwin's application, as filed in 1887, disclosed for the first time the fundamental and essential features of a successful, rollable film. . . ." On March 27, 1914, Mr. Eastman settled with the then owners of the

[401]

Goodwin patent, the Ansco Company * and the Goodwin heirs, for five million dollars in cash.

It is thus established that Hannibal Goodwin was the inventor of the first flexible transparent photographic film—an opinion in which three examiners-in-chief of the United States Patent Office and four United States judges, seven unbiased and judicially trained minds, have all concurred without a dissenting voice, after a careful consideration of the voluminous record. The point was raised during the trial that the Eastman company improved the process, and the Eastman lawyers argued that a large and important industry had developed in the twenty-six years elapsing since the Goodwin patent had been filed. "This industry," says their brief, "is enjoined on a patent the application for which was uniformly rejected by the five different examiners who successively had it in charge during its eleven years pendency in the Patent Office." To which argument Judge Coxe most caustically replied, "Truly an extraordinary and deplorable condition of affairs! But who was to blame for it—Goodwin or the five examiners who improperly deprived him of his rights during these eleven years? We are unable to see what he could have done to enforce his rights during this period or how any blame can attach to him for his inaction." Judge Coxe further stated: "It matters not that the defendant's process produces better results than that of the patent. Assuming this to be true, it does not give the defendant the right to use Goodwin's discovery because it has introduced improvements. . . . Undoubtedly there was progress, but as we have had occasion to point out before, one cannot use a patented invention because he has improved it." [423]

This case has been discussed at some length, and rightfully so, for it is the most important legal controversy in the whole history of photography. Incidentally, we have indicated during its discussion the tremendous development of amateur photography during the period—a development which dates from the invention of the nitrocellulose film by Goodwin in 1887 and the introduction of the Kodak in 1888 by George Eastman. Goodwin is rightfully entitled to his place in film history. This is no attempt to discredit the important position that George Eastman occupies in American photog-

* The Ansco Company succeeded Anthony and Scovill in 1907.

raphy, but is merely an attempt to give Goodwin his due. The fact that the name of Kodak and its products is known in every home of the civilized world is some indication of Eastman's place in history.

<p style="text-align:center">*　　*　　*　　*　　*　　*　　*</p>

One must not think that there have been no important developments in American photography since 1914. There have indeed been a great many, but special attention is called to two: The discovery of sulfur sensitization in 1925 by Sheppard and his co-workers of the Eastman Kodak laboratories, which enables a further increase in light sensitivity to be made, and the volume production of photographic emulsions sensitized to yellow, green, red, and infra-red light.[423a] Photographic emulsions as ordinarily prepared are not sensitive to these colors (as many an amateur has found out), all such rays producing black images in the finished print. By the introduction of suitable dyes during manufacture, the photographic emulsion can be sensitized to any or all of these colors. The pioneers in the discovery of color sensitization were Dr. Hermann Vogel, the genial photographic ambassador from Germany, and the American, Frederic E. Ives, an early worker in the field of the half-tone process. Vogel made the discovery that sensitization was possible in 1873, and Ives did his pioneer work during the period from 1879 to 1885.[424]

It is only since 1928, however, that large-scale production of these so-called panchromatic materials has been undertaken. Panchromatic film has been a boon for the serious amateur, the professional photographer, and the producer of the cinema.

It may be realized what a vast industry American photography has become, when it is stated that in 1935 some 500 tons of silver were consumed in this country alone for photographic purposes. The combined value of all photographic materials and instruments sold in this country was approximately seventy-five million dollars.

Very probably, although no exact data are available, amateur and professional photographers used at least half of this production; the remainder was consumed by the cinema industry and hospitals (for X-ray work). Again, while no exact data are available, it seems prob-

able that there are at the present time at least fifteen million amateur photographers who are actually engaged in their hobby in this country.*

Contrast this state of affairs with the hand-buffed silver plate, the cigar box and spectacle lens, and the handful of amateurs in 1839.

* The New York *Times* (May 16, 1937, section 4, p. 9) estimated that even during the recent depression there were one and one-half million cameras owned by New York's metropolitan population of seven million and that one million three hundred thousand photographs were being taken weekly.

Zoopraxiscopes and Less Wordy Innovations

SOME THIRTY-TWO YEARS after Coleman Sellers' invention, the kinematoscope, first utilized photography in reproducing motion, Eadweard Muybridge displayed at the World's Fair of 1893 an instrument for the same purpose, which he called by the exuberant title, the *zoopraxiscope*. The *zoopraxiscope*, if not better in nomenclature than the *kinematoscope*, was a distinct step in the evolution of the modern motion picture. The name of Muybridge, well known as a photographer long before the christening of the zoopraxiscope, is therefore an important one in American photographic history.[425]

Muybridge was born in England in 1830 as Edward James Muggeridge, but he early showed his individuality by changing his name to Eadweard Muybridge and migrating to this country. His early history in this country is obscure, for his name does not appear in American photographic journals until 1868, when comment occurs concerning his views of Yosemite, which were made in 1867.[426] These and subsequent views of Yosemite brought Muybridge a national and international reputation. Muybridge's photographs of Yosemite were characterized by cloud effects that were truly superb for their day. They were obtained, of course, by the use of two negatives, one containing the view and the other the clouds. Muybridge exhibited these pictures as large prints, 22 inches square, both at home and abroad. They were very much admired in Berlin, London, and Vienna in 1873, and during the years immediately following. At Vienna they were displayed at the International Photographic Exhibit and were awarded a medal for their excellence. Muybridge also made photographs of the Modoc Indian War in California in 1873, and, in addition, some early views of Alaska. These, together with the Yosemite views, had secured for Muybridge in the early seventies the reputation, as stated in *Anthony's Photographic Bulletin*, of being "one of our very best artists." [427]

In 1872, Ex-Governor Leland Stanford of California, the owner of a large stable, wagered a friend, Frederick MacCrellish, twenty-five thousand dollars that race horses in rapid motion, at some time during their gait, took all four feet from the ground at once. Observation was insufficient to confirm Stanford's theory, so he employed Muybridge, one of the best known California photographers, to make, if possible, a photographic record of the horse in motion.[428]

Muybridge's early efforts were not especially successful as photographs, but they did show that the horse was not always in contact with earth. It will be recalled that in 1872 the wet plate was the fastest material at hand. Even with large apertures and brilliant illumination, stopping rapid motion by the camera was virtually impossible. Some of these early efforts of Muybridge, however, gave promise of obtaining a really successful photograph. They gave so much promise, in fact, that Stanford commissioned Muybridge to proceed with his efforts. No great progress was made until 1877 and '78, when the so-called "lightning process" was introduced, which materially reduced the time of exposure.

By 1879, Muybridge's photographs of the horse in motion were attracting marked attention on both sides of the Atlantic. Wilson, in the *Philadelphia Photographer,* commented, "Mr. Muybridge, you have caught more motion in your photographs than any previous camera ever dreamed of." Abroad, Vogel took a number of Muybridge's photographs to the German minister of agriculture, who agreed with Vogel that "the curious postures of the legs of the horse, which caused a surprise here, are interesting in the highest degree for the theory of animal locomotion."

These photographs were secured by an elaboration of Muybridge's original method. An intensely white background, brilliant sunshine, large aperture, drop shutters actuated by springs and rubber bands to secure an exposure that Muybridge estimated as 2/1000 of a second, plus the "lightning" collodion finally gave the desired results. True, the photographs were not much more than silhouettes, but they amply confirmed Stanford's hypothesis that there were times in a horse's gait when all four feet were off the ground.[429]

Muybridge had originally started with one camera, but as the

Eadweard Muybridge. (From a photographic portrait made late in life; courtesy U.S. National Museum.)

work proceeded more cameras were added until finally a battery of twenty-four instruments placed side by side was employed. The shutter in each camera was at first operated by a string which the horse broke as he passed in front of the lens. Later this method was

[407]

changed so that the operation of the shutter was secured electrically. Fine wires were laid across the track directly in front of each camera. A steel-tired buggy drawn by the horse completed an electrical circuit as it came to each camera, which caused the shutter to drop. This ingenious device was the work of John D. Isaacs, of the engineering staff of the Central Pacific Railway, controlled by Stanford, who had detailed Isaacs to aid Muybridge.[430]

As this account suggests, Stanford had spent a very considerable sum in order to prove his original contention. The San Francisco *Call* stated that, up to 1880, he had spent between forty and fifty thousand dollars upon this hobby. The work was extended to include not only the recording of moving horses but of moving dogs, cattle, rabbits, and men, as well.[431]

In 1879, Muybridge devised an instrument which he first called the *zoogyroscope,* but he later changed the term to the *zoopraxiscope.* The zoopraxiscope was a projection lantern that contained a number of photographs printed on a glass wheel which could be rotated, thereby bringing the slides successively into position in the lantern and projecting them in succession on the screen. By the use of a suitable shutter the illusion of motion was produced and the successive photographs of animals in motion reproduced the original motion of the animal.* If Muybridge had been the first to accomplish this feat he should, without question, be called the father of the motion picture. But in this reproduction of motion on the screen he was anticipated by Henry R. Heyl of Philadelphia. Heyl used a projection lantern employing a number of slides (approximately an inch square) upon a rotatable wheel, as did Muybridge. By using successively posed photographs and then projecting them rapidly one after another, he produced the illusion of motion. Heyl made his first public exhibition on February 5, 1870, in the lecture room of the American Academy of Music in Philadelphia. Heyl thus preceded Muybridge by some nine years although he did not have the advantage of the "instantaneous" views of Muybridge. The motion that Heyl was able to reproduce most successfully was that of a waltzing couple, a number of posed photographs of the

* The maximum number of photographs Muybridge used on the wheel was approximately two hundred.

Zoopraxographical Hall, Columbian World's Fair, 1893. (From Muybridge, *Descriptive Zoopraxography*.)

couple in various stages of the waltz being secured by Willard, a Philadelphia photographer whom Heyl employed, since he himself was not a photographer. So successful was Heyl with this one scene that it was possible to synchronize music with the images as they appeared on the screen.[432]

Despite the fact that Muybridge's claim as the father of motion pictures is distinctly clouded,* he rightfully occupies an important place in the history of the motion picture industry. By his photographs and lectures he called distinct attention to the possibilities of reproducing motion on the screen—a problem which was not completely solved until the introduction of the roll film. One of the most important consequences of Muybridge's photographs was their influence in the field of art. Muybridge, himself, especially emphasized this aspect. He left Stanford and California in 1881, went East and then abroad, lecturing and illustrating his lectures with the zoopraxiscope. He visited London, New York, and Paris, where the Muybridge lectures created marked interest, especially among artists and physiologists.

The importance of the Muybridge photographs in this connection is best realized when it is recalled that prior to the time of Muybridge, the artist in depicting an animal in motion, in the vast majority of cases, had shown the animal with both forefeet extended in front and both rear feet extended behind, a typical "rocking

* It should be noted, however, that Muybridge was the first to reproduce photographs of moving animals. The photographs employed by Heyl were "still" pictures. Even Heyl's efforts were antedated by "magic lantern" pictures in which a movable element containing a figure could be moved in and out of the projection lantern. The moving figure appeared on the screen against the background of a still picture, and a crude illusion of motion was produced. For the development of this interesting sidelight of our history the reader is referred to an article by L. W. Sipley, *Pennsylvania Arts and Sciences*, Vol. I, page 40 (1935).

horse" gallop. No wonder, then, that remarks were made concerning the "curious postures of the horse," a comment which was shown to be applicable also to other animals in motion. After the Muybridge photographs became known, artists were forced to change their ideas and methods of representing a moving animal. Meissonier, the celebrated French painter of animals, for instance, is said to have lain awake all night after Muybridge had exhibited his photographs to him, so great was the shock to his sense of truth.[433]

It is not at all unlikely that the best known American portrayer of the horse in action, Frederic Remington, was influenced by these photographs. It is a fact that Remington's artistic career dates from 1880, practically the same time that the Muybridge photographs were becoming well known. Remington was a close student of the horse, and while no positive information is available, it seems almost inevitable that Remington was familiar with, and influenced by, these striking photographs of the horse.[434] If true of Remington, it was still truer of the later portrayers of the horse in action, especially of the Western horse—including such artists as Russell and Schreyvogel. Certain it is that a comparison of sketches in the popular illustrated journals before and after the Muybridge photographs became well known shows that the depiction of horses underwent a marked change in form at this time.

In 1884, Muybridge became connected with the University of Pennsylvania, where his studies on animal locomotion were continued until 1887. He then returned to England to make his home. When the Chicago World's Fair of 1893 was opened, Muybridge was invited to give lectures on animal locomotion at the Fair and an elaborate "Zoopraxographical Hall" was constructed for him. Here paid lectures illustrated by zoopraxiscope were daily made and were witnessed by thousands. A spectator at the Hall noted that horse races were "reproduced with such fidelity that the individual characteristics of the motion of every animal can readily be seen; flocks of birds fly across the screen with every movement of their wings perceptible. . . ."[435]

The development of the cinema industry subsequent to Muybridge's day has been described in other volumes, so that it need not concern us further here. It is sufficient to state that the great

The Stanford track and Muybridge equipment.

Background and arrangement for measuring strides.

The twenty-four cameras employed by Muybridge. (All illustrations from heliotypes reproduced in *The Horse in Motion,* 1880.)

growth did not take place until after cinema film reached commercial production. American photographic firms began producing film on such a scale in June, 1896.[436]

<p style="text-align:center">* * * * * * *</p>

If photography has created the outstanding amusement of the modern world, it has also touched modern life through a phase of culture which may not, at first glance, be so distinctly realized. I refer to the present-day illustration of newspapers, magazines, and books. Here photography has played an exceedingly important part, although a far more technical one. A complete history of photomechanical illustration would require a treatise in itself, but since it forms only a fraction of the whole history of photography we must confine its story here and in the following chapter to a brief outline.

From the first days of the daguerreotype, interest and attention had been directed toward the end of establishing methods whereby facsimile copies of an original photograph could be reproduced along with the printed word.

In the daguerreotype era, but one photograph could be obtained for every exposure of the camera. Numerous investigators therefore directed their attention toward the problem of producing copies of the daguerreotype, especially copies that could be used as illustrations in book or magazine.

Several methods were found and were used to some extent, but they were far from satisfactory. In the most successful of these methods, the finished daguerreotype was etched, either by acid or by electrolysis. The silver areas, the dark part of the picture, were "bitten" into, while the mercury-coated areas, the high lights, were affected to a smaller extent by the etching agent. After etching, the plate was inked, wiped, and an impression made on paper in the same manner as for an engraving. The method was not extensively used, since the etching could not be made deep enough to take sufficient ink; if etched too deeply, detail disappeared. The method had the advantage, however, of correcting the right-to-left reversal of the image on the daguerreotype plate. So far as I have been able to ascertain, the method was never used for book or magazine illustration, but was used to a limited extent for separate copies of the daguerreotype on paper.[437]

[412]

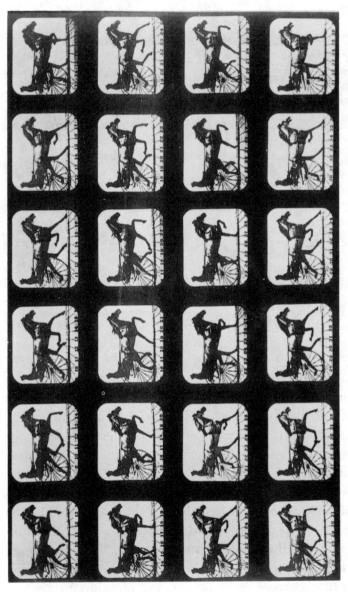

The Stanford horse "Edgerton" trotting (photographed in motion by Muybridge; from a heliotype in *The Horse in Motion*).

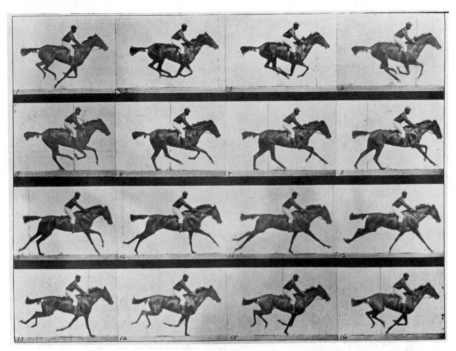

The horse "Annie" in gallop. Compare the position of the horse in No. 4 of this series with that of the Remington horse in the next page of illustrations. (From Muybridge, *Animal Locomotion*, 1887.)

Another method of producing copies of the daguerreotype, although not exactly facsimile, was devised by Joseph Saxton, of Philadelphia, one of the earliest amateur photographers of the country. Saxton, of the United States Mint, produced a ruling machine that, in effect, transferred the image on the daguerreotype to smooth metal. The metal plate was then engraved in the usual manner and prints in ink obtained from it. By this method at least one daguerreotype, that of the Mint Building, was reproduced in *A Manual of Gold and Silver Coins,* the first edition of which appeared in 1842.[438]

The desire for copies of the daguerreotype led John Plumbe, the best known of the early daguerreotypists, to announce in the middle forties that he had solved the problem. His copies, which he called Plumbeotypes, prove upon examination to be nothing more than hand-drawn lithographic prints.[439]

One curious use of the daguerreotype, and one which long survived the daguerreotype portrait, was its employment in the prep-

Upper. The Conventional method of drawing a horse in rapid motion prior to the publication of the Muybridge photographs. ("A Freshener on the Downs," from *Scribner's Monthly,* Nov. 1877; reproduced by permission of the Proprietors of *Punch,* the copyright owners.) *Lower.* An early Remington drawing: "In with the Horse Herd." (Illustration to an article by Theodore Roosevelt, *The Century, March,* 1888; courtesy D. Appleton-Century Company.)

aration of bank notes. This method was in use as late as 1873, and probably was employed for some years after this date. Stephen H. Horgan, well known in the field of printing and illustration, began his photographic career in a tintyper's gallery in 1870, as a boy of sixteen. In 1873 he found employment with Abraham Bogardus, the New York photographer. Here he learned daguerreotypy, for Bogardus made daguerreotypes for the American Bank Note Company. The use of the daguerreotype in this field of illustration is described in Horgan's own words: [440]

"The pen or pencil drawings of designs for engraving on steel were reduced to proper size by the daguerreotype method. I was assistant to the daguerreotypist (in the Bogardus establishment) who was quite willing that I should learn the art as he was an old man and I might take his place when he was taken ill (which usually took place after pay day. A long sleep usually rested him).

"The Bank Note Company were secretive about their use of the daguerreotypes though I suspect the design was etched into the copper plate (of the daguerreotype) with a steel point; the incision filled with sanguine, an impression pulled on transfer paper, which was then transferred to the white wax ground on the steel plate for the engraver."

<p align="center">*　　*　　*　　*　　*　　*　　*</p>

As can be seen from this brief discussion, there was, for the daguerreotype, no satisfactory method of facsimile reproduction available. The same statement could be made for the paper photograph, although Talbot, in 1844, had published his *Pencil of Nature,* which used actual photographs as illustrations. This appears to be the first book so illustrated. As far as I have been able to ascertain no American book or magazine prior to 1853 employed original prints for this purpose.

With the advent of the collodion process in 1851, paper prints from negatives became available, and it was soon suggested that these paper prints be inserted in books or magazines as illustrations. The first American magazine to follow this suggestion was the *Photographic Art Journal,* which in April, 1853, included a paper print of Edward Anthony. The print, as has already been pointed out in a previous chapter, was one of Whipple's crystallotypes. From this

[416]

Alaska: the Parade ground at Sitka (photograph by Muybridge about 1870). The Modoc War: camp south from Signal Tower, Tule Lake in distance (photograph by Muybridge, 1873). (Both photographs, courtesy F. P. Farquhar, San Francisco.)

time on, the *Photographic Art Journal* quite regularly bound a photograph into each monthly number. At times small photographs were pasted upon a sheet of paper of magazine size and at other times the print was made as large as the magazine page, although only a portion of it was sensitized. Although most subsequent American photographic journals followed this practice up until the beginning of the half-tone era, few, if any, other magazines did so.

The first American book which I have found to be illustrated by actual photographs in the same manner as the *Photographic Art Journal* was *The Crystallotype,* published by the Putnams in 1855. This was an illustrated record of the New York Crystal Palace Fair of 1853. An earlier edition of this book had appeared as *The World of Art and Industry* but it was illustrated by woodcuts.[441]

After 1855, actual photographs were used to illustrate a considerable number of books. The larger publishers did not use them, since the number of prints required for books printed in large editions made the cost prohibitive. The inclusion of photographs, too, usually made the book thus illustrated stiffer and thicker than did the use of woodcut illustrations, since it was necessary to mount the photographic prints on fairly heavy paper or cardboard. Volumes

[417]

which are illustrated by actual photographs are usually of local character—city histories, biographies of leading citizens, or books published in a small edition. From 1860 until 1890, the number of books so illustrated was quite large, although it is not easy to locate them at present.[442]

Yosemite Valley—composite photograph by Eadweard Muybridge, 1869.

Photography and the Pictorial Press

THE PICTORIAL PRESS has long been a popular institution—possibly more popular in this country than in any other. The first successful and continuous venture in this field, however, occurred abroad, when Herbert Ingram published Volume One, Number One, of the *Illustrated London News* on May 14, 1842. Ingram, who lost his life in a boat accident on Lake Michigan in 1860, sensed the public's partiality for *illustrated* news as it appeared in earlier spasmodic efforts in this direction and in iliustrated monthly magazines. The means for obtaining and reproducing pictures quickly in large volume on the press were, in 1842, totally lacking, but Ingram by infinite labor, persistence, and foresight established the *Illustrated News* on so firm a basis that it continues to the present day.

L'Illustration in Paris and *Illustrirte Zeitung* in Leipzig followed the *News* in appearance by one year.[443] In this country, after several unsuccessful efforts by others, Frank Leslie, a wood engraver trained in the hard school of the *Illustrated News* during its formative period, published on December 15, 1855, the first number of *Frank Leslie's Illustrated Newspaper.* As Leslie stated in the first issue, his object was to seize promptly and illustrate the passing events of the day; he modestly admitted, "Our journal is the most comprehensive and interesting pictorial record of events to be found in either hemisphere." [444]

Leslie's was followed in 1857 by *Harper's Weekly,* which in its earlier issues used illustration chiefly in its stories. Fletcher Harper, the founder of the *Weekly,* soon found that by including the pictorial news of the day, especially of those events close to the lives and experiences of his readers, an increase in circulation resulted, which made possible its success. Although reliable figures are not readily available, *Leslie's* and *Harper's Weekly* are commonly cred-

ited with possessing a larger circulation than any of their competitors, either illustrated or non-illustrated.

Photography affected the early pictorial press in two ways: it supplied copy and it aided in the reproduction of illustration. Copy supplied by the camera did not come into extensive use until well after the dry plate era—save for portraits—because the inability of the camera to arrest motion was an insurmountable handicap in portraying action. The "artist on the spot" was the recorder of the scene and, although the pictorial magazines were certain to credit each picture as being "drawn by our artist on the spot," the artist occasionally made a slip and was somewhere else—probably in the home office—rather than "on the spot." Rivals were quick to call attention to such dereliction and to accuse the transgressor of having pictured the scene before it occurred, or more frequently of having pictured a scene that never occurred. Such detected lapses, if we may judge by the continued demand for the periodicals, must have caused only a passing grin from the reader.

The greatest influence which photography early exerted on the illustrative art was through the woodcut.* The woodcut, for many years, was the standard form of illustration in books, magazines, and newspapers. It was prepared by sketching the desired illustration or diagram in reverse upon the surface of a specially selected wood block. Skilled wood engravers then cut away the wood in the spaces between the drawn lines, thereby leaving the design in relief.† Such a design could be inked, and prints made by impression upon paper; but when large numbers of prints were required (as in books or

* Although we are considering here only printing press illustration, it should be pointed out that photography also vitally affected another form of illustrative art. Lithographs, such as those published by the famous firm of Currier and Ives, were in time supplanted in popular affection by the paper photograph. This was especially true so far as portraits were concerned. Harry T. Peters in the first volume of his *Currier and Ives, Printmakers to the American People*, tells an amusing story of Tom Thumb, America's most celebrated dwarf, which illustrates the point. P. T. Barnum and Mr. Currier were trying to convince Tom that more of his lithographic portraits should be made. But Tom refused and asked to be taken to Sarony's studio so that a cabinet size photograph could be made, as the photographs "were much more fashionable."

† The early illustrated weekly newspapers labored under real difficulty in the rapid production of the woodcut, as a large one, say of single-page size, is said to have required three weeks for its production. Some ingenious wood engraver hit upon the idea of dividing the block into many pieces after the design was placed upon it and giving each piece to a different engraver. After engraving, the pieces were reassembled and bolted together into the finished whole engraving. In this way, in case of necessity, a large engraving could be made overnight. Charles Wells in England is commonly credited with introducing this innovation, but Frank Leslie had employed the process almost from the start of his newspaper and described it in his *Illustrated Newspaper* in the summer of 1856.[446]

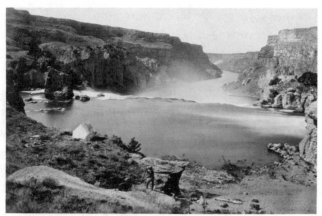

Illustrating the methods of reproducing photographs before the
introduction of facsimile methods. *Upper*, Shoshone Falls, Idaho,
from above. (Photograph by T. H. O'Sullivan, 1868; courtesy
Capt. W. H. Crosson, U.S.A.) *Middle*, a hand-executed wood en-
graving of the photograph. (From *Harper's Magazine*, 1869.)
Lower, a hand-executed lithograph of the photograph made by
Julius Bien of New York and published in the official report of
the King expedition which O'Sullivan accompanied.

magazines) the soft wood block was not used for the purpose. Rather, the design on the block was pressed into a clay or wax bed, producing an exact impression in the soft bed. From the clay impression a metal block could be obtained by pouring molten type metal upon it; a stereotype identical in form with the original woodcut was thus produced. From the stereotype the actual printing on paper was accomplished by the usual method of inking and pressure. If a wax mold were made, it was coated with carbon, and metallic copper deposited upon it electrolytically. This deposit, when stripped from the wax, produced a copper electrotype that, backed with type metal, was used for the actual printing of the illustration. The stereotype was utilized quite generally until 1850. In 1852, *Harper's Magazine* for the first time employed the electrotype in reproducing its pages. The use of the electrotype, however, did not become common until some years later, when the introduction of the electric dynamo made it possible to reduce materially the time required for its production.[445]

After the collodion process was well established, numerous attempts were made to photograph directly on the wood block and thereby utilize the photograph as the form for the wood engraver to follow. The technical difficulties were considerable, and the first American satisfactorily to solve the problem was J. D. Brinckerhoff of New York, who for many years was prominent in photographic and publishing circles. The first published effort of Brinckerhoff appears in the *Photographic and Fine Art Journal* for February, 1855. The print, secured by photographing on wood, was a portrait of C. C. Harrison, America's pioneer manufacturer of photographic lenses and cameras. This illustration showed an unmistakable advance in woodcut portraiture.[447]

Brinckerhoff did not patent his process, but several years later Robert Price of Worcester, Massachusetts, and C. B. Boyle of Albany, New York, both secured patents for a process of the same general nature. Price's method was used by the *Scientific American* for the reproduction of woodcut portraits, the first of which appeared May 21, 1859. Price's patent was granted, however, on May 5, 1857; Boyle's on February 8, 1859. Boyle also obtained an English patent for this procedure. From 1858 to 1865, there seems to have

been a gradual increase in the use of photography on wood in the preparation of woodcuts. After 1866, the process was quite generally employed; and it still is when woodcuts are used for illustrative purposes.[448]

The perfection of photography on wood was a double gain to the field of woodcut illustration. For portraits, facsimile copy was provided the wood-engraver. For illustrations drawn by an artist, the drawing could be made any size that suited his convenience. By the aid of the camera, this drawing could be photographed in reverse and reduced or enlarged to the size of the wood block to be cut. The very beautiful illustrations which for many years (approximately 1880-1900) were the mainstay of such well known journals as *Harper's Magazine* and *The Century* were prepared by this process.

Closely allied to photography on wood, although used for the purpose of illustration in a somewhat different manner, was photography on zinc. The process appears to have been originated by Gillot, a Parisian lithographer, in 1859. It did not come into extensive use in this country until after 1880, although it was doubtless employed to some extent before this time. The Moss Engraving Company of New York, and the Levytype Company of Philadelphia, Chicago, and Cincinnati, were the principal practitioners of this process, although other methods were used by both of these firms.

The principle of the method was based upon the fact that a zinc plate coated with a mixture of egg white (albumen) and potassium bichromate is sensitive to light. A reversed negative of the subject desired (in line only—no half-tones could be duplicated) was placed against a zinc plate coated with the above mixture and exposed to light. The light on passing through the transparent parts of the negative—the black lines of the original subject—fell upon the albumen mixture and hardened it; the remaining areas were unaffected. After exposure, the zinc plate was lightly inked and then washed in cold water. The cold water dissolved the albumen where light had not affected it—the lines of insoluble albumen remained, making an image of the original. The plate was inked again, the lines of the image taking up the ink, and it was then

A portrait copied on wood by hand—the usual method until about 1865. The subject is United States Commissioner of Patents, Charles Mason. (From the *Scientific American,* Sept. 12, 1857.)

The first portrait in the *Scientific American* engraved from a photograph on wood. The subject is United States Commissioner of Patents William D. Bishop. (From the *Scientific American,* May 21, 1859.)

subjected to treatment with acid. The acid attacked the clear zinc spaces, and, by continuing the etching, a zinc relief plate suitable for printing could eventually be obtained. The plate could be backed with a wood block and used in the locked form with type. Zinc plates could also be bent and used in rotary presses.

As has been said, this method could be used only for line work and the lines had to be distinctly drawn. It was especially suitable for printing maps, plans, and diagrams. It is stated that the diagrams in the *United States Patent Office Gazette* were published by such a method, but the method was probably the modified one described below.

The modification did away with the etching, for it was found that the hardened albumen lines on the zinc plate, after exposure under the negative and washing, would take printer's ink and the clear zinc areas would not. Under pressure, the plate would yield a print on paper. This method, of course, as those acquainted with such processes will know, is simply a form of lithography.

Newspaper illustrations just before the advent of the half-tone era: *left*, "McKinley's forces march up Broadway" (from the *New York Tribune*, Nov. 1, 1896); *right*, the Princeton-Yale game of 1896 (from the *New York Tribune*, Nov. 22, 1896). (Both illustrations, courtesy *New York Herald Tribune*.)

A reproduction of an American-made Woodbury print: a glimpse of the Schuylkill from Laurel Hill Cemetery. (Photograph by John Moran, Philadelphia, 1872.)

Probably the most popular method in the early eighties in this country for the publication of illustration in line was that called "the swelled-gelatin method" of making photo-relief plates. Various modifications of the process were employed; one of the earliest in this country was that worked out and patented by Louis E. Levy and David Bachrach, Jr., of Baltimore, in 1875.*

The method served nicely for the reproduction of engravings, lithographic prints, or even woodcuts, since, unlike the zinc processes, it was not absolutely essential that the lines of the original be clear, black, and sharp. Not only was this method used for making

* The method, in brief, was as follows. The drawing (or other original copy to be reproduced) was photographed in reverse, by copying a mirror image of the original. The negative thus secured was placed over a heavy glass plate coated with a mixture of gelatin and bichromate and exposed to light. Like the albumen mixture, the bichromated gelatin hardened when exposed to light. Upon washing such a gelatin film in *cold* water after exposure, the parts of the gelatin not acted upon by light absorbed water and swelled. The lines of the original subject (that portion behind the transparent portions of the negative), being hardened, did not swell, and remained at their original level. A gelatin intaglio was thus obtained. From the intaglio, a relief was obtained by pouring a paste of plaster of Paris over it. When hardened, the plaster relief was used to make an impression in wax. Finally, an electrotype relief was obtained from the wax impression, by depositing copper upon it by means of the electric current. The electrotype relief was inked to obtain the final print on paper.

illustrations but it was used also to produce cheap editions of expensive books, such as encyclopedias and dictionaries.[449]

Although the Levytype had some advantage over the zinc etching process in that clear black lines were not absolutely necessary, it was still impossible by either method satisfactorily to reproduce original copy that showed intermediate tones between black and white (that is, half-tones) such as are found in paintings or photographs. The wood engraver here had the advantage, for by varying the number of relief lines or dots the illusion of half-tone could be produced in the finished print. As is obvious, such work was done by hand and not photo-mechanically. Photographs, especially portraits, were copied by both the zinc etching and the Levytype processes, but here again hand work was necessary. In such instances, the photograph used as copy was taken in hand by the artist, who sketched the principal lines upon the photograph with bold, black strokes. The photographic image was then bleached away, and, from the line drawing, the cut for printing was finally produced.*

The development of these relatively simple photo-mechanical processes led naturally to the use of illustrations in daily newspapers.

As early as 1873, the New York *Daily Graphic* made its appearance; it was the first American daily newspaper to use illustrations during its life. Although surviving for sixteen years, it was ahead of its day, for the printing difficulties (both mechanical and financial) of reproducing pictures were still too great to make its continuance successful.[449a]

Joseph Pulitzer acquired the New York *World* in May, 1883, and on October 17, 1883, there appeared on the front page of the *World* a diagrammatic illustration of a murder, and this was soon followed by illustration in the Sunday edition.[450] The next year, the *World* secured the services of two artists, Valerian Gribayédoff and Walt McDougall, who were first employed in illustrating biograph-

* Another method was occasionally employed and is still used in many small newspaper plants. It is called the chalk plate process. A bed of chalk-like material about 1/16" in thickness is spread and pressed on a polished steel plate. The illustration in line is then sketched lightly on the chalky surface. The lines are cut through to the steel plate by suitable tools and the form thus produced used as a stereotype mold. As is evident, it is one of the most rapid methods of producing a plate used by the press. The Chicago *Tribune* employed this method when it first began using illustration (1885). Zinc etchings, however, soon replaced the chalk-made stereotypes. (Chicago *Tribune*, Golden Jubilee edition, June 10, 1897, p. 5.)

ical sketches and in cartooning, but their efforts were soon directed toward the picturization of the daily news. Their efforts really mark the beginning of the modern era of newspaper illustration. Both have claimed the honor of being the originator of newspaper illustration.[451]

Whatever the relative merits of their claims may be, within a few years after the advent of Pulitzer and the employment of these two artists, the *World* had broken all previous American circulation records for newspapers.

It is very probable that the illustrations of McDougall and Gribayédoff played a prominent part in the phenomenal success of the *World*. The *Journalist,* a magazine of the newspaper trade, gave the illustrations the credit at the time, for in its issue of August 22, 1885 (page 5), there appears the statement:

"It is the woodcuts that gives the World its unparalleled circulation. When Joseph Pulitzer went to Europe he was a little undecided about the woodcuts. He left orders to gradually get rid of them, as he thought it tended to lower the dignity of his paper, and he was not satisfied that the cuts helped in its circulation. After Pulitzer was on the Atlantic Col. Cockerill began to carry out the expressed wishes of its editor and proprietor. He found, however, that the circulation of the newspaper went with the cuts, and like the good newspaper general that he is, he instantly changed his tactics. He put in more cuts than ever, and the circulation rose like a thermometer on a hot day, until it reached over 230,000 on the day of Grant's funeral. This ought to be conclusive as to the influence of woodcuts on the circulation of a newspaper. The only question is how soon the people will be surfeited. When that time comes there will, probably, be a change and John will, undoubtedly, be the first to see it."

A contemporary account of the *modern* method of illustrating the *World* as done by McDougall appears in the *Philadelphia Photographer* for 1886.[452] The author of the account was visiting the *World* office one afternoon when news of a large fire was received and artists and reporters were at once assigned to the scene. The reporters sprang to their feet upon receiving the assignment, and hurriedly donning their raincoats made all haste to the fire. There the artists dashed off—by hand, of course—a number of sketches of the burning building. The sketches were then rushed back to the *World* office, finished, and passed to the engraving room. Here zinc

One of the earliest photolithographs made in this country (by Cutting and Bradford o. Boston, 1858).

blocks of the sketches were photographically produced, and the zinc cut set with the type. From the whole page form, a clay impression was produced from which the stereotype was cast.

The author of the account, who had accompanied McDougall to the fire, skeptically remarked, "It was then five o'clock and the pictures were to be in the paper the next morning. I expressed some doubt in regard to their appearance, but McDougall's confident smile assured me it was a certainty." McDougall's smile was evidently based on past experience, for by two o'clock in the morning the paper emerged "with the results of the night's work in the shape of six accurate pictures."

One wonders what would have been the comment of Mc-Dougall's friend had he been told that fifty years later an event could occur one evening and the next morning a *photograph* of the scene would appear on the front page of his newspaper, even though he lived half the world away from the original happening.

[429]

Reproduction made by Egloffstein's method. A portion of the same print considerably enlarged to show the action of the screen. (Both illustrations, courtesy U.S. National Museum.)

Even as late as 1890, as an account given in the Washington *Star* shows, the zinc and swelled-gelatin methods were still those employed in illustrating metropolitan newspapers. An examination of the files of several of these papers reveals that not until after 1897 are reproductions of the intermediate tones in photographs at all common in the regular weekday issues. When they do appear, they are reproduced by the half-tone processes.[453]

* * * * * * *

Up to 1870 there was used in this country no commercially successful method of reproducing continuously the intermediate tones between pure black and white by purely mechanical processes. That year, however, saw the introduction of two such processes, both of foreign origin. One of these was the Woodburytype, the other the Albertype.

The Woodburytype, originated by Walter Woodbury of England in 1866, utilized a bichromated gelatin film which was exposed under the negative it was desired to reproduce. Exposure and washing in warm water produced a gelatin relief of the negative. The

[430]

gelatin relief, curiously enough, when under pressure, produced an impression in a lead plate. From the lead plate—an intaglio plate—illustrations could be produced by inking the plate and printing in a suitable press. As the hollows in the lead plate contained varying amounts of ink— depending upon the amount of light the original gelatin relief under the negative had received —different shades of light and dark were continuously reproduced.

It was, at the time, a very distinct advance in the art of photomechanical reproduction. It was

An early print made by Ives original process. The subject is Edward L. Wilson, editor of the *Philadelphia Photographer*. (From the *Philadelphia Photographer*, June, 1881.)

used principally for book illustration. John Carbutt, the Chicago photographer, became so interested in these illustrations after he saw specimens sent from England, that he sold his Chicago gallery in 1870, acquired the American rights to the process, and moved to Philadelphia, where publication of Woodbury prints was begun. Carbutt demonstrated the process before the National Photographers' Association, which met at Cleveland in the summer of 1870. The *Philadelphia Photographer,* as far as I have been able to ascertain, was the only magazine to use the process and then only twice to illustrate the method. The first of these illustrations, the original of which was English-made, appears in the January, 1870, issue of this journal; several others of American origin appeared shortly after.[454]

The Albertype, the invention of J. Albert of Munich, was the forerunner of a host of processes the prints from which are now known collectively as collotypes. The number of names describing the various modifications of the process is legion, a fact that makes the early history of the process especially confusing. Collographic printing, heliotype, heliograph, lichtdruck, phototypie, Albertype, Artotype, are but a few of the names applied to modifications of the

same general principle. It was probably best known in this country under the name of "Artotype."

The original process was first patented in this country on November 30, 1869, by Albert, and the American rights were acquired by Edward Bierstadt of New York.

A scene in Shanty town, New York: the first print in the New York *Daily Graphic* reproduced in half-tone by the Horgan method, March 4, 1880, slightly enlarged. (Courtesy the *Inland Printer*.)

Like many of the processes so far described it depended upon the light sensitivity of bichromated gelatin. Exposure of a bichromated gelatin film under a negative of the illustration it was desired to reproduce, by suitable treatment, produced a printing surface which took up ink in proportion to the amount of light action which the film had received under the negative. The shadows receiving the greatest amount of light action took up the most ink, the high lights absorbed none. The intermediate tones were faithfully and continuously reproduced.

Like the Woodburytype, the Albertype, or some of its modifica-

[432]

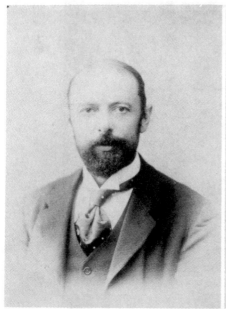 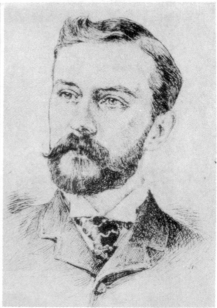

Frederic E. Ives at the age of forty years (courtesy of Mr. Ives).

Stephen H. Horgan (after a sketch by Valerian Gribayedoff in the *Cosmopolitan*, Aug., 1891; courtesy *Hearst's International Cosmopolitan*.

tions, was used principally for book illustrations, but to a far greater extent than was the Woodburytype.* Through the early seventies, Bierstadt pushed the sale of the Albertype with vigor, but because of its relatively high cost, its use was restricted. In 1879, several improvements having been effected, it was reintroduced into this country under the name of the Artotype, Bierstadt still controlling the rights to the process. In this year and the years immediately following its use increased rapidly. Licenses and instructions were sold to local photographers who used the process rather than the usual albumen-silver print for the reproduction of individual prints of celebrities. In the albums of this period Artotype prints can frequently be found.[455]

* The most notable exception to this statement was the New York *Daily Graphic*, mentioned previously, which in its issue of December 2, 1873, reproduced, through the efforts of William A. Leggo, an American pioneer in the field of photo-mechanical reproduction, an illustration showing continuous intermediate tones. It was done by a modification of the Albertype but necessitated two printings, one for the illustration and another for the type. The *Graphic* continued to use photo-lithography during the course of its life, chiefly under the direction of Stephen H. Horgan.[456]

Upper. Making a half-tone. The illustration to be reproduced is on the copyboard in front of the camera. The screen, held by the photo-engraver, is inserted in the camera directly in front of the negative. Exposure is then made, and the negative used to prepare the printing block as described in the text. *Lower.* The master printing block, in copper, is retouched by the engraver to eliminate small defects and to aid in bringing out detail. From the copper half-tone, a nickel replica is made from which the actual prints are made. (Both photographs, by William Vandivert, reproduced in *Life,* July 19, 1937; courtesy of *Life.*)

The big disadvantages of both the Albertype and Woodbury-type, for book and magazine illustration, were cost, method of printing, and bulk. The cost of a print made by either process was about the same as that of an ordinary silver print, although prints by both photo-mechanical processes had the advantage of permanence—that is, they did not fade. Since special paper and special presses were necessary, an illustration could not be placed on the same page as type. Then, too, such prints, like the silver print, had to be mounted on cardboard, thereby increasing the thickness and stiffness of the volume. Even with these disadvantages it would doubtless have been used more extensively in its day but for the development of a far more flexible method, that of the so-called "half-tone." * [457]

Left. The printing surface of a small half-tone greatly enlarged. The scale of magnification can be seen by comparison with the small print in the lower left-hand corner. *Right.* A print from the enlarged plate. Examine this from a distance of ten feet or so. (Courtesy Commercial Engraving Publishing Company, Indianapolis.)

It is evident that the problem before the student of photo-engraving in the days preceding the half-tone, at least as far as the illustrated press was concerned, was to secure not only a photo-mechanical method of reproducing the intermediate tones of the copy, whether the copy were photograph, drawing, or painting, but to secure a printing block that could be used in the same press and on the same paper as type, and, when necessary, with type.

Many men over long periods of years sought to solve this problem satisfactorily; the ultimate success achieved was therefore the result of the cumulative effort of a number of men. Almost without exception their energies were devoted to securing, by purely photo-

* This must not be understood as meaning that the collographic process is no longer used. Many modern illustrations are made by this method.

graphic methods, a printing block, the image of which was broken up into lines and dots—the number and size of such lines and dots in a given area determining the blackness of the area. Of course, these investigators, in turn, were but following the method of the wood or metal engraver who translated high light, half-tone, and shadow, by varying the extent of the printing surface in exactly the same way.

Even as early as 1852, Fox Talbot, the English inventive genius, had actually secured a patent for such a process. Talbot placed a silk gauze between the photographic negative and the sensitive surface that was eventually to become the printing plate, hoping by this method to secure the necessary reticulation. The process, however, was not successful—at least not on a large scale.

Between this time and 1880 there were more than a dozen individual efforts to solve the problem. Each investigator contributed some idea or suggestion which, either positively or negatively, was of aid in securing final success. At least five Americans—and probably others—made important contributions to the solution of the problem: F. W. von Eggloffstein, Stephen H. Horgan, Frederic E. Ives, and the Levy brothers, Louis E. and Max.

Von Eggloffstein, in 1865, secured the first United States patent for a photo-engraving process employing a screen—the characteristic method by which modern half-tones are made. The screen used by von Eggloffstein was ruled on glass, as many as three hundred slightly undulating lines being employed to the inch. The screen was placed against the negative from which the printing block was eventually to be produced and was therefore between the negative and the original copy. The final plates were etched in intaglio on the copper plate press. A number of New York capitalists became interested in von Eggloffstein's process; the Heliographic Engraving Company was organized to employ it, and a large sum of money was spent in attempts to develop the process commercially; but the efforts were not successful, although the process did succeed in reproducing half-tones, as the accompanying illustration shows.[458]

To Horgan goes the credit of producing the first half-tone published in an American newspaper; to Ives goes the credit for producing the first successful method used in producing half-tones in such

Early photogravures by Henry Fox Talbot according to his patent specifications of 1852. (Courtesy Miss M. T. Talbot, Lacock Abbey.)

well-known magazines as *Harper's Monthly* and *The Century,* and for the first successful method of reproducing the half-tone in color. To the Levy brothers goes the credit for the large-scale production of screens used in the half-tone process.

Horgan, whose name has already appeared in these pages, was employed in 1874 as a photographer by the New York *Graphic.* The *Graphic,* incidentally, was started in 1873 with the express purpose of exploiting photography to the limit of its capabilities.[459] Horgan soon became manager of the extensive photo-mechanical equipment of the *Graphic;* in this capacity he was led to the experiments which resulted in the publication of the first newspaper half-tone, made by the use of a screen, in the March 4, 1880, issue of the *Graphic.*

On the editorial page of the *Graphic* for this day, the following reference is made to the half-tone:

"On the lower left hand corner is an illustration entitled 'A Scene in Shanty Town, New York.' We have dealt heretofore with pictures made from drawings or engravings. Here we have one direct from nature. Our photographers made the plate from which this picture has been obtained in the immediate presence of the shanties which are shown in it. There has been no redrawing of the picture. The transfer print has been obtained direct from the original negative. As will be seen, certain of

[437]

the effects are obtained by the use of vertical lines. This process has not yet been fully developed."

Horgan obtained the printing block from which this print was made by interposing a screen of fine parallel rulings between the negative of "Shantytown" made in the camera and the sensitive surface of bichromated gelatin which was eventually to produce the printing block. The screen was made by photographing a mechanically ruled surface on the film of a wet collodion plate, the rulings being slightly out of focus. The film, after exposure and development, was stripped from the glass plate and became the half-tone screen.

Although the half-tones so made were crude when compared to modern ones, they did show detail in shadows, and therefore intermediate tones were produced on the printed page "without the slightest touch of the hand on the photographic work."

The *Graphic* produced several such half-tones, but printing difficulties prevented a wide adoption of the method. The regular and almost exclusive use of the half-tone in newspaper work was reserved for a much later period.[460]

Ives' original attack on the problem of reproducing half-tones was made in a somewhat different manner. Ives started his career as a printer, but became a photographer, and in 1874 secured the position of official photographer at Cornell University, Ithaca, New York. His printing and photographic training naturally turned his attention to photo-engraving and while at Cornell he effected important improvements in the "swelled gelatin" method previously described. It was while he was at Cornell that work was begun on the original Ives half-tone process, which finally resulted in a patent issued August 9, 1881, although commercial production of printing plates had begun several months before this time. The first published half-tone made by this process to appear was one of Wilson, the editor of the *Philadelphia Photographer,* in the June, 1881, issue of that periodical. This journal continued to use such plates frequently during the early eighties. Between 1881 and 1886, Ives plates were used in smaller number by such prominent journals as *Harper's Monthly* and *The Century. Harper's* used approximately

[438]

fifty such illustrations (out of many hundred) in this period, and *The Century* a still smaller number.

The preparation of these Ives plates started with the formation of a gelatin relief (such as those made in the Woodbury process) of the illustration it was desired to reproduce. The gelatin relief was pressed into plaster of Paris, forming an intaglio. In the plaster intaglio the high parts are the shadows of the original, the deepest depressions the high lights. An elastic pad of rubber-like material was then prepared by making many parallel V-shaped cuts across its face, crossed by other cuts not quite so deep. This procedure left the pad with a series of tiny protruding pyramids close together. Upon inking the pad, the faces as well as the sides of the pyramids were covered by the ink. The inked pad was then pressed against the relief. The shadows, because of the elasticity of the pad and the ink on the sides of the pyramids, were completely covered by ink. The shallow depressions were touched by only the faces of the pyramids, leaving a series of dots, while the deepest depressions (the high lights) were not touched by the inking surfaces at all. When the pad was removed, a reproduction of the original picture, in black and white, was seen. The half-tones were now represented by a varying number of dots rather than by a continuous tone. At the normal viewing distance, however, the tones appeared continuous as in the original picture. The picture on the cast was now rephotographed and a printing relief plate made in the usual way, as the picture (on the cast) was now in line and point.

In 1885-86, Ives adopted an optical method of producing the "V-line" effect instead of the mechanical one of the rubber printing blanket. This effect was secured by the use of a screen, the principle which had been used by Horgan and somewhat later by Meisenbach, a German, who was the most successful of European students in this field. Both Horgan and Meisenbach, however, were following the lead of still earlier students of the art.

Ives employed as a screen a glass plate containing ruled crosslines and covered by a second plain glass, the so-called "crossline sealed screen." Ives maintained that he was the first to make the crossline sealed screen. but it is difficult to determine the extent of

his priority in this claim as his work from 1881 until well after 1886 was done under bonds of secrecy.[461]

The problem of screen making was a stumbling block which delayed the wide adoption of the half-tone process for some years. Ives' process of screen making was secret, as has been said. In 1888 M. Wolfe, of Dayton, Ohio, began the manufacture of a really successful screen, but Wolfe's screen lacked permanence. Louis E. Levy, of the Levytype Company, conceived the idea of etching lines on glass and blackening the depressions. Levy's brother, Max, worked out the design and construction of precision machinery to make the rulings accurate, and together they patented their process on February 21, 1893. The Levy process is the one in use today.[462]

Although the difference in practical detail between the two Ives processes mentioned above was marked, users of the plates made by the two processes were unable to discover any difference in the character or quality of the illustrations produced. It is noticeable, however, that after 1886 a marked increase is apparent in the number of half-tone illustrations in *Harper's* and *The Century,* representative illustrated magazines. Not that the woodcut illustration had disappeared—in fact, it reached its heyday in this period. Even as late as 1890 the woodcut was still the mainstay of the popular journals. By 1893, half-tone illustrations were very common, but they did not occur in greater proportion than the woodcut until the late nineties, a result which can undoubtedly be attributed to the production of the Levy screen.* [463]

* The modern half-tone is made, through the agency of the camera, by copying the original illustration or photograph to be reproduced, upon a collodion negative. (The wet process thus still has an important use!) The half-tone screen is placed between the copy and the negative but much nearer the negative than the copy. The selection of the best screen distance is a matter of skilled and practical judgment on the part of the engraver, who can vary the quality and the effects of the finished half-tone print by varying the distance. The exposed and screened negative is developed and the collodion film stripped from its glass base. The reversed film is then printed (by exposure to light in a printing frame) upon a sensitized metallic surface, the sensitizer being a suitable bichromated gelatin mixture. After printing for five to six minutes under the electric arc, the metal plate is removed, washed to remove the sensitizing mixture unacted upon by light; and the remaining image is hardened by careful heating. Etching, in successive stages (to remove metal *around* the dots), eventually produced the desired printing surface. The metal plate is then mounted on a wooden block, type-high, to produce the familiar zinc or copper half-tone. The quality of a "half-tone" depends not only upon the skill of the engraver but also upon the character of the screen employed. For newspaper work, a screen ruled 60 or 85 lines to the inch is usually employed; for much commercial work screens containing 100 to 135 lines per inch are used. For the fine half-tones employed in better-grade magazine and book illustration, the number of lines to the inch ranges from 150 to 200. Occasionally the screen may go as high as 400 lines to the inch, when the most exact reproduction possible of the original is desired. A well made half-tone possesses a variation of from 0.001 to 0.003 inch in depth between the extreme high lights and the middle tones.

[440]

The photograph as copy in illustrated magazines was also slow in being adopted. Even though the gelatin dry plate had been introduced by 1880 and "instantaneous" photographs became possible, the number appearing in the pictorial press was strangely very small. In the first half decade of the eighties, *Harper's Weekly,* for instance, was using them in relatively small number and then chiefly for portraits. Only two photographs of action scenes were reproduced during 1885 by this journal, one of which was a view of Vesuvius in eruption, which received the credit line, "From an instantaneous photograph." The other illustration depicted a tennis match at Newport. Both illustrations were reproduced, however, in woodcut, the photograph merely serving as copy for the artist! Incidentally, of the seven or eight hundred illustrations that appeared in this journal during the year under discussion, only two were reproduced in half-tone.

By 1899, the score had changed considerably. The following table of an issue for a single week in March of several pictorial journals is of significance, not only because it shows the trend toward the photograph, but because it also shows the greater interest Americans were taking in this form of illustration.

Journal	No. of Illustrations from Photographs	No. of Drawings
Illustrated London News	28	19
Harper's Weekly	35	8
Leslie's Weekly	44	3
Illustrirte Zeitung (Leipzig)	8	14
L'Illustration (Paris)	10	12

It should be observed, too, that by far the larger proportion of all illustrations tabulated above were reproduced by half-tone, both at home and abroad.[464]

Half-tone illustrations were beginning to appear in books by 1890. Among the earliest of American books so illustrated was the *Autobiography of Joseph Jefferson,* published in 1890 by the Century Company. Only two of the seventy-seven illustrations, however, are in half-tone. The following year Charles Scribner's Sons published the *Life of John Ericsson* by W. C. Church, in which four of

1904-1905

Revillon Frères

Importers and Exporters of

SKINS

Manufacturers of

FURS

Of All Descriptions

All goods sold by our house are strictly of our own manufacture

Our expert furriers produce a workmanship of the highest grade

The importance of our stock enables us to fill orders of any amount

Every department in our store is a specialty by itself

In case some of the items of our stock should be completely sold out at the time of receipt of order, we will propose to our customers the nearest substitute

Patterns and sketches of various styles, also estimates and skins, sent upon request

We have always in stock **Job Lots** at various prices

An Inspection Solicited

Revillon Frères

13 and 15 W. 28th St., New York Cable Address: **Nolliver, New York**

Telephone Connections

Photography and advertising.

PARISIAN ACCENT

Youthful chins are forgiven their upward tilt of conscious superiority. The gesture adds only pardonable emphasis to the style perfection of Revillon

Frères furs with their authentic Parisian accent. Back of their style is the authority of an honored name that has spelled quality for over two centuries.

Revillon Frères

PARIS NEW YORK LONDON
5th Avenue at 54th Street

Photography and advertising. A comparison of this illustration with the previous one shows strikingly the remarkable changes which have occurred in advertising illustration in the last thirty-five years (Both illustrations from *Stage*, Aug., 1937; courtesy Revillon Frères, New York.)

the fifty-two illustrations are in half-tone, and Harper and Brothers published a translation of Daudet's *Port Tarascon* in which fifty-eight of one hundred and twenty-five illustrations were made by the new process.

It was but natural that the wood engraver viewed the introduction of the new process with alarm. For here again was the old story of the threat of destruction of an art or craft through the agency of science and mechanics. By 1890, concern for the profession was a matter of public discussion. *The Century Magazine,* the leading patron of the wood engraver in this country, was optimistic, however, for we find it stating (in June, 1890) that it did not "agree with those who think that wood-engraving in America has seen its best days, and is likely to be superseded by mechanical 'processes.' The nature of art is against such a conclusion. Moreover, while current periodical illustration has gained much by the various mechanical or actinic processes in vogue for the reproduction of photographs from nature, and for the reproduction of original pictures, the time still seems far distant when wood-engraving must retire in favor of the process. . . . The fact remains that the engraver's art gives results that can be obtained only by the trained hand and the artistic temperament." [465]

F. Hopkinson Smith, versatile engineer, artist, and writer, also contributed to the discussion, and, on the threshold of the new era of illustration, advised young men with artistic talents seriously to consider the new field. He remarked in 1892: "They should realize that modern science—photography with its resultant processes—has made a new art, distinctly honorable—the art of illustration, that this art really began in their own time and that every day its influence is widening and its rewards increasing." [466]

The same progressive attitude was expressed by Joseph Pennell, noted etcher and critic. Writing in 1895, he said, "In many ways wood-engraving as a trade or business has been, it may be only temporarily, seriously damaged. However, in the very short period since mechanical reproduction has been introduced, those wood-engravers who really are artists have been doing better work, because they can now engrave, in their own fashion, the blocks they want to. The art of wood-engraving has progressed if the trade has

languished." Pennell also pointed out another fact overlooked by many of those concerned with the fate of wood-engraving. The artist of an original drawing or painting which is to be used for illustration prefers "an absolute reproduction of his drawing, to somebody else's interpretation of it. He is not eager to have another person interpret his ideas for the public; he would rather the public should see what he has done himself with his own hands. This reasonable desire, process work [half-tone] now begins to realize." [467]

A compromise was to some extent effected between the exponents of engraving and its critics by the procedure of allowing the engraver to "touch up" the half-tone plate. This condition must have existed early in the history of half-tone but the fact does not come out into the open until the late nineties when illustrations are frequently found credited to a "Half-tone plate engraved by ——," the engraver who touched up the plate being specifically named. But half-tone (or "process work" as it was originally called) repeats the history of the collodion plate versus the dry plate. Slow in adoption, it eventually replaced all older processes. Today, by far the greatest amount of newspaper, magazine, and book illustration is accomplished through this medium.

In fact, the half-tone, more than any other factor, has been held responsible for the tremendous circulation of the modern periodical and newspaper. It has, indeed, revolutionized the mechanics of journalism, for it has completely changed methods of advertising, of paper and ink making, as well as of press construction and press work.[468]

It is fair to point out, however, the half-tone is not perfect. Unless smooth paper, special inks, relatively slow printing, fine screens, and hand retouching of the metal printing plate are employed, considerable detail and many of the delicate intermediate tones of the photograph, or copy, are lost. When great care is employed, it is possible at times to improve the print over the original, especially in those cases when poor copy only is available. Even with the production of the best print from the half-tone block, enlargement by means of a lens to reveal minute detail (as is possible in a photograph) is impossible, for the detail examined in the half-tone print will be that produced by the screen itself.

In the development of half-tone illustration the newspapers naturally lagged behind the magazines, since the difficulties of reproduction were still greater. Cheaper paper and ink, higher speed presses, and the necessity of stereotyping the shallow half-tone were, of course, the cause of these difficulties.

As we have seen, the New York *Graphic* had used a half-tone reproduction as early as 1880, but the printing difficulties involved did not permit general use. No definite record of the use of half-tone in American newspapers again appears until 1894, although Louis E. Levy made experimental trials of the process in his Philadelphia paper, the *Sunday Mercury,* in 1888.[469] In 1894, the Boston *Journal* succeeded in stereotyping a half-tone which it published in May, 1894, but again the difficulties encountered prevented the continued use of this type of illustration.[470]

The year 1897 really marks the advent of half-tone illustration as a regular feature of American newspaper journalism. On January 21, 1897, the New York *Tribune* published on its front page a half-tone illustration of Thomas C. Platt, newly elected senator from New York. Within the next month, some two dozen half-tone illustrations were used by the *Tribune.* These illustrations were due to the work of Stephen H. Horgan, who had pioneered their use in the New York *Graphic.* By 1890, large web perfecting presses were being adopted by metropolitan newspapers in all parts of the country; Horgan experimented with and eventually devised a successful method of utilizing half-tone stereotypes in such high speed presses, and patented the process.[471]

After the New York *Tribune's* successful efforts early in 1897, other newspapers began similar trials. The Chicago *Tribune,* for instance, first published half-tone illustrations in its regular edition of March 21, 1897. By 1900 the half-tone process was in common use. Other newspapers, however, did not employ it for some years. The Boston *Transcript,* for example, did not begin its use until 1906. This slow adoption was not due to technical difficulties but to the conservative attitude of the publishers themselves, who opposed the use of illustration in any form. The welcome with which illustrations were received by readers is said to have been a distinct surprise to the publishers.[472]

[446]

The illustrated Sunday supplement on magazine paper has a history which practically parallels that of the half-tone in the daily newspaper. The New York *Times* is said to have led the way in this feature of journalism. Adolph S. Ochs took control of the *Times* in the late summer of 1896; within three weeks he had issued (September 6, 1896) an illustrated magazine on smooth paper with the regular Sunday edition. The illustrations for the magazine section were half-tone reproductions of photographs. The illustrated Sunday section is credited with being one of the most important features which reinvigorated the *Times* after Ochs became its owner.[473]

The New York *Tribune* followed the example of the *Times* by publishing regularly an illustrated Sunday section beginning May 30, 1897, although a special supplement, illustrated in half-tone, had appeared on January 30, 1897. The Chicago *Tribune* began a regular illustrated Sunday section on June 20, 1897, specifically called the "Half-Tone Part."

It may not be amiss in concluding our discussion of photography and the pictorial press to point out some of the criticisms, disadvantages, and obvious abuses which have followed in the wake of half-tone and high-speed photography, that is, the photography which makes possible the picturization of all but a little of the world's events and personalities. Such a discussion seems especially desirable since we appear to be on the threshold of an era in which the pictured news will be more extensively used than ever before.[474]

The *Illustrated London News* had scarcely made its appearance before Wordsworth, the British poet, had penned as severe a superficial indictment as has ever been made of the pictorial press.[475] The sonnet reads, in part:

> "Now prose and verse sunk into disrepute
> Must lacquey a dumb Art that best can suit
> The taste of this once-intellectual Land.
> A backward movement surely have we here,
> From manhood,—back to childhood; for the age—
> Back towards caverned life's first rude career.
> Avaunt this vile abuse of pictured page!
> Must eyes be all in all, the tongue and ear
> Nothing? Heaven keep us from a lower stage!"

If Wordsworth was so deeply moved by the comparatively dignified and sedate *News*, it is difficult to imagine what his poetic diatribe against the pictorial press would have been if he had lived to see its abuse since his day. Confining our attention only to the picturization and publication of the news by the camera,* we see photographs of events and personalities reproduced which are trite, trivial, superficial, tawdry, salacious, morbid, or silly—on the same page and of the same size as the interesting, the significant, and the important. Frequently they are found in such numbers and in such confusion as to form a totally indigestible mental meal. Many times the publisher's only principle of selection appears to be *"Any* photograph is better than no photograph."

In addition, reproduced photographs have been purposely and recklessly mislabeled, either in the mad rush for news, or for purposes of ulterior or sinister propaganda. Photographs have been faked and reproduced as original records of a person or event by composite printing, or by enlarging and cutting out portions of several photographs, recombining, and retouching the enlarged composite and rephotographing to a smaller size. By the time the faked photograph is reproduced in half-tone, it is impossible to detect the forgery from the print alone. Fact can also be falsified by manipulating negative or print during processing, and by selecting the type of photographic emulsion or printing paper. A similar cause of criticism may be found in photographs that have been made from some other angle or plane than the conventional one for the distinct purpose of producing the wrong impression. Although no valid objection can be made to the use of the camera at any angle, if fact is to be conveyed, any departure from the conventional should be stated.[477]

So extensive have these abuses been in the past that mention of the term "photograph" in journalism has come to mean *sensational* journalism. Such prodigious and free use of photographs in picture newspapers and magazines has in a measure defeated their own ob-

* In the past, the camera has occasionally ventured, with no very marked success, into the field of illustration for fictional articles. The early attempts were interesting, but, as an intelligent observer pointed out, "one was dreadfully conscious of posed models, wigs, glued whiskers, rented costumes and false drops." One magazine of large news-stand sale has, however, used photographs solely in fictional articles, having succeeded in making its pictures convincing in their appearance of reality.[476]

ject, presumably that of disseminating news. Such journals are carelessly thumbed through, the reader glances hastily at one picture—looks but does not see or think—and passes on to the next in the same manner and then throws the periodical aside—a picture album with little purpose or reason.

These criticisms and abuses the pictorial press must meet and correct if it is to command the respect of intelligent people. That such a press has certain advantages over that using only the printed word is almost as evident as are some of its defects. A photograph, or its reproduction, can tell in a moment what might require many moments, or even hours, to describe in writing. Not only can it describe more rapidly but it can fix mentally more vividly, completely, and indelibly than can the printed word. The world's problems, and the world's knowledge—and hence the world's news—are yearly becoming more voluminous and complex. It will be granted that it is advantageous to devise methods that will convey news and ideas more quickly and concisely than does the written or spoken word—not that there is any great possibility of supplanting these age-old methods altogether—but the new method, or methods, must ably supplement the spoken and written word. The picture, and especially the factual photograph, is apparently the only method which has been devised as yet for this purpose. In fact, one of our leading journalists, Henry R. Luce, has even gone so far as to say: "The photograph is not the newest but it is the most important instrument of journalism which has been developed since the printing press." [478]

Another important and significant feature—and one which the modern pictorial press has been slow in recognizing—is the ability of the photograph to picture and dramatize the normal life, thus making it news. The history of the pictorial press shows that war, individual murder and other crime, morbid and gruesome events, when pictured, have brought increased circulation. Doubtless many of the abuses of the pictured press have risen from this cause. Yet the surprising fact remains that during the first fifty years, at least, of the *Illustrated London News*, its highest circulation was reached during the Crystal Palace Exposition of 1851, despite the fact that

[449]

three years later England became engaged in her greatest war since Waterloo.[479]

The fact that such arts of peace are of great pictorial news interest was rediscovered in a recent issue of a modern journal which published an article in illustration on the growing of wheat. The editor of the journal states, with some amazement at the evident favorable reception with which the public received the issue: "The article had nothing to do with any frantic row in Congress over a farm bill, nothing to do with the horrors of drought and dying cattle. And it was the lead article and ran for nine pages. Now can you imagine any non-photographic magazine, intended to interest millions of readers, daring to devote its first nine pages to a descriptive contemplation of the fruitful and normal and quiet labors of farms and horses and harvesters and the wheat itself ripening beneath the sun?"[480]

The universal appeal of the photograph, as illustrated in this instance, should go a long way toward the correction of the journalistic maxim that the abnormal makes the big news. That it has a universal meaning—to the child—to the illiterate—to adults of all tongues—can scarcely be used as a criticism that the pictorial press is on a lower level of intelligence than the non-pictorial press. The same picture will be of different significance to each individual, dependent upon his previous experiences, his training, and his tastes. The picture is literally a universal language; of the pictured forms, the photograph is the most literal, the most factual, the most readily and rapidly obtained, and therefore is almost solely used in reporting the news in the modern press. Whatever may be the faults and flaws of the pictorial press it is probable that humanity has in this agent one of her most powerful weapons in the fight for the abolition of war, in combating ignorance and disease, and in the attainment of social justice. Through the use of this medium it should be possible, if ever, to reach more rapidly that long sought goal—the brotherhood of man.[481]

The Restoration of Daguerreotypes

Carefully remove the daguerreotype from its case and matt (see page 99 of text). After removal, handle only by the edges. Blow gently on the surface to remove any dust particles, and then immerse, face up, in distilled water. Rock the water back and forth to wash the surface; and, if any adhesive or paper present on the copper back, continue washing until these are removed. Next, immerse in a 1 per cent solution of potassium cyanide in distilled water, rocking the solution as before. The cyanide solution should remove all discoloration due to oxidation. If the discoloration does not disappear, the cyanide solution can be warmed slightly to hasten the process. No part of the daguerreotype should protrude, or come in contact with air, while in the cyanide bath. Care should be taken that the daguerreotype is not left in the cyanide bath longer than is necessary to remove the discoloration, as the image may be removed by too long immersion in the bath. This is especially so of daguerreotypes made before the gilding process became common. As gilding was practiced after 1841 quite universally, it will be only the very early daguerreotypes which have not been so treated.

After removing from the cyanide bath, the daguerreotype is thoroughly washed in distilled water to remove all traces of the cyanide bath, and it is then transferred to a bath of 95 per cent grain alcohol. After a brief stay in this reagent, the daguerreotype is firmly clasped by a pair of tongs at one corner of the daguerreotype plate—preferably a corner that will be subsequently covered by the matt. The plate is then drained free from as much alcohol as possible. It is then held above a small flame. The alcohol may be ignited, or the plate may be held so far above the flame that drying proceeds more slowly. In any case, continue heating until the film of liquid

has completely disappeared. The object of the alcohol treatment and heating is to dry the daguerreotype plate without leaving ugly water stains on the surface.

After drying, the matt and glass cover are placed over the daguerreotype, the glass being firmly bound along its edges to the plate itself. Commercial adhesive silk or paper serves well for this purpose. The glass, of course, should be thoroughly cleaned before being bound to the daguerreotype plate. The metal binder is then put into place, and the whole returned to the daguerreotype case.

A final word of warning: Be extremely careful of the daguerreotype surface when it is not protected by glass!

1. *The Knickerbocker,* v. 14, p. 560 (1839).

2. *Photo-Miniature,* v. 5, p. 537 (1903-4).

3. *Life of H. W. Longfellow,* Samuel Longfellow, Boston, 1886, v. 2, p. 67. Quoted by permission of the publishers, Houghton Mifflin Company, Boston.

3a. Georges Potonniée has discussed this question fully in *History of the Discovery of Photography,* translated by Edward Epstean, Tennant and Ward, New York, 1936.

4. *Researches on Light,* R. Hunt, Longmans, Brown, Green and Longmans, London, 1844, p. 34.

5. *Comptes Rendus,* v. 8, p. 4 (1839).

6. *Photographic Art Journal,* v. 1, p. 27 (1851), reprinted from the *Hand Book of Heliography.*

7. *Comptes Rendus,* v. 9, p. 250 (1839). I believe this is the first account of the Daguerreotype to appear in the scientific press.

8. Quotation from reference 7 above.

9. Quotation from London *Globe,* August 23, 1839.

10. The statement of Delaroche is found in the *History and Handbook of Photography,* by Gaston Tissandier, New York, 1877, p. 63.

11. *The Camera and The Pencil,* M. A. Root, New York, 1864, p. 350.

12. These articles were reviewed on the anniversary of the moon hoax by the New York *Sun,* Aug. 24, 1935.

13. *Samuel F. B. Morse, His Letters and Journals,* E. L. Morse, Houghton Mifflin Co., New York, 1914, v. 2, p. 129. It should be stated that there is some evidence that Morse was familiar with the actual process before the news arrived in this country. In the *American Journal of Science and Arts,* Oct., 1839 (see reference 15), it is stated that "a professional gentleman" of New York was familiar with the process before its description arrived. The professional gentleman is undoubtedly Morse, but I am inclined to think, for reasons developed later in the text and notes, that his familiarity was one of the finished products and not of the actual process itself. In *Niles Register,* Sept. 21, 1839, p. 64, is the bold statement, "We may say the secret is already known to one or more individuals in this city, but they are restricted from promulgating it, we understand, until the *British Queen* arrives." Here again I am inclined to think that the "one or more individuals in this city" were professing to know more than was in their actual knowledge. Both at home and abroad (outside of France) there were individuals professing to know Daguerre's secret before it was published. In one account, *Journal of the Franklin Institute,* v. 28, p. 202 (1839), reprinted from *Magazine of Natural History* (London), under date of March 25, 1839, an Englishman went so far as to

describe the process in print before Daguerre's method was published. A comparison of his description with Daguerre's process shows that he not only missed the bull's-eye but the target as well.

14. Under date of Nov. 19, 1839, Morse wrote Daguerre that he had been experimenting "with indifferent success" since the receipt of the description of Daguerre's process. *Life of Samuel F. B. Morse*, S. I. Prime, D. Appleton and Co., New York, 1875, p. 407. A similar statement was made by Morse in 1855 in a letter addressed to M. A. Root (see reference 18).

15. *American Journal of Science and Arts*, v. 37, p. 375, Oct., 1839. This is corroborated by *Niles Register* (Baltimore) which in its issue of Sept. 21, 1839, states (p. 64), "We have reason to believe that the secret of M. Daguerre's . . . invention will be known here on the arrival of the *British Queen*."

16. *National Intelligencer* (Washington, D. C.), Sept. 25, 1839. New Yorkers, at least, had the news brought by the *British Queen* on the afternoon of Sept. 20, 1839 (Friday), for the New York *Weekly Herald*, Sept. 21, 1839, states that "we got our packages (from the *British Queen*) by 2 o'clock."

17. Information by courtesy of Mr. Alfred Rigling, librarian of the Franklin Institute, Philadelphia. The *Gazette* account was reprinted in the *Journal of the Franklin Institute*, v. 28, p. 209 (1839).

18. Morse's recollections of his initial venture into daguerreotypy are found in a letter written sixteen years later. This letter was addressed to M. A. Root of Philadelphia and was originally published by Root in the *Photographic Art Journal*, n.s., v.

2, p. 280 (1855). The letter has been reprinted many times since, appearing in both biographies of Morse (i.e., those of S. I. Prime and of E. L. Morse). The letter is dated Feb. 10, 1855. A somewhat similar letter of Morse's dated Nov. 18, 1871, appears in the *Philadelphia Photographer*, v. 9, p. 3 (1872).

19. The advertisement first appeared in the New York *Morning Herald*, Oct. 3, 1839; and also on Oct. 4, 5, and 7, 1839. The original *Herald* account (that of Sept. 30th) also appeared in the New York *Weekly Herald* for Oct. 5, 1839. The item beginning "The New Art Daguerreotype" is from the New York *Morning Herald* of Oct. 4, 1839. That this lecture and the advent of the daguerreotype created more than an ordinary stir of interest is evidenced by the statement of the New York correspondent of the *United States Gazette* (Philadelphia), who wrote under date of Oct. 5, 1839, to the *Gazette* of Oct. 7, 1839, as follows: "The new science of Daguerreotype, as it is called, has created some sensation here, and we are to have a lecture this evening upon the subject by a young gentleman who is highly recommended by several of our most learned men."

20. The information of Seager is based in part on Morse's letter mentioned above; and on reference made to Seager which appears in the article, "The Daguerreotype," which was published in the *American Repertory of Arts, Sciences, and Manufactures*, v. 1, pp. 116-132, March, 1840. C. E. West in the New York *Times* for Feb. 19, 1883, gives his account of the initial venture and mentions Seager. The West account must be discounted for exactness of detail, for he (West) was describing events taking place forty-four years earlier. Accord-

ing to the West account, Seager took the process to Morse, and Morse was credited (by West) with making the first daguerreotype in this country. As we have seen, the contemporary account of Sept. 30, 1839, makes no mention of Morse but credits Seager directly. West is corroborated, in part, by a brother of George W. Prosch, Morse's instrument-maker, who states that Seager, an Englishman, was returning to this country and just as he was sailing from London a friend threw him a copy of Daguerre's manual which Seager took to Morse upon his arrival in this country. The Prosch statement, likewise, cannot be given too much weight as it was made in 1882. *Anthony's Bulletin,* v. 14, p. 76 (1882).

21. Chilton really deserves more than the passing notice I have given him. He is mentioned many times by the early daguerreotypists for the aid which he was able to furnish. It was to his advantage to do so as doubtless he sold them materials for their early trials. For a sketch of Chilton, see *Photographic Art Journal,* v. 10, p. 54 (1857). He was listed in the New York City Directory for 1839-40 as an M.D. and chemist.

22. For a biographical sketch of Draper, see George F. Barker, *National Academy of Sciences, Biographical Memoirs,* v. 2, p. 351 (1886). Draper's studies on the chemical action of light, referred to in the text, will be found in the *Journal of the Franklin Institute,* v. 23, p. 469 (1837); v 24, pp. 38, 114 and 250 (1837). Snelling, in 1854, stated that Draper had early used chlorine in conjunction with iodine to increase the sensitivity of the plate. *A Dictionary of the Photographic Art,* New York, 1854, p. 71.

23. The quotations from Draper will be found in an article by him in *The London, Edinburgh, and Dublin Philosophical Magazine,* v. 17, p. 217, Sept., 1840.

24. Letter by M. A. Root in the *American Journal of Photography,* n.s., v. 2, p. 355 (1859). See also Root's book, *The Camera and The Pencil,* p. 351; and J. F. Sachse, *Journal of the Franklin Institute,* v. 135, p. 271 (1893). I have found a contemporary account which substantiates Root and Sachse, at least, approximately. It will be found in the *United States Gazette* (Philadelphia), Oct. 24, 1839, p. 2, col. 1. It reads: "There was on Tuesday, exhibited to us a photographic plate of the Central High School taken by Joseph Saxton. It is the first attempt, and is sufficiently successful to demonstrate the beauty of the art when perfected; and we add that the success also shows the art to be quite susceptible of great and immediate improvement." The Tuesday referred to is Oct. 22, 1839, so that the daguerreotype was in existence by that time.

25. *The Camera and The Pencil,* M. A. Root, p. 352; the Sachse article, reference to which is made in 24; the work of Johnson is mentioned in the *National Gazette* (Philadelphia), Feb. 8, 1840, p. 3, col. 1, and Feb. 11, 1840, p. 1, col. 3.

26. *The Camera and The Pencil,* M. A. Root, p. 353.

27. *McClure's Magazine,* v. 8, p. 10, Nov., 1896.

28. I am indebted to Miss Margaret McClure, of Lexington, Ky., for the information relative to Transylvania College. The material is from an unpublished paper by Miss McClure, "Silhouettes and Daguerreotypes," presented before the John Bradford Historical Society in the spring of 1933.

29. V. 1, p. 131 (1840).

30. Gouraud in his *Description of the Daguerreotype Process* published in Boston, in 1840, states (p. 14): "Within fifteen days after the publication of the process of M. Daguerre, in Paris, people in every quarter were making portraits. M. Lusse, of the *place de la Bourse,* was one of the first amateurs who succeeded in making them in the most satisfactory manner." This would indicate, if Gouraud is reliable, that the first portraits were made in Paris. Very likely it was attempted almost as soon as Daguerre described the process, but considering the very long exposures required even portraits "in the most satisfactory manner" must have been far from true representations of the subject and cannot have been successful portraits. There is considerable evidence also that Gouraud was not a reliable witness (see discussion in text toward end of chapter and reference 52) which would invalidate his testimony. Tissandier, the French authority, writing in 1877 states, "Already in 1840, attempts had been made to obtain portraits with the Daguerreotype; but the long exposure necessarily rendered them fruitless." *History and Handbook of Photography,* N. Y., p. 72. Compare also this statement with the Draper portrait and Herschel's letter written to Draper and published in the text.

The most authoritative French authority on this question, Georges Potonniée, makes only brief reference to the earliest French daguerreotype portraits. In his *History of the Discovery of Photography,* translated by Edward Epstean (New York, 1936), Potonniée refers (p. 173) to the optician Richebourg who claimed to have exhibited daguerreotype portraits *toward the end of 1839.*

30a. See references 14 and 18.

31. *Philadelphia Photographer,* v. 5, p. 53 (1868). Bogardus, writing in the *Century Magazine,* May, 1904, p. 86, also mentions Dixon's claim, but probably Bogardus' source of information was the same as that given above.

32. Sachse lectured on this phase of our history before the Franklin Institute of Philadelphia on Dec. 16, 1892. The lecture was published in the *Journal of the Franklin Institute,* v. 135, p. 271 (1893). It was reprinted in the *London Photographic News,* 1893, pp. 294 and 326. See also Sachse's articles in *American Journal of Photography,* v. 13, pp. 241, 306, 355, 403, 451 and 543 (1892); v. 14, p. 369 (1893); v. 17, p. 552 (1896); also *L T W* in the *British Journal of Photography,* v. 67, p. 422 (1920). Several very early daguerreotypes made in Philadelphia are reproduced in half-tone in Sachse's Franklin Institute article.

33. Daguerreotype portraits made by Wolcott of New York and by Cornelius and Goddard of Philadelphia were exhibited at a meeting of the Franklin Institute on this date. *Journal of the Franklin Institute,* v. 29, p. 301 (1840). In the same journal, p. 393, it is stated that on May 28, 1840, were exhibited some daguerreotype portraits "taken at the establishment of Mr. R. Cornelius in 8th Street, near Chestnut." In the *Proceedings of the American Philosophical Society,* May 15, 1840, v. 1, p. 213, it is recorded that "two Daguerreotype Portraits, the one of Mr. Du Ponceau, the other of Mr. Vaughan, taken by Mr. Cornelius" were presented to the society by Dr. Goddard. Inquiry directed to the present librarian of this organization reveals the fact that these daguerreotype portraits are no longer among the possessions of that society.

The above *Proceedings* also give some relevant information. At the meeting of the Society for Dec. 6, 1839, it is recorded (v. 1, p. 155): "Dr. Patterson laid before the Society a specimen of the Daguerreotype by Mr. Robert Cornelius, of Philadelphia." This establishes the fact that the first Cornelius daguerreotype was made by Dec. 6, 1839. Whether it was a portrait or not we have no way of knowing. At the meeting of the Society on March 6, 1840 (v. 1, p. 181, of the above *Proceedings*), "Dr. Patterson exhibited some specimens of the Heliographic Art (daguerreotype) of a large size, executed by Mr. Robert Cornelius of Philadelphia, and stated to the Society that Mr. Cornelius had succeeded in obtaining beautiful representations upon highly polished silver plate." Sachse cites this as evidence that Cornelius was making portraits by this time (March 6), but again the information indicates only that Cornelius was making progress in the new art. There is nothing to tell whether the "representations" were portraits or views.

The sources tabulated above are all, of course, secondary ones, being based largely on the researches of Sachse. I have made a considerable examination of the contemporary material, and while not complete, the available original evidence substantiates the point of view stated in the text. Examination has been made of the *National Gazette* of Philadelphia, a triweekly newspaper, from Feb. to June, 1840, as well as of several other Philadelphia papers of this period, and while mention of portraits by Cornelius was found several times, the first extended account occurs in the *National Gazette*, June 27, 1840, p. 3. However, earlier mention is made of portraits by Cornelius in *Niles Register* (Baltimore), May 30, 1840. The *National Gazette*, April 23, 1840, p. 1, mentions daguerreotype portraits of "American production" but does not specify the maker. The weight of all available evidence then indicates that Cornelius was not making portraits until late in the spring of 1840.

A series of letters and notices of W. R. Johnson in the Philadelphia papers should also be mentioned in this connection. Johnson wrote under date of Oct. 19, 1839 (*United States Gazette*, Oct. 22, 1839, p. 2), that he had just brought with him from abroad a complete set of apparatus for making daguerreotypes. On Jan. 31, 1840, Johnson announced a lecture on the daguerreotype. (*United States Gazette*, Jan. 31, 1840, p. 3, adv.) In his announcement he states that the lecture would be illustrated by "various samples of the art produced in this city, including architectural pieces, landscapes, interior views, statuary and objects in natural history." Notice particularly that no mention is made of portraits. It seems reasonable to assume that if any portraits had been made in Philadelphia, Johnson would certainly have mentioned them in the announcement. Johnson was acquainted with the work of Saxton, Goddard, and Cornelius, for he mentions them in an extended letter to the *National Gazette*, Feb. 11, 1840, p. 1. He refers again to the fact that each of these men had made by the above date "a number of successful attempts in the execution of the process of M. Daguerre." Here again it seems reasonable to assume that if any one of these had made a successful portrait by the daguerreotype process, the unusualness of the event would have caused Johnson to so state.

Cornelius lived and died in Philadelphia and was one of its prominent citizens. He was born March 1, 1809, and died Aug. 10, 1893. I am in-

debted to Mrs. Robert G. Barckley of Milford, Pa., whose grandmother was a sister of Robert Cornelius, for information and aid concerning him. For biographical sketches of Cornelius see *History of the Cornelius Family in America,* C. S. Cornelius, Grand Rapids, Mich., 1926, ch. 8, p. 2; *Philadelphia Inquirer,* Aug. 11, 1893, p. 1.

34. *London, Edinburgh, and Dublin Philosophical Magazine,* v. 16, p. 535 (1840).

35. Draper made the claim as can be seen in his letter to Herschel on July 28, 1840. It was made again in Draper's *Textbook of Chemistry,* published by Harper and Bros., 1846, p. 93. A typical statement of later life will be found in his *Scientific Memoirs* (Harper and Bros., N. Y., 1878), p. 215. See also letter of C. E. West, New York *Times,* Feb. 19, 1883.

36. *American Repertory of Arts, Sciences, and Manufactures,* v. 1, pp. 401-404 (1840).

37. I am indebted to Professor John W. Draper of Morgantown, W. Va., a grandson of Dr. Draper, for this information. Professor Draper kindly lent me the very excellent ambrotype of Dr. Draper, a copy of which appears on page 125.

37a. See reference 23.

38. A comparison of the method of lighting described by Draper and Wolcott shows them to be remarkably similar (references 40, 41, and Wolcott's patent). It may be that Draper adopted his method independently, but Wolcott complains about the matter as follows: "The manner of illuminating the person, described in the same article [that by Draper in the *Philosophical Magazine*] appears to be a description of the method originally used by me."

American Repertory of Arts, Sciences, and Manufactures, v. 2, p. 401, Jan., 1841.

39. Here again in the use of the head rest, Draper's publication was preceded by Wolcott's. Wolcott mentions it in his patent of May 8, 1840, U. S. Letters Patent No. 1,582. The head rest had been very early suggested. The *Athenaeum* (London), Aug. 24, 1839, p. 637, in commenting on the fact that Daguerre believed portraits impossible, suggested that "the head could be fixed by means of supporting apparatus."

40. *American Repertory of Arts, Sceinces, and Manufactures,* v. 1, p. 193, April, 1840.

41. Johnson originally asserted that Oct. 6, 1839, was the date upon which Wolcott's first portrait was made but later changed the date to Oct. 6 *or* 7. Since Oct. 6, 1839, falls on Sunday it is more probable (if Johnson is correct) that Oct. 7, 1839, is the date. Johnson's original statement will be found in *Eureka,* a New York magazine for inventors, v. 1, pp. 7, 23, 60, 69 and 92 (1846). The later claim (Oct. 6 *or* 7), he maintained, was confirmed by an entry in the account book of Wolcott and Johnson. *American Journal of Photography,* n.s., v. 1, p. 10 (1858-59).

S. D. Humphrey, the editor of the *Humphrey's Journal,* strongly advocated the claims of Wolcott. Humphrey claimed in 1855 that he had in his possession Wolcott's original daguerreotype portrait made on Oct. 6 (7), 1839. *Humphrey's Journal,* v. 7, pp. 7 and 97 (1855) and v. 9, p. 352 (1858).

In 1858, the Mechanics' Club of New York City took up the question of the first photographic portrait and the claimants for the honor; Draper, Johnson (for Wolcott), and Morse

were asked to present their statements. Draper responded in a letter dated May 3, 1858, addressed to the committee consisting of Messrs. Stetson, Cohen, and Seely (the editor of the *American Journal of Photography*), which was published in *American Journal of Photography*, n.s., v. 1, p. 2 (1858-9). The committee considered the evidence submitted but apparently their report was never published. The context of the report can be judged, however, by the comment of the chairman of the Club, Mr. Tillman, who remarked that "the criticism of Dr. Draper's claim was too severe." *American Journal of Photography*, n.s., v. 1, p. 12 (1858-59). We thus have two of the three editors of the photographic journals of the time definitely opposed to Draper's claim. The third, H. H. Snelling, of the *Photographic Art Journal*, remained neutral but stated that he talked to both Morse and Draper and neither claimed priority (*American Journal of Photography*, n.s., v. 1, p. 11 (1858-59)). Snelling never committed himself on Wolcott's claim.

The most damaging contemporary evidence against Draper's claim in my judgment is that given by his own assistant, W. H. Goode. Goode in an article dated Dec. 17, 1840, published in *American Journal of Science and Arts*, v. 40, p. 137 (1841), states, "The most important application of which this art was susceptible—taking portraits from life, to which it owes its chief interest—was made *about the same time* * by Professor Draper and by Mr. Wolcott, a mechanician of the city of New York. Neither possessed any knowledge of the views of the other." For Goode to make this statement when he must have been aware of Draper's claim is the equivalent of admitting that Wolcott had a very good claim for priority.

* Italics mine (R. T.).

42. *The Camera and The Pencil*, M. A. Root, p. 353. L T W (see reference 32) states that Cornelius opened the first gallery in this country on Feb. 16, 1840, but produces absolutely no authentication for it. A comparison of the lighting methods used by Cornelius given by Sachse (reference 32) with those of Wolcott shows that they are of the same character. A contemporary account of Cornelius' method will be found in the *National Gazette* of Philadelphia, June 27, 1840, p. 3.

Root, writing in 1856-64 (*The Camera and The Pencil*, p. 354), states "theirs [i.e., Wolcott and Johnson's] were the first rooms open for portraiture in the United States." Seely, the editor of the *American Journal of Photography*, and a member of the committee appointed to investigate the claims of Draper, Wolcott, and Morse, also makes a similar statement. *American Journal of Photography*, n.s., v. 3, p. 197 (1860-61). See also letter of "G" published in *American Journal of Photography*, n.s., v. 4, p. 41 (1861-62). G. refers to the first Sunday in February, 1840, as the date of his visit to Wolcott and Johnson's gallery and also mentions the *Sun* account given in the text. Obviously "G" is in error by a month.

43. It may be that Morse, whose professional work is described later in the text, used this method at first. His correspondence indicates that he had considerable difficulty in obtaining a lens. Further, Johnson states (*Eureka*, v. 1, p. 25 (1846)), "Professor Morse also came and proposed to Mr. Wolcott to join him in the working of the invention."

44. The account of the introduction of Wolcott's process into England is substantially that given by John Johnson in *Philadelphia Photographer*, v. 5, pp. 174-7 (1868),

where will also be found a reprint of Claudet's letter bearing on the subject. This account is corroborated by Jabez Hughes writing in the *Photographic News* (London) and reprinted in *Humphrey's Journal,* v. 15, pp. 269 and 278 (1863-64), and by Wolcott's correspondence published in *American Journal of Photography,* n.s., v. 3, pp. 119 and 142 (1860-61). Claudet, writing in 1845, states "the invention of Mr. Wolcott was at the time a great improvement, and deserves to be recorded in the history of the daguerreotype as a very clever and very ingenious arrangement." *Journal of the Franklin Institute,* v. 40, p. 113 (1845).

For a brief biographical sketch of Wolcott see *American Journal of Photography,* n.s., v. 4, p. 525 (1861-62).

44a. See reference 18.

45. *Life of Morse,* S. I. Prime, p. 403.

46. Several of these names have been found in the contemporary literature, or in Morse's personal papers and letters which are in the Library of Congress, and which have been thoroughly examined for the present history. The reference to Brady may be found in Chapter 3; Southworth describes his experiences as a pupil of Morse in *Philadelphia Photographer,* v. 8, p. 315 (1871); for the reference to Cridland, I am indebted to Dr. Howard Jones of Circleville, Ohio, who allowed me to examine his correspondence with W. D. McKinney of Columbus, Ohio, on the subject. Cridland, the grandfather of McKinney, was originally a framemaker living in Philadelphia. He first became acquainted with Morse in framing some of his (Morse's) paintings and portraits.

Even as late as April 17, 1841, there is a reference to Morse's daguerreotyping activities, for on this date there appeared in *Niles Register* (p. 112) the following item copied from the New York *Journal:* "By a peculiar preparation of the plate, discovered by Mr. Geo. Prosche of this city, daguerreotype likenesses are taken at the studio of Professor Morse, with the most perfect correctness in a second of time—as quick, indeed, as the aperture of the lens can be opened and shut again." Prosche, who was Morse's instrument-maker, was evidently trying out "a quick" which at this time was just coming into use.

47. Reference to the inferior character of the first American plates is made by Johnson in his *Eureka* articles (see reference 41). Goode in *American Journal of Science and Arts,* v. 40, p. 137 (1841), states, "American plates are exceedingly imperfect. The silver abounds with perforations, which appear as black dots in the pictures; it also assumes a yellow instead of a white coat in burning." See also the same journal, v. 43, p. 185 (1842), for similar observations.

48. In an interesting letter of Wolcott's, dated June 25, 1840, and published in *American Journal of Photography,* v. 3, p. 42 (1860-61), Wolcott refers to Stevenson as John G. Stevenson, who was evidently doing a very good business in Washington, for Wolcott was with him and states, "I am busy, busy, busy."

49. The invitation of Gouraud's, which I have quoted, was addressed to Thomas A. Cummings and will be found in Cummings' *Historic Annals of the National Academy of Design,* Philadelphia, 1865, p. 158. As the date on which Cummings was requested to be present (Dec. 4, 1839) is the same as that recorded in Hone's *Diary,* v. 1, p. 391, Dodd, Mead and

Co., 1889, I have assumed that Hone received the same invitation. Cummings, by some inadvertence, signs the invitation François *Pamsel* rather than François Gouraud.

50. New York *Morning Herald*, Feb. 4, 1840. Gouraud's exhibit is also described in *Niles Register*, Jan. 11, 1840, p. 312, where it states that Gouraud was to go to Havana to make daguerreotype views to be sent to Paris. *Niles Register*, Feb. 11, 1843, p. 384, also has this interesting comment: "We learn from the New Orleans papers that the beautiful magical pictures of M. Daguerre of Paris, which have been seen and admired by thousands in this country, were entirely destroyed by fire on the night of the 29th ult."

51. Gouraud so advertised in the New York *Morning Herald*, March 5, 1840.

52. A number of these letters have been found in Morse's papers in the Library of Congress and, as might be expected, are favorable to Morse. One of Gouraud's letters may be seen in the Boston *Daily Advertiser and Patriot*, June 26, 1840. If Morse is reliable (and I believe that his honesty has never been questioned) there is a letter of Morse's dated Oct. 27, 1840, which would indicate that Gouraud was a liar as well as a charlatan.

53. This manual is now extremely scarce. The only one I have seen is in the library of Harvard University. While Gouraud's manual was the first separately published one, mention should be made of a translation of Daguerre's manual which had appeared in a regular issue of the *Journal of the Franklin Institute* for November, 1839 (v. 28, p. 303). It was translated by Professor J. F. Frazer of the University of Pennsylvania.

54. Fizeau's process was announced, but not described, by Arago in *Comptes Rendus*, v. 10, p. 488, March, 1840. It was described in full in *Comptes Rendus*, v. 11, p. 237, Aug., 1840.

55. The introduction of the accelerator has been variously credited to John Goddard (*London Literary Gazette*, Dec. 12, 1840); to M. Claudet, a Frenchman resident in London and holder of Daguerre's patent rights in Great Britain, *Comptes Rendus*, v. 12, p. 1059, June, 1841; and to Dr. Paul B. Goddard of Philadelphia. The last claim is made by Sachse (reference 32) and Root, *The Camera and The Pencil*, p. 352. I can find no authenticated claim for Dr. P. B. Goddard, however. Both Sachse's and Root's claim is based on a note appearing in *Proceedings American Philosophical Society*, v. 3, p. 180 (1843), which alludes to Goddard's first employment of bromine in the photographic process, which is stated to have been in Dec., 1839. As the statement was not published until four years later and is not further authenticated, the evidence cannot be admitted. Furthermore, there is no indication in the statement that Goddard employed bromine as an accelerator of iodine. Goddard may have simply made some experiments in which he replaced iodine by bromine. However, it was stated at a discussion of the photographic section of the American Institute in 1858 that "It was an undisputed fact that Dr. Goddard of Philadelphia introduced the use of bromine." *American Journal of Photography*, n.s., v. 1, p. 11 (1858-59). See also reference 22.

Johnson stated that John Goddard was in the employ of Johnson and Beard in London and that he (Johnson) worked with Goddard. According to Johnson's statement, Wolcott

was the first to attempt accelerators for the daguerreotype plate and Johnson continued these efforts when he reached England in the fall of 1840. John Goddard's final success, then, may have come from Wolcott's initial effort. *Eureka*, v. 1, p. 92 (1846), and *Philadelphia Photographer*, v. 5, p. 176 (1868).

56. Reference to Wolcott's mixture is fairly common in the early literature on daguerreotypy. The composition of the mixture is given by R. J. Bingham in *Philosophical Magazine*, v. 29, p. 287, Oct., 1846.

57. *A System of Photography*, S. D. Humphrey, 2d ed., Albany, N. Y., 1849, p. 7. See also a similar comment by Lester, *The Gallery of Illustrious Americans*, New York, 1850.

58. The 3d, 4th, and 5th United States patents in photography, all on coloring daguerreotypes, were:

3. Letters patent No. 2522, March 28, 1842, issued to B. R. Stevens and Lemuel Morse of Lowell, Mass.
4. Letters patent No. 2826, Oct. 22, 1842, issued to Daniel Davis, Jr., of Boston, Mass.
5. Letters patent No. 3085, May 12, 1843, issued to Warren Thomson of Philadelphia, Pa.

No. 2391, the second United States patent in photography, was issued to John Johnson, Wolcott's partner, Dec. 14, 1841, for a device used in polishing daguerreotype plates.

59. *Memoirs of John Quincy Adams*, J. B. Lippincott and Co., Philadelphia, 1876, v. 11, pp. 401 and 430.

60. *Voigtlander and I in Pursuit of Shadow Catching*, James F. Ryder, The Cleveland Printing and Publishing Co., Cleveland, 1902, ch. I. I am also indebted to Ryder for much of the information in the paragraphs which immediately follow in the text.

61. My information concerning Plumbe has been pieced together from a variety of scattered sources. The origin of his Oregon railroad scheme, together with some biographical material, will be found in *Annals of Iowa*, John King, Series 3, v. 6, p. 289, an article which was reprinted from the Dubuque *Daily Times* of Jan., 1869. King makes no mention of his career in daguerreotypy, however. The connection between Plumbe, the originator of the Pacific railroad, and the daguerreotype is found in the *New England Historical and Genealogical Register*, v. XI, p. 367, Oct., 1857. Plumbe's New York gallery was located at 251 Broadway from 1843 to 1846 inclusive. For the source of the above information I am indebted to Miss Dorothy Barck, head of the reference department, The New York Historical Society.

In addition, the following information has been used: Root, *The Camera and The Pencil*, pp. 360 and 361; advertisements or news notes in *The National Intelligencer*, Washington, D. C., Jan. 22, 1846, Feb. 24, 1846, May 21, 1846, May 30, 1846, and July 7, 1846; *Antiques*, v. 8, pp. 27 and 28, July, 1925, an article on Plumbeotypes by R. P. Tolman; *Photographic Art Journal*, v. 1, p. 138 (1851). I have given some additional information concerning Plumbe in my article "John Plumbe, America's First Nationally Known Photographer," which appeared in *American Photography*, v. 30, p. 1 (1936). The meeting between Plumbe and Stevenson described in the above article is imaginary. Plumbe was in Washington in the summer of 1839 and doubtless made the acquaintance of Stevenson, as Stevenson's daguerreotypes were a popular topic of conversation.

Samuel C. Busey, *Columbia Historical Society Records,* v. 3, p. 81 (1900), credits Plumbe with being the first daguerreotypist in Washington, but does not assign a date to the origin of Plumbe's efforts. Busey evidently means that Plumbe was the first permanently located daguerreotypist in Washington as the advertisement of Stevenson quoted in the text certainly antidates any efforts of Plumbe's.

Zina E. Stone in *Old Residents Historical Association,* Lowell, Mass., v. 5, p. 165 (1894), states that Plumbe was probably the first permanent daguerreotypist in Boston. Before the close of 1841 there were three daguerreotypists in Boston of whom Plumbe was one. United States Patent No. 2826, dated Oct. 22, 1842 (see reference 58), was assigned to John Plumbe of Boston.

62. *Memoirs of John Quincy Adams,* v. 12, p. 8.

63. The destruction of the National Daguerrean Gallery is described in *Humphrey's Journal,* v. 4, p. 12 (1852). There were similar "National Galleries" started at other periods. The work of Brady, which is described in the text, was one; another which received considerable public notice was that of D. D. T. Davis of Utica, N. Y., the daguerreotypes of which were made in 1849-50, in Washington (*Western Photographic News,* v. 2, p. 273 (1876)). This was also destroyed by fire, *Photographic Art Journal,* n.s., v. 2, p. 121 (1855).

64. For the further history of this engraving see *American Review,* v. 4, p. 431 (1846); v. 6, 654 (1847). The mezzotint engraving by T. Donly measured 32" x 40" and contained over 100 figures, all of which are said to have been reproduced from daguerreotypes made by Anthony and Edwards in the years 1842-46. The scene supposedly depicts Clay's last address in the Senate in 1842, but not all the persons represented in the engraving were actually present. The first reference to the *American Review* (given above) lists quite a number of the characters portrayed and comments, "Such a specimen of American skill and enterprise has not before been seen."

The plate was retouched and improved in 1847 and additional impressions made. These bear the imprint of E. Anthony, 247 Broadway.

The engraving is also described in *Photographic Art Journal,* v. 1, p. 318 (1851).

65. French plates, however, always gave American plates good competition. Many daguerreotypists preferred the French plates. Most of the profession entered in the Anthony competition of 1853 (described later in the text) used French plates, the favorite being the "Star 40." The star was the trademark which appeared on the edge of the plate in one corner and the "40" referred to the number of parts of silver contained in the plate, i.e., a "40" contained 1/40 silver, the remainder being copper. This practically amounts to saying that 1/40 of the thickness of the plate was silver, the remaining 39/40 being copper. In addition to "40's," "20's," "30's," and "60's" were manufactured. *Photographic Art Journal,* v. 1, p. 92 (1851); v. 7, p. 7 (1854).

66. My information relative to the Anthonys is based upon Root, *The Camera and The Pencil,* pp. 361-363; an obituary of Edward Anthony appearing in the New York *Daily Tribune,* Dec. 15, 1888; and the sources listed below. H. T. Anthony died in 1884. H. T. Anthony was in charge of the manufacturing division of E.

and H. T. Anthony and Co. and was himself an enthusiastic amateur. "He was a photographic dictionary, encyclopedia, and text book combined," says E. L. Wilson on his death (*Philadelphia Photographer,* v. 21, p. 341 (1884)). The Anthony establishment as it appeared in 1854 is described in the *Photographic Art Journal,* n.s., v. 1, pp. 202-206 (1854). A number of woodcuts of various phases of the manufacturing departments are included. The story of Anthony's connection with the northeast boundary survey has been repeated a number of times. The earliest of these accounts which I have found is given in the *Photographic Art Journal,* n.s., v. 1, p. 120 (1854), which also includes additional biographical information concerning Edward Anthony.

I have attempted to locate more original evidence for it, but so far have not succeeded. James Renwick, who employed Anthony on the boundary survey, made three reports to the Secretary of State concerning the survey, but in none of these does he mention Anthony or daguerreotypes. However, Renwick seems to have been troubled because he was spending too much money on these surveys and he may have thought it inadvisable to make a formal report on the matter, especially since the art was so new and untried for such a purpose.

It would appear from the information given in reference 64 that Anthony and his partner were in business by 1842 and that Edward Anthony was in business for himself by 1847. The firm name in this period is variously given as Anthony, Edwards, and Chilton; Anthony, Edwards, and Clarke; Anthony, Edwards and Co.; and Anthony, Clarke and Co. . . . See *Democratic Review,* v. 13, opp. p. 563 (1843); v. 14 (1844), frontispiece; v. 16, March, 1845 (portrait), June,

1845 (portrait); and v. 18, p. 157 (1846), where a very favorable notice of the daguerreotype portraits in the *Democratic Review* of this period is credited to their "National Miniature Gallery." It seems probable that Edwards and Anthony did most of the actual photographic work. The Chilton may have been the James R. Chilton mentioned in Chapter I or an H. Chilton, a daguerreotypist, to whom are credited several portraits in the *Democratic Review.* See, for example, *Democratic Review,* v. 14, opp. p. 447 (1844). For an early history of Scovill Manufacturing Company and its connection with American photography see *Humphrey's Journal,* v. 10, p. 295 (1859).

Information relative to the more modern history of E. and H. T. Anthony has been supplied by the late B. B. Snowden of the Agfa-Ansco Corporation.

67. The Jackson daguerreotype which is reproduced in the text has been variously credited to Brady; to Dan Adams of Nashville, Tenn.; and to Anthony, Edwards and Company. Brady's claim is as follows: In the Townsend interview (see reference 71) he states, "I sent to the Hermitage and had Andrew Jackson taken barely in time to save his aged lineaments to posterity"; a daguerreotype of Jackson in Brady's New York gallery is referred to in *Photographic Art Journal,* v. 1, p. 63 (1851); a wet plate negative of the daguerreotype is among the Brady negatives in the War Department files and is the copy from which the illustration is reproduced. Adams' claim is described in *McClure's Magazine,* v. 9, p. 803 (1897), where it states that the original daguerreotype was $1\frac{1}{8}"$ x $\frac{3}{4}"$, which suggests to me that this is a copy of the original daguerreotype. The claim of Anthony,

Edwards and Company is found in an insert to *Democratic Review*, v. 17 (1845). The portrait is dated "Hermitage, April 15, 1845" and states "from a Daguerreotype by Anthony, Edwards and Co." It was first published in the Sept., 1845, issue of the *Democratic Review*.

This would appear to give Anthony, Edwards and Company the best claim, as Jackson died June 8, 1845. Brady may have been the operator sent to make the daguerreotype despite his statement given above. It is also possible that Brady and the Anthony firm pooled their interests and financed the venture. Brady did work for this firm as evidenced by a portrait of Millard Fillmore after a daguerreotype by Brady and published by Edward Anthony. The Jackson portrait was also published again in the *Democratic Review*, July, 1846. Charles H. Hart, a leading authority on historical portraiture, states that this daguerreotype "is without doubt the most important portrait of Jackson in existence." *McClure's Magazine*, v. 9, p. 795 (1897).

68. *The Diary of President Polk*, edited by Allan Nevins, Longmans, Green and Co., N. Y., 1929, p. 374.

69. See, for example, "M. B. Brady. His Photos, 1861-65," by Charles Flato, *Hound and Horn*, v. 7, pp. 35-41 (1933).

70. *The Gallery of Illustrious Americans*, C. Edwards Lester (Editor); M. B. Brady, F. D'Avignon, C. Edwards Lester, publishers, New York, 1850.

71. For a man who was so prominent, information concerning Brady is exceedingly meager. The most important sources of information regarding his life are (a) an article by C. Edwards Lester, "M. B. Brady and the Photographic Art," *The Photo-graphic Art Journal*, v. 1, pp. 36-40, Jan., 1851, and (b) an "Interview with Brady," by George Alfred Townsend, which appeared in the New York *World*, April 12, 1891. In addition there are obituaries of Brady which appeared in the Washington (D. C.) *Post*, Jan. 18, 1896; the Washington *Evening Star* of the same date; the New York *Tribune*, Jan. 19, 1896; some information in Root, *The Camera and The Pencil*, p. 375; *The Gallery of Illustrious Americans*, described in reference 70; and many scattered notes through the literature of the times, some of which are given below. Lanier in the *Review of Reviews*, v. 43, p. 307 (1911), states that Brady was born in Ireland and that he accompanied Morse to Europe on his trip in 1838-39, but he does not authenticate these statements. Townsend, an able journalist and one of the first to sign his name to newspaper articles, in his interview quotes Brady as saying he was born in the Lake George country, New York, about 1823-24. I have checked all the additional dates and statements given in the Townsend interview and they agree with the date as furnished by Lester forty years earlier (or from other contemporary sources). Lester, however, does not give his birthdate or birthplace but says that "he is now [1851] about thirty years of age." The Washington *Star* obituary states that Brady was seventy-six years old when he died on Jan. 16, 1896, in New York City. This would mean that he was born in 1829 or 1830. This seems unlikely, for he had a brother, John, who was born about this time. John Brady died Aug. 9, 1851 (New York *Herald*, Aug. 11, 1851). Considering Brady's statement and the above facts, it is evident that Brady did not know his exact age but that he was probably born in 1822 or 1823.

From the agreement of the Town-

send and the Lester statements I feel that considerable confidence can be placed in the Townsend interview and that it is probably correct. Coupled with this, is the fact that few Irishmen are ashamed of claiming "the old sod" as the land of their birth—if Brady had been born there he would have said so. The story concerning Brady's trip with Morse to Europe advanced by Lanier I am certain is in error. Neither Lester nor Townsend say anything about it; there is no mention of Brady in the letters of Morse of this period (1839) either published or unpublished (at least of those in the Library of Congress), and further, both the Lester statement and the Townsend statement (written forty years apart) agree on Brady's introduction to Morse through William Page *after* Morse had returned from Europe in 1839.

The statement concerning Brady's photographs of the presidents is given in the Townsend interview, and is verified by an examination of the list of Brady negatives acquired by the war department and published in the *Subject Catalogue No. 5, List of the Photographs and Photographic Negatives Relating to The War for the Union*, Washington, Government Printing Office, 1897, and by information furnished by Mrs. M. Handy Evans of Washington, D. C., one of the heirs of M. B. Brady.

Concerning Brady's method of conducting business and his absences from business during the latter part of the daguerreotype era are the following facts: Brady was in Europe from June, 1851, to May, 1852. He seems to have been in poor health when he left but was considerably improved upon his return. *Humphrey's Journal*, v. 2, p. 117 (1851); v. 4, p. 47 (1852); *Photographic Art Journal*, v. 3, p. 130 (1851); v. 3, pp.

320 and 383 (1852). A few years later we read, "Mr. Brady is again rusticating in the country." *Photographic Art Journal*, v. 9, p. 288 (1856).

In the *Photographic Art Journal*, n.s., v. 1, p. 104 (1854), we read, "Although Mr. Brady is not a practical operator, yet he displays superior management in his business and consequently deserves high praise for the lofty position he has attained in the daguerrean fraternity." Again, "Brady has retained constantly the most skillful and learned professors in the art." *Photographic Art Journal*, n.s., v. 1, p. 256 (1854). See also Brady's advertisement in the *Gallery of Illustrious Americans* (reference 70) where he states that "the operating department is arranged in the most scientific manner and directed by persons of acknowledged skill in the profession." Also several years earlier we read, "Brady is not an operator himself, a failing eyesight precluding the possibility of his using the camera with any certainty, but he is an excellent artist, nevertheless." *Photographic Art Journal*, v. 1, p. 138 (1851). Brady also conducted a daguerrean college, of which he was president, in connection with the New York gallery, in which training in daguerreotypy was taught. *Photographic Art Journal*, n.s., v. 1, p. 256 (1854).

Brady's first daguerreotype establishment began business in 1844. He first appears in the New York City Directory for 1843-44 as Brady, Math. B., jewel case man, 164 Fulton. The next issue of the Directory, 1844-45, lists him as follows: Brady, Matthew B., jewel, miniature and surgical case manufacturer, 187 B'way, opposite John: Also Daguerrean miniature gallery, 207 B'way, C. Fulton, entrance 162 Fulton. This is confirmed by Brady's announcement of the opening of his permanent Washington

gallery in the *National Intelligencer,* Jan. 26, 1858, where he states, "Mr. Brady brings to his Washington gallery the results of *fourteen* years' experience in Europe and America."

Brady's success at the Fair of the American Institute is given in *List of Premiums Awarded by Managers of Annual Fair,* 1844, p. 7. Anthony, Edwards and Co., John Plumbe, and Brady all received a diploma "for the best daguerrean likenesses"; in the *List* of the same title for 1845, p. 8, Brady and P. Haas were both awarded silver medals; same *List,* 1846, p. 11, Brady received a silver medal for best specimen of daguerreotype; same *List,* 1849, p. 12, Brady received gold medal for best daguerreotype. This was the first gold medal awarded by the American Institute for daguerreotypes. It is interesting to note that the first award for a daguerreotype by this Institute was made in 1840 to A. S. Wolcott; a diploma for the best specimens of daguerreotype likenesses, above *List,* 1840, p. 47.

I have reviewed Brady's early career in an article, "M. B. Brady and the Daguerreotype Era," which appeared in *American Photography,* v. 29, pp. 486 and 548 (1935).

72. *Statistical View of the United States,* a compendium of the Seventh Census, J. D. B. DeBaw, Washington, 1854, p. 126.

73. Gurney received the gold medal from the Fair of the American Institute for daguerreotypes in 1851 and 1854, and the Anthony prize in 1853. See the *Daguerreian Journal,* v. 2, p. 340 (1851); *Photographic Art Journal,* v. 6, p. 383 (1853); v. 7, p. 7 (1854); v. 8, p. 384 (1855); also a gold medal for paper photographs at the Fair of the American Institute in 1856. *Photographic Art Journal,* v. 9, p. 384 (1856).

74. This sketch of Jeremiah Gurney appeared in the New York *Star,* Nov. 6, 1887. Gurney and Fredricks dissolved their partnership in 1856. Charles D. Fredricks opened a separate establishment in Aug., 1856. *Photographic Art Journal,* n.s., v. 3, p. 288 (1856).

75. A long article on "Photography in the United States" appeared in the New York *Daily Tribune,* April 29 and 30, 1853. If we assume that there were two thousand daguerreotypists at work in 1853 and that each produced on the average 1500 daguerreotypes a year (an average of five a working day) the figure of 3,000,000 daguerreotypes annually would represent a reasonable figure. The large establishments and especially the daguerreotype factories mentioned later in the text must have turned out hundreds of these daguerreotypes daily. The river boat daguerreotypist mentioned later in the text made 1000 daguerreotypes in four months! In addition, Snelling remarks (*Photographic Art Journal,* v. 3, p. 66 (1852)), "Mr. Gurney informs us that he received $120 for pictures taken entirely by himself in one day." As Gurney's was one of the large establishments he certainly must have had other operators besides himself, so that the total number turned out in a day must have been large.

76. *The Daguerreian Journal,* v. 3, p. 20 (1852). Daguerreville was one mile south of Newburgh, N. Y., on the west bank of the Hudson. It was the seat of a large manufacturing establishment of daguerreotype supplies owned by W. and W. H. Lewis.

77. *The House of the Seven Gables* was begun by Hawthorne in the fall of 1849, so that his familiarity with the daguerreotype and daguerreotyp-

ists antedated 1849. See *Nathaniel Hawthorne and His Wife,* by Julian Hawthorne, v. 1, p. 381 (1885). The long quotation from Hawthorne's work will be found in Chapter 6, *The House of the Seven Gables.*

78. *The Living Age,* v. 9, p. 551 (1846). The article on the daguerreotype is one reprinted from the *Christian Watchman,* probably of the same year.

78a. *National Gazette* (Philadelphia), June 27, 1840, p. 3.

79. The story will be found in the *Western Photographic News* (Chicago), v. 2, p. 218 (1876).

80. This incident with others will be found in the *Photographic Art Journal,* v. 7, p. 359 (1854).

81. *Photographic Art Journal,* v. 8, p. 252 (1855).

81a. See reference 78.

82. *The Daguerreian Journal,* v. 2, p. 19 (1851).

83. *The Illustrated London News,* v. 18, p. 425 (1851).

84. *National Intelligencer,* June 7, 1851.

85. *Exhibition of the Works of Industry of All Nations, 1851.* Reports by the Juries, London, 1852. Printed for the Royal Commission. The awards for class x, in which photography was included, will be found on pages 63 and 64. Brady's reads "daguerreotypes," Lawrence's "daguerreotype," and Whipple's "daguerreotype of the moon." A more extended discussion of the photographic exhibits will be found on page 244 *et seq.* of the Report. The second quotation is from the *Official Description and Illustrated Catalog,* London, 1852, 3 vv.; v. 3, p. 1464.

86. Whipple's daguerreotypes of the moon are described in the *Photographic Art Journal,* v. 2, p. 94 (1851), where a biographical sketch of his life is given. See also *The Camera and The Pencil,* M. A. Root, p. 364.

87. *Scientific Memoirs,* John W. Draper, New York, 1878, p. 214.

88. *The Evolution of Photography,* Werge, p. 54.

89. For the remarks on European daguerreotypes see *Humphrey's Journal,* v. 4, pp. 314 and 348 (1852-53). See also the remarks attributed to Claudet, one of the most celebrated London daguerreotypists, in the *Photographic Art Journal,* v. 1, p. 188 (1851).

90. *The Camera and The Pencil,* M. A. Root, p. 363, and Werge, *The Evolution of Photography,* p. 54, describe Mayall's career.

91. *The Camera and The Pencil,* M. A. Root, p. 359. Thomson also hailed from Philadelphia originally. Sachse, *American Journal of Photography,* v. 13, p. 451 (1892).

92. See, for example, the buff pictured and described in *Photographic Art Journal,* v. 1, pp. 59 and 60 (1851).

93. The quotations are from *The Evolution of Photography,* pp. 48 and 54.

93a. See reference 92.

94. See biography of Whipple mentioned in reference 86 and *Daguerreian Journal,* v. 2, p. 114 (1851); *Photographic Art Journal,* v. 3, p. 271 (1852). Werge, *The Evolution of Photography,* says (p. 53), "On the whole, I think Boston was ahead of New York for enterprise and the use of mechanical appliances in connection with photography." This was in 1853.

95. *The Illustrated London News,* r. 21, p. 76 (1852).

96. *La Lumière,* v. 1, p. 138 (1851). It was translated by both *The Daguerreian Journal,* v. 3, p. 19 (1851-52), and the *Photographic Art Journal,* v. 3, p. 22 (1852). If the reader is interested in the description of an actual gallery let him consult *American Photography,* v. 29, p. 548 (1935), where there appears a pen picture of Brady's gallery opened in March, 1853, which is reprinted from *Humphrey's Journal,* v. 5, p. 73 (1853-54). The reprint does not differ greatly, save in ornateness of wording, from that given by *La Lumière.*

97. For daguerreotype portraits of Daguerree see *Photographic Art Journal,* v. 3, p. 294 (1852); *American Journal of Photography,* n.s., v. 4, p. 15 (1861-62); *Anthony's Bulletin,* v. 12, p. 56 (1881); C. W. Canfield, "Portraits of Daguerre," *American Annual of Photography,* 1891 and 1893; G. Cromer, *Bulletin de la Société Française et Photographie,* 3d series, v. 20, p. 6 (1933).

98. My notes are filled with a good many references relative to price and size. The following are illustrative: *Photographic Art Journal,* v. 1, p. 213 (1851); v. 6, p. 32 (1853); *The Daguerreian Journal,* v. 1, p. 51 (1851); v. 2, pp. 114 and 209 (1851); v. 4, pp. 58 and 287 (1852-53); *Philadelphia Photographer,* v. 7, p. 265 (1870); Werge, *The Evolution of Photography,* p. 53. Sachse, *American Journal of Photography,* v. 18, p. 103 (1897), reproduces a portion of the 1844 cash book of Langenheim Brothers, a leading Philadelphia firm of daguerreotypists. The average price charged for about three hundred daguerreotypes was slightly under five dollars apiece.

99. I have taken Brady's advertisement from *Humphrey's Journal.* v. 5, p. 16 (1853). It was reprinted with comment from a New York daily.

100. The visitor was John Werge. See *The Evolution of Photography,* p. 200.

101. New York *Daily Tribune,* June 18, 1853. See also *Humphrey's Journal,* v. 5, p. 207 (1853-54).

102. *The Daguerreian Journal* was so called for its first three volumes (1850-51); from volumes 4 to 13 inclusive (1852-1862) it was continued as *Humphrey's Journal of the Daguerreotype and Photographic Arts;* volume 14 was called *Humphrey's Journal of Photography and the Heliographic Arts and Scinces;* volumes 15 to 21 (1864-1870), *Humphrey's Journal of Photography and the Allied Arts and Sciences.* Publication was suspended from Jan. to March, 1852.

The *Photographic Art Journal* was so called from volumes 1 to 6 inclusive; after that it was the *Photographic and Fine Art Journal;* volumes 1 to 6 (1851-53) were referred to as series 1; series 2 included volumes 1 to 12 (1854-9) and series 3, volume 1 (1860).

Beginning with 1861, the *Photographic and Fine Art Journal* was combined with *The American Journal of Photography and the Allied Arts and Sciences.* The combination was announced in *American Journal of Photography,* n.s., v. 3, p. 207 (1860-61). The last journal, edited by Charles A. Seely, A.M., was founded in 1852, and included volumes 1 to 6. Beginning June, 1858, a new series was published and included volumes 1 to 9. *The American Journal of Photography* stopped publication in 1867 when it was combined with *Humphrey's Journal* (so announced in

Humphrey's Journal, v. 19, p. 235 (1867-8)). The earliest competitor that the first two journals had was the French photographic journal *La Lumière.* The only copy of v. 1, No. 1 of *La Lumière* I have examined was dated Feb. 9, 1851. Both No. 1 and No. 2 of this file were also marked "2e," which would suggest that they were the second edition of each. Just why there should be two editions of a magazine is a mystery. Possibly the first edition of No. 1 was not intended to be periodical in form. In v. 1, p. 138, of *La Lumière* will be found mention of both the *Daguerreian Journal* and the *Photographic Art Journal,* with the date of the first issue given, and no attempt is made to claim priority of publication of *La Lumière* over either. The title page of v. 1 of *La Lumière* reads "Première Année—1851."

A biographical sketch of Snelling (with portrait) will be found in *The Camera,* v. 47, p. 391, Dec., 1933, by A. J. Olmsted of the United States National Museum. I have been able to find but little concerning Humphrey and Seely. All three were very active in photographic circles from 1849 to 1860.

103. For notice of Hill's daguerreotypes in color see *The Daguerreian Journal,* v. 1, pp. 209, 217; v. 2, pp. 17, 21, 28, 113, 145, 305, 340 (1850-51); *Photographic Art Journal,* v. 1, pp. 62, 116, 124, 187, 191, 255, 333, 340, 377-379 (1851). The quotations attributed to Morse will be found in *The Daguerreian Journal,* v. 2, p. 21 (1851) and the *National Intelligencer* (Washington), June 14, 1851, where a lengthy letter from Morse describing his visit to Hill is given. The reference to Hill's appearance before the Senate committee is given in the New York *Daily Tribune,* April 29-

30, 1853. Hill actually made an attempt in 1855 to revive the interest of daguerreotypists in his color process. A storm of protests in the form of letters to the photographic journals followed—one such letter referring to Hill as the "Prince of Humbugs"—so there is little doubt as to what his contemporaries thought about him. *Humphrey's Journal,* v. 8, p. 321 (1855), and *Photographic Art Journal,* v. 8, p. 32 (1855). The man may have had a process, or he may have *thought* he had one, i.e., deluded himself. Root, writing several years later, says, "His [Hill's] endeavors succeeded but partially, if at all, and—there appears to have been deception in the matter." *The Camera and The Pencil,* p. 376; Root, p. 316, also says that he examined one of Hill's alleged colored daguerreotypes and he was certain that it was colored by hand. Hill died in 1865. *Humphrey's Journal,* v. 16, p. 315 (1864-65).

104. This estimate, I believe, is conservative. It is based upon the production of 3,000,000 annually, the estimate of the New York *Tribune.* (Reference 75.) If this number were produced yearly in 1849, 1850, 1852, and 1853, the big years of daguerreotype production, the total would be 12,000,000. In 1851, as a result of the Hill fiasco, and in 1854, as a result of paper photography, the annual production was probably less; but in both these years production of daguerreotypes must have been large— say 3,000,000 for both years combined. In addition there would have to be added the production for the years 1840-1849 and 1855-1860, which in total would make not an inconsiderable number.

105. *The Evolution of Photography,* p. 42. An obituary of White-

hurst appears in *Philadelphia Photographer*, v. 12, p. 300 (1875).

106. See Sachse's account of the Langenheims, *Journal of the Franklin Institute*, v. 135, p. 271 (1893). For a contemporary mention of the Langenheim daguerreotypes of Niagara see Philadelphia *Public Ledger*, May 7 and June 4, 1846, Mr. F. D. Langenheim, a son of William Langenheim, has kindly loaned me a set of the original daguerreotypes which are reproduced in the text. The mounting plaque is dated in print "July, 1845."

107. The article first appeared in the *London Photographic News* for 1865. Werge reprints it in his book, p. 140.

108. Root, *The Camera and The Pencil*, mentions the daguerreotypes of Cady and of Beckers, p. 369. Cady's daguerreotypes are described in *American Journal of Photography*, n.s., v. 1, p. 11 (1858-59).

109. *Jury Reports of Great Exhibition*, p. 277. See also *Photographic Art Journal*, v. 2, p. 317 (1851), and *American Journal of Photography*, n.s., v. 3, p. 365 (1860-61).

110. The story concerning Hesler and Hiawatha is given in a letter of Hesler's to the *Philadelphia Photographer*, v. 13, p. 67 (1876), and reappears in his obituary given in the Chicago *Tribune*, July 7, 1895. Mrs. A. B. Hesler of Evanston, Ill., a daughter-in-law of Alexander Hesler, informs me that the letter written by Longfellow is not now in existence, probably being destroyed in the Chicago fire of 1871, although she has heard Hesler describe its contents many times. The autographed copy of *Hiawatha* is in Mrs. Hesler's possession, however. Not knowing the original wording of the Longfellow letter, it is difficult to decide how much the Hesler daguerreotype was responsible for Longfellow's original conception of the poem. In *Henry W. Longfellow*, written by Samuel Longfellow, Houghton Mifflin Company, Boston, 1886, there is included the daily journal kept by Longfellow. Under date of June 22, 1854, Longfellow writes, "I have at length hit upon a plan for a poem on the American Indians, which seems to be the right one and the only. It is to weave together their beautiful traditions into a whole." Six days later he decided to call it *Hiawatha* and started work on it. The record in his journal would indicate that he had contemplated such a poem for some time. Possibly the Hesler daguerreotype with the beautiful cadence "Minnehaha" crystallized Longfellow's ideas. Hesler's trip to the upper Mississippi is mentioned in the *Photographic Art Journal*, v. 2, p. 50 (1851), where it is stated, "Mr. Hesler writes that he has been taking views of the upper Mississippi, Fort Snelling, the Falls of St. Anthony, etc."

The reference to Charles Sumner is plausible, as he was one of Longfellow's most intimate friends.

111. For a table of exposures see *Photographic Art Journal*, v. 1, p. 164 (1851). See also *The Daguerreian Journal*, v. 2, p. 369 (1851). Extensive examination of these two journals will show many others. The *Photographic Art Journal*, v. 5, p. 302 (1853) states that successful daguerreotypes could be obtained in $1/10$ second. Southworth and Hawes (Boston) advertised, "Our arrangements are such, that we take miniatures of children and adults *instantly*." See reprint of this advertisement in Boston *Evening Transcript*, Nov. 7, 1934.

112. "The Lost Art of the Daguerreotype," Abraham Bogardus,

The Century Magazine, n.s., v. 46, p. 83 (1904).

113. *Photography,* Edward Weston, Esto Publishing Co., Pasadena, Cal., 1934. No. IIc of a series "Enjoy Your Museum." I am indebted to Mr. Carl Thurston, editor, Esto Publishing Co., for permission to quote from the copyrighted booklet, *Photography.*

114. The early history of Talbot's experiments is based upon the introduction to *The Pencil of Nature,* a collection of Talbotypes published in 1844 (London).

115. Talbot's two early papers will be found in *Proceedings of the Royal Society,* v. 4, pp. 121 and 124 (1837-43), and *Philosophical Magazine,* series 3, v. 14, pp. 196 and 209 (1839).

115a. A fourth pioneer should at least be mentioned, Hippolyte Bayard, a countryman of Daguerre's. Bayard, however, seems to have obtained his incentive and ideas from the work of Daguerre and of Talbot. It has never been clearly determined by what process Bayard secured his original prints, for they are said to have been positive prints made in the camera. Bayard first exhibited his prints in the summer of 1839 before Daguerre's process was announced, but after Talbot's publication. In the first account of his process (Oct. 24, 1839) Bayard distinctly states that his paper was soaked in common salt solution and then dried and washed with silver nitrate. Thus far he was following Talbot. Bayard then fumed his paper with iodine vapor, exposed the paper in the camera and developed with mercury vapor (as in Daguerre's process). Bayard fixed his prints in sodium thiosulfate (following Herschel). In Bayard's second published description (Feb. 24, 1840) he specifically states that his paper

was prepared according to Talbot's method. Bayard also described his process a third time (1860), the third description not agreeing with either of the first two.

The fact remains, however, that there are prints of Bayard's still extant. How they were made is uncertain. They are valuable in that they form interesting early photographic records of Paris. Bayard's contribution and influence on the subsequent development of photography—rightly or not—was negligible. His claims, as an early pioneer in photography, have been ardently advanced by Georges Potonniée, *History of the Discovery of Photography,* New York, 1936, Chapter 15. Potonniée does not appear to have read, or at least considered, the published papers of Talbot and of Herschel cited in references 115 and 116.

116. Herschel's original papers will be found in *Proceedings of the Royal Society,* v. 4, p. 131 (1837-43), and *Philosophical Magazine,* series 3, v. 16, p. 331 (1840). Herschel had used the term "photography" or its equivalent several weeks prior to this in a letter to Talbot. As the letter is not well known I have reproduced the relevant portion of it through the courtesy of Miss M. T. Talbot, a granddaughter of Fox Talbot, and Mr. Alexander Barclay of the Science Museum of London. The letter is from Herschel to Talbot, and also mentions Herschel's use of the now familiar hypo:

Slough, February 28, 1839.

"My dear Sir,

"You are quite welcome to make such mention as you may think proper to M. Biot of my process for washing out by the Hyposulfite of Soda and perhaps it may be as well to send him a few specimens for

which purpose I annex a few—with remarks. No. 1 is a specimen *washed out with pure water*. It appears to be very effectually preserved—though in other respects a very bad specimen. No. 2 is the same subject more successfully photographed *—washed with Hyposul Soda Feb. 19. Afterwards I mixed the two washes—they answered tolerably well but I have not yet been able to use the muriate alone with success.

* "Your word photogenic recalls () exploded theories of thermogen and photogen. It also lends itself to no inflexions and is out of analogy with Litho and (Chalcography)."

The words in parenthesis are difficult to decipher from Herschel's original handwriting and I have supplied the terms which appear to me to be proper. *Chalcography* is the art of engraving on copper or brass. The term also may have been *chirography*, the art of handwriting.

The term "photography" appears to have been used first in print by a correspondent of the German publication, *Vossische Zeitung*, Feb. 25, 1839. The discovery of this fact was made by Buchner, *Zweihundert Jahre Kultur im Spiegel der Vossischen Zeitung*, No. 27, p. 106 (1932).

117. For Talbot's paper of 1841 see *Proceedings of the Royal Society*, v. 4, p. 312 (1837-41). For Reade's claim, see *Photographic Art Journal*, v. 7, p. 268 (1854), where notes on a suit against Talbot are reprinted; *also* Werge, *Evolution of Photography*, pp. 14-26.

118. U. S. Letters Patent No. 5,171; see also *Photographic Art Journal*, v. 1, p. 300 (1851).

119. *Journal of the Franklin Institute*, v. 27, p. 264 (1839).

120. *American Journal of Photography*, n.s., v. 1, p. 2 (1858).

121. *The Camera and The Pencil*, M. A. Root, p. 356. Mention of calotypes made by several New York professionals will be found in *Humphrey's Journal*, v. 1, p. 244 (1851).

122. *Proceedings of the American Philosophical Society*, v. 1, p. 171 (1840). A biographical sketch of Carey Lea appears in *Dictionary of American Biography*, Charles Scribner's Sons, N. Y., 1933, v. 11, p. 71.

123. *American Journal of Science and Arts*, v. 43, p. 73 (1842). Hunt's remarks will be found in his book, *Researches on Light*, p. 66, London, 1844. A biographical sketch of Channing will be found in *Dictionary of American Biography*, v. 4, p. 8 (1930).

124. *McClure's Magazine*, v. 8, p. 10 (1896).

125. I am indebted to the library of Harvard College for this information. The negatives are among the records of Harvard library. A biographical sketch of Cooke will be found in *Dictionary of American Biography*, v. 4, p. 387 (1930).

126. *Living Age*, v. 2, p. 337 (1844), reprinted from the English journal, *The Spectator*.

127. *Philosophical Magazine*, series 3, v. 16, p. 239 (1840).

128. *American Journal of Photography*, n.s., v. 3, p. 121 (1860-61).

129. United States Letters Patent No. 7,458, June 25, 1850. See also Whipple's review of his work in *Photographic Art Journal*, v. 6, p. 148 (1853). Niepce de Saint Victor's process was first published in *Comptes Rendus*, v. 26, p. 637 (1848).

130. Hyalotypes are described and credited to the Langenheims by S. D. Humphrey, *A System of Photography*, p. 91, Albany, 1849; Root, *The*

Camera and The Pencil, p. 371; *Daguerreian Journal,* v. 1, p. 328 (1851); v. 2, p. 180 (1851). The patent issued to Frederick Langenheim was United States No. 7,784, Nov. 19, 1850. Mention of the Langenheim Talbotypes will be found in the *Scientific American,* v. 4, p. 260 (1848) and in *London Art Journal,* April, 1851, p. 106.

131. *Humphrey's Journal,* v. 4, p. 73 (1852). Mention of the Langenheim Talbotypes and hyalotypes at the Great Exhibition will be found in the *Official Report of the Jury,* p. 277. The photographic record of the Great Exhibition is mentioned in the *London Illustrated News,* v. 2, p. 136 (1852).

132. *The Chemist* (London), March, 1851.

133. Towler, *The Silver Sunbeam,* 3d ed., N. Y., 1864, chapters 14 and 17.

134. The manual was by Alphonse de Brebisson and was translated from the French, *Photographic Art Journal,* v. 4, p. 116 (1852).

135. *Photographic Art Journal,* v. 4, p. 381 (1852).

136. *Humphrey's Journal,* v. 4, p. 256 (1852-53).

137. *Photographic Art Journal,* v. 7, p. 64 (1854).

138. *Photographic Art Journal,* v. 5, p. 254 (1853).

139. For comment on Whipple's position and the subsequent growth of paper photography see *Humphrey's Journal,* v. 5, p. 73 (1853-54); *Photographic Art Journal,* v. 7, pp. 127, 170, 256, 351 and 383 (1854); v. 8, pp. 160 and 383 (1855). Root, *The Camera and The Pencil,* p. 371; Werge, *The Evolution of Photography,* p. 52. In addition to the cities listed in the text, paper photography had reached San Francisco by 1856. *Photographic Art Journal,* v. 9, p. 31 (1856). Whipple died in 1891, *American Annual of Photography,* p. 242 (1892).

140. *Photographic Art Journal,* v. 7, p. 96 (1854).

141. *Photographic Art Journal,* v. 7, p. 160 (1854).

142. *Humphrey's Journal,* v. 7, p. 8 (Jan. 15, 1856).

143. United States Patent No. 11,-213, July 4, 1854, which covered the use of camphor in collodion positives; United States Patent No. 11,267, July 11, 1854, which covered the use of balsam to seal two glasses together. No. 11,267 was known as the ambrotype patent. United States Patent No. 11,266, July 11, 1854, covered primarily the use of bromides in collodion, and was the patent which caused grief among photographers for so many years.

144. Directions for mounting and coloring ambrotypes will be found in *The Photograph and Ambrotype Manual,* by N. G. Burgess, N. Y., 1858, 4th ed., chapter 12.

145. *Photographic Art Journal,* v. 7, p. 351 (1854). While Herschel had called attention to the principle upon which the ambrotype was based (see Hunt, *Researches on Light,* London, 1844, p. 54), the method and principle were elaborated in more detail by M. Martin, *Comptes Rendus,* v. 35, p. 29 (1852).

146. *Photographic Art Journal,* v. 8, p. 23 (1855).

147. *Humphrey's Journal,* v. 6, p. 312 (1855).

148. For the early history of the ambrotype see *Photographic Art*

Journal, v. 9, pp. 160, 167, 244, 320 and 356 (1855) and especially v. 8, p. 221 (1855) and v. 9, p. 158 (1856). See also Root, *The Camera and The Pencil,* p. 373. Marcus A. Root was born in Granville, Ohio, Aug. 15, 1808, and died in Philadelphia, April 12, 1888. *McClure's Magazine,* v. 9, p. 945 (1897). Root's *The Camera and The Pencil,* published in 1864, contains the only history of American photography available prior to the present volume. Unfortunately, Root did not document his statements so that it is of little value save for the events contemporary at the time of publication.

149. *American Journal of Photography,* n.s., v. 2, p. 75 (1859).

150. *Photographic Art Journal,* v. 9, p. 352 (1856).

151. *Humphrey's Journal,* 1856. My copy of this item does not give the volume or page number and I do not have an original at present. The letter, however, is dated Jan. 28, 1856, and is from E. B. Gage of St. Johnsbury, Vt.

152. Advertisements of the "factories" are common in the newspapers of the late fifties. For comments on such establishments see *American Journal of Photography,* n.s, v. 2, p. 204 (1859).

153. Reports on the Fair of the American Institute will be found in *Photographic Art Journal,* v. 8, p. 384 (1855); v. 9, pp. 351 and 384 (1856); v. 10, pp. 346 and 383 (1857). These references have been checked against the Official Lists of Premiums of the American Institute for the same years.

154. The photographic literature from 1854 to 1868 abounds with discussion of the bromide patent. It would be useless to tabulate all of these. The general consensus of opinion may be found in a letter by Root, *Photographic Art Journal,* v. 8, p. 356 (1855), at the beginning of this period, and the extensive report given at the close of the period by the *Philadelphia Photographer,* v. 5, pp. 281-314 (1868). I also have in my possession copies of the correspondence during 1865, of E. P. Smyth and Timothy H. Hubbard of Boston, who were the assignees of Cutting's patent at this time. The correspondence indicates that while extensive efforts were made to collect royalties under this patent, considerable difficulty was encountered. The royalty fees show considerable variation, probably being what the agents of Smyth and Hubbard could collect.

155. See Gardner's obituary, *Philadelphia Photographer,* v. 20, p. 92 (1883). Gardner was employed by Brady at the New York gallery until 1858 when he was sent by Brady to take charge of his Washington gallery. In 1863 he opened a gallery under his own name. Gardner's first advertisement of his own gallery appears in the *National Intelligencer,* May 26, 1863. His work during the Civil War period is discussed in a later chapter.

156. I have not been able to find much information on the charges made for the large-sized pictures. They must have been expensive. One operator complains: "Nobody likes them [photographs] plain, because they are not pretty, all cannot afford to have them colored and the consequence is, that very few of them are sold, comparatively, nor will they be sold very fast until they can be furnished in colors for from ten to fifteen dollars for the whole size and other sizes in proportion." *Photo-*

graphic Art Journal, v. 8, p. 271 (1855).

157. Harper's Weekly, Oct. 17, 1857, p. 659.

158. Photographic Art Journal, v. 7, p. 192 (1854); v. 8, pp. 96 and 192 (1855); v. 10, p. 349 (1857).

159. Photographic Art Journal, n.s., v. 1, p. 253 (1855).

160. United States Letters Patent No. 16,700, Feb. 24, 1857. Other enlarging cameras are mentioned by Root, The Camera and The Pencil, p. 378. Woodward's camera is mentioned most frequently in the contemporary photographic literature.

161. Humphrey's Journal, v. 15, p. 67 (1863-64).

162. Such photographs are mentioned in the reports of the Fair of the American Institute (reference 153). See also references 158 and 159.

163. The remarks are those of Snelling, Photographic Art Journal, v. 10, p. 346 (1857). Mention of the high price of the life-size portraits will be found in American Journal of Photography, n.s., v. 1, p. 223 (1858-59).

164. American Journal of Photography, n.s., v. 1, p. 112 (1858-59).

165. The Atlantic Monthly, v. 1, p. 404 (1858).

166. The History of American Painting, Samuel Isham, The Macmillan Company, N. Y., 1915, chapter fifteen.

167. Representative American Plays, A. H. Quinn, The Century Company, N. Y., 1919, p. 429.

168. The articles appear in The Atlantic Monthly, v. 3, p. 738 (1859); v. 8, p. 13 (1861); v. 12, p. 1 (1863).

169. Humphrey's Journal, v. 13, p. 261 (1861-62). The quotation from Holmes will be found in his first article (reference 168).

170. The instantaneous pictures employed ordinary collodion and ordinary development, but required the best illumination possible. The negatives were frequently strengthened, in modern terms, intensified, by mercuric chloride. American Journal of Photography, n.s., v. 2, p. 208 (1859-60); and The Photograph and Ambrotype Manual, N. G. Burgess, N. Y., 1858, 4th ed., p. 210. See also Humphrey's Journal, v. 14, p. 202 (1862-63).

171. American Journal of Photography, n.s., v. 1, p. 148 (1858-59). The quotation is from Lake Price, an English authority on photography.

172. Covered Wagon Days was written by A. J. Dickson. The pioneers were Mr. Dickson's parents who immigrated to the beautiful Gallatin Valley in the summer of 1864.

173. I am indebted to M. Cromer, French authority on the history of photography, for the account of the origin of the carte de visite photograph.

174. The reference was found in Humphrey's Journal, v. 11, (1859-60), where a correspondent from Atlanta, Georgia, writes under date of Nov. 7, 1859, "Your correspondent exhibited a pack of Photographic Visiting Cards." It may be that these cards referred to were the true cartes de visite, which, according to Seely (American Journal of Photography, n.s., v. 4, p. 456), writing in 1862— "were introduced in this city about six years ago." Seely describes the "true" carte de visite as the size of a postage stamp and actually mounted on a calling card. Judging from the

fact that the photograph commonly called the card style was becoming popular in London and Paris in 1859, I am inclined to think that the Georgia correspondent is referring to the more familiar form.

175. Rockwood's statement will be found in the Troy (N. Y.) *Daily Times,* May 10, 1890, 4th ed.; see also statement by Rockwood in New York *Times,* April 13, Part II, p. 5 (1902). In these later accounts of Rockwood, the date of introduction of the card photograph is incorrectly given. However in *Anthony's Bulletin,* v. 12, p. 159 (1880), Rockwood specifically states that card photographs were introduced in this country in 1859. The statements in Werge, *The Evolution of Photography,* pp. 74 and 200, would tend to corroborate Rockwood's claim. The last statement of Werge (p. 200) was written in 1865. Root's *The Camera and The Pencil,* p. 381, credits C. D. Fredricks with introducing the card photograph.

176. *American Journal of Photography,* n.s., v. 3, p. 272 (1860-61), Feb., 1861.

177. United States Letters Patent No. 32,287 (Grumel's) and No. 32,404 (Anthony and Phoebus). C. D. Fredricks advertised in *Leslie's Illustrated Newspaper,* May 10, 1862, that they had acquired rights to Grumel's patent; see also *Humphrey's Journal,* v. 15, p. 62 (1863-64). The Anthonys stated in 1870 that they were the first to introduce albums in the United States (*Anthony's Bulletin,* v. 1, p. 6 (1870)). It may well be so, as they were certainly the largest and most progressive photographic supply house in the country at the time.

178. The *American Journal of Photography,* Jan. 1, 1863 (n.s., v. 5, p. 312) says, "The most noticeable thing in connection with the holy days this year is the great display of photograph albums. Not only in photographic establishments and book stores, but also in news stores, in fancy stores, and in all permissible places are seen large numbers of these most beautiful and acceptable presents. It is a sign and proof of the best feature in our civilization." For an amusing contemporary sketch of the popularity of cards and albums at this time, see "My First Carte-de-Visite," in the *American Journal of Photography,* v. 5, p. 337 (1862-63).

179. *Humphrey's Journal,* v. 15, pp. 12 and 32 (1862-63).

180. For information on exposures during the card period, see Holmes' *Atlantic Monthly,* v. 12, p. 1 (1863); *Humphrey's Journal,* v. 15, p. 283 (1863-64); v. 19, p. 108 (1867-68); Towler in his *Silver Sunbeam* says, "The time of exposure will be from ten to twenty seconds in the glass room, probably more" (3d ed., p. 144); Waldack and Neff, *Treatise on Collodion,* Cincinnati, 1857, p. 61, state a general rule which I have frequently found quoted—"The exposure to light of a negative is never less than twice the time required to make a positive (i.e., an ambrotype)." Exposures for ambrotypes I have found recorded as being from three to twenty seconds in the professional gallery.

For information on the 4 tube camera and manipulation of the negative, see A. S. Southworth, "United States Letters Patent No. 12,700," April 10, 1855; Simon Wing, "United States Letters Patent No. 30,850," Dec. 4, 1860; *American Journal of Photography,* n.s., v. 4, p. 85 (1861-62); v. 5, pp. 423 and 528 (1863-64).

181. For information bearing on the introduction of albumen paper,

see *Humphrey's Journal,* v. 13, p. 304 (1861-62); *American Journal of Photography,* n.s., v. 4, p. 191 (1861-62); *Humphrey's Journal,* v. 15, p. 96 (1863-64); Werge, *The Evolution of Photography,* p. 203, says, "Up to 1860 the American photographic prints were all on plain paper—the introduction of the carte-de-visite forced the operators to make use of albumenized paper."

For information on printing and toning, see the article by Holmes, reference 180, and Towler, *The Silver Sunbeam,* 3d edition, chapters 31 and 32.

182. The origin of the term "card" in this sense is a guess. I have never seen it used in this meaning until fairly modern times. If anyone finds that it was used prior to the eighteen sixties my explanation will have to be ruled out. J. R. Bartlett in *Dictionary of Americanisms,* Boston, 4th ed., 1877, does not list the term card; nor does R. H. Thornton, in *An American Glossary,* London, 1912, in this sense, although in v. 1, p. 147, of this work are listed a number of illustrations of "card" in the sense of an advertisement. E. Weekly, *An Etymological Dictionary of Modern English,* N. Y., 1921, p. 252, states, "As applied to a person, *queer card, knowing card,* it may be an extension of the metaphor *good card, sure card,* etc., or it may be an anglicised form of Sc. *caird,* tinker."

183. For comment on backgrounds, see *American Journal of Photography,* v. 5, p. 48 (1862-63); *Humphrey's Journal,* v. 13, p. 241 (1861-62); *Philadelphia Photographer,* v. 8, p. 54 (1871). Reference to Claudet's use of backgrounds will be found in the official report of the jury for the Great Exhibition of 1851, p. 276. A history of these backgrounds in American photography is given by Paul Brown,

Philadelphia Photographer, v. 16, p. 219 (1879). According to Brown, the painted background was introduced into this country by Henry Ulke, a German, in 1857. The commercial production of backgrounds was started by a Mr. Ashe for the Anthonys.

184. *Humphrey's Journal,* v. 13, p. 292 (1861-62).

185. *Humphrey's Journal,* v. 14, p. 94 (1862-63).

186. Among the first of the celebrities to be placed on sale in card form was Major Anderson of Fort Sumpter. It was announced in big type, "Major Anderson Taken," but he was taken by G. S. Cook, the Charleston photographer. The Anthonys bought these negatives from Cook, and, during March, 1861, were making a thousand prints a day. *Humphrey's Journal,* v. 12, March 1, 1861, p. 9. See also the same *Journal,* v. 14, p. 26 (1862-63); v. 16, p. 93 (1864-65). An Englishman advertised in *Humphrey's Journal,* March 1, 1861, for negatives of "A. Lincoln, President Buchanan, and other celebrities," which shows that the demand was not limited to this country alone.

187. Heenan's remark will be found in *American Journal of Photography,* n.s., v. 4, p. 481 (1861-62), where it is reprinted from *Once a Week,* an English journal. For an account of the Heenan-Sayers fight see *My Confidences,* Fred. Locker-Thompson, London, 1896, p. 255, and *Harper's Weekly* of 1860.

188. Copies of engravings and other works of art, and those photographs so small that stamps could not be affixed, were exempt from the tax. For photographs having a retail price of 25 cents or less, a two cent stamp was required; those selling

from 25 to 50 cents were taxed 3 cents, and those from 50 cents to $1.00 required a 5 cent stamp. If the finished photograph sold for more than a dollar, 5 cents was added for every additional dollar or fraction. See *Humphrey's Journal*, v. 16, p. 137 (1864-65), and *Philadelphia Photographer*, v. 1, p. 144 (1864); v. 3, pp. 217 and 256 (1866).

189. *Humphrey's Journal*, v. 7, Nov. 15, 1855.

190. United States Letters Patent No. 14,300, Feb. 19, 1856. It was assigned to Wm. Neff and Peter Neff, Jr., of Cincinnati, Ohio.

191. Biographical information concerning Smith has been furnished me by Mrs. Julia Smith Slosson, East Aurora, N. Y.; Dr. Howard Jones, Circleville, Ohio, and Mrs. Harry Hart, Melville, Montana, to all of whom I am indebted for their aid. A brief sketch of Smith's life appears in the *National Cyclopedia of American Biography*, v. 12, p. 466, but no mention is made of his photographic labors. The daguerreotype experiments of "Mr. H. L. Smith of Cleveland, Ohio" are mentioned as early as 1840. (*American Journal of Science and Arts*, v. 40, p. 139 (1841).)

Sketches of Neff's life appear in *National Cyclopedia of American Biography*, v. 13, p. 253, and in *Bulletin of the Geological Society America*, v. 15, p. 541 (1904).

192. *Humphrey's Journal*, v. 8, p. 99 (1856-57). See also reference 193.

193. *Photographic Art Journal*, v. 9, p. 192 (1856).

194. *Photographic Art Journal*, v. 9, p. 384 (1856).

195. *Humphrey's Journal.* v. 8, p. 99 (1856-57).

196. I am indebted to Elza P. Griswold of Peekskill, N. Y., a son of V. M. Griswold, for information concerning his father. See also *The Photographic Times*, Aug., 1872, and *The Ferrotype and How to Make It*, by E. M. Estabrooke, Cincinnati, 1872, chapter 6.

197. *American Journal of Photography*, n.s., v. 2, p. 128 (1859-60).

198. United States Letters Patent No. 29,652, Aug. 14, 1860. Assigned to Waterbury Button Co., Waterbury, Conn., of which town Maltby was also a resident.

199. V. 12, p. 10, Sept. 1, 1860.

200. *Humphrey's Journal*, v. 12, p. 9, Dec. 1, 1860.

201. The volumes of *Humphrey's Journal* for 1859 and 1860 and of the *American Journal of Photography* for the same period, make frequent comment on "The War of the Roses"; both of these journals favored Neff.

202. The first quotation is from *Humphrey's Journal*, v. 13, p. 319 (1861-62). See also v. 13, pp. 208, 240 and 272; v. 14, p. 128 (1862-63) of this same journal; and *American Journal of Photography*, n.s., v. 3, p. 80 (1860-61). The quotation from the New York *Tribune* appeared Aug. 20, 1862.

203. *Humphrey's Journal*, May, 1862, says, "We see they are using the melainotype for cartes-de-visite, to be inserted in albums"; v. 14, p. 48 (1862-63). It would appear that tintypes were slow in being used for this purpose as they were made some four or five years earlier than the paper *cartes de visite*. Reference to small tintypes will be found in *Humphrey's Journal*, v. 14, p. 32 (1862-63).

204. See Estabrooke, reference 196, for a complete history of the tintype from 1860 to 1872.

205. *Humphrey's Journal*, v. 12, July 1, 1860. Patents for photographs on tombstones were issued as follows:

No. 7,974 Solon Jenkins, Jr., West Cambridge, Mass., Mar. 11, 1851 (for daguerreotypes).

No. 22,850 J. Bergstresser, Berrysburg, Pa., Feb. 8, 1859.

No. 26,370 H. S. Jones & A. S. Drake, S t o u g h t o n, Mass., Dec. 6, 1859.

The November, 1934, *Bulletin of the Holman Print Shop* (Boston), comments on some daguerreotypes inserted in tombstones at Arlington, Maine.

The last sentence in the paragraph in the text is not directly a quotation, but the sense is borrowed from O. W. Holmes, *Atlantic Monthly*, v. 8, p. 14 (1861). Holmes says, "How these shadows last and how the originals fade away."

206. United States Letters Patent No. 100,291.

207. The information included in these paragraphs comes very largely from Estabrooke (reference 196) chapter 6 and p. 40 *et seq.*

208. *Philadelphia Photographer*, v. 10, p. 24 (1873). Similar comment is found earlier. *American Journal of Photography*, n.s., v. 5, p. 216 (1862-63), states, "The melainotype is one of our peculiarly American institutions." See also v. 5, p. 231, of this same journal.

209. The first edition of *The Silver Sunbeam* was announced in *Humphrey's Journal*, v. 15, p. 255 (1863-64). The second and third edition followed within six months. The quo-

tation which I have given is from my own copy of the third edition, which is dated June 1, 1864. For other information concerning Dr. Towler, I am indebted to Mrs. Harry Hart, Melville, Montana, and to Mrs. Julia Smith Slosson of East Aurora, New York. Mrs. Hart and Mrs. Slosson are granddaughters, not only of Dr. Towler but of Hamilton L. Smith, the inventor of the tintype.

210. Holmes realized that he was introducing a new word, for he says, ". . . or stereographs, if we may coin a name." *Atlantic Monthly*, v. 3, p. 743 (1859). The quotation in the text from Holmes is found also in the *Atlantic*, v. 8, p. 18.

The quotation of Vogel's which heads Chapter X will be found in the *Philadelphia Photographer*, v. 20, p. 282 (1883).

211. An extensive history of the stereoscope and the principle of binocular vision were published some years ago by C. F. Himes, *Journal of the Franklin Institute*, v. 92, pp. 263, 340 and 413 (1871); v. 93, pp. 141, 351 and 407 (1872); v. 94, p. 49 (1872). See also bibliography in *Stereoscopic Photography*, Arthur W. Judge, London, 1935.

212. *Photographic Art Journal*, v. 7, p. 320 (1854); Sachse, *Journal of the Franklin Institute*, v. 135, p. 271 (1893). See also obituaries of William Langenheim, *Philadelphia Photographer*, v. 11, p. 185 (1874) and of Frederick Langenheim, *Philadelphia Photographer*, v. 16, p. 95 (1879); and reference 130. The *London Art Journal*, April, 1851, was the first to credit the Langenheims with the use of photographic pictures in the magic lantern. Frederick Langenheim some years later corroborated this account in *Anthony's Bulletin*, v. 5, p. 194 (1874).

213. The paragraph from the Chicago paper is reprinted in *Photographic Art Journal,* v. 7, p. 347 (1854).

214. United States Patent No. 9,611; a report on Mascher's patent is given in *Journal of the Franklin Institute,* v. 59, p. 214 (1855). Mascher stated that his first stereoscopic daguerreotypes were made June 10, 1852. See also *Photographic Art Journal,* v. 4, p. 254 (1852). *American Journal of Photography,* n.s., v. 1, p. 58 (1858-59).

215. United States Patent No. 13,106, June 19, 1855. The stereoscope is described by Werge, *Evolution of Photography,* p. 52, and in the *Philadelphia Photographer,* v. 8, p. 315 (1871).

216. *American Journal of Photography,* n.s., v. 1, p. 82 (1858-59); *Humphrey's Journal,* v. 11 (1859-60). The letter of the Georgia correspondent is dated Nov. 7, 1859, and reference is made to the photographic exhibit at the Fair of the South Central Agricultural Society at Atlanta during October of 1859. The growing interest in the stereograph during 1858-59 is also revealed in the Patent Office records. Previous to 1859 there had been a few patents issued for stereoscopic cases or methods of exhibiting stereoscopic views (for example, in 1858 there were none), but in 1859 there were some nine patents issued covering these devices. Of these nine, three were issued to Alexander Beckers of New York. An illustration of one of Beckers' stereoscopes can be seen on page 172.

217. For the part of Holmes in the modification of the stereoscope, see not only the *Atlantic Monthly* essay but also the *Philadelphia Photographer,* v. 6, p. 1 (1869), which contains a short letter from Holmes. This account was reprinted as a separate pamphlet, *History of the American Stereoscope, 1869.* Ives, *A Bibliography of Oliver Wendell Holmes,* Boston and New York, 1907, p. 182, states that the device was patented Aug. 13, 1867, but the patent office records show no issue to either Holmes or Bates, and Holmes specifically states that no patent was ever applied for. The confusion on this point arises from the fact that Bates registered a trademark with the patent office for his wares on Aug. 13, 1867.

In quite recent years, the American Antiquarian Society of Worcester, Mass., has undertaken the very laudable project of following up Holmes's suggestion and has established a stereoscopic library. Their library includes, at the present writing, some twenty thousand stereographs and forms a valuable graphic history of the United States in the period 1860-1890.

218. *Scientific American,* n.s., v. 15, p. 351 (1866); Ferrier's process (albumen) for making glass stereographs is described in *American Journal of Photography,* n.s., v. 4, p. 30 (1861-62).

219. *Philadelphia Photographer,* v. 4, p. 195 (1867). This item also mentions that "the Anthonys have long taken the lead in publishing stereographs. Their variety is endless and overwhelming." The large volume of business in stereographs done by the Anthonys can also be traced in their trade publication, *Anthony's Bulletin of Photography,* the first issue of which appeared in Feb., 1870. While primarily issued in the interests of the Anthonys it contained much useful advice and information for the photographer and has been a valuable source of material for my studies. *Anthony's Bulletin* was published as such from 1870 to 1902 (vv. 1 to 33).

It was then incorporated with *Photographic Times,* which later was merged with *American Photography,* one of the leading photographic journals of the country at present. The reader will note that the woodcut of the Anthony building on Broadway reproduced on page 182, bears the legend "American and Foreign Stereoscopic Emporium." This was published in 1859 or possibly earlier.

Additional comments bearing on the history of the stereographic trade are frequently encountered. For instance, *American Journal of Photography,* n.s., v. 4, p. 240 (1861-62), remarks, "The series of fashions we had in the art are steps of progress—the daguerreotype, ambrotype, 4-4 photograph, stereoscope, and at last the card photograph." Again the *Philadelphia Photographer,* v. 5, p. 164 (1868), says, "There was a time when stereoscopic pictures were the rage—cartes and albums superseded them."

There is hardly an issue of the *Philadelphia Photographer* from its beginning in 1864 and on, which does not mention the receipt of one or more of a series of American stereoscopic views sent in by various photographers over the entire country. Such mention is frequently of value in tracing the date of the prints which is seldom recorded on the prints or their mounts themselves.

220. King's account of the balloon trip will be found in the *American Journal of Photography,* n.s., v. 3, p. 188 (1860-61). See also Boston *Herald,* Oct. 15, 1860. Holmes's comment is in the *Atlantic Monthly,* v. 12, p. 12 (1863). A detailed history of aerial photography will be found in *Photo-Miniature,* v. 5, p. 145 (1903), where Black's photograph of Boston is for the first time reproduced.

221. *American Journal of Photography,* n.s., v. 3 p. 31 (1860-61).

222. *Humphrey's Journal,* v. 12, p. 9 (?) (1860-61), and the "Townsend Interview," New York *World,* April 12, 1891. See also *American Journal of Photography,* n.s., v. 3, p. 175 (1860-61).

223. *Leslie's,* v. 11, p. 106 (1861). Not only is a description of the Brady gallery given here, but so also is an account of the Prince of Wales' visit to the establishment on Oct. 13, 1860. The account states that in addition to imperial photographs, a number of *cartes de visite* were made—which shows that the popularity of this type of photograph was rapidly increasing.

224. See the "Townsend Interview," New York *World,* April 12, 1891; *Six Months in the White House,* F. B. Carpenter, New York, 1866, p. 46; *Everyday Life of A. Lincoln,* F. F. Browne, Chicago, 1914, p. 215. In *The Life of Lincoln,* Ida M. Tarbell, N. Y., 1924, v. 2, opp. p. 158, it states, "It was a frequent remark with Lincoln that this portrait and the Cooper Institute speech made him President."

225. For extensive information on photographic portraits of Lincoln, see *Portrait Life of Lincoln,* F. T. Miller, Springfield, Mass., 1910; *The Photographs of Abraham Lincoln,* F. H. Meserve. Privately printed, New York, 1911; and *Lincoln Lore* (Fort Wayne, Ind.), Nos. 110, 114, 116, 119, 121, 123, 125, 127, 128, 130, 133, 139, 211 and 245 (1931-33).

226. *Humphrey's Journal,* v. 17, pp. 16 and 29 (1865-6).

227. *The Evolution of Photography,* p. 72. See also *Humphrey's Journal,* v. 15, p. 62 (1863-64).

228. *American Journal of Photography,* n.s., v. 5, p. 552 (1862-63).

229. *American Journal of Photography*, n.s., v. 5, p. 255-257 (1861-62), reprints from the *Photographic News* (London) an article "Photography in America" which is of considerable interest. See also the same journal, v. 5, pp. 145, 167, 181, 198 and 238 (1862-63), for quotation given in text.

230. *Leslie's Illustrated Newspaper,* April 5, 1862, p. 334.

231. A biographical review and estimate of Rutherford's scientific work by B. A. Gould will be found in the *National Academy of Sciences, Biographical Memoirs,* v. 3, p. 417 (1895). It is Gould who calls him "the father of celestial photography" (p. 439 of above memoir). Rutherford was an active member of the Photographical Society of New York and was its vice-president for several years. His comments at meetings of this society which appeared in the *American Journal of Photography,* n.s., vv. 3-5 (1860-63). Rutherford states that he first began his photographic work in 1857, *American Journal of Photography,* n.s., v. 4, p. 381 (1861-62). His photograph appearing in the text, appeared in the issue of May 15, 1862.

232. For Draper's own account of these moon photographs, see Smithsonian *Contribution to Knowledge,* v. 14, Washington, 1865, article 4. See also *Harper's Weekly,* v. 8, pp. 184-6, and p. 307 (1864). An extensive review of Draper's life and scientific work will be found in the *National Academy of Sciences, Biographical Memoirs,* v. 3, p. 81 (1895). It was written by George F. Barker who also prepared the memoir of the elder Draper.

233. *American Journal of Photography,* n.s., v. 2, p. 266 (1859-60), and same journal, n.s., v. 4, p. 67 (1861-62); *Scientific American,* n.s., v. 2, p. 73 (1860).

234. The use of magnesium as a source of light for photographic purposes was of German origin. *American Journal of Photography,* n.s., v. 1, p. 12 (1858-9); n.s., v. 3, p. 148 (1860-61). For mention of Towler's efforts see *Humphrey's Journal,* v. 17, p. 260 (1865-66). For a history of flashlight photography see *Photo-Miniature,* v. 3, p. 191 (1901).

235. *American Journal of Photography,* n.s., v. 4, p. 496 (1861-62).

235a. The *Philadelphia Photographer* was published under this title from 1864 to 1888 (vv. 1-25). Beginning in 1889 it appeared as *Wilson's Photographic Magazine,* under which title it continued until 1914 (vv. 26-51). In 1914 it was merged with *Camera,* one of the leading photographic journals of today. The history of the remaining early American journals is given in notes 102 and 219.

236. *Scientific American,* n.s., v. 10, p. 167 (1864). The same journal, n.s., v. 2, p. 361 (1860), had previously published an article, "Stereoscopes for Amateurs," which gave directions for making stereographs. The photographic journals of the period (1858-1863) offer numerous substantiations to the rising interest on amateur photography—in fact, too numerous to tabulate. The first of the amateur societies to be organized was the American Photographic Society established in 1858. This, while not solely composed of amateurs among its members, was very largely so. Dr. J. W. Draper was its president for some years and attended regularly, and made annual addresses which are reviews of the work of the year. They will be found in the *American Journal of Photography* for this period.

At one of these meetings a Reverend Dr. Moore was introduced as an "old amateur." Moore stated that in 1851 he believed he was the only amateur photographer in New York City. *American Journal of Photography,* n.s., v. 4, p. 428 (1861-62).

237. See *The Silver Sunbeam* for directions concerning tannin plates; *American Journal of Photography,* n.s., v. 4, pp. 347 and 523 (1861-62).

238. *Philadelphia Photographer,* v. 1, pp. 50, 76 and 89 (1864). The amateurs were Messrs. Borda, Graff and Fassitt. Borda was the author of the account of the trip.

239. *American Journal of Photography,* n.s., v. 4, p. 328 (1861-62); *Anthony's Bulletin,* v. 19, pp. 301, 338, 356 and 403 (1888). The last reference is an account of the club by Coleman Sellers, whose work is described later in the text.

240. *Atlantic Monthly,* v. 12, p. 1 (1863).

241. For the information concerning Sellers, I have drawn on the articles mentioned in the text (those written by Sellers); two biographical sketches in the *Journal of the Franklin Institute,* v. 165, p. 165 (1908) and in *Cassier's Magazine,* v. 24, p. 352 (1903). The last sketch by Dr. Henry Morton is the most extensive. I have also received useful information from his grandson, Coleman Sellers, 3d, and from Mrs. Henry Sellers of Ardmore, Pa., daughter-in-law of Coleman Sellers.

242. United States Letters Patent No. 31, 357, Feb. 5, 1861.

243. *Atlantic Monthly,* v. 8, p. 15 (1861).

244. *American Journal of Photography,* n.s., v. 3, p. 272 (1860-61).

245. Sellers quotes the letter in his memories of the exchange club, *Anthony's Bulletin,* v. 19, pp. 301, 338, 356 and 403 (1888).

246. *The Photographic History of the Civil War,* F. T. Miller, editor, The Review of Reviews Co., New York, 1911, 10 vv. Subsequent reference to these volumes is abbreviated to *P. H. C.*

246a. I am indebted to Mr. H. Armour Smith, director Yonkers Museum of Science and Arts, for supplying me with the descriptive titles of the Mexican War daguerreotypes. Some twelve daguerreotypes, mounted in a homemade walnut case with six pictures on each side, were acquired by Mr. Smith some ten years ago. Ten of the twelve, judging from the handwritten titles—which are apparently contemporary with the daguerreotypes, are views made in and around Saltillo, Mexico. The other two are important views of Fort Marion, St. Augustine. This fact suggests to me that the collection was probably made by an army officer stationed at Fort Marion and then (or before) taking part in the Mexican War. Of the ten views supposedly made in and around Saltillo, only four (with a possible fifth) can be regarded in any sense as war views. The titles of these four read: "Group of Mexicans — Lt. Doubleday"; "Virga. Regt. Calle Real to Sd."; "Genl. Wool and Staff—Calle Real to South"; "Webster's Batty. Minon's Pass Mts.—just N. of Buena Vista to Ed."

As the ten views are all in or very near Saltillo, and as there are no other Mexican views, it seems more reasonable to assume that they were made by a local daguerreotypist than it is to assume that any hardy United States daguerreotypist set out with intent to daguerreotype the Mexican

War. It should be recalled that Saltillo was a city of some thousands population even in 1847 and like most cities of the civilized world it undoubtedly had its daguerreotypists by that year. That these daguerreotypes were virtually unknown is shown by the fact that John Frost in his *Pictorial History of Mexico and the Mexican War* (Richmond, Va., 1848) makes no mention or use of them, although in the preface Frost does mention the use of daguerreotype portraits. If he had been acquainted with the Saltillo daguerreotypes there is little doubt but that he would have mentioned it.

It should also be pointed out that there is some contemporary indirect evidence validating the authenticity of the daguerreotypes and their handwritten titles. For instance, General Wool *was* a soldier of the Mexican War and he was in Saltillo in the fall and winter of 1846 and 1847 (*The War with Mexico*, R. S. Ripley, New York, 1849, v. 1, pp. 339 and 378); Webster's battery (of two twenty-four pound howitzers) *was* north of Buena Vista and on the heights south of Saltillo (Ripley, v. 1, p. 397).

The historic value of these photographs would repay an extended study.

247. So stated in the London *Times*. I have used the reprint of the *Times* article appearing in *American Journal of Photography*, n.s., v. 5, p. 145 (1862). Even before this date (1862) notice of the use of photography in war had appeared in the American press. For instance we read in the abstract of foreign news of the *American Journal of Science*, series 2, v. 19, p. 413 (1855): "A number of photographers are attached to the army in the east and share in the fatigues of the Crimean campaign. Four hundred proofs have already been sent by them to Paris. They present the facts representing the land and sea forces in all their aspects and circumstances with astonishing precision."

248. *Atlantic Monthly,* v. 8, p. 27 (1861).

249. *American Journal of Photography*, n.s., v. 4, pp. 67 and 213 (1861).

250. *American Photography,* v. 29, p. 486 (1935).

251. The "Townsend Interview," New York *World*, April 12, 1891. All other quotations attributed to Brady in the text are from this source.

252. *American Journal of Photography*, n.s., v. 4, p. 120 (1861).

253. *Humphrey's Journal,* v. 13, p. 133 (1861-62).

254. See *P. H. C.*, v. 1, pp. 27 and 30-54; v. 8, pp. 14-16. *Harper's Weekly*, v. 6, p. 663 (1862); v. 7, pp. 534 and 722 (1863); and the "Townsend Interview." Root, *The Camera and The Pencil*, which, it will be recalled, was published in 1864, states that Brady "photographed 'war scenes' or 'incidents of the war,' having eighteen or twenty assistants employed on the work for months" (p. 375).

255. The names of these men have been obtained from Gardner's *Photographic Sketch Book of the Civil War*, Philip and Solomon's *Washington* (1865), to which reference is made in the text, and from several articles in *Anthony's Bulletin*, v. 13, pp. 212 and 311 (1882). On p. 222, *Anthony's Bulletin*, v. 13, the statement is made, "There are very few of them [i.e., the Civil War photographers] left now." Many of the prints in Gardner's *Sketch Book* are found among the

Brady negatives in the Signal Corps at present. For description of Gardner's work see reference 155.

The extent of O'Sullivan's work can be determined by an examination of the Gardner *Sketch Book*. Over half the negatives were made by O'Sullivan. See also *Harper's Monthly*, v. 39, p. 465 (1869), and Chapter XV of this book. Roche's work is mentioned in *Anthony's Bulletin*, reference to which has already been made.

I am indebted to Mr. Arthur A. Stoughton of New York City for calling my attention to Laudy. Mr. Stoughton wrote me that when he was attending Columbia University in the eighties, Laudy was a chemical instructor there and frequently described his experiences as Brady's assistant in the field during the Civil War. A biographical sketch of Laudy, but with no reference to his Civil War experiences, will be found in the *Columbia University Quarterly*, v. 8, p. 42 (1905).

Mr. Leon Conley, Haddonfield, New Jersey, has kindly furnished me information concerning Samuel C. Chester. An obituary of Chester will be found in the Camden (N. J.) *Courier-Post*, April 26, 1937.

256. *P. H. C.*, v. 2, pp. 126-7; v. 3, p. 145; v. 5, pp. 16, 223 and 272; and *Subject Catalog* No. 5 described in reference 262.

257. *Photographic Views of Sherman's Campaign*, George N. Barnard; Wynkoop and Hallenbeck, N. Y., 1866. This is a 30 page pamphlet designed to accompany a set of 61 photographs made in the field from negatives by Barnard. The photographs themselves are extremely scarce at the present time. They were very large (imperial size) and the book containing the prints sold for one hundred dollars. For a review of the book and prints see *Harper's Weekly*, v. 10, p. 771, Dec. 8, 1866.

The only mention of any of the Civil War photographers that I have found in the official records will be found in the *War of the Rebellion*, Series 1, v. 31, part 1, p. 314, where Capt. O. M. Poe reports: "The accompanying photographic views are intended to illustrate still further the locality rendered historical by the siege of Knoxville. They are the work of Mr. Geo. N. Barnard, photographer at the chief engineer's office, Division of the Mississippi."

Coonley, who had apparently an official appointment, is mentioned in *P. H. C.*, v. 1, p. 35.

258. The only sources of information on Southern photographers of the War is curiously enough the *P, H. C.* See v. 1, frontispiece, pp. 24, 25, 99 and 100; v. 3, p. 170; v. 4, p. 130; v. 6, p. 187. Concerning the difficulties Southern photographers had in securing supplies, see *American Journal of Photography*, n.s., v. 4, p. 47 (1861-62).

259. Greely, *McClure's Magazine*, v. 10, p. 18 (1898). I also have examined *Subject Catalog* No. 5 on this point, as well as the catalog of the Ordway-Rand collection mentioned in reference 264.

260. *Atlantic Monthly*, v. 12, p. 11 (1863). For Holmes's personal experience on the battlefield of Antietam in search of his son, see the *Atlantic Monthly*, v. 10, p. 738 (1862).

261. The stories of Roche and Coonley are given in *Anthony's Bulletin* (reference 255); that of O'Sullivan, in *Harper's Monthly* (reference 255).

262. The history of the Brady collection in the possession of the government is given in *Subject Catalog*

No. 5, List of the Photographic Negatives Relating to the War for the Union, A. W. Greely and David Fitzgerald, Government Printing Office, Washington, 1897.

This contains a catalog of the 6001 items of the Brady collection, plus nearly fifteen hundred additional items distributed between some six minor Civil War collections. In addition to the subject, information is given as to the size of the negative, but no information is available concerning the history of the negative; i.e., date made, by whom, etc.

I am indebted to the Chief Signal Officer of the United States Army for directing that an examination of the Brady negatives be made for me. Under date of Jan. 22, 1936, this officer informs me:

"The prints of pictures from the Brady file are made from a set of copy negatives, made several years ago when the file was transferred to the custody of the Signal Corps. Since that time, very few prints have been made from the original negatives, which are kept locked in special steel cabinets in the film vaults. This policy was thought necessary in order to protect the original file from excessive wear and tear due to handling in the printing operations. A survey of the files indicates that approximately 7% are in such condition that a satisfactory print cannot be obtained and that approximately 11% are cracked, chipped, or otherwise slightly damaged, but which are printable."

I have never seen the Brady catalog of 1869. Neither the Library of Congress nor the New York Public Library possesses a copy. The Library of Congress card for it reads: "Brady, Matthew B. *Brady's National Photographic Collection of War Views, and Portraits of Representative Men,* New York and Washington, D. C., New York, C. A. Alvord, 1869 . . ."

263. *Congressional Record,* 43d Congress, 2d Session, v. 3, part 3, p. 2250.

264. For a history of the Ordway-Rand collection, see *P. H. C.,* v. 1, p. 52; *Miscellaneous Documents United States Senate* No. 19, 48th Congress, 2d Session; and *Original Photographs Taken on the Battlefields During the Civil War by M. B. Brady and Alexander Gardner,* Edward B. Eaton, Hartford, Conn., 1907, pp. 7 and 9. The Senate publication contains a catalog (with a classification of size) of some four thousand negatives of the Ordway-Rand collection. It also states that the Brady collection acquired by the Government was made up principally of views which were taken during the first year of the war in the vicinity of Washington, and during the last year of the war in and about Petersburg and Richmond, together with a smaller number of negatives taken in and about Chattanooga and Atlanta. This, of course, refers to the Civil War negatives alone. An examination of the Ordway-Rand collection shows that it embraced the entire war period and included many fields of operation.

Col. Godwin Ordway, Washington, D. C., a son of Gen. Albert Ordway, has an extensive collection of the prints made from the Ordway-Rand negatives. I am indebted to Colonel Ordway for information concerning his father and the important Ordway-Rand collection. These negatives, by the way, have again disappeared. *The Review of Reviews,* publisher of the *P. H. C.,* does not have them (letter from *Review of Reviews,* Dec. 20, 1935) and the Patriot Publishing Co., also interested in the enterprise, is no longer extant.

In addition it would appear that if

all the Brady negatives were made in duplicate, a comparison of the Brady collection (that under the supervision of the Signal Corps) with the Ordway-Rand collection (after deducting the two thousand Gardner negatives) shows that a considerable number of the Brady negatives also remain unaccounted for.

265. Information about these portraits of Lincoln will be found in the sources cited in reference 225.

266. *History of the American Frontier,* F. L. Paxson, Houghton Mifflin Co., Boston and New York, 1924.

267. *The Frontier in American History,* F. J. Turner, H. Holt and Co., New York, 1920. The movement of the frontier mentioned in the text is also based on Professor Turner's book, pp. 6 and 8.

268. For a description of Fitzgibbon's gallery, see *Photographic Art Journal,* v. 7, pp. 104 and 192 (1854); v. 8, p. 32 (1855); v. 9, p. 128 (1856); *Frank Leslie's Illustrated Newspaper,* v. 4, p. 213 (1857). For biographical information concerning Fitzgibbon, see *St. Louis Practical Photographer,* v. 1, pp. 31 and 61 (1877). Fitzgibbon died in 1882; *Philadelphia Photographer,* v. 19, p. 315 (1882).

269. *Oregon Trail Blazers,* Fred Lockley, New York, 1929. Under date of May 1, 1935, Mr. Emil Britt of Jacksonville, Oregon, a son of Peter Britt, writes me that as far as he knew his father made no daguerreotypes on his overland trip. He further informs me that Peter Britt was trained in 1847 by J. H. Fitzgibbon, the St. Louis photographer, whose work is described in the text. Britt's original daguerreotype gallery is now maintained as a private museum.

270. *The Daguerreian Journal,* v. 2, p. 115 (1851).

271. *The Daguerreian Journal,* v. 2, p. 371 (1851). The quotation in the text is from *Photographic Art Journal,* v. 2, p. 252 (1851).

272. The catalog was published in *Photographic Art Journal,* v. 5, pp. 126-9 (1853). The New York Public Library informs me that they have an eight-page catalog published as a separate in 1851. Both the catalog published separately and that found in the *Photographic Art Journal* include but 131 items, although the statement is made that there were 300 daguerreotypes in the collection. An examination of the catalog explains the discrepancy: Groups of related views were placed under one number; thus No. 2 reads, "Views of San Francisco, before and after the May fire, taken from the top of Russia Hill, north of the city." The Sutter daguerreotypes referred to in the text are No. 100 of this collection, "Residence of Capt. Sutter; group in front, of the Captain, his daughter and son-in-law"; No. 126, "East and South view of Sutter's Fort"; and No. 129, "Portrait of Capt. Sutter." Vance evidently either came or went (or both) by way of Panama, as there are several views of this country included.

For about ten years, Vance was San Francisco's leading photographer. He is not listed in the city directories until 1854, and his name from that date until 1864 appears regularly. Apparently he sold his gallery in that year to Bradley and Rulofson. He also had a gallery in Sacramento from 1853 to 1861. Other biographical facts concerning Vance are scarce. The San Francisco *Alta,* July 17, 1876, contains the brief note, "R. H. Vance, formerly a photographer here, died in New York recently." I am indebted to Miss Mabel R. Gillis of the California State Library at Sacramento for the information in this

paragraph. An extensive description of the California galleries in 1857 will be found in the *Photographic Art Journal*, n.s., v. 4, p. 112 (1857); n.s., v. 1, p. 384 (1854).

273. The purchase by Gurney is recorded in *Photographic Art Journal*, v. 3, p. 195 (1852), their purchase by Fitzgibbon in the same journal, v. 6, pp. 53 and 129 (1853). They are described as on display in Fitzgibbon's gallery in *Photographic Art Journal*, n.s., v. 3, p. 384 (1856). The sale of Fitzgibbon's gallery is mentioned in *St. Louis Practical Photographer*, v. 1, p. 31 (1877).

274. Mr. Peterson wrote me at length under date of June 1, 1933, and again on June 22, 1933. I acknowledge with thanks his interest and help.

275. Information concerning J. Wesley Jones can be found in *Amusing and Thrilling Adventures of a California Artist while Daguerreotyping a Continent* by John Ross Dix, for the author, Boston, 1854; New York *Tribune*, Oct. 31, 1853, p. 1 (adv.); Dec. 10, 1853, p. 1 (adv.); and "Jones' Pantoscope of California," *California Historical Society Quarterly*, v. 6, pp. 109 and 238 (1927). The last item is a verbatim transcription of Jones' lecture notes used in the lectures advertised in the *Tribune* and in other eastern cities. Little information about Jones himself is available. It appears from some correspondence published in the California *Quarterly* (see above) that he was, in the early fifties, a resident of Melrose, Massachusetts. Mr. Alvin F. Smith, Historian, Church of Jesus Christ of Latter Day Saints, informs me that a Capt. John W. Jones of the Oquawka (also spelled Aquauka), Illinois, company of emigrants is mentioned in the *Deseret News* (Salt Lake City) under dates of June 27, 1850, and July 1, 1850, p. 34. Jones in his lecture notes mentions meeting Orsan Pratt in the summer of 1851 while Jones and his party were daguerreotyping. Mr. Smith has kindly examined the journals of Pratt available for this period but no mention is made of Jones. The history of Jones and the subsequent fate or existence of his daguerreotypes, if they were actually made, are an interesting problem for further study.

W. H. Jackson, who considered the question "Who First Photographed the Rockies?" (*The Trail*, Denver, Feb., 1926, p. 12), awarded the honor to Carvalho, but he was evidently unfamiliar with the information available on Jones. Stanley also may have preceded both Jones and Carvalho, for he was on the western frontier many years in advance of either. Just when Stanley acquired his daguerreotyping ability is unknown. According to the biographical sketch of Stanley (reference 282) Stanley lived in New York, Philadelphia and other eastern cities in the years 1839-1842, i.e., when daguerreotypy was first introduced. If he became acquainted with the process there, he may have made daguerreotypes on his first trip to the frontier (1843). No mention can be found for its use by Stanley, however, in the catalog of Indian portraits, painted by Stanley, published by the Smithsonian Institution in 1852.

276. The author has made a step in this direction. See "A Photographic History of Early Kansas," *Kansas Historical Quarterly*, v. 3, No. 1, pp. 3-15 (1934).

277. See reference 110; *Photographic Art Journal*, v. 7, p. 384 (1854).

278. Mention is made of Whitney's daguerreotypes of Indians in *Photo-*

graphic Art Journal, v. 7, p. 320 (1854). A number of Upton's views have been reproduced in *Photographic History of the Early Days of St. Paul,* by E. A. Bromley, St. Paul, 1901. For mention of Eaton, see *St. Louis Practical Photographer,* v. 2, p. 21 (1878). W. H. Jackson bought Eaton out in 1868, *Pioneer Photographer,* p. 57.

279. Hillyer gives a review of his career in *Philadelphia Photographer,* v. 13, p. 333 (1876). During the Civil War, Hillyer was appointed the official photographer for the State of Texas, and as such his photographs became well known. He practiced his profession until his death at Bowie, Texas, in January, 1903. He was then sixty-nine years old. I am indebted to Mr. L. D. Hillyer of Brownwood, Texas, for this biographical data of his father.

280. *United States Executive Document,* Serial No. 770, p. 154, where it is recorded that Perry "gave notice to Mr. Brown, the artist in charge of the daguerreotype apparatus, that he must prepare his materials, occupy the building, and commence the practice of his art." Brown had the rating of Acting Master's Mate (v. 2, p. 414 of above, Serial No. 769).

281. *36th Congress, First Session, Executive Document No. 56* (1860), pp. 37 and 103.

282. *Annual Report Smithsonian Institute,* 1924, p. 507.

283. Mr. Jackson so wrote me on Jan. 13, 1933. See also reference 275.

284. Mrs. Fremont so states in *Memoirs of John Charles Fremont,* Chicago and New York, 1887, p. xv.

285. *Incidents of Travel and Adventure,* by S. N. Carvalho, New York, 1859. The five quotations given in the text from Carvalho's book will be found on pp. 24, 64, 68, 76 and 83 of the "Incidents." Carvalho was thirty-nine when he went on the Fremont expedition. He was primarily an artist with the brush, working both in portraiture and landscape. He was born in Charleston, S. C., in 1815; sailed to the West Indies when twenty years old as supercargo on a trading ship. The ship was wrecked near Cape Hatteras, but Carvalho swam ashore with a rope which saved the passengers and crew. He made a sufficient sum by drawing charcoal portraits to enable him to return to the States, and this decided him on an artistic career. His most noted works were Rocky Mountain scenes, based very probably upon his experiences with Fremont. In its day the "Grand Canyon of the Colorado" painted by Carvalho was quite famous. He died in New York City in 1899. I am indebted to his son, S. S. Carvalho of New York City, for this biographical sketch of the elder Carvalho's life.

286. *Photographic Art Journal,* v. 8, p. 124 (1855).

287. *33d Congress, First Session, Senate Miscellaneous Document, No. 67.* Fremont's report is dated June 13, 1854.

288. *Fremont's Memoirs,* p. xvi. If anyone is interested in seeking Brady prints of the Carvalho daguerreotypes, a likely lead would be to get in touch with the descendants of the engravers who made the plates mentioned by Mrs. Fremont in the reference above. It is possible that some of the plates in the *Fremont Memoirs* were copied from the Carvalho originals as described in the text—which ones it is very difficult to decide.

289. *Report upon the Colorado River of the West,* J. C. Ives, Govern-

ment Printing Office, Washington, 1861, pp. 32 and 34.

290. *Report of Explorations in Great Basin of Territory of Utah in 1859.* J. H. Simpson, Government Printing Office, 1876, p. 8.

291. *36th Congress, Second Session, House Executive Document, No. 64.*

292. The New York Public Library, the United States National Museum, and the heirs of A. Bierstadt have been questioned concerning the stereoscope views made on the Lander Expedition with negative results. A possible lead for further search would be to locate the heirs of "S. F. Frost of Boston."

293. *Report on Expedition of Yellowstone and Missouri Rivers in 1859-60,* W. F. Raynolds, Government Printing Office, 1868, p. 109. Hutton is listed as the topographer and assistant artist of the expedition.

294. Watkins' work is described by C. B. Turrill in *News Notes of California Libraries,* v. 13, p. 29 (1918). Watkins, despite the physical infirmities mentioned in Turrill's articles, lived to be eighty-seven. The last six years of his life, however, were spent in the Napa State Hospital for the Insane. I am indebted to Miss Mabel R. Gillis, State Librarian, for information relative to Watkins.

295. *Atlantic Monthly,* v. 12, p. 8 (1863).

296. Watkins' work is discussed at length many times in the photographic journals. For accounts during the 1860's, see *Philadelphia Photographer,* v. 3, pp. 106 and 376 (1866); *Humphrey's Journal,* v. 18, p. 21 (1866-67); also the letter of Savage in reference 299.

297. *Jensen's Biographical Encyclopedia,* p. 708 (1920). Savage was associated first with Marsena Cannon in Salt Lake City, later with Ottinger. The firm of Savage and Ottinger was the name under which Savage gained prominence as a photographer. The field work was done entirely by Savage, however. Many of the early Savage negatives were destroyed by fire in 1883, but the Office of the Church Historian of the Latter Day Saints still possesses many thousands of Savage photographs. I am indebted to Mr. Joseph F. Smith, Church Historian, for valuable aid in connection with the information concerning Savage.

298. *Complete Works of Artemus Ward,* C. F. Browne, N. Y., 1898, rev. ed., p. 354. The last of the lectures on Mormonism by Browne was given on Jan. 23, 1867, in London, shortly before his death.

299. *Philadelphia Photographer,* v. 4, pp. 287 and 313 (1867). Savage's account is entitled, "A Photographic Tour of Nearly 9,000 Miles." It is dated Aug., 1867. The year undoubtedly is wrong, and should be 1866, as the first part of the account was published in the July, 1867, issue. Also, in the January issue of 1867 (p. 32) there appears the notice, "Mr. C. R. Savage of Salt Lake City has arrived home safely," and it acknowledges the receipt of some of the photographs made on this trip. The subjects included: "A Mormon Camp, preparing to start across the Plains"; "A Home in Nebraska"; "O'Fallon's Bluff"; "Sweetwater"; "Castle Rock."

300. *Philadelphia Photographer,* v. 3, pp. 239, 339, 367 and 371 (1866). The "Mr. and Mrs. Laramie" referred to by Glover in his first letter were really Mr. and Mrs. *Larimer.* The death of Mr. Larimer and the destruction by the Indians of their photographic equipment are described

in *Narrative of My Captivity among the Sioux Indians* by Fanny Kelly, Cincinnati, 1871, p. 38. Mrs. Larimer shared captivity with the famous Fanny Kelly.

301. *Philadelphia Photographer*, v. 4, p. 107 (1867).

302. *Philadelphia Photographer*, v. 4, p. 194 (1867).

303. My account of the excursion was obtained largely from the *Weekly Republican* of Oct. 26, 1866, and *The Weekly Herald* of the same date, both of Omaha. Mr. Jackson suggests that Carbutt's assistant, "Mr. Hien," was T. J. Hine, also of Chicago, and afterwards mentioned in the text.

304. *Philadelphia Photographer*, v. 5, p. 34 (1868). A number of the views are mentioned by name. I have never seen the catalog issued by Carbutt.

305. A catalog of some one hundred and fifty of Gardner's stereoscopic views will be found in the author's paper appearing in *The Kansas Historical Quarterly*, v. 3, No. 1, p. 3 (1934); and v. 6, p. 175 (1937). The Kansas Historical Society possesses the original stereographs included in this catalog, but none of the larger prints mentioned in the text.

The Missouri Historical Society has recently acquired by gift from Mrs. Laura Perry Carpenter one hundred and fifteen of these Gardner photographs, made from whole plate negatives. They are in general the same views and subjects as those listed in the Gardner catalog published in my paper, but some of them have been taken at slightly different angles. They bear Gardner's imprint and one of them (39), "Laying tracks 600 miles

west of the Missouri River," bears the date in print, "Oct. 19, 1867."

306. The Gardner photographs were shown to members of the Philadelphia Photographic Society in the spring of 1868. The showing is recorded in the *Philadelphia Photographer*, v. 5, p. 129 (1868), which reads, "A very interesting collection was shown taken along the line of the Union Pacific Railway, Eastern Division, by Mr. A. Gardner of Washington, D. C., and were loaned by Mr. Josiah C. Reiff of Philadelphia. The sizes range from 8 x 10 to 11 x 14 and include Fort Harker, Fort Riley, Abilene, Junction City, Salina, and other towns of Kansas. Many of them are views on the Plains. Thanks were tendered Mr. Josiah C. Reiff of U. P. R. W., E. D."

307. Although I had vague information that the Gardner photographs of the peace treaty at Fort Laramie existed, positive proof of their existence and authorship was first furnished me by Mrs. N. H. Beauregard, archivist and curator of the Missouri Historical Society, St. Louis, to whom I express my thanks. The Gardner photographs are among some sixty-five views ("Scenes of the Indian Country, 1862-68)" collected by Gen. W. S. Harney of Frontier and Civil War fame, and a grandfather of Mrs. Beauregard. Of the sixty-five photographs, about forty were taken in or about Fort Laramie and all bear Gardner's imprint. Identification of individuals has been made to some extent by the aid of Jackson's catalog (reference 319).

308. Hayden's book was published by Julius Bien, New York. I have based the date of Russel's work on this book, for Hayden says that Russel "spent more than two years along the line of the road in the employ of

the Union Pacific Railroad Co." Hayden selected for inclusion in his book those of Russel's prints which illustrated "some peculiar feature in the geology or geography of the country." A number of Russel's photographs were reproduced in woodcut in the *London Illustrated News,* v. 55, pp. 161, 265 and 537 (1869).

Russel's work is also mentioned in the *Philadelphia Photographer,* v. 6, p. 89 (1869) and v. 7, p. 82 (1870); *Anthony's Bulletin,* v. 1, pp. 33 and 118 (1870).

309. C. B. Turrill's article on Watkins in *News Notes of California Libraries,* v. 13, p. 29 (1918), described the Hart stereoscopic views. Turrill stated in his article that he, himself, at the time of writing the article, had the largest Hart collection in existence. On Turrill's death in San Francisco on May 11, 1927, the collection passed to the ownership of the Society of California Pioneers of the city. Turrill described a complete catalog of the Hart views which is apparently among the records of the California State Library at Sacramento.

310. Report of Secretary of War, *Chief of Engineers Report,* 2d Session, 42d Congress, v. 2, p. 1027 (1871); and *Systematic Geology,* United States Geological Exploration of Fortieth Parallel, Clarence King, Washington, 1878. The dates have also been checked against *Wheeler* (see reference 315).

311. *Harper's Magazine,* v. 39, 465 (1869).

312. *Philadelphia Photographer,* v. 3, p. 243 (1866). Wilson, the editor of *Philadelphia Photographer,* exclaimed when he saw Waldack's photographs of the Cave: "These pictures are the most wonderful ones we have ever seen. OH! is not photography a great power? What else could creep into the bowels of the earth and bring forth such pictures therefrom as these?"

313. The quotations are from the *Harper's Magazine* article cited in reference 311.

314. *Explorations and Surveys for a Ship Canal by Way of Isthmus of Darien,* T. O. Selfridge, Washington, 1874, p. 6. I have a fairly complete set of stereographs made by O'Sullivan on this trip. There are seventy-six in the series. The lithographic illustrations in the Selfridge report are chiefly copies of the O'Sullivan photographs, although John Moran (see text p. 313) was the photographer on the Selfridge Survey of 1871 (see p. 33 of report) and a few of his photographs are reproduced.

315. The quotation is from *Preliminary Report of Explorations and Surveys in Nevada and Oregon in 1871,* by George M. Wheeler, Washington, 1872, p. 25. The dates of O'Sullivan's connection with the Wheeler expeditions will be found in that very admirable and useful review of western explorations given in Geo. M. Wheeler's *United States Geographic Surveys West of the 100th Meridian,* Washington, 1889, v. 1, p. 659. Wheeler's book is referred to subsequently in these notes, for the sake of brevity simply as *Wheeler.*

O'Sullivan had a colorful career as a photographer. One of the important Civil War photographers, his experiences in the West and with the Darien expedition rounded out an interesting career. I would very much like to get in touch with some of his descendants, and hope these lines chance to meet their eyes. O'Sullivan died Jan. 14, 1882, from tuberculosis, shortly after he succeeded E. Walker as chief photographer of the Treas-

ury department in Washington. His death occurred at the home of a relative, at Staten Island, N. Y. See *Anthony's Bulletin,* v. 13, p. 29 (1882).

Some of O'Sullivan's negatives are now in the Geological Survey. Most of those made in 1871 were unfortunately destroyed. *Wheeler,* p. 168.

316. Many of the Beaman and Hiller's photographs are reproduced in Dellenbaugh's *A Canyon Voyage,* Yale University Press, 1926. The quotation concerning Powell's feat of 1869 is from this book, p. 3. Beaman describes some of his photographic experiences in *Anthony's Bulletin,* v. 3, pp. 463 and 703 (1872).

317. Mr. Dellenbaugh so wrote me on Nov. 19, 1932. As his many friends know, Mr. Dellenbaugh died Jan. 11, 1935, at the age of 81. I was deeply indebted to Mr. Dellenbaugh for many courtesies. He furnished me a number of clues leading to valuable information on which this chapter is based, besides generously lending me many of the photographs in his own collection for examination.

318. Jackson's experiences have also been more fully described than have any of the other photographers of this period. *The Pioneer Photographer,* by W. H. Jackson in collaboration with H. R. Driggs, World Book Co., N. Y., 1929, is an extremely interesting account of Jackson's early life and his photographic career up to 1880. See also "Photographing the Colorado Rockies Fifty Years Ago!" by W. H. Jackson, *The Colorado Magazine,* v. 3, No.-1, p. 11 (1926), and *Photo Era,* v. 65, 135 (1930).

Much of the discussion in the text on Jackson's work is based on *The Pioneer Photographer.* For a catalog of the negatives made by Jackson from 1869-1875, see *U. S. Geological Survey, Miscellaneous Publication*

No. 5, Washington, 1875. Many of these negatives are still in existence in the U. S. Geological Survey, but have been renumbered since the catalog was issued.

319. *Descriptive Catalog of Photographs of North American Indians,* W. H. Jackson, *Miscellaneous Publication No. 9, United States Geological Survey,* Washington, 1877. "A catalog of over 1000 negatives made at great labor and expense, during a period of about 25 years." The photographers are not listed, nor are the dates on which the photographs were made included, as probably in most cases they were unknown.

320. The naming of Jackson Canyon and Jackson Butte are mentioned in *The Pioneer Photographer,* pp. 92 and 253; of Mt. Hillers in F. S. Dellenbaugh's *A Canyon Voyage,* p. 208; for the naming of Mt. Watkins, see *Place Names of the High Sierra,* F. P. Farquhar, San Francisco, 1926, p. 102. I am indebted to Mrs. H. J. Taylor, former librarian at the Yosemite National Park for information concerning Watkins. Mrs. Taylor tells me that C. L. Weed was the first to photograph in Yosemite. Mt. Haynes is mentioned in reference 336.

321. *Congressional Globe,* Jan. 23, 1872, p. 520. Pomeroy endeavored to get consideration, Jan. 22, 1872, and again, Jan. 23, 1872, but objections were made each time. The bill finally passed the Senate, Jan. 30, 1872. See *Congressional Globe* for dates as listed.

322. *The Yellowstone National Park,* H. M. Chittenden, Cincinnati, 1917, new and enlarged edition, pp. 71 and 76. Quoted by permission of the copyright owners, the Stanford University Press.

323. *Life of H. W. Longfellow,* Samuel Longfellow, Boston, 1886, p. 372. Quoted by permission of the publishers, Houghton Mifflin Company, Boston. See also, *Trail and Timberline,* Denver, No. 183, January, 1934, "The Mount of the Holy Cross," Fritiof Fryxell.

Possibly Williams and McDonald of Denver were the first to photograph in what is now the Rocky Mountain National Park as their photographs of the Rockies were well known in the late sixties. See *Philadelphia Photographer,* v. 6, p. 64 (1869).

324. *Wheeler,* p. 627. According to Wheeler, no report of this expedition was ever published.

325. *Anthony's Bulletin,* v. 1, pp. 110 and 233 (1870); v. 2, pp. 157 and 268 (1871).

326. There is a letter in *Anthony's Bulletin,* v. 1, p. 56 (1870), from Sedgwick mentioning his photographic experiences in the West. Sedgwick may have been an assistant or associate of Russel's for a part of the time. I also have a catalog of *Professor Sedgwick's Illuminated Lectures,* Newton, N. Y., 1879, 4th ed., in which many of Sedgwick's and Russel's views are reproduced in woodcut. It cites many laudatory comments from the newspapers of the East relative to these lectures.

327. *Senate Executive Document, 42d Congress, 2d Session, No. 66,* p. 3. Jackson also mentions Hines' work in *The Pioneer Photographer,* p. 109.

328. *Wheeler,* p. 666. Bell describes some of his experiences in *Philadelphia Photographer,* v. 10, p. 10 (1873). Bell's work is also mentioned in the same volume of the *Philadelphia Photographer,* p. 116. Jackson's use of dry plates is mentioned in *The*

Pioneer Photographer, pp. 72 and 275.

329. *Wheeler,* p. 641. The T. Hines is doubtless T. J. Hines of Chicago who accompanied Captain Barlow in 1871.

330. The quotation is from Custer's *Boots and Saddles,* edition of 1885, p. 292. The scientific work of the expedition was in charge of J. A. Allen, *Smithsonian Report for 1873,* p. 41. Inquiry addressed to the Smithsonian Institution has produced no further information concerning the photographer and his work on this expedition. In *The Conquest of the Missouri* (see reference 333A) there is reproduced a photograph of Stanley's stockade on the Yellowstone, dated 1873, and credited to S. J. Morrow. If correct credit has been given, this citation would identify Morrow as the photographer of the expedition.

331. *The Black Hills Engineer,* v. 17, No. 4 (1929), "Custer's Black Hills Expedition of 1874," by C. C. O'Harra. Some forty-two of the Illingworth prints are reproduced in half-tone. The Minnesota Historical Society also has many of Illingworth's early negatives. Illingworth opened a gallery in St. Paul in 1867, and, as has already been stated, was on the Fisk expedition to Montana in 1866.

332. *Wheeler,* p. 719.

333. *Wheeler,* p. 649.

333a. For a brief biographical sketch of Morrow (1842-1931) see the Yankton *Press and Dakotan,* June 6, 1936. A number of reproductions of Morrow's photographs will be found in *The Conquest of the Missouri,* J. M. Hanson, Chicago, 1916. I am indebted to Elmo Scott Watson, editor, *The Publishers' Auxiliary,* for calling my attention to Morrow and supplying information concerning him.

334. I am indebted to Mr. Lee J. Moss of Superior, Wis., and to Miss Lucile May of the Superior Public Library for information concerning Barry. Barry died in 1934. An obituary will be found in the Superior *Evening Telegram,* March 6, 1934. A portrait of Barry and an account of his portrait of Chief Gall will be found in *The Overland Magazine,* v. 55, 2d series, p. 299 (1910).

335. A few of Huffman's photographs are reproduced in half-tone in the *American Magazine,* v. 103, Feb., 1927, p. 26. Huffman died in Miles City, Mont., Dec. 28, 1931. I am indebted to Mr. Jos. D. Scanlan of the Miles City *Star* for information relative to Mr. Huffman.

336. *Haynes' Bulletin,* March, 1922, St. Paul. The issue of this house bulletin contains a biographical sketch of the elder Hayne's life. F. J. Haynes held the position with the Northern Pacific Railway that Capt. Russel did with the U. P. System, as Haynes was official photographer of the Northern Pacific. He was in this position for over twenty-one years.

337. *Philadelphia Photographer,* v. 13, p. 120 (1876). Jackson's work is frequently mentioned in the photographic literature, both at home and abroad. The *Philadelphia Photographer,* v. 12, p. 91 (1875), has a two-page description of his work; in another place, v. 12, p. 30, is the remark, "We think they equal anything in landscape work we have ever seen made in this country."

338. Mr. Jackson has generously placed his diaries and field notes at my disposal, besides writing me at length many times in answer to my inquiries concerning expeditionary photography.

339. *Philadelphia Photographer,* v. 21, p. 12 (1884).

340. I am indebted to Mrs. John Lytle of Littleton, N. H., for information concerning the Kilburns. Their work is also mentioned many times in the photographic journals from 1867 onwards. The firm name was changed in 1875 to B. W. Kilburn and Co. Edward Kilburn died in 1884. For a description of the Kilburn establishment see *Philadelphia Photographer,* v. 11, p. 138 (1874).

The Keystone View Co., which now owns the Kilburn collection of negatives, was organized in 1892 by Mr. B. L. Singley, president of the Keystone Company. At present, the business of the company is confined to the sale of educational stereoscopic views to homes and schools. The Keystone Company has also acquired the collections of H. C. White Co. and of James M. Davis (to whom the Kilburns originally sold their negatives); the collections of Berry, of Kelly, and of Chadwick; and the educational views originally collected by Underwood and Underwood. (See reference 374.) That stereoscopic views are still in considerable demand is evidenced by the fact that the Keystone Company sell annually over half a million dollars' worth of stereoscopic views made by Burton Holmes. I am indebted to Mr. G. E. Hamilton of the Keystone View Company for the information relative to his organization.

340a. John Moran's opinion on the question will be found in *Philadelphia Photographer,* v. 2, p. 33 (1865).

341. *Photography 1839-1937,* The Museum of Modern Art, New York, 1937, pp. 11-90.

The views of three present day leaders in American photography also bear me out with regard to the point raised in the text. We have already cited Edward Weston's opin-

ion (text, p. 100). The celebrated Alfred Stieglitz says: "Personally, I like my photography straight, unmanipulated, devoid of all tricks; a print not looking like anything but a photograph, living through its own inherent qualities and revealing its own spirit." (New York *Times,* June 24, 1934, section 9, p. 6.) Writing me under date of November 17, 1937, Mr. Stieglitz kindly informed me of the correctness of the quotation and further said, "I not only still subscribe to that opinion but am positive I'll never change it."

In similar fashion, Edward Steichen, likewise a predominant figure in American photographic circles, is quoted directly and indirectly by the New York *Times* (March 6, 1923, p. 15): "No progress has been made in photography since the daguerreotype . . . a photographer is supposed to take things as they are, without injecting his personality into the picture. In the days of the daguerreotype so many difficulties surrounded camera artists . . . that they were satisfied to get any kind of an exact reproduction.

"Mr. Steichen urged a return of sharp pictures and praised 'the meticulous accuracy of the camera.' "

Mr. Steichen was asked to verify the above quotation and under date of Jan. 18, 1938, kindly wrote me as follows:

"While the quotations you refer to present certain elements of what I remember having said, an isolated sentence sounds a little unreal. In detail they cannot have been accurate. At that time I took every opportunity that presented itself to urge the abandonment of certain prevalent soft focus and similar vagaries which paraded under the name of 'pictorial' in favor of a more strictly objective use of the camera. I felt particularly called upon to do this in view of the fact that I had been one of the ringleaders in the production of these technical aberrations."

342. The quotations of G. B. Shaw may be found in *Camera Work,* No. 29 (1910), p. 17; No. 37 (1912), p. 37.

342a. The documentation, in part, of the photograph of Fredricks Gallery (see p. 134) may serve as an example. The subject, of course, is given by the photograph itself— would that all such questions were so simply solved. The photographer is unknown, but it is reasonable to assume that it was some one connected with Fredricks establishment, especially as Fredricks is probably present in the picture (first on right in balcony. Compare with photograph of Fredricks, p. 144). The date of origin can be fixed with some assurance as follows:

1. It will be noted that the sign (at top of building) reads "Photographic, Daguerreotype and Ambrotype Galleries." Ambrotypes were not made before 1855 and were at the height of their favor in 1856 and 1857.

2. The sign on the middle of the building reads "Charles D. Fredricks, late Gurney and Fredricks." Gurney and Fredricks dissolved their partnership in 1856 and Fredricks opened the establishment shown in the photograph in August, 1856. (*Photographic Art Journal,* n.s., v. 3, p. 288 (1856).) The photograph was therefore made after August, 1856. It would also appear from the photograph that it was made some time after this date, for it will be noted that the sign "Daguerreotypes" on the balcony of the establishment has fallen into disrepair.

3. A comparison with a wood-engraving of this same building in *Leslie's Weekly,* Sept. 1, 1858, is

also instructive. The wood-engraving appears to have copied its original faithfully and if we can depend upon it, reference to ambrotypes on the face of the building has disappeared—the fad for ambrotypes passed quickly and by late 1858 it was a dead number. Note, too, that reference to *Gurney* and Fredricks had disappeared and it would appear that the illustration in *Leslie's* represents Fredricks *after* the photograph was made, and the photograph was made, therefore, before September, 1858. Other cases unfortunately are many times not so readily solved. For example, the dating of the Gardner photographs of Kansas (see p. 278) required many weary hours of work. (See reference 305.)

343. The critic was the able New York photographer, William Kurtz. *Philadelphia Photographer*, v. 8, p. 2 (1871).

344. This Lincoln photograph is described in *Lincoln Lore*, No. 131, Oct. 5, 1931, Fort Wayne, 1931. Also F. H. Meserve's book, *The Photographs of Lincoln*, N. Y., 1911.

345. *Philadelphia Photographer*, v. 3, pp. 311 and 357 (1866). Werge, *The Evolution of Photography*, p. 136, credits F. R. Window of London with the sole honor of originating the cabinet size, although Werge incorrectly gives the date of 1867 rather than 1866.

346. The progress of the growing favor of the cabinet photograph can be readily traced in the *Philadelphia Photographer* for 1867, v. 4. See in particular pp. 31, 95, 113, 193, 237 and v. 5, p. 182 (1868). *Humphrey's Journal*, v. 18, p. 353 (1866-67), also comments on the successful introduction. Several modifications of the cabinet photograph were introduced

from time to time. One called the Victoria Card made its debut in 1870 and was a print $4\frac{1}{2}''$ x $3''$ mounted on a card $5''$ x $3\frac{3}{4}''$. *Anthony's Bulletin*, v. 1, p. 143 (1870). A second was the Promenade photograph which was first proposed in 1874. This was a print about $3''$ x $6''$ mounted on a card $4''$ x $7''$. See *Philadelphia Photographer*, v. 12, p. 2 (1875); v. 13, p. 12 (1876).

347. *Humphrey's Journal*. v. 16, p. 152 (1864-65), contains a reprint of an article from the *Photographic News* (London) on retouching to remove pin holes, etc. Mr. W. H. Jackson has furnished me information concerning the blocking out of skies in collodion negatives. Anyone who has ever had occasion to examine wet plate negatives in any number will recall seeing many such skies blocked out with red paper. For information concerning methods of introducing clouds see *Philadelphia Photographer*, v. 5, p. 388 (1868).

348. *Philadelphia Photographer*, v. 4, p. 234 (1867).

349. *Philadelphia Photographer*, v. 5, p. 234 (1868).

350. Published by the Imperial Press, The Cleveland Printing and Publishing Co., Cleveland. A portion of this book appeared in a series of installments in the *Photo-Beacon* (Chicago) for 1902. An obituary of Ryder will be found in *Photo-Miniature*, v. 6, p. 123 (1904).

351. The National Photographic Association was organized primarily to fight the Cutting patent of 1854 and similar events thought to be against the best interests of the profession. See *Philadelphia Photographer*, v. 6, p. 16 (1869). For a report of the first convention (that at Boston) see *Philadelphia Photographer*, v. 6, p. 206 et seq. (1869).

352. For a report of the Cleveland convention see the *Philadelphia Photographer*, v. 7, p. 226 et seq. (1870) and *Anthony's Bulletin*, v. 1, pp. 101-116 (1870). Of course, it should not be imagined that Ryder was the only one to practice retouching before the date of the Boston convention. In fact it appears that others were practicing or experimenting with it before this date (see *Philadelphia Photographer*, v. 6, p. 158 (1869)), but the marked impetus came from Ryder's gallery. See report of Boston convention mentioned in 351 and *Philadelphia Photographer*, v. 6, p. 357 (1869), where Ayres and Kurtz give Ryder due credit.

353. H. H. Snelling, the editor of the *Photographic and Fine Art Journal*, which ceased publication in 1859, emerged from his photographic retirement to lead the anti-forces against retouching. For a fairly complete list of the arguments, from which the quotations in the text were taken, see *Philadelphia Photographer*, v. 8, p. 42 (1870); v. 9, pp. 71, 101, 249, 312, 342, 380, 406, 412 and 427 (1872); v. 10, p. 6 (1873). No wonder Wilson called a stop!

354. *Philadelphia Photographer*, v. 5, p. 170 (1868).

355. A contemporary biographical sketch of Bogardus appears in the *Philadelphia Photographer*, v. 8, p. 313 (1871) and in *Photo-Miniature*, v. 6, p. 664 (1904).

356. A biographical sketch of Vogel appears in the *Philadelphia Photographer*, v. 10, p. 28 (1873). Vogel also contributed a news letter to this journal for many years, there being scarcely a month's issue but that contains one. The letters kept the reader informed of progress abroad and are also interesting for Vogel's comments on American life as seen by a foreigner.

357. The biographical sketch of Kurtz is based on an account in the Sunday New York *Star*, Nov. 6, 1887, which includes the description of a number of prominent New York photographers under the title "Caught in the Camera." See also *Anthony's Bulletin*, v. 14, p. 380 (1883). Obituaries of Kurtz may be found in the New York *Times* and New York *Herald* for Dec. 7, 1904.

358. My account of Kurtz's method of producing the "Rembrandt" pictures is based on discussions found in the *Philadelphia Photographer*, v. 6, p. 292 (1869) where his first New York studio is described; in *Anthony's Bulletin*, v. 1, p. 50 (1870) where his counter-reflector is explained; in *Philadelphia Photographer*, v. 8, p. 2 (1871), which is a discussion by Kurtz himself; in *Anthony's Bulletin*, v. 1, p. 158 (1870) where will be found a British account of Kurtz's method. The long quotation given in the text is from the *Philadelphia Photographer*, v. 6, p. 244 (1869). Mention of awards to Kurtz will be found in *Anthony's Bulletin*, v. 1, p. 228 (1870); *Philadelphia Photographer*, v. 6, p. 426 (1869); v. 8, p. 344 (1871); v. 10, p. 579 (1873). Kurtz's venture in color printing is described in S. H. Horgan's *Half-Tone and Photo-Mechanical Processes*, Chicago, 1913, p. 112.

359. Sarony's connection with the Salmagundi Club, the Tile Club, and his relationship to Smith's *Oliver Horn* will be found in *The Critic*, v. 26, p. 305 (1896); v. 43, p. 31 (1903).

360. The last quotation is from the *Philadelphia Photographer*, v. 15, p. 275 (1878). The *Galaxy* article appears in v. 9, p. 408 (1870) of that journal. The information concerning

Sarony comes largely from an obituary appearing in the *Annual Encyclopedia,* 3d series, v. 1, p. 584 (1896), D. Appleton and Co., N. Y., and from the New York *Star,* Nov. 6, 1887. Napoleon Sarony's relationship to Oliver Sarony is mentioned in *Humphrey's Journal,* v. 17, p. 143 (1865-66), and v. 19, p. 191 (1867-68). See also *Philadelphia Photographer,* v. 13, p. 184 (1876); *Western Photographic News* (Chicago), v. 2, p. 149 (1876); New York *Times,* April 10, 1875, p. 11. Mention is made of Sarony's lithographic ability in F. Wetenkampf's, *American Graphic Art,* N. Y., 1912. *The Quarterly Illustrator,* v. 2, p. 372 (1894), has a discussion of Sarony's efforts in the field of art and reproduces in half-tone a number of these, largely female nudes.

Other obituaries of Sarony may be found in *American Journal of Photography,* v. 17, p. 575 (1896) and the New York *Tribune,* Nov. 10, 1896. The quotation concerning Sarony, given as a footnote in the text, will be found in *Anthony's Bulletin,* v. 12, p. 88 (1881).

361. Both the quotations of Kent and of Hesler are from a discussion during one of the meetings of N. P. A., *Philadelphia Photographer,* v. 8, p. 215 (1871). See also Pearsall, *Philadelphia Photographer,* v. 8, p. 385 (1871) on this point.

362. The problem of photographing small children was discussed many times in the photographic journals. See, for example, *Philadelphia Photographer,* v. 3, p. 196 (1866); v. 9, p. 66 (1872); v. 16, p. 8 (1879).

363. My account of Mora is based upon the New York *Star,* for Nov. 6, 1887; the *Western Photographic News,* v. 2, p. 148 (1876) and the following reviews in the *Philadelphia Photographer,* v. 15, p. 248 (1878);

v. 16, p. 187 (1879); v. 20, p. 194 (1883). I have no complete biographical sketch of Mora. He is last listed in the 1888-89 issue of the New York City Directory. The New York Public Library possesses an illustrated catalog of Mora's "Publics" published in 1879. Small prints about $1\frac{3}{4}'' \times \frac{3}{4}''$ copied from over six thousand such photographs are included in the catalog and show the great variety of backgrounds used by Mora.

364. See *Philadelphia Photographer,* v. 15, p. 351 (1878); v. 16, pp. 9, 220 and 378 (1879); v. 17, p. 301 (1880).

365. For mention of Gutekunst, see *Philadelphia Photographer,* v. 13, pp. 197 and 384 (1876); v. 15, p. 62 (1878); an obituary appears in *Photo-Miniature,* v. 14, p. 210 (1917). The Gutekunst portrait of Grant was probably made in June, 1865, *Philadelphia Photographer,* v. 2, p. 103 (1865). It was twice reproduced in *Harper's Weekly* for 1885 as a front page illustration. Brief reviews of prominent photographers of the seventies will be found in the *Western Photographic News* (Chicago), v. 2, pp. 148-150 (1876). This review is reprinted from the New York *Daily Graphic,* Dec. 30, 1875. Descriptive accounts of the work of most of these men will be found in the *Philadelphia Photographer* and *Anthony's Bulletin* for the period indicated.

366. For prices of cabinet photographs, see first two references in 364. The history of fuming was vehemently discussed in the journals of the early sixties. See *American Journal of Photography,* n.s., v. 5, pp. 359, 397 and 447 (1862-63). These do not credit Anthony with the process, but in a signed letter many years later he specifically made such a claim, *Philadelphia Photographer,* v. 20, p.

211 (1883). This is corroborated by Coleman Sellers in *Anthony's Bulletin* (see reference 245). W. J. Harrison in his *History of Photography*, N. Y., 1887, pp. 85 and 127 also gives Anthony credit. See also *Philadelphia Photographer*, v. 3, p. 19 (1866) where a claim is made for Anthony. Charles Waldack, *American Almanac of Photography for 1863*, Cincinnati, p. 10, states that Henry Anthony *suggested* fuming dry plates with ammonia and that Borda, the Philadelphia amateur, was the first to make the actual trial.

However, the first to note that ammonia fuming would increase the speed of photographic materials appears to have been the Englishman, Hewett. In a letter dated Oct. 20, 1845, and published in *Philosophical Magazine,* series 3, v. 27, p. 405 (1845) he makes the statement that daguerreotype plates, after fuming by ammonia, recorded scenes in "sunshine instantaneously and in five to ten seconds in moderate light."

The carbon process referred to is that of the Englishman, Swann. For an historical review see *The American Carbon Manual,* by E. L. Wilson, N. Y., 1868.

367. See the first two references in 364.

368. *Anthony's Bulletin,* v. 1, pp. 177 and 224 (1870); *Philadelphia Photographer,* v. 13, p. 304 (1876). Many other references to the excellence of the solar enlargements could be made.

369. Vogel's statement will be found in *Philadelphia Photographer,* v. 15, p. 146 (1878). Mention of daguerreotypes in the Bogardus establishment will be found in the *Philadelphia Photographer,* v. 7, p. 400 (1870); Pearsall's activity in *Philadelphia Photographer,* v. 26, p. 119

(1889). For modern attempts, see *The Mentor,* v. 17, p. 36, June, 1929.

370. Composite photographs probably date back into the fifties in this country. There is a discussion in *American Journal of Photography,* n.s., v. 5, p. 524 (1862-63) which speaks of them as an "old" process. The "Dexter" photograph is described in *Philadelphia Photographer,* v. 4, p. 80 (1867); the work of the Bendann brothers in *Philadelphia Photographer,* v. 9, p. 397 (1872); and the Gentile photograph of Sheridan and staff in *Philadelphia Photographer,* v. 14, p. 284 (1877). The cloud effects sometimes introduced from a second negative should strictly be regarded as composite photographs.

371. For a reprint of the quotation see *Anthony's Bulletin,* v. 1, p. 176 (1870).

372. For a chronicle of events of the year 1876 consult any contemporary journal—*Harper's Weekly,* for example. A list of the basic inventions appearing in 1876 and the years immediately following will be found in C. W. Ackerman's, *George Eastman,* p. 33. That 1876 was a transition period in American painting is indicated by Isham, *History of American Painting,* chapter 29; in American sculpture, by Lorado Taft, *History of American Sculpture,* chapter XIV; in American illustration, by Joseph Pennell, *Modern Illustration,* New York, 1895, chapter VI. Pennell states that the year 1876 marks the beginning of the American school of wood-engraving which resulted in a few years in the production of "the best example of an illustrated magazine that the world has to show." (p. 117.) The magazine referred to is *The Century,* which in its earlier issues was *Scribner's Magazine.*

373. *Anthony's Bulletin,* v. 6, pp. 252 and 313 (1875).

374. *Philadelphia Photographer,* v. 13, pp. 182, 196, 226 and 318 (1876) give an extensive account of Photographic Hall and its exhibits. A list of awards will be found in *Philadelphia Photographer,* v. 13, pp. 321 and 384 (1876). In addition to the photographic exhibits, mention should be made of the work of the Centennial Photographic Company which had the concession for the photographic work in the Exhibition itself. This included not only buildings and displays but a gallery was maintained on the grounds where thousands of portraits of visitors to the fair were taken. (Eight hundred seventy-three portraits were made by three operators in one day and that by the wet plate process!) Wilson, the editor, of the *Philadelphia Photographer,* and W. I. Adams of New York were its owners. See *Philadelphia Photographer,* v. 14, p. 4 (1877).

Charles Bierstadt, as were his brothers Albert and Edward, was born in Salingen, Germany. The family came to this country in 1832 and settled at New Bedford, Mass. Charles and Edward began their photographic career in partnership but in 1867, Charles Bierstadt went to Niagara Falls and from this time on devoted himself solely to the making of stereoscopic views, not only of Niagara, but of many places over the world. Underwood and Underwood marketed many of them. Charles Bierstadt died at Niagara Falls in 1903. For the work of Edward Bierstadt, see chapter 21. I am indebted to Miss Anna A. Thompson of Niagara Falls for this information. See also *Philadelphia Photographer,* v. 16, p. 190 (1879).

The celebrated firm of Underwood & Underwood was established at Ottawa, Kansas, in 1880 by two young men, Elmer Underwood, then twenty years of age, and his brother, Bert Underwood, age eighteen. Stereoscopic views secured from Charles Bierstadt of Niagara Falls, J. F. Jarvis of Washington, and the Littleton View Company (of the Kilburns) were sold by house to house canvass. Business grew rapidly and by 1882, the Underwoods were sole agents for these concerns west of the Mississippi River, and by 1884 sole agents for the whole United States. Many house-to-house canvassers were trained as the organization grew, and branch offices were established: in Baltimore in 1887; in Toronto and Liverpool in 1889.

In 1891 the home office was moved from Ottawa to New York City and additional branch offices established over the entire civilized world. The organization began making their own negatives, the Underwoods making many of the important records themselves. In 1896, the firm began to sell news photographs to newspapers and magazines. By 1901, production had reached 25,000 stereographs a day and the yearly sale of stereoscopes (also made by the Underwoods) amounted to nearly 300,000 annually. The news photographs became of increasing importance in their business, however, and the manufacture and sale of stereographs and lantern slides was discontinued in 1921. In 1925, the Underwood Brothers retired. Reorganization of the company in 1931 resulted in the formation of four independent organizations:

1. Underwood and Underwood Illustration Studios of New York, Chicago, and Detroit that deal in photographs for advertisers exclusively.

2. Underwood and Underwood Portraits, Inc., of New York, Phila-

delphia, and Cleveland. This concern makes portraits exclusively.

3. Underwood and Underwood, Washington and Chicago. This organization makes photographs of individuals and events, chiefly of political character.

4. Underwood and Underwood News Photos, Inc., New York. An organization that supplies news pictures of current and historical events and personages. It is stated to have the largest collection of negatives in the world.

I am indebted to Mr. Elmer Underwood, who wrote me at length under date of Jan. 27, 1936, for the information upon which the sketch of the organization given above is based.

375. The article was by G. W. Hewitt and was originally read before the Philadelphia Photographic Society, *Philadelphia Photographer,* v. 13, p. 186 (1876). Reprints of articles on the gelatino-bromide process from British journals also appeared about this time in *Anthony's Bulletin,* v. 7, pp. 179 and 240 (1876).

376. I have followed Werge, *Evolution of Photography,* pp. 58 and 95 et seq., in the history of the English development of the dry plate. See also Neblette, *Photography,* p. 26 et seq.

377. *Philadelphia Photographer,* v. 16, pp. 10 and 189 (1879). The French correspondent of the *Photographer* writes, "Will ever the gelatino-bromide process drive out of the field the silver bath and the salted collodion? Photographers are not experimentalists." *Philadelphia Photographer,* v. 16, p. 85 (1879).

378. *Philadelphia Photographer,* v. 16, p. 216 (1879).

379. *Philadelphia Photographer,* v. 16, p. 177 (1879). The plates were those made by Levy of New York. That Hesler continued his experiments is shown by his statement a few months later when he predicts that dry plates will soon replace wet ones. *Philadelphia Photographer,* v. 17, p. 92 (1880).

380. For the appointment of the committee see *Anthony's Bulletin,* v. 11, pp. 290 and 320 (1880). For its report see *Anthony's Bulletin,* v. 12, pp. 20 and 78 (1881).

381. For a biographical sketch and portrait of John Carbutt see *Journal of the Franklin Institute,* v. 160, p. 461 (1905); and *Dictionary of American Biography,* v. 3, p. 485. *Photo-Miniature,* v. 4, p. 9 (1902-3) credits Carbutt in 1884 with being the first American to use a celluloid base for a photographic emulsion. Mention of the Levy dry plates and cameras will be found in *Philadelphia Photographer,* v. 16, p. 95 (1879). As the notice appears early in 1879 and states that Levy is well known for his dry plates, it is quite evident that he was making them as early as 1878 and possibly sooner.

382. The Defiance dry plate advertised by the Anthonys may not have been a gelatin plate, although it is difficult to understand what other kind of dry plate it could have been. See their description, *Anthony's Bulletin,* v. 11, p. 150 (1880).

The date of Eastman's first venture is given in his testimony of *The Goodwin Film and Camera Company vs. Eastman Kodak Company. Complainant's Record,* v. 2, p. 318. The testimony was given Feb. 1, 1908. This is corroborated by the advertisement of the Anthonys who first announced Eastman's plates for sale in Dec., 1880. *Anthony's Bulletin,* v. 11, p. 367 (1880). The Cramer and Norden firm became the G.

Cramer Dry Plate Company in 1882 and its well known products are still in use. The founder of the firm was Gustav Cramer, a German by birth who, prior to his dry plate venture, was a photographer by profession in Carondelet, a suburb of St. Louis. I am indebted to Mr. G. A. Cramer of this firm for information concerning the history of the Cramer Company. For an obituary of Cramer, see *Photo-Miniature*, v. 12, p. 41 (1914).

383. *Anthony's Bulletin*, v. 12, pp. 51 and 342 (1881). That it was not until 1881 that anything like a general adoption of the dry plate was made by professionals is corroborated by the statement in the *Philadelphia Photographer*, v. 18, p. 388 (1881), "There is no doubt now but what the gelatin emulsion process is making friends wherever it is given a fair trial." See also *Philadelphia Photographer*, v. 19, p. 170 (1882). Even in 1882 the Anthonys reported an increase in the sale of collodion over previous years "despite great increase in use of dry plates." *Anthony's Bulletin*, v. 13, p. 343 (1882).

384. *Anthony's Bulletin*, v. 14, p. 25 (1883) and *Philadelphia Photographer*, v. 20, p. 69 (1883).

385. For defects and difficulties with early dry plates see *Philadelphia Photographer*, v. 17, p. 249 (1880); v. 18, pp. 81, 138, 270 and 372 (1881); v. 20, p. 116 (1883). For references on adoption by professionals see *Philadelphia Photographer*, v. 18, pp. 77, 169 and 206 (1881); v. 19, p. 170 (1882); v. 21, p. 49 (1884); *Anthony's Bulletin*, v. 13, p. 318 (1882); v. 14, p. 31 (1883). Even as late as 1885 the methods of the wet process were being discussed in the photographic journals. *Philadelphia Photographer*, v. 22, p. 9 (1885).

[504]

386. Smith was elected president of the P. A. A. at this meeting—possibly the photographs had something to do with it. *Philadelphia Photographer*, v. 18, pp. 337 and 339 (1881). Concerning the other items mentioned see *Philadelphia Photographer*, v. 19, p. 170 (1882); v. 20, p. 224 (1883); v. 21, pp. 168 and 337 (1884).

387. For reference to the "rapid" collodion process (also called the "lightning process") see *Anthony's Bulletin*, v. 7, p. 227 (1876), many articles in v. 8 (1877) and v. 9, pp. 250, 317 and 368 (1878); *Philadelphia Photographer*, v. 16, p. 7 (1879). The Anthonys licensed the process which was introduced into this country by T. S. Lambert after a French formula. Wilson, of the *Philadelphia Photographer*, was outspoken in his criticism of the Anthonys for licensing it and a long and bitter feud developed between the two journals. The lightning process employed a collodion bath of the following formula:

Sulfuric ether	500 parts
Alcohol	500 parts
Pyroxyline	7 parts
Cadmium iodide	3 parts
Ammonium iodide ...	3 parts
Zinc iodide	1 part
Ammonium bromide .	6 parts
The developer consisted of	
Distilled Water	1000 parts
Ferrous sulfate	60 parts
Copper Acetate (10 % sol.)	20 parts
Alcohol	50 parts
Pure honey	12 parts

The formula for the collodion seems to differ from the formulae given in the best books of the sixties and early seventies in that it contains a somewhat greater variety of salts and noticeably a greater proportion of bromide to iodide than in the earl-

ier negative materials. The developer differs by the addition of the copper acetate and the honey. It is specifically stated that the employment of these formulae would reduce the time of exposure required by one-fourth.

For mention and description of early shutters see *Philadelphia Photographer,* v. 16, p 265 (1879); *Anthony's Bulletin,* v. 10. p. 265 (1879); v. 11, p. 119 (1880); v. 12, pp. 291, 352 and 375 (1881); v. 13, pp. 73 and 102 (1882); v. 14, p. 338 (1883). The majority of these are reprints from British journals as might be expected when it is recalled that dry plates had at least a year's start in use over those on this side of the water.

388. *Philadelphia Photographer,* v. 16, p. 95 (1879).

389. *Philadelphia Photographer,* v. 17, p. 214 (1880); The Anthonys were agents for Blair.

390. *Anthony's Bulletin,* v. 12, pp. 64, 116, 157 and 318 (1881).

391. *Philadelphia Photographer,* v. 18, pp. 151 and 220 (1881); v. 19, p. 371 (1882); v. 26, p. 97 (1889). Adams's son, W. I. Lincoln Adams, gives him credit for first introducing the $10.00 camera and this may well be, as the Anthonys obviously did not make the instruments themselves. *Anthony's Bulletin,* v. 12, p. 157 (1881), and *Munsey's Magazine,* p. 687, August, 1901.

392. For mention of amateur clubs of early dry plate days, see *Anthony's Bulletin,* v. 13, p. 314 (1882); v. 14, pp. 25, 123 and 149 (1883); *Philadelphia Photographer,* v. 19, p. 260 (1882); v. 22, p. 337 (1885), a reprint from the *San Francisco Chronicle;* and reference 393. The *Philadelphia Photographer,* v. 21, p. 381 (1884) mentions some distinguished amateurs of this period, most of them, not

by name, but by paternity. Among others named are Cornelius Vanderbilt, the son of Jay Gould, the grandson of Lincoln, and the daughter of Ex-Mayor Oakey Hall of New York City. The Chautauqua school is mentioned in *Philadelphia Photographer,* v. 23, p. 535 (1886) and the *Photographic Instructor,* edited by W. I. L. Adams, N. Y., 1888. Page 3 of the preface to the *Instructor* states that the school of photography at Chautauqua was established in 1886 and instruction under Charles Ehrmann was first given in the summer of 1887.

393. *Harper's Magazine,* v. 78, p. 288 (1888-89). Quoted by permission of *Harper's Magazine.* See also *Scribner's Magazine,* v. 5, pp. 215 and 605 (1889).

394. *George Eastman,* by Carl W. Ackerman, Houghton Mifflin Company, Boston and New York, 1930. This book is subsequently referred to as *Ackerman.*

395. The career of Eastman thus far described in the text is based on an interview with Eastman by Samuel Crowther, published in *System,* v. 38, p. 607 (1920). See also *Ackerman,* chap. 1. The Eastman letter quoted on page 379 is from *Ackerman,* p. 25, by permission of, and by arrangement with, Houghton Mifflin Company. The date of the Bennett announcement is from Werge, *Evolution of Photography,* p. 102.

396. *Anthony's Bulletin,* v. 11, p. 367 (1880). The Eastman patent is described in United States Letters Patent No. 226,503.

397. *Philadelphia Photographer,* v. 17, p. 8 (1880).

398. The Crowther interview. I am indebted to Mr. Eugene Whitemore, editor of *American Business and Sys-*

tem, for permission to quote from this article.

399. *Anthony's Bulletin,* v. 11, p. 367 (1880); v. 12, pp. 55, 154, 182 and 352 (1881); v. 13, p. 318 (1882); v. 14, p. 418 (1883). For the dry emulsion marketed by Eastman, see *Anthony's Bulletin,* v. 12, pp. 102 and 126 (1881). Relative to the statement that operators were making their own plates, it can be said that Joshua Smith, one of the leading Chicago operators, prepared all his own dry plates in 1881, making them up 5,000 at a time. *Anthony's Bulletin,* v. 12, p. 279 (1881); *Philadelphia Photographer,* v. 20, p. 74 (1883). Reference to the unknown keeping qualities of the dry plates will be found in the Crowther interview; *Ackerman,* chapter one; and *Anthony's Bulletin,* v. 13, p. 410 (1882) where Hesler, the Chicago operator, refers to the difficulty.

400. The Crowther interview, and *Ackerman,* chapter one. The letter quoted is from *Anthony's Bulletin,* v. 14, p. 90 (1883).

401. Reference to Kurtz's use of the electric light is found in *Anthony's Bulletin,* v. 14, p. 21 (1883); *Philadelphia Photographer,* v. 20, p. 97 (1883). The *Philadelphia Photographer* also comments on the use of electric lights in the new Eastman factory. *Philadelphia Photographer,* v. 20, p. 64 (1883).

402. Melhuish's camera is described in a provisional specification of the British patent office issued jointly to Melhuish and to J. B. Spencer, and dated May 22, 1854, No. 1139. That the Eastman experiments in the direction of the flexible film were begun as early as 1881 is found in the Eastman affidavit of 1892. *Complainant's Record,* v. 5, p. 24, United States District Court of Western N. Y., *The Good-win Film and Camera Co. vs. Eastman Kodak Co.*

Much of interest in connection with the early history of film photography will be found in *Photo-Miniature,* v. 4, pp. 1-51 (1902).

403. *The Pioneer Photographer,* p. 274.

404. Description of the film and roll holders has been obtained from United States Letters Patent No. 306,594, Oct. 14, 1884; No. 317,049 and 317,050, May 5, 1885. Also the Eastman testimony, *Complainant's Record,* v. 2, p. 317, *The Goodwin Film and Camera Co. vs. Eastman Kodak Co.*

405. *Philadelphia Photographer,* v. 21, p. 342 (1884); v. 22, pp. 269, 312 and 330 (1885).

406. Eastman's testimony, *Complainant's Record,* v. 2, p. 353, *The Goodwin Film and Camera Co. vs. Eastman Kodak Co.*

407. United States Letters Patent, No. 388, 850, Sept. 4, 1888. Further information concerning the first Kokak is found in *Scientific American,* v. 59, p. 159, Sept. 15, 1888; the Crowther interview, *System,* Oct., 1920; and in the Eastman testimony referred to in reference 404. The *Scientific American* gives a very complete description with four illustrations and the statement is made, "We predict for it a very general use—it promises to make the practice of photography well nigh universal." The first advertisement of the new Kodak in this magazine appears Oct. 6, 1888.

408. For a discussion of the word, *Kodak,* see the Crowther interview and *Ackerman,* p. 65. The original firm name was the Eastman Dry Plate Company. On Oct. 4, 1884, it became the Eastman Dry Plate and Film Co., and on Dec. 24, 1889, the Eastman

Co. was incorporated; the Eastman Kodak Co. (the present name) was organized Oct. 24, 1901. See the Eastman testimony, *Complainant's Record*, v. 2, pp. 318 and 329, *The Goodwin Film Co. and Camera Co. vs. Eastman Kodak Co.*

409. *Anthony's Bulletin*, v. 12, p. 158 (1881); v. 14, p. 375 (1883); *Philadelphia Photographer*, v. 23, pp. 155 and 422 (1886); *St. Louis and Canadian Photographer*, v. 9, p. 506 (1891); *Photo-Miniature*, v. 4. p. 451 (1902-3). A correspondent writing into the *Philadelphia Photographer*, in this year (1886), v. 23, p. 394, states that "a reliable commercially prepared gelatin paper has yet to be placed on the market which shall prove an effective rival of albumen from every point of view."

For the reference to Morgan and Kidd, see Werge, *Evolution of Photography*, p. 138.

410. *Philadelphia Photographer*, v. 24, p. 320 (1887); *Ackerman*, p. 71.

411. A detailed history of these attempts and experiments is reviewed by Dr. C. F. Chandler, the complainant's expert witness, in *Complainant's Record*, v. 2, p. 492 et seq., *The Goodwin Film and Camera Co. vs. Eastman Kodak Co.*

412. *Photographic Times and American Photography*, v. 18, p. 205 (1888).

413. United States Letters Patent No. 610,861, Sept. 13, 1898.

414. *Dictionary of American Biography*, v. 7, p. 408, Charles Scribner's Sons, N. Y., 1931. See also the testimony of Cortlandt Parker, Jr., the son of a close friend of Goodwin; *Complainant's Record*, v. 4, p. 1228 et seq. *The Goodwin Film and Camera Co. vs. Eastman Kodak Co.*, also, *Com-plainant's Record*, v. 5, p. 100, same suit.

415. From the Eastman affidavit of Feb. 13, 1890. *Complainant's Record*, v. 2, p. 340; *The Goodwin Film and Camera Co. vs. Eastman Kodak Co.* The date of issue of the first of these films is found in Eastman's testimony, *Complainant's Record*, v. 2, p. 325, same suit.

416. The history of the Goodwin patent in the patent office is found in *Complainant's Record*, v. 5, pp. 52-148; *Defendant's Record*, v. 2, pp. 387-643, *The Goodwin Film and Camera Co. vs. Eastman Kodak Co.;* the quotation in the text will be found in *Complainant's Record*, v. 5, p. 146.

417. United States Letters Patent, No. 539,713, May 21, 1895.

418. *Journal of the Franklin Institute*, v. 126, p. 478 (1888); *American Annual of Photography*, 1890; *Philadelphia Photographer*, v. 26, p. 409 (1889). For a reference to the Blair film, see *Complainant's Record*, v. 5, pp. 51 and 119, *The Goodwin Film and Camera Co. vs. Eastman Kodak Co.*

419. The patent office record reads "Goodwin having failed to take testimony within the time set, priority was awarded to Reichenbach." *Complainant's Record*, v. 5, p. 134, *The Goodwin Film and Camera Co. vs. Eastman Kodak Co.*

420. The history of the Goodwin patent during its stay in the patent office was subject to great scrutiny by the attorneys of both the Goodwin Film and Camera Company and the Eastman Kodak Company during the litigation. The attorneys of the Goodwin interests, in fact, made a supplemental brief of over one hundred and fifty printed pages of this history. It

would appear from this that Goodwin was unfairly treated by the Patent Office examiners. His case was transferred to no less than five examiners, the first of whom was dismissed by the Patent Office. (*Supplemental Brief for Complainant Re Goodwin's File Wrapper*, p. 50.) Even though Goodwin's treatment in the Patent Office is condemned, there is no evidence presented by these attorneys that the Eastman Kodak Co. was responsible for them. Undoubtedly the Eastman Company vigorously protected its interests and fought the interference proceedings in connection with the Reichenbach patent, but both interferences were requested by Goodwin, himself. Toward the close of their brief, the attorneys for the complainant (Goodwin Film and Camera Co.) make the inference that the Eastman Company were responsible for the long delays of Goodwin's patent in the patent office. Undoubtedly they did delay it, but some of the delay was caused by Goodwin, himself, presumably from lack of funds and discouragement over his unjust treatment in the Patent Office. No fair-minded man can read over the record of the case in the patent office and help but marvel at the conduct offered Goodwin. Both Judge Hazel and especially Judge Coxe in their opinions call attention to it in very plain terms. Said Judge Coxe, "The long delay and the contradictory rulings of the Patent Office would have discouraged an inventor who had not supreme faith in the justice of his cause." *Supplemental Brief for Complainant Re Goodwin's File Wrapper and Contents, The Goodwin Film and Camera Co. vs. Eastman Kodak Co.* For the arguments of the defense in connection with the history of the Goodwin patent, see *Brief and Argument for Defendant*, pp. 151-197d, *The Good-*

[508]

win Film and Camera Co. vs. Eastman Kodak Co.

421. The Goodwin Film and Camera Co. was organized June 16, 1899, but remained inactive for several years. Cortlandt Parker, Sr., of Newark furnished the necessary capital for the construction of the plant, which was begun in Jan., 1900. *Complainant's Record*, v. 5, p. 11; v. 4, p. 1229 et seq., *The Goodwin Film and Camera Co. vs. Eastman Kodak Co.*

422. Testimony of F. A. Anthony; *Complainant's Record*, v. 2, pp. 365 et seq.; of Cortlandt Parker, Jr., *Complainant's Record*, v. 4, p. 1228. The original complaint against the Eastman Kodak Co. was dated Dec. 2, 1902; it was revised Jan. 7, 1903. In the next two years only small progress was made. After 1905 the case was apparently quiet until 1908 when it begins again in earnest. *Complainant's Record*, vv. 1 and 2.

423. Opinion, Hazel, J., Aug. 14, 1913, *Federal Reporter*, v. 207, p. 351 (1914); Opinion, Coxe, J., United States Circuit Court of Appeals for the Second Circuit, Lacombe, Coxe, Ward, Circuit Judges, March 10, 1914. *Federal Reporter*, v. 213, p. 23 (1914). For the cash settlement of the suit, see *Ackerman*, p. 277. Ackerman's view as to the payment of this sum is colored by the fact that he is the eulogistic biographer of Eastman. To a less partial observer it would appear that Eastman was paying for an error of judgment. He was aware that Goodwin's application for patent was prior to both his own application and that of Reichenbach's. His usual policy in such cases was to buy up the rights to a patent whether it might prove successful in practice or not. Undoubtedly, he could have reached an agreement with Goodwin early in the history of the Goodwin patent for a fraction of the final cost.

423a. For a report of Sheppard's work, see *Colloid Symposium Monograph,* v. 3, p. 76 (1925). Chemical Catalog Co., N. Y.

424. Vogel announced his discovery of dye sensitization in a letter to Wilson dated Dec. 1, 1873. *Philadelphia Photographer,* v. 11, p. 29 (1874). Mention of Ives' work is frequently encountered in the period specified in the text, the first one appeared in the *Philadelphia Photographer,* v. 16, p. 365 (1879).

425. For a biographical sketch of Muybridge, see *Dictionary of American Biography,* v. 13, p. 373, Charles Scribner's Sons, N. Y., 1934.

426. *Philadelphia Photographer,* v. 5, p. 128 (1868); one of these photographs is inserted as an illustration in the Nov., 1869, issue of the *Philadelphia Photographer,* v. 6. See p. 418 where it is reproduced in text.

427. For mention of the Muybridge views, see *Philadelphia Photographer,* v. 8, p. 17 (1871); v. 9, p. 119 (1872); v. 10, pp. 201, 469 and 487 (1873); v. 11, p. 53 (1874). Muybridge's initials appear variously as J. M., E. J., J. C., doubtless due to Muybridge's change of name. The quotation is from *Anthony's Bulletin,* v. 2, p. 402 (1871).

428. *Descriptive Zoopraxography,* Eadweard Muybridge, Univ. of Penn., 1893, p. 4; *Animals in Motion,* same author, London, 1902, preface; *A Million and One Nights,* Terry Ramsaye, Simon and Schuster, N. Y., 1926, chapter II. Subsequent reference to the last book is indicated by *Ramsaye.*

429. Wilson's comment is found in *Philadelphia Photographer,* v. 16, p. 22 (1879); Vogel's in *Philadelphia Photographer,* v. 16, p. 141 (1879). For a description of the method used by Muybridge, see *The Horse in Motion,* J. D. B. Stillman, James R. Osgood and Co., Boston, 1882, appendix. As far as I have been able to ascertain, Muybridge never stated that he employed the lightning process, but as it was receiving wide publicity at the time of his successful experiments he doubtless used it. For specific contemporary comment by Muybridge on his process, see *Philadelphia Photographer,* v. 16, p. 71 (1879). Rulofson, the San Francisco photographer, spoke disparagingly of the Muybridge photographs as "diminutive silhouettes" (*Philadelphia Photographer,* v. 15, p. 247 (1878)) which was doubtless the case, but at least they showed the position of the body and the feet of the horse with respect to the ground.

430. *The Horse in Motion,* and *Ramsaye,* chap. II. Ramsaye belittles Muybridge's part in the Stanford episode. But the facts are that Muybridge already had an international reputation as a photographer before he was engaged by Stanford. It is doubtless true that Isaacs played an important part in the successes obtained, but Muybridge's efforts are certainly of equal importance and his subsequent efforts in developing the zoopraxiscope and his elaborate studies at the University of Pennsylvania do not permit him to be so lightly dismissed as Ramsaye does. Ramsaye digs out the fact that Muybridge in 1874 was acquitted of the murder of the seducer of his wife and devotes eleven pages of his book to this irrelevant fact. Ramsaye contends that it accounts for five years of Muybridge's life. As a matter of fact, it was less than four months between the date of the murder and Muybridge's acquittal. Curiously enough the well-known biographical accounts of Muybridge's life specifi-

cally state that Muybridge was never married. (See note 425, for example.) It would appear that acquittal of murder would be an important enough event in the life of any man to appear in his biography.

431. Several reprints from the San Francisco *Call,* one dated Dec. 23, 1879, relative to Stanford and Muybridge, appear in *Anthony's Photographic Bulletin,* v. 11, pp. 13 and 206 (1880); v. 12, p. 122 (1881).

432. This question has been disputed for many years. In addition to that listed in notes 430 and 431, information bearing on the debate will be found in the *Journal of the Franklin Institute,* v. 207, p. 825 (1929) and v. 208, pp. 416 and 420 (1929). The most extended account of Heyl's contribution will be found in the *Motion Picture Magazine,* v. 8, p. 93, November, 1914. See also *Journal of the Franklin Institute,* v. 145, p. 310 (1898).

433. *American Illustrators,* F. Hopkinson Smith, Charles Scribner's Sons, N. Y., 1892, p. 24.

434. I have made attempts to find more positive proof on this point. Vail, in the *Bulletin of the New York Public Library,* Feb., 1929, p. 71, states that Remington, at the time of his death, possessed an extensive library dealing with the field which Remington illustrated and that it was bequeathed to the library of St. Lawrence University. I had hoped to find the book, *The Horse in Motion,* in this library, but a letter directed to the librarian of St. Lawrence University obtained the reply that the Remington books were not in the possession of the University. Neither do they appear to be in the Remington Memorial Art Gallery, at Ogdensburg, New York. I believe that it is not without significance that one of

the magazines to which Remington contributed sketches early published an extensive review of Muybridge's work in "The Horse in Motion," *Century,* n.s., v. 2, p. 381 (1882), where it specifically calls attention to the artist's problem in depicting animals in motion. It hardly seems possible that Remington was not familiar with the Muybridge photographs early in his career. Smith, *American Illustrators,* N. Y., 1892, p. 23, comments on the importance of the Muybridge photographs to the student of art. He further states, however, without evidence, "Remington saw these movements in a horse long before he ever heard of Muybridge or his discovery." Smith, of course, is crediting Remington with impossible physiological abilities.

435. For the latter part of Muybridge's life see reference 425 and *Anthony's Bulletin,* v. 13, pp. 6, 13, 174 and 375 (1882) which deal with Muybridge's lecture experiences in London, Paris and New York. The last reference, which is reprinted from the New York *Times* of Nov. 18, 1882, states in part that Muybridge "lectured last night at the Turf Club—he threw Bonheur's 'The Horse Fair' on the screen as well as Messonier's masterpieces and criticized the position of the animals."

Muybridge seems to have had difficulties with Stanford after the publication of *The Horse in Motion* for he brought suit against Stanford for $50,000 regarding precedence of ideas in connection with the correct theory of animal locomotion. *Anthony's Bulletin,* v. 14, p. 59 (1883). Apparently the suit was never brought to trial as there is no subsequent record of it.

A description of Muybridge's work at the University of Pennsylvania will be found in *The Century,* n.s.,

v. 12, p. 357 (1887); and the two references cited in 428. Muybridge wrote a voluminous report of these studies, "*Descriptive Zoopraxography, or the Science of Animal Locomotion.*" Philadelphia, 1887, 11 vols.

436. Reference 428 and *A History of the Movies* by B. J. Hampton, Covici-Friede, N. Y., 1931. For a reference to the commercial production of cinema film see *Ackerman*, p. 123.

437. Such methods are discussed in Lerebours, *Treatise on Photography*, an American edition of which was edited by H. H. Snelling, *Photographic Art Journal*, v. 1, pp. 146 and 343 (1851). See also *Journal of the Franklin Institute*, v. 33, p. 328 (1842), a reprint of Grove's (English) process.

438. Eckfeldt and DuBois, authors. Philadelphia, 1842, chapter 6.

439. See reference 61.

440. Mr. Horgan kindly wrote me concerning his early experience under date of Nov. 17, 1933.

441. For a description of the first published crystallotype see *Photographic Art Journal,* v. 5, p. 254 (1853). I have never seen a copy of Putnam's *The Crystallotype.* Notice of the book appears in *Putnam's Magazine*, v. 5, p. 335 (1855), where it states that the book is so-called "from a number of fine photographs" which it contains.

442. To illustrate the magnitude of illustrating books by means of actual photographs the two following notes will suffice: "J. Carbutt of Chicago has finished an order of 50,000 cabinet photographs for a biographical work." *Philadelphia Photographer,* v. 6, p. 133 (1869); "J. Landy has just completed an order for 65,000 cabinet prints to be used in illustrating, 'Cincinnati, Past and Present.' " *Philadelphia Photographer,* v. 10, p. 63 (1873). The reader will recall that Hayden's *Sun Pictures of the Rocky Mountains* referred to in reference 308 was illustrated by actual photographs. Wilson stated in 1866, *Philadelphia Photographer,* v. 3, p. 32 (1866), that only feeble attempts had been made up to that time in illustrating books by photographs.

443. *The Pictorial Press,* Mason Jackson, London, 1885, Chapter VIII; "Illustrated Journalism," by C. K. Shorter, *Contemporary Review*, v. 75, p. 481 (1899).

444. *Frank Leslie's Illustrated Weekly,* v. 1, p. 6, 1855. Here will be found a brief history of the pictorial press in America up to the founding of the *Weekly.* For a sketch of Leslie's life see *Dictionary of American Biography,* New York, 1933, v. 11, p. 186.

445. An interesting historical and descriptive article on the making of illustrations and the publishing of books will be found in *Harper's Magazine,* v. 75, p. 165 (1887). The author is R. R. Bowker.

446. *Leslie's Illustrated Weekly,* v. 2, p. 124 (1856). J. C. Oswald's *A History of Printing,* N. Y., 1928, p. 322, gives Wells credit.

447. Harrison died Nov. 23, 1864, *Philadelphia Photographer,* v. 2, p. 16 (1865). Harrison's Globe Lenses were recognized the world over for their superior merit after their introduction in the early sixties. See *American Journal of Science and Arts,* series 2, v. 35, p. 319 (1863), an article by Coleman Sellers. An editorial note in the same issue of this journal describes the use of the Globe lens in government service. See also *American Journal of Photography,*

n.s., v. 5, p. 459 (1862-3) and *Philadelphia Photographer*, v. 2, p. 97 (1865).

448. The technical difficulty of photographing on wood was to secure a material which would hold the sensitive silver salt to the wood and yet not impair the lines of the wood engraving itself. One method, which apparently was used quite extensively, was to photograph on glass with wet collodion in the usual way. The film was then stripped from the glass, transferred to the wood block and solvents employed to dissolve out the collodion. This left the black silver image upon the wood itself which served as the guide for the engraver. *Anthony's Bulletin*, v. 1, p. 45 (1870). Price's process is described in United States Letters Patent No. 17,-231, May 5, 1857; Boyle's in United States Letters Patent, No. 22,852, Feb. 8, 1859.

Photography on wood, while known in the fifties, does not seem to have come into general use until the sixties. In the early illustrated magazines (those of the fifties and early sixties) an occasional illustration will be marked "after a photograph on wood." *Leslie's* were using the process extensively by 1865. *Leslie's Illustrated Newspaper*, Dec. 16, 1865, p. 193; July 7, 1866, p. 251; *Philadelphia Photographer*, v. 3, p. 215 (1866). The patent office was also using this, or a photo-lithographic one, by 1860. *Scientific American*, n.s., v. 2, p. 73 (1860).

The early history of the use of photography in the preparation of woodcuts in the *Scientific American* may be found by reference to that journal in v. 12, p. 390 (1856-57); v. 13, pp. 96 and 117 (1857-58); v. 14, p. 312 (1858-59).

449. For contemporary descriptions of working details of these processes see *Photo-Engraving, Photo-Etching and Photo-Lithography*, W. T. Wilkinson. Revised and published by Edward L. Wilson, New York, 1888, pp. 45, 55, 129 and 181. For reference to the Moss Engraving Co. which was established in 1870 by John C. Moss, see *Anthony's Bulletin*, v. 9, June, 1878; *Philadelphia Photographer*, v. 14, p. 164 (1877); v. 23, p. 246 (1886); v. 27, p. 193 (1890).

The American Photo-Lithographic Company was also engaged in photozincography in the early seventies. *Anthony's Bulletin*, v. 5, p. 116 (1874). The report of progress at the NPA in 1871 indicates that photozincography was employed to some extent at that time. "In photolithography applied to the reproduction of engineering drawings, etc., we find much of practical use and improvement." *Philadelphia Photographer*, v 8, p. 207 (1871).

Interesting items concerning the Levytype Company were published in *Anthony's Bulletin*, v. 6, p. 117 (1875); *Philadelphia Photographer*, v. 22, pp. 127 and 351 (1885). That the Moss Engraving was the largest American photo-engraving concern of the early eighties is specifically stated by D. Bachrach, a partner of the Levytype Company in a report of progress made at APA in 1881. *Philadelphia Photographer*, v. 18, p. 275 (1881). See also biographical sketch of John C. Moss, *Dictionary of American Biography*, v. 13, p. 280, N. Y. (1934).

449a. See reference 456.

450. *Main Currents in the History of American Journalism*, W. G. Bleyer, Houghton Mifflin Company (1927), p. 329.

451. Gribayédoff's claim will be found in the *Cosmopolitan*, v. 11, p. 471 (1891). According to Gribayédoff,

his first illustrations in the *World* appeared Sunday, Feb. 3, 1884. McDougall's claim is stated in *Who's Who*, Chicago (1910-11), v. 6, p. 1222 and in a series of breezy reminiscences in *The American Mercury*, v. 4, pp. 20 and 263, v. 5, p. 147, and v. 6, p. 67 (1925). For the earlier history of illustration in newspapers see reference 444 and *American Graphic Art*, F. Weitenkampf, New York, 1912, p. 216. Any serious student of the history of American pictorial journalism would do well to follow up a lead given by McDougall (*American Mercury*, v. 4, p. 20) who mentions an illustrated New York *World* published in the 1830's. According to McDougall some of the early illustrations were reproduced in a Sunday *World* fifty years later.

452. *Philadelphia Photographer*, v. 23, p. 74 (1886).

453. *Philadelphia Photographer*, v. 27, p. 680 (1890); *International Studio*, v. 16, p. 254 (1902); v. 17, p. 281 (1902).

454. The first mention of Woodbury-types in this country occurs in *Philadelphia Photographer*, v. 6, p. 422 (1869) where reference is made to their display in Philadelphia and Boston. A description of the process appears in the same journal, v. 7, p. 2 (1870). Carbutt's part in the process in this country is found in *Philadelphia Photographer*, v. 7, p. 40 (1870); v. 9, pp. 124, 147 and 437 (1872).

455. The early history of the Albertype will be found in the *Philadelphia Photographer*, v. 7, pp. 18 and 36 (1870); v. 9, p. 204 (1872); v. 10, p. 159 (1873). The Artotype was based on Albert's original patent; a second one by Albert dated April 11, 1871; and a third by J. B. Obernetter (also of Munich) of Sept. 17, 1878, all United States patents, although both patentees were foreigners. The Artotype Company was said to consist of T. S. Lambert, W. A. Cooper, and A. Mueller, all of New York. Bierstadt's connection appears to have been that of principal operator and instructor. Bierstadt for several years was associated with a Mr. Harroun, but later all such Artotypes are credited to Bierstadt alone.

The Artotype was the cause of much bitter discussion between *Anthony's Photographic Bulletin* and the *Philadelphia Photographer* in 1879. Wilson of the *Photographer* maintained that the process was general knowledge and that licenses to operate the process should not be sold. The Anthonys were supplying materials for it and naturally resented Wilson's criticism. Long discussions can be found many times in both journals for 1879. *Anthony's Bulletin* for a number of years after this date was illustrated by numerous Artotypes.

456. Oswald, *History of Printing*, 1928, p. 324. See also references 459 and 460, and issue of *Graphic* referred to in text. The *Graphic* was first issued March 1, 1873, and the last issue appeared September 23, 1889. It appeared in tabloid size as well as in regular size. I am indebted to the Newspaper Division of the New York Public Library for this information.

457. It is only fair to state that most of the photolithographic processes described in the text, both those originating at home and abroad, were due to the pioneer work of the French investigator, Poitven, in the middle fifties. American accounts of this work will be found in *Humphrey's Journal*, v. 9, p. 177 (1857-58), and the *Philadelphia Photographer*, v. 19, p. 212 (1882). It should also be stated that Joseph Dixon,

whose pioneer work in daguerreotypy was mentioned in chapter I, apparently anticipated at least a part of Poitven's work as early as 1839. Dixon first described his work in the *Scientific American,* April 15, 1854, p. 242, and introduced evidence that his claims were correct in the *American Journal of Photography,* n.s., v. 1, pp. 24 and 35 (1858-59). Dixon discovered that a mixture of gum arabic and bichromate was light sensitive, and after exposure, part would take ink and the remainder would not. It is obvious that the discovery, as it was not published for fourteen years after its discovery, played little part in the subsequent development of such processes. It should be noted that contemporary mention of Dixon's process, if not description, was actually made. See New York *Mirror,* v. 17, p. 135 (1839); v. 20, p. 111 (1842).

A more important early American attempt in this direction was the work of Cutting (he of ambrotype fame) and L. H. Bradford of Boston. These men actually patented a process of photolithography in 1858 (United States Letters Patent, No. 19,626, March 16, 1858) and several examples of their work appeared in *Humphrey's Journal.* An examination of these shows that they had nearly solved the problem of half-tone reproduction. As no subsequent use of the process appeared, technical difficulties undoubtedly prevented its commercial success. *Humphrey's Journal,* v. 10, p. 289 (1859).

458. United States Letters Patent No. 51,103, Nov. 21, 1865. For mention of Egglofstein's work see S. H. Horgan, *Half-Tone and Photo-Mechanical Processes,* Chicago, 1913, p. 89; Wm. Gamble, *The Beginning of Half-Tone,* reprinted for U. S. A. by E. E. Epstean, N. Y. (1928), p. 11; *International Annual of Anthony's*

Bulletin, v. 9, p. 201 (1897). I am indebted to Mr. Epstean for a copy of Gamble's reprint.

An examination of the enlarged reproduction by Egglofstein shown in Chapter XXI strongly suggests that he employed his screen twice, the second time at right angles to the first. If this is so, credit is due Egglofstein as the originator of the cross line principle. I am indebted to Mr. R. P. Tolman, curator of the Division of Graphic Arts, United States National Museum, for his very kind aid in furnishing the information and photographic reproductions of exhibits dealing with the development of half-tone.

459. See editorial in first issue of the *Graphic,* March 4, 1873, and *Anthony's Bulletin,* v. 4, p. 119 (1873); *Philadelphia Photographer,* v. 10, p. 128 (1873).

460. Horgan's early work with the half-tone is described in *The Inland Printer* for March and April, 1924. It was subsequently revised by L. R. McCabe and published as a pamphlet, *The Beginnings of Halftone.* See further *The Inland Printer,* Feb., 1927, p. 787. The quotations in the text from the sources are reprinted by permission of *The Inland Printer.* A brief contemporary account of Horgan's work will be found in *Anthony's Bulletin,* v. 11, p. 123 (1880). See also New York *Times,* March 4, p. 3 (1930).

461. The work of Ives is described in *The Autobiography of an Amateur Inventor,* privately printed 1928, and in addenda dated July, 1930, and July 5, 1931. For contemporary accounts of Ives' work see *Philadelphia Photographer,* v. 17, p 48 (1880); *Journal of the Franklin Institute,* v. 125, p. 351 (1888). An advertisement of the Ives' swelled

gelatin process will be found in the *Philadelphia Photographer,* v. 15, Sept., 1878, where it states that the process has been worked "for nearly a year." Other supporting references will be found in *Philadelphia Photographer,* v. 18, pp. 188, 253 and 283 (1881); v. 19, p. 384 (1882); v. 24, p. 510 (1887). During 1882, the *Philadelphia Photographer* used on the title page of each month's issue an illustration made by the Ives' process.

462. United States Letters Patent No. 492,333, Feb. 21, 1893. For biographical sketches of Louis E. and Max Levy see *Dictionary of American Biography,* v. 11, pp. 202 and 203, New York, 1933. The most satisfactory and impartial account of the complete history of half-tone will be found in Gamble (see reference 458).

For contemporary reference to Wolfe's screens see *Wilson's Photographic Magazine,* v. 26, pp. 113 and 439 (1889); v. 27, p. 578 (1890).

463. Reviews of interest in connection with magazine illustration will be found in *Century,* v. 81, p. 131 (1910); *Scribner's,* v. 72, p. 123 (1922).

464. C. K. Shorter, *Contemporary Review,* v. 75, p. 481 (1899). Shorter states that the first half-tone in the London *Graphic* appeared Sept. 6, 1884; in the *Illustrated News* "a year or two earlier."

465. *The Century,* n.s., v. 18, p. 312 (1890). Quoted by permission of the D. Appleton-Century Company.

466. *American Illustrators,* Charles Scribner's Sons, N. Y., 1892, p. 65. Quoted by permission of the publishers.

467. *Modern Illustration,* G. Bell & Sons, London, 1895, pp. 40 and 44. Quoted by permission of the publishers.

468. See title page of a reprint in the *Inland Printer,* Feb., 1927, p. 787.

469. See reference 462 (biographical sketch of L. E. Levy) and *Recollections of Forty Years,* L. E. Levy. Privately printed, 1912, p. 8 of text.

470. *Main Currents in the History of American Journalism,* W. G. Bleyer, Boston, 1927, p. 394.

471. United States Letters Patent, No. 604,472, May 24, 1898; *The Beginnings of Half-Tone,* L. R. McCabe, p. 5.

472. *The Boston Transcript,* Boston, 1930, p. 193.

473. *History of New York Times,* Elmer Davis, N. Y., 1921, p. 212.

474. I refer to *Life,* the first issue of which appeared November 23, 1936, and competitors which have followed in its wake. The rotogravure sections of many metropolitan newspapers are being expanded and feature articles presented in picture with some caption. See *Editor and Publisher,* Nov. 27, 1937, p. 6.

475. The sonnet was entitled, "Illustrated Books and Newspapers." It was composed in 1846 and was among the last poems written by Wordsworth; it was first published in 1850. *Poetical Works of William Wordsworth,* edited by William Knight, Edinburgh, 1886, v. 8, p. 172. Shorter (reference 464) states that the *Illustrated News* is said to have caused the outburst.

The obvious flaw in the logic of Wordsworth's criticism lies in the fact that "tongue and ear" were also used by Wordsworth's contemporaries. These are older arts than the picturing of the cavern. Wordsworth evidently didn't consider their use a return to prehistoric days.

476. The magazine is *True Story,* which is said by Fulton Oursler, to have the largest newsstand sale of any publication ever issued. *True Story* has never used any illustrations in its stories save photographs. For comment on camera illustrations in fictional articles see New York *Times,* Jan. 6, section VII, p. 15 (1918).

477. I have attempted to make no specific list of the flaws and abuses of the pictorial press. My statements, I believe, are sufficiently authenticated by the following references in addition to actual examination of many illustrated journals: C. K. Shorter (reference 464); *Cosmopolitan,* v. 13, p. 701 (1892); *Lippincott's Magazine,* v. 55, p. 861 (1895); *World Today,* v. 9, p. 845 (1905); New York *Times,* Dec. 4, section IV, p. 1 (1932); New York *Times,* Aug. 3, p. 22 (1937); *Photography Today,* D. A. Spencer, New York, 1936, chapter XII.

478. Speech before the Institute of Human Relations, Williamstown, Mass., Sept. 2, 1937; an abbreviated version of this speech appears in *Public Opinion in A Democracy,* special supplement of *Public Opinion Quarterly,* January, 1938, p. 62.

479. *The Pictorial Press,* Mason Jackson, p. 303.

480. H. R. Luce, see reference 478.

481. I am indebted to Miss Gertrude B. Lane, editor, *The Woman's Home Companion;* Wesley W. Stout, editor, *The Saturday Evening Post;* Fulton Oursler, editor, *Liberty;* and William L. Chenery, editor, *Collier's,* all of whom were kind enough to write me at length on various aspects of the problem of magazine illustration and the reproduction of illustrations. Their views, while divergent among themselves, were of real aid in framing my brief summary of the value of the pictorial press.

Index to Illustrations

Index to Text and Notes

(References to *Notes* are so indicated; all numbers refer to pages)

France, subsidizes Daguerre, 5
Franco-Austrian War, 224
Franklin Institute
 fairs of, 128
 first display of ambrotypes, 125
 (Notes), 456
Franklin Institute, Journal of, 108
Fredricks, Charles D., 62, 131, 140, 141, 196
Fredricks, Charles D. (Notes), 477
Fredricks gallery, photograph of (Notes), 497
Fredricks and Gurney (Notes), 497
Frémont, Jessie B., author (Notes), 490
Frémont, John C., 59, 262
Frémont, John C. (Notes), 490
Frontier, defined, 248
Frontier in American History (Notes), 488
Frost, John, author (Notes), 485
Frost, S. F., member of Lander's expedition, 267
Fryxell, Fritiof, author (Notes), 495
Fuming, of albumen paper, 355
Fuming, of albumen paper (Notes), 500
Furniture, mock, 335

Galleries
 of California (1850's) (Notes), 474, 488, 489
 early use of sky light by, 55
 extravagant description of daguerreotype, 76
 fire hazard of, 357
 first American daguerreotype, 34
 first American daguerreotype (Notes), 459
 first New York, 34
 first Philadelphia, 35
 of William Kurtz, 336
 of J. M. Mora, 351
 on Mississippi R., 67
 National Daguerrean (Notes), 463
 Rogues', 127
 of N. Sarony, 345
 tintype, 163
Gallery of Illustrious Americans, 59
Gallery of Illustrious Americans (Notes), 465
Gambier, Ohio, 154
Gamble, William, author (Notes), 514
Gardner, Alexander
 arrives in United States, 130
 author (Notes), 485
 biography of, 231
 biography of (Notes), 475
 catalog of Kansas views (Notes), 492
 photographs early Kansas, 278
 photographs Civil War, 230, 244
 photographs Lincoln, 195, 246, 322
Gardner, James, Civil War photographer, 230
Garfield, James, quoted, 240
Gelatin
 effect on plate sensitivity, 73, 366
 in photography, 364

Gelatin dry plate
 early difficulties with, 369
 early objections to, 372
 effect on amateur, 374
 slow adoption of, 372
Gelatin emulsion
 formula for, 379
 introduction of, 364
Gelatin process "swelled," 426
"Gems" (name for tintype), 164
Geological Survey, 283
Geological Survey, Misc. Publication No. 5 (Notes), 494
Geology, Systematic (Notes), 493
Georgia, introduction of stereograph in, 180
George Eastman (Notes), 501
Gibson, Civil War photographer, 230
Gihon, John L., 359
Gilding, of daguerreotype, 43
Gillis, Mabel R. (Notes), 488, 491
Gillot, M., 423
Glass
 main expense in wet process, 372
 negative, early use of, 113
 photograph on (ambrotype), 123
 re-use in wet plate, 271
 stereograph negatives, 175, 180
Gleason's Drawing Room Companion, illustrations in, 126
Globe lens (Notes), 511
Gloss, in albumen prints, 120
Glover, Ridgway, frontier photographer, 274
Goddard, J. F., 35
Goddard, J. F. (Notes), 461
Goddard, Paul B., 20
Goddard, Paul B. (Notes), 461
Gold toning (of prints), 120
Goode, W. H. (Notes), 459, 460
Goodwin, Hannibal
 biography of, 394
 biography of (Notes), 507
 patent of, 393, 397
 patent of (Notes), 507
 "pioneer inventor," 401
 settlement of suit, 402
Goodwin Film and Camera Company
 organization of, 400
 organization of (Notes), 508
 vs. Eastman Kodak Co., 401
 vs. Eastman Kodak Co., (Notes), 508
Gould, B. A., author (Notes), 483
Gouraud, François, 41, 42, 43
Gouraud, François (Notes), 456, 461
Grand Teton National Park, 302
Graphic, history of New York (Notes), 513
Grant, Professor, 20
Great Eastern, photographs of, 189
Great Falls of the Missouri, early photographs of, 268
Greeley, Horace, quoted, 69
Greely, Gen. A. W., author (Notes), 486

A CATALOGUE OF SELECTED DOVER BOOKS
IN ALL FIELDS OF INTEREST

A CATALOGUE OF SELECTED DOVER BOOKS
IN ALL FIELDS OF INTEREST

LEATHER TOOLING AND CARVING, Chris H. Groneman. One of few books concentrating on tooling and carving, with complete instructions and grid designs for 39 projects ranging from bookmarks to bags. 148 illustrations. 111pp. 7⅞ x 10.
23061-9 Pa. $2.50

THE CODEX NUTTALL, A PICTURE MANUSCRIPT FROM ANCIENT MEXICO, as first edited by Zelia Nuttall. Only inexpensive edition, in full color, of a pre-Columbian Mexican (Mixtec) book. 88 color plates show kings, gods, heroes, temples, sacrifices. New explanatory, historical introduction by Arthur G. Miller. 96pp. 11⅜ x 8½.
23168-2 Pa. $7.50

AMERICAN PRIMITIVE PAINTING, Jean Lipman. Classic collection of an enduring American tradition. 109 plates, 8 in full color—portraits, landscapes, Biblical and historical scenes, etc., showing family groups, farm life, and so on. 80pp. of lucid text. 8⅜ x 11¼.
22815-0 Pa. $4.00

WILL BRADLEY: HIS GRAPHIC ART, edited by Clarence P. Hornung. Striking collection of work by foremost practitioner of Art Nouveau in America: posters, cover designs, sample pages, advertisements, other illustrations. 97 plates, including 8 in full color and 19 in two colors. 97pp. 9⅜ x 12¼.
20701-3 Pa. $4.00
22120-2 Clothbd. $10.00

THE UNDERGROUND SKETCHBOOK OF JAN FAUST, Jan Faust. 101 bitter, horrifying, black-humorous, penetrating sketches on sex, war, greed, various liberations, etc. Sometimes sexual, but not pornographic. Not for prudish. 101pp. 6½ x 9¼.
22740-5 Pa. $1.50

THE GIBSON GIRL AND HER AMERICA, Charles Dana Gibson. 155 finest drawings of effervescent world of 1900-1910: the Gibson Girl and her loves, amusements, adventures, Mr. Pipp, etc. Selected by E. Gillon; introduction by Henry Pitz. 144pp. 8¼ x 11⅜.
21986-0 Pa. $3.50

STAINED GLASS CRAFT, J.A.F. Divine, G. Blachford. One of the very few books that tell the beginner exactly what he needs to know: planning cuts, making shapes, avoiding design weaknesses, fitting glass, etc. 93 illustrations. 115pp.
22812-6 Pa. $1.50

THE BEST DR. THORNDYKE DETECTIVE STORIES, R. Austin Freeman. The Case of Oscar Brodski, The Moabite Cipher, and 5 other favorites featuring the great scientific detective, plus his long-believed-lost first adventure — 31 New Inn — reprinted here for the first time. Edited by E.F. Bleiler. USO 20388-3 Pa. $3.00

BEST "THINKING MACHINE" DETECTIVE STORIES, Jacques Futrelle. The Problem of Cell 13 and 11 other stories about Prof. Augustus S.F.X. Van Dusen, including two "lost" stories. First reprinting of several. Edited by E.F. Bleiler. 241pp.
20537-1 Pa. $3.00

UNCLE SILAS, J. Sheridan LeFanu. Victorian Gothic mystery novel, considered by many best of period, even better than Collins or Dickens. Wonderful psychological terror. Introduction by Frederick Shroyer. 436pp. 21715-9 Pa. $4.00

BEST DR. POGGIOLI DETECTIVE STORIES, T.S. Stribling. 15 best stories from EQMM and The Saint offer new adventures in Mexico, Florida, Tennessee hills as Poggioli unravels mysteries and combats Count Jalacki. 217pp. 23227-1 Pa. $3.00

EIGHT DIME NOVELS, selected with an introduction by E.F. Bleiler. Adventures of Old King Brady, Frank James, Nick Carter, Deadwood Dick, Buffalo Bill, The Steam Man, Frank Merriwell, and Horatio Alger — 1877 to 1905. Important, entertaining popular literature in facsimile reprint, with original covers. 190pp. 9 x 12. 22975-0 Pa. $3.50

ALICE'S ADVENTURES UNDER GROUND, Lewis Carroll. Facsimile of ms. Carroll gave Alice Liddell in 1864. Different in many ways from final Alice. Handlettered, illustrated by Carroll. Introduction by Martin Gardner. 128pp. 21482-6 Pa. $1.50

ALICE IN WONDERLAND COLORING BOOK, Lewis Carroll. Pictures by John Tenniel. Large-size versions of the famous illustrations of Alice, Cheshire Cat, Mad Hatter and all the others, waiting for your crayons. Abridged text. 36 illustrations. 64pp. 8¼ x 11. 22853-3 Pa. $1.50

AVENTURES D'ALICE AU PAYS DES MERVEILLES, Lewis Carroll. Bué's translation of "Alice" into French, supervised by Carroll himself. Novel way to learn language. (No English text.) 42 Tenniel illustrations. 196pp. 22836-3 Pa. $2.00

MYTHS AND FOLK TALES OF IRELAND, Jeremiah Curtin. 11 stories that are Irish versions of European fairy tales and 9 stories from the Fenian cycle — 20 tales of legend and magic that comprise an essential work in the history of folklore. 256pp. 22430-9 Pa. $3.00

EAST O' THE SUN AND WEST O' THE MOON, George W. Dasent. Only full edition of favorite, wonderful Norwegian fairytales — Why the Sea is Salt, Boots and the Troll, etc. — with 77 illustrations by Kittelsen & Werenskiöld. 418pp.
22521-6 Pa. $3.50

PERRAULT'S FAIRY TALES, Charles Perrault and Gustave Doré. Original versions of Cinderella, Sleeping Beauty, Little Red Riding Hood, etc. in best translation, with 34 wonderful illustrations by Gustave Doré. 117pp. 8⅛ x 11. 22311-6 Pa. $2.50

CREATIVE LITHOGRAPHY AND HOW TO DO IT, Grant Arnold. Lithography as art form: working directly on stone, transfer of drawings, lithotint, mezzotint, color printing; also metal plates. Detailed, thorough. 27 illustrations. 214pp.

21208-4 Pa. $3.00

DESIGN MOTIFS OF ANCIENT MEXICO, Jorge Enciso. Vigorous, powerful ceramic stamp impressions — Maya, Aztec, Toltec, Olmec. Serpents, gods, priests, dancers, etc. 153pp. 6$\frac{1}{8}$ x 9$\frac{1}{4}$.

20084-1 Pa. $2.50

AMERICAN INDIAN DESIGN AND DECORATION, Leroy Appleton. Full text, plus more than 700 precise drawings of Inca, Maya, Aztec, Pueblo, Plains, NW Coast basketry, sculpture, painting, pottery, sand paintings, metal, etc. 4 plates in color. 279pp. 8$\frac{3}{8}$ x 11$\frac{1}{4}$.

22704-9 Pa. $4.50

CHINESE LATTICE DESIGNS, Daniel S. Dye. Incredibly beautiful geometric designs: circles, voluted, simple dissections, etc. Inexhaustible source of ideas, motifs. 1239 illustrations. 469pp. 6$\frac{1}{8}$ x 9$\frac{1}{4}$.

23096-1 Pa. $5.00

JAPANESE DESIGN MOTIFS, Matsuya Co. Mon, or heraldic designs. Over 4000 typical, beautiful designs: birds, animals, flowers, swords, fans, geometric; all beautifully stylized. 213pp. 11$\frac{3}{8}$ x 8$\frac{1}{4}$.

22874-6 Pa. $4.95

PERSPECTIVE, Jan Vredeman de Vries. 73 perspective plates from 1604 edition; buildings, townscapes, stairways, fantastic scenes. Remarkable for beauty, surrealistic atmosphere; real eye-catchers. Introduction by Adolf Placzek. 74pp. 11$\frac{3}{8}$ x 8$\frac{1}{4}$.

20186-4 Pa. $2.75

EARLY AMERICAN DESIGN MOTIFS, Suzanne E. Chapman. 497 motifs, designs, from painting on wood, ceramics, appliqué, glassware, samplers, metal work, etc. Florals, landscapes, birds and animals, geometrics, letters, etc. Inexhaustible. Enlarged edition. 138pp. 8$\frac{3}{8}$ x 11$\frac{1}{4}$.

22985-8 Pa. $3.50
23084-8 Clothbd. $7.95

VICTORIAN STENCILS FOR DESIGN AND DECORATION, edited by E.V. Gillon, Jr. 113 wonderful ornate Victorian pieces from German sources; florals, geometrics; borders, corner pieces; bird motifs, etc. 64pp. 9$\frac{3}{8}$ x 12$\frac{1}{4}$.

21995-X Pa. $2.50

ART NOUVEAU: AN ANTHOLOGY OF DESIGN AND ILLUSTRATION FROM THE STUDIO, edited by E.V. Gillon, Jr. Graphic arts: book jackets, posters, engravings, illustrations, decorations; Crane, Beardsley, Bradley and many others. Inexhaustible. 92pp. 8$\frac{1}{8}$ x 11.

22388-4 Pa. $2.50

ORIGINAL ART DECO DESIGNS, William Rowe. First-rate, highly imaginative modern Art Deco frames, borders, compositions, alphabets, florals, insectals, Wurlitzer-types, etc. Much finest modern Art Deco. 80 plates, 8 in color. 8$\frac{3}{8}$ x 11$\frac{1}{4}$.

22567-4 Pa. $3.00

HANDBOOK OF DESIGNS AND DEVICES, Clarence P. Hornung. Over 1800 basic geometric designs based on circle, triangle, square, scroll, cross, etc. Largest such collection in existence. 261pp.

20125-2 Pa. $2.50

MANUAL OF THE TREES OF NORTH AMERICA, Charles S. Sargent. The basic survey of every native tree and tree-like shrub, 717 species in all. Extremely full descriptions, information on habitat, growth, locales, economics, etc. Necessary to every serious tree lover. Over 100 finding keys. 783 illustrations. Total of 986pp.
20277-1, 20278-X Pa., Two vol. set $8.00

BIRDS OF THE NEW YORK AREA, John Bull. Indispensable guide to more than 400 species within a hundred-mile radius of Manhattan. Information on range, status, breeding, migration, distribution trends, etc. Foreword by Roger Tory Peterson. 17 drawings; maps. 540pp.
23222-0 Pa. $6.00

THE SEA-BEACH AT EBB-TIDE, Augusta Foote Arnold. Identify hundreds of marine plants and animals: algae, seaweeds, squids, crabs, corals, etc. Descriptions cover food, life cycle, size, shape, habitat. Over 600 drawings. 490pp.
21949-6 Pa. $4.00

THE MOTH BOOK, William J. Holland. Identify more than 2,000 moths of North America. General information, precise species descriptions. 623 illustrations plus 48 color plates show almost all species, full size. 1968 edition. Still the basic book. Total of 551pp. 6½ x 9¼.
21948-8 Pa. $6.00

AN INTRODUCTION TO THE REPTILES AND AMPHIBIANS OF THE UNITED STATES, Percy A. Morris. All lizards, crocodiles, turtles, snakes, toads, frogs; life history, identification, habits, suitability as pets, etc. Non-technical, but sound and broad. 130 photos. 253pp.
22982-3 Pa. $3.00

OLD NEW YORK IN EARLY PHOTOGRAPHS, edited by Mary Black. Your only chance to see New York City as it was 1853-1906, through 196 wonderful photographs from N.Y. Historical Society. Great Blizzard, Lincoln's funeral procession, great buildings. 228pp. 9 x 12.
22907-6 Pa. $6.00

THE AMERICAN REVOLUTION, A PICTURE SOURCEBOOK, John Grafton. Wonderful Bicentennial picture source, with 411 illustrations (contemporary and 19th century) showing battles, personalities, maps, events, flags, posters, soldier's life, ships, etc. all captioned and explained. A wonderful browsing book, supplement to other historical reading. 160pp. 9 x 12.
23226-3 Pa. $4.00

PERSONAL NARRATIVE OF A PILGRIMAGE TO AL-MADINAH AND MECCAH, Richard Burton. Great travel classic by remarkably colorful personality. Burton, disguised as a Moroccan, visited sacred shrines of Islam, narrowly escaping death. Wonderful observations of Islamic life, customs, personalities. 47 illustrations. Total of 959pp.
21217-3, 21218-1 Pa., Two vol. set $7.00

INCIDENTS OF TRAVEL IN CENTRAL AMERICA, CHIAPAS, AND YUCATAN, John L. Stephens. Almost single-handed discovery of Maya culture; exploration of ruined cities, monuments, temples; customs of Indians. 115 drawings. 892pp.
22404-X, 22405-8 Pa., Two vol. set $8.00

MODERN CHESS STRATEGY, Ludek Pachman. The use of the queen, the active king, exchanges, pawn play, the center, weak squares, etc. Section on rook alone worth price of the book. Stress on the moderns. Often considered the most important book on strategy. 314pp. 20290-9 Pa. $3.00

CHESS STRATEGY, Edward Lasker. One of half-dozen great theoretical works in chess, shows principles of action above and beyond moves. Acclaimed by Capablanca, Keres, etc. 282pp. USO 20528-2 Pa. $2.50

CHESS PRAXIS, THE PRAXIS OF MY SYSTEM, Aron Nimzovich. Founder of hypermodern chess explains his profound, influential theories that have dominated much of 20th century chess. 109 illustrative games. 369pp. 20296-8 Pa. $3.50

HOW TO PLAY THE CHESS OPENINGS, Eugene Znosko-Borovsky. Clear, profound examinations of just what each opening is intended to do and how opponent can counter. Many sample games, questions and answers. 147pp. 22795-2 Pa. $2.00

THE ART OF CHESS COMBINATION, Eugene Znosko-Borovsky. Modern explanation of principles, varieties, techniques and ideas behind them, illustrated with many examples from great players. 212pp. 20583-5 Pa. $2.00

COMBINATIONS: THE HEART OF CHESS, Irving Chernev. Step-by-step explanation of intricacies of combinative play. 356 combinations by Tarrasch, Botvinnik, Keres, Steinitz, Anderssen, Morphy, Marshall, Capablanca, others, all annotated. 245 pp. 21744-2 Pa. $2.50

HOW TO PLAY CHESS ENDINGS, Eugene Znosko-Borovsky. Thorough instruction manual by fine teacher analyzes each piece individually; many common endgame situations. Examines games by Steinitz, Alekhine, Lasker, others. Emphasis on understanding. 288pp. 21170-3 Pa. $2.75

MORPHY'S GAMES OF CHESS, Philip W. Sergeant. Romantic history, 54 games of greatest player of all time against Anderssen, Bird, Paulsen, Harrwitz; 52 games at odds; 52 blindfold; 100 consultation, informal, other games. Analyses by Anderssen, Steinitz, Morphy himself. 352pp. 20386-7 Pa. $2.75

500 MASTER GAMES OF CHESS, S. Tartakower, J. du Mont. Vast collection of great chess games from 1798-1938, with much material nowhere else readily available. Fully annotated, arranged by opening for easier study. 665pp. 23208-5 Pa. $6.00

THE SOVIET SCHOOL OF CHESS, Alexander Kotov and M. Yudovich. Authoritative work on modern Russian chess. History, conceptual background. 128 fully annotated games (most unavailable elsewhere) by Botvinnik, Keres, Smyslov, Tal, Petrosian, Spassky, more. 390pp. 20026-4 Pa. $3.95

WONDERS AND CURIOSITIES OF CHESS, Irving Chernev. A lifetime's accumulation of such wonders and curiosities as the longest won game, shortest game, chess problem with mate in 1220 moves, and much more unusual material —356 items in all, over 160 complete games. 146 diagrams. 203pp. 23007-4 Pa. $3.50

EARLY NEW ENGLAND GRAVESTONE RUBBINGS, Edmund V. Gillon, Jr. 43 photographs, 226 rubbings show heavily symbolic, macabre, sometimes humorous primitive American art. Up to early 19th century. 207pp. 8⅜ x 11¼.
21380-3 Pa. $4.00

L.J.M. DAGUERRE: THE HISTORY OF THE DIORAMA AND THE DAGUERREOTYPE, Helmut and Alison Gernsheim. Definitive account. Early history, life and work of Daguerre; discovery of daguerreotype process; diffusion abroad; other early photography. 124 illustrations. 226pp. 6⅙ x 9¼.
22290-X Pa. $4.00

PHOTOGRAPHY AND THE AMERICAN SCENE, Robert Taft. The basic book on American photography as art, recording form, 1839-1889. Development, influence on society, great photographers, types (portraits, war, frontier, etc.), whatever else needed. Inexhaustible. Illustrated with 322 early photos, daguerreotypes, tintypes, stereo slides, etc. 546pp. 6⅛ x 9¼.
21201-7 Pa. $5.00

PHOTOGRAPHIC SKETCHBOOK OF THE CIVIL WAR, Alexander Gardner. Reproduction of 1866 volume with 100 on-the-field photographs: Manassas, Lincoln on battlefield, slave pens, etc. Introduction by E.F. Bleiler. 224pp. 10¾ x 9.
22731-6 Pa. $4.50

THE MOVIES: A PICTURE QUIZ BOOK, Stanley Appelbaum & Hayward Cirker. Match stars with their movies, name actors and actresses, test your movie skill with 241 stills from 236 great movies, 1902-1959. Indexes of performers and films. 128pp. 8⅜ x 9¼.
20222-4 Pa. $2.50

THE TALKIES, Richard Griffith. Anthology of features, articles from Photoplay, 1928-1940, reproduced complete. Stars, famous movies, technical features, fabulous ads, etc.; Garbo, Chaplin, King Kong, Lubitsch, etc. 4 color plates, scores of illustrations. 327pp. 8⅜ x 11¼.
22762-6 Pa. $5.95

THE MOVIE MUSICAL FROM VITAPHONE TO "42ND STREET," edited by Miles Kreuger. Relive the rise of the movie musical as reported in the pages of Photoplay magazine (1926-1933): every movie review, cast list, ad, and record review; every significant feature article, production still, biography, forecast, and gossip story. Profusely illustrated. 367pp. 8⅜ x 11¼.
23154-2 Pa. $6.95

JOHANN SEBASTIAN BACH, Philipp Spitta. Great classic of biography, musical commentary, with hundreds of pieces analyzed. Also good for Bach's contemporaries. 450 musical examples. Total of 1799pp.
EUK 22278-0, 22279-9 Clothbd., Two vol. set $25.00

BEETHOVEN AND HIS NINE SYMPHONIES, Sir George Grove. Thorough history, analysis, commentary on symphonies and some related pieces. For either beginner or advanced student. 436 musical passages. 407pp.
20334-4 Pa. $4.00

MOZART AND HIS PIANO CONCERTOS, Cuthbert Girdlestone. The only full-length study. Detailed analyses of all 21 concertos, sources; 417 musical examples. 509pp.
21271-8 Pa. $4.50

THE FITZWILLIAM VIRGINAL BOOK, edited by J. Fuller Maitland, W.B. Squire. Famous early 17th century collection of keyboard music, 300 works by Morley, Byrd, Bull, Gibbons, etc. Modern notation. Total of 938pp. 8⅜ x 11.
ECE 21068-5, 21069-3 Pa., Two vol. set $12.00

COMPLETE STRING QUARTETS, Wolfgang A. Mozart. Breitkopf and Härtel edition. All 23 string quartets plus alternate slow movement to K156. Study score. 277pp. 9⅜ x 12¼.
22372-8 Pa. $6.00

COMPLETE SONG CYCLES, Franz Schubert. Complete piano, vocal music of Die Schöne Müllerin, Die Winterreise, Schwanengesang. Also Drinker English singing translations. Breitkopf and Härtel edition. 217pp. 9⅜ x 12¼.
22649-2 Pa. $4.00

THE COMPLETE PRELUDES AND ETUDES FOR PIANOFORTE SOLO, Alexander Scriabin. All the preludes and etudes including many perfectly spun miniatures. Edited by K.N. Igumnov and Y.I. Mil'shteyn. 250pp. 9 x 12.
22919-X Pa. $5.00

TRISTAN UND ISOLDE, Richard Wagner. Full orchestral score with complete instrumentation. Do not confuse with piano reduction. Commentary by Felix Mottl, great Wagnerian conductor and scholar. Study score. 655pp. 8⅛ x 11.
22915-7 Pa. $10.00

FAVORITE SONGS OF THE NINETIES, ed. Robert Fremont. Full reproduction, including covers, of 88 favorites: Ta-Ra-Ra-Boom-De-Aye, The Band Played On, Bird in a Gilded Cage, Under the Bamboo Tree, After the Ball, etc. 401pp. 9 x 12.
EBE 21536-9 Pa. $6.95

SOUSA'S GREAT MARCHES IN PIANO TRANSCRIPTION: ORIGINAL SHEET MUSIC OF 23 WORKS, John Philip Sousa. Selected by Lester S. Levy. Playing edition includes: The Stars and Stripes Forever, The Thunderer, The Gladiator, King Cotton, Washington Post, much more. 24 illustrations. 111pp. 9 x 12.
USO 23132-1 Pa. $3.50

CLASSIC PIANO RAGS, selected with an introduction by Rudi Blesh. Best ragtime music (1897-1922) by Scott Joplin, James Scott, Joseph F. Lamb, Tom Turpin, 9 others. Printed from best original sheet music, plus covers. 364pp. 9 x 12.
EBE 20469-3 Pa. $6.95

ANALYSIS OF CHINESE CHARACTERS, C.D. Wilder, J.H. Ingram. 1000 most important characters analyzed according to primitives, phonetics, historical development. Traditional method offers mnemonic aid to beginner, intermediate student of Chinese, Japanese. 365pp.
23045-7 Pa. $4.00

MODERN CHINESE: A BASIC COURSE, Faculty of Peking University. Self study, classroom course in modern Mandarin. Records contain phonetics, vocabulary, sentences, lessons. 249 page book contains all recorded text, translations, grammar, vocabulary, exercises. Best course on market. 3 12" 33⅓ monaural records, book, album.
98832-5 Set $12.50

MOTHER GOOSE'S MELODIES. Facsimile of fabulously rare Munroe and Francis "copyright 1833" Boston edition. Familiar and unusual rhymes, wonderful old woodcut illustrations. Edited by E.F. Bleiler. 128pp. 4½ x 6⅜. 22577-1 Pa. $1.00

MOTHER GOOSE IN HIEROGLYPHICS. Favorite nursery rhymes presented in rebus form for children. Fascinating 1849 edition reproduced in toto, with key. Introduction by E.F. Bleiler. About 400 woodcuts. 64pp. 6⅞ x 5¼. 20745-5 Pa. $1.00

PETER PIPER'S PRACTICAL PRINCIPLES OF PLAIN & PERFECT PRONUNCIATION. Alliterative jingles and tongue-twisters. Reproduction in full of 1830 first American edition. 25 spirited woodcuts. 32pp. 4½ x 6⅜. 22560-7 Pa. $1.00

MARMADUKE MULTIPLY'S MERRY METHOD OF MAKING MINOR MATHEMATICIANS. Fellow to Peter Piper, it teaches multiplication table by catchy rhymes and woodcuts. 1841 Munroe & Francis edition. Edited by E.F. Bleiler. 103pp. 4⅝ x 6.
22773-1 Pa. $1.25
20171-6 Clothbd. $3.00

THE NIGHT BEFORE CHRISTMAS, Clement Moore. Full text, and woodcuts from original 1848 book. Also critical, historical material. 19 illustrations. 40pp. 4⅝ x 6. 22797-9 Pa. $1.00

THE KING OF THE GOLDEN RIVER, John Ruskin. Victorian children's classic of three brothers, their attempts to reach the Golden River, what becomes of them. Facsimile of original 1889 edition. 22 illustrations. 56pp. 4⅝ x 6⅜.
20066-3 Pa. $1.25

DREAMS OF THE RAREBIT FIEND, Winsor McCay. Pioneer cartoon strip, unexcelled for beauty, imagination, in 60 full sequences. Incredible technical virtuosity, wonderful visual wit. Historical introduction. 62pp. 8⅜ x 11¼. 21347-1 Pa. $2.00

THE KATZENJAMMER KIDS, Rudolf Dirks. In full color, 14 strips from 1906-7; full of imagination, characteristic humor. Classic of great historical importance. Introduction by August Derleth. 32pp. 9¼ x 12¼. 23005-8 Pa. $2.00

LITTLE ORPHAN ANNIE AND LITTLE ORPHAN ANNIE IN COSMIC CITY, Harold Gray. Two great sequences from the early strips: our curly-haired heroine defends the Warbucks' financial empire and, then, takes on meanie Phineas P. Pinchpenny. Leapin' lizards! 178pp. 6⅛ x 8⅜. 23107-0 Pa. $2.00

WHEN A FELLER NEEDS A FRIEND, Clare Briggs. 122 cartoons by one of the greatest newspaper cartoonists of the early 20th century — about growing up, making a living, family life, daily frustrations and occasional triumphs. 121pp. 8½ x 9½.
23148-8 Pa. $2.50

THE BEST OF GLUYAS WILLIAMS. 100 drawings by one of America's finest cartoonists: The Day a Cake of Ivory Soap Sank at Proctor & Gamble's, At the Life Insurance Agents' Banquet, and many other gems from the 20's and 30's. 118pp. 8⅜ x 11¼. 22737-5 Pa. $2.50

SLEEPING BEAUTY, illustrated by Arthur Rackham. Perhaps the fullest, most delightful version ever, told by C.S. Evans. Rackham's best work. 49 illustrations. 110pp. 7⅞ x 10¾. 22756-1 Pa. $2.00

THE WONDERFUL WIZARD OF OZ, L. Frank Baum. Facsimile in full color of America's finest children's classic. Introduction by Martin Gardner. 143 illustrations by W.W. Denslow. 267pp. 20691-2 Pa. $2.50

GOOPS AND HOW TO BE THEM, Gelett Burgess. Classic tongue-in-cheek masquerading as etiquette book. 87 verses, 170 cartoons as Goops demonstrate virtues of table manners, neatness, courtesy, more. 88pp. 6½ x 9¼.
22233-0 Pa. $1.50

THE BROWNIES, THEIR BOOK, Palmer Cox. Small as mice, cunning as foxes, exuberant, mischievous, Brownies go to zoo, toy shop, seashore, circus, more. 24 verse adventures. 266 illustrations. 144pp. 6⅝ x 9¼. 21265-3 Pa. $1.75

BILLY WHISKERS: THE AUTOBIOGRAPHY OF A GOAT, Frances Trego Montgomery. Escapades of that rambunctious goat. Favorite from turn of the century America. 24 illustrations. 259pp. 22345-0 Pa. $2.75

THE ROCKET BOOK, Peter Newell. Fritz, janitor's kid, sets off rocket in basement of apartment house; an ingenious hole punched through every page traces course of rocket. 22 duotone drawings, verses. 48pp. 6⅞ x 8⅜. 22044-3 Pa. $1.50

PECK'S BAD BOY AND HIS PA, George W. Peck. Complete double-volume of great American childhood classic. Hennery's ingenious pranks against outraged pomposity of pa and the grocery man. 97 illustrations. Introduction by E.F. Bleiler. 347pp. 20497-9 Pa. $2.50

THE TALE OF PETER RABBIT, Beatrix Potter. The inimitable Peter's terrifying adventure in Mr. McGregor's garden, with all 27 wonderful, full-color Potter illustrations. 55pp. 4¼ x 5½. USO 22827-4 Pa. $1.00

THE TALE OF MRS. TIGGY-WINKLE, Beatrix Potter. Your child will love this story about a very special hedgehog and all 27 wonderful, full-color Potter illustrations. 57pp. 4¼ x 5½. USO 20546-0 Pa. $1.00

THE TALE OF BENJAMIN BUNNY, Beatrix Potter. Peter Rabbit's cousin coaxes him back into Mr. McGregor's garden for a whole new set of adventures. A favorite with children. All 27 full-color illustrations. 59pp. 4¼ x 5½.
USO 21102-9 Pa. $1.00

THE MERRY ADVENTURES OF ROBIN HOOD, Howard Pyle. Facsimile of original (1883) edition, finest modern version of English outlaw's adventures. 23 illustrations by Pyle. 296pp. 6½ x 9¼. 22043-5 Pa. $2.75

TWO LITTLE SAVAGES, Ernest Thompson Seton. Adventures of two boys who lived as Indians; explaining Indian ways, woodlore, pioneer methods. 293 illustrations. 286pp. 20985-7 Pa. $3.00

150 MASTERPIECES OF DRAWING, edited by Anthony Toney. 150 plates, early 15th century to end of 18th century; Rembrandt, Michelangelo, Dürer, Fragonard, Watteau, Wouwerman, many others. 150pp. 8⅜ x 11¼. 21032-4 Pa. $3.50

THE GOLDEN AGE OF THE POSTER, Hayward and Blanche Cirker. 70 extraordinary posters in full colors, from Maîtres de l'Affiche, Mucha, Lautrec, Bradley, Cheret, Beardsley, many others. 9⅜ x 12¼. 22753-7 Pa. $4.95
21718-3 Clothbd. $7.95

SIMPLICISSIMUS, selection, translations and text by Stanley Appelbaum. 180 satirical drawings, 16 in full color, from the famous German weekly magazine in the years 1896 to 1926. 24 artists included: Grosz, Kley, Pascin, Kubin, Kollwitz, plus Heine, Thöny, Bruno Paul, others. 172pp. 8½ x 12¼. 23098-8 Pa. $5.00
23099-6 Clothbd. $10.00

THE EARLY WORK OF AUBREY BEARDSLEY, Aubrey Beardsley. 157 plates, 2 in color: Manon Lescaut, Madame Bovary, Morte d'Arthur, Salome, other. Introduction by H. Marillier. 175pp. 8½ x 11. 21816-3 Pa. $3.50

THE LATER WORK OF AUBREY BEARDSLEY, Aubrey Beardsley. Exotic masterpieces of full maturity: Venus and Tannhäuser, Lysistrata, Rape of the Lock, Volpone, Savoy material, etc. 174 plates, 2 in color. 176pp. 8½ x 11. 21817-1 Pa. $3.75

DRAWINGS OF WILLIAM BLAKE, William Blake. 92 plates from Book of Job, Divine Comedy, Paradise Lost, visionary heads, mythological figures, Laocoön, etc. Selection, introduction, commentary by Sir Geoffrey Keynes. 178pp. 8½ x 11.
22303-5 Pa. $3.50

LONDON: A PILGRIMAGE, Gustave Doré, Blanchard Jerrold. Squalor, riches, misery, beauty of mid-Victorian metropolis; 55 wonderful plates, 125 other illustrations, full social, cultural text by Jerrold. 191pp. of text. 8⅛ x 11.
22306-X Pa. $5.00

THE COMPLETE WOODCUTS OF ALBRECHT DÜRER, edited by Dr. W. Kurth. 346 in all: Old Testament, St. Jerome, Passion, Life of Virgin, Apocalypse, many others. Introduction by Campbell Dodgson. 285pp. 8½ x 12¼. 21097-9 Pa. $6.00

THE DISASTERS OF WAR, Francisco Goya. 83 etchings record horrors of Napoleonic wars in Spain and war in general. Reprint of 1st edition, plus 3 additional plates. Introduction by Philip Hofer. 97pp. 9⅜ x 8¼. 21872-4 Pa. $2.50

ENGRAVINGS OF HOGARTH, William Hogarth. 101 of Hogarth's greatest works: Rake's Progress, Harlot's Progress, Illustrations for Hudibras, Midnight Modern Conversation, Before and After, Beer Street and Gin Lane, many more. Full commentary. 256pp. 11 x 14. 22479-1 Pa. $6.00
23023-6 Clothbd. $13.50

PRIMITIVE ART, Franz Boas. Great anthropologist on ceramics, textiles, wood, stone, metal, etc.; patterns, technology, symbols, styles. All areas, but fullest on Northwest Coast Indians. 350 illustrations. 378pp. 20025-6 Pa. $3.50

THE JOURNAL OF HENRY D. THOREAU, edited by Bradford Torrey, F.H. Allen. Complete reprinting of 14 volumes, 1837-1861, over two million words; the source-books for Walden, etc. Definitive. All original sketches, plus 75 photographs. Introduction by Walter Harding. Total of 1804pp. 8½ x 12¼.
20312-3, 20313-1 Clothbd., Two vol. set $50.00

MASTERS OF THE DRAMA, John Gassner. Most comprehensive history of the drama, every tradition from Greeks to modern Europe and America, including Orient. Covers 800 dramatists, 2000 plays; biography, plot summaries, criticism, theatre history, etc. 77 illustrations. 890pp. 20100-7 Clothbd. $10.00

GHOST AND HORROR STORIES OF AMBROSE BIERCE, Ambrose Bierce. 23 modern horror stories: The Eyes of the Panther, The Damned Thing, etc., plus the dream-essay Visions of the Night. Edited by E.F. Bleiler. 199pp. 20767-6 Pa. $2.00

BEST GHOST STORIES, Algernon Blackwood. 13 great stories by foremost British 20th century supernaturalist. The Willows, The Wendigo, Ancient Sorceries, others. Edited by E.F. Bleiler. 366pp. USO 22977-7 Pa. $3.00

THE BEST TALES OF HOFFMANN, E.T.A. Hoffmann. 10 of Hoffmann's most important stories, in modern re-editings of standard translations: Nutcracker and the King of Mice, The Golden Flowerpot, etc. 7 illustrations by Hoffmann. Edited by E.F. Bleiler. 458pp. 21793-0 Pa. $3.95

BEST GHOST STORIES OF J.S. LEFANU, J. Sheridan LeFanu. 16 stories by greatest Victorian master: Green Tea, Carmilla, Haunted Baronet, The Familiar, etc. Mostly unavailable elsewhere. Edited by E.F. Bleiler. 8 illustrations. 467pp.
20415-4 Pa. $4.00

SUPERNATURAL HORROR IN LITERATURE, H.P. Lovecraft. Great modern American supernaturalist brilliantly surveys history of genre to 1930's, summarizing, evaluating scores of books. Necessary for every student, lover of form. Introduction by E.F. Bleiler. 111pp. 20105-8 Pa. $1.50

THREE GOTHIC NOVELS, ed. by E.F. Bleiler. Full texts Castle of Otranto, Walpole; Vathek, Beckford; The Vampyre, Polidori; Fragment of a Novel, Lord Byron. 331pp. 21232-7 Pa. $3.00

SEVEN SCIENCE FICTION NOVELS, H.G. Wells. Full novels. First Men in the Moon, Island of Dr. Moreau, War of the Worlds, Food of the Gods, Invisible Man, Time Machine, In the Days of the Comet. A basic science-fiction library. 1015pp.
USO 20264-X Clothbd. $6.00

LADY AUDLEY'S SECRET, Mary E. Braddon. Great Victorian mystery classic, beautifully plotted, suspenseful; praised by Thackeray, Boucher, Starrett, others. What happened to beautiful, vicious Lady Audley's husband? Introduction by Norman Donaldson. 286pp. 23011-2 Pa. $3.00

BUILD YOUR OWN LOW-COST HOME, L.O. Anderson, H.F. Zornig. U.S. Dept. of Agriculture sets of plans, full, detailed, for 11 houses: A-Frame, circular, conventional. Also construction manual. Save hundreds of dollars. 204pp. 11 x 16.
21525-3 Pa. $5.95

HOW TO BUILD A WOOD-FRAME HOUSE, L.O. Anderson. Comprehensive, easy to follow U.S. Government manual: placement, foundations, framing, sheathing, roof, insulation, plaster, finishing — almost everything else. 179 illustrations. 223pp. 7⅞ x 10¾.
22954-8 Pa. $3.50

CONCRETE, MASONRY AND BRICKWORK, U.S. Department of the Army. Practical handbook for the home owner and small builder, manual contains basic principles, techniques, and important background information on construction with concrete, concrete blocks, and brick. 177 figures, 37 tables. 200pp. 6½ x 9¼.
23203-4 Pa. $4.00

THE STANDARD BOOK OF QUILT MAKING AND COLLECTING, Marguerite Ickis. Full information, full-sized patterns for making 46 traditional quilts, also 150 other patterns. Quilted cloths, lamé, satin quilts, etc. 483 illustrations. 273pp. 6⅞ x 9⅝.
20582-7 Pa. $3.50

101 PATCHWORK PATTERNS, Ruby S. McKim. 101 beautiful, immediately useable patterns, full-size, modern and traditional. Also general information, estimating, quilt lore. 124pp. 7⅞ x 10¾.
20773-0 Pa. $2.50

KNIT YOUR OWN NORWEGIAN SWEATERS, Dale Yarn Company. Complete instructions for 50 authentic sweaters, hats, mittens, gloves, caps, etc. Thoroughly modern designs that command high prices in stores. 24 patterns, 24 color photographs. Nearly 100 charts and other illustrations. 58pp. 8⅜ x 11¼.
23031-7 Pa. $2.50

IRON-ON TRANSFER PATTERNS FOR CREWEL AND EMBROIDERY FROM EARLY AMERICAN SOURCES, edited by Rita Weiss. 75 designs, borders, alphabets, from traditional American sources printed on translucent paper in transfer ink. Reuseable. Instructions. Test patterns. 24pp. 8¼ x 11.
23162-3 Pa. $1.50

AMERICAN INDIAN NEEDLEPOINT DESIGNS FOR PILLOWS, BELTS, HANDBAGS AND OTHER PROJECTS, Roslyn Epstein. 37 authentic American Indian designs adapted for modern needlepoint projects. Grid backing makes designs easily transferable to canvas. 48pp. 8¼ x 11.
22973-4 Pa. $1.50

CHARTED FOLK DESIGNS FOR CROSS-STITCH EMBROIDERY, Maria Foris & Andreas Foris. 278 charted folk designs, most in 2 colors, from Danube region: florals, fantastic beasts, geometrics, traditional symbols, more. Border and central patterns. 77pp. 8¼ x 11.
USO 23191-7 Pa. $2.00